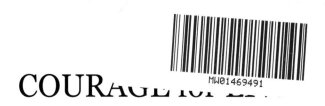

# COURAGE ~~~ ~~

featuring

# HARRIET VIRGINIA MAXWELL OVERTON

The Second First Lady of Travellers Rest Plantation
Nashville, Tennessee
1832-1899

By
Thomas Lee Clark

PUBLISHED BY WESTVIEW, INC., NASHVILLE, TENNESSEE

PUBLISHED BY WESTVIEW, INC.
P.O. Box 210183
Nashville, Tennessee 37221
www.publishedbywestview.com

Photographs are courtesy of Travellers Rest Plantation and Museum.
www.travellersrestplantation.org

This book is a work of historical fiction. Personalities, events, conversations, and written communications have been embellished to tell the story.

ISBN 978-1-935271-97-0

First edition, September 2011

Printed in the United States of America on acid free paper.

# COURAGE for LIVING

*Live with Courage!*

*Thomas L. Clark*

What though the field be lost?
All is not lost; th' unconquerable will,
And study of revenge, immortal hate,
And courage never to submit or yield.

Milton, *Paradise Lost* (1667)

John and Harriet
after the Civil War

# Table of Contents

# GENEALOGY

John Overton II married (1841) Rachel Harding
↓
John Overton III

James Overton                                                      Jesse Maxwell
   Judge John Overton                                      Jesse Maxwell
Mary Waller                                                        Anne Armstrong

## John Overton II married (1850) Harriet Virginia Maxwell

James White                                                       George R. Claiborne
   Mary McConnell White*                       Martha Revenscroft Claiborne
Mary Lawson                                                       Anna Robinson

Children of John Overton II and Harriet Virginia Maxwell:
↓
Martha Maxwell Overton married Jacob McGavock Dickinson
Jackson May Overton married Nannie Hensley
Mary McConnell Overton married John Thompson
Elizabeth Lea Overton married Hugh L. Craighead / W.G. Ewing
Jesse Maxwell Overton married Saidee Gladys Cheney Williams
Robert Lee Overton married Nancy Hamilton Baxter

*Before marrying Judge John Overton, Mary McConnell White
was previously married to Francis May. Five children were born to this union:
↓
Anthony F. May
Andrew Jackson May
Mary Lawson May married Richard H. Barry
James F. May married Eliza F. Perkins
Mary Jane May married Jesse H. Phillips

John Overton II had two younger siblings:
Ann Coleman Overton married Robert C. Brinkley
Elizabeth Belle Overton married John M. Lea

Harriet Virginia Maxwell had two older siblings:
Annie A. Maxwell married Thomas B. Claiborne
Mary Elizabeth Maxwell

Harriet M. Overton

John Overton II with
Overton Dickinson and John Thompson

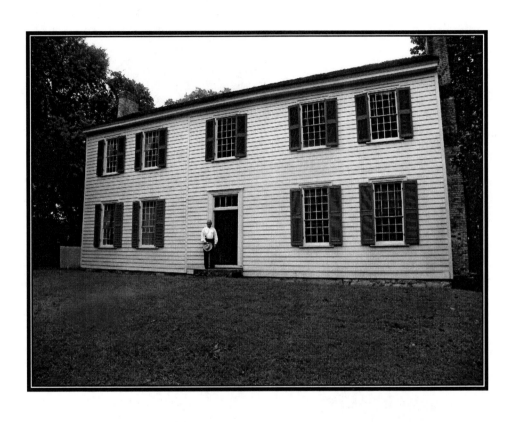

# Acknowledgments

I read somewhere, "No one ever writes a book alone." Two thoughts about the statement are important to me. First, I cannot thank the person enough who wrote those words of wisdom. In like fashion, many of the thoughts and ideas in this book were shared with me by others—some verbal; some in written form. If you find your thoughts on my pages, I hereby acknowledge you for your contribution.

Second, I have written, discussed what I wrote, and then, rewrote. I acknowledge the scores of folk who have had to endure my banter, especially those at Travellers Rest. Your wisdom helped with the rewrites to make this book better.

The staff at Travellers Rest has been gracious to make available to me the historical documents of people and events related to the plantation. Reading firsthand accounts, in diary format, has added depth and personality to Harriet. Researching materials from the library and files have been a special gift for understanding the Overton family.

For Melody G. McCoy, *mon amie. Merci beaucoup. Je t'aime bien.* Her valuable suggestions are appreciated.

A special word of gratitude to the ladies of the Colonial Dames of America in Tennessee, whose foresight and involvement keep the historical Travellers Rest Plantation open to the public. Their efforts for decades have allowed many to experience and share their passion—a living history for all to enjoy. The Board members at Travellers Rest keep the dream alive by giving countless hours to meetings and supporting programs. Their encouragement of the employees is wonderful.

Judge John Overton named his home Travelers Rest. Years later, the name was changed to Travellers Rest. I've used the extra "l" throughout.

To the relatives of Harriet Virginia Maxwell Overton, I acknowledge your understanding of her. I have put thoughts in her head and words on her lips to tell her story. She was a lady of great courage in a turbulent time of Nashville's history. She stayed apprised of the events happening in her world and had a zest for living. I have spent countless hours standing on the same floors she walked on (and maybe stomped) and looked out windows she used. I have made an honest effort to be in her world for several years of researching and writing. I continue to be amazed at Harriet—the second first lady of Travellers Rest.

Finally, to my family and friends who encouraged me, thank you. A special word of gratitude to my wonderful Darlene, who kept me moving forward on the manuscript. She read every word, reacted to every idea, and questioned everything. Her name should be next to mine, but she would not allow it.

Thomas Lee Clark
2011

# Prologue

What is there in a person's background or makeup that causes them to appear on the stage of history at the exact moment they are needed? How is it that some individuals wilt in the face of adversity while others bloom? Why is it that some folk hide their talents in fear while others bravely step forward and provide leadership and direction? Whatever the answers are for the majority of us, Harriet Virginia Maxwell Overton (1832-1899) had the correct answers for herself. From the very depth of her being, she called forth the needed resources to meet the challenges life set before her.

In life, we do not stand on the stage alone; nor did Harriet. She was caught up in the drama of the Civil War in and around Nashville, Tennessee. She made hard decisions and lived with life-changing adjustments as the war neared and then overtook Nashville. The postwar era on the Travellers Rest plantation brought tears at times; laughter at other times; but always challenges. The backdrop for Harriet's life drama was always the effects of the war on her marriage, her family, and her personally. Details of these and other events are unfolded on the following pages.

Harriet Overton's stage was filled with wonderful personalities. They will make appearances as her drama unfolds. The flow of her story will be enhanced by looking briefly at these personalities in Harriet's life.

**Jesse Maxwell** (1741-1821) and his brother, David, came to what is now Middle Tennessee (at the time the land was still within North Carolina's boundary) to claim land given to them for their service at the Battle of King's Mountain in the American Revolution. Each brother was given a tract of land (640 acres) which they combined into one large holding. Jesse married **Annie Armstrong** (1762-1848) and built the family home, Maxwell Hall. George R. Claiborne (1782-1838) and Annie Robinson (1883-1852) are Harriet's other grandparents.

**Jesse Maxwell** (1796-1856) was the son of Jesse and Annie Maxwell. He married **Martha Ravenscroft Claiborne** (1809-1845) in 1827. These are Harriet's parents. Jesse inherited Maxwell Hall. After the death of Martha, Jesse married **Myra Rucker** in 1847.

**Annie Armstrong Maxwell Claiborne** is Harriet's oldest sibling, born in 1828. She married **Thomas B. Claiborne**. Thomas served in the United States Army stationed in Texas. When Tennessee joined the Confederacy, Thomas resigned his commission, came east with his family, and joined the Confederate Army. Annie and her two girls, **Mary "Mollie" Maxwell** born in 1855 and **Harriet Overton** born in 1857, lived with Harriet at Travellers Rest during the war.

**Mary Elizabeth Maxwell** is the middle sister. born in 1829. She also lived at Travellers Rest during the war.

**Jesse Maxwell** is Harriet's younger brother born in 1845 and died in infancy.

**John Overton** (1766-1833) was born in Virginia, studied law in Kentucky, and moved to what is now Nashville in 1789. He met and became a law partner with Andrew Jackson. They were close friends until John's death. In 1796, Tennessee was admitted into the Union as the 16th state. That same year John bought 320 acres of land from the Maxwells. By 1799, the first unit of Travellers Rest was completed.

As statehood came, John was named Judge of the State Supreme Court; and by 1804 he was Judge of the Superior Court of Tennessee. He retired from the Court in 1816 and moved to Travellers Rest as his permanent residence. By this time, a second unit (two rooms) had been added to his home. In 1820, John was 54 years old and married a widow, **Mary McConnell White May**. Together, they had three children: **John Overton Junior** born in 1821, **Ann** born in 1823, and **Elizabeth** born in 1826.

**Mary McConnell White May Overton** was born in 1882 at White's Fort, now known as Knoxville, Tennessee. She married Dr. Francis May. Five children were born into this union: Anthony born in 1801, Andrew Jackson born in 1802, Mary born in 1806, James Francis born in 1812, and Margaret Jane born in 1816. After serving as Andrew Jackson's physician and surgeon at the Battle of New Orleans, Dr. May died in 1817. Mary was left a widow with five children to rear. At the age of 37, in 1820, she became the bride of Judge **John Overton** and became the First Lady of Travellers Rest. She died there in 1862 at age 80.

**John Overton II** was born into luxury. Before he hit his teenage years, he was sent away from the plantation for formal education. In the Judge's words, "My only son John . . . went to New Orleans early in November to School there to learn the French and Spanish languages. He is considered a promising boy of his age . . . . He was smartly advanced in the Latin language before he left us, and will continue to say one Latin lesson a day . . . I wish you could see him; he is a tall healthy looking boy, very sensitive, kind and unassuming."

After the death of the Judge in 1833, John Junior spent years learning to manage the plantation from his mother. After her death in 1862, he became the sole owner of Travellers Rest. In 1842, John married Rachel Harding. She gave birth to John Overton III and soon after died, leaving John a widower with an infant child. In 1850, John married his neighbor, Harriet Virginia Maxwell.

John was a farmer but had a flair for business adventures. He macadamized the road surface of the part of Franklin Pike that ran through his property and created a toll road. By the early 1850s, he negotiated a railway line on his property that connected Nashville with northern Alabama. He continued to

purchase land and add to his holdings. On one occasion he, thinking he was buying an animal, instead had purchased a lot in downtown Nashville. He determined to build a first-class hotel on the lot. Although the hotel project was underway, construction of the upper floors was delayed for several years due to the Civil War.

In February 1862, Nashville was captured by Federal troops and life as John had known it came to a screeching halt. By March, Andrew Johnson was in the city serving as the Military Governor with full power to bring the citizens of Tennessee to their knees. It was a well-known fact that John was a monetary supporter of the Confederate government. That fact was used by Governor Johnson to issue an arrest warrant for him. He would be required to sign an oath of allegiance to the United States. Before the warrant could be delivered, John left the plantation and went south to safer surroundings.

For his financial aid and his personal connections throughout the south to raise money for the Confederacy, John was given the rank of Colonel. He never led soldiers in butternut and gray uniforms into battle, but he made his contribution to the Cause. From that point on and throughout his life, he would be known as Colonel.

John and Harriet had six children: **Martha Maxwell** born in 1853, **Jackson May** born in 1856, **Mary McConnell** born in 1858, **Elizabeth Lea** born in 1860, **Jesse Maxwell** born in 1863, and **Robert Edward** born in 1866.

**Harriet, the governess, and grandchildren**

**Edward** was the faithful house slave at Maxwell Hall.

**Eli** was born a slave in 1811, purchased in 1821 by Judge Overton, and became John Junior's playmate and then body servant. Eli and John were always together. They went to New Orleans together for John's formal education. Eli was continually around educated people, but never lost touch with his own people and maintained their language heritage. Although he did not know it at the time, Eli became a free man in 1863.

**Eliza** was born a slave in 1801 and had worked at Travellers Rest for as long as she could remember.

**Emily Jane** was born a slave in 1824 and cared for the children on the plantation.

**Julia** was a slave at the Maxwell plantation where Harriet was born. She delivered Harriet while waiting for the doctor to come. She always called Harriet "the Sabbath Child." She also delivered Harriet's first two children, Martha and Jackson May.

**Cynthia** learned to cook at her mother's knee. When she learned her trade, Cynthia was sold to the Overtons. She never saw her mother again. Her sale papers indicated she was born in 1817.

**Claiborne Hines** came to the plantation some time after **John Overton Junior** bought the Mississippi property. The two men developed a trusting relationship. Claiborne made an impact on the slave community and their white owners.

Claiborne had a variety of skills but was best at working with the animals on the plantation. He gained the trust of all who knew him. He made deliveries from the plantation to the city, taking produce and returning with payments. He secured all the buildings on the property, and before retiring for the night, would make a visit to the bedchamber window of John and report that "all is well, Massa Overton." Claiborne didn't know how old he was because no one ever thought to tell him.

**Emily** was the cook at Maxwell Hall when Harriet was a child. Jesse Maxwell wrote in his will, "At my death, Emily belongs to my youngest daughter Harriet." When Harriet married, she brought Emily to Travellers Rest.

**Maria** was a house slave who cared for the children. She had thoughts about using the Underground Railroad to secure her freedom but never acted on them. She was loyal to Harriet and protected the children. She had a cousin who was a house slave at Lealand, the plantation of Mr. and Mrs. John Lea..

**Matilda** operated the loom in the weaving room. She made cloth and other household items for the family. She was so talented the Judge rented her out to other plantations. She remembered her birth year, 1799, because she was born in one century and lived in another.

**Emmaline** was an Overton slave who lived with a secret, known only by a few on the plantation.

**General John Bell Hood** commanded the Army of Tennessee and used Travellers Rest as his headquarters during December 2-15 in preparation for the Battle of Nashville, December 15 and 16. General Hood's staff stayed in the Overton home; notably among them was **William Clare**, who was married during his stay. Other notables in the home during this time were: **Generals Nathan B. Forrest, Stephen D. Lee, Edmund W. Pettus, W. M. Jackson, James R. Chalmers, and Benjamin Cheatham, Chaplain Charles Todd Quintard, and Captain Thomas B. Claiborne.**

**William Elliot** was an officer in the Union Army and a friend of Thomas and Annie Claiborne. He had served with Thomas in Texas.

Others whose names are familiar in Tennessee history, such as Andrew and Rachel Jackson, Sam Houston, Governor I. Harris, Tennessee Senator John Eaton, Peggy O'Neill Eaton, are but a few who enjoyed the southern hospitality of the Overtons. Many folk stayed at Travellers Rest as guests and returned often, but their stories are not fully told due to space limitations.

# 1. The Early Years

Edward was somewhat of a human timepiece. No matter what time—day or night—when the Maxwells told him to do a task, he was ready without being prodded. He had long been a house servant at Maxwell Hall and slept each night on a small cot in the hallway not far from the master bedchamber. If Mr. Jesse Maxwell had to rise early for a ride into Nashville for business, Edward was up, dressed, cot put in the closet, and ready to assist Mr. Maxwell. One of Edward's house responsibilities was to keep the fireplaces. This task gave Edward power. He was able to order the other slaves to keep the wood box on the gallery filled with logs, twigs, and kindling. Edward also instructed the servants who slept in the children's bedchamber and the master bedchamber how to manage the fireplaces throughout the night to ensure some heat in the rooms. Three fireplaces required daily attention: one in the eating room on the first floor, one in the children's bedchamber on the second floor where Annie and Mary slept, and most importantly, the master bedchamber. Mr. Maxwell told him which of the other fireplaces in the house needed attention, which meant extra work. However, the main three were always ready at full heat at just the moment they were needed.

The weather in Middle Tennessee during January 1832 was iffy at best. This January was no different. One day the cold, cutting winds from the north kept folk behind closed doors. The next day the bright sun chased away the chilly winds. *What will today be like?* Edward questioned, as his eyes focused on the glass transom over the front door. The light from the transom was his gauge as to the time of day. It was still dark outside. Soon it would be light and the family would be stirring. *Time to begin another day just like all other days and . . .* "no, dis not be like other days," Edward heard himself interrupt his own thought. "Dis be the Sabbath and we be goin' to church." He wouldn't actually be going to church, but he would be taking the Maxwell family later in the morning. He was putting on his heavy outer coat when the master bedchamber door opened and Mr. Maxwell appeared. "Edward," came the gruff greeting, "We will not be going to church today."

"Ya, sir, Massa Maxwell. Is everythin' alright wid yous?"

"Mrs. Maxwell had a bad night. She didn't sleep at all. This may be the day for the new baby to come. In fact, Edward, I want you to ride over to Dr. Wright's home and ask him to stop by Maxwell Hall after church services this morning. But, before you do that, go and get Julia up here to the house. She needs to be ready to help Mrs. Maxwell when the time comes."

"Ya, sir, Massa Maxwell. Dis am goin' ta be a mighty fine Sabbath."

Edward went to the barn, saddled a horse, walked over to Julia's cabin to give her the message, and then headed to Dr. Wright's home on Franklin Pike.

Martha Ravenscroft Claiborne Maxwell was not ready to deliver her third child, but there wasn't much she could do about it now. She had been through the experience twice before and was not happy about the struggle immediately before her. As a small girl, she had planned her life and how she would live it. Many of her dreams had come true. She married a man she really loved, lived in a big house, and gave her husband a son to carry on the family name. Well, the son was yet to make his appearance. Maybe this birth would fulfill her girlish dreams. Maybe this baby would satisfy Jesse's need for an heir. Her hopes were so high for this baby being a male child that from the day she knew she was with child, she referred to the life within her as *him*. She encouraged Jesse to think positively, and in their quiet times together, they made plans for Jesse Maxwell III.

Martha knew the pain in her back was a prelude to the birth event. Yesterday she felt the baby was in position, and as Julia made her inspection, she agreed. "I thinks it be tomorrow, Mrs. Maxwell."

"Lord, Julia, I pray so."

"Just thinks, Mrs. Maxwell, a Sunday baby. What a wonderful blessing!"

Julia had been there for Martha when Annie and Mary arrived. Those births had been relatively easy on Martha, but she was younger and stronger then. Although she was only twenty-two, almost twenty-three, having babies so close together took its toll on her body. How she prayed this would be her last effort at childbearing. Maybe tomorrow her prayers would be answered. *If this baby is a girl, I'll just give her a boy's name and Jesse can rear her as a boy. She can serve as his heir, and life at Maxwell Hall can move on.* That was an interesting thought and brought a smile to her face. "That may just work," Martha whispered softly to herself. She forced a small pillow under her back, hoping for some relief.

Edward turned his horse onto Franklin Pike and saw a carriage in front of Dr. Wright's home. The carriage was not moving, so he slowed to a walk to allow the horse to catch its breath. The morning was cold and it was not good to work a horse too hard. The horse came along side the carriage. Edward removed his hat and politely stated, "Good morn', sir. Top of the morn' to you," before seeing who was in the carriage.

"Who you sirring, slave?" came a sharp reply.

"Well, 'scuse me! I thought you is somebody. You nothin' but a black slave carriage driver sittin' out here in de cold. Where yo master, Dr. Wright? I needs to talk with him."

"He be at breakfast. Why you needs to know?"

"Ain't no business of yourn. You just sit there and enjoy the back side of dat horse while I goes to the house and talks to de doctor." Edward went to the house laughing at what had just taken place. When the message was given and the doctor responded, Edward headed back to Maxwell Hall. He passed the carriage and driver without acknowledgment. When he turned off the Pike toward home, the thought hit him hard, *the fireplace in the eating room! Dat*

*my responsibility. I hope somebody puts fire in it. Oh well, Massa Maxwell can't spect me to be in two places at one time.*

Annie and Mary wondered why they were dressed in their day clothes. After all, it was the Sabbath and they would be going to church later in the morning. Church was a boring experience, but it was a chance to ride in the big carriage. Coming out of their warm bedchamber into the cold was a shock, forcing the sisters to cross their arms and clench their shoulders. The cold was only momentary as they raced down the staircase and into the comfortable eating room. "Father, is today going to be different?" Annie made eye contact with her father as he was standing upright, holding a log in his hands.

"Yes, girls. We'll not be going to church services this morning. We'll have Scriptures and prayers after breakfast. Your mother will not be joining us for breakfast. She's not feeling well." He added the log to the fireplace that was already making the room warm and cozy.

"Father, is the baby coming today?" Mary raised the question without any prompting from Annie.

"Yes, this could well be the day."

"And are we still planning on naming him Jesse Maxwell II?"

"No."

"And why not?" Mary's lower lip began to quiver at her father's response.

"Silly." Annie beat her father to the answer. "Our brother will be Jesse Maxwell III. Our grandfather is one." Annie held up her index finger for one. "Our father is two." The second finger went up. "And . . ." Before Annie could complete the third part, Mary grinned, ". . . and our brother will be three."

"You are correct, Mary. Now let's enjoy some breakfast while it's nice and hot." The trio found their places at the table, glancing at the empty chair usually filled by their mother. "Can we visit with Mother after breakfast?" Mary questioned while placing her napkin in her lap.

"Yes, if she feels up to it."

"But first," interrupted Annie, "we must have Scripture and prayer!"

"And Annie, you are correct. We will. Now let's eat." Jesse Maxwell looked at his girls; *I'm not sure who the third child will be. I do know Mary will grow up with a question always on her lips. Annie will have an answer for Mary's questions and will, without hesitation, share it without being asked. I wonder if the church will ever have female ministers. Annie would be a natural.*

By the time Edward arrived at Maxwell Hall, he saw the smoke rising in a curling pattern from the middle chimney. That meant someone was managing the fireplace in the eating room. He unsaddled his horse, gave it some fresh water and oats, and passed through the back door into the eating room. The room was empty. There were girlish giggles coming from the master bedchamber. He did not enter the bedchamber, but was able to catch Mr. Maxwell's eye. "Massa Maxwell, de doctor be here after church services."

"Now you girls gets on outta here and lets yo mammy rest. She be having a busy day. You too, Massa Maxwell. Yous go finds somethin' ta do." It was understood by all in the room who was in charge as Julia rushed them out and closed the door. "Mrs. Maxwell, the doctor be here to helps you after church services. I be rite here in dis chair if ya needs me. You rest now." With that assurance Martha closed her eyes, not to sleep but to lock in her tears as the back pains shot all over her body. This baby was acting just as Annie had—eager to be born and get life started. *I'm not sure I can wait for the doctor to come,* Martha thought just before she yelled for Julia. "I'm not sure I can wait for the doctor. I feel the baby coming!"

"Mrs. Maxwell, I needs to turn ya so's I can handle yous and the baby." She did and none too soon. By the time Julia got her turned, her legs into position, and extra cloths placed to soak up the blood, the baby's head was showing. "Edward, Ed—ward, EDWARD! Gets in here rite now!"

Edward came at the first mention of his name. "What's da matter wid you, woman? Why you yellin' so?"

"Fetch me some hot water from the kitchen, some mo' clean cloths, and a sharp shaving razor." "And finds Massa Maxwell and tells him it's time!" Julia ordered.

Martha was trying her best to relax. She bit her lip and quickly determined that would not help. Beads of perspiration popped up on her forehead and ran off the side of her face. She arched her back, dug her fingernails into the bedsheets, and pulled in an effort to tense her lower body. It helped.

"The baby am coming. The blessed Sabbath baby . . . am here." Julia was smiling, chanting, and began to sing, "Praise de Lord! Praise de Lord! The blessed Sabbath baby have come and SHE is some kinda beautiful." Martha again closed her eyes. This time she sighed.

Simultaneous with Julia's announcement came a knock at the front door. Again a knock and again. The front door was pushed open and in walked Dr. Wright, hat in hand and carrying his black bag. He handed his hat and coat to his son who came along for the ride and an opportunity to get out of church early. Almost on cue, Jesse and Edward appeared in the hallway outside the master bedchamber. "Doctor, you're early, but you may be too late." Jesse was smiling and laughing at the same time.

"I left the services early. I thought Mrs. Maxwell might need me more than that hard pew."

"From the sounds coming from in there," motioning to the bedchamber, "I'd say you're too late."

"Maybe I can still be of some help."

Jesse took the basin of hot water and other items Julia had requested from Edward and followed Dr. Wright into the room. Julia was placing the baby next to her mother, while Jesse put the items in his arms on the small table and went to check on Martha. "Oh, Jesse, I'm so sorry . . ." She couldn't get the words out to tell him, extending her hand for him to take and hold.

Julia visually checked the items, looking for the razor to cut the cord still holding mother and child together. Dr. Wright looked in his bag for the proper instrument to perform that task. He found it, snipped the cord, and smacked the baby appropriately on its bottom. With a curdling cry, life on her own began.

"Well, Jesse, what are you going to name this girl?" Dr. Wright was reaching in his bag for a booklet where he recorded births, including name, date, location, and parents.

"I don't know that we have a name yet." Jesse looked at Martha with the puzzled look he got when he didn't have an answer.

Martha squeezed Jesse's hand to help him deal with this moment. "Maybe the girls have a suggestion for a name."

"Yes, maybe they do."

"Jesse, I'll add the information I have to my book. You and Martha can tell me later about her name. By the way, here's a card I had printed. Your daughter may enjoy seeing it someday." Jesse read aloud—

> The child that's born on Sabbath day
> Is fair and wise and good and gay.

Julia had finished cleaning the child, wrapped her in a blanket, and handed her to Martha. "Yous men needs to git out of here. I needs to attend to Mrs. Maxwell and we don't needs the two of yous in here. So, git." Julia herded them out of the bedchamber, closed the door, and took care of Mrs. Maxwell.

Annie and Mary, looking through their bedchamber window, saw their father and Dr. Wright standing by a carriage. They scampered down the steps, down the hall, through the front door to the front porch steps. "Doctor Wright," they chimed in unison, "have you come to see Mother and bring the baby?"

"The baby is here already and she is beautiful just like the two of you."

"Thank you, Doctor Wright." Their words died off almost as if they were disappointed at hearing the news.

Jesse joined the girls inside the house and they sat on the steps outside the master bedchamber hoping for sounds—any sounds from behind the closed door.

Julia exited the bedchamber, arms full of dirty bedding, heading for the back of the house when she passed the Maxwell trio on the steps. "Why y'all so down in de mouth? Today a time to be happy for de Sabbath Child in de other room. She happy to be here. Now y'all gits happy faces on!"

"I want to see Mother," a sullen Mary demanded.

"Miss Mary, yo' mammy don't want to sees no sad face and neither do the Sabbath Child. I's be back d'rectly and then we sees 'bout goin' in de room."

Julia was gone long enough to fill a tub with water and throw in the bedclothes to soak until they could be washed later. She was surprised to see

the trio still seated on the steps when she returned. "I sees y'all is still here. Let me go checks with Mrs. Maxwell and da baby."

"Is the baby pretty?" Annie asked not even looking at Julia.

"She be as pretty as ya and Mary when ya be born. She have more hair den either of yous when ya dat size." Julia walked away and into the bedchamber.

"Father, what is our baby sister's name?" Both girls wanted an answer to the question.

"She doesn't have a name. Your mother and I thought you two might want to help name her." With that announcement, broad smiles came to the girls' faces. They jumped off the steps onto the floor and began dancing around and around hugging each other. Each girl took their father's hands, and he became a part of the dance and excitement in the hallway.

Julia appeared at the doorway. "Mrs. Maxwell be very weak. Da three of yous can stay a few minutes. And girls, no dancin' or jumpin' around. Be ladylike."

Martha was holding the new baby in such a way that all Jesse and the girls could see was the top of the infant's head. Then all they saw was a full head of dark hair—lots of hair. Mary was not satisfied with the view and moved to the other side of the bed away from the others. She could feel Julia's eyes on her as she moved. Her persistence paid off. Now she had a full view of the baby's round, reddish face under the mass of dark hair. "Oh, Mother, she's beautiful. She's a peach. I think we should name her Georgia."

"Annie, what do you think of Mary's suggestion?"

"Do any of our relatives come from Georgia?"

"Not that I know of, dear. Other than Tennessee, our families came from North Carolina and Virginia." That statement gave Mary the opportunity to change her mind. "Let's name her Virginia!" She was clapping her hands and jumping.

"Fine, that will be her middle name," Martha said weakly looking at Jesse. "And her first name will be Harriet." *We could name her Harry,* Martha thought, *but that would require a lifelong chore of explaining.*

"Yes," laughed Jesse, smiling at Martha. *Harriet is almost Harry,* he pondered, *but the next child will be Jesse III.* Martha had a way of knowing Jesse's thoughts. She handed Harriet to Julia and closed her eyes while pulling the sheet up around her chin. *Oh, must I go through this again? Will there ever be a Jesse III?*

Martha didn't have to make the request for them to leave because Julia beat her to it. "Yous git now. Mrs. Maxwell needs her rest and don't come back 'till I says so." The last thing Martha heard as she fell into a deep sleep was, "Yous a mighty fine girl, Harriet Virginia Maxwell. You always be da Sabbath Child to me."

Harriet Virginia was born into a family rich in history. From an early age, she heard tales of how the Maxwells got to this land. She learned about her grandfather Maxwell and great-uncle David Maxwell being soldiers in the

Great War fighting the British. As a reward, they were given this land. Although Grandfather Maxwell died in 1821, Harriet learned early that he had built Maxwell Hall, which she was beginning to love so much. Grandmother Maxwell would sit in her rocker on the porch and recall for Harriet and her sisters how the land looked the first time she saw it and how the house had changed down through the years. She would talk about the neighbors, the fun times they had, and the experiences of worship at the church. Most of her stories were about Jesse Junior growing up. The girls giggled and requested more stories. On some occasions, they would want to know about the Armstrong side of the family, and Grandmother Maxwell would continue until something important would interrupt her, sometimes in midstory. Often Grandpa George and Grandma Annie would visit Maxwell Hall, and Grandpa would tell the girls about the Claibornes. Some of the stories he told were truer than others. After his visits, Mother would retell the stories. Grandma Annie was the best storyteller of all. She could remember nearly every move Martha had made as a girl. She always began her family tales with, "When your mother was a little girl about your size…" Then would come the interruption, "Which one of us, Grandma?"

"Just about your size, Mary." Annie and Harriet would sigh but knew that in the next story, Mother would be their size as a little girl. These were grand days for the girls. They each remembered the stories. Harriet came to treasure the land in her memory—the Maxwell land—even though some had been sold off to Judge John Overton. The land was still her fondest memory. Maybe it was because she and her father explored more than her sisters did. Annie and Mary seemed to always be inside learning things from their mother or Julia. Harriet rode on the horse with her father, to the dismay of Martha. *Maybe Harriet will be his boy after all. They play rough and tumble all the time. Every waking moment she is at his side. The only thing feminine about her is the dress she is wearing.* Martha watched the two ride out of sight.

The girls began their education at home by watching what was happening around them. One day Mother announced that Annie would be going to Robertson Academy in the fall. That day came sooner than Mary and Harriet wanted. The next year Mary joined Annie at the Academy and Harriet was left alone. She would be four years old soon and that meant more exploring and lots of adventures. Harriet looked forward to hearing about school from her sisters. Annie was always so excited and covered every detail. Mary had little to say because Annie would tell everything before she had a chance. Neither sister ever asked about Harriet's exploring and adventures. She was ready to tell her stories, but there was never a sibling audience.

As with all childhoods, illnesses came often to Maxwell Hall. Harriet was a healthy child until one of her sisters would come home from school with a cough or a sneeze. Then all three girls would become ill and confined to bed. It was during one of these illnesses that their mother also was confined to her bed. The doctor came but nothing was diagnosed. Martha felt very tired and

that was unusual for her. With bed rest and proper care from Julia, the illnesses passed and the Maxwell ladies were back into daily routines.

The spring of 1836 brought with it the usual beauty to Maxwell Hall. The flowers began to appear in the well-appointed garden next to the house. The crosspath allowed the girls to pick and arrange flower displays for the entire home. The neighbors—Overtons, Hogans, Ewings, and Edmistons—would visit and always left with a basket of flowers. Martha often saved seeds and gave them as gifts to her neighbors. The wonderful orchards of apples and pears were in bloom and promised a full harvest.

On April 30, the family had dressed for church and had boarded the carriage when tragedy hit with full force. Maxwell Hall was on fire! Smoke seemed to come from everywhere, and then the flames could be seen. Jesse shouted for the slaves to come help put out the fire. The task of drawing water and throwing it on the flames was time consuming and, at last, hopeless. When the fire reached the second-floor beams, the weight of the roof was too much. The Hall was a complete loss. The neighbors came, but there was nothing they could do. They gathered around the Maxwell family. For weeks Jesse was at a loss to know what to do. He announced to Martha and the girls that now might be a good time to sell everything and move on. "No, Jesse," she responded with the backing of the girls, "we need to rebuild Maxwell Hall."

"Martha, it would take too long and would be too expensive to rebuild."

"But the new Hall does not need to be as large as the old one. We can cut the trees on the property. The neighbors will help." The matter was discussed and settled. To seal the family decision, four-year-old Harriet appeared, stomped her foot, and laid down the challenge, "Let's get to work!"

Before fall, the Maxwells were in their new home. The bedchambers and the dining room were furnished with everything new. Jesse proposed a toast with wine for the adults and grape juice for the girls at the first meal. "We are happy to be in our new home, and I am grateful to have my Maxwell girls—all four of you." The response brought a feeling of unity.

That very evening at dinner while her sisters chatted, Harriet was thinking how best to ask her question. In the midst of all the noise, she took her fork and began to tap lightly on her glass. Jesse was the only one at the table to hear the sound, and he turned his attention to the smallest family member. "Yes, Harriet Virginia." He stopped the tapping by placing his hand on top of hers. "Father, I have a question."

"And that would be . . ." All eyes and attention turned to Harriet.

"When will I be going to school with Annie and Mary?"

"You are too little to go to school," Mary said with emotion.

Harriet's physical size had never been a public topic of family conversation. There had been questions from Martha's mother because Harriet appeared not be growing at the same pace as her sisters. Martha had shrugged off the question by suggesting she was small boned. One other time at church one of Annie's friends had called Harriet "Shorty." Harriet was just a short

individual and would be so as an adult, but it apparently did not matter to the family until now.

"What do you mean, I'm too short?" Harriet pushed her chair away for the table and stomped her way to the other side of the table where Mary was seated.

"I didn't say 'too short,' I said, 'you are too little.' You are not old enough."

"I am too!" The stomping became more pronounced. It was a serious Maxwell family moment that all would remember, but Jesse and Martha had to fight hard to hold back their laughter. They both covered their mouths with their napkins. Martha moved quickly to handle the confrontation. "I believe what Mary means is you will not be the required age at the scheduled time to attend school."

"Yes, that's what I mean." Mary was a little shaken by Harriet's challenge. Jesse, at the other end of the table, had a pleasant thought; *we will never need to worry about Harriet Virginia Maxwell. She'll never be at a disadvantage. She'll always be equal to any situation. Oh, I pity the man she marries!*

Another year at home passed quickly. Now the three girls were in school together. They began again to have some things in common and could talk about their school experiences. There were some things the girls never discussed outside their tight triangle bond and their parents never knew, at least from the sisters' lips. They never told about the morning Harriet had to stand in the corner because she stomped her foot in an effort to get her way with a classmate.

The sisters were together at Robertson only for one year. The next year Annie entered the Nashville Female Academy with thoughts of a teaching career. Mary followed the following year with no thoughts of the future other than getting out of that terrible place. Harriet was alone again but was equal to the challenge. She was becoming the strong, independent person her father had hoped for with the needed female graces her mother had hoped for, and the embodiment of what Dr. Wright's Sabbath Child card had suggested—fair and wise and good and gay.

If it's true, "into every life some rain must fall," Harriet experienced an extended downpour with dangerously rising waters. Harriet was eight when she and her sisters attended the wedding reception at Travellers Rest for John Overton Junior and Rachel Harding. Their parents had gone to the church for the service, and Julia brought the girls to the house for the reception. When the wedding couple arrived in their carriage, guests in the house came out to greet them. Harriet was properly positioned to see everything until the adults came out and blocked her view. After a few foot stomps, she broke away from Julia's handgrip and reestablished her position. *Here they come. That handsome John and his beautiful bride Rachel are coming right by where I'm standing.* Harriet knew she had made the right decision to reposition herself.

No sooner had her thought passed, when Rachel stopped, leaned over, and handed her a small, white ribbon from her wedding dress.

"Thank you for coming. What's your name?"

"My name is," she sputtered then continued, "Harriet Virginia Maxwell. I live over there," pointing in the direction of her home.

"So, we are neighbors, Harriet Virginia Maxwell. You must come see me, neighbor." The bride and groom moved into the house and the crowd followed. A new friendship was begun with a smile, a white ribbon, and a request. Harriet and Rachel became best friends. They talked about Rachel's pregnancy, Harriet was allowed to hold John Overton III when he was born, and she mourned four years later at Rachel's funeral.

Shortly after Rachel's death, Martha Maxwell announced to her girls that she was with child—hopefully, with Jesse Maxwell III. Because of her poor health, Martha was put to bed and had little contact with the girls. The pregnancy drained Martha's health. After his birth, Jesse Maxwell III lived only a few days. His mother, the lovely Martha, at thirty-six, died within days of the death of her son, the long-awaited Maxwell heir. The year was 1845. Harriet was thirteen years old and a student at the Nashville Female Academy. The rain came, Harriet was soaked, but she sought the sunshine and survived.

# 2. Pledges Do Come True

The Maxwell sisters once again were students together at the same educational institution—the Nashville Female Academy. Annie was finishing her program in the spring and was eager to try her skills at teaching. Mary would endure the system for another year with no definite plans for her future. She had thought about writing as a career, but her instructors at the Academy offered little encouragement. They told her on several occasions that the best writers wrote out of life experiences, and Mary's were limited. She had lived the life of privilege, and it did not look like that would change in the near future. Still, she kept paper and pen handy ready to write, if and when inspiration came.

Harriet was looking forward to the end of the school year and spending more time at home with her father and sisters. The house her father built after the fire was fine, but it was not, and never would be, Maxwell Hall. Jesse had built the house from trees he and the neighbors cut on the property. It was suitable when finished and met the needs of his family. Now that he lived there alone most of the time, the house was excessively large. On a number of occasions, he had thought of selling the house, the land, and moving into the city. The girls talked him out of his plans, suggesting it was still home to them. They realized it was hard for their father living there without Martha and little Jesse. Annie turned down a teaching assistant position in Franklin to be home with him. She was able to tutor on a regular basis, allowing her to be home most of the time. The next year Mary moved back into the house, still waiting for elusive inspiration.

Harriet left home for her final year at the Academy. A major dark cloud hung over her. She had hoped by this time to know what she wanted to do with her education. She was caught somewhere between her sisters. Annie knew exactly what she wanted to do and was looking for ways to bring her plans into reality. Mary, on the other hand, was not a model Harriet wanted to follow. Mary was content to live at home and watch the world go by with writing material nearby.

In the school year 1846-47, seventy young ladies were boarding at the Academy and being trained mostly in domestic skills, but also in English, foreign language, math, art, supervision, and etiquette. Each year the director of the Academy selected a dozen students, out of all those enrolled, to be involved in a discussion group which he labeled "Current Affairs." Harriet was chosen to be a member of this elite group. The selection meant she would be required to do extra reading and would not have as much leisure time as most of her classmates. She was excited to tell her father about the honor.

Edward was right on time at the Academy. He was there to pick up Harriet for a weekend visit at home. Most of the girls did not have that privilege

because they lived far beyond the city limits of Nashville. A number of students lived outside of Tennessee. Harriet appeared at the large double door and heard Edward's voice, "Over here, Miss Harriet." She did not walk down the cobblestone path like a proper Academy lady. *I just hope no one is watching out of the window. I don't need the demerits on my record.* Glancing over her shoulder, she felt she was safe and continued to run toward Edward. She was about to commit a double infraction, according to her supervision and etiquette training—never show public affection to a slave and always refrain from public hugging.

"Edward, thank you for coming. I wasn't sure who was coming, but I'm glad it is you." She planted her head sideways into his chest and gave him a hug with both arms. Edward wasn't sure how to respond other than to say, "I glad to sees you too, Miss Harriet." He put her luggage in the carriage, helped her to her seat, climbed aboard, spoke to the horse, and off they went to the south of the city.

Harriet was chatty for the first part of the trip, telling Edward everything that was happening at the Academy. Occasionally he would say, "Yes ma'am" or "no ma'am" or "dat rite," but never a full sentence. Harriet was in charge of the conversation. He heard what she said about her Current Affairs class, but it did not mean anything to him. So he said, "Good for you" and kept his eyes on the road. When they reached Franklin Pike in the Glen Leven community, he tugged at the reins and allowed the horse to move into a trot. By magic it seemed, Harriet stopped talking and sat back in her seat allowing the wind to blow through her hair. Edward concentrated on his driving but was thinking, *Maybe next time I makes this trip, I let the harse trot all the way!* Shortly, Travellers Rest came into view looking splendid as always. Harriet knew she was nearly home with only one more turn and then down the narrow road. Edward slowed the horse to a walk and again the chatter began. She was still talking when they passed the fence line. Together they saw Jesse who was talking to his neighbor, John Overton.

"Massa Maxwell, looks who I brung." Jesse was all smiles.

"Good day to you, Miss Harriet," John spoke as he tipped his hat.

"And good day to you, Mr. Overton." Harriet was polite but headed for her father and gave him a neck-stretching hug. She did not follow the Academy guidelines when she was home. "Father, I have great news! Mr. Lapsley has invited me to be a part of the Current Affairs class at the Academy."

"That's wonderful news, Harriet! I'm so pleased for you."

"We will be discussing the war with Mexico, some of the policies of President Polk, and some of Nashville's business leaders will be sharing with us what is on the horizon of our fair city."

"Miss Harriet," John was mounting his horse, "I understand the Current Affairs class is a high honor. Congratulations! I'm also very pleased for you."

Adjusting his wide-brim straw hat, John turned his horse west and bade farewell to the Maxwells.

"Give our regards to your fine mother, John," Jesse said as he waved to him.

"I will. See you another time."

"Come, Harriet. Let's go into the house and tell Annie and Mary your good news."

She was a bit reluctant to share the news with her sisters because they had been passed over for the honor class when they were at the Academy, but her father made the announcement with pride. However, when they heard, they responded appropriately.

The Maxwells—Jesse and his daughters Annie, Mary, and Harriet—ate a midmorning brunch on Saturday together. It was a wonderful occasion for all of them. They brought each other up to date on the happenings in their lives. They remembered Martha—wife and mother—with happy thoughts. They missed her and little Jesse. Tears were shed. When Julia came to clear the dishes, almost as a signal, Jesse cleared his throat and said, "Girls, what is the proper bereavement time for a widower?" Eight female eyes focused immediately on the only male in the room. Julia did not believe what she just heard and the rattling of the dirty dishes emphasized her reaction. Annie was the first to speak, "What do you have in mind?"

"Sooner or later you girls will be grown, married, and gone. I'll be left here with no one."

"Father, how old are you?" Mary posed the question, but already knew the answer. She was hoping her father would have a clue to her feelings when he answered.

"I believe I'll be fifty-one this year."

Harriet was direct: "The proper bereavement time is a year."

"Well, it appears I'm well past the time limit."

Annie again challenged her father, "Time limit for what? What do you have in mind?"

"I was thinking of . . ." At that crucial moment there was a loud knock at the front door. Julia placed the dirty dishes she was holding on the pier table and headed for the door. She returned to a silent room. The girls were shaking their heads; Jesse was looking into space. "Eli done brung a message and he say it for da Maxwell ladies." Annie stood, took the envelope, opened it, and read the handwritten message:

> *Mrs. John Overton, Sr. requests the honor of your presence tomorrow afternoon at three o'clock for tea in the parlor of Travellers Rest.*
> *RSVP requested.*

"Mother . . ." Annie emphasized the word, ". . . always had such a wonderful time at Mrs. Overton's teas. All three of us must go."

"Annie, I must get back to the Academy. Will I have time to go to the tea?"

"Yes, but if it appears you will be late, I'll ask Mrs. Overton to excuse you. Edward will be waiting in the carriage to get you back to the Academy before dark."

"Annie, what shall we wear to the tea?" Mary was not too certain about the proper etiquette.

"We'll go in our Sunday clothes. That will be proper and acceptable. We must send our RSVP immediately. Julia, please find Edward and have him saddle a horse for a trip to the Overton home. I'll find note paper and pen."

"There no need to find Edward. Eli waitin' outside. He can takes da note."

The RSVP was completed and delivered to Eli. There was excitement and confusion at the Maxwell home. The girls made their preparation for the next day, and Jesse lost his opportunity to share his news with the girls.

Sunday was a fine fall day in Middle Tennessee, a good day for church. Afterwards at lunch, the conversation was light but dominated by the girls. They had no intention of hearing their father pose his question again. Their plan was to control the conversation so the subject of proper bereavement time would go away. Little did they know their father had a plan of his own.

Annie, Mary, and Harriet arrived at Travellers Rest at the appointed time—not early, nor late, but right on time. Harriet did a quick check in the back of the carriage to make sure Edward had stowed her school bags, if a quick dash to the Academy was required later in the afternoon. Annie thought it would be proper to enter the main double door near the parlor rather than the front door. No sooner had the girls stepped onto the gallery than the doors opened and there stood Mrs. Overton to greet them. "Welcome, young ladies, to my home. It is a delight to have you for tea." Annie spoke for the trio as they had agreed: "We, too, are delighted at your kind invitation."

Mrs. Overton directed the Maxwell girls to the large room on their right. Harriet was the last to enter the house. As Mrs. Overton was closing the door, John appeared in the hallway. Annie and Mary did not see him until they heard him say in a booming voice, "Why, it's Miss Maxwell, the honor student at the Academy!" The other two girls reappeared and John had to add, "No, it's three Miss Maxwells." The girls giggled.

"John, behave yourself. The young ladies are my guests for tea." Of the three girls, Harriet was the only one to remember another time years ago at this very spot, *the sisterhood had pledged, "One of us will marry John some day."* Harriet was shocked back into reality when Mrs. Overton touched her shoulder, guiding her into the large room. "Come ladies, the tea is ready. We have pekoe or herb, which do you prefer?" Mary and Harriet looked to Annie to respond. "I'll have pekoe with sugar," Annie requested.

"I'll have the same, Mrs. Overton." Mary followed her older sister.

"And for you, Miss Harriet?"

"If you would be so kind, I'd like to have herb tea with honey." Mary glanced at Annie and they seemed to read each other's thoughts, *herb tea with honey? It must be something new at the Academy this year.* The choice of young Harriet did not go unnoticed by Mrs. Overton. She recorded the moment in her memory to recall at a later time.

Mrs. Overton directed the conversation by asking questions of each girl. "Annie, you have finished the Academy, have you not?"

"Yes, ma'am, I have."

"And what are you doing now?"

"I'm tutoring fulltime. I have five students. I had a teaching opportunity in Franklin, but Father needed me at home for a while."

"I commend you for thinking of your family, but don't give up your dreams. Annie, you look a lot like your mother. She was a lovely person. I enjoyed our times together."

"Yes, ma'am, and Mother thought a great deal of you and your friendship."

"Annie, my grandson John may need some extra help. Would you be available to help him?"

"Yes, ma'am. I'd be pleased to have the opportunity." Mrs. Overton was ready to move on with the conversation. She turned to Mary. "And Miss Mary, where are you with your education?"

"I've finished the Academy and am living at home with Father and ..."

"Your mother was a very wise woman and a wonderful mother. She taught you girls the value of family. She would be very proud of you. Mary, I interrupted you. You were saying ...?"

"I have an interest in writing and would like to pursue a writing career."

"I wish you good fortune. That is a most difficult career for a woman."

Harriet sat properly, sipping her herb tea, taking in the conversation. She knew her time was coming for a question from Mrs. Overton.

"I may need to leave home," Mary was about to reveal her inner feelings, "to pursue my dream. I may need to go to Boston or New Orleans."

Annie and Harriet looked at each other, wondering where this conversation was going and how Mrs. Overton would respond.

"Maybe so ..."

*Maybe so? What kind of a response is that? Mary is pouring out her soul to you and that's all you can say?* Harriet waited, thinking Mrs. Overton was pausing and would surely continue, but she didn't do so and physically turned in the direction of Harriet. "Miss Harriet, I'm informed you have been invited to join a special class at the Academy. Tell me about it."

"Well, the class is called Current Affairs. We are to read and discuss matters of national and local events. I understand there will be visitors to the class who are involved in some of the events we are to consider."

"That sounds so interesting. I just know you will be equal to the challenge. I feel you are in for some surprises in the class. I'll be anxious to talk with you

the next time you are home. You must come and visit me." Annie and Mary finished their tea and set the china pieces on the table. The conversation continued, but they were not involved. Annie politely cleared her throat and Mary squirmed on the sofa, but the flow of the conversation remained between Mrs. Overton and Harriet. Annie was thinking—*Mary and I may just as well leave and allow them to chat. We could be out enjoying the sunshine or home taking a nap.* The clock on the mantel chimed—relief. Annie stood and announced it was time for them to leave mainly because Harriet needed to get back to the Academy before dark. Exiting on the lower gallery heading for the carriage, Harriet turned and made the observation, "Mrs. Overton, I do like the addition of the upper gallery. I'm sure you enjoy having it."

"I seldom go up there, but John felt we needed it. Well ladies, this has been a delightful afternoon. You must come again soon." It appeared to Annie and Mary the invitation was directed totally to Harriet.

"Yes, we shall," Harriet spoke for the sisters.

The trip to the Academy was uneventful. Edward had little to say, but Harriet filled the time with lots of conversation. The next days and weeks at the Academy were filled with day trips to the city, after-hour chats with new friends, discussions at meal times, and classes. The highlight of Harriet's final year was the time she spent preparing for and participating in the Current Affairs class. Just as Mrs. Overton had suggested, the class had a big surprise for Harriet. The surprise came on the second meeting of the class. Mr. Lapsley unfolded the newspaper and perused the front page. He laid the newspaper on the table and said, "Ladies, I forgot a very important part of our class the last time we met. You need to know that Mrs. John Overton, wife of the judge, is providing the expenses for this class. Without her support, this class would not exist. She is very interested in the role of women in society." *Yes, this must be the surprise Mrs. Overton mentioned at the tea,* Harriet thought as Mr. Lapsley continued. "Your assignment for today, ladies, was to think of Nashville's future and what it needs to do to become a major city. To help us with our discussion, I have invited a special guest. He comes from a most noted family in our community, and he, too, is thinking about Nashville's future. He is only twenty-six years old, but has the responsibility for one of the largest plantations in our area. Please welcome John Overton." *No, this must be the surprise Mrs. Overton had in mind. I cannot believe my eyes. It really is John Overton. Yes, he is twenty-six years old and handsome, handsome, handsome.* Harriet was shocked as she stood with the class to greet their guest, her widowed neighbor. She tried her best, but could not help herself from staring at John. He responded by nodding to her and she knew the gesture was for her and her alone.

Mr. Lapsley requested that all be seated and turned to Harriet with the question, "Miss Maxwell, what do you think Nashville needs to be a major city?" There were sighs of relief from the ladies, knowing they would have a little time to collect their thoughts while Harriet responded. She was ready for

the question, but she glanced at her notes. When she looked up, John was smiling at her. "First, let me say, we are highly honored to have Mr. Overton here today."

"The honor is mine to be in the presence of such a room full of highly educated and charming young ladies."

"To the question sir, my reply is Nashville needs a large hotel with a ballroom large enough to host special events and food service equal to New Orleans."

"Well, Miss Maxwell, that is quite an answer." John looked directly at Harriet. "Where would you build this hotel?"

"In the heart of our fair city, sir." Thinking that the conversation might become a dialogue, Mr. Lapsley questioned, "What do you other ladies think of Miss Maxwell's idea?"

"Wonderful idea." "I agree with Harriet." "Yes, it's a wonderful idea." "Who would pay for it?" The last response brought quiet to the room.

"'Who would pay for it?' is a very important question," replied John Overton. He went on to indicate that financing for the hotel could come from an individual, a group of individual investors, a bank, another hotel, or other sources. The discussion went on for several minutes with no real conclusion.

Standing, Mr. Lapsley moved to the other side of the room where Alice Thompson was seated and posed the query, "Miss Thompson, what do you think Nashville needs?"

"I propose a rail system connecting Nashville with Birmingham."

"And how would that help Nashville?" John beat Mr. Lapsley to the question.

"Sir, it would move commerce between the two cities and could provide passenger service." The discussion was lively. Most of the ladies agreed with the idea although a couple were silent. John liked the idea and had to admit, "Miss Thompson, I have considered your idea. Some of the folk in the city who own toll roads may not agree, but I think it's something the citizens of Nashville need to consider." John stood, removed his pocket watch, flipped its cover, and discovered he needed to be downtown shortly for a meeting with his lawyer.

"Ladies, this has been an interesting session. Mr. Lapsley, I hope you will invite me back again." John gave Harriet a parting smile; she responded with a polite, ladylike nod.

"You shall have another invitation." Mr. Lapsley moved to escort John from the room while the ladies stood and clapped as they exited; Harriet, the loudest of all.

Harriet's final year at the Academy passed quickly and she enjoyed each moment. She knew she would probably never see some of her classmates again after graduation. The closer the final day came, the more Harriet fretted about her future. At fifteen years of age, her entire wonderful, exciting life was before her. She was too young to get married even if she had a proper suitor.

She was too young to work in an office downtown. Her father bought her a little time to think. Jesse arranged for the three sisters to spend the summer in Pass Christian, Mississippi. The week before Harriet's graduation, the three sisters and their father had Sunday dinner together at home. Jesse had two announcements to make and a special presentation. After the meal, as he cleared his throat, Annie excused herself from the room. On cue Annie returned with a large box tied with a beautiful red satin ribbon and placed it before Harriet. Jesse smiled and said, "This gift is from your sisters and me." Inside the box, Harriet found a white dress trimmed with delicate, thin pink silk ribbons. "It's for your graduation," Mary said as she removed the box from the table.

"This is wonderful," a tearful Harriet responded.

"Annie ordered it from New Orleans and it just got here last week." Jesse was doing a good job of holding back his tears of pure pride. "Harriet, there is another surprise gift that Annie and Mary already know about. I'm sending the three of you to Pass Christian for the summer. You will be staying at the Montgomery Hotel." The Maxwell girls gathered around their father and showered him with hugs and kisses.

"I've arranged for John Overton to escort you. He is going there on business, and he'll see that you arrive safely." Jesse hoped his next announcement would be as well received. "By the time you return I'll be married to Myra Rucker." Jesse looked at each of his daughters for a reaction to his announcement. For a brief moment, silence filled the room. Harriet broke the silence. "Father, I'm pleased for you. I know you and Myra will be very happy together."

"We like Myra and we want you to be happy." Annie and Mary almost said the words together. Then the girls began to giggle and smile at each other. "Father," Annie spoke lovingly, "we have known for a while of your intentions toward Myra and we are happy for you. We have already decided to call her Myra and we hope you will understand."

"You girls have the intuition of my wonderful Martha, God rest her soul."

At the Nashville Female Academy graduation, Harriet appeared in her new white dress with the pink ribbon, new shoes, and her mother's locket. Known only to Harriet, inside the locket was the strip of white silk ribbon given to her by Rachel Harding Overton on her wedding day—the friend she missed so much. Mrs. John Overton, Sr. was in the audience and sought out Harriet at the close of the commencement. Handing her a small rectangular box, Mrs. Overton commented, "My dear Harriet, what a proud day this is for the Maxwells. I'm sad that your mother is not here to enjoy your accomplishments, but I know the saintly woman she was is smiling down on you from heaven."

"Thank you, Mrs. Overton. You are so very kind to come today. I appreciate the gift, but most of all I appreciate you remembering Mother. She was very fond of you. If you will excuse me, I must find my father."

"Will you come visit me before you go south this summer?"

"Yes, ma'am, it will be my pleasure to call on you next week." Harriet went to find her father. She saw him on the edge of the crowd reading a piece of paper. As she approached, he looked up with the biggest smile on his face, "There she is, my favorite lady of the Class of 1847, Harriet Virginia Maxwell."

"Oh, Father, I bet you've said that to all my classmates."

"I have not because you're the only one named . . ." His friend John Overton and his mother passing on their way to their carriage interrupted Jesse.

"Good day to you, Jesse. And my congratulations to you, Miss Harriet. I guess you will have time now to build that fancy hotel downtown."

"Yes, sir, I may just do that!"

Mrs. Overton hit the back of Eli's carriage seat with her cane, which was the customary signal to head for Travellers Rest. "Harriet, I look forward to your visit next week." Eli flipped the whip only once and the horse responded with a fast walk, then a trot. "John, how old are you?" She knew, but wanted him to say it.

"Mother, I'm twenty-six. You know my age. Why do you ask?"

"I saw how you looked at Harriet. John, Jesse Maxwell has a variety of flowers in his garden. Be certain you view all of them."

"Mother . . . are you suggesting . . . ?"

"I've said my piece on the matter. You have the heir to the Overton name in your son John. You need to consider your own happiness." With the motherly advice stated, the Overtons headed home.

Later that evening Harriet opened the gift from Mrs. Overton and found, to her surprise, a necklace with fifteen matching pearls. *What a wonderful gift,* she thought as she held the necklace up and glanced into her mirror. *I must go tomorrow and thank Mrs. Overton personally.* She wrote a proper thank-you note for the gift and had it in hand when she rode to Travellers Rest the next day. She spotted Eli sitting on the large steps leading up to the gallery. Seated next to him was young John Overton III.

"Good day to ya, Miz."

"Eli, would you be so kind to hand this note to Mrs. Overton?"

"Ya, ma'am. I's be happy to."

Harriet dismounted and tied the reins to the post. She spoke to young John. "Good day to you, John." He sat, holding his hands up to shade the morning sun but did not respond. "John, I'm your neighbor. My name is Harriet Maxwell." Harriet's new necklace caught the sun's rays and flickered in John's eyes, bringing a smile to his face. "My grandmother gave you that necklace, didn't she?"

"Yes, she did." Harriet sat down next to John to give him a better look. "She is a very kind lady."

The large double doors swung open and hit the stops with a thud. "Good morning, Harriet," came a welcoming voice.

"Good morning to you, Mrs. Overton."

"I see you are having a conversation with John."

"Well, to be honest with you, it's a one-sided conversation."

"John, Miss Harriet was a good friend of your mother. They spent many hours on these steps talking about you before you were born." Five-year-old John stood up, leaned over to Harriet, put his arms around her neck, and hugged her. He cried, tears beading on his cheeks and dropping onto Harriet's riding jacket. She patted his back and whispered in his ear, "I know how you feel. I miss my mother, too."

Mrs. Overton smiled at the scene before her but did not interrupt the bonding.

John broke away from Harriet almost as quickly as he had begun, not saying a word to her. He pointed to the necklace, "Grandmother, look at what she's wearing."

"Yes, I see. It's very pretty and looks nice on Miss Harriet." Even before she finished the acknowledgment, John was running down the gallery toward the kitchen.

"Harriet, won't you come in for a visit? We can have some morning tea and chat a while."

"I'm not properly dressed for the parlor."

"Nor am I. So, we can just visit here on the gallery. Your note was lovely and I appreciate it."

"Oh, Mrs. Overton, words are not adequate to express my gratitude for this lovely necklace. I will treasure it all my life."

"It fits you well."

"I realize the necklace is a formal piece, but I just had to wear it regardless of my outfit. It was worth the breach in etiquette just to see the look on John's face when he saw it this morning."

"Harriet, a poet has written, 'A thing of beauty is a joy forever.'"

"Oh, yes, Mrs. Overton, John Keats: 'Its loveliness increases; it will never pass into nothingness.'" *This young lady is impressive. She drinks herbal tea.* Mrs. Overton was remembering. *She quotes Keats. She bonds well with children. She will make some man a fine wife.*

"About the necklace . . . little John saw it before it was wrapped. The Overton men have a keen eye for beauty, but they tend to be extremely quiet in public. Little John's father has always been a bit timid. His father, the Judge, could sit for hours and never say a word." Harriet and Mrs. Overton chatted for nearly an hour about this and that. At a pause in the conversation, Emily, one of the cooks, walked down the gallery and inquired of Mrs. Overton, "Ma'am, how many will be here for lunch?" The question was an opportunity for Harriet to excuse herself and head back to the Hall. "Thank you, Mrs.

Overton, for a delightful morning. I need to get home and start packing for my trip to Pass Christian."

"Yes, that will be a wonderful experience for you and your sisters." Harriet sat astride her horse and waved to her friend as she headed for home.

Jesse Maxwell had found a large trunk for each of his three daughters. They would be gone all summer and needed to take most of their belongings. They would not need heavy clothes in southern Mississippi in the summertime. Edward loaded the three trunks in the wagon and headed for the boat dock. The Maxwell sisters arrived early the next morning, excited about the adventure before them. The boat trip to Memphis had a couple of stops along the way for passengers to eat and for other travelers to join the trip. After an overnight stay and the transfer to a larger boat, John Overton, Eli, and the Maxwell sisters floated south on the Mississippi River. Accommodations were adequate and the food was excellent. They landed in New Orleans and stayed an extra day before traveling by carriage to Pass Christian. John was anxious to show the ladies the city he had known as a lad. Eli was happy to see some of his friends as well.

The carriage ride to Pass Christian was uneventful. The Delta was flat and filled with plantations. In recent years, the land had been developed as prime cane-and-cotton-producing land. Many of the slaves landing on the Virginia and North Carolina coasts were sold to the Delta landowners. On some occasions, the same slaves were sold or traded back to the plantations in Middle Tennessee and Alabama. At one point during the trip, John had Eli stop the carriage so the Maxwell ladies could see a particular plantation. John's only comment was: "This is a mighty fine piece of property."

Jesse had made arrangements at the Montgomery Hotel for the girls to have a carriage available to them and a weekly allowance. They would sign for their meals and the hotel manager would send an itemized statement to Jesse on a bimonthly basis. The girls saw John and Eli only in passing for the next three days before the men headed back to Nashville.

The Maxwell girls had been gone from home for three weeks and Jesse missed them. Their letters from Mississippi came almost daily. He enjoyed hearing about their experiences of meeting new people in the hotel, going on long carriage rides in the Delta, experimenting with new foods—at least Harriet was willing to try some—fun times at the beach, and attending the weekend dances. Jesse had just finished a paragraph telling of Harriet's experience with raw oysters when he looked up and saw Eli coming down the road to the house. "Good afternoon to ya, Massa Maxwell."

"And to you as well, Eli."

"I's has a note for ya from Mrs. Overton. Here 'tis." Jesse took the note and read in silence,

> *Jesse, Mrs. John Overton, Sr. and John, Jr. request the honor of your*
> *presence at dinner tomorrow evening at six o'clock at Travellers Rest.*
> *Please respond to Eli and he will bring your answer.*

"Eli, please tell the Overtons I'll be delighted to come to dinner tomorrow evening." Jesse watched as Eli disappeared over the hill.

The next evening Jesse arrived a few minutes before six o'clock at Travellers Rest. He was dressed in a dark suit, fresh white shirt, and carrying a bottle of elderberry wine. This dinner was not a formal event, but he still liked sharing wine from his stock. Almost like magic, as he approached, the double doors swung open, revealing the extra tall John Overton.

"Jesse, my friend, it's so good to see you and have you dine with us." John directed Jesse toward the large room and both entered to find Mrs. Overton coming in the opposite door.

"Good evening, Mrs. Overton."

"And a good evening to you."

"Here," handing her the bottle, "is a small token of my appreciation for your hospitality."

"Thank you, Jesse. I hope you're not expecting anything fancy. We are having just a regular farm dinner. Let's be seated."

"Just having someone at the table will be fancy for me. With the girls in Mississippi, the Hall is nearly empty and very quiet at meal times."

"How are the Maxwell ladies faring in Pass Christian?"

"Apparently they're doing fine. I receive several letters from them each week, mostly from Harriet. They are involved in all types of activities. I'm so glad they are having a good time. This may be the last summer they spend together. I wanted them to have this time before . . ."

"I had a note from Harriet just this morning thanking me for sending John as protection on their trip. She also said she was trying to acquire a taste for raw oysters. Jesse, I interrupted you in midsentence. Please continue."

"I wanted the girls to have some time together before I marry Myra Rucker this summer."

John jumped to his feet, popped the cork on the wine bottle, poured three glasses, and proposed a toast, "To Jesse and Myra. May they have a long, happy life together as husband and wife." They clinked their glasses together before John was seated.

"Good for you, Jesse. It's no fun living alone. Have you told the girls the good news?"

"Somehow they already knew and seemed to be happy for me. I guess they have their mother's intuition." Jesse poured himself a second glass of wine, which made four glasses for him in the past hour. He had the first two at the Hall to calm his nerves before dinner. The fourth glass made him bold. "John, when will I be able to return the favor and toast you?"

Mary glanced at her son, hoping he would pick up the message in her eyes. *John, do not respond. Change the subject. Kick the table. Do anything, but do not answer the question.* She was trying to swallow her food so she could take charge of the conversation. She was too late. John pushed his chair away from the table allowing him to stretch his long legs a little. "How about

when I become your son-in-law?" *John, you are as subtle,* she screamed inside her head, *as a hog in a mud puddle. You are just like your father, the Judge. He always answered a question with a question.*

"I had no idea you knew Annie that well. She has not said a word to me."

"Jesse, I appreciate Annie and know she is a fine lady, but I'm not talking about her. I'm talking about Harriet."

"Harriet? My little Harriet?" When Jesse reached for the wine bottle, Mary saw a disaster in the making. *I hope he does not throw the bottle at John. Maybe if we're lucky Jesse will drink the rest of the wine and pass out. We can tell him tomorrow all of this was a dream.*

Jesse held the bottle by the slim neck and let his arm fall; the bottle nearly hit the floor.

"Mrs. Harriet Virginia Maxwell Overton. Mrs. John Overton II. Harriet Overton." It sounded like Jesse was trying out the names to hear their sounds. Mary locked her eyes on her son's with the message, *Let me handle this*!

"Jesse," Mary used the most motherly tone she could muster, "John does not mean tomorrow, or next month, or next year, but when she is of age."

"My little Harriet. Mrs. Harriet Virginia Maxwell Overton, the second First Lady of Travellers Rest. Yes, I believe Martha would be pleased and so am I, but not until Harriet is of age. Then, are we agreed?"

"We are . . ." John saw his mother's hand rise and aimed at him. He stopped in midsentence.

"Jesse, we know your feelings," again she was calm, "but Harriet knows nothing of this. You must not tell her or hint to her in any way. The final decision must and will be hers. Proper courtship is required." The thought crossed her mind, *The Judge gave me only two hours to answer his proposal. I will see to it that his son is more considerate of Harriet.*

With a final sip of wine the evening event was over—and none too soon for Mary Overton.

# 3. Courtship

Jesse Maxwell was true to the agreement with the Overtons. His letters to the girls in Mississippi revealed nothing of the dinner conversation. He did mention, however, that he and Myra Rucker were married, and he was anxious for them to build a relationship with her. The Hall began to look a little more feminine with Myra's touches. Jesse was careful not to compare Myra to Martha but was a little challenged when she announced she wanted to pull up the wool carpets—a pride of Martha's. Myra changed her mind and that pleased Jesse.

The Maxwell girls were surprised to see John Overton in the hotel lobby the evening before they were to leave Pass Christian for Nashville. Annie spotted him first, "Is that really you?" She took him by the arm and swung around to see surprised looks on Mary and Harriet's faces. Flirting was not Annie's style, and it was strange to see her actions.

"Yes, I felt it only right since I brought you here that I should come and escort you home," stated a smiling, half-laughing John. "I needed to make the trip to check on some property I purchased the last time I was here."

"Did Eli come with you?" quizzed Mary.

"Yes, he's out at the property making some last-minute arrangements before we leave in the morning. And how has your summer been, Miss Harriet?"

"Very nice. Very nice indeed, Mr. Overton."

"Ladies, I feel the four of us need to make an agreement this very moment."

"And what is that?" Annie, still holding John's arm, inquired.

"Let's agree to call each other by our first names." The long-time neighbors now became first- name friends, and the relationship lasted a lifetime.

The carriage ride to New Orleans the next morning had a new passenger. His slave name was Claiborne and he created a lot of interest for the Maxwell sisters. Their mother's maiden name was Claiborne, and they were anxious to know how the slave got his name.

"John, would you be so kind to ask Claiborne how he got his name?" Annie inquired for the sisters.

"Claiborne, the ladies are interested in your name. Where does it come from?"

"I thinks it come from being born in the Delta clay."

"How do you spell your name?" Harriet wanted to get to the heart of the matter.

"Ma'am, I doesn't know how to spell. So, I guess ya can spells it any way ya wants. I born in da Delta, dats all I know, ma'am." While Harriet and

Claiborne talked, Mary tore a page from her writing pad and printed the letters CLAIBORNE. She handed it to Harriet, who in turn gave it to John. "Harriet, hand the page to him and tell him what it is," John directed.

"Very well. Claiborne, here is how your name is spelled." She had to stretch to reach the driver's seat, but she was pleased to start any person on the road to education.

"Thank ya, ma'am. I take dis to preacher Bob and he help me learn it."

"Preacher Bob?" Harriet looked puzzled.

"Preacher Bob is one of the slaves on my property. Claiborne will be returning there after he delivers us to New Orleans." John was happy to see a smile come back on Harriet's face after the brief encounter.

On the way to New Orleans, John suggested an alternate route to return to Nashville. "Since the rivers are high between here and home, I suggest we stay on the boat and let it take us directly to Nashville. It will save us a transfer in Memphis. The travel time is a day less and we'll be more comfortable." Annie, seated next to John in the carriage, responded, "I think that's an excellent plan, John," sliding her arm under his. At this outward, unladylike behavior, Harriet pondered, *What is Annie doing? This is the second time she has flirted with John in public. Did she not learn about decorum at the Academy? If this happens again, I'll speak to her.*

John sent a telegraph message to Jesse Maxwell in Nashville, SLIGHT CHANGE IN PLANS. WILL ARRIVE NASHVILLE ON THURSDAY NEXT. MAXWELL LADIES ARE WELL. JO. When Jesse read the message, he wondered for a moment whether John's intentions were as they had agreed. As he processed the matter, he thought, *if John is to be my son-in-law, I must put my trust in him to do what he says he will do.*

Two full days passed on the boat trip before the Maxwell girls saw John again. He was seated at a table with Eli and two other well-dressed gentlemen. They were all intently studying a large piece of paper that had been unfolded and nearly covered the table where they were seated. John spotted the girls coming toward them and stood in an effort to detract their attention from the material on the table. "Ladies, good to see you. Could we have lunch together tomorrow in the dining room?"

Annie answered for her sisters, "We will be delighted to join you for lunch tomorrow."

"Good. I'll make reservations for 12:30. See you then." It was apparent to the girls they had been dismissed without proper introductions or any indication as to what was being discussed. John turned his attention again to the papers on the table.

Mary suggested they find three chairs on the upper deck and enjoy the afternoon sun. The steam whistle blasted as they walked on the deck. "What was that for?" Before Annie or Harriet could respond a boat steward answered, "The captain is signaling the folk on shore to see whether we need to stop in Vicksburg. If he sees a red flag on the pole, he will stop. If he sees a green

flag, he will not stop. When the boat makes the next turn in the river, a flag will be visible."

"Thank you so much," Mary said, "that was very helpful."

Two young soldiers were standing on the dock as the boat made its way slowly to the landing. A plank was lowered and the two men came aboard with their horses. The Maxwell girls were interested in the landing and boarding procedure. They looked at each other and smiled as the two handsomely dressed men boarded. Within minutes, the paddleboat was back in the middle of the Mississippi at full speed headed north.

The next day at lunch, the girls were pleasantly surprised to see that John had invited two guests. The three men stood as the girls approached. "Gentlemen, these are the Maxwell sisters from Nashville. This is Annie, her sister Mary, and their sister Harriet."

Three chairs were pulled away from the table as John gestured with his hand. "Ladies, may I present Second Lieutenant Thomas Claiborne and Second Lieutenant William Elliot." Annie did not hesitate and extended her hand to Thomas. Mary followed Annie's action and was guided to a chair by William. Harriet stood alone wondering what was coming next. "Miss Harriet," John was all smiles, "will you join me for lunch?" The conversation around the table was light and cheery. The Lieutenants indicated they were on an assignment in Vicksburg and St. Louis before going west to Texas to join a unit. They were guarded in their comments so as not to reveal details, but the ladies were not really interested in all the military conversation. Harriet did not hear the comments her sisters were making but tried her best to respond to John. His conversation was always engaging and current because he moved in circles with interesting people. She did not feel like a child of fifteen when she talked with John. They talked and laughed as adults.

The next few days on the Mississippi would always be memorable for Harriet. While Annie and Mary were escorted by the Lieutenants every waking hour, she felt a strong, deep bond with John as they dined together, strolled the decks, and talked of Tennessee events. The afternoon the boat passed Memphis John recounted how his father, along with Andrew Jackson and General Winchester, had purchased the land. One evening at dinner she heard about the railroad deal he was working on to connect Nashville with northern Alabama. The railroad would come right through the Travellers Rest plantation. They talked about John III, which led to remembering Rachel—a person they both loved. On two occasions, John wanted to talk about the grand hotel for Nashville. "Harriet, I have not forgotten about your idea for a hotel in downtown Nashville. In fact, I recall your words, 'a large hotel with a ballroom large enough to host special events and food service equal to New Orleans.'"

"Yes, sir. Those were my very words."

The Maxwell sisters talked each night before going to sleep. Annie was eager for her sisters to know she was falling in love with Thomas Claiborne. "Annie, you have only known him for a few days. How can this be proper?" Harriet was looking Annie in the eyes when she commented.

"Harriet, I could get off the boat in Cairo and go with Thomas if he would say the word."

"Well, Annie, he's not going to say any word that would cause you to get off this boat and go with him. You are going back to Nashville!" There was not so much demand in Harriet's voice as fear.

"I am nineteen years old and old enough to make my own decisions."

"You are not old enough in Father's eyes to make **this** decision." Harriet turned away and stomped the floor to emphasize her point, which not only got Annie's attention, but Mary's as well.

Annie's eyes filled with tears as she turned to Harriet. "I may never get another opportunity like this in my life. I have no suitable prospect at home. Harriet, this may be my best chance."

"Annie, I do not disagree with you. I'm only saying Father needs to be involved in this decision. If Thomas feels love for you, the road that takes him to Texas will be the road that brings him back to Nashville."

"My head tells me you are right, but my heart . . ."

With Annie sniffling and dabbing her puffy eyes, Harriet turned to Mary. "Please tell me you are not in love with William."

"No, I'm not in love with William, Miss Know-it-all. And anyway, who made you all wise? After all, you are only fifteen. Maybe it would be best if you minded your own business."

"My sisters . . . my family . . . will always be my business."

"Well, Harriett, what about you?" Mary was still glaring. "Are you and Mr. John Overton in love?"

"I do . . . ." Before Harriet could answer, Annie moved forcefully into the conversation. "That is a ridiculous question to ask, Mary. Harriet is not old enough to have thoughts pertaining to love. I think it's time for us to go to bed."

Harriet closed her eyes, but could not sleep. She kept pondering Mary's question, *Are you and Mr. John Overton in love? Am I in love with John? I like John. I like being with John. But, do I love him? Annie may be right. Am I old enough to have thoughts pertaining to love? I do have a special feeling when John and I are together. Could it be love? Could it be . . .?*

At times Harriet wondered whether Annie's tears, if dropped into the Mississippi, would raise it to flood stage. When Thomas and William departed in Cairo, Annie nearly fainted even though she was being supported physically by her sisters. Floating the Ohio and Cumberland Rivers was a blur because Annie's emotional condition required their full attention. The girls did manage to get their trunks packed on time for Eli to pick them up and place them in the unloading area of the boat. The girls were on deck when the steam whistle sounded, announcing their arrival at Nashville. They spotted their father and

waved but concentrated their attention on the lady standing next to him. Harriet was very unladylike with her shouting when she spotted her father. Mary was stoic; seeing any woman at her father's side but her mother was strange. Annie was composed—to the delight of her sisters.

The next year and a half at the Maxwell home was spent adjusting. The girls had to learn to interact with Myra. They didn't dislike her, but it took some time for them to treat her like family. Since the passing of her mother, Martha, Annie had taken on the role of the lady of the house, making some of the decisions for the family. Myra was now in that role. The adjustment was easy for Annie after she received an invitation to join the teaching staff at a new female institute in Franklin. The invitation was on a semester-by-semester basis and would be reviewed at the end of each term. She was only fifteen miles away and returned to the Hall one weekend a month for a while, mostly looking for letters from Thomas. She was not disappointed and enjoyed sharing tidbits with her sisters. When the letters started arriving at her Franklin address, she made visits home only on holidays and special occasions.

Mary adjusted to the new situation at home by staying in her room most of the time working on her writing projects. She tried her hand at writing poetry but quickly put that aside. She gave her attention to writing a short story about three sisters. After writing and rewriting, she asked Harriet to read her work, "The Sisterhood." Harriet was impressed and encouraged Mary to send it to a Boston publisher for publication in a ladies' magazine they both read. Unfortunately, no response ever came from the publisher, but Mary continued to dabble at her writing.

In January 1848, Harriet turned sixteen and found herself with little to do. She applied for several work positions in the city, and even though she had graduated from the Academy and had excellent references, she was still too young to be considered for employment. Of the three Maxwell sisters, she worked hardest on developing a relationship with Myra. Her actions did not go unnoticed by her father. He was pleased Harriet made a point of sitting with him and Myra in church. They made shopping trips into the city looking for household items. The two ladies often were found on the front porch rocking, singing, sewing, and just having fun talking. Harriet made every effort to bond with Myra and to make her feel welcome into the Maxwell family. While Harriet adjusted to her home situation, she was also reaching out to her neighbors—Mrs. Mary Overton in particular. Visits to Travellers Rest became a weekly occasion. Sometimes she made visits to the Overtons to tutor John III. He was six and needed help with math concepts and learning the alphabet. He advanced quickly. He was a good student and was always eager to tell his father about new things he was learning. His father did not interrupt his lessons but would stick his head into the room to greet Harriet.

Mary Overton met regularly with Harriet to check on little John's progress. At one of the checkup meetings, Mary was eager to clear up a

matter. "Harriet, my grandson tells me you have a special locket with a secret."

"Yes, ma'am. This is the locket." Harriet held it out for Mary to see. "The locket was in Mother's collection. Father gave it to me and I wear it all the time."

"It's lovely. He said there's a secret."

"The secret for little John is inside the locket." She mashed the clasp and the locket opened to reveal a small piece of white, silk ribbon. "The ribbon was given to me by Rachel. It's from her wedding dress. I keep it in the locket so I won't misplace it."

Mary's eyes moistened and a stream of tears came down her cheeks, requiring her to search in her dress for a handkerchief. Harriet was visibly upset. "I did not mean to make you cry."

"No, dear. You have done nothing wrong. In fact, you have done something very good. Little John does not remember his mother, but you do. His father and I appreciate any help you can give him. Please continue telling him about her." Harriet closed her locket, excused herself from the room, and headed for home.

This was the first fall in three years that Harriet was living at the Hall and Jesse was enjoying every moment. With Annie living in Franklin and Mary isolated in her room, Harriet was a welcome companion for her father. They enjoyed each other's company. Those who knew them both commented on occasions that they were cut from the same cloth. Years before, when Harriet was beginning to walk and could keep up with him, she shadowed her father everywhere on the plantation. At one point Martha had to insist that Jesse treat their daughter like a girl and not a boy. Fourteen years later, when he saw Harriet, he thought of Martha's demand, *"Jesse, treat Harriet like a girl."* Harriet didn't help the matter. She could handle a horse with ease. She could pitch hay for the farm animals with no help. She could split firewood for the kitchen as well as Jesse. She could and did manage the slaves—male and female—when her father was away from the plantation. In her father's eyes, she could do no wrong. When he looked at her from a distance, without her noticing, he wished these times would last forever, but he knew they wouldn't. In less than two years, she could be gone, sharing her life with another man.

Among the many habits Harriet learned at the Academy was to read something every day and stay apprised of current affairs. She found both habits were easy to attain by reading the Nashville newspaper. In addition to her own edification, the newspaper gave her another way to engage her father in meaningful conversation. It seemed President James K. Polk's name was on the front page each time the paper arrived. The war with Mexico was the lead story. The final military victory for the United States and a personal triumph for the President were being discussed all around Nashville and on the Maxwell porch. Jesse was more than pleased to tell Harriet the President was his friend. His eyes were open extra wide when he recounted the political

meeting he attended at the Hermitage, when former President Andrew Jackson encouraged James to enter the campaign for the presidency. "James' national leadership has added over thirty percent more land to the United States," Jesse continued, while Harriet listened intently. "The Treaty of Guadalupe-Hidalgo has given us vast Mexican lands."

"Father, do you think General Scott will be our next President?" Harriet was eager for her father to know she was aware of the national situation. Jesse was impressed and pleased at what he heard.

"No. I hear General Taylor may run and he will probably win the presidency."

"You mean 'Rough and Ready'?"

"Yes, the very same." Father and daughter laughed, and Jesse's smile of pleasure lasted a long time.

Harriet's knowledge of current affairs did not stop on the Maxwell porch but popped up wherever she went. One day she went to visit little John Overton at Travellers Rest and found his father and grandmother sitting on the lower gallery. As she approached the house, she heard Mary Overton say to her son, "Ask Harriet, she'll tell you about it."

"What will I tell you?"

"Mother and I were just discussing the matter of rights for women. What do you think?"

"Oh, I agree with Elizabeth Stanton about revising the Declaration of Independence. I, too, believe it should read 'that all men and women are created equal." John stood up and glared at Harriet.

"How are women unequal to men, young lady?"

"Women have no voice in laws; colleges are closed to women; women cannot vote; church affairs are managed by men—do you want me to go on?" She was nearing the point of stomping her foot but resisted the temptation. Mary stood up, went to Harriet, and hugged her without restraint. They both turned to a stunned man who was walking away from them. "John, you come right back here," Mary said in her motherly voice. He knew he had no choice but to return.

"Harriet is right and you need to tell her so." Mary's smile at her son was hidden from Harriet and implied more than the young lady would understand. "Son, I believe you've met your match."

"Yes, and I'm outnumbered by two lovely ladies. Harriet Maxwell, you are a winner, and I agree with your reasoning."

"Thank you, John." Harriet took little John's hand, walked into the house, and up the steps to his room. John stood near his mother shaking his head. She grabbed his hand and whispered, "She is your match. Don't let her get away."

Weeks and months passed and John took every opportunity to be where Harriet was. He would call on Jesse, hoping Harriet was at the house. He made it a point to be at Travellers Rest when she came to tutor little John. The Maxwells were invited to dine with the Overtons with seating arrangements

made to pair Harriet and John. There were church events, which allowed them to be together to and from the activities. Summer and early fall community picnics drew the two together for fun and serious talks.

The birthday celebration for Mary Overton in 1849 was the event remembered, by all who attended, as the announcement evening. After dinner, the large room was cleared of furniture. The musicians entered the room, and when the music began, John brought his mother to the center of the room for her birthday dance. The onlookers smiled and clapped as the birthday couple swept the room. Mary spotted Harriet standing next to her father and Myra. She guided John in that direction, stopping in front of the Maxwells. With a wave of her hand, Mary stopped the music, released her son, and turned him to face Harriet. "Go ahead, John. Now is an appropriate time." A hush filled the room with all eyes turned in John's direction. Only the crackling of breaking logs in the fireplace and the wind against the glass panes competed with his deep voice.

"Harriet Virginia Maxwell," he took both of her hands in his, "I love you with all my heart. I will be the luckiest man alive if you will accept my proposal of marriage and be my wife." At that moment, a one-time event in her life, Harriet was speechless. Her answer was formed in her mind but the words would not come to her lips. She turned her head and glanced at her father. He was nodding his head and mouthing, yes.

"Yes, John Overton. I will accept your proposal of marriage and be your wife." In less than two months, Harriet would be eighteen years old.

# 4. Engagement and Marriage

The midpoint of the nineteenth century arrived without much fanfare in Nashville. The city was already busy and didn't need any extra excitement. Plans were underway to give President James Polk a favorite son welcome when he and Mrs. Polk arrived from Washington. Although they had property in Columbia, they would be living in downtown Nashville near the state buildings. Soldiers returned from victory in Mexico and were greeted as heroes—Tennessee Volunteers—who had won the war. The old men of the city remembered their war in New Orleans with their leader, Old Hickory. The young soldiers mentioned fighting in Vera Cruz and Cerro Gordo with their leader, Winfield Scott. They swapped war stories, drank beer, and enjoyed being identified as volunteers from Tennessee. For some of the returning soldiers, Nashville was far too tame, and many joined the excitement of discovering gold in California. The exodus to the West Coast had been underway for nearly a year, but many felt the riches would last forever. Off they went to seek their fortune, never to return.

Some of Nashville's citizens discovered other ways of seeking their fortune. John Overton was one of them. For years, the Overton family operated a toll road on the part of Franklin Pike that ran through their property. The lawfulness of the toll road was contested often by those who lived in Franklin and needed to travel to Nashville. John saw an opportunity for even more revenue for his family by encouraging a railroad connection from Nashville to Decatur, Alabama. He was involved with a group of men from Nashville and northern Alabama to plan and build the rail line. When the rail route was plotted, John was able to trade right-of-way through his plantation property for stock in the railroad. He was anxious to share his good news with Harriet. After his meeting in Nashville, he detoured to the Maxwells' before going home. Jesse and Myra were sitting on their front porch. He halted the carriage and tipped his hat to Myra.

"Afternoon, Myra." The thought passed through his mind, *In less than two months these folk will be my in-laws.* "Is Harriet here, Jesse?"

"I believe she's down in the barn brushing her horse."

"Do either of you have any objections if I go to the barn and talk with her?" John did not want to do anything that would appear rude during this phase of the engagement.

"John, please feel free to visit with her. I know she will be happy to see you." Myra smiled at Jesse as John walked to the barn.

"Harriet? Harriet Virginia Maxwell, are you in the barn?" Harriet saw her tall, handsome husband-to-be approaching the barn and hid in a dark corner.

"Yes, John Overton, I'm here. Come in and find me." John was equal to the challenge and walked into the dimly lit barn. As he turned, squinting his

eyes adjusting them to the light, he was hugged around the waist. "Whoever is hugging me, I'm going to give you exactly one hour to stop."

"Oh, John, you are so funny." Harriet's giggle made him smile as he wrapped his arms around her, pressing her face to his chest. He had to bend down to kiss her, but the effort was worth it. While they continued to embrace, John said, "Harriet, I have wonderful news! The railroad route has been approved, and it will be coming through our plantation." That was the first time either of them could remember using a plural pronoun for their relationship.

"John, that is wonderful news! How did your mother react when she heard?" Since their engagement had been announced, she had wondered, *Will Mary Overton accept me? Am I too young to be her son's wife? Should John and I move to another house after we are married?*

"I've not told Mother yet. I wanted you to be the first to know." *Apparently,* Harriet thought, *John has already begun transferring his trust to me. I must find a way to know Mary's mind on our relationship. I've heard Rachel was left out of decisions, when she was John's wife living at Travellers Rest. I must find out.*

"Well, you need to go tell her. She needs to know immediately, before she hears it from another source. And John, it might be best if you . . ." Harriet stopped in midsentence and thought better of finishing.

"If what?" John needed to know Harriet's thinking. Harriet hesitated only for a moment before answering. She never ran from a confrontation. She let the words form properly in her mind and then she spoke. "I want my relationship with your mother and your family to be honest and open. I don't want your mother to feel she is losing you. I want her to feel she is gaining me."

"Harriet, I can promise you here and now that what you want to happen, will happen. When we got back from Pass Christian, I told Mother I wanted to marry you. We talked and she suggested I wait until you were eighteen years old. I agreed. I then talked to your father and we also agreed."

"My father knew your feelings when I was fifteen?"

"Yes. He was very protective of you. I have been looking at you for over two years through eyes of love, just waiting for your birthday. At Mother's birthday party, with so many of our friends present, it seemed an appropriate time to propose marriage to you. I wanted the whole world to know my feelings for you." Harriet tried to be strong and hold her emotions inside, but they surfaced anyway. Tears filled her eyes and dampened John's shirt.

"I didn't mean to make you cry."

"John, my love, these are tears of joy. I've had the same feelings for you but was afraid to believe they would ever come true. My sisters were so involved with their Lieutenants; they never had time to listen to me and how I felt. I knew Father would never understand. So my true feelings have been hidden all this time." John cupped Harriet's face in his big hands and looked into her teary eyes. "And one other thing, Mother is so excited about you being in the Overton family."

"Thank you, John. Now get out of here and go home!" He kissed her in a way that she knew her dreams would come true. They were hand in hand when they arrived at his carriage. Jesse was still on the porch when John left. He smiled as Harriet approached, "Is everything fine with you and John?" She bent over and kissed him on the cheek and laughed, "One of these days, Father, we need to have a long talk."

The next day Harriet was at Travellers Rest for a routine visit with little John. He continued to impress her with his retention of material they had discussed together. He was withdrawn today for some unknown reason. "John, do you feel well?"

"Yes, ma'am, I'm fine."

"Why don't we go outside for a walk? It's such a nice day. We can collect some of the colorful leaves. They are all over the ground. Let's get your coat and cap." As they closed the door behind them, little John spotted his father and grandmother coming down the gallery from the kitchen. "Miss Maxwell and I are going for a walk to collect colorful leaves."

"May I join you?" John asked hopefully.

"No, sir, you may not. I need to talk to Miss Maxwell without you hearing."

"Fair enough. Maybe I can talk with Miss Maxwell later."

"Fair enough." Little John took her hand and off they went. Mary was holding back a laugh until they were down the steps and looked at John. "Little John has the same personality as his grandfather, the Judge. Your father was a very private person."

"Yes, I remember that quite well. He was very good at giving directions and instructions but not a good listener, as I recall."

"He was a good listener but abhorred small talk. He was like another Overton male I know." John nodded his head and they went into the house.

Little John was busy picking up leaves and bringing them to Harriet for safekeeping. He was running and laughing, the complete opposite of the way he had been a few minutes ago. Harriet smiled with each leaf she received. She was catching passing glimpses of her friend Rachel from years ago. *Oh, how I wish Rachel could be here holding these leaves for her son. She would be so proud of him. Rachel, if you are looking down from heaven, I hope you are enjoying watching your son. He is such a fine boy. We talk about you often. Little John is so eager to know all about you. He loves to know you sang to him. At times, he is sad and doesn't understand why you had to go away.* Harriet's gaze moved beyond the treetops into the clouds, when little John returned with another yellow leaf.

"What are you looking at, Miss Harriet?" The question brought her back into reality.

"I was looking at the clouds, but I was thinking about your mother. She liked everything and everybody. She liked the fallen leaves, the snow, the rain, the sunshine, and the wind. We used to sit on the gallery and she would ask

me, 'Harriet, where does the wind come from?' When I didn't have an answer, she would say, 'The wind comes from its hiding place.'"

"Miss Harriet, are you going to become my new mother?" In true Overton fashion, he did not back away from hard questions.

"No, I can never be your mother."

"But you are going to marry my father, aren't you?"

"Yes, I plan to marry your father."

"Then you will become my mother." Harriet began to feel like she was in court, on the witness stand.

"Your mother will always be Rachel Harding Overton. She gave birth to you and loved you very much. I will be like a second mother, but Rachel will always be first."

"What will I call you when you become my second mother?"

"How about Harriet? You can call me Harriet. How will that be?"

"I like that. It can be our secret. Let's go show Grandmother the leaves." Little John's private talk was over and he was ready to move on with his life. He ran off like any other seven-year-old boy who had had a serious talk with his future second mother. He took the steps two at a time, leaped on the gallery, pushed the side door open, and headed for his grandmother's room. "Look what me and Harriet found outside." Harriet was only a few steps behind and close enough to hear him. "John, what did I hear you say?" He paused, looking first at his grandmother and then at Harriet.

"Grandmother, look at what Harriet and I found outside."

"Much better. Thank you."

"The leaves are beautiful, John." Mary was looking beyond little John to Harriet, standing at her open door. Mary had a puzzled look on her face, which was not a surprise to Harriet.

"John," Harriet suggested, "I bet your father would like to see your collection of leaves." He went through Mary's room, into the hallway, past the staircase, and into the parlor to find his father.

Mary still looked puzzled as Harriet entered the room and sat down at the small table. "We had a talk about Rachel being his first mother and me being his second mother."

"Harriet, I'm relieved. At least I know John has talked to his son about the upcoming marriage. How does little John feel about that?"

"He seems to be all right. His big concern is what to call me after the wedding. He decided to call me Harriet."

"You have always had just the right answer for little John when he wants to know something about his mother, Rachel. He has been a little sad the last couple of days. I guess he was thinking about her. You do know he will only be here a couple of more years. John plans to send him to New Orleans for his formal education. He wants his son to have the same opportunity he had at age ten."

"I didn't know that, but I'm sure it would be an excellent opportunity. John talks with fondness of the time he spent in New Orleans. In fact, he and Eli took my sisters and me for a visit to the city when we went to Pass Christian."

"Do you know I've never been to New Orleans or Pass Christian? My first husband, Francis, spoke of some of his impressions of the area. All Andrew Jackson could talk about was defeating the British in New Orleans. John was there in later years after the city had recovered from the war. He was impressed with the food and the social events he attended as a young man." John stuck his head in the room and was invited to come in.

"Thank you for helping little John this morning. He was so secretive about your talk." John was still holding the leaves when he entered the room.

"When little John is ready to share with you," Harriet suggested, "I'm sure he will. I cannot, however, reveal the secret we have together." Mary liked what she was hearing from Harriet, but she was ready to move to another more pressing subject—the upcoming wedding. "Have the two of you talked about your wedding ceremony?"

"Not really," John confessed.

"I've thought about it," Harriet said, hoping her thoughts would be considered. "I'd like to be married here at Travellers Rest surrounded by our families. We could use the large room."

As Harriet continued to talk about the details, Mary's thoughts were collecting; *Harriet has done more than think about the wedding event, she has it all planned. Good for you, Harriet! If you wait around for John, you may never get married. You are a take-charge lady and that's what I like about you.* Mary was brought back into the conversation when Harriet asked, "Well, what do you think?"

"Harriet, I like your ideas." Mary was proud of this young lady. The conversation had become a dialogue as John, still holding the leaves, listened. "You are suggesting February 28. What day of the week is that?"

Harriet thought that was a strange question but was ready with an answer. "It's a Thursday."

"That will be perfect. What do you think, John?"

"Perfect." Neither of the ladies detected any resistance in John's voice. He would have been pleased with a small wedding but knew that would never happen with his mother involved. Besides, he thought, *I have a number of loose ends to tie up before the wedding. I still need to negotiate a closing date for the toll collections on Franklin Pike with the railroad committee. I want to keep them as long as possible. The closing will depend on the completion date for the railroad. Harriet will tell me what I need to know about the wedding. I'll be there to say "I do" and smile a lot at the guests. I'll just let things about the wedding happen and not worry too much.* "John. John!" He snapped to attention and responded to his name, "Perfect. Things are just perfect."

"You have not heard any of our conversation, John."

"But with you two in charge, things will be perfect." The two ladies laughed at him and continued talking. John need not fret; proper and adequate wedding plans were underway for the February 28 event.

The wedding date would be announced at Harriet's eighteenth birthday party hosted by Mary Overton at her home, Travellers Rest. Mary planned the event and it was special. The guest list included only families from both sides—Overtons and Maxwells—and special guests, Mrs. James Polk and the Joseph Acklens, who both declined because of previous commitments. The Overton family included: John III; Robert Brinkley, who was, until her death in 1845, the husband of Ann Coleman Overton Brinkley, the Overton's oldest daughter; Elizabeth Overton Lea, the second Overton daughter; and her husband John McCormick Lea. Mary also invited the children from her first marriage. They had always been close to John. The May family included: Andrew Jackson May; Mary May Barry and her husband, Richard; Margaret Jane May Phillips and her husband, Jesse. The Maxwell family had few names because Jesse limited the list he gave to Mary. He included only his immediate family: Myra, his wife, and his two daughters, Annie and Mary.

The birthday invitation included a phrase indicating there would be a very special announcement made as part of the event. Many who received the invitation ventured a guess and some knew immediately. A couple of the guests thought John would announce his intentions to run for a seat in Davidson County politics. On more than one occasion, the Whig party had suggested he begin a political career. "After all," they reminded John, "politics is a part of the history of Travellers Rest."

Since Harriet's January 8 birthday fell on Tuesday, Mary set the party date for Sunday, January 6, at four o'clock in the afternoon. She reasoned that people could attend church, have lunch, and then come to Travellers Rest for the party. Refreshments would be light—sliced seasonal fruit, a round of cheese, fruit punch, and peach brandy for those who requested it. The highlight would be the birthday cake with the appropriate eighteen candles. The blue-trimmed china would be used for the occasion. This was the very same china the Judge bought in New Orleans in 1828 for use in the large room of the new addition to the house. Mary shopped all around Nashville for a Belgian lace tablecloth for the extended table she wanted to use. Her search was in vain. A shopowner suggested she try putting two regular-sized cloths together. She did not use the suggestion but thought the idea was so unique she had the owner special-order the large-size cloth, hoping it would arrive in time for the wedding. While she was in the shop, Mary bought white curtains for the four windows in the large room. She did not want to take a chance that they might not be available for the wedding in February. Normally, she chose to have no covering over the windows, allowing sunlight to fill the room. She was fearful that an overturned candle might ignite the curtains, causing a fire.

Even the Overtons had no control over the weather. The winter months in Middle Tennessee are always unpredictable. One day can be cool, requiring a light wrap for comfort. The next day cold winds can blow in from the north, causing below freezing temperatures. Southwest winds can bring snow and ice, making travel nearly impossible.

On the Sunday morning of the party, Mary was up early. She went to her bedchamber window to look out, but the shutters had been closed. She wrapped a shawl around her shoulders and headed for the front door. When she opened the door, she felt her prayers were answered. The blue sky was filled with puffy white clouds being blown by a slight southern breeze. As she looked, she thought, W*hat a perfect Lord's day. I could not have ordered a better day. Harriet will have a wonderful birthday and John will make the announcement. Thank you. Thank You. Thank YOU!*

Mary glanced one last time at the large room. Everything was in order as she had planned. The extended table, without the lace tablecloth, was heavy with food. The pier tables that sat between the windows on either side of the room were filled with cups, glasses, and drinks—punch bowls for the soft and canisters for the hard. The large, high buffet held napkins, silver forks, and small, Old Paris china plates. The fireplace was providing just enough heat to knock off the chill. When the room was filled with people, heat would be of no concern. The candles around the room were unlit. Adequate light flowed through the four large windows. In an hour the candles would be needed.

Mary turned a complete circle inspecting each station. She made eye contact with every servant at each station and encouraged them, "This is a very special occasion for the Overtons and the Maxwells. I expect each of you to do your very best." The last servant to be reviewed was the doorman.

"Please open the door and allow our guests to enter."

Since Mary had planned for the event to be a family affair, no formal receiving line was needed. She, John, Harriet, Jesse, and Myra would circulate and do introductions as needed. John and Harriet had slipped into the room using the side door. Mary was pleased that they were ready to greet the families as she had planned.

After an hour of eating and conversation, Mary visited each station, instructing the servants to light the candles when she directed and to clear the food from the room. On cue, a large birthday cake with eighteen lighted candles was brought by two servants to the large table. The voices in the room went silent. The winter day provided just enough darkness to allow the candles to be the centerpiece of the room. With her directive voice, Mary instructed, "John, please bring Harriet to the table." Assignment completed, Mary continued, "Harriet, happy birthday to you, my sweet. May you have the wishes of your heart as you blow out the candles. John, perhaps you have a word to say." Harriet took the clue, bent over the cake, and blew out the candles—all eighteen of them with one breath. John was ready to speak but waited to see the results of Harriet's efforts.

"Well done, Harriet."

"Thank you, John."

Mary snapped her fingers and magically the room was filled with light as the servants lit their assigned candles. John took the time to guide Harriet toward her family and his mother.

"Harriet and I want you to know a date has been set for our wedding. We will be married in this room at midday on February 28." The midday time was an addition John made without the help of Harriet or his mother. He heard a soft, feminine voice say, "Perfect" but did not look at Harriet.

Laughter, smiles, and words of congratulations were directed to John and Harriet, as family members passed by on their way to the cake table and a chance to refresh their drinks. Mary positioned herself and watched the activities around her son and future daughter-in-law. She was pleased and remembered, *He was so happy with Rachel Harding, but with her death, the marriage lasted such a short time. The birth of little John was a gift from heaven. However, it's time for John to move on to the next phase of his life with Harriet. This will be a good match. The very idea of him announcing a midday time for the wedding! These Overton men have no sense of timing. Harriet and I will need to talk about the midday idea.* Mary glanced around the room and noticed the candles were burning rather quickly. Where had the time gone this afternoon? Apparently, Myra had also noticed the candles. She suggested to Jesse that it was time to leave. He announced their leaving by thanking the families for coming. As Jesse, Myra, Annie, and Mary departed the room, it was a subtle clue to the others that the party was over. Harriet stayed to visit with John's family, knowing he would escort her home later.

The conversation in the Maxwell carriage was lively on the way home. Annie and Mary sat in the back seat. "Harriet is just too young to be getting married." There seemed to be a slight edge in Mary's voice as she made the statement.

"Mary, I want you to be happy for your sister," Jesse insisted.

"I'm trying to be, Father. But she is still only seventeen."

"Yes, that's true. But when she marries, she will be eighteen. And that's the age . . ." Myra finished Jesse's sentence, hoping to prevent any further discussion, ". . . many young ladies are getting married these days."

"Yes, thank you, Myra. Harriet has finished her schooling and she has always been very mature for her age. It's not as if she will be moving away. She will be next door." *Moving away* struck hard into Annie's brain. She was hoping to find the right time to tell her father she also would be moving away, far away, to Texas. In her last letter from Thomas was a proposal of marriage. He would be on military leave during the month of August next year and was asking Annie to marry him then and return to Texas. *This is not the time to broach the subject of my marriage,* Annie was thinking to herself. *Father needs time to process the events in Harriet's life.* Mary was not ready to drop

the subject, but as they approached the Hall, Jesse made a request. "Annie, would you help me put the carriage and horse away?"

"I'll be happy to." Mary was pleased. Lately, with Annie living in Franklin and Harriet spending so much time with John, caring for the horses had been Mary's responsibility. Jesse stopped the carriage in front of the house to let Myra and Mary out and then went on to the barn.

Edward was standing at the barn door, stepped out, and took the reins from Jesse. "Thank you, Edward."

"But Father, I thought I . . .”

"Edward can handle the carriage and horse. I just wanted some time to talk with you while Mary was not around. I started to say something on the way home, but Mary was in no mood to hear what I need to say."

"Father, when you were talking about Harriet, you said something about her not moving away. Is that important to you?"

"Annie, I would like to keep my family close at hand, but that's not always possible. I know one day you or Mary could move away to Virginia or Mississippi or Texas. My concern for you girls is that you be happy in life. I believe Harriet is making a life for herself where she will be happy. Mary, for some reason unknown to me, may never be happy. So that leaves you. Annie, I need to hear you say you will be happy with Thomas in Texas."

"Thomas! Texas! Be happy with Thomas in Texas?" Annie could feel her jaw drop and her mouth open in complete surprise. "Father, what are you talking about?"

"I'm talking about Captain Thomas Claiborne of the Mounted Rifles United States Army, currently stationed in Texas, who will be coming to Nashville next August for some special event."

"Father!" Annie's voice had moved up two octaves nearly to a scream. She wrapped her arms around Jesse and began to weep. Jesse did not stop her emotional display but patted her on her back. "I had a letter from Thomas nearly a month ago. He gave me the history of your relationship and told me of his plans for the future. He asked me for your hand in marriage. I wrote him a letter and . . ." Jesse became emotional and had to pause for a moment. Annie looked up at her father, "And . . . and what? What did you write Thomas?"

"I wrote him there was no man good enough for my Annie, but he came closer than any man I knew. I've not heard back from him as yet."

"I have a letter from Thomas that came this week. I'd hoped to share it with you this weekend. I have it here in my purse. I want to read one sentence from the letter." Annie fumbled through her purse until she found the letter, unfolded it, and read, "I know I will never be good enough for you, but I will come closer than any man alive—other than your father!"

"He also has a sense of humor. Although I've never met him, I feel it will be a pleasure knowing him."

"Thomas is wonderful! I love him deeply and want to be his wife."

"Annie, I ask one favor of you and I know it's not fair to ask. Could you and Thomas wait until after Harriet's wedding to make your announcement? If the situation were reversed, I would want the same for you."

"May I contact Thomas and tell him yes?"

"By all means, but explain the situation."

"Father, one other thing. I would like to move back to the Hall after Harriet's wedding. She will be leaving, and I could take the space she is using until after my wedding in August."

"What about your teaching position in Franklin?"

"I've already talked to them about that. One less staff member would help them financially at this time of the school year." Jesse and Annie returned to the house, arm in arm, mutually pleased.

Harriet made her routine visits to tutor little John and spend time talking with Mary Overton about the wedding and the matters of the house. John was busy with the railroad project. He continued to negotiate with the rail executives about making Travellers Rest a scheduled stop on the system both in and out of Nashville. He was also anxious to have a rail spur that would run deep into his west property. This addition would allow him to get his cotton to market much quicker. The railroad project took longer than he had anticipated, but it kept him occupied and that was a blessing for the wedding planners.

Mary and Harriet did more wedding planning each time they visited. The invitations were printed and mailed. Mary yielded to most of her future daughter-in-law's wishes but insisted the invitations contain a RSVP by February 15. This information would aid her in planning the reception. No matter where in the house they began talking, they always seemed to end up in the large room. On one occasion, Mary had the white curtains pressed and draped over the sofa. Harriet spotted them without Mary's prompting.

"These are beautiful!" Harriet ran her hand down the soft material.

"I thought they would add to the occasion." Mary was pleased with the reaction. Harriet missed the custom-made tablecloth on the extended table but was directed that way by Mary's gesture in that direction.

"Oh, Mary . . . I mean Mrs. Overton, this is the one you ordered from Europe." Mary caught the slip and thought this would be a good time to discuss names.

"By the end of this month there will be two Mrs. John Overtons in this house. I suggest we use our given names with each other. The slaves can call us Mrs. Harriet and Mrs. Mary. They can make that change with few problems."

"Your suggestion is fine with me. But you will always be the First Lady of Travellers Rest."

"And you, Harriet, will be the second First Lady of Travellers Rest." With that statement made, Mary had a flashback of Rachel Harding Overton. *I don't recall ever having this conversation with Rachel. Harriet is more mature than Rachel was at the same age. She seems more ready for marriage and*

*responsibility. Rachel never had any interest in the duties of the house or the plantation. She was always very passive when John and I talked about business. She was satisfied reading her books and working on her needlepoint projects. When she realized she was with child, she acted as if she were the first female to be in that condition. Mary Overton, shame on you for having bad thoughts about the dead.* When Mary came back to reality, Harriet was standing in front of the two large west windows pointing and saying, "I would like to have the ceremony facing this direction with the minister, John, and I standing here."

"Yes, I agree. Have you given any thought about who will stand with you?"

"Yes, I want little John to be with his father. Annie and Mary will stand with me. Father will escort me down the staircase and into this room. Mary, would you like to stand with your son and grandson?"

"Heavens no, but I'm so pleased you want to include little John."

"What have you decided about your wedding dress?" Mary knew time was important.

"Myra is making my dress. It is so beautiful. We looked all over Nashville for a suitable dress, and we could not find anything small enough. So Myra offered to make the dress as her gift for the wedding."

The RSVPs were arriving as Mary had hoped. She was keeping a tally and twice a week would report to John. He acknowledged the information but appeared detached. She met with Cynthia in the kitchen about the reception menu and meals for the expected extra houseguests. Cynthia reported that the meat supply in the smokehouse was plentiful. "What about more help for you, Cynthia?" Mary knew the extra activities required additional help, and now was the time to make that decision.

"Emmaline has offered to help." Cynthia waited for Mary's reaction.

"Emmaline! Is that Emily?"

"Yes, ma'am. Da one and da same. She pretty strong in her speakin'. She want to be up near the big house. She say she tired hiding out down in da cabin."

"How many children does she have now living with her in the cabin?"

"She have da oldest boy, born about nine months after Miss Rachel's passin', and the twins, and . . . "

"Wait! Cynthia, are you telling me she has three children? Are they all . . ." Mary could not finish. Cynthia seemed more than happy to continue.

"Yes, ma'am, they all have the same daddy. They another borned in late summer."

"Another child? Why was I not told about this last baby?"

"We's telled not to say nothin'."

"And who told you that?"

"Yous know, ma'am. Dat all I can say." Mary turned away from Cynthia, indicating the conversation was over. Cynthia returned to her daily routine. Mary stood, legs rigid, arms crossed, lips pressed so tightly they disappeared,

and seethed inside with two pressing thoughts. *Why has he acted so irresponsibly? Does he not understand the consequences of his actions? If he will not solve this problem, I will. I'll just sell Emmaline and her children and get her away from the plantation.*

Eli was given the assignment to check with the city market to insure there would be fresh fruit from New Orleans and Central America. Unfortunately for him, he spotted Mary coming out of the kitchen and ran to meet her. "Da man told me ya fruit be on da boat da last week of Febuary. Das all I knows, ma'am."

"What are you babbling about? I didn't understand one word you said."

"Da-fruit-fer-da-weddin'."

"The fruit for the wedding! What about the fruit?"

"It-be-on-da-boat-da-last-week-of-Febuary."

"Oh, now I understand. Thank you, Eli." The report from Eli reminded Mary to check with Matilda in the weaving house. It was just a few yards north of the house separated by Mary's herb garden. White smoke was rising from the chimney in the weaving house. That was a sure sign Matilda was there working. Mary was trying hard to be in a good mood as she pushed the door open. "Matilda."

"Yes, ma'am, Mrs. Overton."

"Do you have any bed sheets put away? With houseguests coming for the wedding, I may need to put up some extra beds."

"Let me check here in the closet. Yes, ma'am, there are five new, never washed sheets."

"Good, I'll have someone from the house come get them just in case they are needed later." Mary walked to the door, paused, and turned around facing Matilda.

"Is there something else, Mrs. Overton?"

"Matilda, what do you know about Emmaline? She lives down in the cabins."

"We were told not to speak about her, ma'am."

"Who told you not to speak of Emmaline?"

"Mr. Gray, ma'am. He told us if we wanted to stay here, we better keep our mouths shut about Emmaline."

"Thank you, Matilda. If Mr. Gray speaks to you again in that manner, you come see me."

"Yes, ma'am." Mary headed back to the house, taking very unladylike long strides and clutching her shawl as she moved.

Harriet never wanted to be in the way but was eager to know about the tally on the wedding guest list. She would have no problem making the family connections with the Maxwells. Few, if any, family from outside Nashville would attend the wedding. The Overton family connections were another concern. She was determined, to the delight of Mary, to know John's family links. As each RSVP arrived, Mary wrote on the envelope how John was

related. Some of the notes suggested direct connections. Other notes linked John to the May family and the Whites of Knoxville. There were returns from Franklin, Columbia, and Memphis. One came from Pulaski with a note, "We will be unable to attend, but would count it a pleasure to have John and Harriet come to the farm for a visit anytime." Harriet handed the Pulaski note to Mary, "This is a very kind note. What is the family connection?"

"They are not really family but very dear friends. The Judge stayed in the Hogan home when he was a circuit judge."

"Are they related to the Hogans we know?"

"Yes, they are."

"Good. Maybe one day we can visit in Pulaski." Mary held a final note in her lap and handed it to Harriet with a comment. "I . . . you . . . we need to make a decision about a request my son-in-law, Robert Brinkley, is making related to his daughter, Annie." Harriet glanced up after reading the note. "How old is Annie?"

"She will be five this year."

"What does John think about Annie coming to stay for an extended period of time?"

"Today, he would honor the request, but Harriet, I need to know your thoughts."

"How long will she stay?"

"It appears Robert's business trip will take him several months or longer. The stay could be up to a year." Harriet got up from the sofa and walked to the window overlooking the lower gallery. When she turned to face Mary, she displayed a beaming smile. "When you send a note to your son-in-law, please add, 'there's always room at Travellers Rest for one more.'" Mary's smile was equal in size to Harriet's. "I'm so pleased to have you join the Overton family."

The days flew by after the birthday celebration for Harriet. The wedding invitations were sent and the RSVP's returned. The wedding dress was finished and all who saw it were amazed at its beauty. Travellers Rest was a beehive of activity. Furniture from the large room was being moved on a daily basis, leaving only the large extended table with the new tablecloth. There would be plenty of room for cake and punch. Throughout the house, rugs were rolled up, taken outside for beating, and returned looking fresh and clean. The furniture in each room was dusted. The fireplaces were prepared for the February weather. Extra beds were put up to accommodate out-of-town guests. Fresh candles appeared everywhere and windows were cleaned throughout the house.

One day before the wedding, the new white, freshly ironed curtains were placed at the windows in the large room. Mary thought it best that the Maxwell girls stay at Travellers Rest the night before the wedding. An upper bedchamber was reserved for them. John's idea for a midday wedding made their stay mandatory—at least Mary felt it was necessary. The house was filled with guests in every room knotted together, visiting, and enjoying peach brandy, fresh cut fruit, cheese, breads, and cakes. The mood was very festive.

Harriet was making her way through the house, stopping to introduce herself, Annie, and Mary to new faces—all related in some way to the Overtons. As the trio reached the staircase, for some unknown stroke of fate, three hands were lined up on the banister. Annie voiced the memory for the other two sisters—Sisterhood! They laughed and each remembered, in a different way, being in this very spot years before.

The noise in the hallway almost drowned out Mary's voice, "Harriet."

She knew the voice well, but could not find Mary. "I'm here under the staircase." When she backed up and peered around the staircase, there sat Mary, a young child, and a middle-aged gentleman.

"Harriet, I want you to meet Robert Brinkley and his daughter, Annie, from Jackson."

"Sir, it is my pleasure to meet you." Harriet extended her hand to Robert.

"I'm sorry we could not attend your birthday celebration."

"Don't give that a second thought. I'm so pleased you were able to make the trip for the wedding." Releasing her hand from Robert's, Harriet shifted her dress and dropped to one knee. Now she was on eye level with a blonde-haired four-year-old hiding behind her father's leg.

"Hello, Annie. My name is Harriet. I heard you were coming to visit your grandmother and Uncle John." Annie was not budging from her safe place. Harriet put her arms out and something in that action moved Annie out of her secure place and toward the open arms before her. Richard and Mary had a similar thought: *That is just remarkable. Annie is so shy. What a surprise that she would go to Harriet. Annie has really never had a female presence in her life. Somehow Harriet has broken through.* The two strangers—one, eighteen, about to be married; one, nearly five whose mother died too early in life—found a level ground for friendship and mutual trust. The little arms wrapped around the older neck and a very soft voice whispered, "My name is Annie." Harriet closed her eyes to enjoy fully the hug, but she was aware from the sniffles that tears were being blinked back.

"Would you like to go upstairs with me and help me find my sisters?"

"No, I want to stay here."

"Very well. Annie, I'll look for you tomorrow at the wedding."

"Robert and Mrs. Overton, I need to excuse myself and go upstairs. Hopefully, I can get some rest but I'm so excited, I'm not sure I can sleep."

"Harriet, very nice meeting you and thank you for making Annie feel welcome."

"Good night, Harriet. Do try to get some rest. Tomorrow will be a full day for you. There is a gift for you on your pillow. By the way, Edward brought your clothes for tomorrow and put them on your bed." Harriet scampered up the steps with the energy of an eighteen-year-old.

Harriet's sisters had decided before she got to the bedchamber that there would be no chitchatting this evening. They all needed their rest, particularly Harriet. Since there were two beds in the room, Harriet slept by herself.

Slipping into bed, she saw the box on her pillow. She set it aside, knowing there would be time in the morning to examine its contents. She was sound asleep in less than ten minutes.

The light tap on the door became progressively louder until Annie said, "Yes, who's there?"

"It me, dat who!" The Maxwell sisters had heard that voice all their lives. Julia pushed the door open and walked in announcing in her morning voice, "You'ens gonna' sleep all day?" Spotting Annie and Mary in one bed, Julia went to the other bed and sang, "It time fer ya to wake up Sabbath Child. Today ya be gettin' married. Wake up Sabbath Child." Going back to the familiar morning voice, Julia barked, "Breakfast be here at the next knock on da door. After dat, da bathtub am comin'."

Harriet located last night's unopened gift. She could not believe her eyes. Her silence was a clue to Annie and Mary to investigate. They plopped on the bed and all three were in awe. Inside the velvet-lined box, they first saw the note,

> *To my beloved Harriet on our wedding day. With all my love forever.*
> *John*

The note was wedged behind the pearl earbobs and matching full strand necklace. Harriet clutched the box to her and began to weep—softly at first and then uncontrollably. Julia came back: "What a matter wit ya child? Ya be happy. It ya weddin' day."

"Julia, I'm a most selfish person. I've thought of today as my wedding, but it's John's wedding day too. I've planned everything for me and did not get John a wedding gift. I'm so selfish." Julia went over to the blanket chest where she had placed her shawl and a small package. "Miz Myra wanted ya to have dis first thing," said Julia as she handed the package to the still sobbing bride-to-be. Inside was a note from Myra, a medium-sized box, and a small piece of paper. After placing the items on her bed, she read the note,

> *Thought you might need these two items. I wish you a blessed wedding day.*
> *Myra*

When she opened the box, Harriet found a gentleman's gold collar button. When Annie saw the items on the bed, she instructed Julia, "Go to the desk in the next door and bring an inkwell and a quill." By the time Julia returned, the sisters had calmed Harriet down to an occasional sniff. "Good, Julia. Harriet," Annie directed, "write a note to John, and Julia can deliver it and the gift to him."

"What should I write?"

"Write to him what he wrote to you." Harriet took pen in hand,

> *Beloved John, please accept a token of my undying love for you.*
> *I am the happiest lady in the world.*
> *With all my love,*
> *Harriet*

Julia went to find John and deliver the gift.

The large clock in the hallway chimed eleven times and could be heard throughout the house. Harriet counted the chimes and thought, *the next time the clock chimes, I will be walking down the staircase to become Mrs. John Overton.* Julia had the breakfast tray and the bathtub removed from the room. She guarded the door from all intruders while two of the Maxwell sisters dressed for the wedding. She would not allow Harriet to put on her dress for fear it would get wrinkled. Julia's way of getting things done had not changed since the girls were little. When their mother was so sick prior to her death, Jesse instructed Julia to take charge of the girls, and she did. Down through the years she had been their teacher, encourager, counselor, their shoulder to cry on, and on occasions, the one who meted out discipline. They consulted her with growing-up concerns. She told them what to expect as their bodies changed and developed. Mary was always the hardest to rear. Some days she wanted to act like Annie—older; other days she reverted to acting like Harriet. She had a hard time being herself.

The house was beginning to fill up, but no one was allowed in the large room. The servants were busy completing their assigned tasks. Since John insisted on a midday wedding, the guests would be expecting more than the traditional cake and punch. The lady of the house would not disappoint them, but the timing was a challenge. Mary wanted the large room cleared of most of its furniture for the ceremony. She knew most of the guests could be fitted into the room for the ceremony with a few having to stand in the hallway around the staircase. That arrangement would allow everyone to see Harriet.

Cynthia and her kitchen helpers had most of the food ready for the guests. Last-minute dishes were still in pots ready to be transported. Eli had enlisted two other slaves to bring up from the cellar the bottles of wine and a small keg of peach brandy. Mary's advance preparation was evident as the door was opened to the large room and guests entered. The room was a showplace. The bright yellow wall covering, highlighted by the white-trimmed door facings and windows, brought positive comments from all who entered. The four large windows were raised slightly, allowing a balmy breeze to emphasize the new snow-white curtains. The weather was just perfect. Even the birds seemed to cooperate—they were singing and the guests noticed. The fragrance of the two large sprays of flowers filled the room. Mary, John, and little John greeted the guests as they entered to the sounds of a violin coming from the far side of the room.

Upstairs, Julia sensed it was time for Harriet to put on her wedding dress. Annie suggested Harriet wear only two petticoats. "Your dress has lots of fullness already. An extra petticoat will make it stick out and look strange."

"Could one of you help me button the sleeves?" Mary and Julia were quick to respond. The three buttons at each wrist were tight. "I need to put on my locket before the dress is buttoned up." The final buttons were being

finished when the process was interrupted by a knock at the door. Since Julia was in charge of the room, she questioned, "Who dat at da door?"

"It's me, Myra." Annie opened the door to find a smiling Myra with something in her hand.

"Harriet, your father found this in your mother's trunk. It was in the barn when Maxwell Hall burned. It's one of the few things of your mother's that survived the fire. This was her wedding headpiece." Harriet held it up to her dress and all agreed it matched perfectly. As she examined the piece closely, she found it had three tiny, sky blue hair combs. "Annie, let's try the headpiece." When it was in place, Harriet turned to Mary, "How does it look?"

"Harriet, you are so beautiful!" Mary could not hold back her tears.

"Ya hush now. Ya gonna mess up ya face." Julia's orders were obeyed.

Harriet walked with Myra to the landing at the top of the stairs. She put her hands on Myra's shoulders and looked into her eyes, "Myra, you have done so much for me—my dress, John's gift, my mother's headpiece. You have done just what my mother would have done. How can I ever repay you for your kindness?"

"You just did. Thank you, Harriet." Myra was on her way down the steps when Annie and Mary came rushing out of the room with the pearls. "Here, put these on." Julia was giving the girls a last inspection when the first chime sounded the midday hour. Annie was the first one down the steps, then Mary. Julia held Harriet back until her sister had made the turn in the staircase. "Now, it's ya turn."

Edward was standing at the foot of the stairs with flowers for each Maxwell sister. Harriet positioned her flowers and took her father's arm as the last chime sounded. All heads turned and eyes fixed on the eighteen-year-old bride as she entered the large room.

John saw his bride for the first time that day and the sight of her was worth the wait. Little John was all smiles as he stood next to his father. Mary was positioned to see everything. She studied each piece of Harriet's bridal attire. *She is a lovely bride. John is smarter than I give him credit. What a lucky day for the Overton family. She brings youth, spunk, kindness, thoughtfulness, tenacity, humor—just what this family needs.*

The wedding party formed a semicircle around the gray-haired minister, Dr. John Todd Edgar, wearing a black robe. Harriet was traditionally protected by her family. Jesse was on her right, separating her from John; her two sisters protected on her left. Little John stood, as tall as he could, on his father's right. As they gathered and looked through the windows, they noticed the slaves outside, dressed in their best clothes. Mr. Gray, the overseer, gave them the day off from work and strongly suggested they be present.

The ceremony began with a prayer and moved quickly to the stated purpose for the event. "We have come on this day to join John Overton and Harriet Virginia Maxwell in holy matrimony." John told the minister weeks earlier the ceremony could be brief, "The only thing I want to say is 'I do.'"

John told Harriet three days before the event what to expect, "The only thing you need to say is 'I do.'" She took that as a directive and not open for discussion, but she concurred.

The minister looked at Jesse and asked, "Who brings Harriet to this moment in her life?" The Maxwell girls knew exactly what their father was about to do. Anytime he answered a question with more than one word, he had a habit of clearing his throat. This he did and then responded, "Her sisters, Annie and Mary, and I do." That was more than was expected and his girls liked it. Jesse released Harriet's hand and extended it to John. In the process, she handed her flowers to Annie and then turned to her groom. Together they heard, "John Overton, do you take Harriet Virginia Maxwell to be your lawfully wedded wife?" Harriet squeezed his hand when she heard, "I do."

"Harriet Virginia Maxwell, do you take John Overton to be your lawfully wedded husband?"

"I do."

"Then, under God and by the laws of the state of Tennessee, I pronounce you husband and wife. 'What therefore God hath joined together, let no man put asunder.'" A brief hush fell over the gathered family and friends. They waited to see whether John would bend down and kiss Harriet. He didn't. Harriet waited also but knew her husband was not a man who showed public affection. That was all right with her. She knew John's heart and that's all she needed. Harriet turned to the crowd and sliding her arm under his, brought him in the same direction. For the first time they heard, "I present to you Mr. and Mrs. John Overton." The hush in the room turned to clapping and words of congratulations.

Mr. and Mrs. John Overton moved about the crowd that afternoon, arm in arm, greeting and thanking family and friends, as everyone feasted on wonderful food and very sweet wedding cake. Then they danced until early dark.

Sometime in late afternoon, Julia went upstairs and found Harriet's nightclothes. She walked through the crowded house until she came to the master bedchamber. There she arranged Harriet's wedding nightclothes. As she hand-pressed the wrinkles smooth, she thought, *Well, Sabbath Child, you is now Mrs. John Overton and he be spectin' ya to acts like a wife. I be prayin' fer ya to do ya wifely duty.* She closed the door and headed for the weaving house where the slaves from Travellers Rest and the Hall gathered. Cynthia brought trays of food and drinks from the kitchen to the weaving house, and the slaves feasted like their master, just not in the big house.

As dark settled on Travellers Rest, the last of the guests said their good-byes. Even those who had stayed in the house the night before were gone. The large room was being cleaned and put back in order under Mary's direction. Little John and his cousin, Annie, nibbled on more wedding cake until their grandmother shooed them away from the table and out of the room. John and Harriet sat on the sofa watching the activity in the large room. "You two look tired."

"Mary, I wouldn't want to do this every day." Harriet was holding tightly to John's hand.

"Thank heavens, you won't. Why don't the two of you get ready and go to bed." She knew as the last syllable left her mouth how the statement sounded.

"Mother, are you suggesting . . .?" Her son was laughing out loud.

"John, you know what I mean, and don't say another word." The three of them began to laugh and enjoy the moment.

"John, your mother is right. We do need some rest." Mary cut her eyes toward John's. No words were needed. Her eyes followed the new husband and wife as they headed to their bedchamber. John pushed the door open and Harriet spotted her nightclothes. "Harriet, if you need some privacy, you can go behind the screen in the corner and change your clothes."

"Thank you." She grabbed the nightclothes and escaped behind the screen. As she undressed and redressed, she could hear John changing his clothes. His coat was tossed over the chair. He dropped each shoe on the wood floor. His pants and shirt, she surmised, landed on his coat. She felt the floor vibrate a little as he sat on the bed, threw his feet up, and became horizontal. Several candles in the room provided just enough light to hide the look of fear on Harriet's face. She headed for the bed.

"Harriet, it might be a good idea to blow out the candles."

"All of them?" She made it to about half the candles when she heard voices outside the window. Something or someone pulled the window shutters open, causing a metal against metal sound. John was on his feet and at the window. He was preparing to flip the blinds open when the music began. Harriet was hugging John around the waist listening to the strange and haunting harmonies in the voices. "What is it?"

"The slaves. They're singing some of their music from the dark continent."

"You mean Africa?"

"I heard music like this in New Orleans when I was a lad. Eli took me to a slave gathering on a plantation down there. White people seldom get to hear this music."

"Why are we getting to hear them now?"

"It's their wedding gift to us. The slaves are from here and also your father's plantation."

"Let me see." Harriet tilted one of the blind slats and peeked through. Several of the slaves were carrying torches, and she could see Edward in the light. The music was over after two songs and the slaves were gone.

"What do you think their words were saying?"

"Probably something like good luck or . . ." John was heading back to bed.

"Or what, John?"

"Come to bed and I'll whisper 'or what?' in your ear." Harriet eased into bed next to her husband, pulled the covers up to her neck, and turned to face

him. John embraced her in his arms, kissed her with passion and whispered, "Or a mating call they use in Africa."

"A mating call!" For John it was a mating call. For Harriet it was an experience her mother-in-law had told her about—but she had not told her everything!

# 5. Change and Children

Mrs. Harriet Maxwell Overton settled into her new home and relationships. The living arrangements at Travellers Rest had been long of standing, and any suggestion about change was met with resistance. Mary's bedchamber was on the front of the house. After she married the Judge in 1820 and moved in, that became her area. She had been in the room for thirty years and Harriet knew better than to make her first battle one she could not win. Traditionally, the other room across from Mary, also on the front of the house, was the master bedchamber and belonged to the man of the house. In 1816 the Judge had selected that room to be his main room because of its location. There he would sleep, eat, write, and entertain. After the Judge's death in 1833, the room stayed the way he left it but unused. The door remained closed and locked and no one entered. When John Junior moved back to the plantation, his mother suggested he take the room. Few changes were made to the room until he married Rachel Harding. Mary prepared the room to be occupied by a husband and wife. She removed the Judge's bookcases and desk and added a fancy folding screen with a formal chair and basin stand. She ordered a two-seat sofa for the room, which Rachel had removed when she came. Rachel opted for a clothes press instead. She needed a place for her growing wardrobe. The new sofa was placed in the hallway between the two bedchambers and became a source of resentment between the two Overton ladies. Each time a guest entered or left the house through the front door, Mary would comment on how the sofa was out of place. On several occasions, the same guests would hear from Rachel on how the hall spot was created just for the sofa. John, both son and husband, found himself in the middle of the dispute a number of times. It was only after Rachel's death that the sofa was removed from the house.

There was no question in Harriet's mind about the arrangements. She would be staying in the master bedchamber and would, in time, make some needed changes. Mary hinted to Harriet at dinner the day after the wedding that she and John might want to move upstairs where they would have more room and privacy. "The master bedchamber will do just fine for us, isn't that right, John?" The question was a test for John. He gave a grunt and neither of the Overton ladies could determine whose side he was on. If John thought he could escape the challenge with a grunt, he was sadly mistaken.

"Edward is bringing my things from the Hall in the morning. I'll have him put them in the master bedchamber. Is that the place to put my things, John?" John was chewing his food and his eyes were focused on the plate in front of him.

"John?" When he looked up, Harriet could tell his thoughts were not in the room and he had not heard her question. "Are we planning to stay in the master bedchamber?"

"Yes, Harriet. That is, unless you would like to move to another part of the house."

"Where we stayed last night will be fine with me." The full intent of Harriet's smile was understood by John, but Mary completely missed the nonverbal communication. Mary placed her fork on her plate, blotted the corner of her mouth, and directed a question to Harriet.

"Would you consider tutoring my granddaughter, Annie, while she's here?"

"Yes, do you think she will need private attention, or could I include her with the time I spend with little John?" John seldom got involved in the conversation between Harriet and his mother, but this time he needed to make some input.

"Harriet, I'm pleased you want to help the children, but you need to be available to travel with me. I need to make a trip to Pass Christian to check on our property."

Mary was a little miffed that John was sharing information that was news to her. "I didn't know a trip was necessary. Are you able to leave the railroad project? Who will get the cotton picked and to market?"

"The project is making excellent progress. If the weather remains good, it will be finished quickly. Mr. Gray will be here. We're paying him to oversee the operation of the plantation. He has a schedule of the work that needs to be done. Plus, you will be here if there is a major decision to be made."

"John, I'm nearly sixty-seven years old. You need to keep that in mind when you're making plans. Do you really want me making major decisions?" Harriet was thinking, *I wonder where this conversation is headed. Is Mary playing on John's emotions? What does she want?*

"Mother, is there something about your health I need to know?"

"No, I'm just saying, I made major decisions while your father was living and after he died, I made all the decisions. When you became of age, we made decisions together. Now that you and Harriet are married, I feel the two of you need to run Travellers Rest."

Harriet was surprised and wondered, *If Mary's motive is pure and she wants to relinquish control, I will be happy to help her. However, if her motive is to gain more control, then John and I need to have a serious talk. She wants me to have some of her control. She never did that for Rachel!* "Harriet, do you have some thoughts about this?"

"Yes, Mary, I do. I'm willing to take over some of the responsibilities you now have, if you are willing to teach me how to do them. I lack the skills to run this house like you have done but I can learn. I'm pretty good with people, but you will need to guide me as I learn to manage the slaves. I will need to count on your directing me when we have social events in the house. I have no illusions about ever replacing you here at Travellers Rest, but I will do my very best, with mistakes of course, to maintain the high standards you have achieved." Harriet took a sip of water and waited, pondering, *who will be the*

*first to speak? Will Mary really share control of the household with me at eighteen? Does John hear what his mother is saying? Come on, one of you say something.*

The wait was short. Mary was never shy about letting her feelings be known. "Harriet, I will do my best to help you do your best. I have looked forward to this day. I've had some fear," Mary glanced over at John, "of what would happen to this home and plantation after I die . . ."

"Mother, there you go again. Is there something about your health you are not telling me?"

"As I was saying, 'after I die,' but I feel secure in knowing a strong female presence will be here for a long time. Son, you may need to have your hearing checked. I am perfectly fine. You need not be concerned about the state of my health." Both ladies were now glaring at John, not so much for what he said, but the tone of his voice.

"What? Why are both of you glaring at me? What have I done?"

"Mary and I would like to know your feelings about what is being discussed. Do you have an opinion?"

"Yes, Harriet. I'm happy you want to share in the household responsibilities. Mother needs some help."

"Son, have you heard anything we have been saying? Harriet will not be helping me! She will be running this house—after she learns what needs to be done. I plan, in my waning years, to be a lady of leisure. I may travel some and visit my other children and their families. I may take my rocking chair out on the gallery and watch the wind blow in the trees. I may . . ."

"Mother, you have made your point. I just remember how you treated Rach . . ."

"Times are different, John. When Rachel came to live here, she wanted to be waited on. She had always been spoiled and expected the same when she came here as your wife." Harriet was hanging onto every word Mary was saying. This was not the Rachel she remembered. "I tried to involve her, but all she wanted to do was read her books, do her needlework, and spend time in bed with you. When the three of us had meals together, the only time she spoke was to complain about the food. In her mind, we were not quite up to the standards of the Belle Meade plantation. Do you recall the sofa that sat in the front hall?"

"Yes, I remember the sofa." John had to laugh at the thought of the sofa. Mary joined him and laughed at the memory. Harriet was now seeing the Overtons up close for the first time. She saw how intense they could be but how they enjoyed each other.

"Harriet, forgive us. John, tell her about the sofa."

"Before Rachel moved into the house, Mother bought a new sofa and some other items for the master bedchamber. Rachel moved the sofa into the front hall and it became a point of contention between them."

"Rachel and I," Harriet injected, "used to sit on that sofa and read books together when I came to visit. We played with little John on the sofa when he was an infant. Whatever happened to it?"

"I sent it to a slave cabin after Rachel passed," Mary confessed. "It was a constant reminder of our silly, rocky relationship in this house. Back to your earlier comments, Harriet. We will begin your training in the morning after breakfast. But, right now, the three of us need to talk about Annie."

"Is there a problem with Annie?" John questioned.

"No, but I fear she may be a wee bit homesick. She needs to get into a routine. I fear her father has allowed her to have her own way since her mother died."

"She seems to enjoy being with little John. The last couple of days they have been like two peas in a pod," Harriet stated. "Last night she wanted to sleep in the room with him, and he appeared to have no problem with it."

"I'm only saying, we need to be aware of her needs for the next week or so. By then she should be adjusted to the routine of the house."

"I need to get back to a routine with little John's education as well. I can include Annie in some of the activities. It's sad when you stop and think about it. Both of them are growing up without a mother."

"I don't want to add to your burden," Mary said, "but Harriet, you may be the best thing for both of the children right now. I can be their grandmother, but you can relate to them better than I can."

John held his comment until he was certain his mother had finished. "Harriet, I appreciate how you have related to my son. I hope you can do something similar for Annie."

"I will. It will be a learning experience for me as well. I'll be able to use what I learn with my own children someday."

John heard only part of what his wife said and showed it when he asked, "Harriet, are you with child?" The Overton ladies looked at each other. Both wanted to respond, but Mary waited to see what Harriet would say.

"John, earlier in the evening your mother was a little concerned about your hearing. Now I'm becoming concerned as well. I said, 'some day' not today!"

Mary hid a smile behind her napkin. "Harriet, John, if you will excuse me, I will finish my tea in the parlor."

"I'll join you," said Harriet. John was left at the table. He thought he heard his mother say to Harriet as they left the room, "Those Overton men, they never will . . ." He wondered how the sentence ended.

The next morning Harriet was out of bed, dressed, and in the kitchen where Cynthia was preparing breakfast. "Good morning . . . I don't believe I know your name."

"My name be Cynthia."

"Good morning, Cynthia"

"My name is Harriet Maxwell."

"Ya means, Harriet Maxwell Overton! Ya married to Massa Overton. Spose I calls ya Miz Harriet?"

"Fine."

"Now, Miz Harriet, what can I do fer ya? Breakfast be ready in a little while when Miz Overton say it time ta eat. When I hears da bell, I brings da food."

Harriet left the kitchen, knowing she had overstepped her bounds with Cynthia. She was not ready to challenge her but would count on Mary to make the needed adjustment when the proper time came. Harriet slipped through the side door and into the family dining room and waited for the bell to be rung so breakfast would be served. She waited longer than she wanted to, but it gave her time to plan her day. *This morning I'll spend time with Mary. Then, this afternoon, I can spend some time with little John and Annie.*

The children did not come to breakfast. It was taken to their room with a note from Harriet,

*Dear John and Annie,*
*This afternoon I will meet with you in your room. We will do some*
*school things together.*
*Harriet*

Little John was happy to receive the note, and he shared and explained its contents to Annie. She was excited to be included.

In the family dining room, Harriet and Mary sat eating. Harriet was expecting John to appear any moment and join them for breakfast. He did not come. "Have you seen John this morning?" Harriet inquired.

"I think he has a meeting with the railroad folk. He and Eli left a few moments ago."

"He did not say a word to me about the meeting or that he was leaving."

"Harriet, John has been single for a number of years, and he has gotten used to acting independently. You will need to remind him that he is part of a couple again. The Overton bloodline somehow produces men who are very private. If I wanted to know something from the Judge, I had to ask him a direct question. If you expect more than a yes or no response, you will need to pose the right question. I saw that trait in the Judge, it's in John, and little John has it also. The Overton girls, on the other hand, are just the opposite. They can talk nonstop on any subject."

"That's an insight I'll need to remember. Where do we begin this morning with my training?"

"I thought we might just walk through the house, which is full of history, and so is the land." The ladies left the dining area, went out onto the gallery, down the steps, and walked to the front of the house. Mary made a wide gesture with her arms indicating, "This land belonged to the Maxwells, but before them the land was occupied by the Mississippian Indians who had lived here, I'm told, many years before Columbus discovered America in 1492."

"We were told, at the Academy, the Indians lived in the Nashville area between 1250 and 1400."

"Did you also learn that the Indians chose special places to bury their dead?"

"I recall something about how they selected land that was elevated for burial."

"Your bedchamber is right on top of a burial ground. The workmen who dug the cellar in 1798 discovered several burial tombs there. When they told the Judge what they found, he jokingly told them to call the place 'Golgotha.' I guess the name stuck because for the first few years of its history, Travellers Rest was called Golgotha. Some of my older friends still laugh about it."

"So, this is really holy ground."

"Maybe to the original Indians who lived here, but not to the Overtons. The Judge would tell the slaves about the Indians being buried here and it would scare them silly. Most of them were happy to stay away from the house."

"My father," Harriet said with some pride in her voice, "told me Mr. Overton bought half a plot—about 320 acres—from the Maxwell estate."

"Yes, I believe it was a part of the land grant given to your grandfather Jesse and his brother after the war. Anyway, the land was purchased about the time Tennessee became a state in 1796. It took some time to get the lumber ready. You know all the lumber in the house came off the property. The black walnut logs in the cellar hold up the 1799 house. Poplar wood was used throughout the house because the bugs hate it and leave it alone."

"I believe it's the same wood father used to rebuild after the fire at Maxwell Hall," Harriet added to the conversation.

The ladies faced the front of the house as Mary continued, "The Judge wanted a house that looked like the ones he remembered from Virginia. When the house was completed, it had four rooms, two up and two down, with a staircase, and a front and back door. The master bedchamber was upstairs and your room was an all-purpose room. The other two areas in the house were used for overflow space when they were needed. Samuel Overton, the Judge's brother, lived in the house before the Judge did. He managed the plantation, the house, and the slaves for the Judge."

"Where did the Judge live?" Harriet questioned Mary.

"He lived in an apartment downtown near his office. For a while, he actually lived in his office. His space was very much like the law office behind us. He had one large room with a fireplace—space to sleep, eat, and work. He even added a porch to make it appear more homey. It was located on the east side of the courthouse square. At one time Andrew and Sam had offices in the same area."

"Sam . . . ?"

"Sam Houston. The Judge and Andrew took him under their wings and helped him develop his political career. They felt he had a chance to be the

President, after being Governor of Tennessee at such a young age. In fact, Andrew wanted him to come to Washington in 1828, but Sam was eager for adventure, so he went to the Texas territory instead. And you know the rest of his history."

"I've heard tales of the honeymoon he spent in the house. Are they true?"

"I'm not sure what you have heard, but it was a strange relationship between Sam and Eliza." Mary covered her arms with her shawl as she talked. "The wind is really sharp this morning. Let's go in the house where it's warmer." Once inside with the door shut and locked, Mary began to chuckle.

"What is it, Mary? What is so funny?"

"I was just remembering the first time I stood here. I was a new bride, for the second time, with five children. On our way back from our wedding in Knoxville, the Judge described this house to me. He felt the house would work fine for the seven of us with a little rearranging. Fortunately, I brought only my three youngest children. Anthony and Andrew stayed in Knoxville. What the Judge failed to tell me was that the two parts of the house were not connected. The original house and the 1808 addition had no connecting doors, here or upstairs. If I wanted to see my children, I had to go out the back door and go next door. The house had been fine for the Judge. He lived here and the law students he was teaching lived over there. They slept upstairs and worked downstairs."

"What did you do?" Harriet now understood why Mary was chuckling.

"I put Mary, James, and Margaret Jane upstairs in what is now the guest bedchamber. The Judge and I lived in your current bedchamber."

"How did the children get upstairs?"

"Before your husband remodeled the house in 1845, there was a staircase there," Mary pointed to the left side. "I had the door cut here, where it is today, and the one upstairs. After doing that, the house was connected on each floor and flowed properly." Stepping through the doorway and into the 1808 addition, Mary pointed out, "Just inside this door was a staircase. The students continued to study in here until about halfway through my pregnancy with John. At that point, I needed a room by myself and I moved in here. I had the staircase closed in this room. You can still see the outline of the hole in the ceiling. The Judge moved his students to the law office outside and required the young men to find boarding places in the community. As I recall, one of the students boarded at Maxwell Hall for a couple of years."

"That's news to me. I'm guessing it was before my sister Annie was born."

Mary opened the door, which led into the hallway and up the main staircase. "Do you have time to tour some more of the house?"

"Yes, I plan to meet with little John and Annie later this afternoon."

"Well, let's go up the staircase and back into the original part of the house." Mary stopped on the midway landing and glanced out of the window.

"When I moved here in 1820, all of that land was planted up to Franklin Pike and beyond as far as your eyes could see."

"How did the flower garden get there?"

"That was a gift to me from the Judge. He hired an English gardener to design and plant what you see. I told the gardener what I wanted in the garden and he created it. Rachel Jackson loved my garden. We spent many wonderful hours walking and talking out there. I do miss her. When either of us planted anything new in our gardens, we always exchanged plants. With the exception of a few trees and bushes, we had nearly identical gardens. If John gets his railroad, most of this will be gone forever. So enjoy it while you can." As the ladies climbed the last few steps, Mary put her hand on the plastered wall and commented, "Before the 1828 addition, this wall had two windows which matched the two front windows. This door we are walking through was not here. You can see here on the floor on the left where the staircase had been."

"I have been in this room many times with little John but never noticed the repaired floor."

"After the law students left the house, this seemed to be a natural room for the children. With them in here, I was able to reclaim the upper bedchamber for our guests. This next room always looks different to me because I remember the staircase being in the corner. John added the upper gallery and then had to cut a new door. This space is the coldest in the entire house. When these doors are shut, there is no way to get heat in here. And here is the famous bedchamber we were talking about earlier. Andrew and Rachel used this room when they visited us. When Sam brought Eliza here, he was the Governor of the state. He was about to run for a second term, and he thought his chances would be better with a wife at his side. Eliza was your age when she married Sam. He was a man of the world and she was so . . . so . . . innocent."

*So . . . so . . . innocent.* Harriet allowed Mary's words to linger in her brain. *I wonder what Mary tells her friends about me. Eliza was your age when she married. So . . . so . . . innocent!* Harriet could not hold back her words, "Mary, do you think I married John too young and innocent?"

"If John had had his way, he would have married you when you were fifteen. He talked to Jesse when you got back from Pass Christian. Your father said you had to be at least eighteen years old. No, I don't think you were too young. Only you can answer the question about being innocent." Mary looked around the room and waited for Harriet to respond—she didn't.

"Let's go look at the upper parlor. The Judge was so proud of this room. He referred to it as the ladies' sitting room. He wanted a place the ladies could use when they came to the plantation for an event or just a visit. He ordered the two game tables and the globed clock from New Orleans. The other furniture and accessories came from various places. Richard, my son-in-law, helped the Judge find most of the furnishings in the room. The six-block carpet helps keep heat in the room. In 1828, the wall treatment was the latest fashion.

The portraits in the room have their own histories. This one of the Judge was painted in 1820 and the one of me is also from 1820. Ralph Earle painted both of them. The portraits capture what we looked like when we got married. The two on the far wall were painted in 1833, the year the Judge died. And this portrait is of my good friend, Rachel Jackson. It was painted in 1828, the year she died. I do miss her. The painting between the windows is my brother, Hugh Lawson White. He was a great help to me after Francis died. He provided for the children and me until I married the Judge."

As the ladies departed the room and went down the staircase, Harriet had a question. "Mary, why don't you have a painting of Andrew Jackson? I thought he was the Judge's best friend."

"He was and he was my friend until 1836."

"What happened?"

"It's a long story, but let me give you a condensed version. Andrew chose to support Martin Van Buren and not my brother, Hugh, in the presidential election. Hugh should have been the eighth President of the United States. When I learned of Andrew's actions, I decided I did not need to see his image in this house. He will always be important to the Judge and his house, but not to me, thank you."

"I thought William Henry Harrison and Daniel Webster ran against Van Buren in 1836."

"They did, but so did Hugh. If Andrew had supported him, he would have been the president."

As they descended the staircase, Mary continued, "Now, let me tell you about this next room." They had entered the large room. Harriet already had wonderful memories of this room. She sensed Mary was upset about the Andrew Jackson matter, so she suggested, "Mary, could we stop now and start here next time? I fear some of this history has upset you and I don't want that."

"Thank you, Harriet. You are not only kind but very perceptive."

"I'll go out to the kitchen and check on the noon meal."

It was a nice day for a long walk. After the noon meal, Harriet checked with Mary about taking little John and Annie on a nature walk. She wanted to allow Mary to have some say in what the children did and to keep her informed of where they would be during the afternoon. Because the air was still cool, Mary suggested the children wear coats, head coverings, and play shoes. If there was mud anywhere along the way, she was sure her grandson would find it. Harriet agreed. When the three were properly dressed, they went exploring. They passed the Judge's law office and headed south. Since the trees were bare, it was easy to spot the squirrel nests. Little John located the first nest and pointed it out to the other two. He was so proud. Harriet congratulated him and gave him a challenge. "John, why don't you suggest an object for Annie to find?" He thought for a minute, while looking around at the trees ahead. Then he said, "Annie, let's see if you can find a pine cone."

"Excellent, John! That's a wonderful idea!" As they continued to walk, John was the first to spot the tall pine tree. He did not give his discovery away but was anxious for Annie to walk under the pine tree where he knew there would be lots of pine cones. A little coaxing was required, but Annie found the pine cone, just as John had thought.

"Congratulations, Annie, now you get to name something for Harriet to find." Harriet was pleased to see and hear these two cousins bond. She hugged them both at the same time; *it's not fair that these children had to lose their mothers at an early age. They are just too young. I want to do everything I can to help them build a strong, lasting relationship with each other.*

"Annie, what do you want me to find?"

"I want you to find a rock." John knew that would be easy, but before he could say anything, Harriet responded, "Let me see. Where do you think I can find a rock?"

As they walked, Harriet knew they were getting close to a main road near Franklin Pike. The people in the community referred to it as Hogan's Road because it led to the Hogan property, as well as other farms. That would be the turning around point of today's walk. The three adventurers sat on a log by the side of the road admiring the pine cones and rocks they had found and giving Annie a little rest before they started back home. John was standing when he spotted the wagon coming down the road. Harriet recognized the wagon and driver as they approached. She waved and called, "Edward! Edward!" He saw them and slowed the horse down to a walk and then to a full stop.

"Miz Harriet . . . beg ya pardon ma'am, Miz Harriet Overton." A big smile came to his face.

"Edward, you came just in time. We need a ride back to Travellers Rest."

"How 'bout I takes ya to da Hall? We be missin' ya thar." Edward was laughing as he lifted Annie into the back of the wagon. John climbed up the large wheel and swung himself into the wagon next to Annie. Edward was still laughing after helping Harriet to the seat next to him. "Next stop, Travellers Rest." The ride was bumpy, since there was no road to follow, but it was better than walking back.

From her window, Mary watched as the wagon approached the house. As it slowed, the children jumped up, holding onto the side of the wagon. Harriet turned immediately, using a hand signal telling little John and Annie to be seated. Mary was pleased at the scene; *she manages those children as if they were her own. It is hard to believe she is only eighteen years old. Harriet is going to be a wonderful mother one of these days. John really doesn't know lucky he is.*

"Thank you, Edward. Please give a kind word to my Maxwell family."

Inside the house at the window, John had joined his mother and together they watched Harriet in action. As soon as Edward put Annie's feet on the ground, she and John started running to the house.      "John and Annie, you two come right back here!" Harriet stomped her foot and pointed to the exact

spot where she wanted them. "When someone does a kind deed for you, the polite thing to do is say, 'thank you.' You owe Mr. Edward a 'thank you' for his kindness."

John was reluctant to follow the demand because he knew Edward was a slave, but he joined Annie anyway in a cheery 'thank you' for the ride.

"Good, now you may go to the house."

The children went up the steps and to the gallery, where John and his mother appeared at the side door. "Grandmother, look at my pine cones!" Annie was more excited than usual.

"They are beautiful, Annie."

"Harriet and John helped me find them while we were walking."

John took his father's hand and motioned for him to bend down. As John whispered in his father's ear, Harriet arrived to join the others. In a very quiet voice John said, "Harriet made me say 'thank you' to a slave. Was that all right?"

"What did she tell you?"

"Father, she said, 'When someone does a kind deed for you, the polite thing to do is say, thank you.'"

"Harriet gave you very good advice, son. I would say the same thing. A gentleman is always polite." John scampered away to find his cousin Annie.

Harriet was smiling as she reached out to take her husband's hand. "John Overton, I love you. I appreciate your total support. Soon, we need to talk about my relationship to little John."

"Harriet," Mary felt as if she was interrupting a special time for her son, but did anyway. "I have some tea set up in the large room, if you would care to join me."

"Wonderful. I could use some herb tea about now. Maybe we could talk about the rest of the house."

"Young lady, you have read my mind."

John stayed on the gallery as the Overton ladies made their way into the large room. Sitting on the sofa with her cup of tea, Mary was the first to speak. "Harriet, I was watching you through the window when you arrived with the children. I appreciate the firm hand you are taking with my grandchildren. They need the discipline you are providing. You are the mother figure they do not have but need desperately."

"Mary, I cannot be their mother, but I can be their friend."

"Believe me when I say, you are more than their friend. You are a Godsend when they need it most. What you are learning now with John and Annie will serve you well when your children come." Harriet took a long sip of tea. She needed the time to process, *when your children come*. Her smile was a dead giveaway to what she was thinking and Mary responded, "Harriet, I did not mean to imply . . ."

"No, ma'am, I know. I do want to have children and the sooner the better. I want to have as many children as John wants."

"Please know I don't want to get into your private affairs, but sooner will be better."

"Mary, I have a special favor to ask you."

"Yes?"

"My mother never told me anything about being in a family way and my sisters don't know either. May I count on you to help me understand what's happening to my body when the time comes?"

"Harriet Maxwell Overton, that is the sweetest thing you will ever say to me!" Mary placed her teacup on the table, leaned over to Harriet, and embraced her. She could not hold back the tears—happy tears. Harriet had to balance quickly her teacup and with her free arm, she returned the embrace.

"I will be by your side every second you need me. After giving birth to eight children, I do have some experience."

At that very moment John stuck his head through the doorway, "May I come in?"

"No!" The ladies' voices were in unison from the sofa. "Son, go find something to do. Go build a railroad." Both Overton ladies were laughing and both would remember this special, meaningful moment.

"When the Judge talked about this room, his face would light up. He told me in the early planning stages that he wanted a room 'unequaled in Davidson County and the surrounding areas.'"

"It is a wonderful room."

"My only regret about the room is that my friend, Rachel Jackson, never had the opportunity to enjoy it. She saw it under construction but never had a meal or danced in the room. We had invited the Jacksons for the Twelfth Night celebration, but she died a few days before the event. The Judge wanted to send the Jacksons off to Washington in fine fashion. He had worked so hard to make Andrew the President. Back in 1823, the Judge brought a group of men to the house, and they became known as the Nashville Junta. They met here and laid out a political agenda and campaign for Andrew. Many folk feel Andrew was cheated by John Quincy Adams and Henry Clay. But Andrew won the next election and became President in 1828. He wanted the Judge to come to Washington, but he declined. He did make a couple of trips to Washington to advise Andrew during his eight years as President."

"Did you ever make the trip to Washington?"

"No, my children needed me here. Besides, someone had to run the plantation. Anyway, all of that is past history and right now, we are talking about this room. The Judge knew what he wanted in this addition of the house. He hired a general contractor and together they made the plans for the house. The Judge had to buy some slaves who had building skills. For nearly a year he had them preparing the lumber and making the bricks. Digging the cellar space was a major and time-consuming project. Richard, my Mary's husband, secured all the fancy trim work, hardware, carpets, drapes, wall treatments, windows, furniture, and scores of other things. When the 1828 addition was

completed, it was a showplace. The new addition connected the 1808 rooms upstairs and downstairs and extended all the way to the 1816 kitchen. At my suggestion, the lower gallery was added to the plans. The double doors over there became the main entrance when this room was used. I recall the Judge, even in his declining years, taking visitors all over this part of the house. He could hardly make it up and down the turning staircase, but he went anyway."

"Surely he didn't use the back staircase."

"You mean the one out of the small dining room?"

"Yes."

"Well, at first, the Judge used that room as an office. When we had guests in the house, his office was also the gentlemen's drinking and smoking room. The room above was for a plantation overseer, whom the Judge never hired. I've used it at times as an extra guest room. I never could put elderly guests up there because of the steep and dangerous staircase. When your husband built the upper gallery in 1845, he put a door up there and we didn't need to use the small staircase. After the Judge died, I turned his office into the family dining room. We also used the room as an office. That way I could close off this large room when it was not being used."

"I've heard there's a story about the pantry."

"Yes, there is. After the fireplace and chimney were finished in this room and the back staircase was completed, there was this odd space between them. The Judge was planning to leave it open for storage. I suggested we make the space into a pantry and that's what I have today for the china and silverware."

"So, in reality, Travellers Rest is the result of the Judge's planning and your gentle changes."

"Harriet, for one so young, you have a special gift for choosing just the right words to describe any situation." The Overton ladies laughed with a shared understanding and finished their tea.

Harriet continued to learn about the house and plantation life from her mother-in-law. Slowly and with care Mary was giving Harriet more control of the household and greater responsibility for decisions.

In mid-August of 1850, the U. S. census was being taken in the Nashville area. Harriet had read an article in the local newspaper about the census. She had mentioned it to John, but he didn't pay much attention to it. Everything, it seemed, took second place to the railroad project for him. He was gone to Franklin or Nashville most days working on the project.

Harriet and Mary sat on the lower gallery trying to find a cool breeze to relieve the heat and high humidity. Harriet heard the distant horse hooves and shortly, both ladies saw the horse and rider approach the gallery.

"Good afternoon, ladies," the rider politely tipped his hat, "is this the home of John Overton?"

"Who wants to know?" Harriet questioned as she stood up to get a closer look at the rider.

"Ma'am, I'm taking the census for the United States Government. Is your father at home?"

"My father doesn't live here."

Turning his head in the direction of Mary, the rider inquired, "Then I'll need to talk with your mother or grandmother."

"My mother and grandmother have been dead for years." Both of the ladies beat back snickers but were able to smile at each other. They both were enjoying the conversation with the young man who was visibly becoming annoyed with them.

"Young man, why don't you ask for the head of the house?" suggested Mary.

"I thought I was."

"No, you were looking at me, but you've been talking to the head of the house."

"But . . . but, I thought . . . she was a child."

Mary stood, "You've been talking to Mrs. John Overton. Now, I suggest you make your inquiry to the head of the house." She turned, walked down the gallery, and entered the kitchen door.

"Mrs. Overton, please accept my apology. You look too young to be married . . . I mean head of the house."

"Well, Mr. Census taker, what information do you need?" He never attempted to dismount, but struggled to balance a small wooden box on top of which were a sheet of paper and a writing instrument. "Ma'am, I need to know the name of each person living in the house, their age, their gender, and their place of birth."

"John Overton—29—male—born in Tennessee

Harriet Overton—18—female—born in Tennessee

John Overton—8—male—born in Tennessee

Mary Overton—67—female—born in Virginia

Ann Brinkley—5—female—born in Tennessee

Alexander Gray—35—male—born in Tennessee, he's our overseer."

"And what is the real estate worth?"

"Does that include the slaves or just the house and the land here?"

"The value does not include the slaves. They will be listed at another time."

"We pay taxes on $208,000."

"Are you saying 2-0-8-0-0-0?"

"Yes, that's correct."

"Thank you, Mrs. Overton. The United States Government appreciates your help." With the information recorded, the census taker was more than happy to ride away. Harriet watched as he rode out of sight and as she lingered she thought, *Mary said I was the head of the house. She trusted me to give the correct information. Today, I fully represented the John Overton family. I must find a way to thank her for all her help.*

The nation, Tennessee, and Nashville were putting away the red, white, and blue bunting from their seventy-fourth birthday celebration when tragic news came from the White House in Washington, D.C. President Zachary Taylor was dead from a coronary thrombosis. The 65-year-old Taylor had served only one year and 126 days of his term. On July 10, Millard Fillmore took the oath and became President. By September he faced three critical decisions which had implications for things to come. On the ninth, the President's signature made California the 31$^{st}$ state in the union. The admission had brought proslavery and antislavery forces into heated debate. The President signed into law the Fugitive Slave Bill on the eighteenth of the month. The new law was highly controversial—it required all runaway slaves to be promptly returned to their Southern owners. Toward the end of the month the Compromise of 1850 Bill was signed into law. John C. Calhoun, until his death on March 31, was the voice of the South working to include the passage of the Fugitive Slave Bill to offset the statehood of California as a slave-free state. Henry Clay was credited with working out the North and South compromise.

Harriet was interested in all things political and maintained a talking knowledge of all the facts. She read the Nashville newspaper each time John brought it home. She even requested that he locate and bring home newspapers from other large cities in the South. Harriet occasionally read the ones from the North, but didn't like them because they portrayed the South in a negative way. *Harper's Monthly* arrived on a routine basis, and after Harriet read every word, she shared the issues with her sisters. She wanted Annie to have the information and hoped Mary might find an outlet for her writing career.

John was always surprising Harriet with small gifts. It was his way of making up for the times he had to be away from the house working on his railroad project. Near the close of the year, at one of the Twelfth-Night celebrations, he placed a small, brown, wrapped gift under her pillow on their bed. When she discovered it, she was surprised, "What is this?"

"It's for you." John was pleased at her reaction.

She tore away the paper and could not believe her eyes. "John, where did you get Hawthorne's *Scarlet Letter*? I read about this book in *Harper's*. It is hard to find in New York City, but I have a copy in Nashville."

"I've had it on order for a while and it came in this week. I'd prefer you read it in here behind the closed door. I'm not sure Mother's strict Presbyterian faith would find the content acceptable."

"I agree and I will read the book in here. John, you are so thoughtful. I love you."

"And I love you, Harriet Maxwell Overton."

Travellers Rest was always a place for holiday celebrations. Neighbors would stop by the house for long afternoon visits. The house was decorated with festive greenery from Mary's garden. New candles were put out, the children had made paper snowflakes for their windows, fresh fruit appeared in

every room, and the smell of freshly baked cookies filled the house. During the last days of the year, the slaves were free of work in the fields. The house servants' workloads were increased with guests in the house, requiring attention and the need for more food from the kitchen.

On December 29, Mary and Harriet were in the family dining room finishing the last sips of their tea. They were in deep concentration, planning the menu for the holiday banquet the following weekend. There would be at least eight guests and that many neighbors coming for the banquet. This was the first big gathering in the house since the wedding, and Harriet was trying to learn all she could from Mary about the upcoming event.

"We need to know what meat is in the smokehouse," Mary instructed.

"I can check with Cynthia and let you know." Harriet was trying to be helpful and learn at the same time. Mary was making every effort to put Harriet in charge.

"You do not need to report to me. When you determine what meat we have, you tell Cynthia what to prepare. She will know what to do about the rest of the meal. Tell her how many guests we expect and she can do the rest. Talk to Cynthia about the cakes as well."

No sooner had Cynthia's name been mentioned than she came bursting through the kitchen door. "I's here fer the dirty dishes," Cynthia said, without any apology for her entrance.

"I'm glad you're here, Mrs. Harriet needs to talk with you."

"Yes, ma'am, Miz Harriet. What ya be needin'?"

"I need for us to check in the smokehouse for . . ." The shrill, high-pitched voice of little John got the full attention of the trio meeting in the family dining room.

"Grandmother! Grandmother!"

Appearing at the outside door near the pantry, Mary intercepted the excited child.

"Yes, John what is it?"

"There's a nig . . ." John spotted Harriet and changed his word. ". . . slave at the front door. He wants to speak to Mrs. John Overton. He said his message was very important."

"Thank you, John. You have done a very good deed." Harriet patted John on the back and looked at Mary. "Should both of us go and talk to the gentleman?"

"Yes, I think that would be wise." They talked as they walked to the front door.

"May I help you?" Mary was looking at a familiar face, but a name did not come to her mind.

"Yes, ma'am." The slave stood twisting his hat in his hands and began to cry. Harriet moved past Mary and stood next to the weeping black man. "What message do you have for us?" She was eager to know why this slave was at her home.

"It be 'bout Massa May. He be dead this mornin'." Now Mary knew a name for the black face. The slave's name was Moses. He was owned by her son, Andrew. "Moses, what are you saying about Mr. May? Did you say he died this morning?"

"Yes, ma'am. He be dead this mornin'."

"How did he . . .?" Mary was so emotional she did not finish her sentence.

"He not waked up from his sleep. Massa May be sleepin' in da Lard."

Harriet took charge of the situation. Little John had made his way through the house and out the front door to stand next to Harriet. "Little John, you go to the barn right this minute and tell whoever you find to hitch up the carriage and bring it to the back door."

"Yes, ma'am." John ran off to the barn to carry out the directive.

"Moses, you go around back to the kitchen and tell Cynthia to give you something to eat and then come to the carriage."

"Yes, ma'am."

When Harriet turned toward Mary, she was sobbing with both hands covering her face. "Mary, we must get ready quickly and go to Andrew." Harriet directed Mary through the front door and into her bedchamber. She sat on the edge of her bed, continuing to sob uncontrollably. A servant was in the room, whose name escaped Harriet at the moment, but she had no trouble giving her orders.

"Get Mrs. Overton ready for a carriage ride. Make certain she is wearing warm clothing. Pack a valise with a full change of day and night clothes. Check her black medical bag to be sure she has her herb bottles. Place the valise and medical bag on the back gallery after you help Mrs. Overton dress. You will be going with us, so get your things together as well."

"Yes, ma'am."

Mary was not saying a word but was in awe at what she was hearing and seeing. Harriet was in total charge of the situation. She was giving orders and everything was under control. Mary was reassured that the future of Travellers Rest was in the right hands.

Andrew Jackson May, Mary's second son from her first marriage, was dead at age forty-eight. She grieved in private and in the company of Harriet. Her daughters, Mary May Barry, Margaret Jane May Phillips, and Elizabeth Overton Lea provided the initial comfort for their mother, as she grieved the loss of her son. However, Harriet was the constant source of healing and recovery for Mary, who went into complete isolation during the holiday season and the celebrations in the house. The doors to her room opened only to allow servants and Harriet to enter and leave. Family members and houseguests abided by Mary's wishes to be left alone with her sorrow. Mary encouraged Harriet to move ahead with the plans for the closing days of the Twelfth-Night celebration, which involved a number of large meals and a final banquet.

Harriet was becoming more directive around the house. She called a meeting of the house servants and the kitchen staff to inform them of Mrs.

Mary Overton's condition and to remind them the celebrations would proceed as planned. At dinner following the funeral for Andrew May, Harriet told John, little John, and Annie what was expected of them during the time of mourning and celebration. John was more than happy to follow Harriet's suggestions. Her leadership role in the house released him to continue pushing the railroad project, since it was reaching a critical stage.

She made routine visits with Mary, sharing decisions she was making about the house and the servants but mostly to be available to Mary when she wanted to talk. Visits did not always include conversation but were always filled with spirit-lifting smiles from both ladies. Harriet shared the decision she had made to get some extra help for Cynthia during the holiday season. "I was talking with Cynthia about the menus and she requested more help. She suggested Emmaline be brought in to help."

"Harriet, there is something you need to know about Emmaline." She noticed Mary's face seemed to pale at the mention of Emmaline's name.

"What about Emmaline?"

"She . . . she and . . . she and my . . . ." She stopped talking when a servant entered the room with an armload of laundry and then continued. "We'll talk about this another time."

"Mary, is there anything you need?"

"No, not really. Is there anything you need?"

"Well, I do have some questions if you feel like talking."

"Just a moment." Mary made eye contact with the servant in the room. "That will be all for now. I'll send for you later."

"Yes, ma'am." The servant left, closing the door behind her.

"Harriet, you can never be too careful talking around the servants. You have some questions?"

"How do you stay so strong in the face of death?"

"Well, I've had lots of practice, and I accept what happens in life as God's will. When my first husband died, I didn't have time to grieve. I had five children to rear. You know I went back to Knoxville to live with my brother, Hugh, and his family. My first son, Anthony, died in Arkansas in 1825. He was only twenty-four-years old. I've never seen his gravesite. James Francis died in 1843 down on Franklin Pike."

"Was that the horse accident?"

"Yes. He was thirty-one years old. His wife, Eliza, came to your wedding. And now I've lost Andrew. John is the only son I have left."

"Mary, have you ever, in all these times of death, questioned God for doing this to you?"

"No, not really. God didn't do these things to me. He allowed them to happen in His own timing. When my daughter, Ann, died, I thought long and hard about God's timing, but I concluded He knows best."

"Your faith is much stronger than mine. When my mother and baby brother died, I was angry with God. What he did was very unfair to me."

"Harriet, God did not single you out when you experienced death in your family. He allowed nature to take its course. Your mother had an illness that caused her death. Your brother, Jesse, had some of the same illness and was not strong enough to survive. God allows; He does not cause."

"I understand the words you use, but not the meaning. I still think it was unfair. Did you want to talk about Emmaline?" Mary could see Harriet was upset talking about death and knew it was not the time to talk about Emmaline. "No, I believe that can wait until another time. It might be best if I got some more rest."

"Very well. I'll check on you later." Harriet then stopped by her room to get a stack of songbooks and sheet music. With her arms full, she went up the stairs to find little John and Annie. At the top of the stairs, Harriet found two children with sad faces. "Who are these children with long faces?"

"We don't have anything to do," John spoke first. Annie echoed John.

"What are the books you have?" Annie quizzed.

"These are music books and I thought we might play some songs and sing." Passing between them, Harriet turned and instructed, "Come, let's go into the parlor." She placed two chairs, one on either side of her, all facing the spinet forte. She selected a piece of sheet music and divided the rest, handing them to the children. She only played at first, and then began to play and sing. The children were thrilled. When she stopped playing, Annie was bobbing in her chair, "Play some more, please." John found a copy of *Yankee Doodle* and handed it to Harriet. "Thank you, John. This is a song all of us can sing." After a half hour of singing, the children were exhausted, as was Harriet, but everyone was happy again. She collected her books, closed the lid on the instrument, and headed down the steps. She could hear the children humming and laughing upstairs.

Travellers Rest was overflowing with guests during the holiday season. Robert Brinkley was on his way back to Jackson and visited with Mary. He was reunited with his daughter, Annie, after several months of being away. Both were happy to see each other.

One afternoon Mary sent a servant to find John and Harriet, requesting they visit her together. When they entered her room, they saw Robert sitting in a chair near the fireplace. He stood and greeted them. "Robert has a special request of the Overtons." Mary smiled and directed her gaze toward Harriet. "Robert, speak to John and Harriet."

"I'm a little bewildered at Annie's attitude. She doesn't want to return to Jackson with me. She wants to stay here with Harriet and little John. It appears the bond between Annie and Harriet is very strong. She tells me she is very happy living here."

"Robert, I've done nothing to encourage Annie's attitude. We are developing a good relationship, but she does understand that she is only visiting and her home is in Jackson."

"I totally agree with you, Harriet. I did not mean to imply anything negative about the relationship you have with Annie. She loves you very much and you are more than her friend. She sees you as a mother figure."

"I'm certain I've not encouraged that!"

"No . . . no . . . no, Harriet. You have done nothing wrong. Annie is a very happy child, and the credit for that goes to you." Mary smiled and nodded in agreement.

"Robert, about the request." Mary wanted him to get back on track.

"Would it be possible for Annie to stay here in your home through the winter?" All eyes turned toward Harriet, knowing that the decision was really hers to make. She remained quiet for a moment and then said, "Robert, let John and I talk, and we'll give you an answer at dinner."

Mary thought, *every day I'm around Harriet she impresses me more with her wisdom. I know she will agree to the request, but she is giving the appearance that John will have a part in making the final decision. She is so smart. I want to hear how she responds at dinner.* As Harriet and John were leaving the room, Mary requested, "Harriet, I'm feeling much better. May I join you for dinner this evening?"

"It would be a pleasure to have you grace our table for dinner. I'll tell the servant to set your usual place. I'll be having herb tea, would you like some also?"

"Yes, Harriet. I appreciate your thoughtfulness." *That young lady is a credit to the Overton family. She is wise, honest, thoughtful, and full of kindness. She is far more mature than any soon to be nineteen-year-old I've ever known. She is a true treasure.*

While dressing for dinner, Harriet broached the subject of Annie with John. "What are your feelings about Robert's request?"

"I have no problem with her staying with us. She is good company for John. However, the burden of her care will fall on you and how you direct the servants who see to her needs. I will support the decision you make. This evening at dinner, you can give our decision to Robert. Before you decide, allow me to add one thing. I'd very much like for us to make a trip to check on the property in Mississippi."

"Do you have a date in mind for the trip?

"Yes, I'd like to go in early March. Consider this; we could begin the trip south, going overland to Memphis, and stopping in Jackson to deliver Annie. I'd like to take John with us. I want him to visit Memphis and New Orleans. I also want him to see the Mississippi property and its operation."

"It sounds like you have thought through the plans very carefully. I'd like to pose four concerns: First, how long will the Mississippi trip take? John, I need to be here to help my sister, Annie, with her wedding. When she leaves in August, I will not see her for a long time. Second, what do you propose to do with your mother? I'd suggest we take her with us, but that is a long, hard trip even for a young person. Your mother is sixty-seven years old. Third, what

about the planting of the crops on the plantation? And my last concern relates to your work on the railroad."

"Well, Harriet, it sounds like you have thought through my plans very quickly. I'll try to answer your questions in the order you posed them. We should be gone about a month. The spring rains should allow us to make the return trip by boat. We'll be back in time for you to be fully involved in Annie's wedding. About Mother's welfare while we're gone, I've talked to my sister, Elizabeth, and she suggested Mother might like to make one more trip to Knoxville to visit with the Whites. She could also spend some time with her daughters, Mary and Margaret."

"You at least need to offer her the opportunity to go with us to Mississippi."

"I can do that. As for your next concern, the plantation will be in good hands with Mr. Gray here as the overseer. I will leave complete instructions and will arrange with John Lea or your father to be available to handle any emergencies. The railroad planning is nearly complete. All of the paperwork has been signed, and materials are being ordered as we speak. Construction workers are being hired and their work will begin in the spring. By the end of '51 the railroad line should be in operation."

"John, while you were talking, one more thing popped into my head. You are not leaving little John in New Orleans, are you?"

"No, but maybe sometime in '52; he needs the experience of being away from home. He'll be ten years old and that's a good age for travel and new adventures. Then I want him to study at St. Evans Academy and, hopefully, the University. The Academy was a good preparatory school for me and it will be for John as well."

"If your son turns out to be half the man you are, the path you have chosen for him will be a good one." John made no response, but he felt affirmed by what Harriet said.

That evening at dinner, decisions were announced and accepted. Mary appeared to be happy with her recovery. Little John and Annie finished their meal with the adults and requested to be excused. Those who remained in the large room enjoyed the fellowship of good friends. At the close of the evening, Mary offered a toast and good wishes were shared for the coming New Year.

# 6. Another Overton Generation

By the second week of January 1851, routine had returned to the plantation. The slaves who worked in the fields turned the dirt to allow it to breathe before spring planting. That process always unearthed large rocks that were used to create rock fences around the property boundaries. The boundaries not made of rock fences were closed in with rail fences. Trees had to be felled, split, and then the fence constructed. It took special skills to build the rock and split-rail fences, and the Overton slaves did an excellent job at both. Straight fence lines marked over 2300 acres of land. Some folk who took Sunday afternoon carriage rides in south Nashville marveled at the straight fence lines. John Overton was always quick to give the slaves credit for their accomplishments. He knew he owned the land, but the slaves made it produce the cash crops of cotton and tobacco. Corn, beans, squash, potatoes, and a variety of vegetables produced on the plantation provided food for the Overtons and their slaves. The slaves also managed various fruit tree orchards on the property.

When the slaves were not working in the fields, they were involved in butchering hogs. After the hogs had been killed, hung up, and gutted, the children gathered around. It was one of the few times on the plantation when the white and slave children were allowed to be together. Little John had asked several times at breakfast if he could see the entire event, but Harriet said, "It's not something children need to see." Mary agreed.

"After breakfast we will put on our warmest clothing and walk out and see the hogs for a few minutes," Harriet instructed. That seemed to satisfy the children. With breakfast finished and the children off to find their warm clothing, Harriet and Mary sat alone in the dining room. John had excused himself to go outside and check on the progress at the smokehouse. Washington, a 33-year-old slave, was in charge of the butchering.

"Washington, how are things this morning?" John's question was coated with the fog that formed from his breath.

"Sir, it be cold this here mornin'."

The slave children had gathered and were warming themselves around the blazing fire. They were not well clothed but were willing to fight the cold to see the sight of the huge hogs hanging near the smokehouse. The older children knew from past winters that when the hogs were butchered, there would be good eating in their cabins for the next two weeks. Parts of the hogs that many would throw away were taken to the cabins. The slaves prized the heads, tails, and hocks.

Washington was in charge and directed his helpers at each stage. He was never involved in the actual killing procedure but took over when the hogs were hung. This year there were four hogs to be butchered. When the heads, feet, and guts were removed, each hog dressed out a little over 200 pounds

each. Washington told four of the slaves to take the intestines down to the running creek below the smokehouse and clean them good. The intestines would be used tomorrow for casing the sausage. When he returned from checking the water in the scalding vat, he spoke to John, now standing by the fire talking to some of the slave children.

"When Miz Overton comin' out?"

"A new Mrs. Overton will be coming out soon, and she'll be bringing my son and niece with her. The children wanted to see the hogs. They won't stay long, but they did want to see what you are doing."

"Ya mean da young Miz Overton?"

"She has not been to a butchering before, so help her understand about the various cuts of pork."

"Yes, sir, I understand. While we waitin' I goin' to dip da hogs and gets da hair off 'em."

"You know what needs to be done, Washington. So go about your business and I'll check on Mrs. Overton and the children." Halfway to the house, he heard the door open and the excited voices of children. John and Annie were prepared for the cold morning. All that could be seen were their eyes. Harriet guided them down the steps and toward John, who looked like a tall chimney with smoke coming out the top. It was not easy for the children to walk with all the clothes they had on, but Harriet was satisfied they would not get cold during the short time they would be outside.

"Good morning, children," John smiled at them.

"Good morning," came the muffled voices of John and Annie.

"Let's go see the hogs." Bareheaded, John stuck his hands into his coat to keep them warm. Harriet was carrying John's winter hat and handed it to him.

"John Overton, put this on. You are going to catch your death out in this cold without your hat."

"Thank you." He did not need to be told a second time to put on the hat. He pulled it down over his reddened ears.

While little John, Annie, Harriet, and John stood looking up at the hogs hanging from the support, Washington came over to take down a hog and place it in the vat.

"When Miz Overton be comin' out?" Washington was looking at John and was not aware Harriet was an adult. Her size made her appear, to Washington, as an older child. John glanced down at Harriet and knew that under her long dress was a foot about to stomp the ground. He moved quickly to prevent any challenge she was about to make. Harriet flung the scarf from around her face and looked Washington square in the eyes. John was too late. She was moving in the direction of Washington when she spoke.

"We have not met. My name is Mrs. John Overton, and who might you be?" Her measured words had a staccato beat to them.

"I's Washington, ma'am. Yes, ma'am, I's Washington." He snatched his floppy hat off and held it in his hand, bowed, but did not make eye contact. He

waited for what would come next. John was very anxious about what was coming. Slaves who misspoke or insulted their white owners could be sold off the plantation. Others could be whipped publicly. The other slaves who were working stopped what they were doing and watched anxiously. The slave children recognized the sound of a white, angry voice and looked at each other with fear in their eyes.

Vapor rose from Harriet's lips, "Washington, I want all the hams, bacon, ribs, chops, and tenderloin you can get from these hogs. And I need as much sausage as you can make from what's left. When I come to this smokehouse, I want to see plenty of pork hanging and lots of pork curing in the trough." She moved closer to Washington, close enough that he could only hear what she said. "How did I do? Did I say the right things?"

When he looked up, all he could see was a very pleasant smile with raised eyebrows, indicating that he needed to answer her questions. As Washington stood up straight, he moved a couple of steps away from Harriet. He smacked the side of his leg with his hat enough to create a little puff of dust. He gauged his voice for all to hear, "Ya done jest fine, Miz Overton. I knows jest what yous wants. They be lots of pork hangin' in da smokehouse whens I's done." John could only shake his head in wonderment at his wife. She appeared to have no fear. She had proven herself equal to any challenge. In less than a year, she had taken charge of the plantation. She had the respect of the slaves and the household servants. She was the perfect hostess while Mary was recovering. He knew of only one thing she had not conquered; she was not in a family way.

Harriet turned toward John and Annie, knowing they had been in the cold long enough. As she began to walk, she heard the laughter of the slave children standing near the fire. She turned and motioned for them to come to her. "Children, come with me." At that command, two groups of children moved toward Harriet—slave children and white children. She extended her arms and like a mother hen, she gathered the chicks close to her. They moved with her. They went up the steps and into the kitchen.

John watched the mixed group disappear behind the kitchen door. He laughed to himself and thought as he headed for the warm house, *Mother will not believe this. I've never seen her show any affection to any slave, and Harriet seems to go out of her way to be friends with them.*

The kitchen was warm and cozy and Harriet knew John and Annie would be in distress if they didn't get out of some of their heavy clothing. As she helped them, the slave children watched with interest at the layers of clothing that dropped to the floor. Cynthia was surprised to see the slave children in her kitchen when she entered through the dogtrot door.

"What you youngins doing in da kitchen?" They did not answer because they did not know why they were there.

"Cynthia," Harriet answered for the children, "They all need something hot to drink and a cookie if you have any." The children—both black and white—reacted with smiles to the word *cookie*.

"All da youngins?"

"Yes, all the children. In fact, when you have it ready, we'll be in the family dining room."

"All yous be in the dinin' room? Miz Harriet, does ya know who dez black youngins be?"

"No, Cynthia. I know they are cold children who would like something to warm them."

"They be Emmaline's youngins!"

"So?" The kitchen door opened with a bang and bounced off the back wall coming to rest half-open. All eyes focused on the huge man standing in the doorway. "What are you slave children doing in here. Get out of here! Before I ..."

"Before you what, Mr. Gray?" Harriet had moved to the center of the room. John and Annie were hiding behind Harriet's wide winter dress. The slave children had moved near Cynthia.

"Mrs. Overton. I didn't know you were in here. I saw the slaves come in and knew they didn't belong in here. I was just getting them back where they belong."

"Right now, Mr. Gray, the children belong in here with me, and I don't recall asking you to join us. You may leave and close the door behind you."

"Yes, ma'am."

Cynthia hugged the children near her. Their eyes were open wide as if they were expecting something bad to happen to them.

"Cynthia, you were saying something about these children before we were interrupted."

"Never mind, 'twasn't important."

"All right then. Children, let's go into the dining room and wait for our warm drink and cookies. John and Annie, you need to bring your clothes with you. We can put them away later." The slave children had heard, from the servants who worked in the house, how big the house was inside. Now they were seeing it firsthand. Harriet arranged the children around the table, placing a cup and small plate in front of each child. She left the room, leaving John in charge. Before she returned, Cynthia had poured a drink and placed a cookie on each plate.

As Harriet reentered the room, she watched John offer each child a bit of sugar or a spoonful of honey. She was very pleased to see John's treatment of the slave children. "Thank you, John, for being so thoughtful and helpful." John and Annie took sugar. The slave children took the honey because they had never seen or tasted sugar before. All the children knew what to do with the cookies.

Harriet had gathered some stockings for the girls and struggled to make them fit properly. The boys got socks and were quick to put them on with

John's help. Shortly, they were out the door, into the kitchen again, and then outside. They waved at Cynthia on their way out. The slave children were better prepared to face the cold with their new stockings and socks, but the real warmth was on the inside provided by a lady they heard called Miz Overton whom they would never forget.

Around 1810, Judge Overton had built an office on the Travellers Rest property about a hundred yards southwest of the house and used it to store some of his books and papers. On occasions, he would meet clients in the office. After he retired and married, he used the building for his law students. When he died in 1833, Mary had him buried near the building. In 1850 when John Junior had an opportunity to put the new railroad line through his property, the building created a problem. When the surveying was completed for the railroad, John was told his father's building was over the right-of-way line. The graveyard would not need to be disturbed, but the building would need to come down.

Mary suggested, "John, rather than destroying the building, why don't you dismantle it and rebuild it in another spot about the same distance from the house?"

"That idea is worth investigating. Let me check with Archer. If he thinks it can be done, we'll do it."

Archer was an Overton slave who was very skilled in construction and had a keen mind. He was a lad of thirteen when the 1828 brick addition was constructed, and he helped make the bricks. Archer was so interested in the actual construction that he was allowed to help build the structure. As he worked, he picked up the speech patterns of the white workmen. He used that skill to his advantage. Ever since, he was the one the Overton family consulted when construction or repairs were required around the property. When John raised the question, "Archer, is it possible to take down the law office and rebuild it?"

"Yes, but why would you want to do that?"

"The new railroad will be coming onto the property this year and the office is in the way."

"If we began the project this week, we could have the building down by planting season and then rebuild it next winter."

"Very good, Archer. Pick your work crew and get the job done."

"By the way, Mr. Overton, where do you want to rebuild the office? It would be best if we only had to move the material one time."

John pointed in a southeasterly direction. "Right over there would be a good spot. Rebuild it about the same distance from the house as it is now."

"One other thing, sir. Do we need to move the graves? My people have some crazy ideas about disturbing the dead."

"No, the graves are fine. They do not need to be disturbed. Archer, I'll count on you getting the work done before planting." John never gave the task another thought, knowing Archer could and would handle the project.

At dinner, later in the week, John added to the light conversation, "I've made the arrangements for our trip to Jackson, Memphis, New Orleans, and then over to Pass Christian."

Harriet placed her fork on her plate and gave John her full attention. "And what might they be?" *It would be nice to know some of his thinking*, Harriet thought, *before he shares it with the entire family.*

"If we leave here in early March, we can be back by early April. The spring rains will raise the Cumberland River enough to allow the big boats into Nashville. I've sent a letter to the Winchesters in Memphis telling them of our plans."

"John," Mary quizzed, "which Winchesters are they?"

"Mother, you remember General Winchester who worked with Father on the Memphis land. His second son is my age. We were at the University at the same time. He lives there and manages the family holdings."

"Yes, I know of him, but have never actually met him."

"Anyway, after we take Annie home to Jackson, we will spend a couple of days visiting in Memphis. I want John to see what his grandfather developed in the city. I'll be able to check on our holdings as well. Then we will take the boat to New Orleans and on to the Mississippi property. And Mother, you will be going to Knoxville to visit."

"Yes, I believe that's the plan. I may spend a day or two with Elizabeth before I go. I've sent a note to Mary and Margaret Jane asking whether either of them would like to go with me. I doubt they will, but at least I asked."

Harriet was always interested in the details. "John, which of the servants will be going with us?"

"Eli will be going and you can choose a female servant for your needs."

"What about taking Emmaline?"

"I don't think that's a good idea. She has her children to take care of, and she may need to help Cynthia in the kitchen." Mary looked up from the cup of tea she was holding and glanced at John. She could tell he had been surprised by Harriet's request and was sitting on the edge of his chair. She did not say a word as she glanced over at Harriet, but she wondered, *what does Harriet know about Emmaline? Has someone told her about this slave woman with a house full of children and no husband? Is she testing John? Maybe she is perfectly innocent in her suggestion.*

John was staring down at his empty dinner plate, hoping someone at the table would change the subject. Relief came in the sound of little John's voice: "Father, how far away is Memphis—how many miles?"

"The trip will take several days and we will stop a number of times along the way. Memphis is about 200 miles."

Harriet became interested in the conversation. "John, have you considered traveling by railroad?"

"Yes, as a matter of fact, I did check the Memphis and Charleston line. We would still need to connect in North Alabama and find a way to Jackson.

Maybe the next time we make the trip south my railroad will be in service. I've rented a large, enclosed carriage for the trip which can be dropped off in Memphis. I plan to take a horse also for Eli to use so he can ride ahead each day and find appropriate accommodations for us. Little Lewis will be going along to drive the carriage and then bring the horse back here."

"That arrangement presents no concerns for you?"

"You mean with Little Lewis? No, he's a faithful slave. He used to carry Father's mail years ago. He hand-delivered the mail to nearly every border in Tennessee. Taking the horse will also give little John some time in the saddle."

"Father, that's a wonderful plan!" Little John's excitement was turned on his cousin. "Annie, did you hear what Father said? I'll be riding a horse all the way to your home in Jackson."

Harriet felt the need to make a correction in what she heard. "Little John, you will have 'some time in the saddle,' not ride all the way to Jackson."

John and Mary did not respond to little John's overstatement, but were pleased, as usual, to hear Harriet take charge of the situation.

The days of winter brought cold winds and several days of storms. By mid-February, a huge snow fell in Nashville. Work was delayed on the dismantling of the law office, and the remainder of the slaves stayed in their cabins. Work for the kitchen and house servants went on as usual. The Overtons still required care and the servants responded. Harriet stayed busy preparing for the trip. She found herself packing for three—herself, little John, and Annie. All of Annie's things would be going to Jackson with her. Little John would need both heavy and light clothing, as would she. The weather in New Orleans and Mississippi would be much warmer and would require proper clothing. She wasn't sure how much room would be available on the carriage for baggage, but she would let that be John's concern.

Elizabeth Lea arrived unannounced, but that was fine; she was family. She came to check on the arrangements for her mother, Mary, and to spend some time with Annie. Elizabeth's driver knocked on the back door. Mary heard the knock and responded. "Miz Elizabeth Lea here to visit the Overtons, ma'am." The driver had been preparing his speech as he drove from the Lea plantation, and he spoke as he had been trained. *How prissy*, Mary made eye contact with her daughter still sitting in her carriage. *She is so formal. She must get that attitude from her father. She was born here, grew up here, and now needs to be announced. I should send her driver back with a message, "Mary Overton does not receive visitors through the back door!"* Mary overcame the urge and told the driver, "Tell Queen Elizabeth, 'I welcome her to my castle.'" The driver delayed long enough for Mary to say, "Please invite Mrs. Lea to come in."

"Yes, ma'am." He seemed pleased.

Mary waited for her daughter at the door, and they proceeded to the family dining room. "Elizabeth, be seated while I walk out to the kitchen and have some tea made. If I had known you were coming, I would have warmed up the

parlor." Mary found Eli in the kitchen and told him to put some more wood in the dining room fireplace. Returning to the room, she quizzed, "Elizabeth, why have you come?"

"Well, Mother, I wanted to check on you and determine what plans you have made while John and Harriet are gone, and I wanted to visit with Annie before she goes home."

"And how is your John?"

"He is very busy these days. He's been doing some of the legal work for Brother and his railroad project. He's also been talking to some men in the city about the judgeship coming open this year. He was wondering about using Father's name, if he decides to seek the position. What do you think? Would it be appropriate?"

"I'm not sure what advantage it would be to use your father's name. He retired from the bench in 1816 and that's a long time ago. Some people may not even remember his name, much less that he was a judge on the High Court of the state."

"But his books are still used in the court system, and every time they are used, his name is mentioned. The current judges and lawyers pass by Father's portrait every day the court is in session."

"If your John thinks it will help him, feel free to use the Judge's name. By the way, neither Mary or Margaret Jane can go with me to Knoxville."

"Do you want me to go with you?"

"No, Elizabeth, I need you to stay in Nashville, in the event you would need to come here for some reason. I will feel much better knowing there is an Overton at Travellers Rest. Your brother has arranged everything during the time we are gone, but just the same, I want an Overton making major decisions. That's how you can best help me while I'm away. I was planning to stay for a month, but I may cut my visit short."

"Mother, you can stay as long as you like and feel secure that everything proper is being done on this plantation. Brother has already met with my John, and things will be handled properly."

"Your brother told me he was also contacting Jesse Maxwell to put him on standby."

"That's good, Mother. Now is there anything else I can help you with before your trip?"

"No, I believe everything is in order. When I arrive in Knoxville, I'll send you a note, and if you need to contact me, a telegraph message can be sent."

"My John can see to that if the need arises." Elizabeth crossed the room to give her mother a hug and kiss on the cheek.

"Give my regards to your John and thank him for his kindness."

"Yes, Mother. I'll visit with you when you return." Elizabeth was out the door, seated in her carriage, and on her way home. Mary wondered as the carriage disappeared out of sight, *Elizabeth did not visit with Annie. She must*

*have forgotten. I guess she did what she came to do. I must remember to send her a note from Knoxville.*

That afternoon when the large carriage arrived was an event to remember. Word spread quickly to the slave cabins. Every cabin was emptied and the slaves peered around the barn at the carriage. Archer and his crew working on the law office took a brief break to come and examine it. The house servants took quick glances through the windows, and some found it an ideal time to sweep the lower gallery. As John went out to check the new arrival, Harriet sent a servant to find little John and Annie. Eli was standing on the backside of the carriage with Little Lewis, when John approached the two men still in the driver's seat. The driver spoke, "This carriage is for Mr. John Overton."

"I'm John Overton."

"These are the papers you'll need in case anyone wants to know who owns the carriage, and you'll need them when you return this beauty in Memphis." John took time to read every word on the papers. Everything met with his approval; he signed the bottom page and returned it to the driver. "Eli, you and Little Lewis get over here."

Eli recognized the tone of the voice and moved quickly around the horses, pushing Little Lewis ahead of him. "Yes, sir, Massa Overton."

"Excuse me, my good man," John looked again at the driver perched above him. "I did not get your name."

"My name's Scotty and this here is . . . ." The interruption was understood by the Overton slaves. They knew Massa Overton had the information he needed.

"These two are Eli and Little Lewis. They will be driving the carriage to Memphis and will need instruction. I expect you to instruct them in the operation of the carriage, the care of the horses, and anything else they may need to know for our trip. When you are finished, Scotty, you are free to go." John turned and headed back into the house, glancing down at the papers in his hand.

Scotty was shaking his head and did not speak until he was sure John Overton was in the house. "He's a hard man to deal with," Scotty was looking directly at Eli.

"Yes, but he be fair. I've knowed him most of his life."

"This here's Zeb. He takes care of the horses." Zeb didn't speak but acknowledged Eli and Little Lewis with eye contact and a wave of his hand. He was still holding onto the reins, although the horses were perfectly at ease. Scotty turned in his seat, placed both of his feet on top of the huge carriage wheels, and dropped to the ground. By the time he reached the carriage door to open it, Zeb was doing the same thing on the other side. As they looked inside, Eli and Little Lewis were amazed at how much room was available. "This beauty," Scotty said with pride, "will seat eight adults. There are planks underneath here that can be used to create a sleeping bed if needed. The seats are made of horsehair and velveteen material. The matching drapes at the

windows are also velveteen. We can even rig up a small stove if it gets too cold."

"Wouldn't dat be dangerous wit da fire inside?" Eli's question allowed Scotty and Zeb to move to the back of the carriage to show off the storage space. Scotty unlatched the slanted double doors to reveal the large storage space. He pulled out the tiny wood stove and showed Eli how the smoke pipe fit. "There's a covered hole on the other side, above the door, where the pipe fits." There was a paper attached to the top of the stove with instructions.

"Well, I be," Little Lewis commented, "what ya white folk thinks of next?"

"This storage space," Scotty explained, "will hold lots of things. If you need more space, you can use the top of the carriage. You'll need to tie things down good 'cause the rough roads will shake 'em loose during a long trip."

Little Lewis had seen all he needed to about the storage. He was interested in the horses. "What kinda breed is they?"

"These horses' parents come from Germany. These two were born in Kentucky."

"How many hands tall they be?"

"They are something over twenty-two hands."

"Ya sure they be able to pull dis carriage?"

"With proper feed, water, and rest, these two can take you wherever you need to go."

"Where we get the feed and water?" Little Lewis was concerned.

"All of that has been taken care of for the trip. Wherever the Overtons stop for the night, there will be provisions for the horses. Our owner has arranged for us to ride with you all the way to Memphis. So we can handle any problems with the carriage or the horses." Little Lewis smiled to indicate he was very pleased at what Scotty said. Eli had been listening to what was being said and had a question for Scotty. "How ya knows all dis information?"

"It was on the papers I gave to Mr. Overton."

Sure enough, just as Scotty had reported, he and Zeb were waiting on Franklin Pike two days later. As the huge carriage approached, Scotty took off his hat and waved it in the air so Eli and Little Lewis could see them astride two horses in front of the livery stable. Another mile up the Pike, Eli directed the horses to turn left onto the main road leading out of Nashville going west. People along the road stopped what they were doing and took notice of the traveling party. The large carriage was eye-catching and created comments and hand waves. Every couple of miles Eli leaned to his left and looked over his shoulder to check on his horse tethered to the back of the carriage. Each time he received a wave from Scotty, who, along with Zeb, was not far behind.

The seats inside the carriage were surprisingly comfortable, like sitting on the sofa in the large room at Travellers Rest. The oversized springs under the carriage provided a smooth ride. Little John rode in the seat next to his father. They looked out the windows and watched the world go by.

Little John was excited to discover he was riding backwards and commented to Annie, "This is a great adventure just like the pioneers had years ago." Annie knew the word *pioneers* but she didn't know any by name. "Who were the pioneers?" Harriet waited for little John to answer. When he couldn't name a pioneer, she was ready.

"Your grandfather Overton was a pioneer. He was born in the colony of Virginia and moved to the area we now call Kentucky. After he received his law certificate in Kentucky, he moved to the Western District of North Carolina in 1789."

"I thought he moved to Tennessee," little John quipped.

"He moved to the land that became Tennessee in 1796."

"Was Andrew Jackman a pioneer?" Annie wanted to get the conversation back on pioneers.     John was busy with a stack of papers and had been reading and shuffling pages most of the morning. His ears heard Andrew Jackman, but his mind processed Andrew Jackson. He cleared his throat and spoke, "Annie, that's Andrew Jackson, not Jackman." Harriet smiled knowing that Annie's mistake would bring John into the conversation.

"Was Andrew Jackson a pioneer?"

"President Jackson and your grandfather Overton were both pioneers."

"I thought George Washington was President." Annie moved to the edge of her seat, hoping to get this comment correct. Harriet settled back in her seat watching John shift in his. *This is wonderful,* Harriet thought. *Now John is getting a little taste of the challenge I've been having with little John and Annie. He can't get up and walk away. He will have to deal with these two bright children.* Harriet put her hand to her mouth hiding a big smile as she looked at John. Her arched eyebrows were a dead giveaway to him that she was doing more than smiling behind her hand.

"Annie, both Andrew Jackson and George Washington were presidents."

"But Uncle John, I thought we were talking about pioneers?" John's forced laugh was a sign for Harriet to get involved. When she spoke, little John and Annie turned in her direction and John breathed a sigh of relief. He had been rescued and he was glad.

"Let's see if I can clear this matter up for us. Annie, Uncle John was telling you that Andrew Jackson, along with your grandfather Overton, was a pioneer in this part of the country. Did you know that my grandfather Maxwell was also a pioneer? He came to the Nashville area and built a house on the land given to him for his service in the Revolutionary War. In fact, your grandfather Overton bought the land where Travellers Rest is from my grandfather Maxwell."

Little John had been listening intently when he asked, "Did you know my grandfather Overton?"

"No, not really. I was just a little over a year old when he died in 1833, but I remember my parents talking about him. They thought he was a fine man." John pretended to be busy with his papers, but Harriet knew he wanted another

chance to have a part in the conversation. "Let's see, we've talked about pioneers and some about presidents, but we've not said a word about Indians." She pulled open the large drape and looked outside. "I wonder . . ."

"Do you see Indians out there?" Little John had his head nearly out the window before Harriet pulled him back into his seat. As he plopped into his seat, he pushed against his father. "Father, do you remember seeing any Indians when you were my age?"

"When I was your age, I recall hearing my father and Mr. Jackson laughing about the Indians they encountered when they first came to the area. Then one time I went with my father to Alabama to look at some land, and on the way he pointed out an Indian village. I saw tepees and men riding horses with no saddles."

"Did they wear feathers in their hair?"

"I don't recall any feathers."

"What about bows and arrows? Did they wear war paint?"

"Son, I believe the Indians I saw were friendly. When we rode by their village, I waved at them and they waved back. They were very friendly."

Harriet noticed John was repeating himself and that was a sign for another activity. "How about some lunch?" she announced and received instant approval from the children. Cynthia had packed a basket full of food. John pulled the cord above his head which rang a small bell near the driver's seat. The sounding of the bell was a signal for Eli to pull off the road and stop the carriage. Getting out of the carriage, stretching, and handling the necessities was a welcome change for everyone. After lunch and back in the carriage, the Overtons were again on their way. The children fought off a nap as long as they could; but in a few miles, both were fast asleep, to the relief of the adults.

The overnight accommodations were meager by Overton standards but acceptable. There was time for little John to ride Eli's horse, and Annie was occupied with a simple needlepoint project Harriet had brought along. When the servant put the children to bed that evening, John and Harriet visited with other travelers in the way station. Harriet was in her usual friendly mood; John was satisfied just to eat and was ready to retire for the evening. Small talk was not one of his social gifts.

Near Jackson, Eli stopped the carriage and was instructed to ride ahead and announce to Robert Brinkley that the Overtons and his daughter, Annie, would be arriving within the hour. Inside the carriage was a scurry of activity. The servant began brushing Annie's hair while Harriet looked for a hair bow.

"Annie, when we arrive at your home and you see your father, I want you to act like a proper young lady. You must remember to walk and not run."

"I am so excited to see Father and Hugh."

"As well you should be. They have missed you as much as you have missed them." Harriet pulled the drape to allow Annie to see as the carriage approached the Brinkley estate. "May I hug and kiss them, Aunt Harriet?"

"I believe they will be expecting a big hug and several kisses."

Robert and Hugh were waiting on the steps when the carriage arrived. John swung open the door and helped Annie down the carriage steps. She started to run and then remembered her instructions from Harriet. As she leaned forward from her seat, Harriet watched the father-and-daughter reunion and recalled the times her father had picked her up and showered her with hugs and kisses. *I'm so pleased for Annie. Although I will miss having her at Travellers Rest, she belongs here with her family. This is her home and they need to be together. What a joy she has been for me. I hope someday to have a little girl of my own.*

John saw the joy on Harriet's face and commented, "We will one day have one just like her and she will never have to leave us."

"John Overton, you are reading my mind. I just had the same thought."

The visit with Robert was only overnight. John was eager to get to Memphis. There was so much to show little John and to tell him the history of the Overton connection to the city. He could tell the story word for word just as his father had told it to him.

That evening after dinner Robert, John, and Harriet made their way to the sitting room where there was a fire blazing in the fireplace. The cousins were getting acquainted upstairs. A servant brought in glasses of brandy and two cigars on a silver tray. Robert glanced at Harriet, "Would you care to partake?" She tried to keep a straight face when she responded, "No, thank you. I've stopped smoking."

"Well, of course you have, silly me. Would you care for a brandy, then?"

"No, thank you, Robert." Harriet was laughing by now and so was Robert.

"There's not been laughter in this house for many months. Thank you, Harriet, for gracing my home. I will always be in your debt for taking Annie into your home. I've been waiting for a special occasion to make an addition to this room. I don't know that any occasion could be more special than this." Robert placed his glass on the mantel and moved to the side of the room where a covered frame was hanging. "John, I had hoped your mother could see this." He removed the cover to reveal a painting of his wife and daughter.

"Robert, this is marvelous!" John moved to get a full view of the painting. "That is my sister's likeness in every detail, and little Annie looks like she's ready to speak. I have seen that look on her face many times at home. What do you think, Harriet?"

"Oh, I agree. Robert, this is lovely. I assume Annie has not seen it."

"No, but she may remember sitting for it. I hope it's not too hard on her, remembering her mother this way."

"No, Robert. You have provided her with a treasure that she will cherish all her life."

"I also have a portrait of Hugh and his mother, but it is not completed yet. I'm hoping that one will be as well done as this one."

"I'm sure it will be." Harriet excused herself for the evening, while John and Robert finished their cigars.

"John, do you want me to open my Memphis house for you to stay in while you're waiting for the boat?"

"No, we'll only be there a brief time, but thank you for the offer."

"I'm glad to have this time with you, and I have a question for you. Do you think there would be any Overton family objections about me marrying again? Since Ann passed in '45, life has been lonely for me. My traveling schedule has not been easy on the children. They both need a woman in the house."

"For my part, Robert, I would be happy for you. I know Mother and Elizabeth would feel the same way. Do you have plans?"

"I was introduced to a widow lady, Mrs. Elizabeth Mhoon. She currently lives in Alabama with some of her family. I do have feelings for her, but I have not declared my intentions. If I do marry again, I plan to sell this place and move to Memphis. A lot of my travel begins and ends there."

"Am I at liberty to share your news, or would you prefer I delay?"

"Let's delay until I'm sure."

"Done. However it works out, I'm happy to know you're considering remarrying. I know the feelings of losing a wife and the joy of finding another good woman."

"Do you have time for one additional discussion before you retire for the night?"

"Yes, I do."

"In a couple of years Hugh will be old enough to begin his formal education, and I'm looking for a place to fill that need. Are there any good boarding schools in the Nashville area?"

"There are good schools but not boarding schools for young men. We do have the University, but Hugh is too young for that experience. You know, I have the same concern about my son, John. That's one of the reasons I'm taking him to New Orleans. I'll be happy to share any schooling possibilities I find."

"That would be very helpful." One last sip of brandy and the evening ended.

Saying good-bye to Annie the next day was easier than Harriet had anticipated. She would miss the child's cheery disposition but knew there would be other times in the future to renew their friendships. The ride to Memphis went quickly, but the Overtons did arrive at their hotel late and John had to carry his son to bed. "John," Harriet suggested, "don't bother changing his clothes. Just put him to bed as he is." John nodded his agreement.

Memphis was a city alive with activity around the hotel. Harriet and her servant visited the shops near the hotel. They discovered the latest fashions from Europe by way of New Orleans. Somehow, word spread quickly that Mrs. John Overton was in the area. Shopowners met her at the door and

escorted her through their shops, pointing out the very best merchandise they had to offer.

John took his son with him when he visited his agent. The Overtons still had major control over much of the property and open land in and around the city. Fifty years after the fact, people in the business community were still talking about the land deal Judge Overton was able to negotiate. At the turn of the century, the Judge had seen the potential in the land and made an offer on nearly five thousand acres of prime property near the Mississippi River. He shared his vision with his friend, Andrew Jackson, and their friend, General Winchester. Both men bought into the plan but not to the extent of the Judge.

After his retirement from the court in 1816, the development of the land and Memphis became his passion. John had been here several times with his father. The Judge had impressed on him the necessity of staying involved in the development of the city and finding an agent who would manage the Overton holdings. John had not been nearly as involved as his father had, but he did have an agent he trusted. Now it was time to introduce the next Overton generation to the land, the city, and the vision. Little John greeted the family agent by extending his hand and giving a firm handshake. His father was impressed and pleased at his son's interest in business matters and the questions he posed to understand the history."

Grandfather Overton was an important man in Tennessee, wasn't he, Father?"

"Yes, he spent most of his life in its development. At the same time, he was building a reputation of honesty, fairness, and a good name. He had a keen head for business as you can see. You can stand in one spot in Memphis, look in all the directions, and the land you see, at one time, belonged to your grandfather. He was quite a man!"

"And Father, you are just like him and so am I. All three of us are John Overton."

"Yes, in some ways we are just like the Judge." With smiles on their faces, father and son headed back to the hotel to meet Harriet. At dinner, conversation was a recounting of the day.

Harriet talked about the shops she had found and some of the purchases she had made. "John, everywhere I went today the shopowners knew the Overton name. I was very impressed."

"That's because their shops are sitting on land my father owned. Many of the shopowners are second generation, and their parents dealt with my father in purchasing the land years ago."

"They would not allow me to pay for anything. They will be sending bills later to your attention."

"I'm glad you had a good time. This was an Overton day for little John as well." Little John was so excited that he jumped right into the conversation. When he did, Harriet stared at him. They had been over this matter of politeness many times and she expected him to act accordingly. "Excuse me

for interrupting, but I have something important to say." Harriet was very pleased at his decorum and smiled. "Yes, tell us about your day."

"I shook hands with our agent. I stood in one spot, looked in all directions, and all I could see was Overton property. We tried to find Mr. Winchester, but he was out of town on business."

"I'm impressed. It sounds like you've had a full day. Now it's time for us to go upstairs and get ready for tomorrow's adventure on the paddleboat. I believe it would be a good idea for you to have a bath this evening before bedtime."

The hotel manager provided transportation for the Overtons to the boarding dock. Eli handled getting the trunks to their boarding location and waited for the Overtons to arrive. The sight of the large paddle wheeler brought back fond memories for Harriet. She remembered floating down the Mississippi with her sisters and the wonderful time they experienced. It was on the trip that Annie met her future husband and became so distraught when he had to leave the boat for his assignment. She had thought her life was over; but within a few months, her soldier boy would be returning to Nashville to marry her. Harriet intended to be a part of the wedding occasion and had a promise from John that they would be back at Travellers Rest to help Annie plan and celebrate the event. The pleasant memories came to an abrupt halt with little John's voice, "Wow, look at that boat!" He had seen small boats on the Cumberland but nothing to equal what he saw in front of him. John and Eli were in the cruise office finishing the final details of the trip and did not get to enjoy little John's excitement. Harriet shared his excitement and reminded him, "We'll be on the boat for several days and you'll be able to do a lot of exploring."

"When can we start?" He had already spotted the gangplank with the guide ropes and was anxious for the new adventure.

"When your father returns from the office, we should be able to go aboard."

John quizzed Eli about Little Lewis, "Have you seen Little Lewis this morning?"

"He be rite outside waitin'."

"Good, I need to talk with him and give him some instructions about returning to Travellers Rest."

"He be ready." Outside, John handed Little Lewis a leather pouch. "In the pouch, Little Lewis, is a letter indicating you are my property. If you are stopped for any reason, use the letter. There's also money for your trip. What you don't spend is yours to keep."

"Massa Overton, Zeb, the darkie from the carriage company, be goin' back toward Nashville tomorrow. He say I can travel wit him, if dat be alright wit ya."

"That will be fine. You are riding on my best horse. I expect you and the horse to be at Travellers Rest when I return. My father, the Judge, trusted you, and I trust you. Have a safe trip."

"Massa Overton, da horse and me be seein' ya on da plantation a little later." They did and the trust between the owner and the owned continued.

The entire trip to New Orleans was magic for little John. His father pointed out various landmarks on the Memphis shoreline. The boat's whistle always caught his attention. When he walked the decks, ate in the dining room, or laying in his bed—the sound of the whistle planted memories in his mind that would last a lifetime. John arranged for his son to talk with the captain in the wheelhouse. The wonderful day came and father and son made their way to visit the captain. The view was breathtaking, and it seemed little John could see for miles from his vantage position. The experience became even more memorable when they approached the city of Vicksburg, and he watched the captain reach for the whistle handle. "Master Overton, would you like to blow the whistle?"

"Oh, yes sir!" John moved toward his son and lifted him to a height where he could reach the handle. The captain had very specific instructions: "You will need to make three pulls. Two short and one long pull to sound the whistle. Show me what you are going to do." Little John cupped his hands together and in the air pulled two shorts, and one long.

"I believe you have it just right. So grab the handle on the pull, and let's blow the whistle and tell Vicksburg we're coming."

Little did Harriet know what was happening in the wheelhouse, but she would hear the full details at dinner that evening. Everything the rest of the way to New Orleans was unimportant to little John. Nothing could ever top the experience of blowing the whistle. In fact, New Orleans did not impress him. He didn't like the food, the weather was too humid, the houses looked funny, and many of the people he met talked a strange language he had never heard before. His father and Eli told him about when they lived in the city. It was a fun place to be with its wonderful food, interesting music, and exciting parties.

The oversell was so heavy that at one point Harriet said to John, "Your son does not like New Orleans because he likes Memphis more."

"How do you know that? Are you certain?"

"Ask him yourself, John. You have reared your son to be honest and he will tell you."

For breakfast the next morning Harriet sent John and little John on while she delayed her arrival in the dining room. "Go ahead and eat. I'll be down shortly."

John had guessed Harriet's plan, so he raised the question, "Son, what do you think of the city?"

"It's a fine city." He answered the question but offered nothing else to the conversation.

"Would you like to live here?"

"No, sir."

"And why not?"

"Father, I'm a Tennessean and I want to live in Tennessee. I want to live on Overton land."

"I can't argue with that reasoning. How would you like to spend some extended time in Memphis?"

"Do you mean live in Memphis like you lived in New Orleans when you were a boy?"

"Yes, you would be in Tennessee and you would be on Overton land. You could go to school, visit with our agent, and hear the boat whistles all the time. Then you could come back to Nashville and attend the University." John realized there was a lot of information packed into what he had just said.

"I like the plan, maybe . . . ." Before he could finish, Harriet entered the dining room and approached the table. Father and son stood as the waiter pulled out the chair and helped Harriet be seated.

"Would the madam care for coffee?"

"Yes, thank you. And I would like a small bowl of oatmeal with brown sugar and a small pitcher of milk."

"Very good, madam."

"And what have the two of you been talking about while you were waiting on me?"

Little John did not hesitate, "We have been talking about my future. Father has a great plan."

"Really? What is it?"

"I'll live in Memphis for a while and then I'll come back to Nashville to attend the University. You know Memphis is the place for the Overtons." Harriet glanced across the table at John and smiled an *I told you so* smile.

"So I've heard."

John was silent and just listened to the conversation. There was really nothing he could add. Little John was saying all that needed to be said.

"What is our schedule for tomorrow?" Harriet pushed her coffee cup to one side to make room for her breakfast.

"We will leave for Pass Christian after breakfast in the morning. Eli can load the carriage early and we can be on our way. Claiborne is due in today with the carriage."

"Is that the same Claiborne I met on our other trip down here?"

"Yes, I believe it is. Son, is there anything special you would like to do today?"

"Harriet bought a book for me yesterday about Andrew Jackson and the Battle of New Orleans. I think I'll spend some time reading it," little John answered.

John was pleased. Harriet was very pleased.

The closer the Overtons came to Pass Christian, the warmer it felt. Little John slipped off his jacket and still complained that he was hot. The bright sunshine and hot Gulf breezes greeted them as they approached the small Mississippi community. Harriet explained to Little John that the area had been a family vacation spot for years. There were grand hotels here and the food was outstanding. He could have catfish prepared anyway he liked it—baked, fried, or broiled. "And little John, if you are really brave, you may want to try an oyster like I did on my first trip."

"Have I ever eaten an oyster?"

"No, but I'll see to it that you have an opportunity while we are here."

When Claiborne pulled the carriage off the main road into a side road, John instructed, "Eli, stop here." He stepped out onto his property. Turning to the carriage, he lifted little John out, eased him to the ground, and took his hand, "Son, this is Overton land. This is the largest piece of property in Pass Christian and it belongs to us."

Harriet was so proud to be an Overton. She heard in John's voice what he must have heard from his father—the land is a part of who we are.

In the next several days, father and son would have special bonding time centered on the land. Little John, the next Overton generation, saw every part of the plantation with his father as his guide. He had never seen sugarcane growing nor the process used to extract sugar, but he knew the end result. Now he understood why sugar was so valuable and had to be kept under lock and key. He knew about cotton, so they didn't spend much time in those fields other than to meet the slaves. Claiborne was able to call each slave by name and indicate how he or she was related. Little John paid close attention to Claiborne's naming of the slaves because he saw a boy in the field about his age. "And dat be Noah, da oldest son of . . . ." *Oldest son,* hung in Little John's brain. *I wonder whether Noah knows I'm the oldest son in the Overton family. I wonder whether he knows my father owns him.* The thought of *owns him* brought a lump to his throat and then a small tear to his eye. The scene of Noah bent over in the field left a vivid picture in his memory. That evening after dinner, while sitting on the front porch, the thought of Noah still bothered little John. "Father, will Noah ever do anything but work in the fields?"

"Who?"

"The boy my age we saw working in the fields. Claiborne called him Noah."

"Oh, yes. No, that's his lot in life."

"I don't understand."

"Well, in the Bible there's a story about Noah and the ark and the great flood."

"What's that have to do with the Noah I saw this morning?"

"The Noah in the Bible had a son named Ham. One day Ham did something that made his father very mad. Noah put a curse on Ham and made

him a servant the rest of his life. Years later Ham and his people went to live in Africa, the Dark Continent. The slaves come from the Dark Continent."

"So that's why there are slaves—because someone made someone else mad? Father, are you making that story up?"

"It's the truth. You can ask Harriet and she will tell you the same thing."

The screen door swung open and Harriet walked over and sat next to John. Little John brushed by her without speaking and went into the house. "You two been having a father-and-son talk?"

"Kind of . . . my son is disturbed about slavery."

"How did that subject come up?"

"He saw a boy his age working in the fields. The reality of slavery hit him today because of the slave boy. I guess he realized the only difference between them was the color of their skin."

"This is not the first time he's been troubled by the difference. While we were butchering hogs, I brought him, Annie, and several of the slave children into the dining room for a hot drink and cookies. I noticed he was very kind to the slave children. He has a tender heart."

"I agree, but if he expects to run Travellers Rest after me, he will need to be more secure."

"He's still young. He has time to learn. He may not want to run the plantation. He may choose to do something else. Let's allow him to be a boy as long as he can." The warm breezes from the Gulf temporarily made them forget that Tennessee was probably experiencing cold, blowing rains as winter gave way to spring.

The last day of the Mississippi phase of the trip was spent in the hotel in Pass Christian. Harriet mentioned to John, "I promised little John he could try oysters, and the best place to get them is at the hotel."

"Yes, that will be a good experience for him. That will give Eli and Claiborne time to get everything ready for our trip to New Orleans. By the way, did I tell you Claiborne will be coming to Travellers Rest with us?"

"No, you didn't, but I think he will fit in nicely back home."

The evening in the hotel dining room was special. Little John watched as the waiter placed the large platter of seafood on the table. He glanced at Harriet and she smiled back. Another waiter placed a small plate between them, holding a strange variety of items in gray colored shells. Some of the items looked like dressing, some like puffed-up corn bread, and then there were the slimy things. Harriet watched his reaction, "These are oysters." Pointing to the plate, Harriet said, "These are fixed with bread, these are fried with a corn meal coating, and these are raw."

John was watching intently. He didn't care for oysters at all. He smiled as his son pointed to the breaded one, "I'll try a small piece, please." He chewed three times and swallowed.

"How did it taste?" Harriet was happy he made the attempt. She found the small fork at her plate and poked a raw oyster, while holding the shell in her

hand. Little John watched in disbelief as Harriet's mouth closed and she chewed. His eyes grew larger when he saw her swallow what she had put in her mouth.

"I'll try one of the others but not the raw one." John laughed aloud and Harriet joined him.

"Little John," Harriet continued to laugh, "I'm very proud of you. It's good to try new things." The food was excellent, the setting was wonderful, and the bonding was for a lifetime.

The next day the trip to New Orleans began very early. The hotel manager handed John a letter. He glanced at it and stuck it in his coat pocket. It was still dark when the carriage left the hotel. John planned to arrive at the boat dock an hour before the paddle wheeler began its voyage up the Mississippi. The boat they would be taking was scheduled to make the trip all the way to Nashville, if the Ohio and Cumberland Rivers were high enough. If not, they would transfer to a smaller boat when they entered the Ohio. Either way, the Overtons would arrive in Nashville by boat.

John pulled out some papers from his inside coat pocket to present at the cruise office, when he rediscovered the letter handed to him early that morning. It was a letter from his mother. She had arrived in Knoxville and was having good visits with family and some old friends. She reported going to several teas and had attended church. Her health was good and she was sleeping well. A family member had given her a painting of her brother, Hugh; she was eager for John to see it. Together they would find a place for it at home. *The best place to hang Uncle Hugh,* John was quietly laughing to himself as he remembered the stories his mother told, *was next to Andrew Jackson. Since mother no longer likes Andrew, maybe I could find a painting of him, put it in her room, and then directly across the room hang Uncle Hugh. They could look at each other all the time. That would be a sight to see, but it will never happen.* "Sir, may I help you?" John's thoughts were interrupted by the agent and he was smiling, but the agent would never have guessed why.

A nine-year-old boy's hope for adventure is never ending. When little John walked the gangplank, he stopped and glanced up at the captain standing on the top deck. He waved, but the captain did not respond. That was a harbinger of things to come. The weather was just horrible. Early mornings were filled with fog and mist, requiring the captain to blow the whistle to inform smaller boats that the paddle wheeler was approaching. It rained so hard Vicksburg could hardly be seen as the boat passed. Most of the trip was spent inside the cabins or in the dining room.

Harriet tried to encourage little John to read some of his books. She made a game of the challenge, asking John to read the same books and discussing them with his son. That plan worked one time. She was a little more successful in getting the bored young Overton to write a story of his trip to share with his grandmother. The days dragged by while the bad weather continued. The

Overtons didn't even attempt to stand on the deck but looked through the rain-covered windows, as the boat passed Memphis.

"John," his father said, "I did check with the captain about visiting the wheelhouse."

"And what did he say?" Little John was hopeful.

"During bad weather like we are experiencing, regulations forbid any visitors. I'm very sorry."

"Thank you for checking. Maybe there will be another time."

"That's true. Maybe there will be many other times. Who knows, maybe someday you will be a boat captain on the Mississippi River."

The rain followed the Overtons all the way up the Mississippi, and they were able to make the turn into the Ohio and then the Cumberland without changing boats. That was a blessing and Harriet was happy to hear the news. Now she would not need to repack their trunks. The Overtons were just finishing dinner, when the captain came by their table and announced the weather was breaking and the sun was about to appear.

"I have a request of you, sir." He was nearly standing at attention. "I'm in need of an assistant in the wheelhouse who has experience at blowing the whistle. I was wondering whether you might know of anyone."

"Let me ponder your request. Harriet, do you know of anyone who might help the captain with the whistle?" Harriet saw a faint smile come to John's face, and she was aware of the game he was playing. They glanced at little John, squirming in his chair eager to make eye contact with his father.

"Father, I know someone with experience."

"And who would that be?"

"Me, of course! Don't you remember I blew the whistle on our way down the river?"

"Well, captain, I believe I have just the one for the job. My son, John, will be happy to help you."

"Very good. I'll send for him in a couple of hours when we are near Nashville." The captain excused himself and disappeared out the door.

"Thank you, Father."

"You are welcome. I'm always happy to recommend an experienced worker."

Later, as little John made his way to the wheelhouse, he saw Eli and Claiborne on the lower deck. Eli was pointing to things on the shoreline and talking a mile a minute. He was giving Claiborne an orientation to his new home.

Shortly after little John blew the whistle, people began to scurry on the deck. Workers on the dock were also busy preparing for the arrival of the paddle wheeler. Eli spotted Little Lewis standing next to the Overton carriage. *What a relief,* Eli thought, *Little Lewis be here to meets us and we is home at last.*

# 7. As Time Goes By

Eli and Claiborne struggled with the trunks and finally secured them on the carriage. There were still a couple of large boxes sitting on the ground. Eli was scratching his head, when John walked up.

"What's the problem, Eli?"

"Massa Overton, either da boxes got to stay or somebody got to stay." John walked around the carriage and back to Eli. By then, another carriage pulled up and Annie Maxwell, Harriet's oldest sister, was waving, "Welcome home, John, it's good to see you. Did you bring Harriet with you?"

John walked over and helped Annie to the ground. "Oh yes. She and little John will be off the boat soon. Little John has been in the wheelhouse with the captain. Harriet is waiting for them to come down."

"Annie, would it be possible to put these boxes on your carriage and take them to Travellers Rest?"

"That will be fine. The reason I came by today was to steal Harriet from you. I have a dress I want her to see while she's in town. Will that be all right with you?"

"That will work fine."

Hearing the conversation, Eli walked over and asked Edward to help load the boxes onto the Maxwell carriage. Harriet and little John had barely made it off the gangplank when she got a bear hug from Annie.

"Harriet, I am so happy to see you! I've had my fingers crossed that nothing would delay your return. I'm going to steal you away from your family for the rest of the day. I have a dress for my wedding. It's in a shop on the square. You can come with me, can't you?"

"Yes I can, but I must tell John my plans."

"I've already told him."

"That's well and good, but I still must tell John my plans!" Annie glanced down to the ground where Harriet's dress was in motion. *I wonder if her little foot is about to stomp.* Harriet was only a couple of months past her nineteenth birthday and had been married a little over a year. Her mother-in-law had challenged her a number of times to stay in control of her life. She was trying to heed the advice. "I'll just be a minute with John and then I'll join you at the carriage."

"Oh Harriet, I'm so excited you're home!"

Harriet walked over to John and he bent down, as was his custom, to hear what she had to say. The conversation was meant to be private and that's exactly what she made it. After a moment, John stood up and nodded his head. She and her servant walked over and got in the carriage with Annie. The Maxwell sisters were on their way to the dress shop.

John instructed Little Lewis to use the back entrance to the plantation. He wanted to check on the progress of the railroad project since he had been gone.

After they passed a long line of wagons stacked with crossties, the carriage came to a stop when it turned off Franklin Pike. John hopped down, looked all around, and pointed to the construction stakes. "Eli, do you see these stakes?"

"Ya, sir, Massa Overton."

"That's where the railroad tracks will be built. There will be two sets of tracks. One will go to Nashville; the other, to Alabama. The iron tracks will be set on these crossties." John did not know at the time how much of the project was finished. The tracks going south had already passed Travellers Rest and would soon be joined with the tracks coming north. "There will be a small building built around here someplace where train passengers can get on and off the train."

"Ya, sir." Eli sounded convincing, but John knew he did not understand the magnitude of the project. Little Lewis and Claiborne sat in the driver's seat and took in the sights. Back in the carriage, Eli barked, "Let's go to da house." He waited for a response. None came, but the carriage was headed in the direction of the house. "Eli, when we get to the law office, stop the carriage. I want to look at the work that's been done. You can take the carriage to the barn, and tell Claiborne to take care of the horse. Show him around the plantation and then find him a place to sleep in the barn. Little Lewis can go about his chores. Tell him to sleep in the barn with Claiborne, just for tonight."

"Ya, sir. I can do all dat."

John leaned toward Eli and in a very low voice said, "You have been very helpful on the trip." Eli was too pleased to respond other than to smile and nod his head. He hoped the other two slaves heard what Mr. Overton said, but he knew they didn't. He'd just have to tell them later. He carried out Mr. Overton's instructions, and after supper, he left Little Lewis in the barn with Claiborne.

When Little Lewis' head hit the pillow and the cover was pulled around him, he fell asleep. Sometime in the night Little Lewis, the forty-nine-year-old slave, passed into his eternal freedom. Early in the morning, Claiborne discovered the cold, stiff body of his fellow slave. He ran to the house. Not knowing which door to knock on, he started down the lower gallery and hit each door. The last door opened and there stood Mr. Overton in his nightclothes and bare feet.

"What do you think you're doing, Claiborne? This better be very important."

"Oh, Massa Overton, comes fast. Da slave done gone ta glory." Claiborne began to cry, wiping the tears with his sleeve.

"What are you saying? The slave in the barn, Little Lewis?"

"He be daid! He be plum daid!"

"Claiborne, you stay right here. Let me put on some clothes, and I'll go with you to see what's happened."

"He be daid. He be daid. He done gone ta glory."

A few minutes later John Overton stood over the cot, in the corner of the barn, where Little Lewis had taken his last breath. Morning light was breaking

in the window and pointed its rays near the body. "Claiborne, go outside, shut the barn door, and don't allow anyone to come in."

"Ya, sir." Claiborne had stopped crying.

John pulled up a stool and sat on it next to Little Lewis' body. His thoughts went back years to the times when he watched his father hand Little Lewis packages tied with strings. He would understand later that the packages contained messages, letters, and legal documents to be hand-delivered in the city or in Franklin. Little Lewis would be gone for long periods, but he always came back and went directly to the Judge, handing him new packages. *You have been a trusted Overton slave all your life. My father trusted you and I trusted you. You were always faithful. Now you are . . .* John's thoughts came to an abrupt end, when he heard loud voices at the barn door.

"No, ma'am, Miz Overton. Yous can't go in da barn. Massa Overton in his sorrow."

"Claiborne, step aside this instant and let me in."

"No, ma'am, Miz Overton. Yous can't . . ." The door opened and John stepped out. "Massa Overton, I tried . . ."

"Claiborne, you did exactly what I asked you to do."

"John, are you all right? What happened? Claiborne disobeyed me. He needs to be. . ."

John put his hand over Harriet's mouth, knowing what she was about to say. "Claiborne was following instructions. Little Lewis is dead. Apparently, he died in his sleep. It will be best if we go back to the house. I'll send for Eli; he will know what to do."

"You go on. I want to have a word with Claiborne."

"Harriet, do you think this is the best time?"

"Yes, I'll be there in a few minutes."

John walked back to the house thinking he would hear Harriet's anger directed at Claiborne, but he heard nothing. Claiborne watched Mr. Overton leave, and at the same time, glanced down at the little adult female standing in front of him. He did not know what to expect. He had witnessed the reaction of white owners when slaves disobeyed.

"I was wrong. You did exactly what Mr. Overton told you."

"Ya, ma'am." Claiborne wanted to smile but did not press his luck. He was trying to understand *I was wrong*. That was the first time in his life he ever heard those words from a white person.

"You did the right thing not allowing me to enter the barn. Mr. Overton did need his time for sorrow. Thank you, Claiborne, for protecting him."

"Ya, ma'am."

"The cabins are down behind the barn. Go down there, find Eli, and tell him what has happened. He will know what to do." Harriet slid her hand from under her shawl and placed it on Claiborne's arm. He smiled and to his surprise, Harriet smiled back.

Mary Overton arrived from her trip in the late afternoon the same day. She was surprised not to see any of the slaves at work on the plantation. She stared a moment at the law office under construction and saw on the lowland a long line of wagons filled with lumber. If she had been closer, she would have seen the railroad flatcar holding the last of the tracks.

"How was your trip?" John was walking toward the carriage to help her down.

"Once I got there it was fine. I don't believe I'll ever make that trip again. I told them in Knoxville, if one of my relatives dies, don't expect me to come. And I don't expect them to come when I pass. So how was your trip?"

"Going down was fine. Little John visited with our agent in Memphis. He did not like New Orleans at all. Coming back, we had rain from New Orleans all the way to the Ohio, but that helped us stay on the same boat all the way to Nashville."

"Where are the slaves? I didn't see any of them working on the property."

"They're in sorrow for Little Lewis. He passed during the night in his sleep. Claiborne woke us early this morning . . ."

"Who's Claiborne?"

"He's a slave I brought back from Pass Christian. He may well be the same type of slave Little Lewis was to Father."

"If he turns out to be half as trustworthy as Little Lewis, you made a wise decision. What arrangements have been made for the funeral?"

"Eli has been making them. He's been with the slaves most of the day. I'm expecting him any time to come to the house." Almost as soon as the words left his mouth, John saw Eli walking past the barn to the house. "Woods can bring your things and put them in your room. We can go into the large room and hear what Eli has to report. Woods, take Mrs. Overton's things to her room and then take the horse and carriage to the barn. There's a new slave by the name of Claiborne in the barn. He'll know what to do."

"Ya, sir, Massa Overton."

Mary looked around the room and thought, *It is so good to be home.* John and his mother were seated on the sofa as Eli began his report. As he stood there, his cupped hands were holding his hat behind his back. He was nearly in tears as he began, "I talked to da old darkies. Dey thinks Little Lewis needs be next to his father, Big Lewis, if dat be what ya thinks, Massa Overton."

John looked puzzled and turned his head toward his mother. "I have no earthly idea where that would be."

"I know. There's a level place just below my herb garden. That's where your father buried Big Lewis years ago. You and Eli were in New Orleans at the time. There should be a stone marker, but it may be hidden by the high grass."

"Eli, do you know the spot Mrs. Overton is talking about?"

"No, sir. But, if it be da same spot some of the old darkies told me 'bout, I's can . . ."

Harriet entered the room with a big smile on her face and outstretched arms headed in Mary's direction. John stood. She took his place on the sofa and embraced Mary. "I'm so happy to see you and know that you are safely home."

"Harriet, you don't know how good it feels to be home. We were talking to Eli about the arrangements for Little Lewis."

"I should not have barged in while you were talking. I can come back later." John moved over and sat in a side chair.

"No, it's perfectly fine for you to be here. Eli, you were saying." Eyes turned toward the slave. Before he could utter a sound, Harriet blurted out, "Eli, pull up a chair and sit down before you continue." Mary turned toward John to see the look of shock on his face. Harriet was not aware of their expressions, nor that she had done anything wrong or unusual. Eli continued talking and the funeral was planned for the next day at high noon.

John looked out the side window of the family dining room and discovered two slaves throwing dirt out of a rather deep hole. He could see the tops of their heads and the shovels as they piled up dirt. Eli had requested that he make some comments at the gravesite, and the slaves would handle the rest of the funeral service. He mulled the assignment over in his mind, as he had breakfast with his family. This was the first occasion they all had been together for a meal in well over a month.

"Father, what happened to Little Lewis?"

John appeared preoccupied with his thoughts and did not respond.

"He died in his sleep, son." Mary spoke in her son's place. "It was his time to die."

Harriet looked up from her plate and knew from little John's expression he did not understand what his grandmother meant. *I hope Mary doesn't tell him about death, using the Presbyterian predestination doctrine.* Harriet continued to ponder, *Why not just tell the boy Little Lewis' heart stopped beating and he died? Please Mary, don't give your grandson the routine church answer.*

Apparently, John did hear the question, but he delayed in answering, because he wanted to use the right words. "Son, your grandfather Overton told me one time Little Lewis had a bad heart, and I guess his heart just wore out. That happens to people when they get old."

"I was just wondering. Would you please pass me another piece of bread?"

Mary was ready to continue the discussion of death, but a fresh supply of bread seemed to be a more pressing subject. Little John finished his second helping and then excused himself from the table and left the room. Mary was not ready to drop the subject of death but took another approach. "John, have you decided what type of funeral service we will have today?"

"Eli said there would be singing, praying, and someone will say a few words about Little Lewis. They will also have some African traditions at the funeral."

"What will they be?" Harriet had listened carefully, but now was involved.

"The slaves will walk around the grave three times, they will throw a handful of dirt on the corpse when it's in the grave, and someone will throw some broken pieces of dishware into the grave."

"Will you be attending the service?" Mary's voice was almost challenging.

"Mother, I expect all of us to attend the service."

"Even your son?"

"Especially John. He needs to experience this so he will know how to handle situations like this in the future."

"Very well, then. Should we wear black?"

"Yes, that will be appropriate." Breakfast was completed with an air of victory, challenge, and admonishing, depending on what was heard.

John looked again at his pocket watch, as the Overtons walked toward the back of the house to an area beyond Mary's herb garden. The dirt was piled on the lower side of the grave. Little John tried to step in his father's footsteps but was having trouble. John escorted his mother and his wife over the uneven ground. When her footing was secure, Harriet released her arm from John's and motioned to little John to come stand by his father. The house blocked the view, but John was aware that a carriage had arrived. Soon, around the corner of the house, came the Maxwells—Jesse, Myra, Annie, and Mary. Jesse and John exchanged greetings; the ladies smiled and nodded their heads.

"John, my slaves heard about the death and wanted to come to the funeral."

"Thank you for allowing them to come, and I appreciate your family's presence."

"I've known Little Lewis for a lot of years. In fact, I knew his father and remember . . ." Mournful sounds interrupted Jesse, and all heads turned in the direction of the barn. Six slaves carried the white pine box Archer had hurriedly constructed. The words of the funeral hymn—

"Hark from de tomb a doleful soun' my ears hear a tender cry.
A livin' man come through the groun' whar we may shortly lie"

—filled the high noon silence. The pine box was gently lowered into the grave and disappeared into the deep hole. The slaves continued to come and sang,

"We're a-marching to the grave, We're a-marching to the grave, my Lord,
We're a-marching to the grave, To lay this body down."

As promised, there was more singing. Eli talked about the slaves coming from Africa, how hard they worked, and the freedom Little Lewis now enjoyed. John shifted his feet in such a way that Mary thought he didn't like what Eli was saying, but that was not the case. Eli concluded by saying, "Now, Massa Overton goin' ta say some words."

Releasing his mother's arm, John took three steps forward. Surprisingly, little John moved with his father and they stood together. *Did John tell his son,*

Harriet wondered, *to stand beside him? I am so proud of that young man.* John began deliberately, "According to our records, Little Lewis was born in 1802. He served my father, the Judge, for many years. Little Lewis was a trusted slave. I trusted him to return to this plantation from Memphis just a few weeks ago. He will be missed." John stepped back beside Harriet. Sounds of "Amen, Yes Jesus, and Praise da Lard" filled the air. Harriet took his hand and squeezed it, indicating her approval.

The slaves, the older to the younger, lined up and began passing by the large pile of dirt by the grave. Each took a handful of dirt and dropped it in the grave until it was mostly filled. Each slave made three circles around the grave. When Cynthia passed by the grave the last time, she held in her hand a twisted piece of cloth. When she unwrapped the cloth, those around her watched as she dropped broken pieces of earthenware the length of the grave. The slaves watched with interest as Eli placed a small headstone on the grave. On the stone, he had scratched the letters LL FAL. They smiled and began to hum as they headed back to their cabins.

The Overtons and Maxwells stayed in place until the last slave was out of sight beyond the barn. Harriet broke the silence as she announced, "Let's go to the parlor and have tea together. Annie and I will go to the kitchen and prepare the tea." Harriet had not spent much time in the kitchen, but she was able, with Annie's help, to get the tea ready. As they searched for it, they discovered bread left over from breakfast. To the bread tray, they added some fruit jelly and a medium-sized wedge of cheese. By the time they reached the large room, Mary and Myra had placed teacups, saucers, and spoons on the pier table. Mary had retrieved a basket of fruit from the breakfast room. She was surprised but pleased at how resourceful Harriet and Annie had been in the kitchen. "It seems the house servants have gone to the wake."

"Mother, I believe the wake was last evening. Today the slaves are gathering to celebrate Little Lewis' freedom."

"I think it would be best to get the slaves back to work as soon as possible. Their thoughts of freedom may cause them to rise up. We don't want a slave revolt here like they had in Virginia and South Carolina."

"I agree," Harriet offered, "but today we must allow them to grieve in their own ways. Now to another subject. Annie, what do you hear from Thomas?"

Mary Maxwell helped herself to some of the bread and jelly. *The only subject ever discussed any more is weddings. First, it was Harriet's. Now, it's Annie's wedding plans.* Mary Overton noted that all the attention was turned to Annie except for her sister, Mary. Her back was turned on the conversation and her thoughts were elsewhere.

"Thomas will be here sometime during the first week of August." Annie always spoke with flair. "When we return to Texas, his new assignment will be somewhere in the southwest. His superiors have given him a mapping assignment as he makes the round trip. So, we will need to make a steady return and not a quick one."

Mary Overton took a sip of tea and asked, "Have you set a date for your wedding?"

"Yes, ma'am. We plan to be wed on August 19."

"What day of the week is that?"

"That will be on a Tuesday."

"Where will the ceremony be conducted?"

"Father and Myra want me to have it at Maxwell Hall."

Jesse stood and looked at his pocket watch. "Ladies, we must be going. Thank you, Mrs. Overton, for the refreshments."

"You can thank your daughters for finding the food."

"John," Jesse pointed to the property outside the window, "how is the railroad project progressing?"

"I've not seen any reports since we've been back, but it looks like progress is being made. I noticed a couple of wagons filled with supplies parked down on the Pike. I'll let you know when I see the reports."

"I noticed coming in this morning that you are moving your father's law office."

"Yes, looks like there may be another several weeks of work before it's completed."

"John, sorry about Little Lewis. I know you placed a high value on him."

"He was a good slave. I brought a new slave back with me from Mississippi. He's pretty skilled with animals. If you need any extra help with your animals, he's available to you."

"Thanks, I'll keep that in mind." Jesse gave Harriet a hug and patted her back. She hugged him and kissed his cheek. He escorted the Maxwell ladies to the carriage. "John, I'm going to drive down and get my slaves."

"You can leave them here if you want. I can always use the extra help. Thanks for coming."

"Harriet," Mary questioned, "do you think Annie would consider having her wedding here?"

"Mary, that is a wonderful idea. You are so kind to think of it. I'll ask Annie the next time we talk."

John was sorting through the mail when Mary and Harriet entered the house. "Harriet, here is mail addressed to you from the Adelphi Theater."

"What on earth could this be?" She tore the envelope open and out dropped four tickets. "Oh my, my!" There was a sound of excitement in her voice. "I had forgotten all about this."

"What is it?" Mary was intrigued.

"Here are four tickets to hear Jenny Lind in concert at the Adelphi."

"Do you mean Jenny Lind, the Swedish Nightingale?"

"One and the same. Our tickets are for the evening of the 29th."

"I understood the tickets were being auctioned off to the highest bidder."

"Yes, they are, but I made a request at the Adelphi before going to Mississippi, using the Overton name, and here are the tickets." Mary smiled at

her son and felt both were thinking the same thing: *This girl is amazing. Her body may be small, but her brain is extra large. When she wants something, she goes after it. It is hard to believe one so young could be so wise. Thank goodness, she is a part of the Overton family.* "I thought the concert would be a good family outing for us."

"Do you think little John will have any interest in that kind of music?" John continued to shuffle the mail without looking up.

"We can ask him after the concert." Mary smiled at Harriet's response. She was about to say the same thing.

The routine of plantation chores brought life at Travellers Rest back to proper focus. Harriet continued to take on more responsibilities, allowing Mary to enjoy her days. Mary was fond of reminiscing and found Harriet to be a good listener. One spring afternoon while they walked in the garden on the west side of the house, Mary recounted some of her personal history. "The day I arrived on this property in 1820, I was scared to death."

"Mary, I can't envision you ever being scared of anything."

"After Francis' death, I went back to Knoxville to live and rear my five children. I was only thirty-five years old. Francis' estate supported us but emotionally I was having problems. Then Judge Overton came into my life. My brother, Hugh, was more excited about my marriage to the Judge than I was. I guess, now that I look back on it, he was eager to be free of the children and me. You know the Judge and I had a very, very short engagement."

"Yes, I've heard the story. John still laughs when he tells it."

"I guess I saw a future for my children when I married the Judge. Anyway, the day I arrived here, the house servants and a couple of the other slaves ran and stood over there in front of the house. The Judge bought a wagon in Knoxville to transport me, three of my children, and our worldly belongings. He rode his horse. When I got down off the wagon, the slaves looked at me like I was a freak."

"You mean the way strangers look at John when they see him for the first time? Then they look at me and he really looks tall."

"Yes, I suppose. I could not help being tall. For the first two months, when I was outside with the children, the slaves would make a point of looking at me. I could hear their snickers."

"Did their reaction make you scared?"

"No, it was just annoying at first, but after a while they got used to seeing me and I guess it didn't matter. But you know, every new slave the Judge bought after I arrived had the same reaction to my height. But what really scared me was having to be a wife again. It was a strange feeling having another man in my bed. I was used to Francis. With the Judge, it was like starting all over again. He was fifty-four years old when we married. However, I didn't stay scared long. I was pregnant with John within a few months."

"How do you feel when you're pregnant?"

"When that day comes for you, you will be able to answer your own question." Mary grasped Harriet's hand. "But know this, Harriet, I will be here to help you." Harriet squeezed Mary's hand but didn't say a word. They each knew their relationship had reached a new level of trust and respect.

Routine also became part of John's life. He made daily trips to the law office to check on the reconstruction. He was pleased Archer thought the project would be completed in time to get his work crew back into the fields. They needed to be there even if it meant slowing down on the law office work. The railroad project was moving along at good speed, according to the reports John read. He rode over to see his brother-in-law, John Lea, to get legal advice related to his property and the railroad. Elizabeth, his sister, greeted him in the hallway. "Brother, so good to see you. How are Mother and Harriet?"

"They are both doing fine. Is John in?"

"He is, but I want more of an answer than 'doing fine.'"

"Mother has lots of stories from her Knoxville visit. Some of them went down to visit the property where the White fort used to be. They didn't find much, but it gave them something to talk about. She brought back a portrait of Uncle Hugh. We're trying to find the best place for it. Harriet continues to tutor little John, and she's helping Annie make plans for her wedding. Father's law office is about finished." John was looking beyond his sister, hoping to spot the man of the house.

"Well, that little bit of information didn't hurt you, did it? You are getting to be more like Father each day."

"Thank you, Elizabeth. I take that as a compliment. Now, about your husband."

"Oh, you! He's back in his office. May I bring you some hot tea?"

"Can I just say yes, or do I have to go into detail?"

"Since your tongue is so sharp, I'm just going to make you give me a hug." John was nearly a foot taller than Elizabeth and hugging him meant her face would be buried in his chest. It was worth the effort. They had always been close as siblings and since their sister had passed, they were even closer.

John Lea opened his office door and discovered the brother-sister embrace. "What is this? I stay in my office fifteen minutes and a strange man comes into my home and hugs my wife." Laughter from the three filled the hallway and echoed up the staircase. "To what do I owe this pleasure?"

"I need your legal opinion on a railroad matter."

"Come into my office and let's talk." Elizabeth was leaving the hallway when she remembered, "Husband dearest, would you like a cup of hot tea?"

"Yes, wife dearest, that will be fine."

John Overton smiled and shook his head, "Do you all talk that way all the time?"

"Only when we have guests in the house. Now, about your legal concern."

"I would like to have a rail spur on my property off the main line. How do I go about getting it done?"

"Let me review the contract. That will tell me whether any other property owner has requested a spur. I need to be in the city in the next couple of days so I can inquire about that at the railroad office. John, may I use your name?"

"By all means."

"May I ask why you want a spur on your property?"

"If I can get the spur out this way, it can be used by both of us to get our cotton and tobacco to market. We can use a flat car and save time."

"Are the Thompsons interested in a spur to their property?"

"I really have no idea. You are the first one I've talked to about this."

"On another matter of family interest … do you have another few minutes?"

Elizabeth broke into the conversation, "Gentlemen, your tea." She directed the servant to place the tray on the small table near the window. "That will be all. Gentlemen, enjoy your tea. I have some other things to do."

"Elizabeth, you are welcome to stay. In fact, I would like your input."

"And what is it that you two cannot solve?"

John located a letter on his desk and slid the notepaper from its envelope. "This is a letter from Robert Brinkley. He has some interesting news to share and then a related question. He writes, 'I'm considering a second marriage.'" Elizabeth looked in John's direction, "Brother, were you aware of this announcement?"

"Yes, Robert shared this with me while we visited with him on our trip to Mississippi."

"And you've not said a word?"

"Robert asked that I wait until he made the announcement. Harriet is not even aware of his plans."

"What else did he say?"

"Maybe there's more in the letter." John turned back to the letter and continued, "Robert says, 'If marriage is in my future, I will sell my property in Jackson and move to Memphis. I believe Hugh and Annie would enjoy living in a larger city.'"

"Is there any mention of a lady's name? Do you know her name or where she's from?"

"Robert did mention a name, but I have forgotten it. The lady currently lives in Alabama. However, a more pressing concern for Robert is our family's reaction to his possible marriage."

"And what did you advise him?" Elizabeth's tone suggested she was not pleased with her brother's lack of total involvement in this family matter. "Have you talked to Mother about this?"

"No, as I said before, because Robert requested that I not say anything until he made an announcement. Apparently, he has made the first part of his announcement. I guess the second part will be the name of the lady. I'm trying to keep my commitment to him, and I may have already said too much."

"What do you mean 'too much'? To this point, all you have said is, 'the lady currently lives in Alabama.' I guess if I am to know the facts, I'll need to find out for myself."

"Dearest wife," John smiled at his guest, "this letter is addressed to me, and that indicates Robert may not be ready to share his information with you."

"Dearest husband," Elizabeth was standing rigid with her hands on her hips, "I fear you have learned way too much from my brother about keeping confidences. In fact, if I didn't know better, I'd guess you had Overton blood in your body." She approached her brother, motioning him to lower his head. She kissed him on the cheek. "Please do return, when you have more family news you are willing to share. Give my regards to Mother and Harriet. Tell them I will see them within the week." Elizabeth exited the room to the laughter of husband and brother. They heard her utter "I will find out about ..." The last part of her comment was too faint to hear, but both men knew what she had said.

By early May, consistently warm days had reached Middle Tennessee. It was nice to be outside, and little John took full advantage of it. He was free to roam and explore the plantation but knew he must always stay within voice range of the house. One afternoon he found the spring down below the house. It bubbled up and flowed toward the new railroad construction. He laughed as he cupped his hands and allowed the cool water to gather in them, run down his arms, and off his elbows. The temptation to jump in the spring water was overpowering. Off came his shoes and socks; he rolled up his pant legs and jumped in the water. He misjudged the depth of the spring, and by the time he felt his feet hit something solid, he was standing chest high in water. Fortunately, he did not panic and was able to climb out by grabbing hold of a large rock near the water. Unfortunately, he was not only wet, but he had managed to get mud all over his pants and the lower half of his shirt. He grabbed his shoes and socks and painfully walked back to the house. His plan was to sneak into the house and change clothes and no one would be any wiser. However, this was not John's lucky day. In his path to get dry clothes was Harriet and his grandmother sitting on the gallery. He spotted them as he turned the corner of the house.

Harriet saw him out of the corner of her eye. She rose from her chair and walked to the banister. "John, what has happened to you? You are all muddy. Come over here and let me see you. Where have you been?" From her vantage point, Mary could see John in his wet, muddy clothes and she knew exactly what had happened to him. *He found the spring down below the house just as his father did when he was eight years old. Funny how history repeats itself.*

"Harriet, I was standing on this big rock and all of a sudden an Indian hand got a hold of my leg and pulled me into the water. There was nothing I could do. When the Indian let go, I was able to jump out of the water, and here I am."

Harriet was biting her lower lip to keep from laughing aloud. Mary was able to control her snickering by putting the paper she was reading in front of

her face. "Hand me your shoes and socks. I'll keep them here while you go inside and put on some clean, dry clothes. You don't want your father to see you all wet and muddy."

"Harriet, did you notice how dry his shoes and socks are?"

"He said he was pulled into the water. Wouldn't that mean his . . .?"

"Exactly! That boy is recalling the Indian stories he's heard to cover a lie."

"This might be a good opportunity to teach him a lesson about telling the truth."

"I agree. This evening at dinner might be an appropriate time for the lesson."

Later that day the Overtons were together for dinner. John was eager to tell the family about the new railroad engine he had inspected in Nashville that morning. "The engine is so powerful it can pull a dozen fully-loaded flat cars. It also can be used to pull passengers cars. It's the type of engine we'll be using on our railroad line. I want to take little John to see the engine tomorrow."

"That is very exciting. I'm sure little John will enjoy the experience. Right, John?" Little John was trying to be as quiet as possible, hoping his afternoon adventure would be forgotten. "By the way," Harriet was about to begin her lesson on truth, "your son had an adventure also with an engine. . . I mean Indian." Mary could not help but smile when she looked down the table at her grandson. "John, tell your father what exciting thing happened to you today." Both ladies continued with their meal and waited.

"Uh . . . uh . . . Father, I'd like to hear more about your day in Nashville and the engine."

"I'm finished. Now it's your turn. What happened today?"

"Well, you remember the Indians that used to live here a long time ago? They are still here on the property."

"Really! And how do you know that?"

"I was standing on a big rock down next to the spring and all of a sudden this Indian hand got a hold of my leg and pulled me into the water. I had to fight hard, but I was able to get out and run away."

"How did you know it was an Indian?"

"The arm had a bracelet made out of those tiny beads."

"And so you got pulled into the water, but you escaped? That is a remarkable story. I'm very happy for you. I bet you didn't know that the very same thing happened to me when I was a lad. I want to ask you what my father asked me."

"What is that, Father?" Little John did not give away his inner feelings by smiling but hoped this day would soon end. Harriet was afraid her ploy was lost; Mary knew exactly what was coming. "Take your shoes and socks off and bring them to me." Little John struggled but complied. "Are these the shoes and socks you were wearing when the Indian hand grabbed you and pulled you into the water?"

"Yes, sir."

"Then tell me, son, why are they dry and have no mud on them?" The boy stood with no response, staring hard at the evidence before him. "Is there anything you would like to add or subtract from your adventure today?"

Little John hoped time would be his friend and run out on this conversation, but it didn't. After mulling the words over in his mind he said, "Well . . . uh . . . I really did not see an Indian hand. I took my shoes and socks off and jumped into the spring. It was deeper than I thought."

"So you lied to cover up what you did."

"Yes, sir. I'm very sorry that I lied."

"John, you know that telling lies has consequences."

"Does that mean punishment?"

"Yes, and this is the punishment. What is your favorite dessert?"

"Brown sugar cookies."

"All right, for the next month, there will be no brown sugar cookies in the house. Your punishment will be shared by all of us who love you."

Little John's eyes became moist and then the tears came. "Father, is it fair that everyone in the house share my punishment?"

"No, but it's a reminder to you that telling lies affects everyone around you. You have not only harmed yourself: you have brought harm to all of us. There's one more part of your punishment. I want you to go to the kitchen and tell Cynthia that she is not to bake brown sugar cookies for one month. And when she asks you why, you tell her the truth." When the door closed behind little John, Harriet spoke, "John, I think . . ." John raised his hand in her direction and stopped her in midsentence. He did the same to his mother, but to no avail.

"Son, I'm proud of you and how you handled the situation. Little John will have a lesson that will last him a lifetime." John acknowledged the statements with a nod. Silence captured the room, but did not stop the thoughts or the memories.

# 8. Time Draws Near

Harriet and Annie left early enough for downtown Nashville to shop, have a late lunch, and meet the boat that brought Thomas Claiborne and his military friend, William Elliot. Their sister, Mary, decided not to join them for fear William would think she was too forward. They had become friends on the return trip from New Orleans which the sisters had made a few years back. It was the same trip during which Annie had fallen madly in love with Thomas. Now, after years of maturing, marriage would unite them later in the month. Mary had received only one letter from William after she returned. She was never willing to share the contents, unlike Annie, who wanted the world to know the details of her relationship with Thomas. Somehow she felt vindicated, knowing she would soon be married and Mary would not.

Edward dropped the ladies off near the square and was told, "Edward, keep us in sight. We will be shopping and then have lunch. If, by any chance, you hear the steamboat whistle, come and get us. I do not want to be a second late for Thomas' arrival." The old slave would be happy when this wedding was over. Annie worried him to death about every detail.

"Ya ma'am, Miz Annie."

"Harriet, let's look in the dress shop first. I need a nice dress to take with me for entertaining. I'm not sure what will be available when I get to Texas. I may need to take some material with me and learn to sew."

"If you are serious, we need to look at the Howe sewing machines in the shop on the next block."

"That will be fine, but first let's look at the dress fashions." Once inside, the sisters marveled at the displays.

The owner, in her mid-fifties, was working on a window display. "Good morning ladies. May I show you anything in particular? Allow me to finish this display and I'll be right with you."

Harriet responded, "Thank you so much; we'll just look around."

Annie spotted the basque hanging by itself. "Harriet, have you ever in your life seen anything like this?"

"Can't you just see me in that short skirt? The bodice might do, but not that skirt. As short as I am, it would make me look even shorter. John would have the biggest laugh if I showed up with that." Harriet moved beyond the dresses to the bolts of material, leaving Annie with the basque. She spotted a table stacked with colorful muslins. The sign on the table indicated the material was from India.

"Are you shopping for day dress material or better dresses for entertaining?" The shop owner posed the question, hoping to be of help.

Annie arrived in time to answer. "I'll be moving next month to Texas with my military husband. I need a dress to use for entertaining and some day dresses. I'm not certain there will be dress shops near the fort."

"Allow me to suggest a couple of options. First, I could take your measurements, you could select the proper material, and I could enlist a local seamstress to make your dresses. I could then have them delivered to you in Texas. Or you could look at the ones already made in the shop, and I could size them for you and have them ready before you leave the city."

"What do you think, Harriet?" Harriet was the most fashion conscious of the three sisters, and Annie trusted her judgment.

"I like either option. Do you have material suitable for an entertainment gown?" Annie watched and listened as Harriet laid out the plan. She thought, *I was thinking I needed a dress. Harriet knows I need a gown. She is so mature. Maybe marriage does that for you. I sure hope so!*

"Yes, ma'am. I have some velvet and silk in the back room I save for special occasions."

"We would like to see the material and any suggestions you have for patterns." Annie sensed control of the situation slipping from her hands but landing in the capable hands of her younger sister. "Annie, while you are in Texas I'll send you a subscription to *Godey's Lady's Book* or other magazines that come to the house. If you see a dress pattern you like, I can bring it here and have it made."

"Is that possible?"

"Annie, you know when we put our two heads together, anything is possible." With that thought in mind, Annie felt confident enough to select three patterns for day dresses. She also chose a sky blue silk and a pattern for her fancy dress. The velvet material was beautiful, but she knew it would never be cool enough in Texas to have such a dress.

The velvet did catch Harriet's eye. She held it up and spent several minutes running her hand over the material. "Annie, I like the black velvet. How do you think I would look in a fancy velvet gown?" The tables were turned. Now Harriet needed advice from Annie, and she was ready. "You will look wonderful in that material. I'm just sorry I won't be here to see you in it."

Harriet had heard all she needed. She was measured and selected a pattern with a full skirt, tipped sleeves, and a high neckline. The shopowner suggested a full bow for the back of the dress; Harriet agreed. "I'll have a seamstress begin immediately on the dresses and send word to you about a fitting time."

"I'd suggest," offered Harriet, "your seamstress proceed first with my sister's dresses."

"Yes, that will work fine, ma'am. Now, how can I make contact with you for the fittings?"

Annie spoke first, "You may contact me at Maxwell Hall. Address the note to Annie Maxwell in care of Mr. Jesse Maxwell."

"And, ma'am," looking at Harriet, "where may I contact you?"

"Send a note to me at Travellers Rest in care of Harriet."

"Is Mrs. John Lea your sister? She is in here all the time. I send her a note when a new shipment is expected. She is one of my best customers."

"Elizabeth Overton Lea is my sister-in-law. I'm married to her brother, John."

"I beg your pardon, Mrs. Overton. I assumed that . . . ."

". . . that I was an Overton daughter? You are not the first to make that assumption. So we will expect to hear from you shortly?"

"Oh yes, ma'am, Mrs. Overton, and I do apologize for the assumption. I hope I have not offended you."

"No, you have not offended me; however, if you are to be my future fashion shop, you might want to call me Harriet."

"Yes, ma'am, Mrs. Over . . . I mean Harriet. Thank you ever so much for gracing my shop." Harriet's smile was so big it covered her entire face as she turned to her sister. "Annie, where would you like to have lunch?"

The timing could not have been more perfect. Harriet and Annie enjoyed lunch and were seated back in the carriage headed for Front Street, when they heard the steamboat whistle. Edward turned his head to the ladies, "I heared da whistle. Boat a'comin', Miz Annie."

"Thank you, Edward. Find a good spot for us to view the passengers as they come down the gangplank."

"Ya, ma'am."

Annie was anxious. She searched each face on the deck, but it was too far away to pick out Thomas. Thoughts flooded her mind. *We have not seen each other for years. How will he look? How will I look to him? Will there still be the attraction we had years ago? Oh, God, let him love me as much as I love him.*

In the middle of the crowd of people on the gangplank appeared two men dressed in military uniforms. Their hats were so low on their faces it was difficult to tell their ages from that distance. Then, toward the end of the line of people, another set of soldiers appeared. These men were acting differently. They had removed their hats and had them waving high above their heads. One was shouting, "Annie Maxwell, I've come all the way from Texas to marry you!" Heads turned in the boat dock area to hear the young soldier continue, "Annie, are you here?"

Harriet smiled at her sister, "You better go get him before another Annie Maxwell answers his question."

Annie didn't answer; she was out of the carriage and walking quickly toward the gangplank. It was apparent to many in the crowd that the young lady pushing her way through had to be Annie Maxwell. Spontaneous cheers and clapping followed Annie as she reached the end of the gangplank. "Oh Thomas, I'm here . . . I'm here!" As Annie and Thomas embraced, the cheers became louder, and every eye at the dock area was focused on the young couple. "Welcome to Nashville, Thomas! I am so thankful you are here and safe."

"Annie, you have not changed one bit since the last time I saw you. You are so beautiful. You remember William?"

"Yes. William, welcome to Nashville." Annie tried to break away from Thomas, but he was not letting go. So William stood there, with his hat in his hands, unhugged, but welcomed. Traveling bags were collected and the happy trio maneuvered through the crowd and found the carriage. Harriet was standing and totally taken by surprise as they approached. Annie had not said anything about Thomas having a beard. "You remember my sister, Harriet? She is now Mrs. John Overton."

"I recall a young lady from the boat from years ago, but you could not be the same." Thomas was much more outgoing than William. Both gentlemen removed their hats and, in turn, took hold of Harriet's extended hand.

She nodded in response. "I am the same. A little older and I hope a little wiser." She held on to William's hand. "I know Thomas will be quite busy, but I hope you can find some activities in our fair city to occupy your time. I can make a riding horse available to you, or if you should need a carriage, that can also be provided." There was cunning in her offers. She was thinking of her sister, Mary. *Perhaps another romance will develop between William and Mary. I must be careful not to press the issue, but it would be nice for Mary to find a mate. I must talk to Annie about this. She will have a feeling about Mary's interest.*

Harriet and Annie were proud of Nashville and were eager for their visitors to see some of the buildings and other features as they traveled south. "Edward, we want to point out some things to the gentlemen as we go home," Annie directed. "Let's go slow up Spring Street to Spruce Street, and then you can speed up."

"Ya, ma'am, Miz Annie."

Annie began the tour of Nashville, "The buildings behind us are the Brennan Foundry. They are currently making the ironwork for our new State Capitol building."

When the carriage turned onto Spring Street, Harriet took over the tour. "Here on the left is the Ewing family wholesale grocer. They handle food items from various sources. We provide them with some of our farm produce."

"By we," Annie interrupted, "she means Overton."

"As I was saying," Harriet laughed, "as do other farmers in the surrounding area. Next is the First Presbyterian Church. The building was designed and built by William Strickland." Thomas diverted his attention from Annie for a moment. "The church looks fairly new." With one quick move, Thomas' face was pulled back to look at Annie, "Yes, my little sister Harriet and I remember it being opened in '51."

"Older sister, mind your manners." It was apparent to Harriet that Thomas' attention was not on the tour. So she focused her attention on William. "William, on the right is Mr. Stevenson's stone yard. He has made gravestones there for a number of years." Harriet knew what was coming next. Annie never missed an opportunity.

"And William, people are just dying to see Mr. Stevenson." She laughed out so loudly that Edward turned around and smiled. He also knew her routine. The sisters got the giggles and they laughed until tears came to their eyes.

"Annie, you must stop immediately, or William will get the wrong impression of us."

"What about Thomas?"

"I hope and pray Thomas knows what he is getting into."

"Oh, I do, Harriet, and I love hearing you two laugh. It makes me feel good."

"We just passed the St. Cloud Hotel, and coming up on the left is the McKendree Methodist Church." The McKendree name got William's attention.

"Isn't that the church where a group met to talk about secession?"

"Not just secession, William," Harriet's face became motionless, "but Southern secession. It was back in 1850."

All laughter ended as the carriage moved up the street. As it turned onto Spruce Street, Harriet pointed to the right, "On the hill over there is our new State Capitol under construction. It was also designed by William Strickland. And the large building way over there is probably the most famous of all our buildings in Nashville. That's the Nashville Female Academy where the faculty attempted to make ladies of the three Maxwell sisters."

"And they did a mighty fine job," William acknowledged.

As they approached Broad Street, Harriet directed their attention to the left and pointed to the land set aside to construct Nashville's first public school. When the carriage crossed Demombrane Street, Edward snapped his whip and the horses began a quicker pace, stirring up dust as they entered Franklin Pike. Along the way, construction wagons were parked on the left side of the road. Some of the wagons provided transportation for workers; others were laden with supplies.

"Harriet, I've been noticing lots of wagons on this road," William stated, breaking the silence of almost a mile.

"I believe there is some sort of project in the area."

"Now Harriet, don't be modest. Tell William what's being constructed."

"There's a new railroad being put in to link Nashville with northern Alabama."

"Harriet, I declare, you truly have become an Overton. You share little or no information at all. Father says, 'Getting information out of an Overton is like pulling teeth.' Harriet's husband, John, is one of the driving forces in getting this railroad line. It will run on his property for several miles. And when I say 'his property,' I mean their property."

"Annie, I'm sure the gentlemen have little interest in a railroad being constructed in Nashville. Tell me something interesting about Texas."

"Texas is big, very big. The Texas we've seen," Thomas' voice had excitement in it, "is very flat and has few trees. The sky is so blue and wide

it's really hard to describe. Some days there are no clouds, and the sky looks like it goes on forever. There are more trees on this road than I've seen in all of Texas."

William was quick to add, "You need to like beef. It is the main meat in Texas. I've longed for the taste of pork sausage ever since I've been out there."

"And don't forget beans," Thomas forced a little laugh. "The army serves beans with every meal. For a four-month period, we had a Mexican cook at the fort, and we had beans served every way imaginable. In Texas, they have what they call a tortilla. It's a thin, flat piece of dough about the size of a small dinner plate. The cook puts it in a hot skillet and fries it on both sides. Then it's piled with small pieces of cooked beef, cooked beans, and onions. The whole thing is wrapped like a cigar, and you eat it with your hands. Sometimes the tortilla is dipped in a tomato and hot pepper sauce. The sauce is so hot it will bring tears to your eyes."

Somehow, Annie heard her future in what was being shared. "And Thomas, do you expect me to cook like that?"

"Annie, I will eat whatever you cook."

Harriet could not allow that comment to pass without a challenge. "Thomas, you have never eaten any food Annie's prepared. In fact, you don't know whether Annie can cook."

Annie glared at Harriet and then laughed. "You're a big one to talk. What can you cook?"

"I do not know anything about cooking, but I just thought Thomas needs to be prepared."

"I will take care of Thomas and he will be fine. I may just hire one of those Mexican people to cook for us."

"And you're going to eat tor-til-las with your hands? Annie Maxwell Claiborne eating with her hands. That would be sight I'd pay to see." Harriet had to laugh. Annie knew her sister was right and joined in the laughter. Thomas and William sat back and heard the sisterly interchange but did not understand the full impact.

Edward guided the horses up the road leading to Travellers Rest and stopped the carriage at the back steps. William placed his hat on the seat as he lowered himself to the ground. Getting out of a carriage was always a challenge for Harriet because of her size. William was very skillful in helping her out safely to the ground.

"Thank you, William, and once again, welcome to Nashville. Thomas, you will need to spend some time with Father and learn more about Annie's cooking skills."

"Harriet, will you stop!" Annie knew Harriet was joking and she treasured the moment. *These may be our last few days together for a long time, or maybe forever.* The sisters could hear each other's laughter as Edward turned the carriage and headed for Maxwell Hall.

August 19 was the target date. Every activity seemed to revolve around that date. Annie had decided on an afternoon ceremony. The wedding would be small; only family and maybe some neighbors who had known Annie since she was a child would attend. Although Harriet had offered the large room at Travellers Rest, Annie wanted to be married at the Hall. Jesse was pleased with her choice. He had thought all along that the parlor would be large enough after the furniture was removed. Myra and Mary offered to be in charge of the reception after the ceremony; Annie accepted. The pastor of the First Presbyterian Church would perform the ceremony. All the details were in place and everyone was pleased.

After Annie received a note from the dressmaker, she and Harriet went to Nashville for their fittings. They were surprised how quickly the dresses were ready and with a few minor adjustments, Annie would be able to take them with her. Harriet's request to complete Annie's order first was honored, and she did not need fitting. While Annie was being fitted, Harriet had Eli drive her to the next block and stop at the shop advertising the sewing machines. She placed an order for the very best machine the shop had to offer. "Be sure," Harriet instructed, "to include all the needed attachments. Please have the machine packed securely for an overland trip and deliver it to Travellers Rest, south of Nashville."

"And how would you like to pay for the machine, ma'am?"

"Please send the statement to Travellers Rest in care of Mr. John Overton."

"And are you related to Mr. Overton?" The sound of her booted foot stomping the wooden floor caught the shopowner off guard. The look on her face emphasized that he had challenged the wrong person. "Sir, I may be unusually short and not yet twenty years old, but I'll have you understand that I am married to Mr. John Overton of Travellers Rest."

"Ma'am, I was only . . ."

"My good sir! I can appreciate the fact that you were protecting your business. I can assure you payment will be made properly when the machine is delivered."

"I will have the machine delivered tomorrow without fail. Mrs. Overton, I appreciate your business."

"Good day, sir." Eli had watched and heard the entire encounter through the open front door. When Harriet walked out the door, there was a wide smile on her face. "Well, Eli, how did I do?"

"You is becoming an Overton. Ya, ma'am, you sho is." *How interesting,* Harriet thought as she rode to pick up Annie, *John used the same expression soon after we were married. You need to become an Overton. When you need something, use the Overton name. When I use the Overton name, people are surprised. I guess it will be that way until Nashville discovers who I am. Anyway, I'm glad John and I agreed that I would get a sewing machine as a wedding gift for Annie and Thomas. I hope they are surprised.* Annie was

waiting by the front door of the shop; Eli stopped and helped her aboard the carriage. "Thank you, Harriet."

"For what?

"You know for what. The dresses you paid for, of course."

"I hope you enjoy them as much as I enjoyed . . ." Harriet stopped short in saying she had paid for the dresses. She was learning, with some struggle, not to allow the Overton money and position to change her nature.

"I will enjoy them and think of you each time I wear one of them." Annie began to cry. She did not realize the emotional strain the upcoming wedding was having on her. It hit her all of a sudden she would be leaving in a few days, and her family would not be coming with her. She would be leaving and might never return to Nashville. She moved over beside Harriet and the sisters embraced. Annie whispered, "I'm nervous about my wedding night. I don't want to disappoint Thomas. You are the only one I've talked to about my fear."

"Annie, don't be afraid. Your part is easy. Thomas has the difficult part."

"Difficult?"

"You do remember how all this works? You do remember the talks we had at the Academy about . . ."

"Well yes, silly. I remember the 'talks'."

"Thomas will find pleasure, but he will be concerned that you also find pleasure. That's the difficult part for him."

"Did you find pleasure on your wedding night?"

"I don't remember. I was too nervous and afraid." Harriet cupped her hand over her mouth to stifle a laugh. "Anyway, finding pleasure with your husband is a subject not even sisters need talk about. Annie, if you will allow nature to take its course, everything will be fine. Can we talk about another subject?"

"Yes, if we must."

"On Sunday, the tenth, I'd like to have a luncheon for you and Thomas at my home for the Maxwells, Overtons, and William. Would one o'clock be a good time? Mary Overton was a little dismayed that you chose not to use the large room for your wedding ceremony. The dinner will help ease her feelings."

"I hope I did not offend her. She has always been so kind to our family."

"No, she just wanted to share what she has. She is a very giving person."

"And how is your relationship with her?"

"Little by little she is giving up control. She is really a brilliant woman. You know she ran Travellers Rest after the Judge's death until John was old enough to take over. He still relies on her judgment. But even then she does not offer suggestions unless she is asked. She knows every slave by name and their market worth. She knows every inch of the plantation. She has been very involved in the Memphis property holdings. Nothing gets by her. Yet she has been willing to mentor me in all phases of plantation life. I've made some big

blunders in the last year, but she laughs and tells me I can't learn unless I'm willing to make mistakes."

"Blunders . . .?"

"Just a few days ago we were in the large room with Eli making funeral arrangements for Little Lewis. He was standing up and I told him to sit down. I think John and his mother were shocked at what I did. Later that day, Mary told me I had made a mistake in relating to Eli. She reminded me, in no uncertain terms, never to get on a personal level with a slave. "The day may come," she said, "when you need to sell a slave. If you are on a personal level, it will be hard for you to make the decision to sell them.""

"I can see Mary's point."

"Yes, I do, too, and I appreciate her willingness to correct my actions. Well, I don't know how we got into all of that, but back to the dinner. Rather than sending an invitation to the Hall, I'll count on you telling those involved. Will Thomas' parents be coming for the ceremony?"

"No, I had hoped they would, but they are not."

The sisters continued to talk about a variety of subjects, knowing that there would be only a few such days left before Annie headed off to Texas. When Eli turned off Franklin Pike, they realized they were near the Hall. Thomas was standing on the porch ready to greet his bride-to-be. The short ride to Travellers Rest gave Harriet a few minutes to reflect on the day and recall some memories of Annie and herself as little girls.

John was seated at the small table on the gallery. He was sorting through the mail when the carriage arrived. He was so preoccupied with one envelope that Harriet was able to walk up beside him. "That must be a very interesting letter," Harriet said as he looked up.

"It's from Robert Brinkley."

"What did he write? How is Annie doing?"

John continued to sort the mail, hoping to find something to occupy Harriet's mind while he read Robert's letter. "Ah, here's a magazine for you, Harriet." Handing her the magazine, he turned his attention to the unfolded letter in his hand.

Harriet's procedure for reviewing any magazine was to begin at the last page and work forward. She found the advertisements in the back interesting, and the pages were always filled with the latest inventions that every home needed. The sewing machine ad caught her attention and reminded her, *I need to tell John about the sewing machine I bought for Annie and Thomas' wedding present. He does not need to be surprised when the statement comes to his attention.* Harriet looked at John and saw the intensity in his face as he went through the pages of the letter. She creased the page at the top as a reminder and then continued flipping pages. *I must remember to show this magazine to Annie. There are lots of dress fashions for her to see. This is the magazine I'll send her when she lives out West.*

"Robert writes that Annie is doing fine. She's being reacquainted with her brother, Hugh, and she has become interested in playing the piano. Harriet, while you were at the Academy, did you ever hear of a school in Brook Hill, Virginia?" John looked up from the letter.

"As a matter of fact, there was a Virginia girl on my hall from Charlottesville who talked about her brother being a student there. Does Robert mention it?"

"Yes, he's considering the school for Hugh. We talked about Hugh and little John's future schooling. Maybe they could attend the same school together."

"Cousins in the same school. That sounds like a good idea. However, little John is still a little young to be going off to school."

"I was thinking in a couple of years. By the way, do you know my father's family is from near the Charlottesville area? Father was born and reared in Louisa County at Frederick Hall. I believe I still have an uncle living there. I need to ask Mother."

"Do you remember how excited little John got in Memphis when you told him about the Overton property there? If you do decide to send him to Virginia, you might want to mention the Overton property there also."

"Harriet, that is a wonderful idea. I'm wondering whether Robert knows about the Overton family connection in Virginia. He might want to use that knowledge with Hugh. Another thing Robert mentioned in his letter is about a second wife."

"Is he saying he's married again? Who is she? Where is she from? Do we know her?"

John had to smile at the barrage of questions. He raised his hand to slow down a very inquisitive Harriet. "Robert talked to me in confidence about this when we visited him. He mentioned her name, which I've forgotten. I do recall she is from Alabama. He does not indicate a wedding date. He wants me to tell Mother and Elizabeth. He would like to know their reaction."

"I suggest you either remember her name or contact Robert and get some more information. Your mother will want details."

Harriet and John both turned at the sound of a horse and carriage coming down the lane. John recognized the horse and carriage from a distance and hoped the passenger was not who he thought it was. If it was his sister, Elizabeth, he was out of time to get more information from Robert. John was always happy to see Elizabeth, but at times, her air of superiority bothered him. He walked to the carriage and was greeted with, "Good day, John. Is our mother receiving guests today?"

"I'm sure she will always be happy to see you. Do come in for a visit."

Harriet moved quickly to rescue John. "You go tell your mother she has a visitor, while Elizabeth and I visit here on the gallery." John was happy to follow instructions. "Elizabeth, how is your John these days?"

"He is quite busy as usual, thank you." Harriet was still standing when Elizabeth sat in the chair next to the table where the mail was stacked.

"Elizabeth, excuse me and I'll go to the kitchen and have some tea made. There's a new magazine on the table you might find interesting." Harriet went to the kitchen. Elizabeth glanced at the table, spotting not only the magazine but also a light tan envelope, which she recognized immediately.

Mary appeared at the door and inquired, "Elizabeth, what brings you here? Would you prefer going into the parlor?" Mary always had to offer her daughter a choice. Even as a child, Elizabeth insisted on making choices. Her mother had carried the childhood activity over into adulthood.

"No, Mother," Elizabeth stood and kissed her, "here on the gallery will do just fine. Harriet has gone to the kitchen for tea. I came unannounced. I hope that's all right."

"Elizabeth, you are welcome anytime, announced or unannounced." *Elizabeth, you are getting prissier with age.* Mary held Elizabeth's hand as they were seated. *When you are my age, no one will be able to stand you. I guess I'm to blame for your attitude. You are my last child, and I must have pampered you too much. Oh well . . . I doubt you'll ever change.*

"Mother, how was your trip to Knoxville?"

"It was a good trip. I visited most of my kinfolk. Some of us made a visit to where the old fort stood that Father built. That was a good memory. My niece gave me a portrait of my brother, Hugh. The weather was still a little cool coming off the mountain. Even though I took my time traveling, at my age, it was a hard trip for me."

Elizabeth spotted Harriet and timed her next question. "Mother," Elizabeth finished when Harriet arrived, "have you had any late news from Robert Brinkley?"

"I have not. Harriet, have you or John heard anything from Robert since you've been back?"

"I believe John received a letter from Robert today. He may have the letter with him. Let me find him."

"No need, the letter is . . ." Elizabeth interrupted. She glared at the envelope on the small table. " I'm sure he will share any news he has from Robert." Harriet went into the house and found John sitting on the bed in their bedchamber. "John, your presence is requested on the gallery."

"Upper or lower?" This was a rare attempt at humor and Harriet enjoyed the moment.

"I believe lower. That's where Elizabeth is waiting with fire in her eyes. You had better bring Robert's letter with you. I'll leave the three of you to have some Overton family time."

"I don't think so," he grabbed her hand and it almost disappeared in his, "young lady, you are an Overton and anyway I need your support." Hand in hand, they walked to the gallery and sat in the double chair. The tea had already arrived, and Mary was preparing to serve.

"John, your sister was asking about Robert Brinkley."

"Yes, I have a letter from him today." In typical Overton male fashion, John was finished.

"And . . .?" Elizabeth said in a challenging tone. Harriet squeezed John's hand, unnoticed by the other ladies. He forced a very small smile directed at her.

"And all seems to be fine in Jackson with the Brinkleys," John calmly stated.

"Elizabeth, what's been happening with you and your John since I've been gone?" Mary thought the Robert Brinkley matter was finished; Elizabeth didn't.

"Tell her, John," Harriet said, "or I will." Elizabeth was getting red in the face, but not from the tea.

"Tell me what? What are you talking about, Harriet?

"Robert is getting married again to some Mhoon woman from Alabama and moving to Memphis." Elizabeth was fanning herself and making strange sounds like an injured animal. Harriet squeezed John's hand again. He sat motionless except for the movement of his huge eyebrows. Mary noticed and knew her son was laughing inside his big frame.

"That's wonderful news," Mary added in a soothing tone. "I'm happy for Robert and the children. He's had to be father and mother to Hugh and Annie since their mother died."

"But, Mother . . ."

"But what, Elizabeth? Do you think Robert needs our approval to get married again? I don't think so. He loved my Ann, your sister, dearly until the day she died. That's been over six years ago. He deserves to be happy with a new wife." Mary turned to John," Son, you're sitting over there not saying a word. What do you think?"

"Mother, I believe you've said all that needs to be said. When Robert does get married, and I don't know when that will be, I believe we need to send him a nice wedding gift from the Nashville Overtons and relatives."

If looks could kill, John would have died a thousand deaths from the glare he received from Elizabeth. She moved to the edge of her seat, locking her knees in an effort to calm herself down. "And what else did Robert have to say in his letter?"

"I'd be happy for you to read his letter."

Harriet felt she needed to get right in the middle of the sibling interchange. "John, tell them about Brook Hill."

Before John could respond, Elizabeth took over the conversation. "Are you talking about the Brook Hill in Virginia?" John knew all he needed to do with Elizabeth was to nod his head in agreement and she would do the rest, and she did. "My John," Elizabeth stated with an edge to her voice, "stayed a couple of days at Frederick Hall on his way to Richmond. While he was there,

he met Dr. Minor, the headmaster, who wrote him later inquiring about possible students in the Nashville area."

"I didn't know about John's trip to Richmond. No one told me a thing."

Elizabeth knew her brother was poking fun at her and she took his remark as a sign to continue. "My John does a lot of things you know nothing about. In fact, I do a lot of things you don't know about." If it had been ladylike to stick out her tongue, Elizabeth would have done so. "He visited with several of our Overton relatives in Louisa County. My, my, the day is passing so quickly. I've stayed far too long. I must return home. John will be home soon and dinner must be ready." Elizabeth had dropped the bait about the Overton relatives, but no one bit. They were happy the visit was coming to a close. Departing hugs and kisses were shared all around.

When the carriage, with its prissy passenger, was out of sight, Mary put her arms around John and Harriet and laughed, "Son, if one of your newfangled railroad engines ever runs short on steam, I know where you can get a big supply."

The day before the prewedding dinner, Harriet and Mary were in the large room. A week before, Mary had helped Harriet with the basic menu. After hearing Harriet's plans for the menu, Mary made some suggestions about what foods needed to be served together and in what order. Meals at Maxwell Hall had never reached the banquet level where food was served in courses. Food was always brought to the main table and desserts placed on the sideboard. Extra beverages might be placed on a pier table. All food items were in the dining room at the same time and the family would access them when needed.

At Travellers Rest, formal dinners were an eating experience. Harriet was learning every detail. Mary was an excellent teacher, and she wanted Harriet to excel as a hostess. Harriet didn't know at the time, but Cynthia, the slave cook, knew from experience the order in which food was served. She managed the flow of everything. The house slaves took orders from her when there was a dinner in the house. Mary had trained her and they had worked well together on most of the formal dinners served. Cynthia had ordered the food, and those items requiring early preparation were already done.

"Harriet, while I have some of the china pieces brought out, why don't you go to the kitchen and talk with Cynthia." Mary was eager for her to develop a good relationship with Cynthia.

"Yes, I can do that." As she entered the kitchen, she heard Cynthia humming a hymn. Harriet knew the tune and began harmonizing with her. When the two finally made eye contact, they stood before each other and continued singing. "Miz Harriet, I didn't knows ya could sang."

"Well, I knew you could sing, so I just thought I would join you."

"My, child, ya full of surprises." She had not forgotten the cold day Harriet took the slave children into the family dining room for cookies and hot drinks. That amazing event was the talk of the Overton slaves and endeared her to them.

"Cynthia, I came in to see whether you needed anything for tomorrow's dinner."

"No, ma'am, I did all could be did early. I be cookin' plenty in the mornin'."

"Do you need any extra help tomorrow?"

"I's already telled the house servants what they be doin'. Would it be all right if I gets Emmaline to helps me in da kitchen fer tomorrow?" Cynthia was eagerly waiting for Harriet's response.

"That will be fine, Cynthia. Do I need to tell Emmaline or will you?"

"Thank ya, I can tell her." As Harriet headed back to the large room, Cynthia pondered, *Miz Harriet do not knows 'bout Emmaline, and I not goin to be da one who say da secret to her.*

"And how are things in the kitchen?" Mary knew, but she wanted to hear Harriet's opinion.

"All that can be done at this point is completed. Cynthia will be in the kitchen early in the morning. She has talked to the house servants and will be using another of the slaves to help her."

"Good. The Judge bought this china in 1828. It came from New Orleans. The pattern is Old Paris. We have a complete service for twelve. I'm telling you all this information in the event someone should ask."

"Mary, this is so beautiful and there is so much of it."

"You will use every piece at your dinner. Over here is the crystal and the flatware with the serving pieces." Harriet was keenly aware that Mary was using the word, *your*. Her expression of awe pleased Mary. She had the same feelings the first time she saw all the pieces on display.

"Now, Harriet, what wine do you want to use?"

"Is there more than one?" Mary laughed as she put her arm around Harriet's shoulder. She was so pleased at Harriet's innocence and honesty.

"Yes, the first wine you serve can be used with the soup and the main course. When the fish course is served, you will use another wine. A third wine will be served with dessert; and then at the close of the evening, you will bring out the peach brandy. Your guests may not drink all the wine you offer, but you need to offer it anyway."

"My goodness!" Harriet's response was halfway between a laugh and a cry.

Mary knew all the information was overwhelming. "Harriet, if you will allow me the privilege, I will select the wines and instruct the servants."

"Oh, that would be wonderful, but under one condition."

"And what would that be?" Mary was perplexed; *I've offered to take this responsibility from her. What on earth would prompt her to make a condition to my offer? She's young and never hosted a dinner before. I guess I can excuse her this time.*

"I would like to arrange the table seating so we are seated next to each other. That way, I can watch you and you can tell me what needs to be done

next. John and little John can be seated at one end of the table and we can be seated at the other end. The guests will be seated in pairs."

"Are you sure that's what you want?" *This young lady, not yet twenty, is so mature in her thinking. I would never have thought of using the arrangement she is suggesting, but if that's what she wants, that's what we will do.*

Harriet tried to recall her "Lady of the House" training from the Academy. She knew the Lady controlled every movement at the table. The guests would take their cues from her. When she placed her napkin, they would follow. When she lifted her soup spoon, they would do likewise. The various dinner courses would be served at her signal. She wanted to make John proud of her, and the best way to do the proper thing at the correct time was to have Mary at her side.

"Yes, ma'am. You are the teacher and I am the student. I remember some things from my hostess training at the Academy, but you know exactly what needs to be done at the dinner. You have hosted the President of the United States in this room, so I trust your judgment and need your help."

"And you shall have it, Harriet. You will do just fine." Harriet excused herself, leaving Mary in the room with her thoughts. *The first time the Judge and I planned a formal dinner in this room I was terrified. I had no idea how to use all the new china. I didn't know anything about wines. Fortunately for me, Rachel Jackson knew everything. I've always been sad she never had a chance to enjoy this room. I was never able to show her what she taught me. Now I have another opportunity to pass along Rachel's lessons.*

Some memories fade away; others remain vivid throughout a lifetime. Harriet's first formal dinner went off without a hitch. The Maxwells and guests arrived at Travellers Rest right on time. Annie held on to Thomas' arm and the couple made the perfect bride-and groom-to-be. Mary was escorted by William Eliot in a gentlemanly military fashion. Both he and Thomas chose to wear their uniforms. Every button was polished and sparkled when the sun rays hit them. Their leather belts and straps had been lightly oiled and looked like new. Mary's dress made her look older than she was but it was intentional. She enjoyed being with William. Jesse and Myra were the last to step onto the gallery. Jesse was smiling more than usual, and Myra held on to his arm, feeling very special to be a Maxwell.

The Overtons—John, Harriet, Mary, and little John—created an informal receiving line and ushered their guests through the double doors and into the large room. The room was a showplace. The large windows were raised slightly to catch any breeze available. The candles, already lit, flickered occasionally when a breeze wafted into the room. The table was extended to accommodate the ten chairs placed around it. Mary had been able to take Harriet's design for the seating and turn it into a masterful reality. The table was square rather than its usual rectangular shape. John and his son sat at the side near the oversized sideboard. Harriet and Mary sat opposite them. Harriet

would be able to use the fisheye mirror over the sideboard to view the servants behind her and give them directions as needed. The guests of honor, Annie and Thomas, were seated on a side by themselves. Thomas was able to converse with John; Annie with Harriet. The fourth side seating placed Jesse near little John, William and Mary in the middle, leaving the final seat for Myra.

Harriet had not planned for place cards at the table, but Mary had taken care of that detail. It was only after all were seated that the pure elegance of the table was apparent. The fine china and crystal picked up the glow of the candles on the table. The two small bowls of fresh flowers on either side of the guests of honor were eye catching. By prearrangement Harriet made eye contact with John. He caught the signal, rose, and greeted the guests.

"It is an honor to have each of you in our home this evening. You are good and trusted friends and neighbors. Thomas, you have come all the way from Texas to wed one of the beauties of Nashville. You are a fortunate man indeed. I, too, picked a beautiful flower from the Maxwell garden. William, I trust this will not be your last visit with us at Travellers Rest." After a brief blessing for the sanctity of marriage and the bounty of food and drink, John looked at Harriet. "My wife has ordered this banquet and I suggest we begin."

She nodded in acknowledgment, picked up her napkin, and signaled the servants to bring the soup. When all were served, she glanced over at her mother-in-law and they moved in sync as together they picked up their soup spoons. The first movement was done to perfection; the rest came naturally. The dinner progressed as planned at just the right pace. Little pockets of conversations were created and then dissolved. Each person at the table was having a wonderful time interacting.

Through the flickering candlelight Harriet caught John looking at her. When their eyes met, he smiled. In the time she had been married, Harriet had come to recognize John's looks. This evening's look said, "You are doing a fine job. I'm very pleased and proud of you." A nod of her head said, "Thank you." At one point late in the dinner, Harriet leaned toward Mary, partially covering her mouth with her napkin, and whispered, "Should John give a toast to Thomas and Annie?"

"Yes, he will at the appropriate time."

After the dessert plates were removed and the servants refilled wine glasses, John pushed his chair back and stood. "This seems like an appropriate time to toast our special guests. I'll begin and others may follow if they choose." Mary placed her hand on Harriet's, hidden from those around the table, and gave it a pat. "Lift your glasses to Thomas and Annie. May they always be as happy as they are right now." The clinking of crystal glasses added to the sounds of "Here! Here! To Thomas and Annie."

Jesse was the next to stand. "To Annie, my firstborn, and to Thomas, a new son in the family, may you love each other faithfully. May you grow old together and perhaps one day make your home in Tennessee." Around the table, guests sipped wine and spoke words of encouragement.

To the surprise of all, little John stood to make a toast. With his glass of water held high, he stated, "Miss Annie, Mr. Thomas, I put my glass up to wish you happiness." Annie was already teary eyed, and this toast brought a flood of tears. Harriet was so filled with pride; she set her glass down and began to clap. She was joined by the others in appreciation of the young John Overton's actions.

Then William stood, almost at attention, as he lifted his glass and looked across the table. "Thomas, you are a lucky man to have found such a perfect mate. Annie, you have chosen the very best. May you both have a wonderful life together. I salute you, soon-to-be, Mr. and Mrs. Thomas Claiborne."

In like manner, Thomas stood. "Thank you for your toasts, kind words, and wishes. This evening will always be in our memory. Our special gratitude to Harriet Maxwell Overton for this wonderful expression of love and kindness. May the Almighty's blessings always be on this home and all who dwell herein. Finally, to my bride, whose love and grace have been unchanging since we first met, Annie, I love you with all that's within me, for now and forever." Annie's emotions were at such a peak that all she could do was stand and embrace Thomas. Those around the table understood.

All formal gatherings at Travellers Rest always ended with peach brandy. The slaves made the brandy on the plantation. The same process for distilling had been used since the Judge harvested his first crop of peaches. The orchard had grown and continued to yield quality fruit for the brandy. Stories were told around Nashville that most any evening after a full court docket, John Overton, Sam Houston, Andrew Jackson, and friends would tap a keg of the Overton peach brandy and recount the day's experiences. The Overtons continued the tradition by offering small snifters to those who wanted to try the brandy. Harriet had planned one more event for the evening. She signaled the servants to bring in some gifts for the honored couple. First came the dresses Annie had ordered—the day dresses and the fancy entertaining gown. "The day dresses are gifts from your sisters."

"Harriet, you tricked me."

"You may thank our sister, Mary. It was her idea when she discovered you had ordered them."

"Thank you both. I shall remember you when I wear them."

"And the gown," added Myra, "is from your father and me. It is a lovely color and design for you, Annie."

"How did you know? Harriet, I thought you could keep a secret."

"Thomas, the contents of the large box will benefit you, but it will be especially handy for your new wife. Rather than opening the box this evening, I've prepared a small envelope to show you what's in it." Harriet handed Thomas the envelope and he handed it to Annie. When she opened it, she saw a magazine illustration of a sewing machine and was thrilled. Again came a flood of tears. For once in her life she was speechless. Harriet was also in tears

but managed to say, "The machine is from the Overtons and comes with much love and best wishes."

"I have no words but thank you. Harriet, John, Mrs. Overton, and little John, I appreciate your kindness and promise you I will make good use of the sewing machine."

"My dear," Mary Overton added, "if you can figure out how to use that contraption, more power to you." Harriet smiled at the comment and did not challenge it, knowing, in her heart, she had purchased the right gift for her oldest sister. She and John had agreed on the gift and that was all that really mattered.

The moon was bright when the Maxwell party headed for the Hall. Harriet and John stood on the gallery with arms around each other. They watched as the carriage faded out of sight.

"Harriet, that was a wonderful dinner party. You looked after every detail and it all went like clockwork."

"I can't take full credit. Your mother guided me in the preparation and directed me this evening. She also selected all the wines."

"Well, it was not evident that Mother did any directing this evening."

There was a surprise party for Annie three days before her wedding. Mary wanted to do something special for her sister. Classmates from the Academy and friends from church were invited to the Hall. Harriet was enlisted to take Annie on their final carriage ride together and then return her to the Hall for the surprise. As Annie's girlfriends arrived, they hid in the house and their carriages were hidden. When Annie and Harriet returned and entered the Hall, peals of laughter greeted them and Annie was totally surprised. Some of her friends were married; others were not; but they all enjoyed the surprise party. On this day they were just friends gathered to wish her good luck and farewell.

On the following Tuesday the Maxwells and the Overtons gathered at the Hall for the wedding ceremony. The minister mentioned how Annie and Thomas had met and how their love had matured long distance. He stated that they would be leaving tomorrow, headed for Texas. The occasion was happy and sad. Jesse, Myra, Mary, and Harriet forced smiles and laughs, but deep inside there was a sadness, knowing that the tight family circle was about to become smaller. Annie was glowing and made a beautiful bride. Thomas was handsome in his dress military uniform and officer's sword. Seeing Thomas and the sword was the best part of the wedding for little John. He endured the rest of the ceremony and activities. William had arranged for the newlyweds to spend their wedding night in a Nashville hotel. It was a gift from Thomas' fellow soldiers back in Texas.

The Maxwell slaves and servants gathered outside near the carriage. Edward had found a black suit and a top hat and was perched in the driver's seat. Harriet positioned herself near the carriage. She was hoping to have a

final word with Annie. Jesse and Myra stayed on the porch as Annie and Thomas boarded the carriage.

"Annie, enjoy tonight," Harriet whispered softly, "and do write often."

"I will and I will. I love you, little sister."

Harriet watched Annie leave, maybe never to see her again. Harriet's mind flooded with memories of her childhood with Annie and Mary. She was brought back to reality as she focused on the back of the carriage. There she saw the large box tied to the carriage—the contraption, a source of power.

# 9. Family Matters

The fall of 1851 was typical for Tennessee. Some days the weather was mild and balmy. On those days little John was outside exploring the plantation. He had limits set on his adventures after his encounter with the mystery Indian who had pulled him into the spring below the house. Most of his time was spent near the reconstructed law office and near the family graveyard. On occasions he ventured over to see the railroad construction. One afternoon he sat watching an engine make a trial run on the tracks near the house. He thought, *One of these days I'm going to ride on a train and see how far it goes. Maybe Father will be able to get me a ride in the engine cab as he did on the boat. I wonder if the engine has a whistle.* To his amazement and delight, the sound of a whistle abruptly stopped his wondering. He saw an extended arm from the cab, then a shoulder, and then a head. It was his father in the cab waving and yelling, "John, oh John, John Overton!"

He stood up and waved with both arms, "Father, is that really you? May I ride on the train?" A steep bank separated father and son. The short distance was far too dangerous for either of them to get to each other.

"John, you go to the house and tell Harriet I want you to come to the railroad tracks. Then go find Eli or Claiborne and tell them to bring you to the crossroad."

"Yes, sir!" With most instructions John took his good old time, but this time was entirely different. He was headed for the house to find Harriet before his father returned to the train. He hit the side door with such force it banged off the sidewall, "Harriet, Harriet, come quick!" Fortunately, she was just around the corner in her bedchamber reading when she heard his excited voice. She dropped her book and moved quickly, encountering little John heading for her.

"What's the matter? Are you hurt? Has there been an accident?"

"No." John was a little breathless from his run to the house. "Father wants me to come down to the railroad engine."

"John, your father is in the city."

"No, ma'am. He is in the railroad engine right down from the house. He told me to tell you and then get Eli or Claiborne to drive me to the crossroad. I'm going to ride the engine!"

"John, is this another Indian story?"

"No, ma'am. You can come see for yourself."

"All right, you go to the barn and find Eli or Claiborne. Tell them to bring the carriage. I will go with you to the crossroad."

As John ran to the barn he wondered, *Will I ever hear the last of my Indian story? Forget that dumb story; today I'm going to ride the railroad engine.* He approached the barn with the same intensity he had stormed the house. "Eli, Eli! Claiborne, Claiborne! Where are you? I need to talk with you right now!" The tone of his voice was demanding. Eli appeared from the barn first and

then Claiborne. They were responding to the sense of emergency in the voice and not the source.

"Yes, little John. What ya needs?" Eli was troubled by the superior attitude John had developed at such an early age, but he knew it was a learned trait. There would be little chance of changing an Overton trait.

"I need a carriage ride to the crossroad. My father is waiting for me there on the railroad engine. Harriet will be riding with me. So,, bring the carriage to the house immediately."

I will do dat." John waited to hear the word "Sir," but it did not come. Eli was not intimidated by John's demand nor when to get the carriage ready. John headed for the house creating dust as he scuffled his shoes. He was mad and felt insulted, but the thought of riding the engine was a more pressing challenge.

Harriet stood on the gallery basking in the warm sunshine. She saw the dust John was creating. "John, pick your feet up. You are wearing out the bottom of your shoes."

"Eli made me do it."

"Eli told you to drag your shoes and make the dust? I question that."

"No! He made me . . ."

"No . . . what!" Harriet's voice was unusually stern.

"No, ma'am." John realized he needed to be calm. "Eli made me mad. He did not call me sir when I gave him a command."

"And just what did you say . . . I mean command of Eli?"

"I told him I needed a carriage immediately. He said, 'I will do dat.' But he did not say 'sir!'"

"Did you ask Eli if he had time, that very moment, to get the carriage ready? Was he busy doing another chore? Maybe, he was doing something your father assigned him to do."

"No, ma'am. I did not ask him. But you know he doesn't do much around here. He's just a lazy nig . . ."

"John, stop! That word may be in your vocabulary, but it's not in mine. Never . . . ever . . . use that word in my presence!"

"But . . ." To the relief of the two strong-willed Overtons, Eli driving the carriage out of the barn was a welcomed sight. Harriet knew this discussion would surface again. It was hard to break old habits, particularly when they have been ingrained in thought patterns for years.

"Eli, do you know where to find Mr. Overton?"

"I believes he be at da crossroads."

"Let's get moving," John said demandingly, "I want to see the engine."

Eli gave no verbal response but headed toward the crossroad. In a few minutes the carriage stopped near the crossroad. The new railroad construction had created a mess of the roads, but they were still passable.

John was eager for his son to see the engine. He was surprised to see Harriet in the carriage. "I'm glad you came, Harriet. Would you like to see the engine up close?"

"Is it safe? Look at that pile of rocks and dirt. Won't the engine crush them?"

"It's perfectly safe. That pile has been built to hold the weight of the engine and the many cars it will pull." John, Harriet, and little John walked a distance before they found a level place to approach the tracks. The engine was massive, bigger than Harriet had expected. Little John kept pulling on his father's arm wanting to get closer to the engine. The engineer was out of the cab squirting oil on the wheel bars.

"This is Mr. Lark, the train engineer." John's introduction was acknowledged, but did not divert the oiling procedure.

"Ask him, Father." Little John was more demanding than requesting.

"Mr. Lark, would it be possible for my son to look in the engine cab and maybe blow the whistle?"

"Yes, I'm always looking for young men who may someday become engineers."

Harriet was not so sure that bad behavior should be rewarded in this way. She realized John knew nothing of his son's actions, and Harriet did not want to spoil the experience for the boy. However, some behavioral adjustments needed to be made before it was too late. Lately, Harriet felt she was walking a very thin line when it came to providing discipline. Somehow it seemed easier to work with little John when she was his tutor rather than his stepmother. She stored the events of the day in her memory and planned to talk to her husband later about her relationship with little John.

The railroad project required a lot of John's time. Most days were spent in the city meeting with the construction teams—some working on the tracks; others putting the finishing touches on the depot. Some days were spent traveling to Franklin to meet with lawyers and other railroad directors. He was one of the younger directors and one of the larger property owners where railroad right-of-way was required. This latter fact gave him some leverage. He was careful to keep his brother-in-law lawyer, John Lea, totally informed, for he had already negotiated a rail spur for the Overton property. It would be helpful to both of their plantations.

The first light of day coming through the windows in his bedchamber at Travellers Rest woke John. He eased out of bed quietly, hoping not to wake Harriet, dressed, and made his way to the family dining room. Each morning he met with his overseer to hear progress reports and lay out work plans for the fields and upkeep of the facilities. Although John was just thirty-one years old, he was the complete master of the plantation. His mother had been a good teacher. She was always anxious for him to take charge, but she was never willing to trust him with the responsibility until he was ready. That's the agreement she felt the Judge would have wanted. Since Harriet had entered the family, Mary had relinquished all control of the plantation to her and John but still provided a strong, even dominant, reign over the Memphis property.

Harriet was still in her bedclothes and heavy robe when she entered the dining room. John had his back to her but turned when he heard her voice. "Good morning, John." She did not acknowledge the overseer because there was something about him she didn't like. Mary's feelings about the overseer were even stronger; she just did not trust him.

"Good morning, Harriet. What are you doing up so early?"

"I need to talk with you . . . privately." She looked past John and focused on the overseer. "That will be all for now, Mr. Gray. I'll see you in the morning."

"Yes, sir." Harriet's eyes followed him as he left the room.

"What do you know about the overseer? What did he do before you hired him?"

"Harriet, he is a good man. He has the respect of the slaves and they follow his orders. The reports he gives me are trustworthy and he carries out my instructions."

"I don't know, John. I just have a problem with a person who won't look me in the eye. It's as if he's hiding something. Anyway, I wanted you to know I'm coming to the city today, and I expect you to take me to a late lunch." John had returned to the table and was looking for a particular piece of paper.

"Yes, that will be . . ." Harriet walked over, put her arms around his neck, and turned him around.

"John Overton, you look me in the eye when you answer me." She was laughing when she kissed him and tightened her arms around his neck.

". . . a good idea. Why don't you meet me at the depot about twelve o'clock. I want you to see the new sign on the depot and then we can have lunch."

Harriet's fancy, black velvet dress had been ready for several weeks. Annie's wedding and some other responsibilities kept her close to home. This was the first opportunity she had taken to go to the dress shop in the city. When Harriet pushed the shop door open, the little bell attached to the door announced her entrance. The shopowner looked over the shoulder of a lady she was helping, excused herself, and walked quickly to greet Harriet.

"Good day, Mrs. Over . . . Harriet. I am glad to see you. How may I help you?"

"And good day to you. I've come to pick up my velvet dress."

"Oh, Harriet. I'm so anxious for you to see it. The seamstress who made it said it was the prettiest dress she has ever made. I've been so tempted to display it in my window but I didn't. Do you have time to try it on?"

"Yes, and that is a very good idea. I'd hate to get home with the dress and then find out it didn't fit."

"If you will come with me, I'll show you the dressing room." The room was functional, nothing elaborate. The owner pointed to the full-length mirror, the small table with a crystal glass and a pitcher of water, a small overstuffed chair, and a rack for holding garments. "I'll just be a minute. Your dress is in

the workroom." She returned holding the dress horizontally over her outstretched arms. "Here's your dress. I will be back shortly to help with the buttons."

Harriet slipped out of her dress and into the new one. The seamstress and owner were correct she thought. *This is a wonderful dress. I love the velvet material. It looks so rich and the fit is just right. The bow in the back really does enhance the dress. I feel like a queen.* The ringing of the doorbell was faint but indicated to Harriet that a customer was entering or leaving. She continued to twirl in front of the mirror trying to view the dress from every angle.

"Mrs. Overton?" Harriet did not recognize the voice coming from the closed curtain.

"Yes, who's there?"

"My name is Grace. I'm the seamstress who made your dress. Miss Barbara asked me to offer my services to you. May I come in?" Grace was the same age as Harriet and a few inches taller. She was wearing a simple day dress covered by a full-length apron. Her hair was bobbed. Spectacles were perched on top of her head. A pin holder was strapped to her wrist. She looked every bit the seamstress.

"Please come in. May I call you Grace?"

"Yes, ma'am."

"My name is Harriet. Grace, this is a beautiful dress." She swished the skirt part of the dress back and forth but it made no sound. The velvet muffled her attempts.

"May I help you with the buttons?"

"Yes, please do."

When the buttons were finished, Grace pulled the slight wrinkles out of the bow in the back. "There, now look at the back." Harriet was even more pleased with the bow now that it was full and the streamers were patted down. "Grace, have we met before? You look so familiar." Grace was about to speak when she and Harriet heard a very loud voice at the front of the shop.

"I told you I wanted black velvet!" The voice was caustic.

"I sold the only bolt of black velvet I received this season," Barbara said apologetically.

"Can you order another one?" The customer was very curt.

"I can order another bolt, ma'am, but it will not get here in time for the holiday season."

"Well, I . . . " Harriet recognized the voice and when she opened the curtain, the customer stopped in midsentence. "Elizabeth, so good to see you this fine day." As she walked to the front of the shop, she had a slight swagger.

"Harriet, what are you . . . good morning." Harriet positioned herself to give her sister-in-law a full view of the fancy, black velvet dress. Elizabeth was not about to challenge Harriet in this setting, and she decided immediately she would not comment on the dress either. "Harriet, ladies, if you will excuse me, I'm late for an appointment."

"Yes, Elizabeth. One should not miss an appointment." Elizabeth nearly knocked the bell off the door as she exited the shop. Barbara and Grace stood motionless with frozen expressions on their faces, waiting for Harriet's response.

"Grace, how do I know you?" Harriet tried hard to keep her composure and not laugh, but a smile came first, then a full, deep laugh. "I'm not laughing at you. I'm just wondering what Elizabeth thought when I walked out in my new dress." Barbara and Grace did not laugh as long or as loud as Harriet, but they both fully enjoyed the moment. "Grace, I must know how . . .?"

"We were classmates at the Academy our first year. I only stayed two months. My mother died in a freak accident and I had to go home."

"Yes, I remember you. Your home is near Columbia. Your family and President Polk were good friends."

"Yes." Grace was pleased and became emotional. She used her apron to wipe her tears.

"Your hair was longer when we were at the Academy."

"Yes. I keep it short now so it doesn't get in the way of my work." Grace disappeared into the workroom.

Harriet turned her attention to Barbara, who helped her remove the new dress. "I hope I didn't create any problems for you and Elizabeth."

"Mrs. Lea is a good customer. She's a mite high strung at times. However, this is not the first time she has been upset. I'm sure she'll be back."

"Barbara, I need a special favor from you."

"Yes. What can I do?"

"I would like to add five dollars to the cost of the dress. I want the extra to go to Grace, but I want it to come from you."

"I understand. I will handle it as you wish. We have a heavy cloth bag to protect your new dress. I'll get it for you."

Harriet glanced at a stack of magazines on a chair. "Barbara, what kind of magazine is *National Era*?"

"I'm not really sure. One of my customers left it here. Thank you, Harriet. Thank you for everything. This has been quite a morning." The dress was bagged and placed on a hanger at the front of the shop. When Claiborne helped Harriet to the carriage, he was told to go in the shop and get the dress. He was able to find a way to hang the dress upright.

"Claiborne, now we are going to meet Mr. Overton. He's at the railroad depot on Broad Street. I believe it's somewhere between High and Summer Streets. Can you find it?"

"Ya, Miz Overton. Eli told me how to gets there."

"Very well then. Off we go." Claiborne found the depot and parked the carriage in front. Harriet was admiring the new lettering on the side of the depot, Nashville & Decatur Railroad Depot, when John appeared. "John, I'm very impressed."

"And all this time you thought I was down here wasting time."

"No, you told me about the building. You just didn't tell me how grand it was. What's the building next door?"

"That's the Taylor Depot."

"Is it related to your depot?"

"Yes, it's a commissary warehouse. They will handle freight for us. How about some lunch?"

"You'll need to tell Claiborne how to get where we're going. He's not real familiar with downtown Nashville."

"Claiborne, we're going to the City Hotel. Take this street to the river, turn left, and head for the Public Square."

"Yassir."

John sat across from Harriet. He pushed the hanging bag to one side, but it was still in his way. He put a handful of papers on the seat next to him and continued to fight the bag all the way to the hotel. Harriet smiled at him and thought, *John, I'll be happy to move the bag or change seats with you. All you have to do is ask.* "John, do you want to move the bag and get it out of your way?"

"No, I'm sure you have a reason for hanging it here, and that's fine with me." *You are one stubborn man, John Overton.* She had to laugh at the thought.

"I talked with your sister in the dress shop this morning."

"Is she as prissy as ever?"

"John, you need to have kind thoughts about Elizabeth. She adores you." As luck would have it, for both Harriet and John, while Claiborne was securing the carriage in front of the hotel, Elizabeth, in her carriage, pulled up beside them. Harriet had to grin, watching John greet his sister.

"Elizabeth, we were just talking about you."

"I trust you were kind in your words."

"Always. Do you have plans for lunch?"

"Yes."

Harriet had not spoken but was enjoying the sibling conversation. She noticed Elizabeth's eyes focused on the dress bag hanging in the carriage.

Lunch was delightful for Harriet, but John was distracted. He kept looking around the room thinking that at any moment Elizabeth would appear at the table.

"John, I'll have today's special, and please order the same for Claiborne."

John gave her a "what do you mean?" look when he placed their order. "Two of your specials for here," he instructed the waiter, "and the same for my carriage driver, Claiborne, outside."

Time alone, away from Travellers Rest, with John was always special for Harriet. The meal was accented with small talk, which John did not like but endured, and a discussion of the upcoming holiday season. "John, I would like to do something special for your mother—a party, a dinner, or something. I was thinking about inviting all her children and their mates to the house." John

was listening but not hearing. His mind was miles away thinking about the railroad project. "John, I want to have a child," she said in a whisper.

"Yes, that sounds fine to me."

"What does? What sounds fine?" The sound of Harriet's voice set off an alarm in John's head.

"Harriet, what were you saying? I was thinking about something else."

"Well, at least you're honest! I need to be getting back home." Harriet rose, placed her napkin on the table, and headed for the carriage. "Do you need a ride back to the depot?" John knew by the tone of her voice she was upset and ready to go. He fumbled at the table to find money for their bill. He dropped more than enough money on the table and had to take large steps through the hotel lobby to catch her. Fortunately for him, Claiborne was thanking her for his meal.

"Harriet, please forgive me."

"We don't have many days like this when we can have a meal and enjoy each other's company. We are too young to act like old married people." John knew from the way she was standing that her foot was about to stomp, and it did. "I expect you to listen to me when I speak to you." The tone of her voice softened but her message was clear. "Claiborne, take us to the depot, and then I need to go home."

"Ya, ma'am." Harriet's foot stomping seemed to calm her disposition and John was glad.

"Now, John, about the holiday party."

"Anything you want to do will be fine. You just tell me what I need to do." He never lost eye contact with her all the way back to the depot. He had switched seats with her and did not have to battle the swinging dress bag during their carriage ride. "I'll be home before dark this evening."

"Be careful." He was standing on the ground, making them about the same height. Harriet leaned over and grabbed him, kissing him with intent. "I love you, John Overton."

"I love you, Harriet Virginia Maxwell Overton!"

On the way home, Harriet closed her eyes and relaxed her shoulders, not intending to nap, but she did. About the time the carriage reached Franklin Pike, she was jolted awake by the sound of the train whistle. She shifted her weight and realized she was sitting on the papers John had left in the carriage. When she tugged the papers lose, she noticed a copy of the same magazine she had seen that morning in the dress shop. The *National Era* appeared not to be a regular magazine but a journal. The pages were filled with lots of copy and few illustrations. In addition to the title on the front cover, there was a cut line, "Dramatic Critique of Slavery" by Harriet Beecher Stowe. The name Harriet caught her attention immediately. She read the introduction to the Stowe article, "Mrs. Stowe is a teacher at the Hartford Female Academy. She is also active as an abolitionist. She is writing *Uncle Tom's Cabin (Life Among the Lowly)*, exposing the evil and immorality of slavery. This article is one of a

40-week serial. The reader has already met Uncle Tom, Eliza, and Eva in previous articles. In this one the reader will be introduced to evil Simon Legree. This series of articles will appear in book form in August 1852."

Harriet slammed the pages shut. She had read enough. Her thoughts were running wild. *The very idea of writing that slavery is evil and immoral. If they weren't working for us, what would they be doing over on the Dark Continent? They are much better off here than there. They have a place to stay and they get all they want to eat. I'll bet Harriet Beecher Stowe has never even been on a plantation. She has no idea how slaves are treated. I wonder where on earth John got this journal.* As hard as Harriet tried to resist, she was drawn back to the Stowe article. After reading three pages, she noticed a section circled with ink. Someone must have thought the passage important. As she read the words silently, she found herself mouthing some of the words.

> Legree drew in a long breath; and, suppressing his rage, took Tom by the arm, and, approaching his face almost to his, said, in a terrible voice, "Hark 'e, Tom! —ye think, 'cause I've let you off before, I don't mean  what I say; but, this time, *I've made up my mind,* and counted the cost.
>
> You've always stood it out again' me: now, *I'll conquer ye, or kill ye!*—one ort'other. I'll count every drop of blood there is in you, and take 'em, one by one, till ye give up!"

The ride to Travellers Rest was most uncomfortable for Harriet. She knew each house along the way had servants and field hands—all black slaves. She could not but wonder, *is there a Simon Legree living behind each door? Are the slaves so mistreated even to the point of death? Does my father beat his slaves? I've heard him yell at the slaves, but never beat them. What about John? Does he whip them? Does Claiborne hate me because I'm white and he's black? Is little John and his attitude toward the slaves a Simon Legree in training?* When she arrived, Harriet walked directly to the kitchen. "Cynthia, what do you know about Harriet Beecher Stowe?"

"I never heard of her. Why you ask?"

"Have any of the slaves talked to you about *Uncle Tom's Cabin*?"

"Miz Harriet, we don't have no Tom on da plantation. Who he is? Do he live on yo pappy's plantation?"

"No."

"Cynthia, do you know what the word *abolition* means?"

"No. Does I needs to know?" Harriet did not answer and was out the door when Claiborne called, "Miz Harriet."

"Yes, Claiborne. What do you need?"

"Does ya needs da bag ahangin' in da carriage?"

"Yes, I do. Please bring it to me." He did and she thanked him for it and the safe carriage ride. She watched him drive the carriage to the barn and said to herself, "I wonder what Legree would have said to Claiborne." *It seems to me a natural thing to thank someone—black or white—who does a good deed*

*for you. I thanked Claiborne and it felt like the right and natural action. I could have said "bring it to me," but adding "please" just seemed right. I didn't even think about what I was saying. It just flowed out of my mouth. I've never really thought about my attitude toward the slaves. They have always been around me, from my birth till now. Maybe I'm color blind. Most of the time I don't see color, I see people. But, at the same time, I would not want a slave eating at the table with me. How do I really feel about a free black? A black man took our order at the Hotel at lunch. He brought our food and filled our glasses. I didn't give that a second thought. Harriet Beecher Stowe has really stirred some deep emotions in me. The slaves here on the plantation need me—or do they?* Harriet hung her new dress on the rack in her bedchamber and tucked the *National Era* in with her music books. She determined not to surface the subject of abolition with John.

Harriet wanted to do something extra special for Mary, her mentor. Mary was at the age in life when she didn't need things. She had all she needed and really all she wanted. Her recent trip to Knoxville convinced her that travel was in her past. She enjoyed Travellers Rest and didn't mind telling folk she found fulfillment in being a homebody. Even going to downtown Nashville to shop was low on her priority list. She did look forward to seeing her church friends on Sundays. On pleasant days, she could be enticed to take a carriage ride around the plantation. Her family had always been her joy, but these days finding the right times to visit her grown children was difficult. They were busy with their own families and she didn't like to intrude. For nearly two years her treasured moments were spent with Harriet. They walked on the plantation, took carriage rides to visit neighbors, or checked on the progress of the railroad. One day they ventured out to the peach orchard. The carriage was parked and they walked out to the bluff. From that vantage point, the highest on the plantation, they could survey most of the Overton property. As they faced north toward the city, Mary commented, "Harriet, do you see the highest point there with the outcropping of trees?"

"Yes." Harriet had to shield the sun from her eyes.

"That's St. Cloud Hill. That was Overton property. The Judge bought the land and enjoyed riding up there where he could overlook the city. He left the property to our daughter, Ann, and now it's in the Brinkley family. Someday maybe Hugh or Annie will find a use for it. Over to your right is Nolensville Pike and to your left, nearly to Compton Hill, is our plantation. After the Judge purchased this property from your grandfather Maxwell, he just kept adding other tracts. These trees in the orchard were his pride and joy. After the orchard was established, the Judge bought a slave who knew how to distill the peach crop into brandy. The volume of brandy got so large the Judge shipped some of it to New Orleans, but he always had an adequate supply for his friends to enjoy at the house."

"John talks about coming up here with his father. I believe it's one of his favorite memories."

"John does not care much for the orchard. His interests are more with the railroad. I hope the generations to come will continue this orchard. It has been such a vital part of the Overton land."

"I'm sure when the railroad project is complete, he will have more time to give to the management of the entire plantation." Harriet found herself defending John's time with the railroad project. She knew how important it was to him. He was not a lawyer or judge like his father, but he was making his mark on Nashville. Both Overton men were builders in their own way. Harriet was convinced John was doing what he liked, and that was all that really mattered. Others could think what they wanted; she was content to love him and totally support his dreams.

Harriet decided what she wanted to do for Mary. She would celebrate Mary's sixty-ninth birthday by inviting her children and mates to a surprise birthday party.

"John, what do you think? Can we surprise your mother?"

"Harriet, if anyone can do it, you can. How can I help?"

"November eleventh is on a Tuesday. I would like to have the party at the City Hotel. I believe they have a special meeting room that would be large enough to accommodate us for a luncheon. I want to invite Elizabeth, Mary, Margaret Jane, and of course their mates."

"What about Eliza, James' wife, and Robert Brinkley?"

"Yes, of course, I will include them. John, I want you to make the reservations at the Hotel for the eleventh. Tell the manager I want white tablecloths and napkins, matching china , crystal, and silver. I would also like to have his suggestion for a menu. I want to have an appropriate wine and Overton peach brandy."

"You want brandy for lunch?"

"Humor me, John. Your mother is concerned about the peach orchard. The brandy will reassure her about its importance. She always tells me, 'We cannot have an Overton event without peach brandy.' And I'll count on you to start the toasting of your mother using the brandy."

The following week Harriet wrote personal invitations to the family:

> *Mr. and Mrs. John Overton request the honor of your presence at a*
> *surprise party for Mrs. Mary Overton on the occasion of her*
> *sixty-ninth birthday. The family will gather at the City Hotel in*
> *Nashville on November eleven at one o'clock for the celebration.*
> *The event is to be kept secret.*
> *Your RSVP is requested.*

In a few days, the invitations arrived at the following homes: Mr. and Mrs. John Lea, Mr. and Mrs. Richard Barry, Mr. and Mrs. Jesse Phillips, Mrs. James May, and Mr. Robert Brinkley. The RSVPs came in promptly to Harriet's delight. All of the invitations were accepted. Ten family members would gather to celebrate with Mary, the guest of honor. John had to laugh

when he read the RSVPs. Elizabeth's postscript on her husband's acceptance note read, "Has the seating for the event been predetermined?"

Harriet knew John was reading the Lea note, "John, I'll count on you doing the seating arrangement."

"Harriet, I've noticed you seem to have a better understanding of Elizabeth than I do. Why do you think that is?"

"Elizabeth and I are the youngest children in our families and we require more attention. And mister, don't you ever forget it!"

"Yes, ma'am, that makes everything much clearer. Thank you."

A week before the surprise party, Harriet told Mary she and John wanted to take her to lunch on her birthday. "We will drive into the city and meet John at the City Hotel."

"I don't need anything fancy," was Mary's usual response.

Tuesday morning, November eleventh, carriages from various parts of the city made their way to the City Hotel. Harriet had Claiborne add the wind protectors to the carriage, but it was such a fine day they were really not needed. The ladies wore their winter wraps and felt warm enough even when the carriage traveled under large trees, temporarily blocking the sun's rays. As they rode past the depot on Broad Street, Harriet pointed out the building to Mary. "That's just a part of what your John has been doing with his time. That's where passengers will soon enter and exit the railroad cars. They will board the train there and pass right by Travellers Rest on their way south to Alabama. You'll be able to ride the train to Franklin, Columbia, Pulaski, and all the way to Decatur."

"Did you know the Judge rode on horseback to those communities to hold court? He made a lot of friends in those little towns. He would stay overnight in homes when there were no boarding houses available. I need to take you to those parts of Tennessee some day. Some of the Hogan family still live in that area."

"I would like that very much. The Hogans? Are they related to the Hogans we know?"

"Yes, the same family." The ladies continued on to the hotel.

John was waiting at the main door of the City Hotel. "Here's the birthday girl."

"I wish. Son, at sixty-nine I'm too old to be called a girl. You can call my carriage mate a girl, if you like. Today, I'm fifty years older than Harriet."

Harriet smiled at John and shook her head. "Is everything ready for us?"

"Yes, our table is waiting." John gave her a look that said, *thank you for caring about Mother*. Mary held on to her son's arm as they entered the lobby. She turned and noticed Harriet was following some paces behind. "Wait, son," Mary said in a whisper, "you have another lady to escort." He entered the dining room standing as tall as he could, escorting two Mrs. John Overtons— one tall; the other a bit shorter and much younger. The headwaiter directed the trio to follow him. He pushed open the double doors and out came the happy

sounds—surprise, Surprise, SURPRISE! Mary squeezed John's arm, and it brought a larger than usual grin to his face. Elizabeth had positioned herself to be the first to greet her mother. "Are you happy with our surprise birthday party for you?" Mary scanned the room and looked at each face. Her semi-trance was broken by hearing, "Mother . . ."

"Yes, Elizabeth, I'm very happy and very surprised. Thank you."

At some point during the next two hours, each guest came by to greet Mary. Each hug, each kiss, each word allowed her to recall memories—some happy, some sad, but all appropriate. As the dessert plates were removed and wine glasses refilled, John tapped his glass to get everyone's attention. "I believe it would be appropriate to share a toast with the birthday girl . . . I mean birthday lady."  Robert stood and remembered how he had been accepted into the Overton family when he married Ann and remarked that her memory was especially strong today. Mary Barry, the oldest living May child, said tearfully, "Mother, happy birthday to you from Anthony, Andrew, and James—your sons who have passed on, but whose spirits are here to greet you today." The birthday lady sitting with John and Harriet blew a kiss to her oldest child and mouthed, a *Thank you*. Elizabeth scooted her chair back, but Margaret Jane stood first. "Mother, this has been a special day for all of us— Mays and Overtons. I hope we will plan to do this again. Happy birthday." Now it was Elizabeth's turn and all eyes focused on her as she stood. "Mother, happy birthday. I'm glad we surprised you. This has been a hard secret to keep these last few weeks." There were nods of agreement and smiles around the table, knowing it was Elizabeth speaking. "You are a special lady. You have been able to blend your two families and make us one big family. Thank you, and you have my very best wishes on this special day."

"Thank you, Elizabeth." Mary chose to remain seated. "And thank you all for coming and making this day very special for me. I don't know how many more birthdays I will celebrate, but I will always remember this one."

"Before we depart," John stood, "I would like to say a few words." Two waiters entered the room carrying small glasses of brandy and placed them in front of each guest. "This special day would not have been possible without the First Lady of Travellers Rest." Glasses were lifted and clinked throughout the room. "And without the second First Lady, Harriet Virginia Maxwell Overton, who insisted, while planning this event, it would not be an Overton gathering without Overton peach brandy." No one in the room was more pleased than the First Lady. She lifted her glass, bypassing John, and found Harriet's glass. "Harriet, I love you as much as any of my natural born children. You are God's gift to me in my old age. I pray that one day you will have a daughter-in-law as loving and kind. Thank you so much."

The holiday season was right around the corner. Plans were made for the Twelfth Night celebration at Travellers Rest. Harriet and Mary spent time together and enjoyed the season. Family and friends visited and houseguests were welcomed. John appeared to be busy with his railroad project but was

encouraged privately, by both wife and mother, to stay home and enjoy his family. He took their advice and was glad to enjoy the slower pace.

Elizabeth Overton Lea insisted on having the party of the season at her home. No one resisted her offer. On the evening of the party, guests arrived to find the modest house a showplace. It seemed the Leas had spared no expense, and Elizabeth flitted about her guests with ease and grace. She was, as always, the perfect hostess. She greeted each guest by name at the front door, and by her practiced gestures, guided them to the lavish bounty waiting in the dining room. She was preoccupied giving instructions to a servant when Harriet arrived with John and Mary. Elizabeth had fully intended to be at the front door when her mother arrived. Harriet handed her full-length cape to the servant and took a quick look at her hair in the hall mirror. Mary moved toward the dining room and was met by her daughter. "Mother, when did you arrive? I'm sorry I was not at the door to greet you. I was busy with one of the servants. You look wonderful! Did John and Harriet come?"

"Oh yes, they're taking off their wraps. They're in the hallway. Elizabeth, I need to use the necessary."

"You can go to my bedchamber. Becky will be in there to help you. If you will excuse me, I must attend to my other guests." Elizabeth spotted John, head and shoulders above the rest, standing with a group of women. As she approached, they parted to reveal Harriet standing and chatting, exquisitely dressed in a black velvet gown. It was tailored to highlight every positive feature. The black velvet enhanced the strand of matched white pearls and earbobs. When she turned her head ever so slightly, the pearl and silver hair combs picked up the light from the many candles in the hallway. Harriet was stunning. She knew it, Elizabeth knew it, and most of all, John knew it. He did not leave her side the entire evening, afraid he would miss the compliments she was receiving. The party, as Elizabeth had hoped, was a huge success. Everyone who attended said so. But the highlight of the event was the nineteen-year-old charmer in the black velvet gown.

The New Year brought more birthdays, anniversaries, and life-changing events. Harriet reached her second decade. Being twenty didn't feel much different. John added another necklace to her collection, and she wore it when they celebrated their second wedding anniversary. John arranged for a long weekend at the City Hotel with breakfast in bed and a drama at the Adelphi Theatre. He had another treat for her waiting at the depot. The Nashville & Decatur line had its first passenger car and it was ready for a test ride. When she walked into the depot with John, several people were already in the car. She recognized the Mayor and his wife; John Lea waved; Mr. Lapsley from the Academy with ten young scholars from the Current Affairs Class; the pastor of the First Presbyterian Church; and seated near the front was little John Overton. "Harriet, I thought you might enjoy taking the first passenger train trip from Nashville to Franklin."

"What a treat. Did you arrange for all these passengers to be here?"

"Yes, I thought you might like some company." Harriet politely greeted her fellow passengers, the whistle blew, the car lurched forward, and then smoothed out. John suggested the windows be closed to keep out the cold. The girls from the Academy were full of giggles until Mr. Lapsley gave them the look. Harriet had often experienced his look while she was a student there. Little John had his nose pressed up against the window, and a little circle of fog formed each time he breathed. His father was more excited than anyone in the train car. He had ridden in other cars before, but this adventure was on the railroad that had been his dream for years. Seeing the backs of buildings and homes was a different feeling. In what seemed like only a few minutes, the train was passing St. Cloud Hill and soon afterward, the Thompson property at Glen Leven. John pointed to the right and there was the Overton peach orchard. Without warning, little John stood up and pointed, "There's Travellers Rest! That's where I live!" All heads turned in the direction that he was pointing. Harriet caught his excitement. "I do declare, John Overton, this car nearly passes through our back yard."

"Coming up next will be our station. Do you want to get off?" The whistle sounded as they passed through the property.

"Not on your life! This is too exciting! I want to go all the way to Franklin."

"Let's see, I think the Brentwood station is next, then a couple more stops, then we'll be in Franklin."

"John, how will we get home?"

"Since the train only has three cars, the engineer will use the side rail in Franklin to turn them around and head back to Nashville."

Little John added, "That's why there are two sets of tracks—one for going and one for coming." He was glad he had listened when his father told him about the double tracks.

"Well, aren't you the bright one." Harriet knew little John liked compliments.

"And when we get back to our station, the train will stop and you can get off. I bet there will be a carriage waiting for you. I'm planning to ride back to Nashville with Father."

"It sounds like you know a lot about the train. I'm proud of you." Harriet patted him on the back, which was her way of giving him approval.

That evening at dinner all little John could talk about was his train experience. "Grandmother, today has been very exciting. I wish you could have been there."

"Perhaps next time I will join you, when the weather is a little warmer."

"It was not cold in the passenger car. We put the windows down and there was heat on the floor from the engine. Did you know the Overtons have their own station? It's not far from the crossroad. When we came back from Franklin, the engineer blew the whistle and stopped right at our station."

Harriet was enjoying the adventure from a child's viewpoint. "Tell me, little John, which did you like better, the boat or the train?"

"Oh, the boat because I was able to blow the whistle. Maybe when I get to blow the train whistle I'll like it better."

"Well, son, maybe I can arrange for you to ride with the engineer. That would give you an opportunity to blow the whistle."

"Father, when can you make the arrangements?"

"We still need to do more test runs. We need to test the strength of the engine. We need to know how many cars it can pull and, also, how many fully loaded cars it can pull. The construction crews want to test the railroad beds."

"What's a railroad bed?" Harriet and Mary were also interested in knowing what John was talking about.

"The rails need to be as level as possible. That helps the entire train run smoothly. Sometimes when the rail is placed near a river, the ground is soft and the weight of the train might sink the rail and cause a wreck. So the construction crews make the beds strong by placing rocks as a foundation. If that doesn't work, they may need to build a bridge for the train. That's one of the problems we are having in Decatur. We need to cross the Tennessee River. As soon as that can be finished, our railroad line and the Chattanooga & Memphis line can be linked."

"When will all of that be finished?" Harriet was very pleased with little John's interest in the project, and so was his father.

"I'll tell you what, son. When the weather warms up a little, we'll make a trip south to Decatur and find out. In the meantime, I'll keep asking the engineer to find a time for you to ride with him."

"Thank you, Father."

"Since the four of us are here, there's something else I'd like to talk about."

"And what is that?" Harriet had no clue but was anxious to hear what her husband had to say.

"Little John is now ten years old and ready for his away-from-home experience." Mary remembered the day the Judge said the same thing about their son. John had just turned ten and the Judge sent him to New Orleans. Eli, the slave the Judge bought to care for John, went along as a companion. John had missed the last two years of his father's life. That was a fact Mary always questioned about the New Orleans experience. She was hoping the process would not be repeated, but it sounded like it was going to happen. She thought as John continued to speak, *if I do not challenge this idea, I will have no peace in my heart.* "Son, what value did your time in New Orleans have on your life?" Mary jumped into the conversation and hoped for the best. Harriet knew John's thinking about this and determined not to comment unless called on to do so.

"The time I spent in New Orleans allowed me to encounter a different lifestyle. I grew up here on the plantation and never knew anything else. When

I was a boy, the city of Nashville was growing but it was still rather small. New Orleans, on the other hand, was a thriving city. It was a city filled with different languages and cultures because it was a seaport. The food and restaurants were amazing. The entertainment in the city allowed me the opportunity to learn how to dance and appreciate music." Harriet had to smile at that comment. John was light on his feet for such a large man. He was very skillful when they danced together. "I had to learn French to survive. If you will remember, Father arranged for me to stay with a French-speaking family."

"And do you think your son will benefit from a similar New Orleans experience?" Little John was totally engaged in what he heard but was very anxious about his father's response to the question.

"Last summer when we visited New Orleans, he told me he did not like the place. I want to honor his feelings."

"So what do you have in mind?"

"I thought Memphis would be an ideal city for him." A broad smile came to the ten-year-old's face, and to Mary's, and to Harriet's. "With the railroad connections, he can travel by rail and the trip will be an easy one."

"Where will he stay?" That was exactly the question little John was about to ask. John pulled an envelope from his coat pocket and removed three sheets of paper. Harriet recognized the envelope from the stack of mail in the hallway. "This is a letter from Robert. He is moving to his Memphis home immediately. He makes no mention of the Jackson estate."

"Did he say anything about matrimony?"

"No."

"What is mat-ri-mo-ny?" Little John was very careful to sound out each syllable. Harriet could remember the countless times she had done the same thing for him when he was trying to pronounce new words.

"Matrimony means getting married." His grandmother was kind in her answer and hoped it would appease her grandson's inquiry. "So what else does Robert say?"

"He would like for our John to come for a long visit soon. He's anxious for John and Hugh to have some time together similar to what John and Annie had here."

"What about his schooling?"

"Robert mentioned the possibility of John coming to Memphis when he was here for your birthday party in November. I had the same question about schooling. He was planning to put Hugh and Annie into a private school when he moved. He was hoping to find a school for them to attend and still live at home. From his letter, he seems to have found just that. He's certain John would have no problems enrolling. He has a private room for John at his home, or the two boys could room together. Robert has a full staff of house servants in Memphis. The situation seems ideal for John. What do you think, John?"

"Father, I was planning to help you with the railroad project." John fully acknowledged his son's comment. "I enjoy my school here, but when I come home there are no other children to play with, and I don't like playing with the slave children. If I went to live with Uncle Robert, Hugh and Annie would be there. But the best thing about living in Memphis would be learning more about the Overton property."

The last statement from her grandson made the most sense to Mary. Her son, John, had little interest in the Memphis property. His priority was the railroad and when that was finished, she was certain he would find another project. That's why she continued to work with the Overton agent in Memphis. Maybe with proper tutoring and a business education, her grandson could some day take over the responsibility of the Overton property. She motioned for little John to come to her. She put her arms around him. "You are wise beyond your years. If I didn't know better, I'd swear you don't have a drop of May or Harding blood in you. You are one hundred percent Overton. You walk and talk like your grandfather Overton and now you even think like him." She looked over at her son, "John, I can support whatever you decide."

Harriet had been noticeably silent during the conversation. "Harriet, what is your thinking about all this?" John realized his wife was blessed with good judgment and he counted on her thoughts. "It appears to me the matter has two sides. Little John should have a say in his future. He's already told you he didn't like New Orleans. The other side is yours as his parent and guide. You know some of the pressures he will face when he goes away because you had a similar experience at his age. You can tell him what to expect and then stay in touch by mail or wire. Both sides seem to agree on Memphis. Little John will not meet your expectations if he does not know what they are. He may not want to be a businessman like you, just as you chose not to be a lawyer like your father."

Mary hung on Harriet's every word and remembered the Judge's similar words: *Mary, I have no idea what our son will make of himself. We have talked about him studying the law, but he has no interest in it nor in medicine either. He doesn't talk about any particular profession. He may find fulfillment in life being a farmer and running this plantation. In any event, he needs to widen his horizons. I think a few years in a totally different environment will help him. I want to provide him with all the educational advantages available. I really feel he's destined to make his mark in life in his own way.* "What did your father expect from you? That may be a starting point."

"Well, Mother, you may need to help me here. Father wanted me to be happy; he wanted me to do what I wanted to do, but he expected me to be the best at what I did."

"The Judge wanted you to experience a totally different lifestyle than what was here on the plantation. That's why he chose New Orleans. He talked about expanding your horizons. At one point, he talked to his brother Thomas about

you having a military career. He thought you were too quiet to be a politician. I thought you would have been very impressive in a pulpit."

"You mean as a minister?" John's laughter at the thought brought big smiles from the other three.

"Yes. If it was preordained, that's what you would have been. But it didn't happen. Back to your son. Harriet is exactly right. You need to tell John what you expect of him and give the rest to the Lord to work out." John stood up, walked to the window, looked out, and pondered his mother's words. *What you expect of him. You need to tell John what you expect of him. I've never given the matter that much thought, but she and Harriet are right. John needs to know what I expect of him.* While John was deep in thought, Harriet walked over to the writing table and found some paper, a sharp quill, and a bottle of ink. She wanted little John to have, in writing, what his father expected.

"Son," John continued to stand and Harriet was prepared to record, "There are seven things I expect from you:"

1. Find in life what makes you happy and pursue it.
2. Acquire all the education you can to help you in your pursuit of happiness.
3. Do unto others, as you would have them do unto you.
4. Respect and honor your family and your heritage as an Overton.
5. Do something in life to help the next generation.
6. Be honest, truthful, and a man of your word.
7. Respect your freedom.

"Do you understand, Son, all the words I've said?"

"No. What's the 'next generation' and what do you mean, 'respect your freedom'?"

"The next generation is those people who come after you. You will come after me as I came after my father. I am building the railroad for you and the people who will come after me."

"Yes, now I understand."

"And your freedom is very important. If you don't respect your freedom, you could lose it."

"Do you mean I might become a slave?"

"No, nothing like that. What I mean is . . ." John could not find the correct word, although he thought of several ideas. Harriet looked up from her writing and noted a look of bewilderment in his eyes. "What your father may mean is, your grandfathers and our grandfathers had to fight the British to gain freedom for themselves. If you don't protect your freedom and respect it, someone could come and take it away. Do you remember the stories your father told you in New Orleans about Andrew Jackson?"

"You mean when he left Tennessee and went to New Orleans to fight the British?"

"Yes. What do you remember about the fight?"

"The Red Coats came all the way from England to fight and take New Orleans away from us. If they had won they would have taken New Orleans, and then Louisiana, and then Alabama, and then Tennessee, and then Virginia, and then all of America. Then we would have a King rather than a President."

"I could not have said it better myself. Now, do you have a better understanding about your freedom?"

"Yes, ma'am, I do. Thank you. When will I be moving to Memphis?"

"I'll send a wire to Robert and we'll determine an appropriate date. In the meantime, I'd like for you to study the seven things I've suggested to you, and when I hear back from Robert, we can make plans."

"Very good, Father. By the way, how old did you say my cousin Hugh is?"

"I believe he was born in the same year as you. Isn't that right, Mother?"

"Yes, I believe the two of you are the same age."

Less than a week had passed when a wire came from Robert in Memphis indicating that all arrangements were in place. Hugh and Annie were excited their cousin was coming to stay with them. His arrival would help them in their transition to their new home and environment. The schoolmaster had been contacted, and he was willing to accommodate the Overtons by enrolling John in his school. The building he was using for his school was owned by the Overtons, making his decision an easy one.

The Overton agent in Memphis had responded to Mary's wire inquiring about tutoring John in the family business. He was more than willing to work out a schedule and could include Hugh if he wanted to be involved. *Two grandsons in the family business*, Mary thought, *might someday soon relieve me of more responsibilities.* She was happy to share the information with John and they both realized it would be a great opportunity for the next Overton generation.

Claiborne was able to locate one of the travel trunks in the barn. He cleaned it up and brought it up to the house. Harriet worked with little John, helping him try on his clothes. Whatever he had outgrown was given to the slave children. He would be taking all his clothes with him to Memphis. She made a list of clothing items he needed. John could purchase them in the city and then the packing could be completed. The last item to be packed was the list of seven expectations from his father recorded by Harriet. There was a document pocket in the trunk, and he placed the paper there for safekeeping. "John, the items on that paper will be your constant link to your father. Those are the same expectations he has for himself."

"Yes, ma'am." He was snapping the latch as he spoke.

"I'd suggest you review the seven items each week until you can say them from memory. From now on when you have a decision to make, your father's wisdom will be there to help you. Right now, they are words on a paper, but if you will allow them to become a part of you, they will be guidelines for the

rest of your life. You are a very fortunate young man to have a father who cares enough about you to give you a set of guidelines."

"Harriet, when will I be coming home?"

"You can come anytime you choose. However, I'd suggest you develop a routine in Memphis with your schooling, learning the Overton business, free time activities, and getting to know your cousins. Now, I suggest you go downstairs and visit with your grandmother for a while. Tomorrow you and your father will be traveling to Decatur for you to catch the train to Memphis." Harriet checked the trunk latch and hooked the leather straps. John went down the steps to find his grandmother. He spotted her in the corner of the large room sitting on the sofa. He stuck his head in the room, "I've been looking for you."

"Well, it looks like you found me. Come on in and let's talk. What have you been doing this morning?"

"Harriet has been helping me pack my clothes—the old ones and the new ones Father bought for me. The trunk is full."

"I understand tomorrow is the big day for you."

"Yes, ma'am. Father and I will be traveling to Alabama. I'll be catching a train there for Memphis."

"Are you excited about this new adventure?"

"Yes, ma'am. I'll be living with my cousin Hugh. He's my age. We'll be going to school together."

"That will be great. Two of my grandsons will be living together." A wrinkle appeared on John's forehead. He didn't quite understand the part about two grandsons.

"I didn't know Hugh was your grandson."

"Yes. You are my grandson, Hugh is my grandson, and I have three Lea grandsons—John, Luke, and Robert. I also have grandsons on the May side of the family." John shook his head and his grandmother laughed.

"How do you keep up with all that information?"

"That's the duty of a grandmother. She keeps up with her children and grandchildren." The visit went on for another half hour, to the delight of Grandmother Mary.

Early the next morning the Overton men were on their way south. Cynthia packed a big basket of food, the type a growing ten-year-old likes to eat. Harriet and Mary stood on the back gallery waving as Eli drove the carriage away. Both ladies realized a child was leaving, but someday a man would return to continue the Overton legacy. The ladies returned to the house. Mary headed to her room; Harriet went upstairs to do some rearranging of the furniture in little John's room. She stopped long enough to look through the mail stacked on the hallway table. The latest issue of her fashion magazine was on top, hiding three letters tied together with a brown string. She recognized the stationary. There were three letters from Annie, but she

wondered why there were three. She opened each one and checked the dates. They were written on three consecutive Tuesdays.

Annie and Thomas had taken a weekend trip just inside the Mexican border. She was very informative about what she saw and some of the strange foods they experienced. In the second letter, they were back at the fort. She was meeting with an older military wife, learning to sew on her new machine. Harriet was pleased to learn the sewing machine was the ideal wedding gift. The third letter had the information she was looking for—a clue as to why the three letters had arrived at the same time. It seems Thomas had the responsibility of mailing Annie's letters. He apparently forgot to mail the first two. Harriet had to laugh, thinking Thomas was just a typical new husband. Anyway, the three letters would be her and Thomas' secret. The next time she wrote Annie, she would need to pose a question about the Mexican food and also mention the sewing lessons. Now that little John was on his way to Memphis, Harriet would have a little more time to correspond with Annie and enjoy the pleasure of reading.

By October, the Overtons were adjusted to not having a child in the house. The routine of plantation life was quite normal. Conversations at mealtimes focused on adult topics. John shared progress reports on the railroad. He read notes from Robert Brinkley stating that little John was making a good adjustment to his new home. The summer months had allowed the boys to bond, and they were almost like twin brothers. School had begun and the boys were making good progress. Their English teacher was requiring them to express themselves in writing. Hugh was struggling; John was flourishing. John had sent one of his papers in the mail for all to see. The title of the paper was, *"Guidelines to Live By."* John had written seven guidelines. At the top of the paper the teacher had written, "Excellent work, John. Well thought out and precisely written." At the bottom of the paper was a brief note in John's handwriting, "Thank you, Father. Well done! Your son, John." John smiled broadly as he passed the paper to his mother, then to Harriet.

News of national events came to Travellers Rest either by Nashville newspapers or gossip heard on Sundays at church. Everyone was talking in whispered tones about the new book, *Uncle Tom's Cabin*, and the lectures of Frederick Douglass. Reports on the antislavery movement were in the headlines of every newspaper. Even the presidential election between Franklin Pierce and General Winfield Scott seemed to be second-page news. John felt the abolitionists were getting way too much attention in the newspaper and stopped it for a while, until the ladies at home insisted he bring the newspaper to them.

Letters from Annie were filled more and more with military language. She was learning a whole new vocabulary; sometimes it made sense, sometimes it didn't. According to Annie, the military lifestyle was the only way to live. She was becoming a promotional agent for Texas: Everything was bigger in Texas.

The sky was bluer. The roads were longer. The longhorn cattle were larger. The farms-ranches, she called them-had more acres. A twenty-seven-year-old named Richard King had bought 75,000 acres to raise cattle. Harriet pondered the facts; *I wonder whether Mr. King has three or four cows to fill up his ranch? Since everything is bigger in Texas, it must be three!*

Harriet loved to ride her horse. She had become very proficient at the Academy, but married life did not allow much time for riding. One autumn morning she decided to treat herself. After breakfast, she dressed in her riding clothes and had Claiborne saddle her horse. He helped her get up on the horse. She felt a button pop on the back of her dress. *Not to worry,* she thought, *my coat will cover it. I'll have Cynthia look at it when I return.* She rode over to the Hall to visit with her father, Myra, and hopefully Mary if she was at home. By the time she arrived, her face was flushed and she had a pain in her back. *I am getting out of shape. A twenty-year-old should not be feeling this way after a short horseback ride.* Edward was walking up from the barn when she got to the house. "I do declare. Yous looks just likes Miz Harriet whos used to lives here."

"Edward, you old sweet man. Come help me off this horse." When her feet hit the ground, the pain hit again. She held on to Edward to catch her breath.

"Is ya all right, Miz Harriet?"

"Yes. I'll be fine, Edward. Can you go in the house and tell Mr. Maxwell his youngest daughter is here for a visit?" Julia was coming out the door and passed Edward. He turned toward Harriet and pointed not saying a word. "I not believing my eyes! Is that you, Sabbath Child?" Julia's body was bent over after all the years, and she took her time getting down the front steps. She really needed to use a cane but was too vain to use one.

"Julia, I need a hug." The hugging routine had been going on for twenty years and neither one tired of it. Julia gave Harriet her usual two-armed hug around the waist. Harriet flinched.

"What the matter with you, child?"

"I think I pulled something in my back."

Julia stepped back, looked Harriet in the face, and placed both hands on her stomach. "It not the horse ride over here, Sabbath Child, you with child." Julia's smile was so big and full of teeth Harriet nearly missed the words, "you with child."

"Julia! Julia! Are you sure?" Tears were filling her eyes.

"Is dat da sun a shinin' up dere?" She pointed and looked at the same time. Julia had used the same expression with the Maxwell girls for so many years that they still used it with each other.

Jesse appeared on the porch and was all smiles to see his youngest daughter. "To what do I owe this pleasure?" Before he came down the steps, Harriet turned to Julia and whispered, "Please do not say anything." Julia nodded. Jesse grabbed Harriet and swung her around. Julia moved next to

them, "Massa Jesse, you needs to remember Miz Harriet is a married woman. You can't be handling her likes dat." She pulled them apart and held on to Harriet.

"Yes, I know. I'm just so happy to see her." Julia tightened her grip on Harriet's arm, guided her up the steps, and into the house. Myra and Mary were seated near the fireplace in the open area. "Hello ladies," Harriet's cheery voice filled the room. Julia left the room humming a hymn tune and smiling. "What brings you to the Hall?" Mary was interested because Harriet did not visit on a regular basis. She handed Annie's three letters to Mary and then sat in an empty chair facing Myra. "And Myra, how have you been?"

"I'm doing just fine, thank you. And how are the Overtons?"

"Mary is healthy and John is busy with his work. Little John has gone to Memphis for schooling and bonding with his cousins. And I'm still trying to learn how to manage the household." An hour passed with everyone having a part in the conversation mostly about Annie and her Texas adventures. When Harriet left the Hall, she was riding in a small wagon next to Julia in the driver's seat. Harriet's horse was tethered to the back of the wagon. "Miz Myra, I takin' da Sabbath Child home sos we can visit." The truth was that Julia didn't want Harriet on the horse with a chance of falling off before she got home. "I's be back shortly." The Maxwells waved, unaware of the secret leaving on the wagon.

Julia waited for Harriet to break the silence and it didn't take long. "Julia, how did you know about my condition?"

"Ya have all da signs in ya face, in ya back, and in ya belly. When da last time ya had da visit?"

"You mean . . ."

"Yes, da woman visit!"

"I missed last month and it's about time for this month."

"Ya waits two mo weeks. Don't tells nobody ya feelins. I's come back in two weeks and we talk." Harriet always thought of Julia as a member of the Maxwell family. She never remembered thinking of her as a slave or a servant. Julia filled the void when Harriet's mother died. She always had a listening ear and sound advice for a child growing up without a mother. Harriet followed the directives without question.

Two weeks seemed like an eternity for Harriet. She was having unusual feelings. At meal times, food had no appeal, which was a first for her. The cologne Mary wore was becoming very strong, almost stifling. For the last two mornings, she had been sick on her stomach and skipped breakfast. At dinner John commented, "Harriet, you don't eat enough to keep a bird alive." He was becoming concerned and mentioned it to his mother after Harriet excused herself from the table.

Right on time, Julia appeared at Travellers Rest on the fourteenth day. She had in her hand the three letters from Annie. That was her official reason for seeing Harriet. When Julia saw her sitting in the rocking chair on the gallery,

flashbacks of Harriet's mother, Martha, came to her mind. Harriet had the same gray hue to her skin. Her eyes had dark circles under them and they looked dull.

"My, my, lordy, my, just look at ya, Sabbath Child." There was never any doubt who was in charge when Julia was around. She walked down the gallery, pushed open the kitchen door, and hollered for Cynthia. "Gets me some hot tea, some day-old bread, and makes some chickin broth. Brings it to Miz Harriet's room." On the way back to Harriet, Julia spotted a house servant cleaning the large room. She motioned to her to come outside. "I's needs ya to helps me with Miz Harriet." They managed to get Harriet to her room and into bed. "Yous go find me a basin of well water and some small cloths." Julia continued to give orders.

Hearing all the commotion, Mary came out of her room. She recognized Julia as being a Maxwell slave but could not recall her name. "What's going on here? What are you doing in Mrs. Overton's bedchamber?"

"Dis child am sick. I's be here to help her."

Harriet opened her weak eyes, lifted her head, and spoke in a whisper, "This is my mammy, Julia. I need her help." She closed her eyes and her head sank into the pillow.

"Julia, what can I do to help?" Mary was very concerned.

"We needs some fresh air in dis room. Yous can open all da windows . . . please. And tells Massa Jesse I's here."

Julia did not leave Harriet's bedchamber for three days. She continued to give orders and they were followed without question. On the fourth day, Harriet felt much better. She was sitting up in bed and color was back in her face. John stuck his head in the room without saying a word. He looked first at Harriet and then at Julia, who was still giving orders.

"Massa Overton, yous come in here and sits in this chair next to yo wife. She has somethin' to tells yous." John entered and sat in the chair as directed. "Sabbath Child, I's be goin' back to da Hall. Yous needs a full bath and then walks around some but not too much. Yous needs to tell your husband somethin'."

"Thank you, Julia, for everything. What would I ever do without you?" Harriet pulled the old slave to her and gave her a kiss on the cheek. Tears ran down both their cheeks and blended together. Julia pulled the door shut behind her until she heard the latch click, leaving Harriet and John alone in their bedchamber.

"Harriet, you have something to tell me?"

"In May or June of next year there will be a new Overton in the family. John, you are going to be a father again." John could not hold his joy inside. He clapped his hand and did a jig on the wood floor, causing quite a racket with his heavy boots. His reaction gave Harriet a wonderful feeling and offset, somewhat, the fact that she was about to throw up.

# 10. Growing the Family

The focus at Travellers Rest temporarily changed in late 1852. John continued to work on the railroad project. He rarely took overnight trips but counted on his partners to pick up the slack. He read every word on the progress reports that came to him on a regular basis, marking those items needing followup or jotting down questions. He occasionally read parts of the reports to Harriet. He wanted her ideas and evaluation. He chose carefully any intrusion on her time and respected those days when he could tell she was not feeling well. Since he was at home more, he instructed the house servants to come to him for their concerns. It was his plan and intent to protect Harriet at all costs. His memory of Rachel and her struggle during pregnancy made him overcautious. He did not want the same fate to claim Harriet.

The very day he learned of Harriet's pregnancy, John called the house servants, Cynthia, and Claiborne to the gallery near the kitchen. "I wanted you to know Mrs. Overton is with child. She will deliver next summer. I expect you all to keep her condition in mind as you serve her. I want her every request honored by you with no questions asked. Cynthia, if she wants certain food at unusual times, try your best to meet her needs. Those of you working in the house, I want you to arrange your work so one of you will be near Mrs. Overton at all times. In a few months she will need some help adapting her clothes. If you have any questions about your duties, come to me or my mother, Mrs. Overton."

"Massa Overton, Miz Harriet have a way 'bout her to be independent."

"Cynthia, you are exactly right. Do the best you can. I'll talk with her and tell her what I have told you. That may make our care of her a little easier. I'm sure you have things to do. You are dismissed."

Cynthia had one more comment and, in her usual manner, spoke her mind. "One more thing, Massa Overton."

"Yes, Cynthia."

"We's happy for ya and Miz Harriet." John acknowledged the comment with a smile and a nod.

Harriet was seated at her writing desk in the hallway outside the lower bedchambers when John entered the house. "Good morning, my little mother. How long have you been up?"

"I heard you get up, and I was out of bed before you had your first mouthful of breakfast. I want to start a letter to Annie and let her know our good news."

"How do you want to tell our other relatives our news?"

"I plan to tell Elizabeth this Sunday at church, and that should be sufficient." John's laughter was his agreement with the plan. "I'll send Robert a note, and I think it would be wonderful if you sent a letter to your son. I plan

to have a long visit with him when he's here for the holidays. I want him to understand that his position, as first son, will not change with the birth of our child. John, he also needs to hear that from you."

"Thank you, Harriet. You always handle family relationships with ease. Speaking of relationships, I talked to the house servants, Claiborne, and Cynthia this morning. I told them about your condition."

"Let me guess. You told them to treat me with extra special care. I've become this little weak, frail girl who's going to have a baby. I may do crazy things, but they are to smile and say, 'yes, ma'am' all the time. Is that what you told them?"

"Well, I didn't use those exact words."

"John Overton, you listen to me! I appreciate your love and care for me, but I'm not the first woman in the world to give birth to a child, and I won't be the last. Your mother is going to be with me each step of the way. Julia will be with me when the time comes. I want you to continue working, and I don't want you underfoot every moment until the child comes. I'm happy you talked with the slaves, but I need to be me. Now, go build a railroad or something; I need to write Annie."

"Yes, ma'am. May I approach the queen for a royal kiss?"

"Yes, you may." John bent over and kissed Harriet. She put down the pen, grabbed his face in her hands, and gave him a long, passionate kiss. After John left she stared at the blank piece of stationery, then finally picked up the pen and began writing a letter to Annie.

*My dear sister Annie,*

*I have the most wonderful news to share! I'm with child and our Julia tells me I should deliver by next summer. Julia knew my condition before I did. I made a visit to the Hall to share your letter with Mary and Father. I rode my horse and experienced some back pain. Julia came to me. She looked into my face, put her hands on my stomach, and told me I was with child. I questioned her and you know what she said, "Is da sun a shinin' up dere?" (Ha, ha) I was very sick last week, but mammy Julia came and nursed me back to health. Mary (mother-in-law) is so helpful. She anticipates my every need and tells me ahead of time what to expect. She is wonderful to me. I may have already told you, but little John is spending time in Memphis with the Brinkley family (my brother-in law). He is having a great time with his cousins, Hugh and Annie. He will be back at TR for the holidays. I pray all is well with you. My love to Thomas. The Maxwells are all fine and send their love.*

*Your loving little sister,*
*Harriet*
*2 November 1852*

Mary was a constant companion for Harriet. They saw each other every day. She told the mother-to-be what to expect as her body changed, as her

mood made unexpected swings, and as food became unimportant and then very important. Mary suggested, and Harriet agreed, there would be no overnight guests in the house during the holiday season. Celebrations would be kept low key. The family would celebrate the Twelfth Night and light the Yule Log, but other festivities would be kept to a minimum. The slaves had feared they would be forgotten during the season, but Harriet insisted they be given their usual gifts of new clothes, shoes, and, in some cases, gold coins. John continued the tradition begun by his father and ordered fresh fruit from New Orleans for the house. Each room had the smell of fresh citrus mixed with cloves. Harriet presented each slave child with a selection of fresh fruit, hoping it would make their holiday happier. The regular candles in the house were replaced by French-scented ones and added to the smells of the holidays.

Even during the holidays, some routines were required on the plantation. The animals had to be cared for, meals had to be prepared, the smokehouse had to be filled with freshly butchered meats, firewood had to be collected, and the spinning wheels and loom were never idle. Other than the routines, plantation life during the winter celebration was lived at a leisurely pace.

The big event of the season was the anticipated arrival of little John. He had sent a note to his father asking permission to bring Hugh with him. Harriet suggested, "This might be a good time for a name change. We have called your son little John all these years. Now might be the right time to call him John. We don't want to embarrass him in front of his cousin."

"Won't it be confusing having two John Overtons in the house?" A sheepish grin came to Harriet's face, and John knew something funny was coming.

"Well, we could call you big John. How would that be? Maybe we could refer to you as number two and him as number three."

"No, I believe we'll go with John and John."

"Good. Send John a note today and tell him we are looking forward to having him and Hugh home for the holidays. Would you help me do something special for your mother while John is home?"

"What?"

"I believe it would be fun to have a luncheon here at the house for her and her five Overton grandsons. John and Hugh will be here, and I could invite Elizabeth's three sons. Elizabeth could help me with the event."

"Do you also want to invite the May grandsons?"

"No, not this time. I believe five young lads will be quite enough for your mother and the house." John knew she was right, and he appreciated her constant efforts to do nice things for his mother.

Harriet had a dual purpose in wanting to visit her sister-in-law, Elizabeth. She wanted to get Elizabeth's reaction to the Lea grandsons coming for a luncheon with their grandmother, and she wanted to give her a verbal RSVP to the Lea holiday party. Claiborne prepared the winter carriage.

Winter winds and cold temperatures had arrived in Tennessee, but they were a welcome relief from the hot, humid days of late summer. Harriet would take the cool weather compared to the heat anytime. The trip from Travellers Rest to Lealand was connected by a bumpy, dirt road. Claiborne made the trip easy for Harriet by allowing the horses to walk rather than trot. The ride was so slow that the horses didn't stir up any dust.

She always enjoyed this trip. She was reminded of the afternoon she and her husband-to-be went horseback riding around the entire Overton plantation. The Judge had amassed a large plantation. To ensure the property stayed in Overton control, he provided in his will for his three children to have his land holdings. Elizabeth's portion on the Northwest corner was now known as Lealand. The home she shared with her husband, John, and their three sons was not impressive. She felt the four-room house was temporary. She, in fact, called it her summer home.

Harriet took a moment to admire Lealand, as the carriage approached the driveway. That would have pleased Elizabeth had she known it. Harriet thought for a moment about going around to the side door but knew nothing was informal at Lealand. The doorknocker on the front door was heavy and needed only one knock. The servant who answered the door did not recognize Harriet and asked, "May I help you, ma'am?" Her English was proper, which came as a surprise. She blocked the doorway, keeping Harriet outside.

"I would like to see Mrs. John Lea."

"And whom may I say is calling?" Before Harriet could answer, she spotted Elizabeth coming toward the door.

"Step aside, Meg." There was an edge to Elizabeth's voice. The tone of her voice reversed when she saw her visitor. With arms extended and a bright smile, she greeted her sister-in-law. "Harriet, it's so good to see you! What brings you to Lealand?"

"I hope I'm not intruding, Elizabeth. I have a couple of matters to discuss with you. I thought a visit would be better than a note."

"No, I was having a dress fitted but that can wait. Let's go to the parlor." Elizabeth turned and bumped into Meg. "Meg, what are you doing? Go to the kitchen and bring hot tea to the parlor."

"Yes, ma'am."

"Harriet, I hope Meg's actions were not offensive to you."

"No, not at all. I was surprised at her command of English. Maybe next time she'll recognize me."

"My John bought her in Charleston. He was there on a business trip. She also reads and writes and is a little high spirited at times. Now, tell me about these matters we need to discuss." They were seated in the well-furnished parlor.

"First, John and I will not be coming to your holiday party. I'm already popping buttons on all my clothes and some days I don't feel like doing anything, much less getting ready for a party."

"I know that feeling. I was the exact same way with my first child." Meg entered the parlor with the tea tray. "Meg, I want you to meet and remember Mrs. John Overton. She is my sister-in-law, married to my brother. She lives at Travellers Rest."

"I'm very pleased to meet you, ma'am."

"That will be all, Meg." Elizabeth flicked her hand to dismiss the servant. "I'm sure you have work to do." Meg exited the room, smiling at Harriet.

"How are you feeling these days? Have you felt the baby move yet? Do you know when you became pregnant?"

"Elizabeth, that's why I wanted to come today and talk to you. Your mother has been very kind to me helping me understand what's happening to my body. She . . ."

"Enough said. Mother has a good heart, but she is . . . is . . . a little overprotective. When I was pregnant with our first son, she told me, over and over, way more than I needed to know. She told me about her eight pregnancies—the good and the bad. At times, she nearly scared me to death."

"Exactly. I knew you would understand. Elizabeth, I need your help." Elizabeth poured tea for both of them and handed Harriet a cup. At that very moment, a bond was formed that held the two ladies together for a lifetime. Harriet had said the magic words and Elizabeth graciously responded. They talked. They laughed. Elizabeth remembered; Harriet learned.

"Elizabeth, I do have something else to discuss. Little John is coming home for the holidays and bringing Hugh with him. I would like to have a luncheon for your mother and her five grandsons. What do you think of the idea?"

"I think it's a wonderful idea. I wish I had thought of it. What can I do to help?"

"You just know everything there is to know about rearing boys. Your boys are so polite and well mannered. You have loved and cared for them since they have been in the world."

"You are very kind."

"I need your help in selecting food they like and will eat, how to prepare the table, and which china to use. I need to know what subjects the boys and your mother can talk about at the table."

"Give me a week. Then I'll come to your home. We can determine a proper menu and decide what to do. I'll also be able to visit with you, and we can talk more about your baby." Harriet and Elizabeth parted with hugs and kisses. They were happy, more than ever, to be sisters-in-law.

The temperature dropped drastically to below freezing. The winds from the north brought snow flurries and then an ice storm. All outside work came to a halt on the plantation. John sent Eli and Claiborne to the slave cabins. The slaves were happy to have time off from work; at least most of them did. Three of the male slaves were brought up to the main house to replenish the log supply and tend the fireplaces in the house. Seven cords of hardwood were at

the back of the house, some split and others, fireplace-size logs. The roads were iced over and for days nothing moved on Franklin Pike. John was housebound by the weather, and it was a good time for him and Harriet to talk about the new baby.

"Julia was up for a visit the other day. I had hoped she could tell me what sex she thought the baby would be, but she thought it was too early to tell. She actually predicted all four of the Maxwell children. My father was convinced I would be a boy, but Julia kept telling him otherwise."

"How can she tell the sex of an unborn child?"

"There is something about carrying the baby high or low. She has been right more than she has been wrong."

"Harriet, I don't care if we have a boy or a girl. I'm just praying you and the baby will be healthy."

"I have three great teachers to help with my pregnancy. Your mother, Elizabeth, and Julia are providing me with a wealth of information. They are advising me what to do and what not to do. Surprisingly, most of their suggestions are the same. I am to eat regular healthy meals; get a lot of rest; stay active; don't lift anything too heavy; and stay away from people who are sick."

"Have you given any thought to a name for the baby?"

"I have only thought of a girl's name. I'm thinking Martha Maxwell Overton."

"What if it's a boy?"

"No thoughts other than we will not name him John."

"I think John is a good name. It has served me well."

"I like it too, but you can get too much of a good thing. You need a title like your father. Maybe we could call you Railroad John. How would you like that?" Harriet giggled; he responded with a hearty laugh. "You do remember when your son comes for the holidays, we are to address him as John?"

"Yes. In the letters I've been sending him, I've used his name. Anyway, about the new baby, it might be a good idea to have a boy's name ready just in case."

"I agree and I'll leave that choice to you."

At dinner that evening, Harriet broached the idea of a special holiday event for Mary. "Harriet, I don't need another surprise birthday party. One in a lifetime is enough."

"But Mother," John chided, "you did enjoy the surprise." John was fearful Harriet would take the comment the wrong way.

"I enjoyed my party very much. Everyone should be so honored, at least once. I just know it was a lot of work for Harriet and she does not need that extra pressure right now." Harriet enjoyed the brief interchange. She was always amazed at the Overtons' ability to take words, twist them around, and then come out with positive comments. It was a gift she did not have but hoped she could develop.

"No. No. Mary, what we have in mind is not complicated. Elizabeth and I would like you to have a holiday luncheon with your five Overton grandsons. I'm sure you have some stories you'd like to tell them about their parents. The older the boys get, the harder it will be to get them together. This holiday seemed like an ideal time for a luncheon. The boys love you so much, and the luncheon would be a wonderful memory for them."

"Very well, I'll do it under one condition."

"What do you have in mind?"

"I will help you with the luncheon details. I do not want any extra pressure on you."

"As much as I would like to say yes, I cannot. Elizabeth is planning the details, and I'm sure, when the weather gets better, she will be here to share her plans. When she comes, we can finalize our plans."

"Once Elizabeth sets her mind, there is no changing it, regardless of how many suggestions are made. She gets that trait from her father. She likes to be in charge."

"Good," Harriet said spryly, "it will be a learning experience for me. I can learn from Elizabeth just like I've learned from you."

"We'll see. Just be prepared for . . ."

"Mother," John interrupted, "you know how Elizabeth is and things will work out just fine."

"Maybe."

As predicted, when the weather broke a week later, Elizabeth arrived. John Overton Lea, the Leas' rambunctious seven-year-old, jumped from the carriage before it came to a complete stop. Rather than going to the front as he was instructed, he headed around the house to the side door. His hard, heavy shoes bouncing over the gallery provided warning enough that there was a visitor at Travellers Rest. He did not knock on the door but pushed it open and announced, "We're here to visit Grandmother and Aunt Harriet!" Elizabeth could hear his voice all the way to the carriage. Their arrival was not at all how she had planned. She had practiced with John in the carriage ride from Lealand. She thought he knew exactly what to do but forgot he had a mind of his own. Mary and Harriet responded to the announcement and went to the door to greet Elizabeth. Mary hugged John; he broke loose after a few seconds and was off exploring. "Come in out of the cold, Elizabeth."

"Why don't we go to the dining room and visit there?" Harriet knew the large room was not warm enough for Elizabeth. She walked ahead, opening doors, and headed for the kitchen, hoping to find Ned—and she did. "Ned, please add some logs to the fireplace in the dining room."

"Ya, ma'am."

"Cynthia, we will need some hot tea in the dining room. Elizabeth is here for a visit and brought one of her sons with her. So, add a glass of sweet milk and some cookies."

"Does I needs to pull out da best china?" Cynthia was fighting back a laugh.

"Of course. Need you ask? And be sure we have the linen napkins," Harriet jokingly added.

The morning was filled with conversation about plans for the holidays. As promised, Elizabeth had the special luncheon planned in detail. The menu was presented, the table setting suggested, and even the seating arrangements were stated. "Elizabeth," Harriet said with excitement in her voice, "everything sounds just perfect."

"Thank you, Harriet, I try my best. Now Mother, will you need Harriet and me in the room during the luncheon?" Elizabeth glanced over at her son. "John Overton, you have had enough cookies!"

"No, Elizabeth, I'll be fine with the boys. You and Harriet can find a quiet place in the house and visit during the luncheon." Mary thought, *I want the boys to have fun and not be intimidated by your looks and directives. I may be old but I still enjoy having fun, and I want the luncheon to be a fun event.*

"Very well, Mother. We will see you on the morning of the luncheon. And if you change your mind about coming to the Lealand holiday party, you are always welcome."

"No, I agree with Harriet. Under the circumstances, we are keeping holiday celebrations to a minimum this year."

"Come, John Overton. It's time for us to go to Lealand. Say your proper goodbyes to Grandmother and Aunt Harriet." The morning was over, to the delight and relief of all involved.

The holiday season of 1852 came and went. For some, the season was lightning fast; for others, it was much slower. Travellers Rest and Lealand each had its own pace.

John and Hugh's arrival brought noise to the usually quiet house, which was expected and received with joy. The two cousins roamed the plantation, rode horses, and explored the new railroad construction. John was pleased to discover the Overton station, although it was smaller than he had expected. The boys made a trip into the city to see the new depot and spent some time on Front Street watching the boats. They felt the activity was at a slower pace when they compared it to Memphis. Two days after the special luncheon with their grandmother and the three Lea cousins, they rode over to Lealand to visit their Uncle John and Aunt Elizabeth Lea.

Toward the end of the week, Harriet took young John aside to talk to him about her being in a family way. "John, your father and I want you to know you will always be honored as the firstborn in the family." She continued until a deep sigh from John indicated to her he had reached his interest threshold. Harriet closed the conversation with, "John, I'm so happy you are going to be a big brother for our child."

"Yeah, me too," was not the total response she was looking for, but it would do. The boys headed back to Memphis the second week of the new year, happy for the visit but ready for their usual routine in Memphis

Harriet's pregnancy had its emotional moments. She could be reading one of her magazines and tears would come into her eyes for no reason. Elizabeth had told her this might happen and not to be frightened. These moments would come, but they would pass. Mary had also talked with her son. "John, you can expect Harriet to be moody, and at times she may cry for no apparent reason. Please be sensitive to her feelings." John was happy to have the advance warning. He remembered how Rachel had acted before giving birth to their son. He always tried to bring home only good news from his travels. He shared details with Harriet and she appreciated it. When there was good news in the local newspaper, John unfolded the paper and pointed out items to her. When there seemed to be only bad news, he threw the paper away.

At sundown one day in early spring, Harriet was standing on the gallery when John's carriage arrived. She had felt the baby move and she was eager to share the news with him. His large frame unfolded as he exited the carriage and climbed the steps to greet Harriet. As he leaned down to kiss her, she held on to him. "I have wonderful news, John! I felt our baby move."

"That is wonderful news. I'm so pleased for yo . . . for us. That must mean our time is drawing near."

"Your mother told me it will be a while yet."

"Well, Harriet, it won't be as long as it has been. This is an exciting time for us."

"And how has your day been? What did you do today that I need to know about?"

"I had lunch with John Lea. He had some contracts for me to sign. He has worked it out for us to have the rail spur I wanted. The construction crew will be working on that soon. We talked about you."

"I hope it was kind."

"He said Elizabeth was so pleased with the luncheon for the grandsons. She appreciates your care of Mother and your thoughtfulness. She wants our two families to stay close. She thinks of you as a sister."

"That is kind of Elizabeth. I, too, have a sisterly feeling toward her. She is a wonderful friend and has been so helpful to me."

"Right before I was leaving the depot, the police were gathered at the small, two-story building over on Summer Street just south of Broad Street."

"What was the problem?"

"I have no idea. I'll need to check it out the next time I'm in the city."

They walked into the house and entered the parlor. "By the way, I have some mail for you." That news brought a smile to Harriet's face, which pleased John as he handed her a magazine and three envelopes. She dropped the magazine on the small table, planning to explore it later. She shuffled the three envelopes trying to determine which one to open first. She recognized

the script writing on two of the envelopes but did not recognize the third. She opened the third one to find a note signed by Grace Evans. The name was a mystery until she read the first sentence of the note:

*I missed seeing you prior to the holiday season at the dress shop. I pray you are in good health and had a lovely holiday. I went to Columbia for the holidays for a visit with my father and siblings. Even my oldest brother and his family came up from Pulaski for a couple of days. It's good to be with family during the holidays.*

*As I rode down Franklin Pike on my way to Columbia, I saw your home. I was reminded of your kindness in identifying our acquaintance during your visit to the dress shop. I had lost all contact with the girls in that phase of my life until you reappeared. I would like to find some way to nurture our newly found friendship. Perhaps we could dine together on a day you are in the city.*

*Again, thank you for your kindness. I am a friend rediscovered—*

<div style="text-align:right">*Grace Evans*</div>

Harriet folded the note and held it close to her heart. *Had life's circumstances been different,* she thought, *I could have been Grace Evans. My good fortune allowed me to finish the Academy. Then I fell in love with John Overton and now, we are about to bring new life into the world. I am most blessed. I must talk to John sometime about his understanding of predestination.*

"John, do you know any Evanses from Columbia or Pulaski?" He looked up from his newspaper. "Evans . . . Evans . . . no, I don't. Should I?"

"This note is from Grace Evans, a classmate from the Academy. I met her at the dress shop in the city."

The second envelope was no mystery. It was from Elizabeth and basically restated what John reported from his luncheon with John Lea. Elizabeth was happy to have Harriet as a sister-in-law, but they seemed more like sisters. Her sons talked about the good time they had at the luncheon with their Grandmother Overton and their cousins. Elizabeth reiterated her commitment to be available during the months preceding the baby's arrival.

"This note," Harriet held it up, "is from Elizabeth."

"Why would she send a note? Why not just come over for a visit?" John was shaking his head as he talked.

"Thank-you notes are proper etiquette, and your sister is very proper."

"If you say so." He turned his attention back to his newspaper.

The third envelope was handled with special care. Harriet was eager to know its contents, but for a moment, she studied the beautiful handwriting on the envelope. Annie was so skillful with her writing. Each letter was perfectly formed with proper curls in just the right places. Her thoughts regressed to her childhood. *Annie, I want to learn how to write like you. Harriet, first you must learn your letters. Then you must learn to print your letters on a blackboard.*

*And then you must learn how to use a quill and ink. No! No! No! I want to learn now! I want you to learn me now. I will teach you on your fourth birthday and that will be soon enough. For now, you can watch me practice my writing. Hand me the quill, but do not touch the ink bottle.* On her fourth birthday, Harriet had received from Annie two quills, five pieces of newsprint—which their father found in the city—and a note she could not read. Annie read the note:

> *Dear Harriet,*
> *As promised, today I will begin teaching you how to write.*
> *Love,*
> *Annie*

The process took four years, but Harriet was a willing student. She followed the directions Annie gave her. First she mastered her letters, to the delight of Annie and the amazement of her middle sister Mary, who was also being taught by Annie. Then she spent many hours by herself, practicing with her quill and gooseberry ink. As directed, Harriet used the small blackboard her father gave her, but most of her effort was trying to master her quill pen. It was not unusual to find her at the dining room table, after the evening meal, laboring away to improve her skills. More than once Julia had to snuff out the table candles and send her to bed. On one occasion Harriet protested at Julia's suggestion, "It time fer bed, Sabbath Child. Ya sisters done went upstairs."

"I'm not ready for bed. I want to stay and practice my letters. You go on about your business."

"Ya is my business and ya mammy say it time fer bed." Unfortunately for Julia, Harriet had just refilled her quill pen with ink in preparation to write. When she turned toward Julia a second time to protest, the ink shot out of the quill and landed dead center on Julia's white apron. Two sets of eyes stared at the ink stain. Harriet's mouth gaped open. Before Julia had time to react, Mrs. Maxwell appeared at the door of the dining room. The ink stain was hidden from her view and Julia did not turn around. "Harriet," her mother's stern voice filled the room, "why are you not upstairs getting ready for bed?"

"I was . . . ." Her eyes were focused on the ink stain and a sense of fear came over her.

"Young lady, when I talk to you, I expect to have your undivided attention. Now you look at me."

"Yes, ma'am." Harriet stood up, walked past Julia, and faced her mother. "I have something to tell you. I did . . . did a bad thing to . . . to . . ." Her words were weakened by the lump in her throat and she began to whimper, unable to finish her confession.

"What is it, Harriet? What have you done? What bad thing have you done?" The whimper became tears, and the confession was gone for the evening. "We will continue this in the morning. Now go with Julia upstairs and go to bed." Julia still had her ink-stained apron hidden when Mrs.

Maxwell left the room. Harriet moved back to the table to retrieve her writing material when she faced, once again, the ink stain. Julia was removing her apron when Harriet looked up and confessed, "Julia, I did a bad thing to you and I am sorry."

"Un-huh, ya done a bad thing and tomorrow what ya goin' tells ya mamma?"

When John cleared his throat and refolded his newspaper, the sounds brought Harriet back to reality. "You look like you're a thousand miles away."

"I was, but only a few miles. I was recalling a time in my childhood when I was learning how to write. I was an immature child at times. I threw gooseberry ink on Julia's white apron because she made me stop writing and wanted me to go to bed. I must remind her of that when she comes for a visit."

"And what made you think of that incident?"

"I was looking at Annie's very clear writing style on this envelope." She held it up for John to see. He agreed.

"What's the news from Annie and Thomas?"

"I've not opened her letter yet." She slid her finger under the flap of the envelope and released the folded pages. "Now, let me see, Dear Sister Harriet . . ." She gasped and exclaimed, "Oh my!"

"What is it?" John dropped the newspaper in his lap.

"Annie thought she was pregnant but discovered two days before writing this letter she was not. I told her about some of my symptoms in a previous letter, and she thought she was experiencing the same thing. Bless her heart. I know she's disappointed. I hope she can become pregnant soon. She will be such a good mother."

"Yes, I agree."

Harriet returned to her letter, silently reading Annie's thoughts and did not share them with John. *It is not my dear Thomas' fault that I am not pregnant. He, of late, has been doing more than his part. Each time I look into his eyes, be it day or night, he is ready to make a baby. Two days ago when I had the visit of nature, I was somewhat sad and somewhat happy—if you know what I mean!*

"Sister Annie is becoming proficient with her sewing machine. She has made three day dresses from the material I sent. She is anxious to receive any new magazines showing ladies' fashions."

"I believe the magazine I brought you today has some ladies' things in it. In fact, I saw something in the magazine I want you to explain to me. I'll get it and show you." He found the *Godey's Lady's Book* on the table where Harriet left it, thumbed through the pages, found the page he wanted, and returned to the room. Harriet continued to read and enjoy the writing skill of her older sister. She always sent such newsy letters. It was fun to read of her adventures out west. "Annie saw an Indian chief in full headdress the other day. There were colored beads all over his leather clothes and moccasins. The woman with him had a child strapped to her back in some type of carrying case."

"Speaking of clothes, look at this drawing and tell me what you see." He handed her the magazine with the pages folded back, revealing a line drawing of a lady in a strange looking outfit.

"John, that's the latest fashion from Europe. A designer has used a Turkish-style pantaloon and created a lady's dress."

"You can see her limbs hanging out."

"No, her legs are covered and nothing is exposed."

"It's a total disgrace. The next thing you know, ladies will be showing their ankles in public."

"Maybe so." Harriet knew John well enough not to pursue the subject any further. She turned her attention back to the letter in her hand. She continued to smile and remember Annie.

Promptness in answering letters was a trait Harriet nurtured. Within the week she had finished a letter to Annie and had John send it. She always gave Annie an update as to families, friends, and events in the Nashville area. She clipped the current fashions from her magazines and sent those with the letter. She added a note to the illustration John had shared: "John is concerned that ladies soon will be showing ankles in public. I hope the fort in Texas is ready for the public display."

A few days after that, she sealed the envelope of a note to Grace Evans at the dress shop in the city. Harriet wanted Grace to know her latest news. She included in her note, "In my current condition, I will not be in the city anytime soon. However, I welcome you to Travellers Rest. If you will let me know when you might visit, we could have lunch here and renew our friendship. I would find your visit most enjoyable indeed. Since I am with child, you will, of course, see me with a larger figure than the last time we visited. In any event, let me hear from you." Harriet handed the envelope to John as he was leaving the house headed for the depot in the city. "Would you be a dear and take this note to the dress shop near the square?"

"Is that the shop where you had the black velvet dress made?"

"As a matter of fact, it is. I'm pleased that you remembered."

"Well, young lady, the delivery of this letter will cost you."

"And, kind sir, what might the cost be?

"The price is an extra kiss, ma'am." They embraced. Harriet delivered a peck on his cheek and then a long, passionate kiss on his mouth. "There, my good man, is your payment." She placed his large hand on her extra round belly and laughingly added, "We both thank you for your kindness."

June 1853 on the plantation was delightful for everyone but Harriet. Looking from the lower gallery, the garden was ablaze with color. Flowers provided a pallet of color that even an artist would have difficulty reproducing on a canvas. The fields were green with plant growth. The fruit trees had survived the late winter-early spring temperature changes. The fruit blooms had turned to small balls of fruit, suggesting the harvest would be bountiful

this year. Peach brandy and apple products would grace the tables for years to come. Mary and Harriet walked in the herb garden at the back of the house. The bees were active and hard at work in the garden. "Harriet, how are you feeling?"

"I just cannot get comfortable no matter what I do. If I'm in bed, I can't roll over. And every hour of the night I feel the pressure to use the necessary. John has been sleeping upstairs for the last few nights. It's not fair to rob him of his sleep just because I'm awake. My back hurts all the time, and the baby takes spells kicking. I know it's normal, but it hurts."

"Everything you said is normal. I would be concerned if you were not experiencing what you describe." Mary kept moving about the garden checking the plants. "Do we need to talk about the delivery of your baby?"

"No, you and Elizabeth have prepared me well. I know what to expect. Julia has talked me through the procedure a number of times. She has everything ready in my bedchamber."

"Mother Nature will give you a wonderful clue when birth is near."

"You mean the sharp pains?"

"Yes, those will come. The pouch the baby is living in may break, releasing fluid, and you will feel a gush. Your undergarments will become wet. At that point, Harriet, you need to call for help. The birth of your child may be near."

"I hope I remember everything."

"You won't remember everything, but you will remember enough. And years later you will remember only the joys of the birth." They both turned, shielding their eyes from the sun, and watched as a horse-driven, two-wheeled cart stopped at the barn. It was Julia in her day dress, topped with a white apron and wearing a wide-brimmed straw hat. She approached the garden, singing and then humming. "Good mornin', ladies—Miz Overton, Sabbath Child, how is ya today?"

"Julia, it's good to see you. I need to get inside out of this sun." Mary walked toward the house.

"And how be the momma in waitin'?" Julia placed her hand on Harriet's stomach and as fate would have it, the baby kicked. Harriet smiled.

"Honey, da baby am ready to come. Today maybe; tomorrow fer sure."

"Julia, how can you be so sure?"

"It a gift givin' to me by da Lord. I told your mammy the same 'bout Miz Annie, and Miz Mary, and 'bout ya. Ya best be gittin' up to da house. I be stayin' wid ya 'till the baby be born. I be sendin' word back to Massa Jesse. He's be wantin' to knows."

Thursday evening and night were miserable times for Harriet. She could not do anything to get comfortable no matter how she turned. At Julia's suggestion, she tried to focus on a wonderful childhood experience. Each time she would drift into soft sleep a pain would hit her and she would yell, gasp for breath, and tears would fill her eyes.

Julia finally moved a chair next to the bed, sat down, and held Harriet's hand. "Ya rest now, Sabbath Child. Julia here fer ya. Tomorrow goin' be a special day." Harriet did not respond, but the squeeze Julia felt on her hand said volumes. The house servant sleeping on a cot in the hallway was snoring. Julia tried to close her eyes, but the snoring rhythm coming from the hallway and the moans from Harriet made sleep impossible. Sometime in the wee hours of Friday morning, Harriet asked Julia to help her to the necessary. Nature took its course just as Mary had predicted. She struggled back to bed where Julia positioned her for delivery. "Ya out dere, gets up! I needs ya help!"

"What ya needs?" came a quiet reply.

"Gets to the da kitchen and gets me a pot of hot water . . . and be quick." Knowing it would be needed at any moment, Cynthia already had the pot of water on the stove. When the kitchen door was pushed open, Cynthia was on her feet. "Is it time? Is da baby comin'?" The noise in the hallway roused Mary from sleep. She put on a robe and shoes and made her way across the hallway to Harriet's bedchamber. "Julia, how is Harriet doing?"

"She ready, Miz Overton."

"What can I do to help?"

"Why don't ya sits here in dis chair and talks to her. I needs to get dis table over close to da bed. I be needin' dis soon." Cynthia brought the hot water herself and placed it on the table as directed by Julia. Cynthia told the house servant to clean up the hallway, then go to the barn, and get Claiborne and Eli. Mary didn't know what that was all about, but knew there must be a good reason.

For the next three hours, it was confusing to know who was in charge, but Julia had no doubts. When Eli appeared in the hallway, Cynthia ordered him, in no uncertain terms, to ride over to Lealand and bring Elizabeth Lea. Mary didn't know at the time, but Elizabeth left orders with Cynthia on her last visit. "The very second you know Miz Harriet is in labor, you send for me."

Elizabeth arrived at Travellers Rest and entered the bedchamber as Julia announced, "I sees the child's head." Complete silence captured the room, broken only by a violent scream from Harriet. Moments later the baby was born. Julia skillfully attended to the baby. The females in the room were greeted by the shrill cries of the newest Overton family member. Julia cleaned the baby, wrapped her in a blanket, and laid her in her mother's arms. There was not a dry eye in the bedchamber.

Cynthia left the room, went out on the gallery, and told Eli to "gets up the steps and gets the pappy down here." Eli met John coming down the steps, fully clothed. He had been awakened by Harriet's final scream. Julia was pushing the table away from the bed when John entered the room. Her work was done. The baby was successfully delivered; the new mother lay in a clean gown on clean sheets. Julia plopped in a chair in the corner of the room and gave a huge sigh.

All eyes followed John as he moved into the room and looked down at Harriet. He bent down on his knees and rested his elbows on the bed. He took Harriet's hand, kissed it, and uttered a question Harriet would cherish always: "My love, how are you doing?"

"I'm fine, a little tired, but fine. John, I have a special gift for you. Her name is Martha Maxwell Overton." The third day of June 1853 turned out to be a warm, sunshiny day. The sun was bright overhead, but paled when compared to the smile on John Overton's face when he held his daughter for the first time.

# 11. More Children are Born

Two wires went out to announce the birth of Martha Maxwell Overton. One went to Master John Overton, in care of Mr. Robert Brinkley of Memphis; the other, to an army outpost addressed to Mrs. Thomas Claiborne, Ft. McIntosh, Laredo, Texas.

Robert did not see John until dinner. Before they sat down, he handed the wire to the lad with the suggestion, "John, wires are usually important. You may want to open this now before we eat." John flipped the envelope open and discovered a single piece of paper. The message was funny and strange at the same time. He looked at the message. Then he smiled at his Uncle Robert and reread the brief message, MARTHA MAXWELL OVERTON, YOUR HALF-SISTER, HAS ARRIVED. MOTHER AND DAUGHTER ARE DOING FINE. YOUR FATHER.

"Is there a problem, John?"

"I don't know, sir." John handed the wire to his uncle. Robert read the message and said in his deep voice, "This is wonderful news. We have another girl in the family."

"Which half, sir?"

"Pardon?"

"Father says I have a half-sister. Which half do I have?"

"Oh, now I understand." Robert had to laugh. "You and little Martha have the same father but different mothers. That makes Martha your half-sister."

"I've never heard that term before. Hugh, did you know about a half-sister?"

"No, that's strange." Annie, sitting next to her father, pulled on his hand and questioned, "Father, am I a half or a whole sister?"

"You are very much a whole sister. Now, I think it's time for us to have dinner."

In Texas, the wire was received with some hesitancy. To Annie a wire indicated urgent news, and she feared it might be bad news about her father. She held the envelope in her hand and felt her heart beat heavy against her chest. Thoughts of her father came to mind, as she took the wire from the envelope. Her apprehension turned to joy when she read, MARTHA MAXWELL OVERTON HAS ARRIVED. MOTHER AND DAUGHTER DOING FINE. J.O.

Julia stayed through the weekend and returned to the Hall on Monday morning. Harriet was still weak, but Julia felt confident her Sabbath Child and baby daughter were in good hands with Cynthia. Julia and Cynthia had both struggled trying to keep Harriet in bed. They allowed her to get up long enough to use the necessary and to change the sheets on her bed. They prodded her to drink lots of liquids and take broth which she didn't

particularly like. Harriet nursed Martha whenever she was hungry and was pleased her milk satisfied her daughter. When Martha was not nursing, she slept in a fashionable, Philadelphia, factory-made bassinette provided by Elizabeth. The original blue ribbons had been changed to pink, and a small satin pillow had been added. Elizabeth had given birth to three boys and was ready for the bassinette to hold a little girl—an Overton at that!

Julia was surprised to find the Maxwells on the front porch when she arrived at the Hall. Mary left the porch and went to the cart. "How are Harriet and the baby?"

"They both doin' fine."

"I wanted to come up and see them after Claiborne came and told us the news, but Myra thought it best that we wait until you came back." Mary turned from Julia and called to her father, "Get the carriage ready. I want to go see Harriet and Martha. She needs to meet her Aunt Mary." While Jesse was preparing the carriage, Myra went to her flower garden and picked a bouquet to take as a gift. *Harriet has her own flower garden, but it's the thought that counts,* Myra thought as she wrapped the flowers in a sheet of newspaper.

Edward drove the carriage. He was eager to have a glance at the new baby, if he were given a chance. Mary and Myra chatted as they approached Travellers Rest. Jesse had thoughts of Harriet's birth and early childhood. When she learned to walk, she became his shadow and followed him around. She was the son he didn't have. At this very moment he was happy Harriet was his daughter. The thought struck him, *I am Martha's only grandfather. She is my only grandchild. How wonderful!*

From her bedchamber, Harriet could see her family coming up the road. Cynthia happened to be in the room. "Please hand me my mirror and comb. I must look a fright."

"No, ma'am, Miz Harriet. Yous have the glow of a new mammy. Yous looks beautiful. Yous don't needs a thing. Yous is perfect just like ya is." Regardless, Harriet ran the comb through her hair and the mirror did reveal what Cynthia suggested—she did have a glow. A smile lit up her entire face. "Cynthia, please go and welcome my family and bring them in here. And if Mr. Overton is in the house, tell him we have company." Martha continued to sleep undisturbed by the sounds around her.

"Yes, ma'am, I's be happy ta do dat."

Harriet adjusted the pillows, allowing her to sit up somewhat. She was more comfortable sitting in bed than on a hard chair. She saw the bouquet of flowers before she saw people. "How lovely and thoughtful," she said as she watched Myra extend the floral gift.

As Jesse made his way around Myra, his shoe hit the bassinette, jarring Martha awake. She stretched, yawned, and forced her eyes open, but remained silent. "Sorry," he apologized, as he bent over and kissed Harriet on the forehead.

"She needs to be awake anyway, when her grandfather comes for a visit," Harriet offered.

"I wanted to come on Friday, but I was told to wait." Harriet heard Mary's voice but could not see her.

"Mary, please come and sit on the bed next to me." They hugged as they had done so many times in their lifetime. "You received wise advice. I would not have been very good company during the last few days. I've been pretty busy." Myra smiled, acknowledging what she heard.

"How are you feeling, Harriet?" Mary was wiping a tear that had dropped on her cheek.

"I feel like I just had a baby. Julia, Cynthia, and Mary have taken good care of me. According to them, I have another week in bed. They want me to rest all I can." Jesse was looking at Martha and she began to cry—not a hurting cry, but an I-want-some-attention cry. Everyone turned to Jesse and focused on him. "Father, I believe your granddaughter is talking to you."

"Really? What should I do?"

"You may need to pick her up and hold her." He stretched his arms toward Martha and stopped.

"Myra, help me. I've forgotten how to do this." Myra moved to the bassinet, pulled back the blanket, picked up the baby, and handed her to Jesse. She placed the newborn in his arms and adjusted the blanket. The emotion of the moment caught Jesse off guard. He tried, with all his might, to beat back the tears of joy he knew were about to come. As he gazed into Martha's face and remembered the significance of her name, the flood came. Mary was on her feet and took the baby in her arms, allowing her father to leave the room.

John pushed through the side door and walked into the hallway to find Jesse wiping his eyes with a handkerchief. "Good day to you, Grandpa. I'm so glad you're here to see Harriet and Martha."

"And congratulations to you! Martha is a beautiful child. I know you're proud of her."

"We are very happy she is here. Harriet looks good, don't you think?"

A voice came from the bedchamber, "If you gentlemen out in the hall are going to continue talking about me, you might just as well come in here where I can see you."

"I believe we have been found out." Jesse was laughing now, after regaining his composure. When John entered the room, Martha went from crying softly to wailing. "I guess that's her 'feed me' cry. I have that effect on ladies. I enter the room and they cry."

"John Overton, will you ever be serious?" Harriet was half laughing when she looked up at her husband. The room was filled with laughter. Mary handed Martha to her sister and wished somehow their roles were reversed.

"Let Myra hold her a minute while I change my position and get more comfortable." Harriet had made every effort to include Myra in the family. Jesse had been so secretive about his intentions toward Myra Rucker. The

Maxwell sisters had guessed their father's plans even before he told them. They were not at the wedding, however, for that occurred when they had made their eventful trip to New Orleans and Pass Christian.

"Thank you, Harriet." Myra was looking at Martha. "I know your mother would be so proud of you. You know if there is ever anything I can do for you and your family, all you need to do is ask."

"Myra, thank you for your kindness. I appreciate you more than you will ever know. Martha is going to be an active part of your life as well as Father's. Your granddaughter will have many wonderful experiences at the Hall."

Myra handed the baby to Harriet and announced, "It's time for us to get out of the room. Martha is hungry." She almost caught herself saying, *my granddaughter*, but stopped short. She shooed the visitors out of the room and was closing the door behind her, when she heard, "Myra?"

"Yes, Harriet."

"Would you be so kind as to tell Cynthia I need her? Thank you." Cynthia was standing at the carriage talking to Edward, when Myra delivered Harriet's message.

"Don't yous leaves 'till I say so," she instructed Edward.

"Yes, Cynthia, I's waits rite here." Cynthia was gone a few minutes. Jesse and Myra were saying their good-byes to John; Mary was already in the carriage.

"Edward! Edward, gets up here! Miz Harriet wants to sees ya."

"I's comin'." The folk on the gallery were unaware of what was happening. Edward entered the bedchamber. His old hat was in his hand and he bowed several times, never really looking at Harriet or the baby.

"Edward, sit in the chair next to me. Cynthia told me you wanted to see Martha."

"Ya, Miz Harriet, just a little glance." His head was still bowed even while sitting in the chair.

"Well, you are going to have to look up if you want to see her. Did you ever hold me when I was a baby?"

"Ya, ma'am. I holds ya and singed to ya whiles Julia tended to ya mammy."

"Edward, would you please hold Martha?"

"Oh, Miz Harriet. Is ya sure?"

"Yes, and some day I want you to come back and sing to her." Gently, Martha was placed in Edward's arms. He was filled with emotion when he looked into her face and choked out the words, "Ya is Harriet Virginia Maxwell true and true. Ya be a blessin' to all of us'ns." Edward handed the baby back to Harriet, bowed several times as he left the room, and made his way to the driver's seat on the carriage. On the way to the Hall, the Maxwell family talked about the baby and Harriet. Edward guided the family home humming to himself and thinking, *Ya be a blessin' to all of us'ns.*

Later that evening Jesse and Myra sat on the front porch in rocking chairs. "It was wonderful seeing Martha today," Myra broke the silence.

"It's hard for me to believe the little girl that used to run around here is the mother of my granddaughter." He drew on his pipe and released the smoke into the air. "I think I'll start looking for a pony for Martha."

"It may be a little early for a pony; maybe a rocking horse."

"Did I ever tell you I put Harriet on a pony about the time she started walking? Martha thought I'd lost my mind. She marched out of the house, took Harriet off that pony, and stomped back into the house. I thought for sure my goose was cooked."

"Which of your girls is the most like Martha?"

"All three of them have some of her traits. Annie looks like her, Mary talks like her, and Harriet is about Martha's size and has her temper. Have you ever seen Harriet stomp her foot? It's like seeing Martha all over again."

"Harriet is a remarkable woman. She told me this morning that the baby was our granddaughter. I never expected the honor. I'm looking forward to having Martha visit us."

As hoped, Martha Maxwell Overton did spend lots of time at the Hall. When John had to be out of town on business, Harriet would bundle up Martha and take her for long visits with Papa, Gran, and Aunt Mary Maxwell. By the time she began to smile and learn how to sit alone, she recognized faces and voices other than her mother's. Harriet was pleased her daughter was becoming socialized. There seemed to be arms reaching to hold her wherever she went.

Grandmother Overton knew the importance of mother-daughter bonding in the early months and held Martha only when Harriet offered. But when her granddaughter reached the crawling stage and wanted to be free from her mother to explore, they spent many wonderful hours together in the large room—Martha exploring; Grandmother hovering. Mary was able to relive many of her memories of her own children as she watched Martha grow.

Harriet kept a record of Martha's achievements. She shared them with her sister, Annie, when they exchanged letters. If no mention of them was made, Annie would ask in her next letter, "What is Martha doing now?" Martha laughed aloud and waved her arms and legs when someone in the family played peek-a-boo with her. The activity became a family favorite with the Overtons and the Maxwells. John enjoyed hearing his daughter babble. Sometimes his deep laugh at her antics would scare her. He would watch her stare at him, her chin would quiver, and then she would start to cry. His response always was, "Where's your Momma?" She would look around until she found Harriet and then reach her arms out to be rescued.

Martha's first winter in the plantation house was a cold one. Harriet kept her away from anyone who even looked like they might sneeze or cough. As hard as she tried to protect her, one night Martha woke up sneezing. By

morning, she had a runny nose and a slight cough. She ate very little for breakfast and remained fussy even when her father made funny faces at her. Everyone around the table knew something had to be done.

"Harriet, I'll send Eli for the doctor down on Franklin Pike," John said with a serious look on his face.

"What do you think, Mary? What did you do for your children when they got sick?"

"I doctored them myself. My husband, Francis, would create a poultice for the cold and dilute a few drops of brandy in warm water for the cough."

"Mother, Martha is just six months old. Do you think it's wise to treat her with home remedies?"

"I treated you with home remedies and you survived."

"Mary, is a poultice the same thing as a plaster? Julia made mustard plasters for my sisters and me when we got a chest cold."

"Yes, the principle is the same. In fact, I suggest we use some mustard powder for Martha."

"I'll leave you two doctors to your work," as John left the room shaking his head. Harriet's face showed concern for Martha and John.

"Harriet, don't fret about John. He is just like his father. When one of our children was sick, the Judge was no help at all. I usually had to tell him to go find something to do. I used home remedies on all eight of my children, and like John, they survived. You take Martha and get her ready for a nap, and I'll go to the kitchen and make the plaster and get the peach brandy." Martha responded well to the treatment and soon recovered to being her usual playful self.

No one would admit it, but much of plantation life centered on Martha and her schedule. When she took an afternoon nap, no work was done in the house or outside near her room. Planting, harvesting, housework, butchering, house repair—all happened on schedule but stopped when Martha appeared with her mother, father, or grandmother. The slaves were always eager to see the new Overton baby.

By the time of her first birthday in June of 1854, she was standing alone but not yet walking. She babbled all the time for her own enjoyment but was not understood by others. She knew names and faces and would laugh joyfully when picked at by her loved ones.

Cynthia had a table and chairs placed on the lower gallery for Martha's party. In the center of the table was a cake with white icing. The family gathered around the table. The Maxwells had come, and the John Leas were there with their three boys. Naturally, Martha was the center of attention and was passed around from one set of arms to the next. Harriet was delighted to share her daughter and reveled in the love shown to her little one. The cake was being cut when John and his son, who was visiting for the month, arrived at the side of the house. Martha was being entertained by her Aunt Elizabeth, when she heard the familiar deep tones of her father's voice.

"Sorry, we're late. There was a little commotion in the city and we were late leaving." Harriet stood to greet John.

"Commotion, what . . ." Her words trailed off when she saw Martha stretch her little arms in the direction of her father and uttered, for the first time, "Da-da." Martha crawled out of Aunt Elizabeth's arms into her father's. She patted his face with both chubby hands, giggled, and repeated, to the delight of all present, "Da-da." It was a moment recorded in John's memory to which he would often return. "And how is the birthday girl?" No sooner had he kissed her on the cheek than she turned in his arms looking for her mother. Harriet was making mental notes of these scenes to share with Annie in her next letter.

Finally, Martha was seated in her mother's lap, while all the guests pulled their chairs closer to the table to enjoy the birthday cake which Cynthia had sliced and placed around the table. While Harriet chatted with Elizabeth, Martha thought it was past time to try some of her cake. She stretched out her arms, leaned forward, and with both hands began hitting at the cake in front of her. She made a direct hit, sending icing in all directions around the table. Quickly, icing was in her mouth, all over her face, and in her hair. Harriet moved defensively to guard against being struck by little hands filled with cake and icing.

John, Martha's half-brother, was laughing at the scene with great pleasure. Harriet stood and placed Martha in his arms and watched as she patted icing on his cheeks. He continued to laugh and drew the little tot to him. Their father had a full view of the scene as it unfolded and continued. As he watched he thought, *How smart of Harriet. She turned a natural occurrence into an extra special bonding experience. John will always remember the time his half-sister patted his cheeks with icing. All of us around the table watched him hug Martha. There is no doubt in my mind that a brother-sister relationship is developing between them. Harriet has a wonderful gift of building family relationships.*

At dinner that evening, Harriet followed up on the comment John made when he arrived late for the party. "John, you said there was a commotion in town this morning. What was that all about?"

"Oh, the commotion. Yes. Do you remember me telling you about the house on Summer Street just off Broad? Sometime back the police were gathered all around the place."

"Yes, I remember and you were going to find out what happened."

"Yes, I was, but I haven't as yet. I'll look into it later. I have an announcement to make." John looked around the table to ensure everyone's undivided attention. "I have a letter from Robert Brinkley. He is announcing his marriage to Elizabeth Mhoon."

"Is he married to Miss Mhoon already?" Mary questioned. "Or is he announcing the date for his upcoming wedding ceremony?"

"Thank you, Mother. My announcement was not clear. Robert will marry Miss Mhoon on October 24. He has invited us to come to Memphis for the event." All adult eyes at the table turned to the children playing and laughing. John was making faces at Martha.

"John," Grandmother Mary quizzed, "did you know Uncle Robert was getting married?"

"You mean to Miss Elizabeth? Yes, he told me before I left to come home, but he said it was a secret and I should not tell anyone. He told me he would send Father a letter explaining everything." Mary shook her head and laughed.

"You are the soul of Judge John Overton living in a twelve-year-old body."

"What does that mean?" He looked first at his grandmother and then to his father.

"Son, it means we are proud of you for keeping Uncle Robert's secret. Your Grandfather Overton was a secret keeper because he kept lots of secrets people told him. He knew things about . . ." Mary did not allow her son to finish.

"He knew things about Andrew Jackson . . . secrets that went to their graves."

"Like what? What kind of secrets did Grandfather Overton have?" John's interest was piqued after her comment.

"Your grandfather told me one time he was leaving orders to destroy all of his official papers and correspondences at his death. He did not want people trying to figure out what he had written without him there to explain. I remember specifically what he said about Andrew Jackson, 'I protected him in life and I will protect him in death.'"

"What did he mean by that?" Harriet was now involved in the conversation.

"Harriet, I believe there was a document or correspondence related to Andrew's marriage, among other things. The Judge never did talk about it much. I do remember he had a meeting here at the house months prior to the 1828 election and he told Andrew, 'I'll take care of that.' Apparently he did because things worked out for Andrew."

"There's one other item in Robert's letter." John was looking over the top of the letter in his son's direction. "Robert is planning to send Hugh to a boarding school this fall. He still has in mind the school in Brook Hill, Virginia. He's wondering whether our John would have an interest in going and being Hugh's roommate." John, at the other end of the table, continued to play with Martha and was paying no attention to the conversation around him.

"John, do you know anything about a boys' boarding school in Virginia?" Mary interrupted the children's play.

"Hugh was telling me about one up there somewhere. I think they learn you things for college."

"I believe that's teaching you things for college, John!" Harriet corrected.

"Yes, ma'am. They teach you things for college."

"Would you be interested in going away to school with your cousin Hugh?" John posed the important question and waited.

"I really do like being in Memphis. I've learned a lot about the city and the Overton business while I've been there." That comment really pleased Mary. She was hoping some day to hand over her Memphis responsibilities to an Overton male. "I still have a lot to learn, but it wouldn't be as much fun without Hugh there."

"The school in Brook Hill is run by a headmaster named Dr. Minor. His school prepares young men, like you and Hugh, for college. There is another piece of information that should be of interest to you, Son."

"What's that?"

"The school is in Louisa County. That's where your Grandfather Overton was born and grew up as a boy. He still has a brother living at a place called Frederick Hall, not far from the school. You would be able to visit more Overton land—original Overton land." The adults waited for John to respond.

"When would I need to leave? How would Hugh and I get to Virginia?"

"I'll need to contact your Uncle Robert about a date. Then I will need to send a wire to Dr. Minor and inquire about enrollment. Hopefully, there would be a place for you and Hugh for the fall term. Your Uncle John Lea has met Dr. Minor and should be able to help with your enrollment. I can check with him. Son, the best part is that you could make the trip all the way by train."

"How long will I have to stay up there in Virginia?"

"I need to check with Dr. Minor, but I think it would be for both terms of the school year. Of course, you can come home on holidays and for the summer months. However, there are lots of things to do in Virginia. There's Richmond, Williamsburg, and Washington to visit and explore. My father used to tell me about all the good hunting in Louisa County and fishing at Lake Anna. You may like Virginia so much I'll have to beg you to come back to Tennessee. And with Hugh there with you, I don't know, I may need to rethink this." John tried to keep a serious look, but Harriet's broad smile brought a smile to his face too.

"Father, I believe as gentlemen, we can work this out to the satisfaction of each of us."

"Yes, I'm certain we can. By the way, where did you learn to talk like that?"

"That's the way Uncle Robert talks, but he uses his hands a lot more than I do." Peals of laughter filled the room. Even Martha laughed along with the adults.

By late June, Martha took her first few steps and declared her independence. After that, she was on the run. It seemed someone was always chasing after her and all worried she would fall down the steps in the house and off the gallery. It was Aunt Mary Maxwell, on one of her frequent visits, who taught Martha how to bump down the steps while holding on to the rails.

Now she would be safe. They were becoming fast and true friends. Harriet cherished these moments for Mary and Martha alike. She shared them with Annie by mail and once again, the three Maxwell sisters had something in common—another Martha.

The fall of 1854 was hectic for Harriet and her family. John arranged for them to make the trip to Memphis on the train to attend Robert's wedding to Elizabeth Mhoon. Aunt Mary was kind enough to care take of Martha and that gave Harriet one less worry. All of the Maxwells enjoyed having Martha at the Hall.

Since Hugh wanted to stay for his father's wedding, enrollment at Brook Hill was delayed until early November. Dr. Minor was made aware of the special circumstances and agreed the delay was justified. John Lea had been instrumental in working out the details, and in fact, would later travel with John and Hugh, dropping them off on his way to Richmond for business.

Robert Brinkley's home in Memphis was a comfortable city home and properly decorated for someone of his economic status. Robert, Hugh, and Annie were at the train station to meet and greet the Overton clan. He moved quickly and offered Mary a hand as she exited the passenger car. "Welcome to Memphis, Mrs. Overton."

"Robert, when are you ever going to call me Mary?" She gave him a kiss on the cheek and patted the other with her hand.

"I trust your trip was without incident."

"Yes, we spent the evening in Decatur. The fall colors of the trees on the way over were magnificent. In my opinion, the train is the only way to travel. It sure beats traveling by carriage and having so many stopovers."

"Mary, the day will come when you will be able to sleep on a train in a comfortable bed, when you travel great distances."

Harriet was the next to exit the train. "Harriet! Harriet, over here!" Annie's arms were waving in the excitement of the moment. She pushed her way to the steps and took Harriet's hand away from her father's. She wrapped her arms around Harriet and buried her head in her bosom. "Oh, Harriet, I'm so glad you came."

"Who are you, young lady?" Harriet pushed Annie away, holding on to her hands. "You sound like Annie and you look like Annie, but you are much too big to be the Annie Brinkley I know."

"Harriet, it's me, your Annie." Harriet drew her back into an extended hug. She whispered into her ear, "Go over and give your grandmother a big hug and properly greet her. Welcome her to Memphis. Go on now. We'll ride in the carriage together later."

Hesitantly, Annie broke away and greeted her Grandmother Mary. "Welcome to Memphis. I'm so pleased you could come. We are going to have great fun while you're here. I have something very special to show you at the house."

"Annie, you are growing like a beautiful summer flower. You remind me of another beautiful girl I knew years ago."

"Do you mean my mother?"

"Yes." Mary had to fight back the tears she knew were ready to fall. She held Annie's hand while they waited for John and his father to exit the train. John didn't use the three steps but jumped from the car platform, to the delight of Hugh, who was waiting for him. His feet no sooner hit the ground than Hugh embraced him, hitting him on the back. They were laughing and making all kinds of sounds that only two happy twelve-year-old boys could possibly make.

Robert extended his hand, as his brother-in-law adjusted himself to the solid ground beneath him. "John, the long train ride will make one a little wobbly."

"It's good to have my feet on the ground again."

"Did Elizabeth not come with you?"

"She was planning to come right up to the last minute, and then one of her boys became ill. You know how she is about her children."

"Oh, dear. I was counting on her being in charge of things for the wedding and the dinner afterwards."

"I feel sure Harriet and Mother can fill in for Elizabeth rather nicely. You can tell them what you need, and I'm certain they will see that it gets done properly."

"Great suggestion. I'll talk with them this evening after dinner."

Robert had provided two carriages and a wagon for the valises and packages. Once the vehicles were loaded, the family headed to the Brinkley home. The only prearranged seating on the carriages was for Annie and Harriet. Annie told her father, "I have so many things to tell Harriet, I must begin in the carriage when she arrives. I don't want to waste a single minute."

"I believe that can be arranged," her father responded, "if you promise not to tire Harriet. I want her to manage some of the wedding arrangements, and she will need some time to think."

"Good. I'll be able to visit and help Harriet at the same time. We will be a good team."

In the other carriage Robert was giving an overly detailed account of his relationship with Elizabeth Mhoon. As the carriages and wagon pulled into the driveway, Robert apologized for monopolizing the conversation. He directed a group of waiting servants to take the valises and packages to the various rooms in the large home. Eli helped the servants by identifying which items went where. The valises went to the bedchambers, the packages to the parlor. Mary and Harriet chatted a moment about the outward beauty of Robert's home.

John engaged Robert in a conversation about schooling for Hugh and John. They were talking apart from the ladies. "Let's go in the house. I have someone I want you to meet." He directed the Overtons through the front door into the parlor. A teenage mulatto, female servant stood at the parlor door

holding a tray with linen napkins and glasses filled with fruit punch. She smiled each time a glass left the tray, but did not utter a sound.

"Robert," Mary broke the silence, "when do we get to meet Elizabeth?" Almost as if on cue, Elizabeth Mhoon appeared through the door which connected the parlor with the dining room. Robert introduced the Overtons, making certain to share a personal comment about each one. He began with Mary, moved to John, and finished with Harriet.

"Please be seated," Elizabeth said in a soft, directive voice. She moved gracefully to a two-seat sofa, patting the seat where Robert was to sit. "Would anyone care for more fruit punch?" The young servant came to attention, ready to move to the nearest empty glass. She handled the large pitcher with ease. "Leah, I believe Mr. Overton has an empty glass."

"Elizabeth," John nodded, "I've had this juice once before when I was a lad living in New Orleans. It's very tasty. What is it?"

"It's papaya juice. The fruit comes from the Caribbean. I have one of the boat captains bring me a supply of papayas each week. Leah makes the juice for us in the kitchen."

"Harriet, we should order some papaya for the holiday season and serve our guests."

"We can do that if you like. The color would be perfect for the season."

"John, how long were you in New Orleans?" Elizabeth loved to talk about places she had been.

"I was there nearly four years." He looked in his mother's direction for confirmation.

"His father, the Judge, thought it would be a good experience for him to have some growing up time in a different culture and environment." Mary seemed pleased to be involved in the conversation.

"And where did you live in New Orleans?" Elizabeth directed the question at John, but was very much aware he might not answer before Mary did.

"Eli and I lived with a Conti family on Perdido Street, one block off of Poydras Street. The family had some connection with the Cotton Exchange. I was able to spend time at the Exchange. Mr. and Mrs. Conti spoke only French. Fortunately, their children were bilingual, but I did learn enough French to shop in the stores and eat in some of the restaurants. Do you have some history in New Orleans?"

"I've been there a number of times but never lived there. My father grew cotton and had a business arrangement at the Exchange. Who is Eli?"

"Eli is my trusted body servant. We have been together since I was a lad. You'll see him around. He's with me on this trip."

"Elizabeth," Harriet jumped in to change the subject, "Robert indicated you may need some help with the wedding. Mary and I both are willing to help." The ladies discussed and made detailed plans for the wedding, including the ceremony and the dinner.

Robert and John found a quiet corner of the parlor to discuss plans for their sons' schooling in Brook Hill. Robert was especially pleased to learn that John Lea would travel with the boys and get them settled in school.

The noise level increased when Annie entered and announced, "Grandmother, I promised you something very special, but you will have to come with me." Annie extended her hand in a gesture to help Mary up. They walked hand in hand to the far side of the parlor. There between the massive windows was the surprise. "Well, what do you think?" Mary stood, almost breathless, admiring the portrait of her daughter and granddaughter. "Annie, this is a wonderful surprise—two beautiful ladies in one portrait. Thank you so much for sharing it with me."

Robert walked over to where Mary and his daughter were standing. "Did Annie tell you we have a portrait of Hugh and his mother? However, I had to send it back for more work. We had hoped it would be back in time for you to see it as well."

"Robert, the likeness is remarkable. It looks like she is ready to speak. Thank you for having this done."

"I thought it would be a nice keepsake for Annie."

"Father said it will be one of my wedding gifts or a gift for my first home."

"This is a gift you will always treasure. Again, thank you, Annie for the wonderful surprise."

The days before the wedding went smoothly. Mary and Harriet saw to the wishes of Elizabeth, freeing her to welcome members of her family from Alabama. The house was full of two families who enjoyed each other, centering their attention on Robert and Elizabeth. All of the furniture was removed from the parlor, allowing the bride and groom to stand facing the fireplace while the guests gathered in the rest of the room. Harriet had placed five small flower baskets on the mantel. She thought as she arranged the baskets, *This will do fine. The flowers are not overpowering but are needed for the occasion.*

Mary whispered to Harriet as Robert, Elizabeth, and the minister entered the room, "I'm so happy for Robert. He has been too long without a wife in his life. She will be good for him and especially good for Hugh and Annie."

The ceremony was brief but dignified. The minister spoke without notes and smiled widely when Robert kissed his bride. After a period of offering congratulations and good wishes, Harriet directed the new couple and guests to the reception table. Oohs and aahs filled the room at the spread of food on the table. Elizabeth approached Harriet and Mary and commented, "The table is beautiful. I am so happy. Thank you for doing this for Robert and me. I will never forget your kindness." As the candles melted away and darkness approached, Mary suggested, "Let's bid the bride and groom a good evening and allow them to retire. Thank you all for coming." The servants moved

quickly to clear the table and reset the furniture. In less than an hour the house was quiet.

The next day Mary was able to visit with the Overton agent in the city and was very pleased to hear him recount some of the times he had spent with the young John Overton. When Mary mentioned that John would be leaving for school in Virginia, he was somewhat surprised but fully understood the need for more education. "I'm hoping my grandson will some day live in Memphis and take over the family business."

"He seems to enjoy the city and knowing everything about the Overton holdings. He is full of questions and is a quick learner. I have truly enjoyed my time with him. If he tires of being in Virginia, I'll be more than happy to have him as an associate and teach him what I know." Mary was tempted to surface this offer with her son, but she knew he was determined for young John to have the Virginia schooling experience.

When the Overtons and Hugh Brinkley arrived back at Travellers Rest, activities moved at a fast pace. Martha was excited to be reunited with her parents and John. She was wary of Hugh and clung to Harriet when he tried to talk with her. Claiborne had met the train at the Overton Station, bringing both a carriage and a wagon. Since there were only three days before the boys and John Lea left for Virginia, the travel trunks were left on the wagon and kept in the barn. Claiborne also brought a leather pouch filled with mail and Harriet's magazines. John took the pouch and handed it to Harriet. She searched through the mail until she came to an envelope with Annie's familiar script. The envelope was very light, not heavy as usual, with multiple pages of sisterly chitchat, army news, travel reports, and general ramblings. Harriet removed the single sheet and sighed when she read,

> *Dearest Harriet,*
> *Still not with child, but still hoping.*
> *A.*
> *October 1854*

*Annie didn't even sign her full name,* Harriet thought as she folded the sheet and returned it to the envelope. *She is depressed. What can I do? She is so far away. Maybe I need to go to Texas and visit her. I need to talk with our sister, Mary, about this.* She dropped the envelope into her purse, wishing she could help Annie.

While they stood on the gallery, Harriet retrieved Annie's note and handed it to her sister Mary. "Have you or Father heard from Annie in the last week?"

"No, it's been several weeks." Mary read the terse note. "She sounds upset."

"Yes, and I'm afraid some of it may be my fault. When I write her, I tell her everything Martha is doing."

"Well, Harriet, I do the same thing. I thought she would want to know about Martha. If I didn't tell her about Martha, I wouldn't have any news at all."

"Maybe when we write her next time, we need to tell her less about Martha. By the way, did Martha do all right while we were away?"

"Her days were filled with all the attention we could give her. Father and Myra had the best time with her. They watched her every move. Even Julia picked at her and made her giggle. She fights afternoon naps unless someone is in the room with her until she goes to sleep. After her first night of restless sleep, Myra suggested we give Martha a warm bath before bedtime. That did the trick."

"Good, I'll need to remember that. Mary, would you mind watching Martha long enough for me to check on young John and Hugh? He is supposed to be packing the rest of his belongings for his trip in two days."

The following Friday morning, the boys and their Uncle John were on their way north. They boarded the Nashville & Chattanooga line. They would transfer railroad lines in Chattanooga and head north passing through Knoxville, up the Shenandoah Valley, north of Afton Mountain, turn east toward Charlottesville, and arrive at Brook Hill. John Lea sent a wire when they arrived and indicated that all made the trip safe and sound. He would check on the boys on his return trip from Richmond in ten days.

The ladies at Travellers Rest, same as last year, decided not to entertain during the holidays. Young John stayed in Virginia but made an extended visit at Frederick Hall with the Overtons for the holidays. His grandfather's brother, William, was delighted to have young John Overton and Hugh Brinkley visit. Their presence added to the holiday spirit and allowed William to recount many of his boyhood experiences. John was quite pleased to hear stories about his grandfather and added these accounts to the legacy and lore of Judge Overton. He reported some of William's stories to his father in a holiday letter to the family. John read his son's letter and later shared it at dinner one evening, commenting, "I believe I've done a good thing for John. Not only is he getting a good education; he is learning family history." Mary and Harriet nodded in agreement

Harriet had a surprise visit from Grace Evans. She heard a faint knock at the front door, which was unusual. Most of the guests used the side door or the double doors. Mary's servant answered the knock, opened the door, and stared at Grace without saying a word. Grace broke the stare standoff by asking, "Is Harriet Overton at home?" The door closed, leaving Grace standing outside on the stoop and a little confused. She knocked again, this time with more force. Three minutes passed and then four. She was about to really make her presence known when the door opened and there stood Harriet with Martha pulling at her skirt. "Grace! Grace Evans, do come in this house! How long

have you been standing out there? I do apologize for the servant. We seldom have guests come to the front door. Let me take your wrap."

"I was beginning to wonder whether I had the right house. And who is this precious little one?"

"This is Martha." Harriet lifted her and held her at eye level to Grace.

"Hello, Martha. My name is Grace. I'm a friend of your mother's." Grace was surprised when Martha repeated, "Grace" and leaned forward, putting out her arms. Grace took the child from an astonished Harriet's grasp.

"Grace, this is a first. She has never done this before. I'm amazed."

"I have a little gift for Martha, if that's all right. It's in my bag. I had hoped to get it to her earlier, but I've only been back at the shop for about a month."

"Have you been ill?"

"No, my sister-in-law needed some help and I was the only one available. Her third child came early and only lived less than a month. The whole situation did something to her mind. I went home to help her and my brother and their other two children."

"How is she now?"

"She's doing much better after an extended period of rest. So I came back to work, and now I'm headed back to Columbia to visit my father for the holidays." Harriet found Grace's bag and discovered a rag doll inside. She handed the doll to Grace. Grace laughed, "Do you recognize the dress material? She handed the doll to Martha who wrapped it in her arms and began to sway back and forth.

"I do declare. I believe I have a holiday dress made of the same black velvet." Harriet and Grace laughed as they headed to the parlor.

"I really don't have long to stay. I've arranged to ride your husband's train to Columbia this afternoon. I was told at the depot the train would stop for me at the Overton Station."

"How did you get to the house?"

"I rode out Franklin Pike with a friend until I saw your home and then I walked. It's really not far for an old farm girl."

"I'm so glad you came for a visit. I have been very neglectful of our friendship. I apologize for that. I fully intended to get into the city and take you to lunch. In my defense, I was not very good company waiting for Martha to get here and . . ."

"Harriet, you do not need a defense. I've not had a child, but I do know rearing one can be time consuming. Friends just pick up where they left off and go on. That's how I feel about our friendship."

"Me too, Grace. And I'm still planning to come to the city and take you to lunch." They both glanced down at Martha sitting on the carpeted floor, still hugging her new rag doll dressed in black velvet.

Harriet arranged for Claiborne to drive them in the closed carriage to the Overton Station. They continued to visit while waiting for the train to come.

As it pulled away, Harriet and Grace waved to each other. *Of all my classmates at the Academy, Grace is the only one,* Harriet pondered to herself, *who has made any attempt to keep a friendship alive. I must do a better job next year to take her to lunch in the city. I wish I'd remembered to ask her about a special sewing project. I'll do that next spring.* A blustery wind blew through the leafless trees, and Harriet knew that was a sure sign colder weather was on the way.

The first week of 1855, a blanket of snow covered the entire Nashville area. The city and surrounding communities came to a standstill. Sleet came first, and then snow fell sometime during the day each of the first five days of the New Year. People stayed indoors and tried to keep warm. Strong winds blew the snow into high banks on all the Pikes leading in and out of the city. Boat traffic on the Cumberland River was limited. The rails were caked with ice and covered with snow, making travel impossible. As bad as the situation was, it was worse at the Lealand Plantation. Elizabeth Lea had to cancel her holiday party. Not only did she look forward to showing off her lovely home, but she knew her guests enjoyed coming to see what new furnishings she had added, and it was a social event of the season for them to share with their friends.

Meg was told to report the party cancellation to the other servants in the Lea house. "Meg, tell them the deep snow will prevent us from having a holiday party this year. I will be giving them new assignments shortly. None of you will have free time during the holiday season. Now go, do as you're told."

"Yes, ma'am." Quickly, she gathered the cooks, servers, and the outside carriage attendants.

"Listen to me, slaves. Your mistress wants you to know . . ."

"What's ya mean 'Yaur mistress', ya a slave jest likes us," one of the cooks voiced.

"As I was saying before that darkie interrupted me, your mistress wants you to know there will be no holiday party at Lealand this year, but you do not have free time. Your mistress will be giving you slaves assignments shortly." Another of the kitchen helpers moved in front of Meg, so close their noses touched. "Ya a darkie, ya a servant, ya a slave, ya a nig . . ." Meg clasped her hand over the mouth of her challenger before the last word could be formed on her lips. In full view of the other slaves, Meg brandished a small knife in her other hand and directed it at the helper's throat. "Don't you ever say that word to me, and that goes for the rest of you as well." Meg made direct eye contact with every person in the room. "Now, get out of my sight and get back to your slave duties." In a few days, the snow would be gone, and Meg was thinking of going as well. There was no more questioning Meg about her control of the house.

John Overton was not a pretentious man around Harriet. He enjoyed the holiday season, even the parties, but he always looked forward to Harriet's birthday. He loved to surprise her with special gifts. When she was happy, it made him happy. Each birthday since they had been married was a special celebration at their home. This year, her twenty-fourth year, was celebrated with the Overton and Maxwell families. Gifts from her father and Myra, her sister Mary, and Mary Overton were placed on the buffet near the dining table in full view of Harriet, which she glanced at all during dinner. As the table was being cleared and the peach brandy poured, John stood, gathered the gifts, including his gift he had hidden earlier in the drawer, and placed them before the guest of honor. Harriet was all smiles as she opened her gifts: a white shawl from her father and Myra; two matching pearls to add to her necklace from her mother-in-law; earbobs from her sister Mary; a copy of Henry David Thoreau's *Walden*, with a note which read, TO MY MOTHER ON HER BIRTHDAY. LOVE, MARTHA; and finally John's gift. Her mouth gaped open as she opened his gift. She held her breath, cupped her hand to her mouth, and finally spoke. "John Overton! How did you ever get this?" John smiled as he sipped his brandy.

"What is it?" Myra wanted to know.

"It's Stephen Foster's latest composition, *Jeanie With the Light Brown Hair*. It's sheet music for my piano and it's autographed. Look! 'To Harriet Maxwell Overton. Happy 24th. Stephen Foster. 1855.'"

Mary Maxwell cleared her throat and glanced at her father. "Harriet, we have one more gift for you. Father, please give Harriet the letter."

"Oh yes, this letter was in our box," he said as he handed it to her. She recognized the script immediately. It was from Annie. The letter was addressed to Mr. Jesse Maxwell with a heavily underlined note, PLEASE HAND TO HARRIET ON HER BIRTHDAY. The Maxwells were beaming as Harriet unfolded the note inside the envelope. They knew the message already. Two letters had come from Annie a couple of days ago—one for the Maxwells; the other, for the birthday lady. The Maxwells had already celebrated the news but were sworn to secrecy.

Harriet stood straight up from her chair. Her voice was powerful as she announced, "Annie is with child! Praise God from whom all blessings flow!" She held the letter up and smiled broadly. Mary joined her and the two sisters embraced, celebrating the good news.

John stood, lifted his glass, and exclaimed, "A toast to Thomas and Annie on their wonderful news. May their family develop and grow with wonderful health." Glasses clinked around the table with smiles from everyone. Martha was fast asleep in her highchair and undisturbed by the loud celebration.

The ladies moved from the table to the sofa and high-backed chairs and continued to talk about Annie's wonderful news. Jesse and John stayed at the table enjoying another glass of brandy. "John, do you keep up with the political news happening around the country?"

"I read what's printed in the Nashville newspaper. Do you have a specific concern?"

"What does that Lincoln fellow from Illinois mean by gradual emancipation of the Southern slaves?"

"Jesse, his thinking is all tied up with the Kansas-Nebraska Act Congress passed last summer. Each of those new territories have the option between pro-slavery and abolition. The side that wins will have the voting power in the House and Senate."

"You mean if the House and Senate vote for abolition, we'll have to free our slaves?"

"I'm not sure. I do know a new political party has been established, and its main purpose is to do away with slavery. They're calling themselves Republicans."

"What do you think President Pierce will do about this?"

"As little as possible with the national election coming next year."

"Jesse," Myra said, getting his attention. "We'd better be heading for the Hall while we still have some daylight." Everyone stood and prepared to leave. A servant brought the Maxwells' wraps. "Thank you so much for coming to my birthday party and for bringing such wonderful presents. I'll enjoy them forever." Harriet closed the door as they exited to keep the cold air out of the large room. She found the sheet music from John and went to the piano. John and Mary sat by the fire as Harriet played. Martha aroused as the soft music began to fill the room and let her presence be known.

. An oversized box arrived at Travellers Rest. It was addressed to Mrs. John Overton, Sr. The driver told Mary he was from the Smith Jewelry Company in Nashville. "This is a mighty cold day to be out making deliveries, young man." Mary signed the delivery sheet and requested, "If you would be so kind to bring the box inside, I would appreciate it." She directed him through the double doors and into her bedchamber. "Please place the box on the small table." She went to her nightstand, found a few coins, and handed them to the young man. "No, ma'am, I can't take that, my boss will . . ."

"I've known your boss since he was a small child at church. This money will be a secret between you and me. The only way your boss will know is if you tell him."

"Thank you, Mrs. Overton. You are very kind."

"Sometime in the future, when you are a successful businessman, you can return the kindness. Now, you'd better get started back to the city."

"Thank you again, ma'am." Mary closed the doors to her bedchamber and carefully opened the box. She removed the silver pitcher and placed it in the middle of the table. *Perfect! Just perfect!* Mary smiled as words and phrases ran through her mind. *It is even more grand than I expected. Now, to check the engraving. Let's see, MMO to HVO.* She took a handkerchief from her dress pocket and wiped across the letters to make doubly certain they were correct. And they were. Mary could see her image in the solid silver pitcher. *I hope*

*Harriet will be pleased. It really is a lovely keepsake. Someday she can give it to Martha for her keepsake.*

Cynthia looked the plantation over, as instructed by Mary, for something blooming. She found only green herbs from Mary's garden which filled the pitcher. It was prominently placed on the dining table the evening of February 28, 1855. Harriet noticed the pitcher, but turned her attention to Martha, who was being seated in her highchair. John didn't notice anything new, but then he never did. After they were seated, Mary directed a comment to John, "Son, this is a special day in the Overton family."

"It is?" he half smiled as he looked at Harriet for a clue. Harriet cut her eyes to the silver pitcher while she patted Martha's hand. He was still unaware.

"What happened to you, in this very room, five years ago? "

"Harriet and I were married." He felt relief. He exhaled noisily. Mary and Harriet exchanged smiles and were both pleased at John's memory. Mary leaned forward and turned the pitcher around, revealing the inscription. "Happy fifth wedding anniversary to both of you. It makes me happy to see the two of you happy. I hope this pitcher will always be a reminder to you, Harriet, that you are very special to me and the entire Overton family." Tears formed in Harriet's eyes as Mary spoke. She ran two fingers over the inscription and said, "MMO to HVO. Mary, this will be a treasure forever for me and in the Overton family." Martha did not care about the pitcher or the celebration. She was hungry and made her needs known. Their attention turned to a fussy Martha.

That evening when all was quiet, John and Harriet reviewed their five years of marriage. They laughed together in their bed surrounded by pitch-black darkness; Harriet giggled at times. They held each other, kissed passionately, and celebrated their love.

By June, the plantation was alive with the smells of returning flowers in the kitchen garden. Mary's herb garden was filled with color, fields were green with growth, fruit trees were heavy, and the weather was just wonderful. Martha had celebrated her second birthday, and it was a turning point for her as she made advances in her vocabulary and speech patterns. One morning at breakfast, in the midst of the table conversation, she blurted out, "Go to Hall. See Mare-we." All eyes turned in her direction. "What did you say, darling?" Harriet wanted to hear her daughter say that again. In fact, she wanted everyone at the table to hear Martha repeat it.

"See Mare-we at Hall."

"You want to see Aunt Mary at the Hall?" The two-year-old responded by nodding her head.

Harriet turned to the servant, "Go tell Claiborne to get the carriage ready. Martha and I are going for a morning visit."

The Maxwell plantation was not ready for a morning visit, but the appearance of Martha had a way of taking priority. Mary heard the carriage

arrive, left her bread-baking project, and walked onto the front porch. She was in her day dress covered by a full apron. She wiped her flour-covered hands on her apron as she spoke. "What brings you to the Hall? Is everything all right?"

"We are fine. Everything is fine…no, everything is wonderful! At the breakfast table a short while ago your niece put her first two sentences together, and guess what she said?"

"Get down. Now!"

"Not even close. She said, 'Go to Hall. See Mare-we.'" Harriet handed Martha down to Claiborne and then took his big hand and stepped from the carriage. Martha spotted Mary and began squirming to get down.

"What is Mare-we?"

"That's you, silly. Don't you recognize your own name?" Martha was around the horse in a flash and headed for the porch yelling, "Mare-we! Mare-we!" Mary moved to the bottom step, opened her arms, and was nearly knocked over by the charging two-year old. "Hello, my darling. How are you today?" The two hugged until Martha squirmed.

"Me fine. Cookie, pease."

"Well, you will need to ask your mother about the cookie. Go find Myra in the house while I go find Grandpa. I know he will want to see you."

"Mama, cookie pease."

"Maybe a very small one." Almost on cue, Myra appeared at the door with her hands behind her back. "Did I hear Martha Overton on the porch?" Martha had played this game before. She walked behind Myra, searched each hand, and was rewarded with a cookie.

"What do you say, Martha?"

"Tank-you."

"You're welcome, Precious. And Harriet, how are you? Would you like to sit out here or go inside?"

"Out here will be fine. We can't stay long. Martha said Mary's name at breakfast and I wanted her to hear it." Mary reappeared on the porch. "You found your cookie, I see. Father was in the barn. He'll be right up." Martha sat contentedly in Myra's lap eating her cookie a small bite at a time. When she heard the familiar voice, "Martha. Martha. Where is my Martha?" She put the remainder of the cookie in her mouth, slid down, and looked all around for the voice. The scene being played before her sent Harriet's memory into reverse. *I remember that voice. Back then it was saying, "Harriet. Harriet. Where is my Harriet?" I don't recall much about being two years old other than hearing Father say my name. He must have known that hearing one's name was important. I'm so glad Martha is developing a strong relationship with her grandfather.* Jesse continued to play the game until Martha spotted him at the side of the porch. She took off, bouncing with each step, and he engulfed her in his arms. "Cookie pease, Papa."

"Martha, one cookie is enough. Papa doesn't have any cookies." Jesse looked at Harriet as if to say, *"I have lots of cookies in the kitchen. And if my*

*granddaughter wants a cookie . . .*" He did not verbalize his thoughts, knowing he would be outnumbered.

"Is Julia in the house? I want her to see Martha, and then we need to be heading back home." Harriet always took time to visit with Julia and wanted Martha to know her as well.

"I believe she's out back of the house in her herb garden," Mary said, pointing in that direction. "Come on, Martha, let's go see Julia." Sure enough, Julia was singing and hoeing in the garden when Harriet interrupted, "Julia, how does your garden grow?"

"Wid weeds." That's what she had said for as long as Harriet had asked the question.

"And who dis mighty fine lady be?" She held out her hand, and Martha grabbed it.

"Cookie pease."

"Julia, this young lady has already had a cookie and I believe one is enough." Julia had to laugh.     "Sabbath Child, I 'member when ya didn't wants a cookie, ya wanted two—one for each hand. Miss Martha likes ya was in many ways. She pretty, likes ya and she strong willed, likes ya. And dats good! World need mo strong willed ladies. Looks here at me in da eyes. I do declare, ya with child again."

"What did you say, Julia?"

"Ya knows what I's say. Is dat da sun a shinin' up dere?"

"But I haven't been . . ."

"Yes ya has . . . at least one time of late."

"Please. Please. Please. Let this be our secret."

"Jest likes last time . . . and we gots Miss Martha."

Harriet and Martha went directly home. She told a house servant to take care of Martha. She went to her bedchamber, found a hand mirror on her dressing table, and looked at her eyes. *How could Julia look into my eyes and tell I was carrying a child? Are the words written on my eyeballs? How does she know? Maybe she is wrong this time.* Harriet checked her calendar and shook her head. A week later she knew Julia was right again. She told John in private and then shared the news with Mary at dinner.

Harriet was eager to tell her Maxwell family her good news but decided to wait until Annie's child was born. She wrote Annie the good news and swore her to secrecy, explaining her reasoning.

During the last week of July, two letters arrived from Laredo, Texas—one addressed to Mary Maxwell; the other, to Harriet Maxwell Overton. Both letters announced the birth of Mary Maxwell Claiborne to Captain and Mrs. Thomas Claiborne. No sooner had Harriet finished reading the news than she heard a carriage arrive at the side of the house. Mary Maxwell ran up the gallery shouting, "Harriet! Harriet! We have another girl in the family, and her name is Mary." The two sisters, each still holding Annie's announcement, met on the gallery, hugged each other, and jumped up and down as they had when

they were children. Jesse and Myra came up the gallery in a normal fashion but were just as excited about Annie's news.

"Harriet, we need to send the new baby some gifts." Mary was breathless as she spoke. "What can we send?"

"Why don't I ask my friend, Grace, at the dress shop to make Mary Maxwell Claiborne a fancy, white christening dress? Better yet, she may have a dress in stock. Since the weather in Texas is so hot, she doesn't need anything very heavy."

"Can we go to the city tomorrow and get the dress and some other things?"

"Yes, that is fine with me. I'll come by in the morning after breakfast to pick you up. Father, would it be possible to take Julia with us? There's something I want to do for her and Cynthia in the city."

"That will be fine. Julia will enjoy the outing." As Jesse talked with Harriet, he was looking for Martha.

"Are you looking for Martha?" Harriet had to smile at her father's look of innocence.

"You know I am. Where is she?"

"She and John rode down to the Overton Station. He needed to check on something."

"Is she riding on a horse with John?"

"Yes, I believe she is."

"Good. I've been waiting for this day to come." Harriet knew her father was anxiously waiting for the time to come when he could get a pony for Martha. Each of his daughters had had ponies, to the dismay of their mother, but they learned to ride.

Harriet positioned herself in the front of her Maxwell family. "I have some good news I want to tell you. I am carrying our second child. If Julia is correct, and she usually is, the baby will be here in the New Year." As promised by Harriet and predicted by Julia, Jackson May Overton entered the world on February 17, 1856, just a few days before John and Harriet's sixth wedding anniversary.

# 12. Farewell to Family and Friends

Mammy Julia directed the birthing of Jackson May, giving Harriet suggestions to make the event less traumatic than it might have been. He was a big baby for Harriet's small frame, but she managed. As with Martha, Cynthia was in the room during the birth to aid Julia and give moral support to Harriet. Mary Overton checked on the birthing process and left the room occasionally to update John and Martha. Although Martha had not been around many children her age or younger, Harriet made a great effort to help her understand what was happening. "Even a two-and-a-half-year old," declared Harriet, "can understand some of the concepts of what is happening in the process."

Waiting was not a favorite activity for John, but he took advantage of the time to be with Martha. He was not good at baby talk. When he spoke to Martha, it was always in his own vocabulary. "Your mother is getting a new baby for us."

Martha's consistent response to any statement for the last several weeks was "Why?"

"Why?"

"You will be the baby's big sister, and you can help Mother take care of the baby."

"Why?"

"Because that's what big sisters do."

"Why?"

John was aware he did not play this "why?" response well. He was relieved when the door opened to the large room and his mother came in to update him. "Julia said it wouldn't be long now."

"How is Harriet doing?"

"Harriet is doing what she needs to do. She is very brave. She is a very strong lady."

"I'm overly anxious for her, but I . . ." His voice faded out without finishing the sentence.

"Son, you need to realize that Harriet and Rachel approached carrying their children differently. Harriet stayed active; Rachel tended to stay in bed and sit most of the time. Rachel was not strong physically when she delivered your son. Harriet is much stronger. You know she just might stand up and stomp her foot if the baby doesn't come soon." She waited for a reaction. It came as she had hoped.

"Mother, you are so right." John was laughing and his mother joined him. "She does mean business when she stomps. She's little, but she's mighty." Their conversation was interrupted by the shrill cry of an infant with good lungs that filled the house.

"John, I believe the baby has arrived." Mary took Martha by the hand and followed John through the house to his bedchamber. The infant's cry

resounded in the hallway. Martha covered her ears, which brought smiles from her father and grandmother. The crying stopped and the door opened. Cynthia stood cuddling and humming to the bundle she held. Her smile indicated that all was well inside the room, but John asked anyway, "Is Harriet all right?" The question impressed Mary and she was pleased to hear her son ask it. She was in the process of lifting Martha up so she could see the baby when they heard Harriet's voice, "Where is my Martha? If you're in the hallway, come in and see me."

Cynthia handed the infant to John, questioning, "What his name goin' to be, Massa Overton?" The question caught him off guard. Harriet had said months ago, "John, I want you to be ready with a boy's name when our baby is born. Julia has already said it's going to be a boy this time."

"Well, Cynthia, we will call him Jackson . . ." John hesitated long enough to see the expression of surprise on his mother's face. That would be the last name she would have chosen. She didn't like the name Andrew nor Jackson and detested hearing the names together. "And his middle name is May." That brought a smile to Mary's face. *How thoughtful of John to continue the May name in his family. Francis would be honored to be remembered in such a fine way.*

"Jackson May Overton." Harriet repeated the name and liked the sound. The name had family ties in it. "John, that is a wonderful name. When Jackson is older, you will need to tell him why you chose his name and the meaning it has to the Overton family."

Harriet turned to Cynthia and said, "Please find Eli or Claiborne and ask one of them to ride to the Hall and then over to the Lealand plantation and tell them the news about Jackson May Overton's birth. And then I want you to come back here."

"Yes, ma'am."

John sat in a chair next to the bed, still unable to take his eyes off the little round face looking back at him. Martha was sitting in the bed next to her mother. "Martha, can you stretch out your arms in front of you like this?"

"Why?" John had to smile when he heard the all-too-familiar question.

"Because I want you to hold your new brother, Jackson May, that's why."

"Al-wite. Hold Jacks."

"Jackson. Jack-son. Jackson." The look on John's face indicated he was not sure this was a good idea, but he trusted Harriet to know what she was doing. He placed Jackson gently into the stiff arms of his daughter and then relaxed in the chair, but did not take his eyes off his two children and their mother. Martha looked down at her new brother and said, "Hi, Jack-son." That brought smiles and laughter from all in the room.

"Martha, how about letting grandmother Overton hold Jackson?"

"Al-wite." The transfer was made, to the relief of Martha and Grandmother Overton. John also was able to relax even more and sighed, as he reached across the bed and took Harriet's hand. Cynthia returned, nodded at

Harriet, and went over and stood next to Julia. Harriet looked at both slaves and knew, without a doubt, the safe delivery of both of her children was due to them. "Julia and Cynthia, come here," pointing to the foot of her bed, "and let me talk to you."

The response was in unison, "Yes, ma'am."

"In my wardrobe are two long packages. John, can you get them for me? One has Julia's name on it; the other has Cynthia's name." John found the packages and delivered them.

"Cynthia," Harriet said, "you have always been kind to me since I've been in the Overton family. Julia, you have always been my mammy. Both of you have worked long hours to make me comfortable when I was with child, and you helped me have a safe delivery for both Martha and Jackson May. I wanted to say thank you in a tangible way. You may open your packages, if you like."

Julia was the first to react. She untied the package and unfolded the wrapping paper. Her eyes became wide and her mouth gaped open. "My, oh my, Sabbath Child, what has ya did?" Her throat tightened and tears came to her eyes. She had never seen a dress so beautiful in all her life. The dress material rustled when she held it up for Cynthia to see. The red color was just perfect for her. The puffed sleeves, the lace around the neck, and the row of five pearl buttons at the end of each sleeve was a sign of an expensive garment.

After seeing what Julia found in her package, Cynthia delayed no longer and tore open her gift. Her dress was made with the same design but in green material. She held the dress up for Harriet to see. Harriet made a waving motion toward the full-length mirror in the corner of the room. She didn't need to say a word. In the excitement of the moment, Harriet had the finishing touches for the dresses. "John, I need your help again. On top of the wardrobe are two hatboxes and two more packages. No fine lady can be seen in a new dress without new shoes and a bonnet."

Mary stood in the doorway, still holding Jackson May and observing the drama being played out before her. *Slaves with new dresses, shoes, and bonnets. What is Harriet thinking? Is she planning to dress all the slaves in fancy things? Where does she think Julia and Cynthia will ever go to wear those things?*

"Miz Harriet, how did you know what size we be?" Cynthia was wiping tears from her cheeks.

"Do you remember the day you, Julia, Mary, and I took the carriage into the city and had lunch?" Julia moved over close to Cynthia. She wanted to know, too. "We went shopping for a gift to send Annie for her new baby." Julia and Cynthia nodded their heads in acknowledgment. "My friend Grace looked you over that day, figured your sizes, and then made your dresses accordingly."

"You knows, Miz Harriet, I never had a store-bought dress in all my days." Cynthia held the dress against her, allowing Harriet to have a full view.

"Dis dress, Sabbath Child, be my goin' home clothes. When I close my eyes for da last time, somebodies puts dis dress on my corpse. I's be goin' out of dis world in style!" Julia did a double turn and repeated, "I's be goin' out in style."

"I'm so happy you like your things. Seeing you happy makes me happy." Jackson May began to squirm and gnaw at his hand. Julia knew the sound and knew what the infant needed. "You be gettin' ready," Julia looked at Harriet. "Da rest of yous be needin' to leave sos dis youngin cans gets some dinner." Jackson was handed to Harriet. Julia emptied the room, closing the door behind her. It was time for mother-son bonding. Harriet looked forward to these quiet times with her son; Jackson was happy his mother was willing to share herself.

John Overton didn't realize the birth of his son would make the news it did. He stopped by the newspaper office on his way to the depot a day or two after Jackson's birth. He was hoping to place in print a birth announcement, including a listing of the proud parents, grandparents, and relatives. Much to his surprise, the paper's editor had made the birth a news item. John had followed the same procedure for Martha, but her announcement was buried on page six. In Jackson's case, the headline on page two read, A NEW OVERTON GENERATION BEGINS. The editor apparently kept a file on the Overtons. The article mentioned the father, John Overton, as a successful Nashville businessman and the driving force behind the Nashville & Decatur Railroad. The mother, Harriet Virginia Maxwell Overton, was a native of Nashville and came from an old, very well-known Nashville family. The Jackson and May namesakes were spelled out, pointing out their connection to the history of Nashville. The article took two paragraphs to relate Judge John Overton to the new birth in the family. Grandmother Mary Overton was linked to her famous husband, as usual. Jesse and Myra Maxwell were mentioned as grandparents. The article closed with a listing of other relatives including Master John Overton, Mrs. John Lea, Mr. Robert Brinkley of Memphis, and Mary Maxwell. No mention was made of the May children. John reread the article and then turned his attention back to the front page.

The carriage ride from the depot to Travellers Rest always gave him ample time to scan the entire newspaper and time to read fully most of the front-page articles. Most of the articles related to events outside of Nashville and Tennessee. He was eager to read about railroad progress being made throughout the country. He was happy to be a small piece in the larger picture of the growing industry. On today's front page was a follow-up article entitled, RAILROAD TRAVERSES ISTHMUS OF PANAMA. W. H. Aspinwall had conquered 47 miles of jungle and swamp to link the Atlantic Ocean and Pacific Ocean by rail. The adventure had cost him $150,000 per mile. *Some people who read this article,* John reasoned, *will think Aspinwall has lost his*

*mind. What they don't realize is that passengers and freight can now travel by rail from New York City to San Francisco in five weeks. To make the same trip by sea would require nearly 19,000 miles, and then one would have to travel around Cape Horn.*

He was folding the newspaper, ready to put it in the leather pouch with the other mail, when his eye caught a one-paragraph article on the corner of the page. He had to laugh at the title, STRAWBERRY FEVER LEADS TO SHORTCAKE. The editor was not above running satirical articles at times. *It must be important. It's on the front page. I wonder what it's about.* As he read, he just knew Harriet would find this amusing. "The wide strawberry craze has hit a new high in New Orleans. Tables throughout the city are being filled with a new dessert. A light pastry is being served with fresh wild strawberries with whipped cream on top. Some of our fine ladies are calling it strawberry shortcake. I'm looking forward to a tasty summer, how about you? What will we think of next?"

Eli brought the carriage to a halt at the back gallery. The stop brought John out of a twenty-minute nap. "We home, Massa John."

"Good. Tend to the horse and wipe the dust off the carriage before you put it in the barn."

"Ya, sir." Eli had been following the same routine for a long time. He had been taking orders from John Overton for over twenty-five years. They had traveled together, eaten together, and slept in the same room, but John had never made any effort to discover anything about Eli's personal life. One day when John was ten years old, Eli was given to him by the Judge as a gift. From that first day, John had given the orders and Eli complied. He had never been mistreated. He had been verbally corrected on a number of occasions and reminded of his role and responsibilities as a slave. He never made any effort to learn about his birth parents in Virginia. He drove the carriage and took Massa John where he needed to go. The thought of freedom had crossed Eli's mind only twice that he could remember. One time he took a message from Massa John to Emmaline, who lived in a slave cabin with her children. He found her sitting outside her front door nursing an infant. "What ya doin' down here, fool?" She seemed to dislike the sight of him because he had special privileges. He never had to sweat and work in the fields. All he did was follow Massa John around. "Ya been kissin' Massa John's backside today?"

"Emmaline, whys ya talk like dat to me? I just a slave likes ya and all da others down here."

"Yeah, but ya could be free."

"Ya means run away?"

"Yeah, sometimes when ya in da city, gos to da underground and be free."

"What underground?"

"Da Underground Railroad, ya fool!" Eli gave Emmaline the message and then headed back to the barn, hoping no one had heard them talking and especially the word *free*.

The next time Eli gave serious thought to freedom was again in the context of the Underground Railroad. He had taken the carriage for a wheel repair to the blacksmith just around the corner from the railroad depot. Jake, a slave who had bought his freedom, owned and operated the shop. He was so skilled as a blacksmith that the citizens of the city overlooked the fact he was black because they needed his services. Eli was explaining to Jake about the needed repair when their attention was drawn to a loud commotion up the street. "What dat up dere?" Eli had moved outside to get a better look at the crowd, including several policemen on horseback.

"Das da Underground Railroad."

"Dere's no railroad up dere. It be over at Massa John's depot."

Jake looked around before he spoke.

"Da Underground Railroad is da name used by da slaves who lookin' fer freedom."

"What ya mean freedom?"

"Das all I sayin'." Jake went into his shop to get a part for the wheel. Eli stayed outside and watched as three blacks—two men and a woman—were dragged into the street. Their hands were tied together in front of them. The three ropes were handed to a policeman on horseback. He tied the ropes to his saddle horn, spurred his horse, and headed up the street. Realizing what was happening, the two black men stood to their feet; the black woman remained seated on the ground until the slack in the rope was gone and she felt her body being dragged. She was helped to her feet and the three were forced to walk fast and then trot the several blocks to the city jail.

Eli went inside the building to find Jake working on the wheel. "What's goin' to happen to dem?" He was shaking as he spoke.

"Dey be goin' to jail rite now. Den dey be talked to and find out who be dey massas. Den dey be sent back to da plantation."

"What happen to dem at da plantation?"

"What ya think, fool! Dey be whipped out in public and den sold south. If ya lookin' to takes freedom now, don't be using' da Underground Railroad. Dats all I's sayin'."

In less than an hour, the wheel was fixed and Eli was on his way back to the depot. As he pulled the carriage past the house where earlier two black brothers and a black sister were treated like wild animals, he thought, *Bein' tied up and dragged just ain't rite. Dem three has de rite to be free just like Jake. I's have da rite to be free like Jake, too. I's be free when da good Lard call me home.* The thoughts of freedom lingered until he turned off Broad Street into the depot parking area. He spotted Massa John and he was fully back into reality.

"Eli, what was all the commotion around the corner?"

"Three blacks tries to get on board da Underground Railroad. I guess dey don't has no tickets. Deys gone off to da jail."

"How does the carriage work?" John had no interest in Eli's jabbering.

"It workin' fine, sir."

"I'm going to the office to get some papers and the mail pouch. Then we can head for home."

"Ya, sir, Massa John." Freedom was not an active word in Eli's vocabulary, and he put the morning's activities out of his mind. He found fulfillment in being at John Overton's beck and call.

John noticed his sister's carriage as he pulled up to the house. However, her visit became secondary when he heard Martha squeal with delight after spotting him. She was playing on the gallery with her doll. She had spread a blanket and was feeding it from a small pot Cynthia had provided from the kitchen. She was trying to care for her doll like her mother was caring for Jackson May. Harriet had gone inside the house to have Jackson changed. Mary Maxwell sat in a chair not far from Martha but did not interfere with her make-believe time.

Elizabeth excused herself and went in the house to visit her mother. During their conversation, she mentioned she had come to see Jackson May and brought a stack of clothes her boys had outgrown, as well as other infant items.

Martha scampered down the gallery to greet her father, knowing he would pick her up and plant a big kiss on her cheek. It was their daily routine and both enjoyed the encounter.

"Hello, my princess. How have you been today?" Martha did not respond, but a voice came from inside the house, "Very well, my prince. And how have you been since last we met?" Harriet was now standing at the opening of the side door, holding Jackson up for John to take him. "Here, I'll trade with you. You hold Jackson and I'll take this big girl."

"I'll do it for a welcome-home kiss."

"John, how fresh you are, but I like it." Martha liked being called a big girl. Harriet had taken special care to prepare Martha for the new baby, and she used every opportunity to continue the education. "Well, big girl, what would you like to do?"

"Get down!" Martha was learning early to make her wishes known. She was able to identify the various people in her circle with activities she liked to do. With her father, a kiss was the activity. Being with her mother meant sitting in her lap and looking at a book or magazine and being able to turn the pages. Her doll, with no name, was always at her side for the mother activity. A visit to see Cynthia in the kitchen meant the possibility of a cookie. Special tea parties with Grandmother Overton was an activity she enjoyed. Time with Aunt Mary involved running, jumping, and walking around the house holding hands. In Martha's mind, right now was an Aunt Mary time. When Harriet put Martha down, she ran over to Mary, took her by the hand and said, "Go. Come, go!" Off they went down the steps and into the yard and soon disappeared from the watchful eyes of Harriet.

John still had the mail pouch hanging on his shoulder by its strap. When he realized it, he motioned to Harriet. "There's a newspaper in the pouch and some other mail. Look on page two of the newspaper."

"What is it?" She removed the pouch, pulled the flap, and located the newspaper. She made her way to the rocking chair and sat down. As long as Jackson was having bonding time with his father, she took advantage of the time to read. "Let's see, page two." She found the article, A NEW OVERTON GENERATION BEGINS. Harriet smiled as she read and reread the article. "How did you manage to get this article in the paper?" John was smiling at the open eyes of his son and the stretching the infant was trying to do.

"I went by the newspaper office and gave the editor the basic information, just like I did for Martha when she was born. I thought Jackson May would get the same coverage she got."

"The only two people not mentioned are Julia and Cynthia." John found one of the wicker chairs with the big cushions and flopped down, still holding Jackson in front of him.

"There's a small article on the corner of the front page you may find interesting."

Harriet refolded the newspaper and located the article. The headline was confusing to her, "John, why would I be interested in prohibition in New York State?"

"No, dear, the other corner. It's the article about strawberries."

Her gaze crossed the page and discovered the article John had mentioned. After reading it she looked up and said, "Thank you, John. I'm glad to know you're keeping up with the important things in life." About the time she folded the paper and laid it aside, Elizabeth and her mother came out of the house onto the gallery. "Brother, I didn't realize you had come home."

"I've only been here a few minutes. How are you this fine day?" He stood, balanced Jackson, and bent over and kissed Elizabeth on the cheek.

"It's always good to come home and see all of you. Martha and Jackson are growing so fast. I was just telling Mother about Meg."

"Who's Meg?" John asked. "I don't believe I know a Meg,"

"She's our house servant. John bought her on one of his trips. She can read and write and has a sharp tongue. She's been answering the front door."

"What's the problem? Is she sick?"

"No, she ran away. Some of the other slaves said she was talking about the Underground Railroad. Do you know anything about that railroad?"

"Interesting you should ask. Just a minute." John handed Jackson to Harriet, walked down toward the barn, and called for Eli. The ladies watched from the gallery as John and Eli talked.

John returned to the gallery and continued the conversation. "Eli told me that while he was over at the blacksmith shop this morning, he saw three slaves—two men and a woman—being taken to jail. He used the phrase, 'from the Underground Railroad.'"

"What do you mean, jail?" Elizabeth questioned.

"What I mean is, if the woman was your Meg, she may be in jail. It is not a good place for a female slave. I'd suggest you have your John or your overseer check tomorrow at the jail."

"What shall I do if Meg is in jail? She is highly intelligent for a slave. She has been very helpful to me with the other slaves. She fully understands my directives and informs the others in a language they can understand."

"Elizabeth, if any of my slaves were caught and put in jail, I'd probably sell them south and never bring them back here. The spirit of freedom in a slave is not a healthy attitude on the plantation. Slaves sing about freedom in the fields, they talk about freedom in the cabins, and pretty soon some young buck or a spirited female gets itchy feet."

"It's those damn northern abolitionists!"

"Elizabeth, mind your tongue." Mary Overton could not believe her daughter could talk like that.

"Mother, I apologize, but crusaders like that John Brown are going to be the ruination of our plantations and our style of living." Elizabeth pulled a lace-covered hand fan from her sleeve and began to revive herself. Harriet guided her to a chair and helped her sit. The servant standing on the gallery was directed to fetch a basin of cool water from the well and a small towel. When the servant returned, Harriet instructed, "Take Master Jackson, put him to bed, and stay with him."

"Yes, Miz Harriet." Harriet looked the servant directly in the eyes and was certain she had heard and understood every word spoken in the last ten minutes. By nightfall, she was also certain the gallery conversation would be repeated in every slave cabin. Harriet handed Elizabeth a cool, water-soaked towel.

A sense of order and calm was restored after Elizabeth was revived and on her way to Lealand. Mary Maxwell joined the Overtons for dinner, since there would be plenty of time to return to the Hall while it was still light outside. During early summer, the Overtons enjoyed eating dinner on the gallery. The sun was on the west side of the house and that made the meal quite pleasant. They had to contend with rain showers and an occasional fly or bee would be present, but mostly, it was a good experience. Martha thought every meal on the gallery was a picnic, and her appetite responded accordingly. The conversation around the table was light until Harriet raised a question. "John, please explain to me the whole abolitionist issue. Elizabeth seemed very upset about it, and I'm wondering whether I should be upset also."

"The best I understand, it's a movement in some of the northern states to do away with slavery. Many of the bad things happening are out in the Kansas and Nebraska areas. In fact, there have been some deaths when some new settlers brought slaves with them. A former slave named John Brown has been at the center of some of the trouble. The abolitionist concern in our area centers on what has been called the Underground Railroad. You remember

Elizabeth mentioned it earlier. The railroad doesn't have cars, engines, or rails but is a system the abolitionists are using to help runaway slaves get out of Nashville. There are safe houses, where the slaves stay, from southern cities all the way to the northern states. The runaways use the rivers at night to make their escapes. I told you some time ago about the police gathering on the street next to the depot. I guess they were raiding a safe house." The ladies at the table could hardly believe what they were hearing.

"Son, there's always been a concern about runaways. Your father had a couple, and the Maxwells did as well."

"I know, Mother, but now the slaves are being encouraged and helped to run away."

"John, what would happen to our plantation if our slaves ran away? Before you answer ..." Harriet noticed that the servant standing at the kitchen door was taking in every word. "Maria, come here."

"Yes, Miz Harriet?"

"Step into the kitchen and help Cynthia with the rest of dinner."

"Yes, ma'am."

"Now John, what would happen?"

"I would have to buy new slaves and would need to get our overseer more help to watch them. I probably would have to sell off or lease some of our plantation land."

"Son, your father spent many years developing this plantation. You can't just sell it." There was a sharp edge to Mary's comment.

"Mother, I was trying to be realistic in answering Harriet's question. If the land does not produce a cash crop and there are no slaves to work it, something will have to be done. The land taxes will continue to increase. I understand that in Virginia, the Carolinas, Mississippi, and other states land is being leased to sharecroppers. Right now most of the sharecroppers are white families, but free blacks are also getting involved."

"How does sharecropping work?" Mary Maxwell got interested in the discussion.

"As I understand it, Mary, the landowner divides his property into small farms. The sharecropper produces a crop, sells it, and gives the landowner a percentage of the profit."

"So, John," Harriet pushed her dinner plate to the middle of the table and uncharacteristically put her elbows on the table, "the real problem we have is with the power of the antislavery folk on the national level and the local abolitionists."

"Yes. The presidential election this fall will be important to the slave question. And somehow we need to deal with the abolitionists on a local level." There was silence at the table. Maria reappeared on the gallery holding a large tray. She picked up the dinner dishes and utensils. Suspicious eyes followed her every move around the table and then back to the kitchen. No comments were made, but their thoughts were the same. *I wonder whether*

*Maria is loyal to this family. I wonder whether she is thinking about the Underground Railroad. Is she planning to run away? Can she be trusted with the children, the food, and the valuable items she handles every day? Is it safe to have her in the house?*

John broke the silence and somber mood around the table, "Harriet, was there any important mail in the pouch?"

"There was a fashion magazine I need to read and send to Annie and two letters." She had to stand to retrieve the letters from her pocket, hidden in the folds of her dress. "Yes, here's one addressed to you from your first son." She handed the envelope to her husband while showing the other envelope to her sister Mary. "And this one has news from Texas. It's from Annie."

"Please read Annie's letter aloud," requested Mary. They were always excited to have news from their sister.

"Annie writes,"

> Greetings to you, little sister, and to all at TR. Our lives continue to be centered on Mollie (Thomas has given our daughter a new name and she responds to it). It's hard to believe she has been with us nearly a year now. She is crawling everywhere in the house. She keeps us on the run. When we walk about the fort, she waves and smiles at everyone. She has become a social creature. Soldiers vie for her attention. I took her today to see the new camels the army is planning to try out in the desert around here. The weather is challenging—it is hot and hotter! A visiting chaplain finally came to the fort, and he conducted Mollie's christening. She was just beautiful in her dress. Thank you again for your thoughtfulness. I must close for now. I want to get a letter in the mail to Father and Mary.
>
> As always, I remain,
>
> Your Big Sister
>
> P.S. Thomas just told me he has been granted a leave for mid 1858.

"Did she really say camels, like the ones in Egypt?" Harriet laughed at Mary's question.

"Mother," John said when Harriet finished reading aloud, "listen to this:"

> Tell Grandmother the ginger cookies in Virginia are not nearly as good as the ones in Tennessee.

John passed the letter to his mother. "Harriet, what were you saying about camels?"

"Annie's letter mentioned camels. John Overton, you were not listening!"

"Guilty as charged."

"Oh, you. How is John doing at school?"

"He's just finished the term and is looking forward to several field trips this summer. He wrote, 'I'd like to be home, but the fishing is better in Virginia.' His health is good, but Hugh has been having some illness. He

reports, 'The mountains of Virginia are much better than the mosquitoes in New Orleans.' I guess that confirms I made a good decision for him."

"Yes, you did, John. You made a great decision for your son." The mood around the table had changed. There were smiles and laughter. The kitchen door opened and Cynthia came in with a tray of desserts. "What do we have this evening?" John eyed the tray, trying to see.

"It be somethin' Miz Harriet seen in one of her magazines. She say we needs ta make dat for Mr. Overton. It be called strawberry shortcake." John placed his hand on Harriet's without saying a word. The expression on his face spoke volumes, and that's all Harriet needed.

The echo of the fast-moving horse came up the dale below the house before the rider could be identified. The closer the sound came, the bigger the rider appeared until Mary announced, "That's Edward. What in the world is he . . .?" Before she finished her statement, the yells from Edward bounced off the walls of the gallery. "Miz Mary! Miz Harriet! Come quick. It Julia. She be goin' to glory. She callin' fer ya. Come quick." He delivered the message, leaned forward on the saddle, and released all the emotions he had been holding inside. Harriet went to Edward, helped him down, and held him as he continued to weep. John went to the barn to get the carriage. Mary lifted Martha from her highchair and handed her to her grandmother. By the time Mary reached Harriet and Edward, he was composed enough to repeat, "Julia be goin' to glory." Both sisters understood Julia was dying, but didn't know whether she had already died.

"Edward," Mary held him by the shoulders and looked him in the eyes, "is Julia dead or alive?"

"She alive whens I leave da Hall, but she be goin' to glory."

"All right, Edward. You did a good deed getting the news to us. You ride on back to the Hall and tell Mr. Maxwell we are on the way." Edward dug his heels into the horse's side and took off. The carriage was ready before Edward was out of sight. Eli helped Mary into the carriage and turned to help Harriet.

"Just a minute, Eli. I need to say a word to Mr. Overton."

"Yes, ma'am."

"John, you will need to see to the children while I'm gone." He had a questioning look on his face. "Tell Maria to take care of Jackson May. She will know exactly what to do."

"But what about Jackson's . . . uh . . . dinner?"

"Maria will know exactly what to do. Your mother can help you with Martha. I may need to stay the evening and night."

"Do you want me to come with you?"

"No, I need you to be with our children. I'll send Eli home with a message for you when I know what the situation is with Julia." John was impressed. Harriet knew just what to do in a time of crisis. She was a take-charge lady. It was hard, at times, for him to realize she was only twenty-four. In a few minutes, she had assessed the situation and developed a plan. At times like

these, he realized why life at Travellers Rest ran like a fine clock. When he had to be away from the plantation on extended business trips, he had full confidence in Harriet's abilities. She thought clearly and acted decisively.

Once in the carriage headed for the Hall, Harriet closed her eyes in an effort to collect her thoughts. Mary knew, since childhood, it was best not to disturb Harriet when she was thinking with her eyes closed. *I have seen that look so many times. Harriet has always been a thinker. She will know what to do when we get to the Hall. She will take charge, as usual, and tell the rest of us what to do.* The carriage rolled over an uneven part of the road, rocking its passengers from side to side. Harriet had felt that sensation so many times in her life, she knew that at the next turnoff, the road led to the Hall. Thoughts raced through her mind. *What will I be able to do to help Julia? If she is truly dying, what can I say to her? Knowing Julia, she'll do all the talking. Julia. Julia. Julia.*

Jesse and Edward were on the front porch when they spotted the approaching carriage. Their eyes followed the turning wheels until they came to a stop in front of the house. Edward helped Mary down and she went directly to her father. "What are we going to do?" She could not hold back her tears and buried her face in her father's chest. Harriet's feet had barely hit the ground when she directed a question to her father: "Where is Julia?" He knew from that tone of voice who was in charge, and he was glad.

"She's in our bedchamber." Harriet stopped on the porch long enough to give a directive. "Edward, go to the cabins and bring all the slaves here to the front porch." Jesse had no idea what that was for, but he knew it must be part of her plan. A few feet from the bedchamber, Harriet stopped. She took a deep breath, ran her hands down the front of her dress, and attempted to put the strands of her hair in place. *Lord, help me to do and say the correct things in this hour of Julia's need. Amen.* Julia was in the bed she had attended for so many years. The four Maxwell children had been birthed there. Martha Maxwell had taken her last breath in the very spot where Julia now labored to breathe. Myra stood by the bed and smiled as Harriet entered the room.

"Julia, what's happened to you?" Harriet spoke in her bravest voice.

Julia's lips moved to form words, but no sound was made. Harriet and Myra both knew that she was saying, "Sabbath Child. My girls ..." Julia's eyes opened wide and with a weak smile breathed her last. Harriet leaned over and closed Julia's eyes for the final time.

Myra touched Harriet's shoulder as she left the room to find Jesse and Mary on the porch. "Jesse, Mary, she's gone. She died just a moment ago. Harriet's with her. You need to come in and be with her."

"Harriet, are you all right?" Jesse turned her and noticed she had not shed a tear. Her lips were pressed tightly together, and he knew she was gritting her teeth to keep from crying. He held her in a bear hug and whispered, "It's all right to cry. Julia would expect you to be sad and happy for her. Her spirit has gone to glory." When Mary added her hug to Harriet's, it seemed to release the

dammed up tears and the Maxwells, father and daughters, grieved. They hugged each other for several minutes, glancing from time to time at Julia— their slave, their servant, their friend.

Mary found a stack of small towels Myra kept on the stand next to the basin of water. She moistened one and wiped her face. She moistened a second towel and handed it to Harriet. "Harriet, what do we need to do now?" Mary looked at their father for his reaction; there was none.

"Father, with your permission," Harriet was wiping her face, "I want to talk with the slaves. Julia talked about the black Baptist preacher named Merry. I'd like for him to have her service."

"How do we find him?"

"I'll send Eli with Edward this evening. You will need to write a permission note for Edward to travel after dark."

"Yes, I can do that."

"One of your slaves needs to make a coffin tonight and have it ready early in the morning. Mary, Myra, and I will prepare Julia's body. Tomorrow the slaves can have their wake and dig a grave for Julia, and day after tomorrow we can have her funeral service. Where do you want to bury her?"

"Down with the other slaves. There's a plot down below the barn. Will that be satisfactory?"

"That will be fine. I'm trying hard to remember Julia was our slave, but she needs to be buried with the other slaves." Mary butted in and suggested, "Father, we could bury her next to Mother and little brother." Harriet didn't wait for her father to reply.

"No, Mary. We need to bury Julia with her own people. Father, two more things. Your slaves need extra food for the next couple of days, and they need time off from the fields."

"Yes, I can do that because it's for Julia."

"All right then. Let's go on the porch and talk to the slaves. Father, you speak to them first and then I'll fill in with some of the details."

The next day, by midmorning, Julia looked as though she were sleeping. The wooden coffin was placed on the porch, which was in full shade of the huge oak tree next to the house. As the slaves passed by, they smiled to see their friend in her new red dress with matching bonnet and her new leather shoes with the toes pointing skyward. They spoke African words to Julia. Harriet would never have known their words had she not heard two children say, "Julia, you is free. Gone to glory."

Although Harriet had been to funerals, none of them quite compared to what she experienced at Julia's. When Reverend Nelson Merry arrived in his open carriage with fringe dangling around the roof, the slaves gathered to greet him and affectionately called him Pappy.

He had been the sexton in the First Baptist Church for years. In 1853 when the congregation opened a Negro mission in the city, they ordained him to lead it. He had visited the slave quarters on the plantations around Nashville, but

the Overton and Maxwell slaves had never been allowed to worship in the mission building where Reverend Merry preached. He was impressive, even to the whites at the Hall. His full head of black wavy hair and full beard topped his strong physique. The black cutaway frock coat made him appear very distinguished. His diction and choice of vocabulary, mixed with slave expressions, demanded full attention from his audience, which might be one person or a whole host of people.

Everyone in the yard at the Hall turned to look as a carriage and three wagons arrived. Eli brought the carriage to a stop and jumped down to help Harriet to the ground. She was dressed in black with a headpiece supporting a veil. Eli turned back to the carriage to assist Cynthia, but Pappy was already helping her. Cynthia wore her new green dress with matching bonnet and store-bought shoes. She was something to behold. She was not exactly dressed for mourning a friend, but she was not going to miss the opportunity to wear her new outfit. While she was dressing earlier in the day, she thought, *I's certain Julia would be doin' da same iffin it be me in da dead box and she be comin' to sees me. I's sure do looks good!* Pappy extended his arm and Cynthia took it. They lined up behind Harriet, as did the Overton slaves. They would follow her lead in paying respect to Julia before they joined the Maxwell slaves.

Harriet looked at Julia but then wished she had not. The body was beginning to show signs of decay after only two days because of the Tennessee heat. She joined her father, Myra, and sister Mary on the porch. As she passed the coffin, Cynthia whispered into Pappy's ear. He walked her back to the last Overton wagon where she had packed food for the day. She had spent most of the day before preparing the feast. Harriet had told her to prepare enough food for everyone to have a good meal on Julia's going-home day. Although he didn't come to the funeral, John sent a small keg of peach brandy. He and his mother were helping by staying home and keeping Martha and Jackson May. By their doing this, even the Overton house servants were able to attend the funeral.

Cynthia pointed the wagon driver to the area near the barn where makeshift tables had been put up. "Takes da food down dere and sets it on da tables. I's be down later to check."

Six male slaves gathered at the porch near the coffin. After the top boards were nailed in place, the coffin was hoisted on their shoulders and they served as pallbearers. Reverend Merry, with Cynthia at his arm, began to walk to the gravesite, motioning the slaves to fall in line behind the white folk. Harriet, Jesse, Myra, and Mary became mere specks in a sea of black faces. Cynthia began with her powerful voice the mournful sounds of a hymn:

> We're a-marchin' to da grave,
> We're a-marchin' to da grave, my Lord,
> We're a-marchin' to da grave,
> To lay dis body down.

My sister says she's happy,
By de grace of God we'll meet her,
In de last long solemn day,
When we stand around de throne.

Harriet had never heard anything so mournful, yet so uplifting. The combined voices of the slaves ministered to her in her time of sorrow. She began to hum the tune as a second round of the hymn began. She watched as the pallbearers placed the coffin on the three ropes stretched out near the freshly dug grave. Harriet glanced around her and discovered she was encircled by black bodies. *Today there are no blacks, no whites. We are here today to remember our friend Julia.* Almost as soon as the thought left her mind, she was brought back to reality by the voice of Pappy.

"Our sister Julia didn't have a last name. She lived all her life and was never free to use a last name. She was brought into this world as a slave, she lived her life as a slave, and she died as a slave. But, children, Julia is no longer a slave and she has a last name." Pappy had the skill of moving from white language to black expressions from one breath to the next. "Children, Julia be free in da bosom of our Lard. She now have a last name. The Lard say to Julia, 'welcome home my child.' In heaven our sister Julia be known as, Julia my Child." Pappy paused to wipe the perspiration from his brow. He was also waiting for the amens from his gathered congregation. He signaled the pallbearers and they lowered the coffin into the grave out of sight of those gathered. When they pulled the ropes out, Pappy continued the service. He had again changed his language as he read, "The lord is my Shepherd . . ." As he read each phrase, he tied it directly to Julia. The mourners responded appropriately and he smiled each time.

Pappy closed his time with a prayer, appealing to God to receive the spirit of Julia my Child and give her a well-deserved reward. He reminded God their sister was now free for eternity. When he opened his eyes, he leaned down and picked up a handful of dirt from the pile next to the grave. As he leaned over the grave, he reminded his congregation, "Our sister Julia was made from dust and will return to dust. Her dust will be here waiting for the great gettin'-up morning. Hallelujah! Amen." He dropped the dirt on top of the coffin and stepped back from the grave.

Harriet watched as each slave followed Pappy's example. Dirt covered the coffin. She saw the pallbearers reach down and pick up shovels. The thought came to her strongly, *I need to do what the slaves did. Julia was my friend, too. I need to honor her. Will the slaves think I'm mocking them if I put dirt in the grave? Will my father and Mary understand? What would Julia want me to do?* There was no voice, just an impression and a thought of Julia, *Is dat da sun a shinin' up dere?* Harriet moved toward the pile of dirt, removed her glove, and grasped a handful of dirt. The slaves watched as she tossed the dirt in the grave. They heard her say, "Rest in peace, Julia. You are home and you

are free." Jesse, Myra, and Mary followed the actions of Harriet but said nothing.

Pappy excused the crowd, and they headed to the tables full of food and drink. He turned to Harriet, "Thank you, Mrs. Overton, for inviting me today."

"Reverend, Julia spoke of you often and I know she was pleased today." She extended her ungloved hand to Pappy. He took her hand and held it gently.

"On behalf of myself and the black folk, we appreciate you adding the dirt to Julia's grave. Most white folk don't even come to the funeral."

"Julia was special to me. She helped my mother at my birth. She cared for me as a child. My two children had a safe birth because of Julia's care. I will miss her greatly."

"Mrs. Overton, I do not mean to intrude into your personal life, but are you the Sabbath Child Julia always talked about?"

"Yes." Harriet felt a tear roll down her cheek. She reached into the shallow pocket of her dress and pulled out two gold half eagles. She pressed them into Pappy's hand, "Reverend, you have been very helpful today. One of these is for you; the other is for your church. I hope our paths cross again under happier times."

"Thank you, Mrs. Overton. I will put this to good use. I, too, look forward to the future."

As Harriet turned to leave, she took one last look at Julia's grave and noticed Cynthia dropping pieces of broken earthenware on the pile of dirt that covered the grave. She wanted to inquire why but figured it was another slave funeral custom. She could ask Cynthia later. Harriet was so emotionally drained from the past few days that she fell asleep in the carriage on the ride home and had to be shaken awake by Maria when they arrived. "Maria, go check on Jackson May. If he is awake, bring him to me."

"Yes, ma'am."

Harriet could hear Martha laughing in the distance. She figured Grandmother Mary must have her in the herb garden on the other side of the house. *I believe I'll just sit here on the gallery for a while and relax. It is so quiet and peaceful and the breeze is so refreshing.* Mothers don't get to rest and enjoy the cool breezes when there are infants and small children in the house. Harriet had barely closed her eyes and taken a deep breath when John walked out of the side door holding Jackson, with Maria right behind them. Since Jackson was cooing and seemed to be in a comfortable place, Harriet did not disturb him. John eased into a chair next to his wife. "You've had a very busy three days. How are you feeling?"

"Tired." Jackson heard his mother's voice and turned his head toward her. He began kicking his feet and making sounds that only his mother would understand. She placed his head on her knees and grabbed his thrashing feet. The more she talked to him, the louder he got with his chatter that quickly turned into laughter. Jackson's actions brought smiles to the faces of his parents.

As Martha turned the corner of the house, she was running as usual. The basket she was holding was swinging so high she dumped out all the herbs she and her grandmother had collected only moments before. Grandmother Mary was close behind her, bending over and trying to salvage some of their harvest. Martha spotted her mother on the gallery. She threw the basket down, scampered up the steps, and greeted her mother, "Mama! Mama, you came back."

"Yes, sweetheart, I came back. Come here and give me a big hug and a kiss." The reunion was wonderful for both mother and daughter.

"Jack-son sleeping?"

"No, he's trying to talk, but he's not having much luck."

"Mama been away."

"Yes, Mama had to be away to say good-bye to a good friend."

"Bye bye!" The brief reunion was over. Everything was in balance again. Martha ran down the gallery into the house. Maria was right behind her.

Mary retrieved the tossed basket and secured the herbs. She puffed as she climbed the steps and then flopped into her favorite gallery chair. "I'm not as young as I used to be. How did things go at the funeral?"

"Everything was just fine. Thank you both for filling in for me with the children. I appreciate you allowing the Overton slaves to come to the service. When I left, they were really enjoying the extra food and especially the peach brandy. Cynthia was in charge of the brandy keg and she was being very stingy with it."

"I hope Jesse didn't mind."

"No. He was very pleased."

"Has anything happened while I was away I need to know about?"

"John Lea," John answered her question, "was over this morning to bring us our mail and tell us about their slave girl, Meg."

"What about Meg?"

"She was the female the police captured at the Underground Railroad the day Eli was at the blacksmith's shop. She was trying to run away. She had taken a bag full of silverware and some of Elizabeth's jewelry. John left her in jail. He's trying to sell her."

"Could you use her to help in Pass Christian?"

"No, Harriet. My guess is, if she tried to run away one time, she'll try it again. Whoever buys Meg will need to break her spirit. Her life for the next few years will be very hard."

"What do you mean? I don't understand."

"She will probably be in leg chains, and her owner will put her in the fields. She might even end up being bred with some healthy buck." Harriet looked at John, her eyebrows raised, but didn't ask any more questions.

"Son, could we change the subject?" pleaded Mary. "Tell Harriet about the fight."

"Who's been fighting?"

"The article was in yesterday's newspaper. John Lea was talking about it this morning. It seems two of the Washington politicians were at odds about some name-calling. Senator Charles Summer, a Massachusetts abolitionist, called Senator Andrew Butler of South Carolina a chivalrous knight."

"What's wrong with that? Why would anyone get upset about that?"

"Well, Summer said Butler had taken slavery as his harlot. Senator Summer's nephew, Preston Brooks, who represents South Carolina in the House, didn't like the insult to his uncle, his family, and his state. So he severely beat Summer with a cane. All of this took place on the floor of the Senate."

"So, John, what does all this mean for us?"

"Normally, matters as serious as this one begin at the local level and work their way to Washington. However, the slavery issue appears to be at the highest level of government and may well cascade down through the state and local levels. The presidential election this fall will be very important in determining what happens to slavery in the southern states. John Lea hinted that South Carolina could secede from the union."

"It wouldn't be the first time. You remember John Calhoun tried to lead South Carolina to leave the union over a tariff imposed by President Jackson."

"And Andy Jackson wanted to hang Calhoun." Mary had high interest in the slavery discussion, but quickly lost interest when the name of Andrew Jackson was mentioned. "If you will excuse me," Mary headed for the double doors, "I'm going inside to read a while."

"Mother, we're just going to talk about Andy Jackson a few more minutes." John laughed as he watched his mother leave. Her voice faded away, but he could hear plainly, "One mention of that name is more than enough for me."

"John, you shouldn't tease your mother like that. You know how she feels about Andrew Jackson. You do know she calls our son May, don't you? He may hear that name so much, one day he will drop the Jackson and just be called May."

"Well, at least, he's not another John Overton." They continued to talk until the sun set and darkness covered the gallery.

The next day, in Nashville, John sent a wire to Annie Maxwell Claiborne with the simple message: JULIA DEAD. DETAILS LATER. HMO. Harriet took most of the morning composing a letter to Annie, detailing the events surrounding Julia's death. She tried to find the correct words, using three sheets of paper but destroying each of them. On the fourth piece of clean paper Harriet began,

*Dear Sister Annie,*
*A part of our history is gone forever. Julia's last words were about*
*you, Mary, and me. I honestly believe she had a vision of us as little girls.*

Harriet wrote a sentence about each event of the last three days including: dressing Julia in her new red dress, the kind words from the Reverend Nelson "Pappy" Merry, the mournful sounds of the slave music, tossing dirt into the grave, the wake, and the feast the slaves enjoyed after the graveside service.

> *Please know our Julia is in a better place. As the slaves say, "She in the bosom of the Lard and she be free."*
> *The entire Maxwell family will be counting the days until you, Thomas, and Mollie (Mary Maxwell) return to Tennessee on leave. You did not say how long you will be at home. When you know for certain, let me know. I will plan some special activities for us.*
> *Annie, is there anything you need? Let me know. John tells me items may now be sent by railroad, cutting down on delivery time. Hugs and kisses to all of you in Texas.*
>
> > *Love and affection,*
> > *Harriet*

As she sealed the envelope, her thoughts drifted. *How I would love to see Annie. We have been apart far too long. I have not seen Mollie, and Annie has not seen Martha and Jackson May. What we need is a Maxwell family reunion. Maybe one of these days, Thomas will get a new assignment, and we can get our families closer together.*

Life on the plantation became rather routine during planting and harvest times. No big events were planned and everyone settled into the routine. Time moved on. Harriet's days at Travellers Rest were no exception. She continued to handle household responsibilities with Cynthia and the servants. There was always housecleaning, seeing to minor maintenance problems, and caring for family members. John and the overseer managed the fields and the slaves.

In the early morning hours of August 18, Harriet's comfortable routine was broken, and her life was changed forever. The faint knocks on her bedchamber door brought her out of a deep sleep. "Yes, what is it?" John was a heavy sleeper and did not rouse.

"We needs ya, Miz Overton." She could hear voices on the other side of the door as she slid her feet into some shoes and wrapped a robe around her. When she opened the door, all she could see were two flickering candles. The hallway was eerie with no light coming through the transom window. "Why do you need me, Maria?"

"It be Massa Maxwell." She knew that voice without ever seeing a face. She had heard Edward's voice all her life.

"Edward, what's wrong with my father?" She moved close to look into his face through the candlelight.

"He had a spell and falls. I hears the loud noise and goes to help Miz Maxwell. She say come gets ya, Miz Harriet." She cupped Edward's face in her hands and knew from the perspiration she felt, he had ridden hard from the Hall.

"Edward, thank you for coming so quickly. Now, go to the barn and tell Eli to bring the carriage. Maria, come and help me dress. Be quiet, though; we don't want to wake Mr. Overton."

"Yes, ma'am." The precaution to Maria made no difference. Edward slammed the side door as he headed for the barn. She could hear his every step as he shuffled down the gallery. John sat up in bed. "Harriet, is that you? Are you all right?" She walked around to his side of the bed and looked at him through the candlelight.

"Father has had a spell and fallen. I must go check on him. Edward and Eli will be with me. I will be safe. You go back to sleep. I'll send Eli back with information." She kissed him and patted his head. She dressed quickly, gave instructions to Maria, and boarded the carriage.

Mary was waiting on the porch at the Hall. Harriet could see her sister's silhouette in the gray hues of sunrise, when the carriage topped the hill. The light from Mary's candle flickered in the early morning breeze. Harriet's words were strong and direct as she stepped up on the porch, "How is Father?" There was no verbal response; only a hug. The shuddering of Mary's body against hers was the answer. Harriet's tears, in the arms of her sister, began her grieving process even before she entered the house. The sisters went to their father's bedchamber and found Myra sitting in a chair next to the body of Jesse. She had placed a small pillow under his head and spread a blanket over his body. "I am so sorry." Harriet mingled her tears with those of Myra's.

"Your father was a good man."

"What do you think happened to him?"

"It was not unusual for him to get up in the middle of the night and use the necessary. He would shake our bed getting in and out. I knew when he got up, but I was not fully awake. I heard a loud thump and your father moaning. By the time I got to him, he had stopped. I lit a couple of candles and went back to help him up. He was not breathing. By that time, Edward was in the room and we both tried to set Jesse upright, but he was deadweight. So we placed him as he is now. I went to get Mary and sent Edward to get you. Edward sent one of the slaves on horseback to get Dr. Wright down on Franklin Pike. What time is it?"

"It must be about half past five or six o'clock. The sun was just beginning to rise when I arrived."

"Girls, he was such a good man. What am I going to do without him?" Mary put her arm around Myra and led her out of the room, leaving Harriet alone with her father's body. She reached down to stroke his hair and discovered it stiff and sticky. She found a small towel and wiped the traces of her father's blood from her hand. She had a flashback to her childhood when her father had fallen off his horse and hit his head. They had been riding together in the lower meadow. She rode back to the house to find her mother and tell her what had happened. When Harriet got back to the accident scene, her father was sitting up. He had blood all down the back of his coat. When she touched her father's hair, it was stiff and sticky.

Harriet sat in the chair next to her father and gazed into a candle on the side table. *Poor Annie,* she thought. *I must get the news of Father's death to her quickly. I know she cannot come home, but I know she would want to be here. Why does she live so far away? I wonder whether Myra is prepared to make the funeral arrangements. What will become of the Hall with Father gone?* She continued to ponder all these concerns. Her thoughts were interrupted when Dr. Wright entered the room. He examined Jesse, as Harriet looked on without moving from her chair. Myra and Mary had entered the room with the doctor and stood just inside the door. "Mrs. Maxwell?" the doctor looked at each female in the room.

"Yes, doctor," answered Myra. He stood up and faced her.

"May I talk with you in private?" Myra thought the request was a little strange but realized he was being cautious.

"Dr. Wright, these are Jesse's daughters, and I'm certain they want to hear anything you may say to me."

"Judging from the dried blood on Mr. Maxwell's head, he apparently hit his head when he fell. He appears not to have made any attempt to break his fall, indicating he was unconscious when he hit the floor. In my opinion, he had massive heart failure and expired before he fell. I did not have an opportunity to check my father's records before I came. Had Mr. Maxwell consulted my father recently about any health matters?"

"I don't recall Jesse saying anything about it, if he did. Do either of you recall anything?" Harriet and Mary shook their heads.

"Mrs. Maxwell, I'll complete and leave a death certificate for you to take to a mortician. I'd suggest you take the body soon, in the next few hours, before major decomposition takes place. I'll report Mr. Maxwell's death to my father. I know they have been friends for many years."

"Thank you for coming, Dr. Wright. Give our regards to your father."

Harriet sent Eli back to Travellers Rest to give John the news of her father's death and to inform him she would be going with Myra to the mortician in town. Harriet made a snap decision. She suggested to Mary that she stay at the Hall to handle family business. Later in the morning, Mary gathered the slaves and announced the death. The majority of the Maxwell slaves knew Mary better than they knew Myra. She sent trusted slaves to the neighbors to share the news about Jesse. Mary was at the Hall to receive neighbors and friends who came to pay their respects to the Maxwell family.

Harriet's assumptions were correct. Mary would have a larger role to play in the management of the Hall, and her physical presence at this critical time was a starting point.

When John received the news about his friend Jesse Maxwell, he took a deep breath and said a brief prayer. He left the family dining room and went to the kitchen. "Cynthia, prepare a basket of breakfast food for two people. No, make that five people. I will be leaving shortly."

"Ya, sir." John tapped on the door of his mother's bedchamber. The servant answered.

"Please wake Mrs. Overton. I need to talk with her."

"I'm awake, Son. What do you need?"

"Jesse Maxwell passed away during the night. Harriet is going into the city with Myra to make arrangements. I need to be with Harriet. I'll be leaving here shortly. Please work with Maria. She will know what needs to be done for the children."

"John, be careful and give them my condolences."

John quickly prepared for the day. When he arrived at the carriage, Eli was in the driver's seat and Cynthia was holding a rather large basket. "Very good, Cynthia." He patted her on the hand, which was his way of saying "thank you." One of the first lessons the Judge taught his son was to never say "thank you" to a slave. He felt the gesture broke down a needed barrier between the owner and the slave. John had passed the same lesson on to his first son and would do the same for his other children.

Arriving at the Hall confirmed John's thinking. The ladies were preparing to ride a large wagon to Nashville. Jesse's body was wrapped and lying in the bed of the wagon. Harriet and Myra were just coming out on the porch when John arrived. Harriet was very glad to see him. She scampered down the steps and ran to John's open arms. The tears she had been holding back were released as she sobbed uncontrollably. Mary joined Myra on the porch and watched a couple deeply in love.

"Myra, Mary," John spoke softly, "Mother sends her condolences and is prepared to help in any way she can."

"Thank you, John. You mother is very kind." Myra walked down the steps as she spoke.

"I brought the carriage. I thought you would be more comfortable for the trip into the city."

"I appreciate your thoughtfulness." John put his arm on Myra's shoulder and gave her a squeeze.

"Myra, I'm so sorry for your loss. Jesse has been a good friend for many years. I stand ready to help you in any way I can." Myra moved into John's large frame and began to cry. He held two emotional ladies and provided a safe place in their time of great need.

"John," Myra moved away patting her cheeks with a handkerchief, "I guess we should be going." He helped Myra and then Harriet into the carriage. Harriet noticed the basket and a valise on the seat where she usually sat. "Ladies, I had Cynthia prepare a basket of breakfast food. I wasn't sure you would have taken time to eat this morning." The ladies looked at each other and smiled. "Harriet, there's some fresh clothes in the valise. Maria put all that together in a hurry this morning." Harriet looked inside and was very happy to find a bonnet, which she immediately put on her head to cover her unbrushed hair.

"Harriet, would you look in the basket and get something for Eli and Edward? I'm sure they've not had time to eat this morning." She discovered five of everything, as though Cynthia had planned specifically. On this day, white owners and black slaves enjoyed the same breakfast.

When the carriage and wagon reached Franklin Pike, they were able to pick up some speed. The breakfast basket was nearly empty and the travelers were pleasantly full.

"Myra, we need to talk about Father's body." Harriet knew she was pressing the issue, but she needed to know how much thought Myra had given to the events facing her.

"One time when Jesse and I were coming into town, he pointed out the mortician's house on the corner of Broad and Spruce Streets. He told me he had taken your mother's body there. I brought his favorite black suit, white shirt, and tie. He always looked so handsome when he wore them." Harriet and John listened as Myra talked. "I want Jesse to have a coffin made of Tennessee wood. He loved the land so much. When his body is ready, I want him to lie in state at the Hall so his family and friends can see him one last time." The most important arrangement Myra had not mentioned, but Harriet needed to know and was ready to ask. "And," Myra's face brightened with a faint smile, "I want him to be buried next to Martha and Jesse Junior in the Maxwell graveyard."

"Myra, thank you so much. You have the right to do as you choose. You have just made my letter to Annie so much easier to write. I will always honor you for your decision."

John had not spoken, but Harriet's comments reminded him of some things that needed to be done. "Myra, you need to put an announcement in the newspaper about Jesse's death and the funeral arrangements after you visit the mortician. And Harriet, we can stop by the wire office and send the sad news to Annie and Thomas."

"John," Harriet sounded shocked, "I'm so glad you thought about the wire to Annie. I thought about her this morning after I saw Father. This afternoon when I get back to the Hall, Mary and I will need to figure out a way to contact Father's relatives. There are not many, but they need to know."

"And John," Myra said in a soft voice, "can you go with me to the church to contact the minister?"

"Yes, I'll be happy to do that."

Jesse Maxwell had died in the early hours of Monday. His funeral was on Thursday afternoon at the Hall. He lay in state long enough for family and friends to pay their respects and offer comfort to Myra, Mary, and Harriet, who kept vigil. A place was prepared for Jesse's body in the Maxwell graveyard. Harriet was pleased with the coffin Myra had chosen and the final appearance of her father. Mary had placed a blank journal book on a small table near the large room and encouraged visitors to sign their names and add any comments they chose. She didn't know at the time, but she was creating a family treasure that would help Annie in her grieving process. Neighbors

stayed at the house during the nights, allowing Myra, Harriet, and Mary to get much-needed rest. Food, the very least of Myra's worries, came in abundance. John had Eli deliver two kegs of peach brandy for the men folk who gathered on the porch and an occasional female who stole away with a glass full of the prized nectar. Wakes had a way of being social events, particularly when relatives traveled a good distance for the funeral. Harriet opened Travellers Rest for those who needed a place to stay and even arranged with Elizabeth Lea to handle any overflow. She was more than happy to be of help.

Sometime before the funeral, Myra displayed the family Bible. She opened it to the pages between the testaments and discovered Jesse's handwritten last will and testament. She tucked the document in the pocket of her dress and went looking for John Overton. "John, please read this," Myra gave John the folded sheet, "and tell me what I need to do."

John was not a lawyer, but he knew a good one, his trusted friend and brother-in-law, John Lea. "Myra, I will see to it." She had full confidence that John would do the right thing.

On Friday, back home after the emotionally draining last few days, Harriet took pen in hand and wrote Annie a detailed account of the death, wake, and funeral of their father. She began—

> *My Dearest Annie,*
> *I have felt your presence these last few days so much that at times I*
> *turned around and thought I heard your voice. Your spirit was with us*
> *at the Hall. Myra had Father buried next to Mother and our baby brother.*
> *I thanked her for you, knowing that's the decision you would have wanted.*
> *Myra loved Father deeply.*

Harriet listed for Annie all of the family and friends who came to show their respects. She mentioned the distant cousins from both sides of the family.

> *Mary was wise enough to provide a blank journal for visitors to sign.*
> *She will be sending the book for you to read later.*

She described the coffin Myra had chosen and how their father looked. Annie would read how the Maxwell slaves had honored Jesse with their music. Harriet closed the letter with a bit of long- distance counseling.

> *Annie, I must close for now and get back to my motherly duties, which*
> *I have neglected for several days. Young Dr. Wright told us Father was dead*
> *when he fell to the floor. That fact alone gives me solace, knowing he did*
> *not suffer, as did our Mother. The minister told us the spirits of our parents*
> *would meet in heaven and be happy together for eternity. I'm not sure*
> *whether Myra understood that statement, but I'm comforted, knowing Father*
> *is happy in his new home. I trust you will be comforted as well.*
> *Hugs and kisses for Thomas and Mollie.*
>
> > *Love always for my wonderful sister,*
> > *Harriet*

Harriet placed a copy of the newspaper obituary in the envelope and sealed it. She turned the envelope over and held it next to her heart. *Dear sister, please know how much you are missed and how I long to see you.* She tried to cry but she had no tears left. Her mood changed one hundred and eighty degrees when she heard the giggling of Martha and the fussing of Jackson May. Maria was carrying Jackson and holding on to Martha's hand when they walked through the side door onto the gallery. "Mama! Mama, you are home!"

"Yes, darling. I'm home and I hope to be here for a long time." Martha climbed into her mother's lap. "Maria, come sit with us for a spell."

"Yes, ma'am."

"Maria, you have been a lot of help to me. You took special care of the children when I had to tend to Julia's passing, and you've done the same when I had to be away for my father's funeral."

"Yes, ma'am."

"I appreciate your help. Is there anything special you would like to have?" Maria had never heard that question before; she didn't have an immediate answer, but she didn't want the moment to pass. "Let's me thinks on dat. I tells ya later."

# 13. Letting Go

As 1856 came to a close, Harriet reflected on the highlights of the past twelve months.

Births and deaths flooded her mind. A part of her own life had been buried at the Hall. Julia's demanding voice and her father's hugs and kisses were gone forever. Her sadness was balanced when she looked at Jackson May. He would never remember his grandfather Maxwell, but they had spent many wonderful hours smiling at each other. Jesse Maxwell loved his grandson more than Harriet realized. He would walk on the grounds of the Hall cradling Jackson in his arms and making plans for the future. "Jackson, when you're old enough, I'll buy you a pony and we will ride together. And then we'll have Myra pack us a picnic lunch, and we'll ride down to the pond and go fishing. Someday we'll take the carriage, go into the city, get on a side-wheeler, and float all the way to Memphis. When we get back, you can tell your parents how the captain let you pull the cord on the whistle. Then the two of us will take a long ride on your father's railroad. We are going to do so many things together." Death would rob Jesse of all those wonderful activities, but Harriet would keep the memory of her father alive in Jackson's life.

A newsy letter from Annie brought some needed joy into Harriet's life. Annie was pregnant with her second child. The new baby was due in early fall of 1857. The other good news was that Thomas was getting a new assignment and they would be moving to San Antonio. They would still be in Texas, but the living conditions would be greatly improved. Annie was thrilled that she would be living in her own home and not in the fort. Harriet could feel the excitement in Annie's words:

> And guess what, little sister, there are real stores in San Antonio where
> I can buy things. You will no longer need to send me dress material
> from Nashville. By the way, the sewing machine is still producing
> fashions for Mollie and me from the material you have been sending.

Annie's next words indicated her deep concern for Mary and Myra.

> How are the ladies doing at the Hall? Taking care of things is going to
> be a big responsibility for both of them. I'm wondering whether it would
> not be best for them to sell the Hall and move into the city. It should fetch
> a tidy sum and allow them to live without any financial worries.

She made mention again about Thomas' leave scheduled for the fall of 1858. Annie closed her letter with a request:

> Dearest Harriet, I've not shared my baby news with Mary. Please feel
> free to tell her.

Although it was cold at Travellers Rest, the next day Harriet made a trip to the Hall to share the good news from Annie. She went alone, not wanting to get the children out in the winter air. The sun was warm, but the cold wind was cutting and gave her a slight chill from the short distance she walked to the carriage. The carriage was winterized, but Claiborne threw in some wool blankets for Harriet to wrap around her boots.

Traveling on the road between the two plantations always flooded her mind with thoughts of bygone days. *Father and I used this road the day he taught me how to bounce on the saddle when the horse was trotting and galloping. Mother would never allow more than a fast walk when I was in her sight. Father never allowed me to ride sidesaddle like my older sisters. He never said so, but at times he treated me like a boy. I guess Mother would have died had she known I held and fired Father's black powder rifle. That event was away from the plantation. She never realized the bruise on my shoulder came from the gun. Mother was always so feminine and wanted her three daughters to be ladylike. Then, there was the day on this road when Father spotted a slave running in the Hogan field. There was nobody around, so Father yelled, but the slave kept running toward Franklin Pike. Father told me to get down, tether my horse to a tree, and stand there until he got back. He was gone for a few minutes and soon, two other riders had joined him. He stopped where I was standing and the other riders headed toward the Pike. They were in a big hurry. That's the day Father told me that slaves were expensive property. Mr. Hogan would lose lots of money if the slave was allowed to run away. That's why the riders were in such a hurry to find and bring the slave back to the plantation. That was the day I learned that black skin meant property and white skin meant person. I was a person and mammy Julia and Edward were property. Father owned them just like he owned the plantation land. Julia and Edward belonged to Father just as our horses belonged to him.*

Crossing the small plank bridge brought Harriet to attention and back to reality. She knew she was on Maxwell property. Her father had the bridge built as a precaution. If the small stream of water that traveled along the roadside ever overflowed its banks, he would still be able to get on and off his property. His theory was never tested; the water never rose that high in his lifetime.

When Harriet entered the Hall, she found Myra and Mary sitting by the fireplace having a mid-morning cup of tea.

"Good morning, ladies. I trust all is well and both of you are in good health." She removed her heavy coat and hat, placing them on a peg next to the door. She could not help seeing her Father's winter coat and wide-brimmed hat hanging on another peg. *How many times have I seen Father in those?* She paused long enough for Myra to interrupt, "Harriet, do they bother you? I leave his coat and hat there as a reminder. Jesse's scent is still in them."

Harriet wrapped the coat around her face and true enough, she breathed in her father's scent.

"Myra, you are so right. It's as though he just took the coat off and put it on the peg. Thank you for leaving it there. That's where it belongs." Harriet walked over and backed up to the fireplace.

"Would you like a cup of tea?"

"That would be nice, Myra. Thank you."

"Liza!"

"Yes, ma'am." Liza appeared at the sound of her name.

"Bring Mrs. Overton a cup of tea. Then go in my bedchamber and bring out the tuffet and coverlet and place them next to the large chair."

"Yes, ma'am." She left the room to do her tasks.

"Is Liza new? I don't ever remember seeing her."

"No, she was born on the plantation. I saw her with the other slaves at your father's funeral. She's twelve. She doesn't read or write, but she appears very bright. She has some rough edges, but we are trying to work on those."

"She may be," Mary added, "another Julia in the making."

"Wouldn't that be something? Another Julia at the Hall." Liza reentered the room, holding a teacup and pointed it at Harriet. Before Harriet could take the cup, Mary was on her feet, throwing off the coverlet to the floor. "Liza! Liza! Bring that cup and come with me to the kitchen." In a few minutes Liza returned, holding a silver tray on which was a cup and saucer, teapot, napkin, a silver spoon, a small container of sugar, and a container of honey. Liza had tears on her cheeks and with a trembling voice addressed Harriet, "Ya tea, Miz Overton."

"Very nice, Liza. You may put the tray on the table over there." Harriet pointed and Liza followed the directions and then headed for the back of the house to find the tuffet and coverlet. By the time Harriet had poured and sweetened her tea, Liza was back. She did not wait to help Harriet with the coverlet but left the room in a quick walk.

"Rough edges to work on." Myra was laughing when she spoke.

Harriet sat her cup and saucer back on the tray and found Annie's letter in her dress pocket. "I have a newsy letter from Annie." She handed the letter to Mary.

"There are two very interesting things in her letter." Mary smiled as she read and announced with joy in her voice, "Annie is with child again."

"That's wonderful news!" Myra said as she readjusted her coverlet.

Mary finished the letter with no other comment. She looked at Harriet, "What is the second interesting thing in Annie's letter?"

"She's moving to a larger city. Thomas has been assigned to San Antonio. Annie's hopeful they can have a home in the city and not have to live in a fort. I think that's exciting for them." By this time Mary had passed the letter to Myra and she was reading without comment. She got up, went to her

bedchamber, and returned with an envelope. "Harriet, I want you to read this and then the three of us need to talk."

> *My Dear Mrs. Maxwell,*
>> *Please accept my deepest concern on the death of your husband, Jesse. He was a fine man and will be greatly missed in this community.*
>> *Mr. John Overton shared with me Jesse's Last Will and Testament. The document is very clear as to Jesse's wishes. He does not want to burden you and his daughters with managing the Hall. He wishes the Hall, the property, including livestock and slaves, and all but one slave be sold. Emily, the cook, belongs to Harriet Virginia. The proceeds are to be divided in fourths. He directs that you and the daughters have equal shares.*
>> *The will is legal and should present no problems in probate court.*
>> *I am at your service, or I will be happy to suggest an appropriate attorney to assist you at the court and in executing Jesse's wishes.*
>> *I am in possession of Jesse's will and will hold it in safekeeping until I hear from you.*
>> *Again, I share your great loss and pray God's best for you and Jesse's daughters.*
>>> *Sincerely,*
>>> *John Lea, Esquire*

Harriet folded the letter and handed it back to Myra. Mary broke the silence, "Do either of you find it strange that Annie suggested in her letter what Father wrote in his will? Is it possible Father sent a copy of his will to Annie?"

"Mary," Harriet responded in a calming voice, "I don't believe we can assume anything without hearing from Annie. I believe our sister's concern is for your and Myra's welfare and nothing more. And I believe Father had your and Myra's welfare in mind as well." While Mary pondered the last two statements, Myra added, "I agree with your assessment, Harriet. Jesse was a loving and caring man. He wanted only the best for his family, and his will reflects his wishes."

Mary stood, wrapped the coverlet around her, and turned her backside to the fireplace facing Harriet and Myra. "I suggest we set up a meeting with John Lea and determine how we are to proceed." Both ladies nodded in agreement.

That evening at dinner Harriet shared with John and his mother the wonderful news from Annie. "And when does she expect to deliver?" Mary was always interested anytime a baby was mentioned.

"She thinks it will be in early fall." John smiled at the response, but he had another interest.

"The move to San Antonio will be good for them. You do know," he looked at Harriet, "there is direct railroad passage to San Antonio. You can

now go from Nashville to New Orleans and then on to San Antonio through Houston. Or you could go by railroad to Memphis, a side-wheeler to New Orleans, and another railroad to San Antonio."

"That is very interesting. I believe you have given some thought to this travel plan."

"Yes, I have, but there's only one concern."

"And what might that be?" Harriet knew the slight grin on his face meant he was about to make a joke.

"The railroad officials don't allow ladies with small children to make the trip." He covered his grin with his dinner napkin.

"And if a certain mother with small children showed up at the train station without her children, how would the railroad officials know she had small children?" Harriet grinned back at John. He shook his head, knowing he had been outsmarted.

"Don't worry, John. If I decide to make a trip to San Antonio, you will be at my side all the way. After all, if those wild Texas Indians come after me, I'll need you to protect me."

"Harriet, if Indians ever came after you, they would be in a heap of trouble." There was lots of laughter at the dinner table that evening. Harriet mentioned that Emily, the cook from the Maxwell plantation, would be joining Cynthia in the kitchen. The announcement received no responses.

"I had a brief note from son John. The older he gets, the shorter his written communications." John passed the single sheet to Harriet.

Mary had been quiet during the meal but wanted to know more about her grandson. "How is John doing in Virginia? Harriet, please read aloud his letter."

"Yes, I can do that."

> *Greetings from the land of Overton:*
> *Winter has come. The wind is cutting and the snow is deep. The*
> *headmaster says I'm making the needed progress in my studies.*
> *Hugh and I are looking forward to time off for the holiday season.*
> *We both will be going to the Overtons. I enjoy my time there.*
> *Please tell Harriet I'm sad at the passing of her father.*
> *Give my love to Grandmother, Martha, and the baby.*
> > *With affection, I am*
> > *J.O.*

"There's one thing you can say for John, he doesn't waste words." Harriet handed the letter back to John. He kept all of his son's letters in his writing desk.

After Martha and Jackson May finished their dinner, Maria took them off to bed. The remaining three Overtons gathered around the fireplace for a final glass of wine of the evening.

"Myra received a letter from John Lea explaining Father's will. And . . ." Harriet's voice trailed off.

"And . . .?" John was hoping Harriet would continue.

"And Father wanted everything sold and the proceeds to be divided equally among Myra and the three daughters."

"That seems fair. It would be hard for Myra and Mary to manage the Hall."

"I want to meet with John Lea and allow him to explain what he wrote to Myra. From his letter, it sounds like Father left us with no options. Selling everything seems to be the only option. Since Annie mentioned selling the Hall in her letter, Mary is wondering whether Annie knew what was in Father's will. That really doesn't bother me, but I'm concerned that Annie is not here to have her say. The last thing I want is for there to be mistrust in the Maxwell family."

"Regardless of feelings, the court will act according to your father's wishes. In my father's will, he provided land for Ann, Elizabeth, and me. Somehow, he determined the value of his land, and we each inherited equal portions. I'm certain John Lea can handle Jesse's will correctly. And by the way, Annie can put her feelings in writing, and they will be accepted in court as though she was here in person."

"That makes me feel a little better. As soon as the Twelfth Night celebrations are over, I want to have the Leas, Myra, Mary, and us for dinner. After dinner, John can talk to Myra, Mary and me about Father's will and wishes. In the meantime, I want you to help me compose a letter to Annie to determine her feelings."

"Harriet, I'm happy to help, but it might be best for Myra and Mary to help compose the letter."

"John, you are very wise and your suggestion is excellent. Thank you." Harriet sat her glass on the table, kissed John, and excused herself. She had experienced a very trying day and she was emotionally drained.

The holiday season passed quickly. Harriet and John attended a holiday party at John and Elizabeth's Lealand plantation. Mary made an excuse to her daughter and was able to stay indoors out of the freezing cold. Harriet pointed out to John that Meg was not at the front door to welcome guests.

"Harriet, it might be best not to mention the Meg situation. I think Elizabeth is a little embarrassed about the entire matter."

"My lips are sealed. I will be on my best behavior."

Elizabeth approached her newly arrived guests with her usual flair. "Brother and Harriet—how wonderful to see you both! I trust you are well during this dreadful weather." She exchanged cheek kisses and flitted away as quickly as she had come.

While John went to find refreshments, Harriet walked into the large room where she spotted John Lea. He was cornered by two very large and very loud gentlemen. As she observed, John was listening while the other two talked. He made eye contact with Harriet and politely excused himself. "Harriet, so good to see you." He bent to kiss her cheek and said softly in her ear, "You have

saved me from that dreadful pair of windbags. I'm in your debt." He arched his arm and she took the cue. "And where is your handsome husband?"

"He's gone to get us some refreshments."

"Let's go find him. I need some fresh conversation." When they found John Overton, he was in the dining room trying to balance two glasses of punch and a plate overflowing with food.

"My good man," Harriet directed with a stern voice, "have you not eaten in a week?" John saw her slight grin as he turned in her direction.

"Well, ma'am, my wife told me to eat all I could because the food was free. So I was just following orders." John Lea laughed aloud as he enjoyed the exchange. Harriet relieved her husband of one of the glasses, allowing him to manage the other. She took a small biscuit from his plate and took a bite.

"Mind your manners, ma'am."

"Yes, sir. I'll leave you two gentlemen to your manly conversation, while I see what food is left. By the way, can you," directing her question to John Lea, "and Elizabeth come to lunch at Travellers Rest the third Tuesday of January? I'll invite Myra and my sister Mary. Afterwards, we can discuss the options in Father's will."

"Yes, we will be there." Harriet made her way to the table and filled her plate with the delicious food Elizabeth had provided.

What time Martha and Jackson May were not with their parents, Maria cared for them. She was good with the children and Harriet had a high trust in her abilities. There was no real way to test Maria's loyalty, however, other than giving her a taste of freedom, and Harriet was not sure how to do that. Julia had been a loyal slave on the Maxwell plantation. Jesse always seemed to treat Edward as a loyal slave. He would be sent on errands and always returned to the plantation. Eli was loyal to John and had been for many years. They enjoyed privileges the field slaves didn't have and, outwardly, showed their loyalty to their owners. Only they knew their innermost feelings. *Would they run away if the opportunity presented itself?* was a question Harriet thought of often. There was that time on the gallery when Maria heard the family discuss the Underground Railroad. Harriet noted the inquisitive looks on Maria's face.

During the cold months, Maria and the children stayed upstairs and came down only for meal times. Their room was their bedchamber and their playroom. On occasions, Harriet would climb the staircase and find Maria on the floor playing with the children or at the window pointing to something outside. She did not read to the children because she did not have that skill, but she would talk to them about the illustrations she saw in their books. Reading was reserved for Harriet, and when she did read to them, Maria hung on every word. When Harriet pointed to an illustration in their book and said a word, Maria positioned herself to take it all in. "Martha, can you say girl?" Harriet would point to the girl on the page. "G-I-R-L, girl." Martha would repeat the

letters and say the word. Maria would do the same thing in her head but not aloud.

Martha and Jackson May developed some musical skills by listening to Maria. She sang to and with them. Jackson jabbered only, but Martha picked up the words to the tune. Each day when the train came by Travellers Rest, the engineer would blow the whistle. Maria would hum first and then sing, "Dere go da freedom train," or "da freedom train goin' down da way." She sang to the children when she put them to bed for the night or when they were unhappy for some reason. Sometimes she tried to run the bow across the violin in the room, but only screeches were heard.

One day Harriet appeared in the children's room, holding several books and sheets of paper in her hand. "Children, would you like to hear some music on the piano?" The children and Maria sat on the floor as Harriet played the piano and sang to the tunes she played. When she stopped to find new songs, Martha was quick to say, "Play more, Mama. Sing more, Mama." Maria clapped her hands to the beat of the music and the children followed her with their own clapping. In the middle of one song, they all heard the daily train whistle. Harriet stopped playing and heard for the first time Martha sing, "Dere go da freedom train." Maria clapped and encouraged Martha, "Sings da song child." Harriet glared at Maria, but didn't say a word.

At breakfast the next morning, Harriet announced, "Martha has learned a new song. Martha, can you sing the train song for your father and grandmother?" Martha put her spoon down and in a very controlled voice sang, "Dere go da freedom train." John pushed back from the table; Mary dropped her fork and it made a clanging sound as it hit her plate. "Martha, where on earth did you hear that song?" Martha was sitting directly in front of her grandmother.

"I heard Maria sings it."

"Martha," Harriet jumped in, "please say, 'I heard Maria sing it.'"

"I heard Maria sing it." This time Martha's voice was stronger.

"Now, I want you to say, 'There goes the freedom train.'"

"There goes the freedom train." Martha laughed, thinking she was playing a game with her mother.

"You may be excused from the table. Go out to the kitchen and find Maria."

"Yes, ma'am." Martha went out the dining room door leading to the kitchen. The adults could hear the high pitch of her voice through the closed door, "Maria! Maria, I sings your train song." Back in the dining room, John didn't know what to say. Harriet tried to bring some light into the gloomed-filled room.

"Don't you think our Martha has a wonderful voice? I believe she has some musical talent." John didn't hear Harriet's question or comment. All he could hear was slave language coming from his daughter's mouth and still ringing in his ears.

"Harriet . . . ah . . ."

"Yes, John. I will talk to Maria. Is that what you were about to say?"

"Yes, I think this needs to be corrected immediately."

"I agree. I'll talk with Maria. What would you think of having a tutor live in the house to help with the children's education?"

"Aren't the children a little young for a tutor?"

"Of course, but I was thinking when they are older." John was pleased that Harriet was thinking about the children's future and that she would speak to Maria. With breakfast over, the rest of the day had to be better than it had started.

Harriet gave a great deal of thought on how to approach Maria. She wanted her to continue to care for the children but wanted to limit some of her activities with them.

A week or so later Harriet went to the children's room to talk with Maria.

"Some time ago, Maria, I asked you whether there was something special you would like to have. You told me you would tell me later. This might be a good time to talk. Have you thought of anything?"

"Ya, ma'am. I's like to rides into the city and looks around."

"Is there anything in particular you would like to see?"

"I's likes to see da railroad."

"You mean the freedom railroad? Some of your people call it the Underground Railroad."

"Ya, ma'am. Theys be da same thing."

"Maria, what do you really know about the freedom railroad?"

"It takes ya someplace where ya be free and don't hafs to be a slave. Whens ya gets on da railroad, ya be a slave, but whens ya gets off da railroad, ya be free."

"How would you like to ride on Mr. Overton's train?"

"Do that be the freedom train?"

"Maria, there really isn't such a thing as a freedom train."

"Ya dey is. My cousin Meg tells me 'bout it."

"Where does your cousin Meg live?"

"She be over at the Lealand plantation."

"All right, Maria. Next Thursday, I'll take you to the city."

Harriet came down the staircase and spotted John through the transom over the double doors. He was standing on the gallery waiting for Eli to bring the carriage. "John, I need a favor."

"Anything for you, my love."

"I need to know what happened to Meg, the runaway slave from Lealand."

"John Lea sold her south. The new owner put leg chains on her. I guess she's headed for the cotton fields and breeding in Mississippi."

"Next Thursday, I need to ride into town with you and use the carriage for a couple of hours. Would you arrange that?"

"Consider it done. I'll look forward to our ride."

Harriet scurried about the house on the morning of her luncheon. She was in the kitchen with Cynthia, going over last-minute details. "Everythin' be ready on time. Ya go worry about somethin' else. Leaves me to my work." Cynthia showed proper respect to the lady of the house, but she had her limits. The kitchen was her domain and she protected it.

Harriet headed for the large room to check on the arrangements. The large table was opened to accommodate the four guests coming plus the three Overtons. The children's table was arranged for Martha and Jackson May. Maria would be seated to help the children but not to eat. Harriet wanted Maria to hear a part of the conversation she planned to introduce at the adult table.

The winter sun provided sufficient warmth, allowing Harriet to stand on the gallery to greet the guests. She sent John to the large room to check on the temperature there and manage the fireplace accordingly. Myra and Mary arrived first. Harriet hugged and kissed her guests. Then she directed them through the double doors to the large room. She turned to Edward, who was still sitting on the carriage's driver's seat, and said, "Edward, good day to you. Check with Cynthia in the kitchen for your lunch."

"Yes, ma'am. I be thanking ya, Miz Harriet."

Always punctual, the Lea carriage arrived. Elizabeth was wearing her fur coat and hat, although it was much too warm for either. John guided his wife up the steps and onto the gallery. By this time, John Overton was back on the gallery and standing by Harriet's side. "John, please tell the driver to join Edward in the kitchen for his lunch." Harriet wanted Elizabeth to hear that her driver was being cared for. Elizabeth was impressed. The four exchanged greetings and headed into the house, where they found Myra, Mary Maxwell, Mary Overton, the children, and Maria waiting.

Harriet directed the seating; John offered a welcome and said a brief blessing. The luncheon, as Cynthia had promised, was served. Harriet had arranged the table to provide opportunities for small conversations. She placed John Lea to her right, with a corner of the table between them. This arrangement allowed Maria to hear the conversation and still care for the children. Elizabeth and her mother were at one corner of the table fully engaged in small talk. John Overton was listening to Myra and Mary. This seemed an appropriate time for Harriet to raise a question: "Did you ever find your runaway slave?"

"You mean Meg?"

"Yes, she was the one who greeted at the front door of Lealand."

"She made her way, along with two others, to the house downtown called the Underground Railroad. The city police were staking out the house and caught the three slaves." Maria was very much attuned to what was being said. "She was in jail for nearly two weeks before I was contacted to come and identify her."

"What happened to Meg?" Harriet raised the volume of her voice when she mentioned the name. She wanted Maria to hear the answer.

"I sold her to a Mississippi buyer. The last time I saw her, her new owner had placed leg chains on her, and she was being pushed into the back of a wagon."

"What do you think will become of Meg?" Again, Harriet wanted Maria to hear the answer.

"She'll spend her life in the cotton fields and probably be used to birth children. Why do you have so much interest in Meg?"

"I was impressed with her at Lealand. My John told me she was missing, and I was just wondering what happened to her."

The dessert plates were removed and the drink glasses refilled. John Lea stood and got the attention of all around the table. "On behalf of all of us, allow me to thank John and Harriet for a splendid luncheon. It is always a treat to be at Travellers Rest." John and Harriet nodded a response and the hostess mouthed, "You're always welcome." She continued as John sat down, "Myra, Mary, and I have a meeting with John Lea. So, if you will excuse us, we will retire to the family dining room." As Harriet stood, she turned to Maria, "You and the children are also excused."

"Yes, ma'am."

John Lea put on his reading glasses and unfolded Jesse Maxwell's last will and testament. He tried to make eye contact with the three ladies around the table. "When this document is read in probate court, the judge will order it to be executed. Normally, it can take up to a year to fully execute the will. If there are special issues involved, the judge will take those into consideration. He will ask if the heirs have an attorney to represent them. If not, he will assign one."

"Mr. Lea," Myra interrupted, "would it be possible for you to be our attorney?" Before he could answer, Mary injected some pressing concerns, "Mr. Lea, does the will allow us any other options? Do we have to sell the Hall? Do we, as the heirs, have any say-so in this matter at all?" Mary began fumbling through her cloth bag until she found an envelope. It was a letter from Annie.

"If you don't mind, let's speak on a first-name basis. Myra, I'll be happy to represent you in court. There are four of you, correct? Jesse's will mentioned you, Myra, and his three daughters."

"Yes, that's correct." Mary handed John Annie's letter as she spoke. He unfolded it, but didn't need to read it because Mary quoted the important part word-for-word:

> *Since Father left a will, I will abide by his wishes and will support*
> *any decisions you, Harriet, and Myra make related to the Hall.*

He folded the letter. "Mary, I'd like to keep Annie's letter with your father's will."

"That's fine. Now, about my other concerns." Harriet sat listening. She was a little surprised about Annie's letter, but didn't say anything.

"Mary, the will could be contested in court. You would need to question Jesse's mental state at the time he wrote his will. However, you would need to prove his mental state. That is rather hard to do without strong witnesses."

Harriet had listened long enough. No one, not even Mary, was going to question her father's mental state. She stood, stomped her foot, and walked to the window. "This discussion has gone too far. We will not question the mental state of our father." Harriet turned and glared at her sister.

"Harriet, calm down," Mary said in a whisper. "I was only interested to know about possible options."

"Ladies, I suggest," Myra directed, "we allow John to finish his comments. I trust him to do the right thing for all of us." Harriet sat down and extended her hand to Mary. They joined hands and turned their attention to John.

"Thank you. The judge will probably set a one-year deadline for selling the Hall. You can come to the court hearing, but it's not necessary. I'll take a statement from each of you and Annie's letter. The official court record will show that I represent the Maxwell heirs. The judge will order a statement be posted for any and all claims against the estate. I'll post that in the local newspapers. In a month or so, I'll have the Hall, property, livestock, and slaves appraised. At that point, I'll enlist an agent to sell it all. He will work with you on a selling price and any other directions you choose to give him. The agent will have a fee, and I will have a fee. The remaining proceeds will be divided in four equal parts. I know that's a lot of information in a short time, but that's what will happen. Do you have questions?"

"What happens between now and the time the Hall sells? I mean, what about planting the fields, the harvest, selling the harvest?" The serious look on Mary's face indicated her concerns.

"Mary, life at the Hall goes on as usual with one big difference. Jesse is not there to be the manager. Someone will need to take his place. That can be one of you, or you can hire someone."

John didn't want any more involvement in activities at the Hall. "I'll keep you all informed as we move forward. I will need an address for Annie so I can send her all the details we have discussed today in a letter."

"Thank you, John," Myra said for the three, "we have full confidence in your efforts on our behalf." John left the room, found Elizabeth, said his thank-yous, and rode back to his plantation.

In the late summer of 1857, a chapter of Tennessee history was closed as the Hall was sold. The Maxwell name lived on in the state but not at the Hall. There being no male heir for Jesse Maxwell, his original land grant from his father and holdings were sold and divided among his wife, Myra, and three daughters: Annie Claiborne, Mary Maxwell, and Harriet Overton.

Myra left the area and moved in with relatives north of Nashville. She stayed in touch with her stepdaughters through the mail and an occasional visit to Travellers Rest.

Annie continued her life as a military wife to Thomas and mother to Mollie and her new sister, Harriet Overton, born on September 25 in San Antonio, Texas.

Mary Maxwell was invited to come live at Travellers Rest, where she doted on Martha and Jackson May. She would be her sisters' link to the Maxwell legacy.

Harriet announced that she was with child for the third time. She was twenty-six years old.

Maria took her carriage ride into the city as promised. When the day came, Eli told her to climb up on the driver's seat with him. She waved to the other house slaves gathered on the gallery as the carriage pulled away. When they reached Franklin Pike, he released the small flap near his seat that opened to the main part of the carriage. "Massa Overton, is you and Miz Overton all right?"

"We are fine, Eli. It's time to speed up the horses."

"Ya, sir." Eli knew the routine, but he always waited for the order from Massa John. He closed the flap and leaned over to Maria. "I hopes ya don't have no fool ideas of getting' on da Underground Railroad. Da white folks knows it's dere and when dey catches ya, dey goin' to sell ya south. And dat be a bad life."

"Mind ya own affairs. Ya not my master. Ya jest an old slave, Eli. Dats all ya is."

"Jes da same. Da freedom train cause ya only pain."

"We sees bout dat. Yas do da drivin' and I do my own thinkin'." Eli went directly to the depot where John got out of the carriage. "I enjoyed our ride," he said to Harriet.

"Thank you kindly sir, the pleasure was all mine. What time does your train leave?"

"The train will pull out at two o'clock on the dot."

"I would like to reserve two seats to the Overton station. I have some stops to make near city square. Are you free for lunch?"

"No, I have a meeting at lunch with a property agent. You're welcome to join us."

"No, I'll do my shopping, have some lunch, and be back here for my train ride home." Harriet gave Eli directions to the dress shop near the square. When they arrived, she checked her watch and it was nearly ten o'clock. As Eli helped her from the carriage, she glanced up to see Maria with a pleasant smile on her face. "Eli, I'm going to do some shopping on the square and have lunch at the Watson Hotel. I want you to meet me at the hotel at the noon hour. In the meantime, I want you to drive around the city and show Maria the sights. Don't miss the buildings on Summer Street." She had a slight smile on

her face, and the directions were very clear to Eli. He tipped his hat and waited for Harriet to enter the shop before he retraced his route. As he passed the depot again he said, "Maria, dat be Massa Overton's railroad train."

"Where be da freedom train?"

"Dey no freedom train, fool. Ya gots to run and hides at dark time and hopes da dogs don't find ya."

"No, where da train Meg rides on to freedom!"

"Listen to me, Maria. Dey no train to ride. It only a name da slaves gives to runnin' and hidin' in da dark and hopin' da dogs don't find dem. And when da dogs get 'em, dey puts 'em in jail and den dey sold south." By the time Eli had finished talking, he turned the carriage onto Summer Street. He pointed to the building where he had watched the three slaves pushed to the ground and taken away to jail. His vision of that awful moment was clear, and he shook his head as he looked at Maria. "Maria, sometimes freedom be in our hearts. We be slaves on da outside," Eli spoke in a whisper, "but inside in our hearts, we be free."

"But Eli, I wants to be free all over." She buried her face in Eli's coat and wept. Her body shook at first and then he could feel her calm down. He kept his arm around her as he flipped the leather straps, indicating to the horse to start moving. He drove to the river to show Maria the sights. Eli tethered the horse, helped Maria down, and together they walked down Front Street. She saw the Cumberland River and the huge steamboats for the first time. Her sadness was gone; a new world opened before her eyes.

At lunch, Harriet and Grace Evans chatted about when they were girls at the Academy. Harriet was pleased Grace could break free from her work at the dress shop and join her for lunch. She had wanted to do this for some time but was always too busy with her responsibilities at the plantation and the recent events in her life. As they waited for their lunch, Grace's face turned solemn. "I read about your father's passing in the newspaper. Had he been ill?"

"The doctor told me he had a heart attack and had not suffered. By the way, Grace, your note of condolence is one I will always cherish. Your kind voice came right off the page as I read it. You are a good friend." Harriet reached across the table and patted Grace's hand. "Will you excuse me for a moment?" Harriet placed her napkin on the table and walked to the large front window of the hotel. She spotted Eli and returned to the table, where the waiter was placing plates of food on the table. "Sir, would you be so kind to prepare two more plates like mine and take them outside to the carriage. My driver's name is Eli."

"Yes, ma'am. I will see to it immediately."

Harriet and Grace chatted and laughed for nearly an hour. Eli knew food would be coming out to them for lunch. Maria could hardly believe she was eating off of a china plate and drinking from a crystal glass. She enjoyed her lunch while seated on the driver's seat next to Eli.

"Grace, I must be at the depot by two o'clock to catch the train home."

"And I must get back to the shop. Thank you so much for a lovely lunch. Next time you must allow me to pay my share."

"We'll see." Harriet knew there would be a next time, but Grace would never need to pay as long as John Overton had an account at any eating establishment in Nashville.

Eli drove the ladies to the shop. He managed the horse and carriage while Grace made her exit into the shop and then reappeared. She was carrying two packages and handed them to Harriet. "I hope this works, and give my regards to Annie."

"Thank you, Grace. Do come and see me. You know you do not need a formal invitation."

The train ride back to Travellers Rest was comfortable, at least for Harriet. Since slaves never rode the train, the conductor was not sure what to do with Maria, when she followed Harriet up the steps and into the passenger car. One other passenger was already seated when Harriet and Maria made their way to a seat. The conductor grabbed Maria's arm with such force she dropped the two packages she was carrying. "You'll need to come with me. You can't be riding in the same car with these white folk." A frown covered Maria's forehead. She broke his grip and was trying to pick up the packages, when he shoved her. She lost her balance and fell between two seats. She was hurt but did not cry. She wanted to hit the conductor but quickly thought better of it. Maria was about to see a side of Harriet she had only heard others talk about. This little woman had to crane her neck to glare into the conductor's eyes. In spirit and fight, she was more than equal to his size. As she stepped between Maria and the conductor, she held up two tickets directly in front of his face. "Sir, I have two tickets for two passengers to ride on this train."

"I don't care if you have two hundred tickets. The nigg . . ." The sharp point of Harriet's boot heel stomped into his fancy shoe and stopped him in midword. While he was shaking his foot to relieve the pain, Harriet repeated, "Two tickets for two passengers!"

"I have a notion to throw you and that darkie off this train." He was pointing his finger and trying to get out of range of Harriet's boot. Maria sat down in a seat; Harriet continued to stand, facing the conductor, and protecting Maria.

"That, sir, would be a major mistake on your part."

"Why, you little snip of a woman. Who do you think you are?" The other passenger, an older gentleman, rose from his seat and moved toward Harriet, hoping to defuse the situation. As he approached her, she was moving toward the conductor.

"Sir, my name is Harriet Virginia Maxwell Overton. My husband is Mr. John Overton." Her voice was getting louder and her words slower. "He just happens to own this railroad. Now, I strongly suggest you take these two tickets and keep this train on schedule." The conductor turned and gingerly hobbled out of the car. Harriet sat down, put the two tickets in her coat pocket,

and looked out the window. The train lurched and then moved smoothly out of the depot. *I must tell John of this incident. He needs to do a better job of hiring conductors. I hope I stomped a hole in his fancy shoe. The very idea of calling me a 'little snip!' I should have stomped his other shoe, too!* Harriet could feel the warmth of a smile on her face. She was enjoying her thoughts. Maria was hanging on to the packages, not knowing what would happen next. She was sure of one thing—no matter who you are, be very careful of what you say to this little lady.

Later, the train came to a full stop at the Overton Station. The conductor was nowhere in sight. The engineer came out of his cab to help Harriet and Maria onto the platform. He tipped his hat, returned to the engine cab, blew the whistle one short blast, and the train was in motion, moving down the tracks. Claiborne was sitting in the small wagon waiting for his passengers. It had been an eventful day for the two passengers. One had revisited her girlhood with a good friend and dreamed of the future. The other had felt a dream die, while gaining lots of respect for a lady she called Miz Harriet. Maria's dream of freedom was buried deep within, and she never again sang about the freedom train or encouraged the Overton children to sing it.

# 14. Reunion

The James Buchanan presidency didn't please anyone but James Buchanan. The key word most people attached to his presidency was *compromise*. After gaining the Democratic nomination in 1856, he campaigned on a conservative platform. His main plank was a tip of the hat to the southern states. He advocated that Congress had no power to interfere with slavery in the new territories. His Republican opponent, John C. Fremont, supported Congress' role in the slavery controversy. Former President Millard Fillmore was a third candidate in the election and was able to split the popular vote. However, Buchanan was able to win the key states and claim 174 electoral votes, enough to make him the 15th President of the United States.

Harriet's interest in political affairs provided many lively discussions around the dining table and often lasted for several hours. John was faithful to bring home the local newspaper, which provided content for the discussions, and challenged Harriet's continued interest. John knew she wanted to know all about the abolitionist movement. He tried to remember to point out those articles when he read them. She had read and disagreed with the implications of *Uncle Tom's Cabin*. She was frightened by her recent encounter with Maria and the Underground Railroad. Although she felt the matter was under control, the abolitionists' agitation would not go away. The names of John Brown and Dred Scott were finding their way into the Sunday sermons from the pulpit and, thus, into the daily conversations of those in the congregation. Carriage rides back to the plantation, after a Sunday church service, were a continuation of what had been said by the pastor or guest preacher.

"The preacher beat the secession drum pretty hard this morning, didn't he?" John tried to find a way to cross his leg in the carriage without taking up all the room. Harriet pushed his leg out of her space and gave him a shy grin.

"He is from South Carolina, what did you expect to hear? He did use a term I want you to explain."

"What's that?"

"He said, 'The president will never be able to compromise with some of the northern hotheads.' Who are the hotheads?"

"Those are the militant abolitionists who want to punish the cotton farmers in the south. They blame us for the economic problems they are having."

"Why would they blame us?"

"We started selling our cotton to Europe for a better price. Many of the northern cities with textile mills needed our cotton. When it didn't come, they had to close mills and people were out of work. The garment manufacturers needed the cloth and without it, their factories had to close. To top it all, European factories exported cloth and clothing to us."

"So the cloth I buy and send to Annie may be manufactured in Europe, using the cotton they buy from us."

"Yes." John was always impressed with Harriet's ability to summarize assorted facts.

"So we, as good business people, are being blamed for someone else who made bad business decisions."

"That's basically it. Plus, it has not helped matters for Senator Hammond of South Carolina to claim, on the floor of the U. S. Senate, 'Cotton is King' and attribute the economic success of the south to slave labor."

"He did that?"

"From what I understand, there's been a lot of unrest in the Senate ever since the United States Supreme Court handed down its decision on the Dred Scott case. Chief Justice Taney said, 'slaves were property and the U. S. Constitution protects property owners.' The Republicans say slavery is a moral question. The Democrats say it's political. The President is trying to get the two sides to compromise."

"What do you think will happen?"

"I fear the attitude in some of our states is not for unity or compromise, but states' rights. It was very evident from this morning's sermon where South Carolina stands. That state and others are like a keg of black powder with a short fuse. If someone or something lights the fuse, we will have a terrible explosion, and then only the Lord knows what will happen."

"Well, since we have slaves and grow cotton, will we be drawn into the explosion?"

"By *we*, do you mean the state of Tennessee or the Overtons?" Harriet did not answer quickly. She paused long enough for John to look at her with raised eyebrows.

"John, talk to me about both."

"Let's say the Governor of Mississippi approached Alabama, Tennessee, North Carolina, and South Carolina and wanted to form a new country. The new country would be named Cottonland for obvious reasons. Each of those states would have to decide to pull out of the United States. The folk in Tennessee would have a hard time deciding, because cotton is not a major cash crop in the eastern part of the state. The plantations who count on cotton would vote yes, while the small farmers and shopkeepers in the east would vote no. Since Tennessee does not have an outside port, we would have a problem selling our cotton crop."

"Couldn't we still ship our cotton down the Mississippi River to New Orleans and use their outside port?"

"We could if Cottonland would allow us to pass through their country."

"What about us, John? Where do you want the Overtons to stand in this matter?"

"I hope we can remain neutral."

The carriage arrived at Travellers Rest. Eli helped Mary Overton, Martha, and Jackson May out. John followed and turned to reach his hand toward

Harriet. "Don't look so serious, Harriet. What we discussed will not happen this afternoon."

"Do I have your word on that?"

Mary Maxwell did not attend church that Sunday and was waiting on the gallery when the carriage arrived. She greeted the adults and held out her hands for the children. Harriet did not get an answer to her question. She was troubled even more.

By early April 1858, Harriet was overly ready to deliver her third child. She was so uncomfortable that John wanted to call a doctor. "What can he do, John?"

"Maybe he could give you a powder to help you rest at night."

"Your mother has been mixing some of her herbs for me, and they do help. This baby will come when it's ready. You are always so kind to think of my health." John's concern made her think of Julia. She could hear that gravelly voice in her mind. *Sabbath Child, yous needs to be off ya feet and restin'. And don't be ridin' no carriage. And don't be climbin' no steps. And don't be eatin' no heavy food. Take in lots of water and cow's milk. Dats what da baby needs from ya. And don't ya dare be drinking none of dat hard stuff.* John kissed her before he headed for town and the depot. "What's on your schedule today?" Harriet tried to show interest in what John was doing. "I'll be having lunch with Isham and some other businessmen."

"Is that Isham Harris? When were you going to tell me you were having lunch with the Governor? I guess I'll need to read about it in the newspaper."

"Harriet, I'm only one of many businessmen. Anyway, I didn't want to bother you about a luncheon."

"John, please bother me in the future! I'll be waiting this evening for a full report, and I don't want to know what you had to eat." He laughed, held her hand and kissed it, and was out the door.

Harriet stayed in her bedchamber during the next morning. Maria helped her into a padded chair over next to a window. She read the newspaper some and looked out the window, enjoying the colors and freshness of springtime. A little before noon Jackson May entered the room, running as usual, followed by Martha, who walked and stood very ladylike. Jackson broke the silence, "Surprise! Surprise! Mama."

"And good day to you, young man." She held his chubby cheeks in her hands and planted several kisses on him until he backed up to get away from the onslaught. "Good day to you, Martha."

"Good day to you, Mother. How are you feeling today?" Martha was moving into a "no touch" stage and Harriet honored the phase.

"Martha, I'm ready to have this baby." Harriet folded her hands and rested them on her protruding bump. "Would you like to feel the baby move?"

"Yes Mother, I would like that." Harriet took Martha's slender hands, placed them on her stomach, and waited. She watched her daughter's eyes. When the baby kicked and Martha felt it, she could not contain her excitement,

"I felt our baby! She wants to get out. When is she coming out of your stomach?"

"I hope very soon."

Several days later, on April 30, Mary McConnell Overton made her appearance. Now there were two Mary McConnell Overtons in the house. Grandmother Mary McConnell White May Overton was surprised and very pleased to be the first to cuddle her namesake. When Cynthia wrapped the newborn and handed her to Grandmother Overton, Harriet heard her say, "Now the new and old are in the same place."

When Mary Maxwell entered the bedchamber later in the day to see her newest niece, she commented, "Harriet, thank you so much for using my name for the new baby." Harriet didn't feel much like debating the source of the name so she smiled at her sister and said, "You're welcome. I hope the two of you will have a strong bond."

"May I hold Mary?"

"Now is a good time to begin the bonding." Baby Mary was wrapped tightly with only her face peeping out of the blanket.

"You are such a precious baby. We are going to be the best of friends. I may just take you for my own."

Seven days after Mary's birth, Harriet wanted to get up and walk around. She told Maria and Cynthia her plans. Cynthia knew the trouble Harriet had had in giving birth to Jackson May and was sure it was not time for her to be walking around yet. She was right. Harriet could barely stand on her own, and taking steps by herself was nearly impossible.

"Maybe ya sits on da edge of da bed for a spell, but dat be it." Cynthia's voice was strong, but not demanding. She knew better than to tell Harriet she couldn't do something.

"I help ya to gets strong," Maria suggested.

"How yous goin' ta do dat?" Cynthia asked, placing her hands on her wide hips.

"Da three of us goin' to work together. Ya goin' be bringin' Miz Harriet food to make her strong. I's goin' to make her move 'round in da bed 'till she be strong, you'll see." True to her word, after days of Maria's help, Harriet was walking about her bedchamber and eventually, to other parts of the house. Maria was not far behind Harriet, beaming at what she was able to accomplish. John, Mary Overton, and Mary Maxwell were amazed at Harriet's progress. They could hardly believe their eyes the first time she appeared in the family dining room. Maria was right behind her holding baby Mary.

"Don't you look wonderful!" John stood as they entered the room, bending down to kiss her and then stretching his arms out to take his newest daughter.

"I owe it all to Maria and Cynthia. They have taken very good care of me, and I stand here this morning because of them. Maria, back in my bedchamber, in the large clothes press, is a package. Would you bring it to me?"

"Yes, ma'am." Maria knew exactly the package she was looking for in the press. She had noticed it for weeks. It was the same one she had carried when she rode the train from the Nashville depot. She returned quickly with the package and automatically handed it to Harriet.

"No, Maria," Harriet held her hands, palms up, "the package belongs to you. You are a great help to me and the children." For a moment Maria stood holding it until she was encouraged by Martha. "Open it and see what you got."

Harriet looked at Martha. "Martha, repeat after me. Open the package and see what's inside."

"Yes, Mama. Open the package and see what's you got inside."

"Close enough." Harriet looked at John and smiled. "Go ahead Maria, open the package."

She broke the string, let it fall to the floor, and then carefully unfolded the paper. The more of the dress she saw, the wider her smile became. "Who dis for?"

"The dress is yours, Maria. You have earned every thread." The dress was not as grand as the ones Harriet had purchased for Julia and Cynthia, but it was more stylish than a day dress.

"Dis be da best dress I ever had." Maria had tears in her eyes. "Thank you, Miz Harriet." Maria picked up the string, balled up the paper, and left quickly to go to the kitchen to show Cynthia her new dress. Martha and Jackson May moved out of their chairs and went to see baby Mary.

When breakfast was over, Cynthia came into the room to clear away the dishes. Maria was right behind her, wearing her brand new dress. It was a perfect fit. Grace Evans was a good seamstress. She had seen Maria only one time but was able to determine her size.

Maria took the three children and walked to the gallery. John stood and gathered some papers he had dropped on the small table when he came for breakfast.

"I have a family matter to discuss," Harriet said rather matter-of-factly.

"Does it involve me?" John asked. He returned to his chair and gave his full attention to his wife.

"I've been telling you for over a year that Annie, Thomas, and the girls will be on military leave this fall. They would like to spend some time with us. Originally, Annie was planning to stay at the Hall, but obviously, those plans have changed."

"Invite them to stay here," Mary Maxwell suggested.

"Harriet," Mary Overton added, "the sitting room upstairs can be converted into a family room for them. We can move our meals into the large room."

"What about beds? What will we do with the furniture in the room upstairs?"

"We can push it into a corner or we can put it in the cellar. I'm certain Archer can build some temporary panels to divide the room for sleeping arrangements. I know there are extra beds in the cellar or stored away in the barn."

"That was much easier than I thought. However, I want all of us to be certain of what we are doing. We will have two more adults and two extra children in the house. We will have five-year-old Martha, Mollie is three, Jackson May is two, little Harriet is one, and baby Mary is brand new. Will we be able to handle the noise?"

"It will be wonderful to have the children here. Cousins should be together."

"I'm so glad I could help." John was laughing when he spoke. He had not said a word. He just listened as the ladies of the house planned for four more occupants. He thought, *the more the merrier. At least there will be another man in the house. Maybe we can do some hunting or horseback riding while he's here.*

Robert Brinkley in Memphis sent a brief note, stating his daughter, Annie, would be coming to the Academy in the fall and was looking forward to getting back to the Nashville area.

> *I gave her a choice of schools to attend. She has always wanted to do what Aunt Harriet did. I believe she knows being at the Academy will put her closer to the Overtons and Travellers Rest. She is so smart in her thinking.*

He was concerned about Hugh, however. Reports from the headmaster suggested he was only average in his studies. He seldom wrote home.

> *Do you hear from your son, John?*

John was happy to read that Robert was making a good adjustment to his new wife.

> *John, if your mother is well enough to travel, perhaps she would like to come to Memphis this holiday season. She could travel to and from with Annie. That would give granddaughter and grandmother some time together.*
> *Please inquire and let me know.*
>
> > *Always your Brother-In-Law*
> > *Robert*

.    Harriet read the note and conjured up scenes in her memory of when Annie was a small child, even younger than Martha was now. She was pleased Annie was coming to the Academy. *It's hard to believe Annie is old enough, but she is thirteen years old. Regardless of what Robert thinks, most of her time would be spent at the Academy with her studies. She can spend all the time she wants with us, however, and we'll enjoy her company. I must*

*remember to tell Annie about my classmate, Grace Evans.* Harriet handed the note to Mary Overton and waited for her response. Mary had to adjust her reading glasses as she read.

"Wonderful, Annie's coming to the Academy this fall. Isn't that grand news?" Mary was interested in sharing the news as she read, as though it was new information. Harriet continued to respond to Mary's revelations. "Robert has invited me to spend the holidays with them in Memphis. I'll be able to travel with Annie."

"I think you should give strong consideration to the invitation. You and Annie can ride on John's railroad for the trip. What do you think, John?" He had been sitting quietly reading the newspaper but was aware of the conversation.

"If you want to go, I'll make the arrangements. You just let me know. If you want to stay overnight in Decatur, I can arrange that as well."

By the late summer of 1858, Harriet had mentally arranged the events for the rest of the year like a child playing with dominoes. The events would happen in order with some of them overlapping, but there would be order. At night, in the process of going to sleep, Harriet rehearsed the events in her thoughts; *Annie Brinkley will be in town by early September to attend the Academy. My sister Annie, Thomas, and the girls will be here by the second week of September. John will be home from Virginia for a holiday visit by mid-December. Mary Overton has been invited to spend the holidays with the Brinkleys in Memphis.* Planning did not stop with her thoughts.

The next morning at breakfast Harriet commented, "John, I'd like to invite the Brinkleys to stay with us when Annie comes to enroll in the Academy."

"That sounds like a good idea. It will be a good time for his new wife to see Nashville. Will the upstairs parlor be rearranged by that time?"

"Yes, I believe so. I've already talked to Archer about the needed adjustments up there. He's putting together a plan for us to consider."

"Harriet, you know what needs to be done. Please don't delay waiting for me to see his plans. I may be out of town or busy with some other project. I trust your judgment. If we get in a bind for lodging, we can always ask Elizabeth. She'll be glad to help out."

"That's a good thought. I believe the Brinkleys will be gone by the time the Claibornes arrive. In any event, I'll send an invitation to Robert and check with Elizabeth's schedule for that time. I want you to send your son a note asking about his holiday plans. You also need to arrange for your mother's holiday travel." Harriet heard his words, "some other project," and wondered but did not pursue it with him.

"I can do those two things." Harriet liked John's cooperative spirit, but she knew he would need reminders. He always had a way of seeing the big picture but was very good at delegating the fine-tuning to others. That's what made them a good team. He had the visions; she got things done.

The local newspapers carried stories about William Walker and his activities. Walker was a Nashville native born in 1824. A brilliant student, he graduated from the University of Nashville at the top of his class at age fourteen. He traveled throughout Europe and studied medicine while there. Upon his return, he set up his medical practice in Philadelphia. After a few years, he tired of the profession and went to New Orleans where he became interested in law and became an attorney. Then his interest turned to journalism and the newspaper business. While working in San Francisco as a journalist, he conceived the idea of invading and conquering parts of Latin America and giving them English-speaking leaders. He called the process *filibustering,* a method of military takeover.

By 1853, his efforts created the Republic of Lower California and he was their president. Walker turned his eyes and efforts on a bigger prize, Nicaragua. With the help of a few hundred mercenaries, he defeated the Nicaraguan national army and soon named himself as the sixth President of the Republic of Nicaragua.

In the summer of 1856, U. S. President Franklin Pierce signed the papers which recognized Walker's regime as a legitimate government. President Walker encouraged American southern businessmen to invest in Nicaragua by openly supporting the spread of black slavery and hinting at the possibility of filibustering Guatemala, El Salvador, Honduras, and Costa Rica.

The Wall Street tycoon Cornelius Vanderbilt had large land holdings and a major business enterprise in Latin America. He saw Walker as a threat to his financial advances in the area. Vanderbilt had the money and the connections to diminish Walker's power, and by May 1857, his government was overthrown by the locals. He returned to New York City and was hailed as a hero.

Harriet had followed the career of William Walker. She didn't always agree with his tactics but she appreciated his spirit. At least three times a year there would be an article in the local newspaper about him. The latest headline caught her eye, WILLIAM WALKER—WHAT'S HE UP TO NOW! The lead sentence stated, "President Buchanan orders Walker to stay out of Central America." There was always a review of Walker's antics, and being a native of Nashville made him front page news. The articles were fodder for Harriet and John to talk.

"Did you read the article about William Walker?" She knew what the response would be without looking up from the newspaper.

"Did you know William and I were at the University at the same time?" She loved hearing John tell the next part.

"I understand from the article, William was very intelligent."

"Yep, he was twice as smart as the rest of us and smarter than some of our instructors. He must have been sixteen when he graduated."

"The newspaper reports he was a mere fourteen."

"That young? Sounds like you at the Academy. What age were you when you finished the Academy—twelve?"

"John Overton, you know good and well I was fifteen years old! You wanted to marry me, but my father made you wait until I was eighteen."

"Jesse Maxwell was a wise man . . ." John was leaving the room when he finished his thought. "Yes, he was a very wise man indeed." John laughed aloud; Harriet joined him.

Mr. and Mrs. Robert Brinkley and Annie arrived at Overton Station on a beautiful fall afternoon. The leaves on the trees were in full color. There was coolness in the air but not cold. Annie was the first to bound off the train steps onto the platform. She spotted Eli and waved at him. He was driving the carriage; Claiborne brought the wagon for the luggage. As Eli approached, his hat was already in his hands and he was bowing, careful not to make direct eye contact. Annie was so excited to see someone she recognized she ran over to Eli, hugged him, and took hold of one of his hands. "Eli, this is my father and my stepmother." His eyes were still looking at the platform.

"Welcome ta Travellers Rest. De Overtons be waitin' fer ya at da big house. We be goin' ta da house. Claiborne be bringin' ya things in da wagon." As he headed to the carriage, Eli realized Annie was still holding his hand. He opened the carriage door and offered to help Annie in, but she pointed to the driver's seat. "I want to ride with you."

"Ya ma'am, Miz Annie." Eli was smiling; Robert was not.

Harriet and John waited on the gallery and greeted the Brinkleys. Robert helped Elizabeth up the steps to the gallery, where she was hugged by Harriet. "What a delight to have you at Travellers Rest." Harriet loved the sound of her home's name.

"Thank you, Harriet, for your kind invitation to come." The ladies were arm-in-arm as they went through the double doors. Robert was glancing over his shoulder at Annie, still with Eli, as he extended his right hand to his host. John sensed Robert's concern. "Robert, so good of you to come." Nodding toward Annie and Eli, John said, "Think nothing of that. They have been friends most of her life."

The men entered the house and found the ladies in the large room already enjoying tea. Annie was only a couple of minutes behind them. When she entered the room, two heads turned in her direction. Two voices could be heard almost in unison, "Annie Brinkley!" "Looks at ya child!" Annie's face was covered with a wide smile. She saw Aunt Harriet and Cynthia at the same time. Harriet stood; Cynthia was already standing. Annie hugged Harriet, much to the pleasure of her father. She was taller than Harriet, which only Harriet noticed. When they released, Annie turned toward Cynthia but heard a familiar voice, "Annie Brinkley, I do declare." Mary Overton was standing in the doorway with her arms outstretched. "Child, you are the very image of your mother." After an embrace, they went to the sofa together. Annie saw

only the ties on her apron as a dejected Cynthia left the room going to the kitchen.

"Elizabeth, Robert, forgive my manners," Mary had a quiet tone to her voice, "I'm so excited to see this young lady, I forgot to properly greet you. Robert, come here and give me a hug." He followed her command, though reluctantly.

"Father, I need to go outside and tell the slave what to do with our trunks."

"Annie, direct him to deliver your trunks to the upper parlor. That room has been arranged for your stay." Harriet was pointing in the direction of the staircase.

"Yes, ma'am. I can do that." Only Harriet noticed Annie leave the room by the door leading to the kitchen. She smiled and kept Annie's secret.

"Can a little girl still get a sugar cookie in this kitchen?" Annie found Cynthia putting a small log into the bottom of her cook stove.

"Maybe. If ya gots a hug to 'change fer it." The two friends hugged and danced around the kitchen.

"Let me looks at ya. Ya be a beautiful young lady, Annie Brinkley." Cynthia could remember when Annie was a sad little girl after her mother died. Sugar cookies had built a bridge for their friendship and it was being renewed as they visited.

"Cynthia, I need to go check on our trunks."

"I sees ya later child."

After telling Claiborne which trunks to transport upstairs, Annie went to the upper parlor. The room had been transformed from a very stylish ladies' sitting room into a comfortable family room with moveable dividers, which were tall enough to allow for privacy and still let heat from the fireplace circulate in the room. The four large windows still provided adequate light during the day. In one corner of the room was the furniture Annie remembered being there, and it reminded her of the times Harriet brought her and little John to the room for music. Annie heard the sounds of children's voices from the room across the hall. She fully expected to see either Eliza or Emily Jane or both, but was surprised to find neither when she entered.

"Where is Emily Jane?"

"She be down in the cabins." Maria was surprised to see a strange person in the doorway. She moved Martha and Jackson May behind her and spread the sides of her dress to hide the bed where baby Mary was sleeping. "Who is ya and what's ya doin' in dis house?" Maria's voice was high pitched and demanding.

"John Overton is my uncle. I stayed in this room when I was a little girl. Emily Jane and Eliza took care of me." Maria was not convinced and did not move. She was scared, but she would never reveal it to this stranger. Annie backed out of the room and walked down the staircase. She heard the door shut in the room she just left.

When she reached the large room, she heard a familiar voice. "Annie Brinkley, come over here and give your uncle a hug." He pulled up a chair for her where the others were seated. "You are looking more like your mother every day."

"That's what Grandmother said." When Annie sat down, she turned to Harriet and said, "Where are Eliza and Emily Jane? There's a house servant upstairs in the children's room who is acting strange."

"What do you mean strange?"

"I just came from the room. When I walked in looking for Emily Jane, this strange slave girl asked me who I was and what I was doing in the house. She put the children behind her, and I didn't even get to see them. While I was walking down the steps I could hear the door shut tight."

"It appears you have encountered Maria. She's been helping me with the children since Eliza had a spell and went down to the cabins to live. I sent Emily Jane down to take care of her. I forgot to tell Maria we were having house guests."

Harriet was pleased to have Annie's report. *Maria is proving her loyalty by protecting the children*, Harriet thought. *That reminds me. Maria will not be able to care for my children and my two nieces when they get here from Texas. I'll need to get her some help. Emily Jane may need to come back while the Claibornes are here. I should make that arrangement tomorrow.*

"If you will excuse me," Harriet announced, "I want to go upstairs and get the other members of the Overton family. Annie, would you like to come with me?"

"Is it all right if I go?"

"Yes."

When Harriet and Annie got to the door at the top of the steps, she pushed on it expecting it to open. She pushed again and it remained secure. "Maria, it's all right. Open the door. I need to see the children."

"Is ya alone?"

"Annie Brinkley is with me. Now, open the door, I need to see the children." Slowly a crack appeared and then the door was opened halfway. Only Maria's fingers wrapped around the side of the door could be seen. Harriet held the rail and went down the two steps into the room. To her amazement, the children were nowhere to be seen. She scanned the room and listened for a familiar "Mama." Maria had moved quickly to the other door in the room leading through the passageway to Mary's room. She glared at Annie as she entered the room.

"Maria, where are my children?" Harriet stomped her foot twice on the wood floor. The sound resounded out the room, down the staircase, and into the large room. John jumped to his feet and made his way to the foot of the staircase. "Is everything all right up there?"

"Yes, John, everything is fine." Harriet was hoping she had made a true statement.

"Da children be safe in Miz Mary's bedchamber. Who dat be?" Maria did not take her eyes off Annie. Harriet pushed past Maria and went to Mary's bedchamber to find her children safe and playing on the floor. As she looked at them, she realized *Maria did everything she knew to protect my children.*

"Mama." Martha's cheery voice suggested there was no danger. She got up and hugged Harriet's skirt. Jackson May followed his sister's example. "Maria told us to play in here. She said it would be all right."

"Thank you for following Maria's instructions." Harriet picked up baby Mary, held her close, and walked back to the staircase. "Martha, hold tightly to the rail and take one step at a time. Jackson, use the rail and hold someone's hand." Maria and Annie placed a hand in front of Jackson May. He took Maria's. At the foot of the stairs, Harriet turned to Maria, while the others walked into the large room. "Maria, you did a wonderful thing in protecting the children. You are a good person. I'm glad you are here. I should have told you other people would be in the house. In a few days two more small children will be coming to visit."

"Thank ya, Miz Harriet."

"Now, I need for you to go to the cabins and tell Emily Jane I need to talk with her."

"Ya, ma'am."

The Overton children made their appearance before the houseguests. Martha was engaged in conversation with them. Jackson May stayed in his father's lap. Baby Mary had to be taken out of the room for a needed diaper change. Annie introduced herself to her cousins. She had a natural ability of caring for children and they trusted her.

Two evenings later John and Harriet hosted a dinner party for the Brinkleys. The John Leas were invited to meet Elizabeth Brinkley and introduce her to the extended Overton family. Elizabeth Lea was hesitant to bring her three boys but was assured by Harriet the children would be eating in the small family dining room and would have food they liked. Nonetheless, when the Leas arrived, the boys had a house servant with them to care for their needs. Harriet was not pleased but knew that any comment from her would be received as being negative. John, however, was not so kind to his sister. "Elizabeth, why did you bring a slave with you? We have more than enough here."

"One can never have too many slaves. Now just you never mind. Where are the Brinkleys?" She brushed by John, but turned before entering the house to give instructions to the boys and the slave. "Boys, come with me. I want to present you to the Brinkleys. Then you may be excused to the family dining room. Grace, you may wait down by the kitchen door and tend to the boys later."

Harriet and John followed John Lea into the large room. Elizabeth entered the room and was ready to take charge until her mother stepped forward. "John, please present our guests."

"All right, Mother. It's always good to have Robert and Annie at Travellers Rest. And this time they brought Elizabeth with them. This is her first visit, and we welcome her into the extended Overton family."

"Thank you, John." Elizabeth Brinkley moved to John's side and grasped his arm. "I have looked forward to coming here and the opportunity to meet the Overtons. You have been so kind and gracious to include me in this wonderful family."

"Elizabeth, allow me to introduce the family. You know Mother and Mary Maxwell, Harriet's sister. This is John Lea, our brother-in-law and his wife, Elizabeth Belle Overton Lea, and their three boys: John Overton, Luke, and Robert. And of course, my lovely wife, Harriet."

After a few minutes of smiles and greetings, the Lea boys were given instructions by their mother and excused. Annie started to follow her cousins but was encouraged by Harriet to join the adults for dinner.

Harriet had given serious thought of how to balance the conversation at the table during the dinner. With nine at the table, she had to be aware of the pauses. She was ready when the first pause came. Making eye contact with Elizabeth Lea, Harriet said, "Elizabeth and Mary, please share some of your memories about the Academy with Annie." While Elizabeth droned on and on, John placed his huge hand over Harriet's. *Harriet, you are a very wise lady. Linking our families together by using the Academy is a stroke of genius.*

When Elizabeth took a sip of water, Mary Maxwell jumped into the conversation and told how much she had enjoyed her years at the Academy. Attention at the table was directed toward Annie, and all enjoyed her excitement.

Harriet directed the servants to clear some of the dishes and serve the next course. This gave her an opportunity to place the attention on Elizabeth Brinkley, who had been rather quiet. "Elizabeth, how do you like Memphis?" Apparently, Harriet posed the very best question she could have for her guest. Elizabeth was up to date on the new shops and restaurants. Harriet could tell from her expression that Elizabeth Lea was impressed. Whether it was by luck or by design, when she mentioned the new railroad construction in the city, both John Overton and John Lea entered the conversation with questions. Elizabeth fielded their questions and left the other ladies at the table amazed at her acuteness on the subject. Robert was not surprised, and the smile on his face suggested his agreement with what he was hearing.

As dark approached, John Lea announced it was time for his family to head back to Lealand. Proper good-byes were said and the evening was over. Harriet closed her eyes and released a well-deserved sigh.

The Brinkleys left the next day, stopping at the Academy. After getting Annie settled in her room, they took the late train for Decatur and on to Memphis the next day.

Harriet received a note from Elizabeth locking their friendship in place forever.

*My dearest Harriet,*
*Words are not adequate to express my feeling of gratitude to you*
*for a lovely experience in your home. I felt more at home with you*
*than I do when I visit with my own siblings. The Overtons have*
*very wide arms to accept others into their fold. I appreciate you and*
*your warm and welcoming hospitality. Please give me the*
*opportunity to return your kindness by your future visit to Memphis.*
*I am affectionately your new family member and forever friend,*
<div align="right">

*Elizabeth M. Brinkley*

</div>

The sisters, Harriet and Mary, were like schoolgirls waiting for the train to come to a complete stop at Overton Station. They were excited as they walked from the carriage to the platform. They both craned their necks, trying to catch a glimpse of their older sister, Annie, through the train windows. Time and distance had separated the three sisters for over seven years. Now the seconds seemed like hours. "I hope she's on the train." Mary was so nervous she had to hold on tightly to Harriet's arm. They were focused so intently on the door at the back of the railroad car, they didn't realize the three-year-old girl was walking toward them.

"Aunt Mary! Aunt Harriet! It's me, Mollie!" Her words were so clear, her diction so drawn out. However, she didn't need to say a word. Mary and Harriet could have picked Mary Maxwell Claiborne out of a crowd of a hundred three-year-olds. She was the very image of her mother. Mary released her grip on Harriet and ran to greet Mollie. Mary dropped to her knees and was able to look her niece directly in the eyes.

"Which one are you, Aunt Mary or Aunt Harriet?"

"I'm Aunt Mary. May I have a hug?" Little arms had hugged her neck before, but first-time hugs were always special. "And this is your Aunt Harriet."

"I have a sister named Harriet, but she's still little."

"I know. Did she come with you?" Harriet bent over and picked Mollie up, holding her cheek to cheek.

"Yes, ma'am. She's with Mommy and Daddy." Mollie pointed in the direction of the other end of the railroad car. By then a stately woman, holding a baby, and a military officer came into view. Annie handed baby Harriet to her father. She began hurrying down the platform. Annie's arms were outstretched and ready to receive Mary. They were both crying. Harriet was moving toward her sisters as quickly as possible, careful not to frighten Mollie or trip over her own long skirt. She joined her sisters and was included in the long-awaited embrace.

Thomas was able to take Mollie before she was hopelessly trapped in the middle of the Maxwell sisters. He smiled at the ladies in front of him. Annie had told him that going home would be a wonderful reunion. He thought for a few minutes, *the reunion may never end here on the platform.* The train conductor placed five trunks on the platform, all labeled U. S. Army.

"Will that be all, sir?" The conductor tipped his hat, spotted Harriet, and quickly backed away, getting on the train. Thomas was reaching in his pocket for some money when the whistle sounded and the train pulled away. The conductor looked at Harriet through the widow and recalled, with some pain, the last encounter he had with her. He was happy to miss the gratuity and maybe save his toes.

Eli and Claiborne had loaded the trunks in the wagon, and Claiborne was on his way back to the house. The three happy sisters, arm in arm, moved to the carriage.

"I believe we can all fit comfortably in the carriage, if I can hold baby Harriet." Aunt Harriet had a big smile on her face.

"And I can let Mollie ride in my lap," Mary said, trying to find a tickle spot on her niece.

"Annie, you are so suntanned and slim. You look wonderful." Harriet was kissing the baby's cheeks and there was no resistance.

"This is the look of the southwest. The sun has even lightened my hair."

"Thomas, you must forgive us," Harriet said apologetically, "we are just three silly sisters who have not seen each other in over seven years. How are you doing?"

"I am doing fine, Harriet. I'm looking forward to eating some good southern food and rocking on the gallery."

"We can provide all of that and maybe some extras as well. I know John has been saving a very good keg of peach brandy for your arrival."

Maria and Emily Jane had bathed and dressed Martha, Jackson May, and baby Mary. They waited in the large room with Grandmother Overton. The ride from the station had rocked baby Harriet to sleep, and Harriet carried her into the house. Martha could not believe her eyes and reacted. "Mama, do we have another baby?"

"No, Martha, this is your cousin, Harriet Overton Claiborne." Martha looked very confused. The only Claiborne she knew was the Overton slave.

"Is she Claiborne's baby?" Harriet was laughing as she pulled back the blanket to give Martha a full view of the baby.

"No, this baby belongs to my big sister, Annie."

"Oh, Aunt Annie and Uncle Thomas."

"That's exactly right. They will both be coming into the house shortly. And guess what?"

"What?"

"Aunt Mary will be bringing another of your cousins, and her name is Mollie. We will have five children in the house and you are the oldest. So you will need to be a good example for the others."

Sounds of laughter and crying filled the house. There were joyful and stressful times for the children and adults. Harriet had made a good decision in bringing Emily Jane back into the house to help Maria. The two slaves worked well together but had their hands full during the entire Claiborne stay.

One particular afternoon became very eventful when Elizabeth Lea and her three boys showed up unannounced. Eight children were either on the gallery or in the side yard at one time. "We will not be staying long," Elizabeth announced as she exited her carriage. "I had a photo made of the boys for Mother and I wanted her to have it."

"Do come join us on the gallery," Harriet offered Elizabeth. "You remember the Claibornes, Thomas and my sister, Annie. And these are their children, Mollie and Harriet Overton."

"You folks are living in Texas. You know my father, the Judge, had a connection with Texas before it was a state." Elizabeth handed her mother the framed photograph of her three Lea grandsons and then found a seat.

"What's the connection?" Thomas was interested in her comment.

"Sam Houston was a friend of ours. He and his bride, Eliza Allen, spent part of their honeymoon in this house," Elizabeth explained.

Mary was always amused at her daughter when she began giving her pedigree. "That's almost correct," Mary added to the conversation. "Sam was a friend of your father. Elizabeth, you were only two years old at the time. And as I recall, you would have nothing to do with Sam. In fact, his looks frightened you."

"Well, Mother, he was a friend of the Overtons and I am an Overton." Elizabeth stood and ran her hands down the front of her dress to flatten the wrinkles.

"Elizabeth, this is a wonderful photograph of your sons." She held the frame up for all to see. "This is a treasure. Thank you very much."

"I'm glad you like it." Elizabeth blew her mother a kiss. "Nice meeting you, Thomas and Annie. I want you to come over to Lealand soon for lunch. Harriet and I will find a suitable date."

"Thank you for the invitation. You are too kind." Annie stood and faced Elizabeth. "I need to make an appointment with your husband on a legal matter while I'm here. Maybe I could do both on the same day."

"That sounds perfect." There was something about Annie Claiborne that Elizabeth liked. She had an air of maturity about her. Elizabeth beckoned her sons from the end of the gallery.

John Overton had been quiet throughout his sister's visit. He walked over to her and put his arm on her shoulder. "Would it be possible for your brother to come to your mansion for lunch some day?" John had a way of testing Elizabeth and keeping her in reality.

"I don't know, John. Have you learned to eat with a fork yet?" As serious minded as Elizabeth was to others, she loved joking with her brother.

"I've nearly mastered it. Just a few more months and I should be ready."

"Well then, when you come with the others for lunch, maybe you should eat on the back stoop." She placed her arm around his waist and reached up and kissed him on the cheek.

"Good-bye, little sister. Do come again."

Thomas' leave was intended for rest, but his commanding officer had given him an assignment, knowing that he was going to Tennessee. Army officers were always eager to know the lay of the land in all sections of the country. They never knew where their next assignment might be, and they liked to have as much information as possible. "John, what do you know about the river system around Nashville?"

"Are you talking from a commerce viewpoint or a military viewpoint?"

"Both."

"To the west, less than one hundred miles, is the Tennessee River and beyond that, another hundred miles, is the Mississippi River. To the north of Nashville the Cumberland River connects with the Ohio and then the Mississippi. You traveled on the Cumberland when you came for your wedding."

"So do the two rivers run parallel to each other?"

"At first, then the Tennessee flows directly south toward the Mississippi and Alabama state borders. The Cumberland flows north beyond Nashville. If you have the time, Thomas, you could make a trip north and see for yourself. There's a small community west of Clarksville called Dover. It's about seventy miles from here, and I'm told there's a small hotel there. I could have Claiborne drive you there and back, or you could take a horse. You could see both of the rivers and judge for yourself."

Annie also had some visits she wanted to make while in Nashville. She needed to talk with John Lea about the money she inherited from her father's estate. She was hopeful that matter could be settled on the same day she had lunch at the Lealand plantation. Knowing she would be in Nashville soon, John Lea had advised her to leave her money in a Nashville bank. He was a little afraid of sending her a check through the mail. She had agreed, although Thomas thought it would be good to have the money in a Texas bank.

She also wanted to have some time with Myra. The two had written after Jesse's death, but Annie still felt the need for some kind of closure with Myra. When asked, Harriet suggested a downtown restaurant would be a good meeting place. "Would you and Mary like to join Myra and me?"

"I think that's a wonderful idea." Mary agreed. Annie sent a note to Myra, and in the return note, Myra appeared very excited about the meeting. They agreed on a date and location and had a grand time together.

One cool afternoon Annie took baby Harriet for a walk around the house. *I've been here for nearly a month,* Annie was thinking, *and I've not been back to the Hall. Is there anything there that I really want to see again? Yes, I need to see Father's grave and also see where Julia is buried. There may be some slaves there that remember me. I need to see whether Mother's flower garden still exists.* When she returned to the house, Annie went directly upstairs to find her sister Mary. Since she had moved in after the Hall was sold, Mary was

living in the room that, for so many years, had been the guest bedchamber. When John remodeled the house in 1845, he had placed a door to the upper gallery in the passageway. Mary could use that door or she could go through the children's room to reach the staircase. The living arrangement worked well for her and the Overtons. Annie found her sister writing in her journal. "How's the writing coming?"

"I'm still recording my thoughts and someday I'll put it all together."

"Mary, have you and Harriet been back to the Hall since it was sold?"

"The new owners invited us back to get anything we wanted."

"And . . ."

"And the three of us picked out some things, but that was the only time." Annie had a sinking feeling. *My sisters and Myra got some things they wanted. What about me? What about the things I wanted? I would have loved to have the full-length mirror Mother had in her room. I used to primp in front of that mirror. What happened to my rocking chair? My girls would have loved to have that, but it's gone. What about Father's collection of stick pins? He told me I could have them.* Annie's thoughts were making her have bad feelings about her sisters.

"And . . ."

"And what, Annie?"

"And what about . . ." She was interrupted by Mollie. Annie turned to see three-year-old Mollie standing in the doorway to the gallery. "Come with me, I have a surprise for you."

"I was talking to Aunt Mary and it's very important."

"My surprise is more important." Mollie took her mother's hand and they walked down the gallery to a door leading to a room over the small family dining room. Annie was still holding baby Harriet.

"I found her, Aunt Harriet. She was talking to Aunt Mary." As Annie entered, Mollie yelled, "Surprise!"

"Mary and I rescued some things from the Hall. Myra didn't think it was right for her to take anything. We insisted she take the master bed and matching dresser and a clothes press." Annie could not believe her eyes. The room was packed with furniture, dishes, books, linens, and a rack, holding an assortment of party dresses. Mary had slipped in behind Annie. "Did you leave anything?" Annie quizzed.

"Oh, yes. Father, for some unknown reason, saved what had been salvaged from the fire in the old house and put it in the barn. He and Mother apparently got new things for the new house."

"I can remember him talking about the fire. It began in the kitchen, jumped the dogtrot, and spread into the room he used as an office. The two rooms above the office were destroyed. The brick wall between the office and the dining room saved the rest of the house from fire but not from the smoke damage."

"Do you remember," Mary added, "we got all new clothes?"

"Annie, after all these years there is still a slight smoky smell in Mother's dresses." Harriet smiled at Mollie as she moved past her and over to a large clothes press.

"Look, Mama. The surprise!" Annie could not see Mollie until she moved over next to Harriet. Mollie was sitting in the rocking chair. Annie's free hand went to her mouth, "Oh my, it's our rocking chair."

"No, big sister, that's your rocking chair. You shared everything with us but that." Harriet took baby Harriet to hold so Annie could bend down and talk to Mollie.

"Mollie, this is a wonderful surprise! Thank you for bringing me down here."

"Look behind you!" Mollie was laughing because of what Aunt Harriet told her about the mirror. As Annie twisted around she lost her balance, landing on her bottom in front of the mirror.

"Make a face, Mommy, like you did when you were little." Mollie jumped out of the chair, sat in her mother's lap, watching her stick her thumbs in her ears, and wiggle her fingers.

Mary interrupted the laughter, "Annie, we found a wooden box in Father's trunk with your name on it. It was tied with a thin rope. Harriet and I didn't open it but wondered what it was."

"Where is the box?" Annie was hoping she knew exactly what the box contained.

"Father's trunk is over in the corner." Harriet pointed in the direction of the dresses. Annie opened it and retrieved the small box. While she was looking in the trunk, she got a whiff of the smoky dresses hanging close by.

"Ladies, we need to throw the dresses away." She removed the rope and opened the box, discovering, as she had guessed—her father's collection of stickpins. She held the box for Harriet and Mary to see. "Annie, I don't ever remember seeing Father wear those." Harriet was interested but as was obvious to Annie, not envious.

"Most of these belonged to his father, our Grandfather Maxwell. He wore them on rare occasions. In fact, he had the pearl one on at your wedding."

"I will take your word on that."

"Annie, if you would like anything else, I'll have Archer to build shipping boxes for them. He can go ahead and prepare the chair and the mirror for shipping on the train to Texas."

"Mollie, take Aunt Mary's hand and we'll go find Martha and Jackson May. Your mother needs some time in this room to look at things."

Annie stayed in the room viewing each item and remembering her childhood. She enjoyed seeing it all but settled on the three items she treasured most. They would be a constant reminder of her mother and father and her wonderful childhood. One more event was on her list of things to do in Tennessee. She wanted to visit the Hall one last time.

The second week in November was not a good time to be taking a carriage ride, but it was a short trip to the Hall. The Maxwell sisters braced themselves emotionally as they turned off the main road. They had made this trip so many times as children. There had always been a Maxwell to greet them. This time was different. The land had been Maxwell property for many decades; now it belonged to another family. When the Hall came into full view, Annie could not hold back her tears. Harriet was seated next to her and said, "Mary and I did the same thing when we came back."

"I have so many wonderful memories here." Annie was trying to talk through her sobs. "I don't need to go in the house. I just need to see both Father's and Julia's graves. I want to breathe Maxwell air one more time."

"I understand." Harriet patted her sister's hand.

"Are any of the Maxwell slaves still here?" The fields were bare; no slaves were seen.

"I'm not sure." No sooner had Harriet spoken than Mary spotted a familiar face on the porch. Big as life, there he stood. Edward was shading the bright sun from his eyes, trying to determine who was in the carriage. He came down the steps to greet the visitors. He saw Eli in the driver's seat and knew it must be some of the Overtons. "Howdy, Eli. How ya be?"

"I's be fine." Edward took the reins and tied them to the post.

"Who be with ya?"

"Go takes a look. Ya knows 'em."

Annie opened the carriage door, grabbed the hand support, and was placing her foot on the step when she saw Edward offer his withered hand. She had a flashback of a much younger man, *Could this be Edward? This man moves like an old man. I'm not sure he is strong enough to help me down. His hand, what's wrong with his hand?*

Edward looked past Annie and spotted Harriet moving toward the door. "Good day to yous, Miz Harriet."

"And good day to you, kind sir." He took her by the mid-arm and helped her down. He did the same for Mary, greeting her by name. Annie had not moved far and realized, *Edward does not recognize me. He has forgotten how I looked. Have I changed that much in seven years?*

"Edward," Annie spoke distinctly, "It's me, Annie Maxwell."

Edward had a blank look when he physically responded to the voice. He moved a step closer and refocused his eyes. "Well I's be. Praise da Lard! Ya be all grown up and I's didn't knows ya." A smile came to Annie's face. She saw the recall in Edward's tear-filled eyes. "Look here, Miz Harriet, it be Miz Annie. She done come home." Edward put both hands over his face and began to weep—quietly at first and then forcefully.

"Was it something I did?" Annie questioned.

"No, Edward is remembering Father. He weeps like this when he thinks of him."

"Edward," Annie's voice was soft, "Will you take me to Father's grave?" She wrapped her arm in his.

"Ya, Miz Annie. Massa Jesse done gone ta be with da Lard. His bones am in da dirt, but his spirit be wid da Lard." As they walked Annie saw the years of wear on Edward's bent back and the shuffle in his walk. For the first time in her life she didn't see a Maxwell slave; she saw a faithful family friend who needed her support and care. They cried together at the gravesite as she read the names on the three tombstones. The stones for Jesse and Martha were of equal size. The small headstone between them was inscribed, Jesse Maxwell III. Harriet and Mary moved quietly in the direction of the barn; Annie and Edward followed. When they arrived at Julia's grave, Edward bent down on one knee and pulled the grass away from the small stone. The four of them stood in silence. Then Harriet raised her head and snickered. "Harriet, what on earth is so funny?" Mary was somewhat disturbed with her sister's actions.

"Julia doesn't want us to be sad for her."

"How do you know that?" Harriet lifted both hands skyward pointing to the sun.

"Is dat da sun a shinin' up dere?" They all laughed out loud remembering their friend, Julia. The four mourners walked back to the carriage arm in arm. They walked slowly, allowing Edward to keep up. Annie was the last to enter the carriage. She turned to Edward, "The next time I see you we'll be in heaven together."

"Ya, ma'am, Miz Annie." Edward was the first to fulfill her prophecy. A month later, before Annie arrived back in Texas, Edward died in his sleep. He was buried down the hill from Julia with a small stone inscribed, Edward.

Five days before the Claibornes were to return to Texas, a telegram was delivered at Travellers Rest for Thomas. On the front of the envelope, scribbled in big letters was OFFICIAL ARMY BUSINESS. Inside was a strange message, DETOUR. RETURN THROUGH MEMPHIS. ORDERS AT TGO. Thomas handed the message to Annie.

"What does this mean, Thomas?"

"My Commander knows we are traveling by railroad from Nashville. He also knows we are not scheduled to return by way of Memphis. Maybe John can help us go through Memphis."

"What does T-G-O mean?"

"That's military for telegraph office. We'll find out there what this is all about."

"What about the things I want to ship back to Texas?"

"I'll need to ask John about railroad policy."

John was able to make the needed changes in the travel itinerary and arranged for the freight to be held in San Antonio. He later surprised Thomas and Annie with a telegram from Robert Brinkley, indicating the Claibornes could stay with him and Elizabeth for as long as they liked. The Brinkleys

would meet the train and have sufficient house servants to help with the children. The surprise was well received and appreciated

Harriet, Mary, and Annie delayed as long as they could. They could not hold back their tears as they clung to each other. John finally had to say, after checking his pocket watch, "By the time we get everyone into the carriages, the train should be leaving the Nashville depot."

It was the third week of November and there was a bite in the early winter winds. Although the carriages were winterized, the riders needed outer coats and heavy shawls. Mollie was overdressed. Harriet had insisted she wear Martha's winter coat, which she had outgrown. Annie did not argue the point, knowing all the while she would return the coat when they got to Texas.

There was a small waiting room at the Overton Station, but not large enough to accommodate the two families, so they waited in the carriages. Thomas and John needed to stretch their legs and walked the length of the platform a number of times.

"Thomas, it has been a delight having you and your family at Travellers Rest."

"John, you and Harriet have been more than gracious to us. I appreciate everything you have done for us. Perhaps one day you may travel to Texas and we can return the favor."

"That may be possible for Harriet and the children, but I doubt I can make the trip. I have a rather large project I want to begin this coming year that will take a good deal of my time."

"What are you planning?"

"I've taken an option on a property in the middle of Nashville. I want to build a grand hotel. My business friends tell me the city would welcome such a venture."

"John, how grand are you thinking?"

"The building designer, Isaiah Rogers, tells me if we go five stories tall, we can have two hundred forty guest rooms."

"Two hundred and forty rooms!" Thomas practically yelled the number back at John. "Are you serious? I can't even guess what that would cost."

"It's in the range of a half a million dollars." John realized he might have said too much. Thomas' eyes had popped wide open and his lower jaw had dropped. "Thomas, I've not said anything to Harriet about the project. I would appreciate your gentlemanly oath not to speak a word of this to Annie."

"Sure, John. I'll not breathe a word, but please send us news when the project begins."

Back in the ladies' carriage, Harriet was holding tight to baby Harriet. Mary had Mollie in her lap with her arms wrapped around her niece. Annie looked one more time into her purse to be certain she had the check John Lea had secured for her. "Harriet, I sent a thank-you note to Elizabeth, but thank her again for a lovely lunch at Lealand."

"I will do that."

"And Mary, please check on Edward. I don't think he has long on this earth. Here's a three- dollar gold piece for a proper gravestone for him." Mary looked at the shiny coin and dropped it into her purse.

"Yes, Annie, I'll do that."

The engineer blew the whistle as the train pulled into the station. Mollie was excited to see the large puff of steam disappear into the cold air. The sisters knew the time was near for the family reunion to be over. John and Thomas helped the ladies and children to the platform and then to the train. Eli followed them onto the train and placed a large basket on the seat in front of Annie. "Dis here's a little somethin' fer ya on ya trip. It be from Cynthia." Later when Thomas moved the basket, he figured it must have weighed twenty-five pounds.

"Eli, please thank Cynthia for us." Annie patted Eli's hand as he turned to leave. Harriet handed Annie's sleeping baby to her. Mollie sat across the aisle in a seat with her father. Mary tried her best to say good-bye, but the lump in her throat wouldn't let her. She held Annie's face in her hands, kissed her, and waved at Thomas as she left in tears. Harriet had Mollie stand up in the seat and hugged her. She moved to Thomas and kissed him on the cheek. The little makeup she had put on earlier in the morning was tear-streaked when she sat down next to Annie and the baby. Harriet buried her face in Annie's shoulder and looked up to see John tapping on the window. He was waving for her to get off the train.

"Annie, I can't say good-bye to you."

"How about if we just say, 'until I see you again.'"

"Until I see you again." Harriet spoke in a whisper and waved her tear-soaked handkerchief as she left the train. John had one of his arms around Mary and he stretched out the other to Harriet.

The clatter of the wheels moving down the tracks seemed to repeat, *until I see you again*—at least to Harriet.

Only one thing broke the sadness in the Overton home for the next week. They discovered quickly there is no time for sadness or emotional recovery when there are two, sixteen-year-old young men in the house. The arrival of John Overton and Hugh Brinkley from school in Virginia brought more than joy and laughter. They brought with them the spirit of the holiday season. They stayed up talking long after the family had retired for the evening. They slept until midday. They had their own schedules and no one in the house minded at all. Cynthia became their best friend. She doubled the portions of food she prepared for the evening meal and was not at all surprised to find every dish, platter, and bowl empty. She made extra cornbread and cookies and looked forward to the visits in her kitchen from what she called "dem two eatin' mo-chines."

John and Hugh talked nonstop, when they were not eating. At mealtimes, John talked incessantly about the entire Overton history from the old country, through colonial times, until the present. Hugh entertained those around the

table with his tales of hunting and fishing on the original Overton property in Virginia. Neither of the boys talked about school and were quick to change the subject when any questions were asked.

One evening at dinner, Mary Overton broke into the male-dominated conversation to comment, "Annie Brinkley and I are taking the train to Memphis for the holidays. Hugh, would you like to travel with us?"

"I don't know, Grandmother. I may just stay here."

"As you wish." Harriet picked up on the sadness in Hugh's voice. She looked at him, and the joy was gone from his face. He remained that way even though he and John went back to their routine of telling story after story, to the delight of their audience. After dinner and the dishes were cleared away, Cynthia brought in a silver tray with several small glasses and a decanter of peach brandy. John's eyes followed the tray until it came to rest in front of his father. He nudged his cousin, "That's what I was telling you about coming home on the train. That's Travellers Rest's famous peach brandy. Our grandfather sold his brandy all the way from here to New Orleans. He used to drink it in this house with Andrew Jackson and Sam Houston. Father, would it be . . ."

"No it would not, for either of you."

"You didn't allow me to finish my question. How did you know what I was going to ask?"

"Because, my dear son, when I was your age, I asked the same question. And I say to you as your grandfather, the Judge, said to me, 'case closed.'" Hugh snickered and tried to hide it in his hand. His reaction brought a happy glow to his face. Harriet was pleased to see it.

When the drinks were finished, everyone began moving out of the room. Harriet put her hand on Hugh's arm. "Could you stay here for a minute and let's talk?"

"Yes, ma'am."

"Hugh, is there a reason you don't want to go home to see your family?" Harriet suspected the problem might be his stepmother.

"Oh, I don't know. When we lived in Jackson and Mother was alive, things were different."

"I know how you feel. My mother died when I was a little girl, and I miss her so much. She didn't get to come to my wedding or ever see my children. But my father did, and that was very important to me. Did you know your father and Elizabeth came to stay with us when they brought Annie to the Academy?"

"Yes. She wrote me they were going to do that."

"Hugh, Elizabeth can never be your mother, but she can be your friend. For your father and Annie's sake, I think you should go home to Memphis and be with your family. Would it make it easier for you if John went home with you?"

"Do you think he would go to Memphis with me? If so, we could come back here before we go back to school."

"Let me talk to his father. Now don't say anything about this to John."

"All right, I won't. Thanks." Hugh left the room to catch up with his cousin. They talked for a while but not as late as usual. "John, I told Cynthia we would be coming to breakfast in the morning." He pulled the heavy quilts tightly around his neck.

"Great, we need a good hot breakfast. I thought we might go horseback riding tomorrow, if the weather is not too cold."

"I'd like that. I'll see you in the morning."

Cynthia brought the first platters of breakfast food to the table. She was disappointed not to find the two sixteen-year-old eating machines. Harriet noticed the frown on her face. "Cynthia, is something the matter?"

"I spectin' Masters John and Hugh to breakfast."

"You know they usually sleep late." No sooner had Harriet spoken than John and Hugh appeared at the side door. They went to the kitchen first to see Cynthia. Not finding her, they went to the family dining room. "I so happy to sees yas." Cynthia brushed by the boys, talking as she went. "I's be rite back wid mo breakfast."

"You're both up earlier than usual." Harriet smiled and focused on Hugh. Martha stood and directed John to sit next to her and pointed at the empty chair next to Jackson May. "Cousin Hugh, you may sit there." Harriet was pleased with Martha's initiative. "Thank you, Martha, that was well done."

Cynthia entered the room with a platter of flapjacks, eggs, and a pitcher of warm maple syrup. "This looks like a holiday breakfast." Mary Overton smiled at Cynthia.

"No, dis just a starter fer the hungry mens at da table." She looked first at John and then Hugh. She had judged correctly, as usual. When she returned with hot coffee, the platters were empty.

"Massa Overton, is ya ready fer ya coffee?" John looked up from a stack of papers he was intently studying. He sensed there were others in the dining room but had not noticed how quickly the food had disappeared.

"Yes, Cynthia, that will be fine." Most mornings John had his breakfast and was gone to town before the family sat down. The early hours were study times for him. Sometimes the reading was work related; at other times he read for pleasure. Harriet realized this and tried her best to protect his early morning time. She had become accustomed to him reading at the breakfast meal.

Cynthia filled the coffee cups around the table. "Miz Harriet, does I needs to cook up more breakfast?" Harriet noticed both John and Hugh had pushed their plates toward the center of the table. She took that as a sign they were finished. Martha had placed her napkin on the table next to her fork and sat quietly with her hands in her lap. Jackson May, who sat next to his mother,

was still poking pieces of flapjack and guiding them to his mouth. "Cynthia, it appears all of us have had plenty."

Harriet caught Hugh's glance and his arched eyebrows indicated he wanted an answer concerning last evening's brief conversation. She patted John's hand. He had removed his spectacles and was placing them in a leather case. She knew this was his routine, and he was getting ready to leave. "John, is there anything we need to discuss while all the family is here?"

"Yes. Hugh, it's been wonderful having you here, but I know your father is anxious for you to come home."

"Yes, sir, but . . ." Hugh's voice trailed off because he didn't have the exact words to finish his thought. Hugh looked over at his best friend and watched his eyes focus on the floor.

"Do you think it would be too much of an imposition on your family if John went with you to Memphis? You could visit there for the holidays and then stop back by here before you return to school in Virginia."

"Father," John was at full attention and smiling first at his father and then at Hugh. "That is a wonderful suggestion. Could you make the arrangements with Uncle Robert?"

"I can send a telegram to Robert's office today."

Mary Overton was amazed at Harriet's reasoning abilities. *This plan was her doing, but the words came from the head of the house.* "Son, do you think it would be possible for these two young men to travel with Annie and me when we go to Memphis?" Mary watched as her son turned to Harriet for a sign of approval. Harriet nodded her agreement.

"Yes, Mother. I think that's the very thing to do. The four of you can travel together. I feel very good about all of this. What do you think, Harriet?"

"John, what you have decided, we can do."

Mary's thoughts wandered to another time when Harriet impressed her. *"If you would be so kind, I'd like to have herb tea with honey."* The three Maxwell sisters had come for tea. Annie and Mary requested regular tea; Harriet asked for tea the way I like it. I wonder whether Harriet remembers that event. And she still drinks herb tea with honey.*

Annie Claiborne sent a note from Memphis indicating they would be leaving on November 22 headed for New Orleans. They would be traveling on the Mississippi River. Thomas' orders were to study and evaluate the military value of Greenville, Vicksburg, Natchez, and Baton Rouge.

> *We are to stop in each of these locations. When we arrive in New Orleans, we are to take a train to Texas. The military has arranged for us to have a servant to help care for the children.*

While Thomas was traveling in Memphis, Annie and the girls were enjoying the hospitality of Robert and Elizabeth.

> *The Brinkleys have a lovely home and are so kind to share*
> *it with us. Mollie and Harriet are very fond of Elizabeth. I am*
> *already homesick for Travellers Rest.*

Harriet was pleased to learn the Claibornes would be gone by the time the Nashville family arrived in Memphis.

The parting this time at Overton Station was not traumatic. Harriet waved as the railroad car left the station with a part of the Overton family. She knew, in a couple of weeks, she would greet them when they returned. As she rode back to Travellers Rest, she pondered the past several weeks. *We have been in a whirlwind of events. First the Brinkleys came. Then the Claiborne family came for a wonderful visit. Lastly, John and Hugh filled the house with joyful noise. This has truly been a time of reunion.*

## 15. Future Plans

Mary Overton was still heavily involved in the management of Overton property in Memphis. She had always planned for John to follow in his father's footsteps and continue the development of the property. However, he was more interested in his own projects. While visiting with the Brinkleys for the holidays, she was able to review, with the family's business agent, the financial books. As she flipped through the account ledgers, she realized that her husband had established this business relationship over forty years ago. She had been actively involved for nearly twenty-five years, since his death in 1833. *I'm too old for this,* she thought as the agent continued his review. *Perhaps John needs to sell off the remainder of the property, since he has no interest in what happens here.*

"What is the status of the Overton property?" Mary directed her question to the young man seated across the table. He was a second-generation agent for the family. His father had worked directly with the Judge. The agent opened another book under the account ledger.

"Mrs. Overton," he slid the opened book across the table to Mary, "it looks like there are about 600 acres of undeveloped land north of the city on the river. A part of that acreage is on the Mississippi and floods on occasions. I'd suggest the property be sold as a whole plot. If the land is sold in parts, you may never sell the flood prone acreage."

"I agree."

He flipped to a page headed Leased Property. "It appears my late father and the Judge leased a large portion of the prime property. That arrangement still yields a hefty income for the Overtons and this agency."

"As I recall, those leases are for ninety-nine years."

"That's correct. After that time, the property can be leased again for a stated length of time or sold. Most of those holdings are in the heart of the business district."

"Mr. Williams, hopefully, I won't be involved in that decision, but I know someone who might. I'd like to bring my grandson, John, with me for a visit to your office."

"Is that little John who was here with his father a few years back? I was just getting started in the business when they came in to meet with my father."

"Yes, I'm certain it was."

"Mrs. Overton, with your permission, I'd like to know when you are coming so I can clear my schedule to meet with the two of you. The three of us can ride out and see the property to the north. There's a new restaurant out in that area I've wanted to try. They specialize in catfish."

"Mr. Williams, do they serve catfish in the middle of winter?"

"Yes, ma'am they do."

"All right then, we will be here this coming Friday at ten o'clock."

"Excellent! I will see you and your grandson on Friday." He stood, guided Mary out of the conference room, through the outer office, and into her carriage.

Life at Travellers Rest had settled down to a quiet routine after the weeks of family visits. Although it was the holiday season, business affairs went on as usual for John. He checked in at the depot on a regular basis. This morning he told Eli he wanted to visit the property on the corner of Church and Cherry Streets.

"Is dat the bull land?" Eli smiled.

"Yes, that's the bull land." The two men—slave and owner—laughed together when the bull land was mentioned. They each had a story to tell about John's land purchase. Earlier in the spring, John was on his way up Summer Street to meet with John Lea. As the buckboard pulled past the First Presbyterian Church across Church Street, John noticed a crowd gathered near James Stevenson's stone yard. James and his sons not only made gravestones but also dabbled in livestock from time to time. The Overton plantation had several animals John had bought at auction at the stone yard. "Eli, stop the buckboard."

"Ya, sir."

"I wonder what old James is auctioning off today?" They both spotted the huge bull penned up in a wagon. "It looks like a mighty big bull." The bull repositioned itself and rattled the side rails on the wagon, scattering the men gathered around.

"Tell you what, Eli. I have an appointment that I must keep, but I need that bull for the plantation. You take this note and hand it to the auctioneer."

"Ya, sir." John watched as Eli walked to the auctioneer and handed him the note. He read and acknowledged the message by waving his hand. John pulled the horse to attention and drove off to his appointment.

Later that evening after dark, Eli tapped on a window in the large room where John was seated. "Massa Overton, he be comin'." Eli headed for the kitchen hoping his supper was waiting, leaving the auctioneer standing by the double doors.

"Come in, my good man." John recognized the auctioneer from earlier in the day but did not know his name. The auctioneer did not give his name and was thus introduced to Harriet and Mary as the auctioneer.

"May I offer you a peach brandy?"

"That would be very nice, sir." John signaled to the servant as he took two papers from the auctioneer. "That is your note and the other is a bill of sale for the land. As directed, I made yours the last and final bid, and I provided transportation to your slave."

"Land? What land?"

"The land you directed me to . . ."

"I was under the impression I was bidding on a bull."

"Oh no, sir, Mr. Overton. You purchased the large lot on the corner of Church and Cherry. And the Masonic folk purchased the other lot on Church Street next to yours." John held the paper up to a candle but it was too dim in the room for reading.

"I'll need to have my lawyer look over this bill of sale. I'll be in touch with you within the week."

The auctioneer handed the glass back to the servant, "I need to be getting back. Thank you for your business, Mr. Overton."

"Good evening to you. Thank you for giving Eli a ride." John returned to his seat next to Harriet.

"Did you purchase a piece of land in the city?" John was folding the papers for safekeeping in his coat pocket when he answered.

"Harriet, I'm not sure what I've done. John Lea will need to figure it out tomorrow. I think I'll turn in for the night."

"John, for as long as I have known you, you have always made wise decisions. I'm sure this one will be no different."

Eli parked the carriage near the platform. John cracked the door slightly. He never tired of hearing the steam whistle on the train engine. He was able to look down the tracks and see the smoke coming out of the smokestack before he heard the whistle. *I wonder whether John persuaded the engineer to let him ride in the cab and pull the whistle rope. If there was any way humanly possible, I'm certain he did it.* Sure enough, there he was with Hugh waving from the cab. The engine pulled beyond the platform and guided the passenger cars smoothly to a stop.

"Harriet, did you see John in the cab?"

"Not only did I see him, I also heard him. He was yelling louder than the whistle."

"How do you suppose he got up there?"

"He's the third John Overton from Travellers Rest! How do you suppose he got up there?"

Annie Brinkley's new fur coat made her look like a bear. She threw back the hood and surveyed the platform. She spotted Harriet making her way down the platform. "Aunt Harriet! Aunt Harriet!"     "I thought there was a bear loose up here."

"Do you like my new coat? Elizabeth and Father gave it to me."

"Yes I do, it appears to be very warm. Now put the hood back on your head. I don't want you to take a cold." Harriet was surprised and pleased to hear Elizabeth's name mentioned. And for some reason, Annie had mentioned her first. *I hope Hugh had an equally pleasant time with his stepmother also.*

John escorted his mother to the carriage and then helped Harriet and Annie get inside. "Eli, take the ladies to the house and come back and get the boys and me."

"Ya, sir. Will Claiborne be ables ta handle da trunks to da wagon?"

"I'll get the boys to give him a hand. Now go on and then get back here."

Inside the carriage, Harriet passed out heavy blankets to Mary and Annie. "Here, wrap these over your legs."

John walked to the engine to meet the boys, but they had gone back to the passenger car to collect their things. Then they appeared on the platform. John could see from a distance they each had on new coats and were carrying rather long, thin packages tied at each end with heavy cord.

"Boys, you may want to step in the station house to stay warm. Eli will be right back to pick us up." John walked over and hugged his father. That was a first. *I wonder why he did that. I'll need to ask him later. Right now, I need to talk with the engineer.*

"Excuse me, boys, I'll be right back. I need to talk with the engineer for a few minutes." John and his partners in the railroad project were always checking with the engineers. This time his concern was whether the cold weather created any problems for the tracks. This was the second full winter and they were yet to experience a deep snow covering the tracks. "Everything is running smoothly, sir. I'm still waiting for snow or one of those ice storms from the north. Your mother and the children were my only passengers from Franklin. I hope you don't mind John and Hugh in the cab. I asked the young lady to join us but she declined."

"I hope the boys weren't a lot of trouble for you."

"No, sir, but they did have a powerful lot of questions."

"I'll see you at the depot in a few days. I know you are anxious to get this train to Nashville."

"Yes, sir."

John made his way back to the station house and found the boys talking and laughing. "Boys, go help Claiborne put the trunks on the wagon." They leaned their packages against the wall and went to help load the wagon. The exercise helped warm their bodies.

Eli returned to pick up his second load. He had passed Claiborne headed for the house. "Come on, boys, let's go to the house." John was waving his hand as he entered the carriage. The boys were not far behind. Harriet had left the blankets in the seats. They were put to use. Eli flipped his whip and the horses responded. Hugh's high-pitched yell was loud enough to fill the carriage. "Stop! Stop the carriage." John knocked open the small door behind his head. "Eli, stop the carriage. Hugh, what's wrong?"

"Sir, I apologize for my outburst, but John and I forgot our guns. We left them in that little house on the platform." The carriage came to a stop, Hugh pushed the door open, and they threw blankets into the air as they jumped to the ground. They were running to the platform as the word *guns* made its way to John's brain. "Guns!" John heard himself say the word repeatedly. *What are those boys doing with guns? What kind of guns do they have? More importantly, where did they get them?* The boys returned to the carriage happy and smiling.

"Do I understand that you have guns in those packages?"

"Yes, sir." The cousins spoke in unison. Hugh added, "Father gave them to us as gifts. He though it would be good to have our own guns to use when we go hunting in Virginia."

"I see. And both of you know how to use a gun?"

"Father, this gun," John patted the package he was holding, "is the latest Springfield musket. It's muzzle loading with percussion lock and has a rifled barrel. It's a U. S. Army style infantry rifle."     "Well." Both boys knew that tone of voice and braced for the rest of the sentence. "Before either of you unwrap your gun, I want us to talk."

"Father, can we talk now?" The boys waited hopefully for a positive response. Hugh was squirming in his seat.

"Sir, my father talked to us about gun safety before we ever saw them. Grandmother Overton went with us and watched us shoot at targets. John and I know these are not toys and are considered deadly weapons. My father has written our headmaster telling him we are bringing the guns and they are to remain in his possession until we go to the Overton land to hunt."

"Hugh, thank you for sharing that. Your father has done a proper orientation, and I totally agree with what you report. I, too, will send a letter of instructions for gun use to the headmaster. I'd prefer you leave the guns wrapped up in the barn. I don't want Martha and Jackson May to see them in the house at their young ages."

"Yes, sir," Hugh spoke while John nodded his agreement.

"Tomorrow I'll find a place for you to practice your shooting." That offer brought smiles to John and Hugh.

Annie Brinkley stayed only one night at Travellers Rest and went on to the Academy the next day. John and Hugh stayed a few days longer before they returned to Virginia. The evening before their departure, they were in the barn wrapping their rifles.

"Boys, are you in here?" They recognized the familiar voice of their Grandmother Overton.

"Yes, Grandmother." Hugh stood up from the stool he had been sitting on. John continued to wrap his gun on the table.

"I wanted to see you before you left in the morning. I may not be up early for breakfast." Mary sneezed into her handkerchief as she spoke. "I think I've taken a cold. There were many folks sneezing in church Sunday. Anyway, here's a little something for you." She handed each of her grandsons a new three-dollar gold piece. "This will be our little secret. No one needs to know about it. I'm certain when you begin hunting with those new guns, you'll need some money for black powder." She smiled as she handed them the coins and then hugged both of the boys. They returned her hug and thanked her for their gift. "Now I don't want you to save the coins—buy something you want for yourselves." She realized something at that moment: *I may never have this opportunity again. This may be the very last time I see them.* She gave the boys a kiss on the forehead and offered a silent blessing for each of them.

*Hugh, may you grow to be a strong and honorable man like your father and always remember your mother's love. John, you are the link to the future Overton legacy. May you have the tenacity of your grandfather and the diligence of your father.*

Mary had guessed correctly. During the night, her light sneezing turned into a full-fledged head cold. She drank her own mixture of herb tea and stayed in bed. Harriet was pleased with Mary's decision to stay isolated, protecting the rest of the family from catching her cold.

Cynthia made an extra large breakfast for John and Hugh. She watched with pleasure as they cleaned each platter. "I gots a basket of food fer ya trip. No need fer ya to gets hungry on da way." Her laughter filled the dining room as she closed the door behind her. Harriet was laughing also as she watched the boys continue to eat. Martha, ever the young lady, simply smiled. Jackson May forced a laugh because his mother was laughing. Mary sat in her high chair next to her mother waiting for the next spoonful of food.

"John, don't you have something for the boys?" Harriet had to interrupt John from his reading. "As a matter of fact, I do." He handed each of the boys a padded leather gun case inscribed with their names. "These should help protect your guns."

"Thank you, Uncle John."

"You're welcome."

Harriet watched the younger John. He had delayed a response but then stood to his feet and said, "Father, this is a wonderful gift. I accept it, and in return I give you my pledge as a gentleman to always be mindful of gun safety as you have prescribed."

His father stood and extended his hand to him. "Young man, I accept your pledge as a gentleman." Harriet winked at her husband, who was sporting an extremely wide smile. John and Harriet would remember this moment many times in the future, as a defining time in the life of a maturing sixteen-year-old who was the third Overton generation to breathe the air at Travellers Rest.

Eli and Claiborne had the trunks loaded on the wagon and headed toward the station when the boys and John piled into the carriage. The train was right on time for the trip to Nashville where they would make their train connections heading north. John rehearsed for the boys their travel arrangements. They would spend three nights in hotels on the way. Tonight they would sleep in Chattanooga, tomorrow night in Abington, and the last night in Waynesboro, before arriving in Louisa County, Virginia. John's reputation in the railroad business allowed him to prearrange lodging and meals for the boys. They would sign for the services and the bills would be forwarded to John and Robert Brinkley. The boys would not need to carry a large amount of cash. They had some greenbacks with them but were told, "Do not flash your money in public. There are unscrupulous people on the trains and in the hotels who will be delighted to take your money. Be on your guard and always stay together."

"Father, thank you for the advice. Don't worry about us. We both have Overton blood.."

"What does that mean?" Hugh squinted the features of his face together.

"That means, Cousin, we know the value of money."

The boys said their good-byes, entered the passenger car, and found a seat. John placed the food basket between them. Each boy had a leather satchel containing reading and writing material. Those were secured under their seats.

Harriet wanted to put the upstairs parlor back in order, but saw no reason to rush the project. One morning in mid-January, she sent for Archer to come to the house. He was busy making repairs on the slave cabins but stopped what he was doing and went to meet with the lady of the house.

"Yes, Miz Overton. How may I help you?"

"Let's go upstairs and look at the parlor." Once in the room Harriet commented, "Archer, the partitions you built worked out just fine. I would like to save them. There should be a place for them in the cellar."

"Yes, ma'am."

"There are a couple of other matters that need attention. The fireplace needs to be cleaned. After you have removed the partitions and stored the beds away, look at the rug and tell me whether it needs to be cleaned before the furniture is reset. Raise the windows about an inch from the bottom so the room can be aired out. Archer, get some help. I don't expect you to do all the work by yourself."

"Yes, ma'am."

Three days later Archer knocked on the doorframe to the large room. Harriet was sitting on the sofa with Martha and Jackson May reading a book. "Yes, Archer?"

"Ma'am, the room upstairs is ready for the furniture to be reset."

"What about the rug?"

"We swept the rug real good and cleaned up a few spots. I don't think it needs to be cleaned anymore. But you may want to look at it yourself."

"No. No. I trust your judgment."

"Thank you, ma'am. There is one other thing, though."

"Yes?" Archer opened his closed fist, revealing five coins and a folded greenback.

"Come over here and let me see what you have. That's a handsome sum of money, Archer."

"Yes, ma'am, Miz Harriet." She looked at the money and then at Archer. His eyes never left the money. "What do you think I should do with the money?" Archer knew exactly what should be done, but he weighed heavily his answer. He also knew sometimes white masters would leave valuables out to test the honesty of slaves. He knew, as well, there was punishment for dishonesty.

"I believe the money needs to go back to its rightful owner." Harriet smiled, reached up, and closed Archer's hand.

"You are exactly correct and you are the rightful owner. Have you ever heard the expression, 'finders keepers'?"

"Yes, ma'am."

"Well, you are the finder and you are the keeper." He placed his treasure in his pocket and began backing out of the room. "Archer, Maria should be upstairs. Ask her where the rest of the parlor furniture is stored. She can also help you place the furniture in the room." Harriet turned back to reading to her children. The enjoyment was mutual.

John had delayed the important meeting in Nashville until all of the houseguests were gone and the holiday celebrations were over. He wanted Harriet involved in his next project but chose not to burden her while she was so busy. The second week of the New Year, 1859, had arrived and he was ready to move forward with his new venture. He had not talked much about his new dream to Harriet other than the information he shared about the property he purchased. After breakfast on January 12, John and Harriet caught the morning train to Nashville.

"John, you are very secretive about why we are going to Nashville."

"Yes, I know, but I want this morning to be wonderful for you. So you will just need to wait for the surprise."

"You know I don't wait very well. Can you give me a clue about the surprise?"

"Harriet, if I give you a clue you will want a second and then a third. By the time we get to where we are going, you will know the surprise." Harriet took his big hand in hers, looked into his eyes, and sighed. "Not one clue young lady, not one!" He smiled and looked out the window at the passing buildings. He knew they were not far from the depot where Eli was waiting for them. He parked the enclosed carriage in the morning sun, hoping to add some heat to the cab. It was not cold in Nashville but it was still winter.

"Eli, good morning," Harriet spoke with her usual cheery voice. "You left early this morning. Did you get breakfast?"

"Ya, ma'am. I shore did. Cynthia take care of me."

"Eli, we need to go to John Lea's office." John spoke matter-of-factly. He seldom ever engaged in small talk. "You remember where the office is?"

"Ya, sir. We be dere shortly."

John Lea's office was quite impressive. Harriet glanced around the paneled walls and imagined, *Elizabeth designed this office. It has her touches. The walnut desk with the leather chair made the room very masculine. The oversized conference table and eight matching chairs were impressive. The four large windows were graced by very expensive drapes pulled back to allow extra light in the room. This office space was the best in town.* Harriet was so taken with the office that her husband had to raise his voice as he made introductions around the room.

"Gentlemen, I would like to introduce my lovely wife, Harriet Virginia Maxwell Overton." She did not extend her hand but acknowledged each man

as he was introduced. "Harriet, you know John Lea, of course. This is Governor Harris. To his right is Nashville's new mayor, Samuel Hollingsworth. You know the previous mayor, Randal McGavock. And the last is a banker friend, Richard Cheatham. One other gentleman will be coming shortly. His name is Isaiah Rogers." No sooner had his name been mentioned than Isaiah walked into the room. John Lea directed the men to take a seat as he pulled out the chair at the head of the table and motioned for Harriet to be seated there.

"Thank you, John. This looks like your chair."

"Today, Harriet, the chair is yours." Harriet glanced over at her husband with an expression that questioned, *Is this my surprise?*

"Lady and gentlemen," John Overton stood tall as he spoke, "the content of today's meeting is a complete surprise for my wife. She doesn't have a clue as to why we are here. I want to thank each of you for keeping the surprise a secret. Mr. Rogers, I want to turn the meeting over to you for your presentation."

"She knows nothing? With your permission, Mr. Overton, I will reveal the surprise to Mrs. Overton." He moved past her to a large frame hanging on the wall covered with a cloth. Harriet had noticed the frame earlier but thought there must be a reason it was covered.

"I understand the home you were born in burned down and the home you grew up in has been sold."

"Yes, you are correct." Harriet glanced again to her husband for some clue. Nothing.

"I trust this new structure I have designed will in some small way honor your past and speak of your future. May I present to you my vision for the Maxwell House Hotel." He pulled the cloth to reveal Harriet's surprise. Her gasp was not the only one in the room, but it was the loudest. Governor Harris stood to his feet and began to clap. The other men at the table joined him. All eyes turned to Harriet. Her hand was over her mouth and tears formed at the corners of her eyes.

"I am at a loss for words and that is very unusual for me. Gentlemen, please be seated." Harriet's first impulse was to stand up and put her arms around John's neck, but she refrained. "My dear husband is a generous man and it appears he is full of surprises. John, I will always treasure this moment. Your loving gesture honors my family name and is a wonderful surprise. Mr. Rogers, tell us more about the hotel." Harriet fixed her eyes on John while all others turned with Mr. Rogers to his drawings. John felt the stare. When he looked at Harriet, she silently mouthed the words, *I love you, John Overton.* He responded with his usual smile.

Mr. Rogers was excited as he spoke. "The Maxwell House will be a high quality hotel with five floors and 240 guest rooms. There will be steam heat in every room and bathrooms on each floor. The main entrance will be on Cherry Street." He pointed to the eight Corinthian columns at the entrance. "There

will be chandeliers, brass fixtures, gilded mirrors, and mahogany in the lobby. There will also be parlors for both ladies and gentlemen. I've allowed space for billiards, a bar, shaving saloons, and other features yet to be planned. A grand staircase is included in the design. There will be a very large room for dining, and it can also be used as a ballroom when needed. I want to pause here for any questions." Harriet glanced around the room and detected no response. So she raised a concern. "Since you are still somewhat in the planning stage, would it be possible to have a private entrance for the ladies away from the main lobby?"

"Excellent question, Mrs. Overton."

"I failed to point out that right here on Church Street is such an entrance. A lady may enter here, proceed to the parlor, and then be called for at a door near the lobby."

"Are there other questions I can answer?" Mr. Rogers turned, gestured to John Overton, and sat down. John began talking, before he finally stood, and positioned himself behind Harriet's chair. "The financing is being handled by the Bank of Tennessee. Our new mayor has assured me all the required permits will be forthcoming." John acknowledged Mayor Hollingsworth at the table.

"John, where will you get your labor force?" Randal McGavock raised the question without standing.

"I plan to hire slaves and free blacks for the basic work like making brick, moving supplies, cooking crews, and all manual labor. The skilled labor force will come from Nashville, Memphis, Chattanooga, and surrounding communities. I'll place some newspaper ads in Alabama and Kentucky for skilled laborers. That's the procedure I used to build the railroad. I've talked with the main contractor on the proposed Masonic Hall building. He's of the opinion, as am I, that the two projects will be able to use some of the same workers. That project will begin after the hotel but finish first because of its size. Mr. Rogers has agreed to be the construction contractor and will hire a number of sub-contractors. The Mercantile Company in Lebanon will secure the furnishings." John noticed the mayor's hand go up.

"Yes, Mayor Hollingsworth."

"John, do you have a projected completion date? I have a reason for asking."

"I'm hoping to open the doors for business by early 1862. If the construction material flows smoothly, the labor force stays intact, and the weather cooperates, the hotel could be ready sooner. You understand there are a lot of variables involved."

"Thank you. This is very exciting for Nashville. The reason I asked the question is a concern I have about police and fire protection. The city needs to be thinking about expanding those two areas to meet the coming challenges of the city."

"That would be very helpful. Lady and gentlemen, again, thank you for coming this morning. I hope one day to have you come to the Maxwell House for lunch, and we can remember this day." The meeting concluded with those in attendance in high spirits.

After lunch at the St. Cloud Hotel, Harriet made a stop at the dress shop to visit with Grace while John went to the newspaper office to talk with the editor about his new venture.

"Good day to you, Grace." Harriet was in a happy mood, and it was always a joy for her to renew her friendship with her classmate. Grace was busy moving dress material from the back room to the front tables. She beamed when she heard Harriet's voice and then turned to see her. They embraced as old friends should and do.

"Harriet, the angels must have sent you."

"Why do you say that?"

"I planned to write you a note this evening about my good news."

"And what might that be?"

"I'm moving to Pulaski and will be opening a dress shop. The owner here wanted to expand this shop and then decided it would be better to open a second one. She has already rented a space on the square and has placed an order for dry goods. And here's the best part! If the shop is a success in Pulaski, I'll have a chance to buy it later."

"Grace, that is wonderful news! I'll miss our visits but I'm happy for you. When will you be leaving Nashville?"

"Tomorrow is my last day here." There was a lilt in Grace's voice.

"Well, I guess I'd better make my purchases because I know you must have a lot to do to get ready for your move. I'd like four pieces of lighter weight spring material for Annie." Grace directed her to a table in the middle of the shop. "Harriet, let me look in the supply room. I believe we have a new shipment of spring material. I'll be right back." Harriet inspected the material in front of her and found some she liked. As she held the material up, she could envision Annie in a new dress. Grace returned with more options and arranged the material on the table for Harriet to review. "Grace, it is all so pretty, it's hard to choose."

"Harriet, whichever you choose, it will be right."

"You are a natural born saleswoman. I predict the new shop in Pulaski will be a glowing success. I'll take these four."

"If you will give me Annie's full name and address, I'll wrap the material and send it to her."

"Here you are and thank you, Grace, for your kindness." Harriet glanced through the front window and saw that John had returned and was waiting.

"Grace, John's outside waiting for me. When you get settled in Pulaski, I want you to send me your address." The classmates of years past were parting again. Grace continued to wave until the carriage was out of sight.

The ride back to the depot was lively. Harriet was anxious to ask more questions about the hotel. She was eager to know what happened at the newspaper office, and she wanted to tell John about her visit with Grace. Before she could pose her first question, John said, "There's another two hours before the train goes south." He looked, with a questioning expression, at Harriet as he closed the lid on his pocket watch. He did not ask a question, but he was waiting for an answer.

"John, why don't we ride the carriage home?"

"Fine with me." He opened the small door behind his head. "Eli, let's go to Travellers Rest."

"Ya, sir."

Harriet removed the pins holding her hat and put it beside her. Then she unbuttoned her outer coat and breathed a sigh. She spread the blanket over her legs and feet and relaxed.

"Well, little lady, did I surprise you this morning?"

"Completely. I had no idea even after I entered John's office and saw the men gathered in the room. That was a very impressive group of men. Thank you for including me."

"The meeting would not have been complete without you. Did you like what you heard and saw from Mr. Rogers?"

"Yes. He sounds very competent. Do you think you can work with him?"

"Yes. I think we can work with him."

"What do you mean, *we*?"

"It was evident to me this morning in the meeting that you have some ideas for the hotel. I was so hoping you would want to be involved."

"John, I hope you don't think me . . ." Harriet hesitated.

"The hotel project needs a woman's view, and your intelligence is just what is needed. Even if we were not married, I would want your input. When a woman comes to visit the hotel, I want her to have a good experience. She won't if the details are not cared for in the food, the furniture, the furnishings, and the overall appeal. We won't be able to do everything you suggest, but Mr. Rogers and I are going to listen to every suggestion you offer. Harriet, I particularly need your ideas on the proper furniture for the guest rooms and the ladies' parlor."

"John, are you sure? Are you certain you want all of that from me?"

"A grand hotel for a grand lady. That's what I want."

Harriet swallowed hard, but the lump in her throat did not go away. She was at the point of tears and for the second time today, Harriet was speechless. *I want to ask him about the events at the newspaper office, and I want him to know about Grace. If I ask him a question right now, I'll break into tears. I'll have to talk to him later.* They were nearly to Glen Leven when she spoke again. "John, when you finish the hotel, I want you to do something a little easier. Maybe you could run for the office of Governor." They both laughed.

"There are two things I never want to do. One is being the Governor; the other is being in the military."

Shortly, Eli crossed the railroad tracks and entered the road leading to the Overton home. This had been a memorable day for the Overtons. Harriet was glad to be home.

Martha was looking through her bedchamber window when she spotted the carriage coming up the lane. "It's Mother and Father. Come here, Jackson May!" Maria was looking at a magazine she had found in the parlor when she and Archer had put the room back in order. She stood, walked over to the window, and confirmed for the children that, in fact, it was their parents.

"Maria, may we go on the gallery and welcome them home?" Martha made the request while visually searching the room for her coat.

"Ya, but yous needs to put on yous coats." Martha had her coat on and headed for the door leading to the upper gallery. Jackson May was not far behind. Maria had to slide the top latch to unlock the door. Martha turned the knob and walked down the two steps to the gallery. Jackson May jumped and landed on his feet but lost his balance, tumbling to the wood floor. Martha was tall enough to place her hands on the rail and look over, watching Eli help her mother from the carriage.

"Mother! Mother, I'm up here on the gallery!" Jackson May joined his sister. "Hello down there!" He directed his words to his father, who was just then climbing out of the carriage. Jackson May stuck his arm through the rail slats and Maria quickly pulled him away from the rail. His parents below could still see him.

"Hello, Martha and Jackson May." Harriet's voice became sing-songy anytime she put both names together. That was all right with the children. They enjoyed their mother's happy voice. "Go back inside. I'm coming up to see you just as soon as I take off my heavy coat." Although Harriet spent a lot of time with her children, anytime she went to their room was special.

Through all the noise and commotion in the room, Mary was sitting quietly in her crib watching her siblings. When she saw her mother enter the room, Mary demanded attention. Harriet picked her up and held her close. They sat on Martha's bed. Martha joined them and was greeted with a big hug from her mother. "Jackson May, do you need a hug?"

"No, ma'am."

"Well, I need a big boy hug. Climb up here on the bed and give me a hug." Harriet found the correct challenge when she said, "climb." In a flash Jackson May was on the bed, behind his mother, and locked both arms around her neck. He pulled on her, causing her to fall backwards on him. Mary was laughing out loud thinking that bouncing in her mother's arm was a great game. All four were laughing, and even Maria found the sight funny. As the merriment continued, Maria reminded Harriet that it was just a short time until dinner and she needed to get the children ready.

"Children, I need to go down and check with Cynthia about dinner. I will see you shortly. Your father has some exciting news to share with you."

The family gathered in the large room for dinner because Harriet wanted to include the children. She was also anxious for the rest of the family to hear John's report on the hotel. There were no assigned seats at the table, but everyone sat in their usual place. Since the children were around the table, the arrangement was a little more crowded. Martha sat next to her mother and Aunt Mary Maxwell. Jackson May sat next to his father. Maria brought in a high chair for baby Mary, which she didn't like and let her feelings be known. John blessed the food, the family, and the United States. While the food was being served, Martha patted her mother's hand. "May I ask a question?"

"Yes, you may." Martha spoke in a whisper, and the sounds of plates being served made her question even harder to hear.

"Is Frederick Douglass a friend of ours?"

Harriet thought she heard the question, but wanted Martha to speak loud enough for all at the table to hear. "John," Harriet's voice was heard by all at the table, "Martha has a question. Now Martha, ask your question again."

"I wanted to know, is Frederick Douglass a friend of ours?" Harriet turned and glared at Maria, who was giving her full attention to the baby. *I know Maria heard Frederick Douglass' name. What has she been saying to Martha about him? How dare she. I thought the freedom matter with her was settled.* Eyes at the table focused first on John, then to Martha, and then back to John.

"How do you know the name Frederick Douglass?" quizzed John.

"I saw it in a magazine. His picture was in there also. Under his picture was a question, 'Is Frederick Douglass your friend?'"

"Martha, I didn't realize you could read. How old are you now?"

"Father," Martha said with an edge in her voice. "I didn't read it. I'm only five-and-a-half years old. I saw it and Hugh read it to me."

"Oh, I see. Hugh gave you the magazine?"

"Well," Martha had started to eat and then placed her fork on her plate, "is he our friend?"

"To my knowledge, Martha, we have never met Frederick Douglass. So my answer is no."

"Thank you." Martha resumed eating.

Harriet never appeared shocked at any question Martha asked her. They had conversations about a variety of subjects and Martha always seemed satisfied. Harriet looked at Martha and wondered, *Is that the answer she wanted? Will that satisfy her? What else was she thinking?* This conversation raised another thought for Harriet: *Does Martha need a tutor? Is she ready to begin some formal education? John and I can discuss this later. Right now I want him to talk about the hotel.*

"John, tell us about your new project." Harriet watched her sister Mary for a reaction. John repeated the information from the morning meeting but withheld the hotel's name until last. The ladies were impressed with what they

heard and John was happy to answer their questions. *Finally,* Harriet thought, *he's going to share the name. That's what I want Mary to hear. I know she will be pleased.* She could not be silent any longer, "John, have you chosen a name for the hotel?"

"I do have a name in mind, but I wonder whether any of you might have a suggestion?" John looked around the table and saw Martha's raised hand. "Yes, Martha, do you have a name?"

"Yes, I would call it, Martha's Place."

"That is a wonderful suggestion. What would you think of a name like, The Maxwell House Hotel?" John kept his focus on Martha and waited for a response. Harriet watched Martha's eyebrows drop and her lips press together. She knew Martha was considering an answer. "I like your name for the hotel better than mine. The Maxwell House Hotel is a good name." John clapped his hands and with a laughing tone announced, "The hotel has been named. Now all I need to do is have it built." Mary Maxwell glanced down the table at her sister and smiled; Harriet returned the smile. Mary noticed that the candlelight made Harriet's eyes sparkle.

Mary Overton felt a sense of pride in her son's new project, including the naming of the hotel.

Harriet turned her attention to baby Mary, who was fast asleep in Maria's arms. "Maria, put Mary to bed, and I'll bring Martha and Jackson May upstairs shortly."

"Ya, ma'am."

After dinner, the family gathered around the fireplace while John continued to talk about his plans for the hotel. Jackson May climbed up on the sofa and sat next to his mother. Soon he was dozing off, leaning against her. Martha had snuggled on the other side of her mother. "Martha, why don't we take your brother and go upstairs? Then we can find a book to read." Harriet realized that Jackson May had put on weight since the last time she had lifted him. She tried to balance herself with him in her arms but stumbled. John turned just in time to steady her and said, "Harriet, let me carry him upstairs."

"Thank you. That will be a big help." Three Overtons climbed the steps while one sleepy boy nestled in his father's arms.

"Miz Harriet, ya wants me to undress Master Jackson May?"

"No, Maria, just put him to bed as he is. There's no reason to wake him now." Harriet turned to join John, who was already headed down the steps. "Mother," Martha said in a loud whisper. "You were going to read me a book."

"That I am. You find the book and we'll read together." From behind her back, Martha produced not a book but two magazines. They went to the hallway outside the children's room where there were two straight-back chairs and a small table. Harriet lit the whale oil lamp which provided adequate light for reading.. Martha opened one of the magazines to a familiar page and asked, "Mother, will you read to me about Frederick Douglass?"

"Oh my." Harriet glanced at the page Martha indicated and the title caught her eye. She intended to read silently to herself but found she was reading aloud. "Is Frederick Douglass a friend to the slaves in the southern states?" She flipped the pages to the front cover and discovered they were about to read from the *Atlantic Monthly.*

"That's what I asked at dinner. Is Frederick Douglass a friend of ours?"

"Martha, point to all the words you can read." Harriet placed her finger under the article title.

"I know is—a—to—the—in—the."

"That is very good. What about the longer words? How did you know the name Frederick Douglass?"

"I heard cousin Hugh ask the question to my brother John. Then he showed me the picture of that black man." Martha pointed to the image of Frederick Douglass on the page. Harriet slid the second magazine, also an *Atlantic Monthly*, out enough to read the title in large letters, **Emancipation: When Will It Come?**

"Mother, are we going to read?"

"Yes." Harriet began reading, "Frederick Douglass, a free Negro, orator, journalist, and abolitionist, has plans to travel to the southern states to talk with the slaves and slave owners. He has issued an invitation to President Buchanan to join him to view, firsthand, the slave situation. Douglass has noted the need for military protection for himself and the President. He stated, 'If I . . .'" Harriet's words trailed off and Martha could not hear anything. "Mother, you've stopped reading. What happens next in the story? Did Mr. Douglass get to take his trip?" Harriet's thoughts were distant. "What did you say, Martha?"

"I said, 'Did Mr. Douglass get to take his trip?'" Harriet did not answer immediately but continued to stare at the page in front of her. "Martha, we should not be reading this magazine. It's your bedtime. Give me a hug and a kiss."

"Good night, Mother. I love you."

"I love you too. Sweet dreams. I'll read from one of your books tomorrow."

Martha disappeared into her room. Harriet folded the two magazines, placed them under her arm, blew out the flame, and headed down the steps to the large room. She was hoping John was still there. They needed to talk. Harriet had not thought about the abolitionist movement for a while. When she put her copy of *Uncle Tom's Cabin* away, she dismissed the subject. Folk were always talking about it at church. The newspaper mentioned the subject occasionally. The *peculiar institution*, as the northern abolitionist called it, was not in her daily conversations. Now the subject had raised its head again. This time it was personal because Martha was involved. For Harriet, slavery was not peculiar nor an institution. Slavery was a way of life, and that's what she wanted for her children.

"Good, I'm glad you're still here." John, Sister Mary, and Mary Overton acknowledged Harriet's reappearance. "I know now why Martha was interested in Frederick Douglass." She held up the magazine opened to the Douglass article. "Martha got these magazines from Hugh."

"Are they the *Atlantic Monthly* magazines?" Mary Overton took one of them from Harriet.

"Yes, they are. Do you know anything about them?"

"Hugh found them on the train when we were leaving Memphis. I thought he threw them away, but I guess he kept them."

"John, are you familiar with these?" Harriet handed him the second magazine pointing to the word *emancipation* on the cover.

"I've heard some of the businessmen refer to them, but I've not read them. I believe the force behind the magazine is James Russell Lowell." John opened the magazine to the contents page. "It says here Lowell is the editor. It states the content is 'a literary and cultural commentary.'"

Mary Maxwell held out her hand, hoping she could look at one of the magazines. "I've read someplace that Lowell is an ardent abolitionist."

That was not what Harriet wanted to hear. The evening's good news about the hotel was totally ejected from her thoughts by the aggressive invasion of Mr. Lowell and his magazines. Her thoughts on the abolitionist movement were foremost the rest of the evening, the next day, and for weeks to come.

Harriet's letter to Annie in Texas was received with excitement. After family news, Harriet described John's new project. Annie was amazed at the description of the Maxwell House Hotel and thrilled with the name. She tried to envision the land on the corner of Cherry and Church. She knew it was not far from the church and the stone yard. The exact location remained a mystery in her mind because she did not remember any landmarks in that part of the city. The closing paragraph of the letter troubled Annie. She read it several times trying to understand what was really on Harriet's mind when she mentioned the *Atlantic Monthly* magazines.

Annie addressed her return letter to Mrs. John Overton and Miss Mary Maxwell. That was her way of saving double postage and it saved time. She included a newsy general letter and a separate sheet for each of her sisters. Thomas had been very busy debriefing the information he had collected on the return trip to Texas. His superiors were pleased with his detailed reports and the sketches he had drawn. The girls were slowly getting back into a daily routine. The weather was warm, requiring only a sweater when they played outside. Annie and Thomas had discussed what to do with her inheritance but had come to no conclusions. A house would be nice, but selling it when their tour of duty in Texas was completed was a concern. After Harriet finished reading aloud the general letter, the sisters turned their attention to their separate pages. Annie made an effort when writing Harriet not to appear as a know-it-all.

*As a mother, I'm more concerned when the children are quiet than when they are asking questions. I find I can better deal with their thought processes when they are verbal than when they are silent. It sounds like both children, Hugh and Martha, were honest in their actions. Hugh was sharing; Martha was asking. The subject matter may be the real issue. I have seen the Atlantic Monthly in the officers' lounge but have never taken the time to read it. I understand, from Thomas, it is a liberal, antislavery magazine controlled by New England intellectuals. The editor is an abolitionist. We both may live long enough to see our southern way of life challenged, and slavery may turn out to be the central issue.*

Harriet paused after reading her letter and thought, *Annie's right, I may be making too much of an issue where Martha is concerned. She asked an innocent question and wanted a simple answer. How I long for Annie and her family to be back here where we can talk face to face. I love you, my dearest elder sister.*

Harriet returned to her bedchamber and found the small memory box she kept in her clothes press. As she was placing Annie's letter in the box, she noticed the other items she treasured. She took out the small snip of white, silk ribbon Rachel Harding Overton had given her. There were ringlets of Martha's and Jackson May's hair. The red rose John had given her when they were courting was pressed between two sheets of white paper. She dared not open it for fear the rose would turn to dust. She returned the items to their safe place and busied herself with the rest of her day.

In June 1859, Martha had her sixth birthday. Harriet made plans for the event by inviting her Lea cousins and some of her church friends. John thought it was time for his oldest daughter to have a pony; Harriet agreed. A couple of days before her birthday, Martha sat with her mother on the sofa in the large room reading from one of her books. "Martha, is there anything special you would like for your birthday?"

"Maybe a new book that I could read all by myself." The instant answer took Harriet back to her own childhood. *I remember being six and wanting to read "all by myself." My sisters Annie and Mary were in school and already knew how to read. I wanted to be just like them. Mother had told me, "Harriet, do not wish your life away. Enjoy the age you are."* "Mother, did you hear me?" Harriet nodded and smiled.

"Yes, I heard you. I was just remembering when I was your age. Indeed, I will look for a book you can read 'all by yourself.'" Harriet knew her sister Mary had purchased the seven-book set of *McGuffey's Readers* for Martha's gift and wanted to tell her daughter but didn't. The books would be a surprise and would fill her desire to read by herself.

"You know I've invited your Lea cousins and your church friends. Is there anyone else you would like to come to your party?" Martha closed her eyes and squinted her nose. That was her way of thinking.

"Will Maria be coming?"

"Yes."

"How about Miz Cynthia?"

"Yes indeed. She'll be bringing something special to your party."

"I already know what it is." Martha placed her finger on her lips and smiled, keeping a secret deep inside not to be revealed, even to her Mother.

"Is Matilda coming to my party?"

"She can if you want her to." Martha had developed a relationship with Matilda. When Martha and Jackson May played outside, she always headed for the weaving house to see her. The old slave had many stories to tell, and the weaving loom fascinated Martha. Matilda made things for the Overton family and told Martha about the latest creation.

"Is there anyone else you would like to invite?"

"Is Emily coming to my party?"

"Who is Emily?" Harriet racked her brain trying to picture an Emily. She looked at Martha with a questioning gaze.

"She helps Cynthia in the kitchen sometimes. She lives down in the cabins with her mother and the other children. She's my friend and I'd like for her to come."

"It's your birthday and if you want Emily to come to the party, she should come." Harriet made a mental note to talk with Cynthia about Martha's new friend.

Plantation society required that certain attitudes and thinking be developed in the owner's children as soon as possible. A child's attitude toward slaves had to be guided by the parents, mostly the mother. Most often white infants were wet nursed by slave mammies and cared for in early childhood by house servants. When children began to talk and raise questions, plantation mothers became more direct in their children's training. Slaves were always addressed by first name or a nickname. They were always told what to do by direct command. A slave never had an opinion. Even a highly skilled slave knew it was better to listen than speak. Harriet remembered talks she had with her mother about Julia. *"Harriet, Julia is a special person to us, but she is a slave. Your father owns her. She is not to give you orders unless I've told her to do so. If Julia ever mistreats you in any way, you come and tell me."*

In like manner, Harriet's father had talked to her about Edward at The Hall plantation. She would train her children the way she had been trained. Harriet's prebirthday conversation with Martha brought a major concern to the surface. She wondered, *how did Martha develop a relationship to the point that she called a slave girl her friend? That is not a proper development and will need to be corrected. I'll need to wait until after the party to help Martha understand.*

When John was out of town on business, Harriet had the family meals served in the small dining room near the kitchen. The ladies of the house and Jackson May gathered for breakfast. Martha let everyone know, "This is my last day as a five-year-old. Tomorrow I'll be six and ready to read. Mother?"

"Yes Martha."

"Will Father be home for my birthday party tomorrow?"

"Yes, he will. Actually, he should be home this evening for dinner. He took the early train out of Chattanooga this morning just to be sure he would be here for your party."

Cynthia entered the room with a pot of hot herb tea and a pitcher of milk. Behind her was Emily holding a platter of eggs, ham, and bread. "Set the platter next to Miz Harriet," Cynthia ordered.

"Ya, ma'am." Emily was backing out of the room when Martha piped up, "Good morning, Emily, don't forget my birthday party tomorrow." Emily smiled and exited the room. "Mother," Martha directed her question, "You did invite my friend Emily to the party, didn't you?" Cynthia set the pot and pitcher on the sideboard and turned to see the piercing look in Mary Overton's eyes.

"Martha, I was going to talk with Cynthia this morning about Emily. I can do it now. Cynthia."

"Ya, Miz Harriet."

"Martha would like Emily to come to her birthday party tomorrow afternoon. I want you to arrange for her to be there."

"Ya means young Emily and not old Emily."

"Young Emily, of course."

"Young Emily be workin' in the kitchen garden today and tomorrow. She be mighty dirty to be comin' to a party. She don't has no party clothes anyways. Miz Harriet, it might be best . . ."

"Harriet, it might be best for Emily to come to another party later." Mary Overton cautiously added.

"No, the party tomorrow will do." Martha had a huge smile on her face. "Cynthia, tell Emily's mother the plans. By the way, who is Emily's mother anyway?" Cynthia glanced in Mary Overton's direction. The piercing look was replaced with one of deep concern.

"Her mama be Emmaline."

"Is she the one who helps you in the kitchen sometimes?"

"Ya, ma'am."

"I've not seen her in a while. Is she well?" Harriet's comments were completely innocent and seemingly caring. She did not see the exchange of looks in the room.

"She be fine. She be with . . ." Cynthia wished she had not begun another sentence, but she had. She headed for the door leading to the kitchen. Mary Maxwell noticed Cynthia's incomplete sentence. "She is with . . . what?" Cynthia turned, took a deep breath, and looked directly at Mary Overton.

"She be with child." Mary Overton bowed her head and hid her shocked expression behind her napkin.

Hurried preparations were in process at Travellers Rest, Lealand, and one of the Overton slave cabins for the afternoon birthday party. Harriet gave Martha her choice of two party dresses or a new day dress. Maria laid out the dresses on the bed. There were hair ribbons to match each dress and her Sunday shoes. The party dresses required stockings, and that fact sealed her choice. She knew there would be party games and she really wanted to be involved in those activities.

At Lealand, the three Lea boys were frustrated. Their mother, Elizabeth, had ordered a bath for each of her sons and gave instructions they were to be dressed in suits, including long-sleeved shirts, string ties, and Sunday shoes. The fussing was so loud that it reached all the way to John's office at the front of the house. He went to the foot of the staircase to inquire about the noise. "Boys, what's the problem up there?" His booming voice brought silence. Charles, the boys' body servant, appeared at the top of the stairs. "Charles, what's the problem with the boys?"

"Sir, theys upset 'bout their clothes."

"What do you mean upset? Come down here." Charles knew Massa Lea did not like unnecessary noise in the house. John had taken him out of the fields to serve the boys in the house. Charles did everything he knew to do to keep the boys at an even temperament. All of the house servants were extra cautious of their responsibilities since Meg had run away. All of the slaves were under the watchful eye of their owners.

"Massa Lea, the young mens say it too hot to be wearing Sunday clothes."

"Well, let them wear their school clothes." Charles looked up to see Elizabeth standing in the large room. She was listening intently to the conversation.

"But . . . but . . . "

"But . . . what Charles?" He saw his eyes get large and they were focused on Elizabeth.

"Is there a problem, John?" There was an edge in Elizabeth's voice that Charles had heard on many occasions.

"Elizabeth, the boys are going to a party, not to church. They want to have a good time and not stand around like marble statues."

"I will not have our children appear in public as street urchins. Charles, dress the children in their very best school clothes, Sunday shoes, and string ties. I will inspect them before we leave this house!"

"Ya, ma'am." Charles looked to Massa Lea for a sign of approval. He nodded. Charles returned to his responsibilities upstairs with some good news.

There was excitement in Emmaline's cabin. She sent her children outside, leaving a space for Emily to get ready for the party. Cynthia had found a fairly new day dress and one of Maria's white aprons for Emily to wear. They were laid out on the bed. There would be no shoes. She hoped the dress would be

long enough to cover her bare feet. Emily did not have the facial features of the other slaves. Her mulatto look set her apart in the slave community. As a fourteen-year-old, she was a head taller than other children her age. They wondered about her appearance; the adults gossiped as to her parentage. Her mother always told her she was special and she responded accordingly. She didn't fully understand why, but she and Martha were attracted to each other. Their age difference didn't matter because their spirits were bound together.

"Child," Emmaline's face was puffy from wiping tears, "today be extra special fer ya. Yesterday and tomorrow, ya be a slave. Today ya be free." Emily dried herself off after taking her bucket bath.

"Why ya says dat, Mama?"

"I jest wants ya to hears it one time in ya life."

Harriet placed a small package on the bottom step of the staircase, knowing Martha would stop to examine the surprise. Sure enough, she found the gift and noticed her name printed on a small tag attached to the bright, red ribbon. Harriet waited in the large room for Maria and the children to descend the staircase. The click of Martha's shoes on each step echoed and stopped on the final step. She found the package about the time her mother appeared at the doorway. "It looks like the birthday girl. Did you get a gift?"

"Yes, ma'am. See my name there?" Martha was all smiles as she held up the tag.

"You might want to open the gift before you go outside and greet your guests." There was nothing genteel about Martha's gift-opening technique. She ripped the ribbon and then the paper, throwing them on the floor, and then held a small box. Inside she discovered a pair of hair combs just like her mother's but smaller.

"What a wonderful gift!" She held them up for Maria to see. "Mother, please put them in my hair." Harriet was pleased at the response and was hopeful that finally her own hair combs would stop disappearing.

Jackson May pushed ahead of Martha and opened the double door to reveal a large gathering of family and friends. The adults were seated on the gallery sipping fresh lemonade. The yard was filled with children milling around in little groups—some playing with toys; others, just standing. Harriet guided her daughter over to the gallery steps where she was greeted with shouts of **Happy Birthday, Martha!** She enjoyed the moment, hearing a mixture of adult and children's voices. Harriet whispered in her ear, "Martha, the polite thing to do is thank your family and friends for coming to your party. Then you can go and play in the yard." Right on cue, like a royal speaking to her subjects, "Hello! Hello, everybody! Thank you for coming to my birthday party. You have made me very happy." Martha's greeting had not faded before she was with her friends in the yard. Harriet walked over to the adults seated and found Elizabeth standing next to the banister. "That was very impressive. I know you and John are proud of her."

"Yes, thank you, Elizabeth. I'm so glad you and your boys could come. It means so much to all of us."

Martha searched the yard on both sides of the house but did not find Emily. She returned to the gallery after her search to discover Emily standing by herself near the kitchen door. "Emily, I'm so glad you came to the party. Let's go play." Martha took her by the hand, leading her off the gallery and into the yard. The adults on the gallery watched the strange-looking pair.

Martha, like her mother, was petite; Emily was tall and a striking beauty. The small scarf on her head that matched the color of her plain day dress enhanced her long, shiny, straight black hair. Her mother did not allow her to wear the white apron.

Martha noticed, as they went down the three steps from the gallery, that Emily was not wearing shoes. "Just a minute, Emily." Martha sat on the bottom step and removed her Sunday shoes and socks. Mary Maxwell saw Martha's activity first, then Harriet.

"Young lady, what are you doing?" Harriet was taken aback, knowing how much her daughter liked dressing up.

"Emily and I are going to play games and we need to be barefoot. I'll put my shoes and socks back on after we play."

"Very well. I expect you to be wearing shoes and socks later."

"Yes, ma'am."

Soon all of Martha's girl guests removed their shoes and socks and lined them on the steps. Elizabeth did not see her three sons but suspected they were playing in the yard on the other side of the house—shoeless.

Word spread quickly in both yards. Cynthia was putting refreshments on the gallery. There was a cake made with real sugar, ginger cookies, egg custard, and lemonade. There was even ice from the Glen Leven icehouse. Emily realized she needed to be in the kitchen to help Cynthia and ran quickly to the back door of the kitchen. "Sorry, Cynthia. I's playin' wid Martha and I's forget."

"Child, don't ya never mind. Ya goes be with da other youngins."

John Overton had isolated himself on the gallery to catch up on the Nashville news he had missed while in Chattanooga. He had greeted his sister when she arrived and noticed quickly he was the only male there. He smiled and then laughed aloud when he read the headline on page three of the newspaper, OVERTON'S FOLLY OR FINEST HOTEL FOR NASHVILLE. Earlier, the editor ran a front-page article about the new hotel, including the drawing from Isaiah Rogers. This article was a followup with reaction from some of the fine folk in Nashville. John recognized that some of the comments came from individuals who had no vision for the city's future. He was pleased that the majority of those interviewed and quoted supported his efforts for bringing the finest hotel to Nashville.

"John. John, please come to the party." He didn't need to see her to recognize the voice of his mother. He folded his paper and placed it his chair.

The children, with shoes and socks back on, stood around the refreshment table eyeing the treats. They were not disappointed.

As the summer sun disappeared and the sounds of the insects replaced the cheerful sounds of children's voices, Harriet reflected on the events of the day. John sat next to her puffing on his favorite pipe, filling the night air with pleasant-smelling smoke. "John, this has been a good day. Martha had a wonderful birthday party. She was so excited when you brought her pony up from the barn."

"I know. I thought she would never stop hugging my neck."

"You know she has already named her pony. She's going to call him Max."

"Well, Harriet, that's very fitting. Do you remember your father wanted to get her a pony as soon as she was born?"

"Yes, bless his soul."

"Who was the mulatto girl at the party?"

"That's Martha's friend. She's Emmaline's oldest child. Cynthia uses her in the kitchen on special occasions."

"Oh." John took a long draw on his pipe and blew smoke into the air. "I was thinking, could we get away next week and spend some time up at Bon Air? We could go fishing and put the boat in the lake. I may not have much free time for a while."

"That would be lovely. Just the two of us." Bon Air had been a special retreat for them for a number of years.

"Yes. I have some things I want to discuss with you." Harriet knew her husband's serious tone and realized the request was important to him.

# 16. Sounds of Change

The Overtons had been making the trip to Bon Air for years. After Rachel's death, John had stopped going there. He found other activities to occupy his time, and he really didn't like the leisurely lifestyle afforded him at the mountain retreat. He had to be active and involved in a project. Mary Overton mentioned Bon Air to Harriet shortly after she had married John. Mary used the home as a stopping off place when she went back to Knoxville for visits. The property and home was just a little off the main road between Sparta and Crossville. After the railroad was built, the trip to Bon Air was not so tiring. Eli and Cynthia went up to the summer home a couple days before John and Harriet arrived to prepare the house and get supplies. They knew the storekeepers in Sparta and were always welcomed because the Overton slaves paid for the supplies in cash.

Harriet arranged for her children's care with Mary Maxwell in charge and Maria performing her regular responsibilities. Kitchen duties were given to Emily. Cynthia drilled the kitchen routines into Emily's head. Other than the regular meals, Mary Overton always drank herbal tea for breakfast and liked a small glass of peach brandy to help her rest at night. The Overton children could have a ginger cookie twice a week. "Master Jackson May will come to da kitchen," Cynthia warned, "looking fo mo cookies, but no matter how much he beg, don't gives him no mo."

"Yes, ma'am."

"And ifin Miz Martha Overton come to da kitchen, tells her ya busy with work and don't have time to talk. Her mama don't wants her in da kitchen. She afeared Miz Martha may gets hurt in some way."

"I keeps Martha out da kitchen."

"Ya best be callin' her Miz Martha and not Martha. Bein' at a party be one thing, workin' for da Overtons be 'nother thing."

"But, she be my . . ."

"Emily," Cynthia held both shoulders and looked her in the eyes, "whites and blacks don't be friends—ever. Ya needs to get dat thinkin' out of yo head."

"But Martha say we be friends fer ever."

"Miz Martha be a child and she think likes a child. When she get older she be a white owner and ya be black slave."

"My mammy says, 'Emily, yous be special to me and to da Overtons. Ya not a full slave.'"

"Child, ya be a full slave no matter how ya looks and no matter what ya mammy says. Ya borns a slave and ya dies a slave. Now puts dat in yo head and keep it dere!"

John brought a stack of newspapers with him. Some of them were local, and some he had saved from his trip to Chattanooga. The Chattanooga paper was a city paper but carried more of the national news than did the Nashville papers. Politically, the Chattanooga paper was more aligned with the Republicans and the Nashville papers favored the Democrats and Whigs. Reading the papers from both cities often gave John two sides of the same subject. States rights seemed to be a constant front-page theme in all of them. He shuffled through the papers until he found the article about the hotel.

"Harriet, I thought you might find this article interesting." He pointed to the headlines, OVERTON'S FOLLY OR FINEST HOTEL FOR NASHVILLE, as he handed her the folded newspaper.

"John, I've been so busy I've not read anything but children's books for the past two weeks. What is this, FOLLY? What on earth is that?"

"Read on and you'll see." Harriet concentrated on the article, reading to herself until she got to the fifth paragraph and then she sighed heavily.

"John, what does it mean? 'Overton is laying the foundation for a political career. There will never be a Maxwell House Hotel in Nashville.'"

"Did you see who made the statement?"

"Well, yes. He's the same man who spoke negatively about your railroad."

"He's also the man who wanted to be a director on the railroad board. He thinks I'm the one who voted against him. He also thinks I blackballed him in his bid to join the Masonic Lodge."

"Did you?"

"As a matter of fact, I cast the only positive vote for him to be a director. Apparently, the other directors knew something I didn't. And as for the Masonic incident, I was in Memphis the night he was blackballed."

"Have you ever told him the facts?"

"I've tried, but he avoids me. I've been in meetings with him, but he's always surrounded with associates. I've thought about sending him a letter, but that is so impersonal."

"John, I want to make certain he and his wife are on the guest list when the Maxwell House opens." Harriet smiled as she placed the paper in her lap. "In fact, I think we should place them at our table and he can sit next to you. I'm sure he would like to discuss your next project, whatever that might be."

"Maybe they can be in the same room, but surely not at our table next to me. Harriet, you have a strange sense of humor."

John looked out the window and noticed the rolling countryside. Riding a train offered the traveler a different perspective from taking the main roads.

Harriet returned to the newspaper and finished the article about her husband's folly. She refolded the paper and found herself staring at the front page. There was an artist's sketch of John Brown. He was drawn with a long white beard and a head full of white hair. His arms were outstretched with a Bible in one hand and a rifle in the other. Below the image was the caption, "Violent Chaos." The sketch actually took up more space than the

accompanying article. Brown had come east from Kansas and set up his "army of emancipation" headquarters in Maryland. He was just across the Potomac River from Harper's Ferry, where the United States government had an arsenal. The article closed with the warning, "This abolitionist needs to be watched carefully."

"John," Harriet's voice was soft but direct, "what do you think this Brown fellow is up to?"

"From what I understand, he is obsessed with freeing the slaves. If he had his way, there would be no more slavery in the United States. Next year's presidential election will have a lot to say about slavery as we know it."

"So, we could well be in violent chaos."

"Yes, and worse, I'm afraid." Harriet pondered his statement. John watched her as she shuffled through the stack. He was anxious to get her reaction to the tenor of the Chattanooga newspaper. He had already been affronted by the newspaper's Republican leanings. Every paper he had read on his recent trip had an article on Abraham Lincoln. It appeared the eastern part of Tennessee was promoting him for national political leadership. His views on slavery matched theirs.

As Harriet read the front-page articles, she learned more about the seven debates Lincoln had with Stephen A. Douglas. Both were running for the U. S. Senate seat from Illinois. Douglas seemed to be for a more democratic government. Lincoln argued the question of slavery. He contended, "A house divided against itself cannot stand. All men have the right to life, liberty, and the pursuit of happiness." The debate, the newspaper related, did not stay confined to Illinois, but was creating tension in the states and the territories wanting statehood in the Union. "John, why do you think our local newspaper has not carried all this information about Lincoln and Douglas?"

"There was some concern here, but not as strong as in the eastern section of our state. It was only a state election and a Republican one at that."

"Even so, we only got part of the story. We really didn't get to read about the content of the debates."

The sound of the train whistle, announcing their arrival at Sparta, drowned out John's response. He glanced through the window and spotted Eli sitting in the front seat of the buckboard. Harriet busied herself with collecting the stack of newspapers and other items she brought with her. She wanted to get back to the newspapers later and discuss some of her impressions with John.

The retreat home was a happy change from the fast pace at Travellers Rest. Cynthia had a meal on the stove, waiting for the arrival of the Overtons. It was not quite dinnertime, but it was well past lunchtime. John and Harriet had snacked on the train and were ready for a full meal. John could smell Cynthia's famous chicken and dumplings as soon as he entered the front door. "Now this is a proper welcome." Cynthia appeared in the doorway of the rock-walled, enclosed kitchen.

"Good day to ya, Massa Overton. I hopes ya hungry."

"I don't know about Mrs. Overton, but I'm ready to eat." He rubbed his hands together and smiled at Cynthia. Harriet entered the house and had the same reaction to the smells coming from the kitchen.

"Chicken and dumplings."

"Ya, ma'am. Ya favorite."

"Cynthia, give Mr. Overton and me time to freshen up a bit. Go ahead and prepare the dining table and we'll be in shortly."

The meal was wonderful, as expected. Cynthia cleared the table and returned with a small tray. She poured one class of peach brandy and handed it to John. "None for me, Cynthia." Harriet was moving away from the table as she spoke. "John, let's go sit on the porch. You can smoke out there if you like."

"Good idea. I have some important information to tell you."

The his-and-her rocking chairs, as Harriet called them, made sitting on the porch special. The sun was setting but there was still light. The smell of the lake and the sound of insects chirping added to the delight. John lit a large candle with the same match he used to light his pipe. Harriet wanted to know what was so special that John had to tell her, but she decided not to press the issue. *He will tell me when he's ready,* she thought.

"Harriet, how would you like to be the wife of a banker?" *So that's it. That's what he wanted to tell me. That's why we left home, rode the train, and came here to Bon Air.*

"John, I like being married to you. Why would you ask such a question?" She laughed as she watched him turned toward her.

"I'm serious. How would you like being married to a banker?"

"Let me think. A banker keeps regular hours. He works five days a week and takes off on holidays. If he needs money, he doesn't need to go far to get it. That sounds like a pretty good life. Yes, I could be married to a banker, but I'm not, and I'm happy." John knew from past experience that Harriet seldom answered any question with a simple yes or no.

"The directors of the bank I'm dealing with in Chattanooga, for some of the hotel financing, asked me to become bank president."

"And what did you say?"

"I told them I'd need to talk with my advisor and contact them later."

"And what did your advisor say?"

"I don't know. She just heard about the offer." John could see Harriet's broad smile through the candlelight. She reached over, put her hand on his arm, and squeezed it.

"John, you built a railroad. You are building a grand hotel. And you want me to advise you?"

"You manage Travellers Rest, you care for my mother, you nurture our three children, and you put up with me. I'd say that qualifies you as an advisor. What do you think about the bank offer?"

"I think you can do most anything you set your mind to. The key to any challenge is the satisfaction and pleasure it gives you. What would be your responsibilities and how much time will it require? Would we have to move to Chattanooga? Can you be a bank president in one city and build a hotel in another?"

"You see, those are the correct questions an advisor needs to ask. Let me give you some of the details. I went to Chattanooga to secure some more financing for the hotel. A couple of the banks were not interested. The one bank that was interested offered me the job. Currently, the bank directors are searching for a president. I would be like an interim president while the directors search. The bank is fully staffed, and several vice presidents manage the daily activities. I would need to be in Chattanooga once a month for the directors' meeting. The vice presidents would wire me for any major decisions."

"It sounds to me like the directors want a figurehead, not a president. They want someone with a name that says honesty and trustworthiness. They want the Overton name on their bank stationery."

"Harriet, you have a keen way of getting to the heart of the matter. You are exactly correct. They want my name, and I come along with the deal."

"Your advisor thinks you should take the challenge only if she gets to make some trips to Chattanooga with you, Mr. Bank President."

As they laughed together, John's pipe smoke circled near the candlelight.

The brief stay at Bon Air was refreshing and was the environment needed for making decisions. Harriet was glad John insisted on making the trip. She treasured the house, the setting, but mostly the trust she felt from her husband. She also liked her new role of advisor.

Once you've been to the mountaintop as an advisor, going to the valley of being a mother and nurturer may seem mundane and routine. Harriet never found that to be true in her life. She loved getting away for relaxing, but she always looked forward to seeing Travellers Rest on her return. If she came by train or carriage, the feeling was the same. She and John had only been gone a few days, but her eyes searched every window and door as they approached the house, hoping to spot the children. As the carriage pulled up beside the house, Jackson May came out the garden gate with Aunt Mary. She was holding a basket of apples they had collected for the kitchen.

"Mother! Father!" He ran to the carriage as he yelled. "You're home!" Harriet smothered him with a hug and kissed both cheeks.

"Yes, we're home."

"I've missed you." He broke away to greet his father. John picked him up long enough to give him a kiss and then Jackson May wanted to get down. He had completed all the greetings he wanted to give and was on his way.

"Where's Martha?" Harriet quizzed, looking at her sister.

"She's down in the barn with Max." That response pleased John and he headed for the barn.

"And baby Mary?"

"She's taking a short nap. Maria is upstairs with her."

"And how are you, Mary?"

"We are all fine. I was telling Mrs. Overton last evening, 'I don't know how Harriet keeps up with three children.' I don't know how you keep everything and everybody on schedule. These last few days makes me appreciate your abilities."

"Funny, that's the same thing someone else told me recently."

Eli had unloaded the carriage and placed the items on the gallery. Harriet glanced at them and asked, "Eli, did you place the stack of newspapers over there?"

"Ya, ma'am."

John found Martha in the barn. Claiborne had given her a brush and she was busy and did not hear her father enter. "Is there a Martha Overton in this barn?"

"Yes, sir, there is and it's me!" Her voice was cheery and full of childish joy. She handed the brush to Claiborne and ran to her father. "When did you get home? Where's Mother?"

"And how is Max?"

"Father, he is a wonderful pony. I ride him some every day and Claiborne is learning me how to care for him."

"Claiborne is teaching you, not learning you."

"Yes, he's doing that also. See how shiny Max's hair is? That comes from proper brushing."

"It appears you are learning your lessons." John bent over and enfolded Martha. When she broke loose, she ran up the hill to find her mother.

"Claiborne, help Miss Martha all you can. She has a very sharp mind."

"Ya, sir. Dat she do."

The first part of the evening meal was spent with Harriet reporting on Bon Air. Mary Maxwell had never gone with the Overton family to the retreat but was interested in Harriet's comments. Martha and Jackson May remembered the boat rides with their father and were excited to hear about the lake.

"Is the house still in good shape?" Mary Overton asked with interest.

"It is a sound house. I talked with the caretaker. He checks the house after a strong rain for leaks in the roof. To this point, there are none. The windows do not rattle and the doors swing freely."

"Good. At one time we were concerned about the small, wild critters getting in the house."

"We saw no signs of their visits. John has an announcement." John was in a state of daydreaming when he heard his name.

"Harriet, I didn't hear what you said."

"The announcement! What we talked about at Bon Air—Chattanooga."

Oh, yes, Chattanooga. The bank in Chattanooga I've been dealing with needs a temporary president, and the directors have offered me the opportunity."

"What are you saying, son?" Mary Overton quizzed. "What is a temporary president?"

"The bank currently does not have a president. The bank directors asked if I could help them out until they can fill the position."

"What on earth do you know about banking? Granted, you know how to make and spend money. What do you know about the administration of operating a bank?" Mary was deeply interested in her son's announcement. She wanted to be certain he knew what he was doing.

"Oh, the bank has vice presidents to handle the daily operation. I will be at the bank a couple of days a month for meetings with the directors and the staff. Otherwise, I will handle bank business from Nashville by wire communication."

"Oh, now I understand. The bank directors want to use the Overton name to reassure its customers."

"That's interesting, Mother. That's exactly what Harriet thinks."

"She's correct. John, I want to give you a principle of business your father followed. Never sign a document until you fully understand what is written and what is implied."

"Wasn't Father involved in the banking business at one time?"

"He was more of an advisor to the banking system in Nashville. He considered, at one time, being a director at one of the early banks in the city. Banking is one of the few subjects your father and Andrew Jackson did not see eye-to-eye on."

"Was that the National Bank?" Harriet enjoyed hearing stories of the Judge and Jackson.

"Yes. Unfortunately, the Judge died about a year after Andrew's bank veto, and they never did resolve their differences. John," Mary said with a strong voice, "your father would be very proud of your involvement with the banking system."

"Thank you, Mother. I'm pleased to hear you say that."

Harriet moved to the front edge of her chair, straightened her spine, threw her shoulders back, and lifted her glass. "I propose a toast. To the new bank president: may he have great success and a short term in office." Glasses clinked around the table. Even Martha held her glass of milk along with the others for the toast. Jackson May, however, was more interested in what was on his plate than joining the toast.

Isaiah Rogers continued to gather workers and materials for building the foundation of the hotel. John tried his best to stay out of the way, but he looked forward to seeing all the stages of the hotel construction. A couple of times a week, when he was in town, he would walk to the hotel site or Eli would take him by there in the carriage. The workers, mostly from out of

town, began to recognize the familiar face but never knew John's name or his connection to the hotel project. He went to the wire office on a regular basis, and when he was at home, he had the wires from the bank delivered.

Like his father, John did not make snap judgments. He took his time and thought through his decisions. Often he would ask Harriet to read the wires. "What would you advise me to do on this?" She would try to offer a number of logical solutions but would end by saying, "You need to consider the solutions, sleep on them, and then make your decision in the morning." She knew that was his method of problem solving and encouraged him to think with his head and feel with his heart.

John made the trip to Chattanooga for a couple of months before asking Harriet to join him. In September, she went with him and enjoyed meeting his new bank associates. She was proud to see how comfortable he was in this environment. He went about his duties and she visited the city and even took an afternoon carriage ride to a vantage point where she could view the river, winding its way through the countryside.

The local newspapers were a special treat for her during her three-day stay in the city. The articles they printed covered the nation. She found an article describing the discovery of silver on the property of Henry T. Comstock in a small Nevada community. A boomtown, Virginia City, had sprung up seemingly overnight filled with fortune hunters.

One day Harriet read about Dan Emmett, an Irish-American songwriter. He had just published a new song for the Minstrels. He called it *Dixie's Land.* The idea for the song had come from plantation life. The opening line was, "I wish I was in the land of cotton." Harriet folded the paper and set it on the table. She wanted John to read the article and was hopeful he could find the sheet music for her.

An article of interest, which troubled her and John, was in the paper she read on the train back to Nashville. In New York City, a lady named Susan B. Anthony spoke at the Ninth National Women's Rights Convention. She posed a question at the Convention: "Where, under our Declaration of Independence, does the Saxon man get his power to deprive all women and Negroes of their inalienable rights?" Harriet had mixed feelings about the article as she handed the paper to John. After reading it, his reaction was, "That's a strange combination to put together. You can agree, disagree, or be split down the middle about what she asks. Harriet, as a woman do you think, you can pursue life, liberty, and happiness?"

"Yes, I have those freedoms. But I'm not allowed to vote."

"Well, the article doesn't mention voting."

"I know. I just wanted to throw that into the discussion."

"Did you notice that Miss Anthony is a member of the Anti-Slavery Society?"

"Yes, I did. I guess that's why I read the article in the Chattanooga paper and not the Nashville paper."

"I suspect you're right."

The jiggle of the train car didn't help the pain Harriet was feeling in her lower back. She would be happy to get back to Travellers Rest to report on the wonderful few days she spent in Chattanooga.

By the end of September, Harriet knew what had caused her back pain on the train. She told John first and then the entire family, "I am with child."

Elizabeth Lea had not been told the news but suspected as much. On a brief visit with her mother, she talked with Harriet and noted a little fullness around her middle. "Harriet, are you feeling all right? You look a little pale."

"Thank you for your concern, Elizabeth. It may just be the change of seasons."

"Oh, that reminds me. Why don't you and John come to dinner at Lealand after worship next Sunday? I have a new cook and want to show her off."

"We'd love to, Elizabeth. Our husbands can talk about politics, or banking, or something."

"And I'm certain we can find some lady things to chat about."

As Elizabeth left, Harriet wondered, *It's strange Elizabeth did not invite her mother to dinner. I'll bet she wants all the information from John about the hotel and his banking job in Chattanooga. She may suspect I'm with child, but I'll not offer any information until she asks directly. Now, what do I say to Mary Overton when she discovers we are going to Lealand for dinner? I guess I'll just tell her the truth.*

Harriet had gone to bed early but was not asleep when John came in the room. He moved quietly on his tiptoes, hoping not to disturb her. "John, I'm not asleep."

"I was afraid my moving around on these squeaky floors might wake you."

"You are so kind and considerate. I am just resting, not sleeping."

"I'm sorry I missed dinner. I had a late meeting with Isaiah. He's having some problems getting the wood beams out of South Carolina. All of a sudden, manufacturing is slowing down at the mill there. How has your day been?"

"Just fine. Elizabeth was here briefly to visit your mother. She has invited us to dinner at Lealand this Sunday after church. She says she's anxious for us to have a meal prepared by their new cook, but I think she has something else in mind."

"Now you sound like my sister."

"John, if our new baby is a girl, I'd like to name her Elizabeth Lea."

"And if the baby is a boy?"

"Then you get to choose the name."

"Are you sure this world is ready for another Elizabeth Lea?"

"I don't think your sister is planning on any more children, and it's kind of sad that she never had a daughter. She is such a good mother. I think I'll tell her our plans on Sunday."

At breakfast, Martha was coughing and Mary had a runny nose. Harriet decided to leave the children home this Sunday. Mary Overton and Mary Maxwell felt the children might need some special attention; therefore, they stayed home as well.

Harriet had dressed first and was waiting for John in the large room. Jackson May sat with Aunt Mary on the sofa reading one of his books. He was unaware that it was Sunday and he would be missing a trip to church. It was a good trade-off for him. Reading books with Aunt Mary was a fun activity, and he treasured the private time with her.

"Mary, would you do me a favor?"

"Yes."

"Sometime this morning, please tell Cynthia that John and I will not be home for dinner. Since it's just the two of us, we'll find a place to have dinner. Very soon, my condition will prevent us from dining out. We will probably ride over to Lealand for a visit."

"You two lovebirds have a good day."

Harriet smiled but thought, *I wonder why Mary never married. She had scores of suitable beaus. After Annie and I left the Hall, maybe she felt it was her duty to stay with Father. "Love birds!" Is that really how she sees us? She would have been a wonderful mother. Look how she cares for Martha, Jackson May, and Mary.*

"Madam, your chariot awaits." John's voiced boomed when he spoke from the entry area.

"I'm coming, your lordship. Thank you, Mary. I'll see you this evening, Jackson May."

"Good-bye, Mother."

The ride to church was very relaxing for John and Harriet as they made their way down Franklin Pike. There was a nice cool breeze, so they rode to church with the carriage top down. The trees were just beginning to change colors. Along the way, Harriet waved at friends heading in both directions on the Pike.

The pastor was waiting on the steps when the Overtons arrived. He looked like he was in a tizzy, which was not unusual for him on any Sunday. "John, I need your help this morning."

"All right, what can I do to help you?"

"George Wise is ill and he was scheduled to read the Scripture. I need you to take his place."

"Pastor, I can do the reading on one condition."

"And what's that, John?"

"If you want me to read all those strange Old Testament names, I can't do it. You remember what happened the last time I read from the Old Testament." The pastor laughed with John.

"No, this morning's reading is from Saint Matthew 12:22-30. The only hard word in the passage is *Be-el-ze-bub*. I must run. I'll see you in my office before the worship service. We will walk to the platform together."

"I'll see you there later."

John borrowed Harriet's Bible and put on his reading glasses. He opened the Bible to the middle and began thumbing pages. He was thankful to bypass the Minor Prophets and found Saint Matthew. His eyes ran down the passage looking for *Be-el-ze-bub*. There it was, just as the pastor said. *The name is here twice,* John thought to himself. He mouthed most of the passage but read aloud, "Every kingdom divided against itself is brought to desolation; and every city or house divided against itself shall not stand." The thought came to his mind, *I've heard that before, but not from the Bible. Where did I hear it?*

Harriet was so proud of John when his tall frame unfolded and he stood behind the pulpit. He decided not to use Harriet's Bible when he remembered the large pulpit Bible. The printing was larger and he didn't need his glasses. The congregation was so quiet they could hear the pages being turned until John found the selected passage. His voice resonated in the room and demanded attention. When he finished, he left the platform and took a seat next to Harriet. She patted his knee and shared her open Bible with him. He continued to search his mind for the familiar words he had read. He was lost in his own thoughts when he heard the pastor say, "In recent days a northern politician borrowed the words of Jesus and made them his own. Abraham Lincoln has chosen to use 'a house divided cannot stand' as a wedge to attack slavery. Moreover, in attacking slavery, he is attacking every plantation owner in the south."

Harriet found a small pencil in her purse and jotted a note in her Bible, *AL—house divided cannot stand.*

John continued to listen. He wasn't fond of the pulpit being a political stump; nor did he like politicians who tried to use a bully pulpit. It seemed to him both were happening quite often these days.

After the service, the pastor stood at the back door greeting worshippers as they departed. "John, thank you for stepping in at the last minute to read the Scripture."

"I was happy to do so. And thank you for warning me about *Be-el-ze-bub*. I was expecting to hear something about him this morning."

"I did mention him by another name—Lincoln!" The response surprised John to the point that he quit shaking the pastor's hand and headed toward the carriage.

Harriet was holding on to his arm as they walked. "John, please slow down a little. It's hard for me to keep up with you."

"I'm sorry. My mind is preoccupied with parts of the pastor's sermon."

"Me, too. We'll talk about it on the way to Lealand." Harriet sensed John was troubled. As soon as they were in the carriage and on their way, she

commented, "John, I thought you did a splendid job reading the Scripture this morning." Then she probed, "Is there something troubling you?"

"A lot is being said these days about that Lincoln fellow. I guess I was surprised our pastor is so caught up in national affairs."

The discussion continued until the Overton carriage pulled to the front of Lealand. Elizabeth stood on the front step to greet John and Harriet.

"Welcome. John, you did a fine reading of the Scripture this morning. Mother will be sorry she stayed home when she finds out. Harriet, do come in. I trust you are in good health."

"Yes, I trust the same for you. We appreciate your kindness to have us in your home." John guided Harriet by her elbow into the house, fully realizing that Elizabeth had positioned herself to help Harriet. John Lea greeted his guests. "We can sit here in the parlor. The Reverend and his wife will be along shortly."

"Our pastor and his wife are joining us for dinner?" John Overton directed his question to his sister. He glanced at Harriet and smiled.

"Yes, it's been a while since they have been here, and I thought today would be ideal."

"I'm sure our table discussion will be lively." And it was.

At lunch the pastor reported on events in South Carolina. "My older brother lives in Charleston. He wrote me about secret rallies being held in the city. It seems the big concern is Abraham Lincoln and the upcoming presidential election."

"Why, Pastor," John Lea chided, "he may not even be nominated by the Republicans."

"Nonetheless, there are some in Charleston ready to storm some little island in the bay where the government has a fort."

"If they do that," John Overton added, "Charleston will have to fight the United States military. President Buchanan will send in the troops."

"Don't you think that would be an overreaction on his part?" The three males turned their heads in Harriet's direction when she asked the question. Elizabeth had no interest in the conversation at the table. She had hoped the ladies could return to the parlor for their own chitchat. Harriet was very involved in the table conversation and was not about to leave.

"No, Harriet," John Lea responded, "the President is under oath to protect the union—all the states."

"So it's like Andrew Jackson sending federal troops to South Carolina to enforce the tariff back in the '30s."

"Excellent analogy. Yes, the very same idea." John Lea looked at John Overton and gave him an approving smile with a slightly raised right eyebrow.

Elizabeth placed her napkin on the table and gave a very loud sigh. "Ladies and gentlemen, I hope you enjoyed your dinner. Our new cook has a special dessert to present. I trust you left room for some sweets." She rang the servant bell and a large black woman entered the room with a silver tray that

she placed on the sideboard. "Jane Ellen, what dessert have you prepared today?"

"Ma'am, I's has some berry and rhubarb tarts wit fresh whipped cream."

When Elizabeth smiled and lightly clapped her hands, Harriet knew the table conversation had moved from politics to dessert. However, she would discover in the weeks and months to come that the Lea dinner table was not the only table where political matters were discussed. These discussions spread from dinner tables to business luncheons and from banquet tables in hotels to railroad cars and steamboats on the riverways.

Eli was sitting in the driver's seat of the carriage finishing the final mouthful of Jane Ellen's wonderful rhubarb dessert when John Overton and John Lea walked through the front door and stood on the porch. Both men waved to the pastor and his wife as they left. Eli brushed the crumbs from his beard and then stepped to the ground.

"John, how is the hotel construction progressing?" John Lea stayed close to the Overton projects, trying to preempt any potential legal matters. He found, in his law practice, it was better to handle small items when they occurred rather than major concerns.

"Some of the materials we were expecting from South Carolina have been delayed. Mr. Rogers is working around the lack of material at this point. I may need to make a trip to the manufacturers there and see for myself. Do you have any contacts in South Carolina?"

"None that come to mind, but let me do some checking this week. I did have some classmates in law school years ago who were from that area. By the way, how are you and the Chattanooga folk getting along?"

"They're a different breed of people. I know they're citizens of Tennessee just like me, but they have little concept of the plantation environment. The only way they deal with slavery is from what they read in the newspaper, or a free black may come to the bank looking for a loan. I've really had to back off some situations. On my last visit, one of the vice presidents was dealing with a black husband and wife. He came to me for an opinion about their risk factor. Could they repay a loan if the bank decided to give them one? All I could see in the couple was two former slaves and maybe even runaways. I finally told the vice president to get some kind of collateral from them, just as we would from anyone."

Harriet and Elizabeth walked out the front door arm in arm. Elizabeth was patting Harriet's arm, "I will be so honored to have a niece as a namesake. John, Harriet has just revealed to me she is with child, and if the child is a girl, she will name her Elizabeth Lea. I'm thrilled!"

"Congratulations to you both!" John Lea extended his hand to his brother-in-law and smiled broadly at Harriet.

The Overton carriage made a turn onto Franklin Pike before either Harriet or John spoke. "This has been quite a day," John said with a sigh.

"I've had the strangest feeling since the sermon this morning."

"Like what?"

"It feels like something is beginning and something is ending at the same time."

Tranquility placed its coat on the doorstep at Travellers Rest and autumn made its appearance in a few short weeks. The summer flowers were gone. The kitchen garden had yielded its final vegetables. Only Mary Overton's herb garden, at the back of the house, produced anything green. The slaves were busy mending the split-log fences and stacking rocks for future walls around the fields. Everyone in the main house was in good health. Mary Overton sent some of her herb remedies to the slave cabins for sniffles, coughs, and runny noses. There had been a time in her life when she did all the doctoring on the plantation. She made cabin calls. When she married the Judge, he looked to her to keep the slaves healthy. She was proud to tell others about her herb remedies. There was living proof of her skills. The Overton slaves were healthy and working. The five children from her first marriage and the three children she had with the Judge all lived through childhood ailments and survived to adulthood.

John was walking from the Overton train stop to the main house when he was greeted by a familiar voice, "Father! Father!" Martha was in the vale below the house, riding Max. "Does your mother know you're this far from the house?"

"Yes, sir. Have you forgotten that I'm now six-and-a-half-years old? I can now ride Max without help from Claiborne. What do you have in the pouch?"

"I have some newspapers, two magazines, and two letters for your mother. There is also a surprise for you in the pouch."

"What is it? You must tell me this very minute." John was amused at her. *If I closed my eyes and heard only her voice, she would be a six-and-a-half-year-old Harriet Virginia Maxwell. It is amazing how similar they are.* He watched as she arched her back and pushed into the stirrups. *I guess she would be stomping her foot if she were not on the pony.*

"You can have what's in the pouch when we get to the house, after you take care of Max."

"Father!" She was learning at an early age the burden of responsibility. He waited for her on the gallery before going inside. Harriet watched him through the window and wondered about his delay. It was worth the delay to see a smiling daughter and a laughing husband as he handed her an envelope—her very first letter.

"This looks like a letter from your cousin Mollie in Texas."

"Thank you. This is a surprise." Martha ran to her mother to show her the letter.

"Look, Mother. I have a letter from Texas just like the ones you get. It's from Mollie."

"How do you know it's from Mollie?"

"She printed her name on the back." Martha held the envelope up, but did not release it. "And my name is on the other side. See, M-a-r-t-h-a." John walked into the house, kissed Harriet, and looked down at Martha.

"Well, are you going to open your surprise or just hold on to it?"

Carefully, she slid her little finger under the edge, broke the wax seal, and opened the flap. She pulled out the letter and handed it to her mother. "What does Mollie say?" Harriet read to her excited daughter,

> *Dearest cousin Martha,*
> *Hello. How are you? I am doing fine. Texas is hot. Harriet is*
> *fine. Please write me a letter.*
>> *With love,*
>> *I am your cousin Mollie.*

"Martha, this is your very first letter. You must find a special place to keep it." Harriet turned to John, "And how was your day?"

"Fine, but it's always good to be home. The rest of the mail in the pouch is for you." Harriet dumped the contents on the table and handed the pouch back to John. She stacked the newspapers and magazines and took the two letters addressed to her and headed for the sofa in the large room. As she glanced at the letters she thought, *I recognize the letter from Annie, but who sent the other letter?* When she flipped the envelope she saw the initials GE—*my friend Grace Evans.*

> *Dear Harriet,*
> *This is just a note to tell you things are going well for me*
> *here in Pulaski. In addition to selling the store wares, I've been*
> *doing some sewing for three of the ladies in the community.*
> *One is a widow who has a son my age. I saw him today*
> *through the store window. He was sitting in his buckboard.*
> *I guess he was waiting for his mother. Do I sound like a*
> *schoolgirl talking?*
> *I trust this note finds you well. If your travels ever bring*
> *you to Pulaski, please let me know.*
>> *Your friend always,*
>> *Grace*

Harriet held the letter and allowed her thoughts to float back to her days at the Academy. *Girl talk. I've not heard that phrase in years. I wonder whether Grace and I ever girl-talked at the Academy? I'd like to make a trip to Pulaski sometime to see her. I'm pleased she's happy and finding extra work.* "Mother." The sound of Martha's voice interrupted her reminiscing. "I want to write a letter to Mollie."

"Yes, I think you should." Harriet returned to her mail. Martha did not move. She locked her knees and twisted at the hips. "I want to write the letter right now!"

"Later. Mother is busy right now."

"Now!" Harriet heard Martha's foot hit the carpet with a thud; she witnessed the second stomp.

"Young lady! I said later, and I mean later. You sit in that blue chair, with your feet off the floor. I will talk with you after I finish reading my letter." Martha did not cry, but pouted and sighed heavily. Harriet could hear John snickering, and then he laughed from the hallway. She had to hold Annie's letter in front of her face to hide the sheepish smile she displayed. Martha began swinging her legs and distracted Harriet from her enjoyment of Annie's letter.

"Martha, what are you doing?

"I'm sitting in the blue chair like you to told me to." Harriet put the letter in her lap, looked at her daughter, and motioned for her to come sit on the sofa. "Martha, did you like getting a letter from Mollie?"

"Yes, ma'am." Harriet put her hand on Martha's shoulder; Martha slid away from her.

"This is a letter from my sister in Texas, Mollie's mother. I'm happy when I get a letter from her, but the way you are acting is making me unhappy, and I can't enjoy her letter. Why did you stomp your foot a little while ago?"

"I wanted you to hear me."

"I did hear you and I gave you an answer. Tomorrow, when I write a letter to my sister, I'll help you write a letter to Mollie. Not today but tomorrow."

"May I go outside?"

"Yes, you may until the sun goes down. But, first, do you have something to say to me?" John entered the room and sat in the blue chair but said nothing.

"No, ma'am." Martha walked from the room, slammed the door, and ran the length of the gallery.

"John, what am I going to do with her? She actually stomped her foot at me. I wonder where she picked that up." Harriet was frowning.

"If she turns out half as good as you, we have nothing to fear. I hope all of our children will have a sense of independence. Martha sure does. You have done a very good job of nurturing her. I wouldn't change anything about her. By the way, I received a brief note from John. He still likes school. The students are talking about the upcoming election. He is wondering what they will do in South Carolina if the Republicans are elected. And he sends his love."

"I'm glad he sent the note. Most young men his age are not great letter writers. It's interesting he mentioned South Carolina. Annie wrote about a gentleman from there being at the fort. Thomas and some of the officers met with him."

"Did she say what they talked about?"

"He seemed to be very interested in knowing the birth state of the officers. He wasn't on any official business but indicated he was visiting the military units in the southwest."

"I would think the officers come from a variety of states, and a high percentage of them were trained at West Point."

"Annie also mentioned the election. The military brass is trying to figure out how the soldiers' votes can be counted. Mollie and Harriet are doing fine. They are totally accustomed to the ways and foods of the southwest. They are learning a few words and phrases of Spanish. The sewing machine is still in fine working order. She keeps it covered all the time due to the sand and dirt in the air. She and Thomas are very happy for us about the new baby. She sends her love."

John was standing by the time Harriet finished reporting, but did not leave the room until she looked up and said, "That's all."

The next day after breakfast, Harriet and Martha stayed in the small dining room to write their letters. "Now Martha, what would you like to write to cousin Mollie?"

"Something like this," Martha responded, "Dear Cousin Mollie, thank you for your nice letter. I am doing fine and I hope you are also. Love, Martha."

"That is an excellent first letter, Martha. Let me print the letters for you and you can copy them on the paper. I suggest you practice making your letters a few times before you begin."

Martha sat next to her mother and followed instructions. Occasionally, she glanced over at the letter her mother was writing and one time stopped to watch the words come out of the quill pen. She smiled and put her head on her mother's arm. Martha's paper was splashed with ink in several places, some of the letters were backwards, and she folded the paper in quarters before her mother could stop her. "Mother, it might be best if you did the envelope."

"Yes, I'll be happy to do that for you, but I will need your help with the back of the envelope."

When both letters were finished and addressed, Harriet turned both facedown on the table. She pointed to a drawer in the small table in the corner of the room. "Martha, in the drawer is a small metal letter seal. Please find it and bring it to me." When Martha returned with the seal, Harriet moved the candle. "Martha, every important letter has a seal on it. Our seal has a big, fancy letter O for Overton. I'll drip the wax on the envelopes and you can make the seal." Martha was excited to have a grown up responsibility and told her grandmother and Aunt Mary about the experience later in the day.

During the ensuing months of 1859, Harriet studied the national political scene. John had the Chattanooga newspapers sent to the house. He brought bits of news he'd pick up on his trips to Chattanooga. He also found some northern magazines at the newsstands for her. Harriet found time to read widely and was well versed on national events. John's arrival from school in Virginia brought a fresh source of news and information. Harriet was thrilled.

Although her pregnancy sapped her energy on many days, she continued to run the house, nurture the children, and care for John.

The hotel construction slowed during the winter months, allowing John to spend more time at Travellers Rest. He enjoyed the horseback riding activities with Martha. She always wanted to race back to the barn after a midday ride. Jackson May was excited to watch the snow fall and pile up on the grass. John caught his son's excitement and they played together until Harriet made them come inside and warm up. Baby Mary looked forward to the times she rode around the house perched on her father's shoulders. She would pull his hair with both hands and giggle as they went through the house. John, unlike his father, found a unique way to relate to each of his children. The bonding times were cherished and remembered by father and children.

The end of the year passed quietly for the Overton family. The New Year arrived with the Twelfth Night celebration, but in a modified form. The family enjoyed time together and good food. The slaves enjoyed the small gifts and time off from labor. Little did any of them suspect what was about to happen.

# 17. Tense Times

As 1860 made its appearance, Harriet realized she had two important events quickly approaching—her birthday and wedding anniversary. She didn't mind being reminded of the events but would have preferred that they pass quietly. On January 8th she became twenty-eight years old. She began the day as all other days. She stood in front of a marble washstand on which were a basin, a pitcher of water, a bar of French soap, and two hand towels. Above the stand was a mirror where she looked each morning to affix her hair combs and then pat her hair into place. As she gazed into the mirror, she was pleased the image she saw was of her head and shoulders only. She took a few minutes to think, *John is out of town on business and hopefully, the others in the house have forgotten about my birthday.* As she opened her bedchamber door, she noticed the door to Mary Overton's room was still closed. That was the sign she would need to walk down the gallery to the family dining room for breakfast. She flung a shawl over her shoulders and as she tucked her arms, she could feel her extending baby bump. She walked quickly, feeling the January wind whip down the gallery. She peered into the sky and thought, *It sure looks like snow. I hope John remembered to take his scarf and heavy hat.* When she opened the side door, she met Mary Overton coming through the large room.

"Good morning, Mary. I trust you rested well."

"Thank you, I did, but my bones tell me we are in for some falling weather."

"From the look of the sky, I believe you're right. Maybe a good breakfast will help your bones feel better."

Maria had the three children at their places, and they were talking to Aunt Mary. Harriet entered the room after Mary Overton but just in time to see her sister Mary remove her index finger from her lips. Martha and Jackson May still had their fingers positioned on their lips and each were making shushing noises.

"Good morning, sister. Good morning, children. Maria, I'll hold baby Mary while you help Master Jackson May."

"Ya, ma'am."

Harriet sat Mary in her lap while Cynthia and Emily served breakfast. All eyes, except Jackson May's, followed the platter of flapjacks, ham slices, and fried apples from Cynthia's hands to the center of the table. Jackson May was looking at his mother, displaying a very large smile. Emily placed a pot of hot coffee on the sideboard before she placed the pitcher of warm maple syrup near Mary Maxwell.   Mary Overton turned toward Emily, "Child, is that coffee or herb tea in the pot?"

"It be coffee, ma'am."

"You know very well I don't drink coffee in the morning. I prefer herb tea!" She spoke in a gruff voice. Emily looked to Cynthia for help.

"Ya tea be in da kitchen. Emily, go gets it rite now." Cynthia wanted to use a gruff voice also but knew better.

"Harriet, who is this slave child, Emily? She's too young to work in the kitchen. She needs to be out in the fields." Mary Overton was eyeing the platter of food as it was about to come to her.   Harriet   watched   Martha squirm in her chair. Her daughter formed a tight fist around her napkin and her tiny lips pressed together. She knew Martha was about to explode. Her grandmother's comment had just said had lit a fuse that was ready to hit the powder keg. Martha pushed her chair away from the table, placed her napkin on her plate, and grabbed the edge of the table with both hands. "Martha, I need your help with baby Mary." Harriet was hoping to avoid the scene that was about to be played out before the breakfast audience. "Your sister needs some attention, and she's too heavy for me to carry." Harriet steadied Mary's feet on the floor and directed Martha to take her sister's hand. The three left the room and headed for Harriet's bedchamber.

"What's wrong with baby Mary?" Martha was still following her mother's instructions.

"Mary is fine. It's you I'm concerned about, young lady. You were about to be cross with your grandmother. You were about to say something you would be sorry for later."

"Mother, did you hear what she said about my friend Emily?"

"Yes, I did. What you need to understand is your grandmother doesn't believe whites and blacks can be friends."

"But you've told me stories about your friend Julia and she was black."

"Martha, we're not talking about me, and we're not talking about you. We're talking about your grandmother. She doesn't believe whites and blacks can be friends. Nothing you say will ever change her mind. You may not agree with her, but you will respect her." Harriet cupped Martha's head in her hands. "Would you like to stomp your foot? Would that help?" Martha was surprised. That's exactly what she wanted to do.

"Mother!" Martha put her free hand around her mother's skirt and squeezed. They both laughed and baby Mary joined them. *Explosion prevented,* Harriet thought on their way back to breakfast. *I hope I can be around to defuse other situations for Martha. She is so much like me it's scary. I need to be more careful of the example I'm setting for her.*

Mary Overton and Mary Maxwell had finished breakfast when Harriet and her daughters returned. Jackson May was poking at the items Maria had placed on his plate. She was standing behind him ready to help.

"We had some adjustments to make, but we're ready for breakfast," Harriet announced. Mary Maxwell nodded her approval, knowing from experience what the adjustment was. Mary Overton was concentrating on her herb tea.

"Mother," Jackson May blurted out with his mouth full of breakfast, "have you been a good girl?" She smiled at her son, knowing precisely the source of his question. His fourth birthday was just a little over a month away. She and his father had been asking him about his behavior in preparation for his birthday. Mary Maxwell quickly gulped a mouthful of coffee, strangely suspicious of where her nephew was going with his question. She managed to put her cup in its saucer, clear her throat, and put her index finger to her lips in full view of Jackson May.

"I'm always trying to be a good girl, son. Why do you ask?" Mary Overton, Mary Maxwell, and Martha joined in a deep breath, trusting the only male in the room would not give away the secret.

"Father told me to ask you ever so often, and I thought today would be a good day to ask." He finished his last mouthful of food and, using two hands, tipped his milk glass to his lips. He smiled in a way that always disarmed Harriet.

"Jackson May Overton, you are the man of the house when your father is away. So I guess you have the right to inquire of my behavior."

"Mother, may I be excused from the table?"

"You may, but it will cost you a big kiss." There was the Overton smile again. This time the upper part was covered with milk. He moved to his mother, put his arms around her neck, and planted a milk kiss on her cheek, which she did not wipe off until he was out of the room. Harriet looked down the table at her mother-in-law. "He is an Overton through and through. He has his father's smile and affection."

"And he has the Judge's gift with words," Mary Overton said with a sigh of relief. Harriet knew the secret. There would be a birthday party that evening. The others at the table knew that Harriet knew, but the secret remained unspoken.

After hearing Jackson May's position in the family stated, Aunt Mary decided to prepare him for the evening event. He would offer the birthday toast and present his father's gift to his mother. The table was arranged that evening with Jackson May seated in his father's chair, directly across from Harriet. At the appropriate time, he stood with a water glass in hand. He was just tall enough to peer over the edge of the dining table and see his mother. "All rise. Harriet Ginny Max Overton, happy birthday!" His voice was normal as he began but then it rose to a loud crescendo as he finished his toast. He walked around the table and clinked his glass to his mother's.

"Thank you, Jackson May. That was wonderful." Harriet opened her gifts to the delight of the givers. Cynthia entered the room with a birthday cake. Anytime cake was served was a special treat and was enjoyed by all; even Cynthia and Maria had cake with the family.

As Harriet retired for the night, she allowed her thoughts to drift to another birthday. She had been eight years old. She saw the faces, heard the voices,

and was grateful for such wonderful memories. The morning sun coming through the blinds did not wake her the next morning, but the sound of voices on the gallery outside her bedchamber did. She recognized Claiborne's husky voice, but the other man's voice was a mystery.

"Massa Overton not on da plantation." Claiborne was raising his voice.

"It's important that I see him this morning." The other voice was cutting and direct. Harriet rose, put on her robe and slippers, and went to the side door. She yelled through the door, "Claiborne, what is all the commotion out there?"

"It be a Mr. Price from down on da Pike."

"What does he want at this time of the morning?" Her voice changed.

"Am I speaking to Mrs. John Overton?"

"You are, sir."

"Is Mr. John Overton still a Justice of the Peace in this district?"

"Yes, he is."

"Ma'am, I need his services to resolve a matter with my neighbor. It is urgent and needs to be settled today."

"Mr. Overton is in the city on business this morning. I expect him home near noon. If you will kindly leave your name and address with Claiborne, I'll have Mr. Overton come to your home this afternoon." Harriet wanted to see this Mr. Price, but was not properly dressed.

"Very well." There was a bit of anger in the two words. She heard his boots scuffle on the gallery and then a horse walking. She opened the door and took the note from Claiborne. "I'll need you to meet the afternoon train at the Overton Station and hand Mr. Price's note and one I'll prepare to Mr. Overton. I want you and Eli to ride with Mr. Overton in case there is trouble. Come back here before you leave for my note."

"Ya, ma'am."

Later that day John read Harriet's note and Mr. Price's name. He had to smile as he thought, *I wonder what's happened now. Mr. Price always has a bone to pick with someone. I hope I can ease his pain today.* "Claiborne, turn the buckboard around and head south on the Pike." No sooner had they reached the Pike than John saw a small brown bull grazing by the side of the road. "Eli, can you catch that bull?"

"I can try. What we goin' to hold him with? We don't have no rope." As the buckboard pulled near, Eli jumped out of the back and headed in the direction of the bull. Eli yelled. The bull flipped its tail, turned toward Eli, and snorted. He jumped back on the buckboard, bumping against Claiborne. The scene was so funny that John slapped his knee as he laughed and tears came to his eyes. He had not experienced anything so humorous in a long time. Eli didn't see anything at all funny about the situation. Claiborne did, however, and he joined Mr. Overton in the laugh fest. The bull continued to graze. A couple of minutes passed while the laughter continued on the buckboard.

"Massa Overton, what ya need done wit da bull?" Claiborne was wiping his eyes with his coat sleeve.

"We need to get that bull back to the pasture on the Price farm, probably about a quarter of a mile up the Pike."

For some strange reason Claiborne always had a double length of rope tied around his waist. He wore suspenders to hold up his pants, but the rope seemed to do the same thing. He turned to Eli and motioned for him to take the reins. Claiborne jumped down, released the rope from his waist, and walked toward the bull. His voice was soft and calming as he tied one end of the rope around the bull's neck. He tugged on the rope and the bull began to walk down the Pike. It was a sight to watch. As the trio approached the Price land, Claiborne pointed over to the split-rail fence, a portion of which was scattered on the ground. John saw the same thing and pointed for Claiborne to lead the young bull to the open pasture. By the time the bull was in the upper pasture, John and Eli had rebuilt the fence to secure the field. Claiborne retrieved his rope and rejoined the others at the buckboard.

"Both of you did good work. You have made my job as a Justice of the Peace much easier. Let's drive up and find Mr. Price."

The Price farmhouse was a modest one-story structure with five rooms and a detached kitchen. A covered stoop led out from the front door. Strangely, the house had three chimneys and one on the kitchen. Three one-room cabins sat on the south side of the house. A small, two-story barn was about fifty yards from the back of the home. John knocked on the front door and did a quick survey of the farm before the door opened. A plainly dressed girl with pigtails glared up at John. "What do you want?"

"I'm here to see Mr. Price. Is he . . ." The door shut and John had to swallow his last word. He could hear her yelling for her Pa. The door reopened and there stood Mr. Price.

"I have a message to see you. You told my wife you had need of a Justice of the Peace."

"Indeed I do. Some scoundrel in the neighborhood has made off with my bull."

"Is he a small bull?"

"Yes, he's just a little over a year old."

"Well, Mr. Price, I have some good news for you. Your bull is back in your pasture and your rail fence is back up. I figure either your bull knocked the fence down or a bunch of boys, up to no good, took the fence down and let your bull out. I found him down near the Pike."

"Thank you, sir. That's right neighborly of you. Mr. Overton, I know you must have some prize bulls on your plantation. How do you keep them in your pasture? "

"I've discovered that keeping them in a small enclosed place is the best. When it's time for them to do their deeds, I turn them loose in the pasture with the cows. The bulls seem content with the arrangement."

"Thank you. If the arrangement works for you, it should work for me. Thanks again for coming by so quickly. Give my regards to Mrs. Overton. I'm glad you're my Justice of the Peace." The two men shook hands and then John was on his way to Travellers Rest. He was happy he had functioned as a JP, but he was more pleased he had been a neighbor.

Anytime John returned to the plantation after being gone for more than three days, there was a lot of catching up to do. He appreciated his family and extended family. Upon his return, he inquired about their welfare. But he loved coming home to Harriet. He listened intently to her before he ever said a word about his travels. She was always full of wonderful reports about the activities of the children and the happenings on the plantation. "How are you feeling, Harriet?" That was always his first question when he returned.

"I've had some sleepless nights, but I do try and get a nap after the noon meal. The cooler weather has helped my overall health. I've been taking some short walks after breakfast, when the weather is not so cold. Often Martha goes with me, and we end up in the barn checking on Max."

"And how have you been these last few days? Is everything all right in Chattanooga? Are the bank Directors still actively seeking a president?"

"Tell me about the children and your birthday party. Then we can talk about Chattanooga."

"John," she said with a soft laugh, "you missed a treat. At breakfast, on the morning of my birthday, Jackson May wanted to know whether I was being a good girl. His question gave me a clue about what would happen later. He said, 'you told him to ask' and he did."

"I try to remember to tell him to be a good boy while I'm gone. I remind him he is the man of the house and he needs to take care of the ladies."

"Well, you'll be happy to know your instructions are being followed. At dinner that evening he made the birthday toast to me and gave me your present. Jackson May has your charm. Martha and I have had some time to girl-talk, and baby Mary is full of herself as usual. Now, what is new in Chattanooga?"

"First of all, the Directors would like for you to make a return visit. It seems your last visit made quite an impression on their wives at your luncheon. They were amazed at your management skills at such a young age."

"If I feel well in late February or March, I will go with you, but after that I'll not be able to travel until after the baby comes this summer. Maybe we could go to Chattanooga to celebrate our wedding anniversary. "

"Harriet, that would be wonderful."

"What else is happening in the banking business?"

"Something strange is happening in South Carolina. The bank has had several visitors from that state inquiring about loans. Some of the building project managers in Chattanooga are having problems getting manufactured items from South Carolina just as Mr. Rogers is at our hotel. One of the Directors is planning a trip to investigate."

"John, there's something we need to discuss. Your mother was very cross with Emily at breakfast. Emily has been helping Cynthia in the kitchen. In fact, while we were gone to Bon Air, she did all the cooking."

"What's the problem?"

"Emily is the mulatto girl who came to Martha's birthday party. Somehow they have become friends. Your mother suggested, aloud, that Emily was too young to work in the kitchen and belonged in the fields. That comment upset Martha so much, that I had to take her out of the room to calm her down before she became sassy to your mother. I have not talked to your mother about this."

"Who is this Emily, anyway?"

"Cynthia told me she is the oldest child of Emmaline." John was anxious to close the conversation. He faked a yawn and stretched his long arms over his head. "Harriet, it's been a long day, and I need to go to bed. I'll talk with Mother about Emily."

"Tomorrow, I want to hear what happened this afternoon, Mr. Justice of the Peace."

John handed Harriet a letter from his son without comment. She read in silence.

> *Dear Father,*
>
> *Thank you for my very generous birthday gift. I will find an appropriate way to use it. Perhaps I could purchase a one-way ticket to Nashville. I am now eighteen years old. As I have been told, my Grandfather Overton left Virginia at my age to seek his fortune. I, too, would like to leave Virginia to seek my fortune in Nashville or Memphis. I could attend the University or work in the family business. I am prepared to make this decision but desire your blessing. Overton blood flows in my body, and I am ready for a new challenge.*
>
> > *Your devoted son,*
> > *John*

Harriet folded the letter and followed her husband to their bedchamber. "John, this letter sounds so much like you. Your son is very mature for his age. He knows what he wants and has made his case."

"I agree with you. I do want him to attend the University. At the same time, working in Memphis would be like attending the University. His being there would relieve me of some of that responsibility. Mother would be pleased for him to be in Memphis."

"So what are you saying?"

"I will write and tell him I support his decision. You know this means another body in the house."

"He is not just another body, John. He is the Overton heir. Our children will be thrilled when they hear he is coming home. You have made a wise decision."

Harriet's mind was open to new ideas. She was not easily swayed but examined and accepted new ideas on their merit. She felt this trait came from her father. She remembered him as an inquisitive reader. He had books and newspapers around him when he sat in his easy chair. She pored over each page of the newspapers John brought back from his trips—Memphis, Chattanooga, Decatur, and occasionally some New England cities. On the inside back page of the Chattanooga paper she spotted a half-column article entitled, EVOLUTION FINDS A CHAMPION. She folded the paper to isolate this one article.

As a Bible-believing Presbyterian, she had never considered evolution with the Genesis account of creation. She discovered the champion to be Charles Richard Darwin. He had spent time on the Galapagos Islands studying animal life. He was fascinated by how the same types of birds developed different beaks to perform specific functions. He saw that as evidence of evolution. Finally, in 1859 he published his findings in a book, *On the Origin of Species by Means of Natural Selection.* He had printed only 1250 copies. The brief article made her curious. She wanted to read Darwin's book.

Strangely enough, at church the next Sunday when the pastor came to the pulpit, he placed his Bible on one side and another book on the opposite side. "Ladies and gentlemen," he held up his Bible, "from a child I've been taught and believed God created man. My sister in Boston sent me a book by Charles Darwin that brings into question the divine creation process." The pastor picked up the Darwin book and threw it toward a front pew so forcefully it slid under the pew. Harriet's total focus was on the pastor's next words, other than her desire to get up and retrieve the book.

"Friends, we are being attacked on all sides. Books like that are challenging our long-held theology and our rockbed belief system. Our liberty is being challenged by northern politicians who know nothing about our way of life." The last statement brought some scattered verbal agreement from the congregation. Not another word was said about Darwin's book, which made Harriet question whether the pastor had even read it. Her attention waned, and she considered several times how she could retrieve the book under the pew. After the benediction, the congregation headed for the door to greet the pastor. Harriet found the book. As she approached the pastor, she held it up. "Sir, may I borrow this book?" He looked at John for an answer. Finding none, he looked back at Harriet. "Why on God's good earth would you have an interest in Darwin's book?"

"I've found when I'm informed, I may or may not conform."

"Yes, Mrs. Overton, I'm happy to loan the book to you."

"By the way, Pastor, what is your sister's view of the book?"

"She . . . she . . . I'm not certain."

John guided Harriet to their waiting carriage. He smiled, thankful she did not draw him into the interchange with the pastor.

Harriet spent the next two weeks cloistered in her bedchamber. The family, with the exception of John, thought she required extra rest. During the daytime, he knew she was sitting next to the window devouring every word of Darwin's book. In the evenings he saw the book, with little page markers and her reading glasses, on the small table near the window. She did not say a word to him about the contents. He was glad to be excluded on her venture, but knew, without doubt, his time for questions and opinions would come.

The next Sunday, at the close of the service, the pastor announced he would not be at the door. He needed to make a quick exit to visit a sick church member. No name was mentioned, which created some concern in Harriet's thinking. John saw the look of disappointment on her face. "Maybe there is a sick person. You need to give him the benefit of the doubt. The opportunity will come for the two of you to talk." John thought, as they headed home, *Poor Pastor. He's the one that may be sick when Harriet talks to him. I hope, for his sake, he's read that darn book. She's like those snapping turtles down in Pass Christian. When she gets hold of you, she won't let go until she's ready.*

Harriet finished the book, put her notes in her keeping place, and returned it. "Pastor, I'd like the opportunity to discuss this book with you sometime." The opportunity never came. The pastor moved to another church in Crossville, taking the book with him. Harriet was disappointed; John was thankful the pastor escaped being snapped.

The March trip to Chattanooga was long and bumpy for Harriet. At the time, she didn't realize she was only three and a half months from the arrival of her fourth child. She rested her first two days in Chattanooga, encouraging John to go on to his meeting at the bank. "John, I'm dreadfully sorry, but I just don't feel well."

"You are with child. You have every reason for your feelings. My first concern is for your health. If you make it to the bank on this trip, that's fine. If you don't, that's fine also."

On the third day she appeared, to the delight of the bank directors, their wives, and the bank employees. When Harriet walked into the bank, heads turned, employees smiled, and directors bowed. She often reflected on those moments. *Are these people being nice to me because my husband is the president, or because I'm very much with child, or because they genuinely like me?* She didn't care about the first reason, considered the second, and hoped for the third. If those around her had taken a vote, the third reason would have won. She had an innate gift of looking at a person, regardless of their station in society, with full, direct eye contact. Her gaze and gentle smile indicated, "You are important to me." She greeted each bank employee before moving to the directors and their wives. This was the second day the wives had come,

hoping to meet with Harriet. They found in her freshness and a tenacity they didn't find in their upper society friends. She was well educated and versed on a variety of subjects. It was evident to the wives that Harriet adored and honored her husband but had the ability to stand beside him as an equal. They were a team—one tall member and one short member, but a winning team.

"Mrs. Overton," the wife who spoke appeared to be the leader of the eight wives, "We have planned a luncheon in your honor at the hotel today. It's just a short walk from the bank. We can arrange for a carriage if you desire it."

"I'll come on one condition." All the private conversations in the room stopped in midsentences. They wanted to hear Harriet's condition. John had a strange feeling. "You must call me Harriet." The room filled with laughter; John's was the biggest laugh of all. He was relieved. "Sirs, I'm certain," Harriet was standing next to John as she spoke, "you have business to discuss that can be resolved with the help of cigar smoke." She glanced at the large humidor at the end of the table and the ash containers on the table. "We ladies have spent far too much of your money to have our dresses reek of cigar smoke. So, with your permission, we will leave this room before the fresh air disappears." The directors laughed; the wives smiled and moved in the direction of Harriet. They liked to pat her and be near her. As the ladies left the room with their leader, John felt a sense of pride. He realized the rules Harriet had issued to the directors but wondered whether they understood. She didn't like cigar smoke but tolerated it. She was frugal and knew the value of money.

The return trip to Nashville was not quite so hard on Harriet. John had arranged for her to have several small pillows to support her body. He had wished, several times on the trip, that she had stayed home where she could be comfortable. "John, at this stage of my condition, anyplace I am is uncomfortable. I'm glad we had the time together. I like being in your world. You have always made it possible for me to stand beside you."

"I just don't want to do anything that will hurt you in any way."

"For a number of years now you have been my protector. I love you for taking care of me." She took his hand and held it for a long time without either of them saying a word. The click-click of the wheels on the rails became almost melodious. He broke the silence, "How was your luncheon with the ladies?"

"It was very nice. It reminded me of being in Manners Class at the Academy. The tables were prepared with silk and lace. We had china, crystal, and very heavy silverware. Waiters, in formal wear, escorted each lady to the table and handed each a huge dinner napkin after we were seated."

"What about the food?"

"Everything on my plate was in miniature. They served the smallest chicken I've ever seen. The drumstick had one sliver of meat. The breast was not much bigger."

"I'll bet you had a small quail. Did it taste gamey?"

"Now that you mention it, it did."

"What about dessert? I'll bet you had fudge pie."

"Yes, I did, and I ate every morsel of it. I was hungry."

"Speaking of hungry, the train stops shortly up the line for fuel. I'll get off and get us a meal. What would you like?"

"Anything but quail! And if they have one, get me a fudge pie—a whole one." They laughed like newlyweds and enjoyed the time they had together.

When the train stopped, John stood and started walking away. Harriet stood; John stopped. "Are you going with me?"

"John Overton, a lady does not need to answer for her actions when she's in my condition. If you must know, I need to find the necessary. Now, stand aside, sir."

"My lady. You have my deepest apology." After a quick bow, he moved out of her way.

Lunch on the train was different. Meals at the fuel stop were prepared for quick delivery. The train had a schedule to keep and the food suppliers kept pace. Each meal came wrapped in a large cloth napkin tied with a knot that served as a handle. It was accompanied with a jug of chilled water or tea and cups.

John returned to the train and found Harriet, "My lady, food has been secured." He handed her the hidden meal, placed his on the seat in front of them, and wedged the jug in the corner of the seat. He reached into his coat pocket and produced two cups. "The lady in the station told me to leave the jug, cups, and napkins on the seat. Apparently, they are returned to be used again. This is a service we could use on our railroad line."

"Well, sir, let's see what you have secured. Before we open the surprise meal, if there is a little chicken—a quail—in here, I'll be highly disappointed." They were not disappointed. When the napkin was untied and spread out, it served as a small tablecloth. In this case, the cloth became a seat covering. They were pleasantly surprised to find two large slices of bread and an equally large slice of ham topped with a whole pickle cut in half. The apples proved to be very fresh and juicy. There was no fudge pie, but when Harriet bit into one of the three sugar cookies she commented, "Sir, my compliments to the cook."

The remainder of the trip was uneventful. John looked at the Tennessee countryside out of the windows. Harriet took brief catnaps while leaning against the body of her accommodating husband.

Soon they were back in Nashville, aboard the Company carriage, going to Travellers Rest. When they passed a church, Harriet wondered, *Will our new pastor be open to discuss Darwin with me? I'll need to inquire. Maybe he needs to come to the house for Sunday dinner—after the baby comes.* "I didn't finish telling you about my luncheon with the wives. They were very interested in politics on the national level. They hope Abraham Lincoln is the Republican candidate for President. When I told them about his antislavery views, it didn't seem to matter."

"I told you the folk in Chattanooga don't have any interest in the slavery question. They seem, at times, blind to the whole issue. They even seemed pleased at the fiasco that took place last month in Charleston when the Democrats split over slavery. I would not be at all surprised if the Democrats have two presidential nominees this year."

"What would that mean to us in Tennessee?"

"I believe the eastern part of the state will vote Republican and the rest of us Democrat."

"Your father and Andrew Jackson may turn over in their graves."

As Travellers Rest came in sight, both Harriet and John sighed. "John, I like traveling with you, but I'm most comfortable in that wonderful home on the hill."

"Me, too." As Harriet placed her hand in the crook of his arm, she felt her baby kick. John smiled; Harriet smiled, but their present joy was from a different source.

Personal events and national affairs blended and moved as dominoes stacked on end, ready to fall on each other. Elizabeth Lea Overton, the third daughter, was born on June 9, to the delight of her namesake. Harriet had prearranged to have her sister-in-law Elizabeth Overton Lea in the house for the birth. Elizabeth had actually prayed for a girl; Harriet prayed for a healthy baby. When Harriet delivered the baby, Cynthia wrapped it in a sheet and then a blanket. "Cynthia, hand the baby to Mrs. Lea."

Elizabeth was seated but reached out her arms to take the baby. Both Elizabeths were crying. "Cynthia, bring me a basin of warm water and a soft cloth." She wiped away the birth stains and cooed at the baby with each stroke. Elizabeth had birthed three boys, but this moment was a special time for her.

John entered the room and knew, from looking at his sister holding the baby, he had fathered another daughter. He bent over Harriet and kissed her on the forehead. "Thank you."

"And thank you." Martha, Jackson May, and Mary came into the room with their grandmother Overton and Aunt Mary. Before Harriet could touch her children's outstretched hands, Jackson May asked, "Do I have a brother or another sister?"

"You have another sister."

"Good, I'm happy." Harriet didn't have the strength to explore his answer but accepted it as a sincere response. Peace and gratitude settled over the Overton home. A new life was beginning. Mother and baby were doing fine.

The weather in mid-August was mild in middle Tennessee. The Overtons and Mary Maxwell took advantage of the situation and sat on the lower gallery before dinner. The sun was on the other side of the house and the gallery was comfortable. No one knew the gentleman in the buckboard when he pulled up, hitched the horse's reins, and walked in their direction. John stood, "May I help you?"

"Yes, sir. My name is J. B. Cooley. I'm the assistant marshal assigned to take the U. S. Census in this part of Davidson County. I have a few questions for the head of the house."

Mary Overton and Harriet began to laugh. They both were remembering the last census taken in 1850. The census taker could not believe Harriet, then eighteen, was the head of the house. John looked at the ladies, having no idea of the source of their laughter. "John, help the man. I'll tell you the story later."

"Sir, I will need the full names, ages, and financial information about every person living in the house." He wrote as John talked. John looked occasionally at the ladies to ensure he was giving the correct information. They nodded approval at the appropriate times.

| NAME | AGE | VALUE OF REAL ESTATE | PERSONAL ESTATE |
| --- | --- | --- | --- |
| John Overton | 39 | 1,060,752 | 362,690 |
| Harriet Overton | 28 | | |
| John Overton | 18 | | |
| Martha | 7 | | |
| May | 4 | | |
| Mary M | 2 | | |
| Elizabeth L | 2/12 | | |
| Mary W. Overton | 78 | 6,000 | |
| Mary Maxwell | 30 | 6,180 | 13,000 |

Mr. Cooley bowed to the ladies and thanked John for the information. He left for his next stop at the Ewing household.

"Son, when Mr. Cooley introduced himself, Harriet and I had a flashback of the day ten years ago when the last census was taken. The census taker mistook Harriet for a child and looked to me for information. He was shocked when I told him Harriet was the head of the house. I still laugh when I remember the expression on his face."

"Thank you for that."

September brought the first of two critical news events to Nashville. During the second week, the city learned that William Walker had been executed in Honduras. He had become a folk hero to many in the area. The first week of November was the biggest event. The fifty-one-year-old lawyer, Abraham Lincoln from Illinois, was elected the sixteenth President of the United States. He failed to win a majority of the popular vote but won eighteen states and one hundred eighty electoral votes.

President Buchanan's final State of the Union address was printed in full on the front page of every Nashville newspaper. Harriet read every word, rereading many of the longer sentences. His words were strong and his thoughts related to states' rights were a bit confusing. "States have no legal right to secede from the union, but the federal government has no legal power

to stop them." One of his statements was printed in bold type, "**Our union rests upon public opinion and can never be cemented by the blood of its citizens shed in civil war.**"

The statement brought tears to Harriet's eyes. She felt her heart beat rapidly. She thought of her family. She wanted to hold her four children. She needed John to reassure her that all was secure. Harriet was afraid.

# 18. Conflict Brings Trouble

On Thursday, December 20, 1860, Nashville citizens were preparing for the upcoming holiday season. Homes were being decorated with greenery. Holly sprigs with bright red berries were cut and made into centerpieces. Men in pubs were talking about hunting for fresh meat, especially turkeys. Ladies, with their cooks, checked all over town for fresh fruit. Sugar was bought for the holiday sweets. Children counted the days until school was dismissed for the season. Little did the citizens of Nashville suspect what was transpiring in Charleston, South Carolina. That same day South Carolina's political leaders met in St. Andrew's Hall to discuss only one issue. After twenty-two minutes, they voted to secede from the Union. They issued a statement of their intent. Harriet clipped the article from the newspaper a few days later and put it with her other papers.

> *"We the people of South Carolina, in convention assembled,*
> *do declare and ordain . . . that the union now subsisting*
> *between South Carolina and other states under the name*
> *of the United States of America is hereby dissolved."*

The article went on to report, "Church bells rang throughout the city. Charlestonians marched on the city streets and cheered the decision. Cadets at the Citadel fired their cannons to the delight of the marchers." The decision permeated every conversation, every church service, every business luncheon, every social gathering, and every newspaper.

Harriet and John talked about current events each evening before going to sleep. "John, will Tennessee do the same thing and secede?"

"I'm hoping cooler heads will prevail. John Lea is hoping President Buchanan will take some action before South Carolina's decision spreads."

"And if he doesn't, will President-Elect Lincoln be able to do anything? The nation could be in a lot of trouble before he takes office in March."

"That's the dilemma. If President Buchanan doesn't do anything, his opponents will say he's political. But if he sends in the federal troops, his opponents will accuse him of being political."

"So he's between a rock and a hard place. Excuse my French, but he's dammed if he does and dammed if he doesn't." John laughed enough to shake the bed.

"Harriet, you do have a way with words." He kissed her, rolled over, and went to sleep.

John had a meeting with Isaiah Rogers to discuss building supplies coming from South Carolina. "Mr. Overton, the large beams I was counting on for the hotel interiors have been delayed."

"So that means the grand room is on hold until we receive the beams."

"Yes, sir. However, the grand staircase can go in and the beams can be added later when they arrive."

"Will the staircase be safe without the beams?"

"Under normal use it will be fine."

"So, Mr. Rogers, you feel good about the progress?"

"Yes, and we are under roof. That's in our favor. The workmen can begin framing the rooms on all the floors. All the windows are in storage. All the brickwork is completed. The mahogany has arrived for the cabinets."

"What about the columns for the front of the hotel?"

"I've been assured, by wire, the columns are on schedule. It's funny you would ask about the columns."

"Why?"

"Your son was with me the other day on Cherry Street when I was looking at the front of the hotel. He wanted to know whether the hotel was going to have columns and how many."

"Mr. Rogers, don't let John get in your way."

"He is not in the way at all. He is a good runner. He delivers messages quickly. He knows all the foremen by name and can tell you where they are in the hotel. If I want details about the workmen and the progress, I ask him. By the way, he calls himself John Waller. He gets his pay just like the other men." John Overton felt a sense of pride as he walked toward his buckboard. He was creating a hotel for Nashville and a responsible young man for the Overton family.

Harriet paced in her bedchamber, looking out the window waiting for John to come up the driveway. She held John Lea's note between her finger and thumb. *I wonder what is so important that a personal note is sealed with wax. Why didn't the Lea servant just tell me the message? Well, finally John is home.* She wrapped a shawl around her shoulders and went to meet him. She knew he would head for the family dining room first to greet his family, where they were gathered for the evening meal. She got to the steps at the end of the gallery about the same time the carriage arrived. He stepped from the carriage to hear, "Welcome home, John. I have an urgent note for you from John Lea." The sun was nearly set, but the candle she held provided enough light for him to read the brief note.

> *Dear John,*
> *The Governor has requested we meet him in the morning*
> *at ten o'clock. Please come by my office tomorrow and we can*
> *ride together. I suspect secession talks.*
>
> > *John Lea, Esq.*
> > *9 January 1861*

John removed his hat, handed Harriet the note, and motioned for Eli to take the carriage to the barn.

"John, what does this mean, 'I suspect secession talks'?"

"Governor Harris wants counsel about Tennessee joining South Carolina."

"Is that a good thing?" She put her hand on his arm as they went to the dining room.

"Let's not say anything at dinner. I'll know more this time tomorrow."

"As you wish."

The Governor's office was not as plush as John Lea's, but it was four times bigger. John Overton and John Lea entered the smoke-filled room to find the Governor's staff and at least a dozen State legislators milling around. The gathered group moved to a larger room where chairs were arranged in rows. Governor Harris greeted each man as he entered. Seats were taken, a security guard closed the door, and the Governor faced his audience.

"Gentlemen, thank you for coming. Others may join us, but I want to begin. You may not be aware, as of this moment, but the state of Mississippi joined South Carolina yesterday in seceding from the Union. Today Florida will join them, and if my sources are reliable, tomorrow Alabama will do the same. By the end of this month, the entire Cotton Belt may be in a confederation. What will Tennessee do?"

"Our constitution requires the matter be placed before the people." John Overton could not see the man making the comment.

"The Attorney General may need to help us here, but I believe a statewide referendum from the Legislature is called for, and a majority vote will determine the need for secession."

"Actually, sir, a referendum calls for a secession convention to be held and then a vote is taken. The outcome of the convention vote would determine what the state does."

After the issue was discussed for over an hour, John Overton and John Lea left the meeting not knowing why they had been invited ,but confident the Governor would get his statewide vote on the referendum.

The February 9 referendum failed to garner a majority vote. To no one's surprise, west Tennessee supported the referendum, the citizens of middle Tennessee were divided, and east Tennessee wanted nothing to do with a secession convention.

Harriet read the Nashville newspapers and tried to balance her understanding of the secession issue by reading the Chattanooga paper. She requested that John buy her a map of the United States. At first, she kept the map in her bedchamber for her own use. She outlined each seceded state in pencil beginning with South Carolina, then Mississippi, Florida, Alabama, Georgia, and Louisiana. Later, Texas was outlined on her map as it joined the confederation of states. Seven states were now linked by a common cause.

One evening in early February, as the family gathered for dinner, John repeated what he had heard earlier in the day. "Representatives for the seven states have gathered in Montgomery and formed a provisional government. They have created and adopted a constitution that protects slavery. Rumor is

that Jefferson Davis will be named provisional President of the Confederacy. He will create his Cabinet by the end of the month."

"John, what does all of this mean for us in Tennessee?" Mary Maxwell's question was intense.

"Mary, I hope our state can remain neutral, but I fear we'll be caught in the middle and be pressured by the new Confederacy and the U. S. Government to make a choice. Harriet, would you mind hanging your map here in the room?"

"What kind of map do you have?" Mary asked.

"I've been outlining each state as it secedes. Excuse me for a moment. I'll fetch the map and you can see." When she returned, John and his son were in conversation about Tennessee forming an army. She didn't like what she heard. She held up the map as young John pointed to each of the seven states.

"Son, what will happen to the hotel?" Mary Overton's voice was weak and her hearing was failing.

"Mother," John's voice had to be extra loud, "I suspect many of the workmen will return to their home states. Our suppliers south of us may stop sending building material. Mr. Rogers may be required to stop construction, and I will lose a lot of money. The banks will require payment on the loans even though the hotel is not complete." Harriet visibly slumped in her chair as John's words echoed in the room and in her mind. *I will lose a lot of money. How much is a lot? Will we need to sell the land, the slaves, and maybe lose Travellers Rest?*

Harriet read and studied President Lincoln's Inaugural Address printed in the local newspaper. She was hoping to find some clues of what he might do in the future. His words were not encouraging. "No state upon its own mere motion, can get out of the union." *Oh, President Lincoln,* Harriet pondered, *seven states have already gotten out of the union.* "We are not enemies. Though passion may have strained, it must not break the bonds of affection. The mystic chords of memory stretching from every battlefield and patriot grave, to every living heart and hearthstone, all over this broad land, will yet swell the chorus of union, when again, touched, as surely they will be, by the better angels of our nature." *Yes, Mr. President, we can swell the chorus of union, if you will relent your passion to kill slavery. Slavery is part of our southern society. You need to recognize its value.* She clipped the Address and placed it with her other items.

Nashville was consumed with the secession issue. Small clusters of people gathered at nearly every street intersection. Some of the news they shared was factual; some was hearsay.

As the sun rose on April 15, the newspaper boys stood at every road leading into Nashville and at every intersection in the city. Their voices could be heard echoing throughout the city, announcing the three-inch headline, **FORT SUMTER BOMBARDED BY CONFEDERATE CANONS.**

John Overton bought two copies of the paper. After Eli delivered him to the train depot, John told him to take a copy of the newspaper to Travellers Rest and hand it to Mrs. Overton. John took the buckboard, tied up at the depot, and headed for John Lea's office uptown. Every intersection he passed on the way was buzzing with men holding up the front page and pointing to the headline.

The ladies of the house were standing on the gallery when Eli arrived. Jackson May was playing in the front yard and ran to greet Eli.

"Good day to ya, Master Jackson."

"Good day to you, Eli."

"I needs to sees ya mammy."

"Mother is on the side gallery."

As he walked around the corner of the house, Eli spotted the ladies. He removed his floppy hat and extended the newspaper. "Massa Overton say, gives dis newspaper ta Miz Overton."

"You drove all the way from Nashville to bring me a newspaper?" When she opened it to the front page, she knew why. She gasped when she saw the headline. She handed the newspaper to her sister Mary.

"Harriet, what does this mean?"

"It means the state of South Carolina has challenged the United States. The fort in Charleston Bay belongs to the United States."

Mary continued to read the article aloud. "The Confederate officials sent a request to Major Anderson in the fort to surrender. He refused and the fort was bombarded. After two days, the Major surrendered the fort. No one was killed, and the Major and his seventy-three men were allowed to leave the fort. They traveled north on the supply ship sent by President Lincoln. President Jefferson Davis of the Confederate government was pleased with the outcome and commended General Pierre Beauregard and his army of 7,000 for the victory." She concluded as she handed the paper to Mary Overton, "President Lincoln has made no response at this time."

Lincoln did respond later, and what he said was spread across the front page of the nation's newspapers. Every editor who took the time to read the wire from Washington printed special editions. Lincoln was careful not to use the word *war*. He called for 75,000 volunteers to put down the *insurrection.* The action of South Carolina at Fort Sumter was "too powerful to be suppressed by the ordinary course of judicial proceedings." He called on the volunteers to defend "the Union and to redress wrongs already long enough endured." Every state Governor not committed to the Confederacy was urged to send volunteers to deal with the insurrection.

Governor Harris read the wire message and shook his head. *The citizens of Tennessee will now have to deal with the matter of secession. They will not want to send volunteers to fight against kinfolk in the southern states.*

Harriet waited each evening for John's return, hoping for good news. There was none.

The state of Virginia seceded two days after Lincoln's request. The Confederate Congress declared that a state of war existed within the United States. That news brought an air of sadness to the evening meal at Travellers Rest. Harriet outlined the states of Arkansas and North Carolina on her map. It was obvious to all in the room when she sat down that Tennessee nearly jumped off the map. "John, what is our fate? Can the state remain neutral?" Harriet knew the answer but wanted John to talk to the family about the reality of what was about to happen.

"Governor Harris is planning for another referendum in early June. I have no doubt it will pass overwhelmingly. Tennessee will be the eleventh state in the Confederacy."

"What will we do?"

"I will vote that the state remain neutral, but I will support the will of the people." Young John listened carefully to his father's answer.

"Father, will Tennessee have an army? Will I be able to join?"

"Son, I believe it's best we wait for the vote." Harriet looked at her husband and saw the answers in his eyes. *Yes, Tennessee will have an army. Yes, you will be a soldier.*

That evening, Harriet wrote a letter to Annie. Family news was mentioned but kept to a few lines. Mostly, she sent the latest news and specifically, facts about Tennessee.

> *John fears Tennessee will join the Confederacy—soon. There is to be a vote in the state on June 8. What will Thomas do? If he answers President Lincoln's call, what will you and the girls do? You know, dearest sister, you are always welcome to come and stay with us.*

Harriet closed the letter with a written prayer that health and safety would be with the Claiborne family. She longed to see Annie and her family. Many nights they were in her last thoughts before she fell asleep.

June 8 was a busy day throughout the state of Tennessee. Over 150,000 men voted across the state to determine the future of the citizens. The Legislature agreed the tally would come to the Governor's office, be verified, and then announced by wire to the newspapers. As soon as newspapers could be printed and delivered on the streets, the results would be known.

Candles throughout the house were snuffed to close the day at Travellers Rest. Harriet and the others prayed and hoped against hope Tennessee would stay out of the coming conflict. Harriet mouthed a prayer for John's safety, who was staying in Nashville to get the news about the vote. She had a deeper concern for young John Overton. He seemed all too eager to join the army and put his business career on hold.

The sound of John's leather shoes on the wooden gallery was a noise Harriet recognized. Most mornings he would rise, eat breakfast, and leave for the city by sunrise. She rolled over in bed and looked out the window. It was

still pitch dark outside. Harriet rang the small bell she kept at her bedside to summons the house servant, sleeping in the outer room. By the time Harriet put on her slippers, the door to her bedchamber opened.

"Ya, Miz Overton. Ya needs help?"

"Bring your candle in here and light some candles in my room. Did you hear steps on the gallery?"

"No, ma'am." Harriet put on her robe and picked up a candle.

"Come with me."

"Ya, ma'am." The young servant was rubbing her eyes, trying to get fully awake. As Harriet opened the side door, she saw John's silhouette by the kitchen door. "John," Harriet managed a loud whisper, "what time is it?" She walked toward him while tying her robe.

"It's six o'clock. What are you doing up?"

"I've been waiting for you to come home. What's the news?" She retrieved the key from her pocket and opened the side door. "You go in and light the candles and I'll get Cynthia moving. Breakfast will be ready in short order." Cynthia was already making coffee when Harriet entered the kitchen. "Bring in the coffee when it's ready, Cynthia."

"Ya, ma'am. Will ya be eatin' with Massa Overton?"

"Yes, I will. The family will eat later." Harriet entered the family dining room and was greeted with a hug.

"Harriet, my love, Tennessee has voted, by a large margin, to join the Confederacy. The vote was over two to one to secede. East Tennessee is threatening to leave the state and form a new state."

"Can they do that?"

"Some are saying if western Virginia can break from Virginia, then so can the counties in east Tennessee. It's for sure those counties will not supply anything to the Confederacy."

"What will you do about the bank?" Cynthia entered the room with hot coffee.

"'Scuse me. Will both of yas be havin' coffee?"

"Yes." John waited for Cynthia to pour the coffee and leave the room. "I had a wire from the bank late last evening. The directors feel there will be a run on the bank today. They may need to close it until the insurrection is settled. They want me to come to Chattanooga as soon as possible."

"Will people lose their money if the bank closes?"

"Yes, and I'll be one of them. I'll probably need to stop construction on the hotel. I won't be able to pay the workers we still have, and the vendors will want their money up front."

"Are we without funds?"

"No, Harriet. We have land worth a great deal of money both here, in Memphis, and in Mississippi. We have money in several banks. I've tried to build the hotel from borrowed money and not our personal accounts. The hotel will pay for itself, but in its unfinished condition, it's a financial liability. You

let me worry about the hotel. You have enough to do running Travellers Rest."
While eating breakfast they continued talking about the future.

"How do you see your involvement with the Confederacy?"

"I feel I can best serve, using my business abilities and my wide range of contacts. I don't see myself in a military uniform leading a group of soldiers. Our plantations can provide cotton and food supplies. I have contacts from Nashville to New Orleans. The railroad can be used. The Overton holdings in Memphis might be used in some way. The hotel, though not finished, is under roof and I suppose could be used by the army."

"What about young John? Where do you see him fitting into the current situation?"

"John is nineteen years old. He has a mind of his own and is able to make his own decisions. I had hoped the University was going to be a part of his near future. Now I'm not sure. He has done well working on the hotel, but that may be ending soon."

"Can he be involved with your efforts for the Confederacy?"

"Yes, that would be a possibility. I can talk to him."

"I have known your John since he was a small child. At times, I feel like he's my son, too. I want the best for him, but his military involvement must be worked out between the two of you. Please be assured I'll support the decision you two make."

"Thank you, Harriet. I love you for caring for the Overton family."

"By the way, would it be possible for me to ride to the city tomorrow and have Eli take me to the Academy? I need to call on Annie Brinkley . . . I mean Ann Brinkley, as she chooses to be called now. I've not seen her in a few weeks, and she'll be leaving for Memphis soon."

"Yes, I will count on having the honor of escorting you to the city. How about a late lunch while you are there? Maybe Ann can join us. Then you can take the late afternoon train and be home before dark."

"Excellent plan, Mr. Overton. Now, finish your breakfast and consider taking a nap for a few hours. I'll tell Maria to keep the children outside and quiet while you rest. You'll need to excuse me now; Travellers Rest is about to wake up to a new day."

Ann Brinkley made visits to Travellers Rest on a regular basis. She wanted to stay in touch with her grandmother and she cherished the times she had with Harriet. They talked about a variety of subjects, and Harriet treated her like an adult. It was also fun being around Cousin John. He reminded Ann of her brother Hugh.

Harriet went to the Head Master's office when she walked into the Academy. The office décor had not changed in fifteen years. There was a new lamp and a few more books on the shelves, but the furniture was the same.

"Mrs. Overton, so nice to see you. To what do I owe this pleasure?"

"I'm here to visit one of your students, Ann Brinkley from Memphis."

"Of course, Ann is your . . ."

"She is my niece by marriage."

"And how are Mr. Overton and his mother?"

"Both are in good health, thank you. I will tell them you inquired about them."

"Please do." He began looking at a class schedule and then his pocket watch. "Ann should be out of class for the day in about ten minutes. Would you like for me to go to her classroom and bring her here?"

"No, no, that will not be necessary. If you would be so kind to point me in the direction of her classroom, I'll meet her there."

As Harriet walked down the hall of classrooms, she had wonderful flashbacks of the years she spent at the Academy. She reviewed the name plaques on the walls. Each plaque had the year listed and the names of the students enrolled. She found Annie Maxwell's name and on another plaque, Mary Maxwell's name. Further down the hall she found her name, Harriet Maxwell. She wondered, *is Grace's name on the display with mine?* Sure enough, there it was, Grace Evans. Seeing her name brought a smile to her face. *I must send Grace a note and tell her about my discovery.*

The class door opened and the hall filled with young ladies whispering and laughing. "Ann, Ann Brinkley!" Ann turned to find the voice and saw Harriet's outstretched arms.

"Harriet!" Ann squealed in excitement. "What are you doing here? Is anything wrong?"

"No, I was in town and decided to stop by and see you before you leave for the summer. What is your schedule for the afternoon?"

"I have a meeting after our evening meal, but I'm free until then."

"Good. How about having lunch with me and your Uncle John?"

"Do I need to change clothes?"

"No, you look just fine."

"Let me take these things to my room and I'll be right back."

"Very well. I'll wait for you at the front entrance."

Harriet and John tried to make the luncheon light and cheerful, but Ann wanted to talk about the implications of Tennessee joining the Confederacy. She was up-to-date with her information. She knew the facts.

"Uncle John, will the Union Army use the Mississippi River to attack Memphis?" John had considered how the insurrection would affect Nashville but had not thought outside the area to places like Memphis. He wondered momentarily, *What will happen to the Overton holdings in Memphis if the city is captured?* Harriet could tell by the faraway look in his eyes that John was sifting through his thoughts for an answer.

"John, did you hear Ann?"

"Yes. I was thinking about your father, Ann. I was wondering what all of this war talk would do to his railroad. Control of the Mississippi River will be a major concern for both sides. I hope the Confederacy will be able to protect Memphis." The conversation continued throughout the meal. Harriet and John

were impressed with Ann's depth of understanding of current events. John glanced at his pocket watch. "Harriet, if you plan to make the afternoon train, we need to leave soon."

"I'll tell you what; Eli can take us to the depot and then take Ann back to the Academy."

At the depot, Ann thanked her Uncle John for a lovely luncheon. "Harriet, thank you for a wonderful surprise and for allowing me to take long weekends at your home this school year. I probably won't see you again until the fall, when I come back for my last year at the Academy."

"Please greet your father and Elizabeth for us. Say hello to Hugh. Tell him he's always welcome to come for a visit."

"I will, and thank you again for a lovely day. Please give Grandmother Overton a hug for me." Eli turned the carriage and headed for the Academy.

John walked Harriet to the passenger platform, leaving her for a brief moment while he went to his office. Returning, he handed her some newspapers and a leather pouch containing their mail. "This will give you something to do on the way home. I will be back in a couple of days. This may well be my last trip to Chattanooga for a long time."

"I hope not." Harriet knew how much John enjoyed being in the business world and particularly in the banking business. If the bank closed and the hotel construction was put on hold, John would have a lot of free time on his hands. The train whistle sounded, telling passengers it was time to be aboard. Harriet put her arm around John and squeezed. He bent over and they kissed goodbye. "John, take care of yourself. I love you."

"I love you, Harriet Virginia Maxwell Overton." No one in the world ever put all four of her names together but John. The expression filled her with emotion and each time he said it, she cherished the sound of his voice for days.

As the train headed south, Harriet gave her attention to the contents of the mail pouch. The seat next to her was empty, so she dumped the mail. There was a welcome letter from Annie. *Apparently, our letters crossed in the mail. I hope all is well with her.* Harriet gingerly opened the envelope and removed the two pages. One page was addressed to Mary; the other to her.

> *Dearest Sister Harriet,*
> *The insurrection in South Carolina and the secession of*
> *states has caused great upheaval here at the fort. The men*
> *are divided in their loyalty. Thomas has determined to resign*
> *his commission and join the Confederacy. He had a meeting*
> *with John Bell Hood about joining the Texas Brigade. Thomas*
> *will travel with them. They are headed for Virginia. William,*
> *Thomas' good friend, is going to stay in the U. S. army. It is*
> *heartbreaking to think good friends will be foes.*
> *When you read this, Mollie, Harriet and I will be on our*
> *way to Memphis. Our final plans are unclear.*
> *My treasured sewing machine will be staying in Texas.*

*I have found a good home for it.*
*Sadness fills my heart knowing Thomas is leaving, but I*
*am happy knowing I will be closer to you.*

> *I am, as always, your loving big sister,*
> *Annie*

Harriet dabbed the tears from her eyes and bowed her head. *Dear Lord, I have been taught from my childhood that you are the All Powerful. I pray that Your power will protect my sister Annie and her daughters as they travel. Bring them safely to my arms. Watch over Thomas and unite him with his family. I pray for the leaders of this nation that they will call on You for direction. Amen.*

John was engrossed in the wire he was reading from the bank directors while he waited for his train to be called. The platform was filled with passengers, but he paid no attention to those gathered there. He heard the name *John* voiced in the distance, but he continued to read. "John Overton!" As he looked up from his wire, he saw the person calling his name. "Mr. Overton, so good to see you today."

"Governor Harris. The pleasure is all mine. Are you traveling today?"

"Yes. I'm going to Chattanooga."

"I'm headed that way myself."

"Are you going to your bank in Chattanooga?" The arriving train created extra noise on the platform and conversations were interrupted. John nodded as several men gathered around the Governor and whisked him away.

John heard the final "all aboard for Chattanooga" cry from the conductor. As he settled in his seat near the middle of the car, he went through his usual routine. He glanced in both directions to see the passengers. *Looks like a typical travel day.* He didn't notice anyone he knew but was a little surprised to see eight military men seated at both ends of the car. *I hope the train stays on schedule. I wonder where the soldiers are from. Why are they traveling east?* Seeing the soldiers reminded him of Harriet and her concern for young John. *I need to discuss with John his interest in the military. Maybe he would like to attend West Point. I'll talk with him when I return.*

He had just unfolded the wire from Chattanooga when he felt a tap on his shoulder. A man about his age with a well-groomed beard handed him an envelope. The man stepped back, but John could still sense his presence. John broke the seal on the envelope and slipped the note card out.

> *John, please join me. The gentleman who handed you this note*
> *will escort you.*
>
> *Isham Harris, Governor.*

John placed the note and envelope in his coat pocket, gathered his papers, stood, and followed his escort. He noticed that the four soldiers in the front of the car stood and followed as the escort directed them off the train. Folk on the platform watched as the strange group of six men made their way to the last

passenger car. This car was not like the others in the train. It was half again as long as the other cars, painted gray, and had no markings. The window shades were pulled down and two soldiers, with rifles in hand, stood guard at the door of the car. "After you, sir." John was directed into the car where he was met by Governor Harris. "Gentlemen, this is John Overton, the man I was telling you about."

"Governor, I don't understand . . ."

"John, I could not tell you about this on the platform. I was not at liberty to do so at the time. Now I am. These gentlemen are on their way to Richmond. They have come from Montgomery by way of Memphis. Since they were coming through Nashville, they asked that I join them on their trip to Chattanooga." The thin man, who sat behind the stately desk, stood and looked at a paper he held in his hand. He wore a double-breasted coat. His eyes were set close together enough to notice the distinction. His well-kept goatee made him appear regal. He wore no glasses. He looked directly at John. John felt the man was exploring his very soul. "Mr. Overton, you come from a strong southern family. Your father was born in Virginia, educated there and in Kentucky, my home state, and made his fame in Nashville. He invested in Memphis. He advised Andrew Jackson. Judge John Overton left his mark on history."

"Yes, sir, all that is true." John found this personal history a little scary, coming from a man he did not know.

"It looks like you are following in his footsteps. You are a Justice of the Peace, a banker, and a builder of railroads and hotels." The man's eyes scanned the paper in his hand.

"Actually only one railroad, and I have an unfinished hotel. May I inquire your name, sir?" Governor Harris placed his hand on John's back and nudged him forward. "John, may I present the honorable Jefferson Davis." John extended his hand and Davis did the same. The handshake was firm from both men. "My deepest apology for not recognizing you." John did a small bow as he stepped back.

"Mr. Overton, you had no way of knowing me as I had no way of knowing you. I did, however, have an information sheet on you. I understand you tried to keep your state of Tennessee neutral in the conflict." John gave serious thought to his reply.

"Yes. I did."

"What changed your mind?" John made eye contact with the other three men in the car and then back to Davis.

"May I speak freely?" Davis sensed John's reluctance because of the others in the car.

"You may, but before you do, allow me to introduce members of my Cabinet. This is Stephen R. Mallory, Secretary of the Navy. Here is Judah P. Benjamin. He's the Attorney General of the Confederacy. This gentleman is

John H. Reagan from Texas. He's agreed to serve as Postmaster General."
John smiled with each introduction and extended his hand.

"I'm pleased to meet all of you and wish you the best in your endeavors."

"Why don't we be seated?" Davis gestured to the chairs around the car.
"Back to my question." All eyes turned to John.

"I had hoped, even prayed, Tennessee would remain neutral and that the
actions of the Confederate States could be settled with words and not guns. I
thought we might learn a lesson from President Jackson and his response
toward South Carolina and the tariff."

"You are a keen student of history. I commend your reasoning." Davis
stroked his goatee. "John, you are a landowner—a large landowner. You have
land in Tennessee and Mississippi." John was surprised at the mention of the
Pass Christian plantation.

"Yes, I do."

"What would your land be worth if you could not produce crops?"

"That's why I have most of the land. The land in Memphis is commercial,
but I see your point. Logically speaking, to produce a crop, I need a work force
and that work force happens to be slaves."

"Exactly. In the northern states, the work force is white. They work in
factories. The politicians and special interest groups are not concerned about
the conditions in those factories, and that part of the work force is children.
They choose rather to focus on the south and its work force. I am on record in
the U. S. Senate as saying, 'All we ask is to be let alone.' If my message had
been heard, we would not have the current situation. Abe Lincoln is the puppet
of the northern politicians, but he doesn't know it yet. Very soon, I fear, he
will proclaim the death of slavery. Slaves will revolt and the situation will
become grave. He will give orders to invade the southern states in an effort to
break the Confederacy."      Davis moved to the side of the car and pulled
down a large map of the United States. Chairs were adjusted so everyone
could view the map. "John, as you can see," Davis spread his hand and
covered Tennessee, "your state is the key to Lincoln's strategy. He is calling
Tennessee 'the keystone of the Southern arch.' The rivers—Mississippi,
Tennessee, and Cumberland—are vital. The railroad systems connect all
sections of the state. Memphis, Nashville, and Chattanooga are key locations
in his plans. If Tennessee ever falls, the Confederacy will be split in half. I
have appointed five generals to protect our border."

"And who are they, sir?" Governor Harris stood as he spoke.

"Samuel Cooper, Albert Sidney Johnston, Robert E. Lee, Joseph Johnston,
and Pierre Beauregard have agreed to serve."

"Sir, with apologies, I did not hear the name of a Tennessean in your list
of five."

"The five chosen are ranked according to their seniority from West Point,
and no Tennessean qualified. We may need to talk about this later. My
purpose today is to convey my strategy for Tennessee. I have assigned General

Albert Sidney Johnston to secure this part of our border." Davis indicated on the map, pointing from the Mississippi River east to the Appalachian ranges.

John watched with interest as Davis pointed and talked. His thoughts went to his family dining room. *I wonder what Harriet is doing right now. She would love to see this map and hear Davis talk about geography. He could put her in charge of maps for the Confederacy. He could give her a commission. I'd have to address her as General Harriet Overton.* Davis' mention of Tennessee and the Western Theater brought John's attention back. "General Johnston will fortify Memphis and construct small forts on the Tennessee and Cumberland Rivers immediately. He will be moving troops into Nashville. Governor Harris, do you have any reaction other than the generals?"

"Sir, I believe you can count on the full cooperation of the Volunteer State."

John raised his hand. "I have a nearly completed hotel that might serve the army. It's available. I can also provide corn and hogs if needed. My railroad is at your disposal."

Judah Benjamin stood to his feet and hooked his thumbs in his vest pockets. "The Governor told us before you joined us you were totally involved in the Cause. I hope others in the south will learn from your example. I commend you."

"Thank you." The discussion of planning and strategies continued until dinnertime. John felt the train slow down and then come to a full stop. He knew the train was stopping for food and fuel, but he didn't know where. Davis read John's thoughts. "John, because we have been linked to the train, a special stop has been added to the schedule. We felt for safety purposes we needed to stop before we arrived in east Tennessee territory."

"That was a very wise move on your part." Davis pulled back a heavy curtain behind his desk to reveal a dinner table.

"Gentlemen, dinner will be served soon. The necessary is at the end of the car."

John was impressed at the construction of this special car. As he moved toward the necessary, he noticed eight pull-down beds with curtains for privacy. A table large enough to seat eight and matching chairs sat in the middle of the space. The table setting was as elegant as any he had enjoyed in New Orleans and much nicer than his at Travellers Rest. Two soldiers and a steward, dressed in a white coat, stood on the small platform outside the back door. Shortly, the steward served the meal and poured the wine. The meal was acceptable, but the dinner wine and the after dinner brandy was excellent. The gentlemen pushed away from the table while the dishes were cleared away, and a humidor of Cuban cigars was passed. Cigar smoke filled the car as the diners continued to talk and laugh. John was trying to take it all in. He planned to relive every moment with Harriet. At some point before reaching Chattanooga, Davis engaged John in a side conversation. "John, do you have any sons old enough to be involved in the military?"

"I have a nineteen-year-old who can hardly wait to put on a uniform."

"The Congress has issued an order that allows for an exemption of one male member of the family for every twenty slaves they own. How many slaves do you have on your plantations?"

"I have nearly sixty in Tennessee and another thirty or so in Mississippi."

"Governor Harris can provide you with the exemption forms, if you need them." There was an air of question in Davis' last statement and John did not respond. With his next question Davis changed the subject. "John, do you remember Andrew Jackson?"

"I was about three years old the first time he ran for President. I recall him being a tall man. The second time he ran in 1828, I was seven. He, my father, and Sam Houston had many meetings at our home. There was always lots of laughter. At times, six or seven men gathered. Mother tried hard to keep my two sisters and me out of the way as much as possible. I can remember going to bed at night hearing loud voices and laughter coming from my father's office downstairs."

"That is so interesting. One of these days I would like to come by Travellers Rest and visit where all that history took place."

"You are welcome to come anytime. My mother, who is now seventy-nine, could tell you many stories about my father and Tennessee politicians. Her best stories are about Rachel Jackson. They were the best of friends." The conductor entered the car and spoke to Davis.

"Sir, we will be stopping the train in about ten minutes to put your car on a side rail."

"Thank you. We'll be ready." Davis saw that John was confused by the announcement.

"John, my security people are making the arrangements, and they felt it might be best if I did not stop in Chattanooga. Somehow my car will rejoin a train heading north to Knoxville, up through Virginia, and on into Richmond. When they unhook us shortly, there will be plenty of time for you and the Governor to board the regular train. I'm delighted to have had this time with you. I appreciate your support of the Cause. Perhaps one day we can meet at your home, and I can enjoy the company of your fine family."

"The pleasure will be ours. I bid you farewell and God's blessings." The two men parted with a handshake. John bid farewell to the other gentlemen in the car and left the train with the Governor. At the Chattanooga station two carriages and drivers waited near the platform.

"John, did the President say anything to you about your role in the war?"

"He mentioned something about exemptions from joining the military. He indicated you had some forms in your office."

"I talked with President Davis briefly. He authorized me to commission you to a rank of Colonel, attached to the Army of Tennessee. He suggested you use your wide span of contacts and influence to aid the Cause."

"That sounds like a good fit for me. I know my son wants to be involved. I'm selfish enough that I'd like to find a position for him where he could use his educational and horsemanship skills."

"Would he consider being an aide or a courier on a general's staff? John, let me do some checking and I'll be back in touch with you."

"Governor, I cannot thank you enough for getting me involved with President Davis and his Cabinet. That was an experience I'll always remember."

"President Davis said the same thing. He was sorry the time was so limited." The two men parted. The Governor returned to Nashville to prepare the state for war; John spent an agonizing two days closing the bank and severing his relationships with the directors and employees.

For Harriet, a few days of separation from John seemed like an eternity. She missed him terribly when he was away. Even the responsibility of running Travellers Rest did not fill her every waking moment. A number of times each day she looked at her watch and tried to visualize what John was doing. When she judged his time of travel, she always feared for his safety traveling on the train.

Today's reunion was special because they each had a lot to talk about. The whistle from the afternoon train passing the house was her clue that John would be home soon. She checked her hair in the mirror one last time, flattened the wrinkles on her day dress, and headed out the door to greet her beloved. Her children were in the yard playing under the watchful eyes of their half-sibling John.

"Children, guess who's coming up the road?"

"Father is coming!" Jackson May, at five years old, had an overabundance of energy and started running down the road. Martha and Mary joined their mother in front of the house. John held Elizabeth and gathered with the others. The quartet of greeters watched as the buckboard stopped, and Jackson May climbed into his father's lap. John's welcome home was fit for a celebrity overflowing with hugs, kisses, and laughter.

After dinner that evening and the children were in bed, the adults in the Overton family talked as they gathered on the lower gallery. Harriet and Mary both had news from their sister Annie. Mary began, "Annie and the girls are coming to Tennessee. They will be stopping in Memphis before coming to Nashville. She is hopeful of making contact with Robert Brinkley while there." Mary sat back in her chair, pleased with her report. John looked at Harriet, who stated, "I, too, have news from Annie. In addition to her coming, Thomas is traveling with the Texans to Richmond, Virginia. He is applying for a commission in the Confederate Army."

John shifted his weight in his chair waiting his turn and found himself inwardly excited at the mention of the word *commission*. He posed a question

Harriet had already considered. "Harriet, why don't we invite Annie and the girls to stay with us?"

"That is very kind. We could arrange the upstairs parlor again to accommodate them without much trouble." Harriet's thoughts wandered even as she spoke. *The three Maxwell sisters back together again under the same roof. Good can come out of tragedy.*

"I'll wire Robert and tell him to be on the lookout for them and relay your invitation." John lit his pipe and prepared to report on his recent activities. He began with the bank, knowing Harriet would be happy. "The directors made the decision to close the bank in Chattanooga. Some of the clients withdrew large amounts of funds, fearing the current situation. The gossip in Chattanooga is that the city is a target of the Lincoln administration. He sees the city as a gateway to the eastern states in the Confederacy. Many of the families are leaving and moving south."

"But I thought," Harriet commented, "East Tennessee was pro-Union and would welcome Federal troops."

"They are, but many realize their city and surrounding area will be a battleground when the insurrection becomes a war. The Federal generals realize Chattanooga is at the center of the rail system connecting the entire eastern seaboard." John reached into a leather pouch on the floor next to his chair and pulled out a newspaper.

"Father, your railroad connects Nashville with Alabama. Do you think it will play a part in the war?" John's interest and excitement about the war was a little disconcerting for his father and Harriet.

"Yes, somehow, I believe the war will come to our doorstep." John unfolded a copy of *Harper's Weekly* and held up the front page for all to see.

"Do you all know these men?" There were no positive responses. "The men pictured here make up the provisional government of the Confederate States. The gentleman seated at the table is Jefferson Davis. President Davis, these three men, and Governor Harris had a meeting on the same train I was on going to Chattanooga."

"Father, did you get to see President Davis?" Young John took the *Weekly* to get a closer look.

"Yes, I rode in his special railroad car for several hours. He talked about his plans for the military and Tennessee's involvement. We had dinner together. He knew all my personal history. He knew about my father's friendship with Andrew Jackson. He also knew that the Overtons had property in Memphis and Mississippi."

"Son, what on earth was he doing on a train to Chattanooga?" Mary Overton's ears always perked up when she heard the name of Andrew Jackson.

"He and his Cabinet members are on their way to Richmond. That has become the new capital of the Confederacy."

"That's where Thomas is going. I guess," Harriet noted, "he's going there to meet the military staff and find out about his commission."

"Speaking of commissions," John smiled, "The Governor has offered me a commission in the Army of Tennessee." Young John clapped his hands in excitement.

"Are you a general?"

"No, nothing that grand. He did offer to make me a colonel in the army."

"John, as important as that sounds, I hope you declined the offer. I understand you can be exempt because of your slave holdings," Harriet remarked.

"That's true, but I don't want to be accused of not being involved."

"Yes, but I know how you get totally involved in anything you do."

"But Harriet, there's already talk that this is a rich man's war and a poor man's fight. If this conflict escalates as much as some think, all of us will be affected. President Davis felt I could use my contacts and influence to help the Cause."

"I can tell by the tone of your voice, you have already made the decision to fully support the Cause. Overtons have always been united and the Cause will be no exception. We are together!"

Young John echoed Harriet's passion and inquired, "Father, how can I be involved in the Cause? When can I join the army?"

"We will talk when the time comes, but now is not the time."

Since John had time on his hands, he became a student of the conflict. He continued to have the Chattanooga newspaper sent to Travellers Rest, and it continued to foster a Union slant. The local newspapers provided a counterpoint . He added the *Harper's Weekly* to his must read list. The *Weekly* provided drawings of the personalities in leadership roles, battlefield maps, and occasionally drawings of actual battles.

From the first time Harriet heard the word Cause, she never used any other word to describe national events. On a daily basis, she would inquire, "John, what's happening for the Cause?"

"General Johnston's men have nearly completed Fort Henry and Fort Donelson up in the Dover area."

"Now tell me again, why do we need forts there?"

"The two rivers—Tennessee and Cumberland—are direct paths into middle Tennessee. Those rivers are vital for our safety here in Nashville. Look at this." John handed her the local newspaper. "It looks like we have a new hero in the Confederacy." Harriet read the headline in bold type, **GENERAL THOMAS JACKSON STANDS LIKE A STONEWALL AT BULL RUN BATTLE.**

"Did you read the account of the battle?" Before John could answer, Harriet was reading aloud, "General Thomas Jackson became a battlefield hero, and as a result, received a nickname from the troops. This little-known teacher from the Virginia Military Institute was spotted in the heat of battle

atop his horse encouraging his men to fight. As the battle swayed back and forth, someone called attention to Jackson being like a stonewall. His bravery was the spark that brought victory for the Confederacy at Bull Run, Virginia. When Jackson retired from the battlefield, shouts of 'Stonewall' could be heard from our men in gray." Harriet folded the newspaper and handed it back to John. "A hero for the Cause, General Thomas Stonewall Jackson. John, it seems this family can't get away from those Jackson fellows." He laughed.

The next week, when the *Weekly* arrived, on the front page was a drawing of General Stonewall Jackson and a retelling of the Bull Run battle. The article kept referring to the Battle of Manassas, which confused Harriet a little until she realized the foes had a different name for the same encounter. *Regardless,* she thought, *our men won the battle. That's really the important fact.* She was tempted to cut out the drawing of Stonewall and place it with her map, but she knew John would want to see the *Weekly* intact.

Later that evening, after John returned from a meeting in the city, he did review the *Weekly*. "Harriet, you may want to save some of these drawings for the children. In fact, you may want to cut out some of the drawings for them."

"Good idea, I'll do that." John and Harriet had been married for eleven years. She was constantly amazed at how much they thought alike.

"I had an interesting encounter today. I was having lunch with John Lea, and William Driver came up to our table."

"Is he that old sea captain who displays that funny-looking flag?"

"Yes. He talks so fast it's hard to understand him."

"What did he want?"

"He wanted to sell me some items for the hotel."

"I had to tell him I had stopped construction on the hotel because of the war crisis. I told him most of my workers had joined the army. He had a strange response."

"What did Mr. Driver say?"

"He told me not to worry. He said, 'The Union Army will be in Nashville soon and the Confederate prisoners could be used to build the hotel.' He laughed when he said it, but he seemed to be serious."

"Did you tell him about Bull Run? Does he know the Union soldiers ran all the way back to Washington City in fear for their lives?"

"Harriet, I almost forgot. There was a wire for you at the depot. It's from your sister in Memphis." John dug into his pouch for the wire. Harriet read the few words with a big smile on her face.

WILL LEAVE HERE TOMORROW. WILL HUG YOU AND
MARY IN TWO DAYS. AMC

Harriet was so excited. She went looking for Mary and found her in the weaving house talking with Matilda. "Mary, I have great news! Annie and the girls will be here in two days!" The two sisters hugged and went arm-in-arm back to the house.

"Harriet, you were wise to fix the parlor for Annie and the girls."

"Just in time, too!"

"I know this conflict we are in will bring trouble, but it is bringing our family back together."

"I guess it's like one of Mother's sayings, 'All sunshine makes a desert.'"

# 19. Family Crisis

Harriet liked having a full house. She was happy when every bed in the house was filled at night. Young John had moved to the storage room above the family dining room. Annie and her daughters were comfortable in the upper parlor. Mary Maxwell requested that an extra bed be put in her room for Martha. The children's governess, Fraulein Huber, stayed in the passageway between the 1799 and 1808 parts of the house. It was the only room in the house without access to a fireplace. That situation was not a concern until winter months. Then, on really cold nights, the trundle bed in Mary's room was pulled out for Miss Huber.

With a full house, more meals were taken in the large room with a large table for the adults and a smaller one for the children. Most times the small family dining room was used, and Harriet instituted two seatings for each meal. The governess sat with the children and directed the seating and eating activities. Maria was always on hand to help the smaller children. The kitchen chores increased but were handled with ease by Cynthia who was assisted by the aging Emily.

Six children—five girls and one boy—ranging in ages from eight to one filled the house with peels of laughter and, at times, crying. There were plenty of mother-types in the house to handle childhood squabbles. Even Grandmother Overton took her turn. On one occasion she reprimanded Jackson May, telling him why gentlemen did not hit ladies, regardless of age.

The female cousins had wonderful times together playing dress-up and having tea parties. Martha was always the leader inside the house. When activities moved out of doors, the Claiborne sisters took over with their army life experiences and cowboy adventures. Mollie had just turned six when she arrived at Travellers Rest. She was blessed with a vivid imagination, and it took over when the children played under the large trees. Four trees in particular, down between the barn and the smokehouse, became her imaginary fort. She explained to her cousins, "We are inside the fort and over there is the big gate that swings open to let the soldiers in and out. We need to keep the gates closed to keep out the Indians."

"What kind of Indians are they, Mollie?" Jackson May liked being in the fort because Mollie made him the guard at the gate and he had an imaginary rifle.

"Oh, they might be Apache, but mostly they are wild Mexican Indians. So make sure you keep a sharp eye out for them." With Jackson May busy at the gate, the girls could go about living life in the fort. Sometimes cowboys would come to the fort and Mollie would explain why they were there and what a cowboy did in real life. This discussion would always allow Martha to add

some reality to the playtime. "I have a pony and I can ride it all by myself. In fact, I may go and ride Max now." There was an air of privilege in her voice.

"No, you can't!" Jackson May's voice could be heard all the way to the gallery. "You can't leave the fort now. There are wild Mexican Indians out there and they may hurt you if you ride Max now."

Martha did find occasions to be recognized for her age while relating to her cousins. She had the advantage of knowing how to read and shared her skills with them.

As the heat of August turned into the pleasant breezes of September, governess Huber would spread a large blanket under the shade of a tree, gather the children, and Martha would read. Mollie sat next to Cousin Martha as close as possible because she wanted to see the words in the book. She was eager to develop her own reading skills.

Annie brought a perspective to the dinner conversations that helped during the early phase of the war. She knew military language, including the meaning of rank, the size of military units, and how they were divided. One evening she even impressed John and young John when she began defining corps, divisions, brigades, battalions, and companies by using pieces of china and silverware on the table. She helped the ladies understand the difference between infantry, cavalry, and artillery units and how they function in battle.

"You are quite good at this, Annie." Harriet wanted to be encouraging.

"Well, when all you hear, like I have for the past few years, is military language, you begin to understand."

"Do you have any idea where Thomas is?"

"He sent me one letter while we were in Memphis."

"How did he know where you would be staying?"

"When he left Texas, we agreed he would send mail to the recruiting office and Travellers Rest. It's a little trick military families use. Thomas has been assigned to General Beauregard's staff."

"So he was at the battle of Bull Run?"

"Soldiers are not allowed to give their locations. Yes, he could have been at Bull Run, but I don't know for sure." Young John was on the edge of his chair listening to the conversation. He thought it would be a good time to make a comment.

"I bet Thomas helped run those blue coats all the way back to Washington." Every time the war was discussed he got excited. Harriet glanced at her husband with a question in her eyes that he fully understood. *Have you talked with your son about the army? Are you going to allow him to enlist?*

"Annie, did you know Father had dinner and a meeting with President Jefferson Davis?"

"No, I've not heard that." Annie turned in John's direction.

"I just happened to be at the right place at the right time. I was on the train to Chattanooga. The Governor of Tennessee was on the train for a private

meeting with President Davis and three of his Cabinet members. I was invited to join them and was quite impressed with Davis."

"He must have been on his way to Richmond."

"Yes, he was. He wanted to be closer to the action."

"Tell Annie about the end of the trip." Harriet had heard John's account a number of times and thought it was fascinating.

"The entire train stopped west of Chattanooga to unhook President Davis' car on a side rail. Somehow his car was connected to another train going north for the rest of the trip to Richmond. The Governor and I got back on the regular train and continued to Chattanooga."

"So, John, what is Jefferson Davis like?" Annie wanted to hear more details.

"He is very focused on the war. It may just be the times we're in, but his conversations seemed always directed to some phase of the Confederacy. He's concerned about being able to stay in political and military contact with all eleven states. He wants the right people in leadership roles. He would prefer to have military-trained men leading the armies and not count on the political appointments. Take me, for example. He wants me in a supportive role. I can raise money. I can find resources. He wants me to draw in the businessmen rather than having them leave the country. He really would like the United States Government to recognize the concerns of the southern states. If the disagreements could be settled around a conference table, Davis would be very happy."

"Well, that's not going to happen." Harriet held up a copy of the *Weekly*, displaying a drawing of the Bull Run battle. "We've already had blood shed on both sides. One battle does not make a war. Abraham Lincoln will not allow the Union to be divided. There will be more blood shed in the days ahead." Those around the table didn't like hearing what Harriet was saying, but they knew she was correct. Somber days lay ahead for the families at Travellers Rest.

Hundreds of miles to the northeast of Nashville, President Lincoln was also in a somber mood. He studied the large map of the United States on the wall of what had become the war room. His cabinet members watched as he ran his finger along the Kentucky border, stopping at a small dot. "Mr. Secretary Cameron, what military activity do we have in Paducah, Kentucky?"

"Sir, I defer to General Scott for an answer." General Scott and the newly appointed General George McClellan sat in chairs away from the Cabinet members but near the wall map.

"Mr. President," Scott's voice was weak, "General Grant has wired that he is occupying the city and in control of the traffic on the Tennessee River. We could move his troops to help solve the Missouri concern, but I advise against it."

"I agree with you, General. Grant is in the right place. Mr. Secretary, what reports do we have on the activities of General Johnston?"

"Again, I defer to the Generals." Lincoln saw clearly now that Simon Cameron was the wrong man to be Secretary of War. That was a decision demanding attention. General McClellan rose and stood by the map.

"General Johnston has a thin line of defense stretching from the Mississippi River to the mountain gaps in east Tennessee and Kentucky. He has hurriedly constructed two forts here on the Cumberland and Tennessee Rivers." McClellan ran his finger along the lines on the map, ending up with two fingers on the word *Nashville*. "We estimate," McClellan turned to General Scott for an approving nod, "total troop strength to be at 15,000 to 20,000. Troops are being moved there as we speak. Both forts will have some cannon power. Most of the troops will be infantry with some cavalry support. The role of the forts and troops is to defend the rivers."

"What's the recommendation?" Lincoln asked.

"General Scott can divert Commodore Foote's gunboats to the area. Grant's troop strength can be increased to nearly 27,000 men. We can take the two forts and capture Nashville by early 1862." Lincoln smiled broadly, stroked his beard, and looked again at the map focusing on Nashville. He turned this time to General Scott and not Secretary Cameron.

"General Scott, can your army and navy do this? This is not a pipe dream, but reality. If you can execute this plan, what do you think old Jeff Davis will do?"

"General Johnston will have to move south and Beauregard will move his troops west to support Johnston. Our spies tell us Beauregard has become too popular after Bull Run. He calls himself 'The Great Creole' and some of his troops call him 'Napoleon in Gray.' Davis doesn't like it and wants Beauregard far away from Richmond. That will leave General Joseph E. Johnston in command of the eastern line."

"Gentlemen, it sounds like we have a developing plan. Keep me informed. General Scott, I hope your health improves. We have a long way to go before we rest."

"Thank you, Mr. President." The room emptied. Most of the men in attendance that day would revisit the room many times; one would not.

Extra passenger cars had to be added to trains coming into Nashville to support the movement of troops. The train passing near Travellers Rest continued to blow the steam whistle but no longer made regular stops at the Overton Station. Folk traveling north or south waiting at the Overton Station had to wave the train down, hoping there would be space for them to board.

The children looked forward to the extra trains of soldiers passing the house. When they were playing in the side yard near the herb garden and heard the whistle, they headed for a clearing where they could wave at the soldiers as they made their way to Nashville and then on to the river forts. They were close enough to the train to see soldiers with happy faces, singing songs and waving flags and banners. Then there were the sad faces with blank stares glancing at the children but making no sign of acknowledgment. On one of

those train-viewing days Jackson May was in the large room with his mother and the other neighborhood ladies Harriet had invited to come and roll bandages for the Cause. Mrs. Ewing was showing a Confederate flag she had fashioned from a wedding dress. "Harriet, I wish I could find a way to get this flag to the appropriate military people. I'd like for it to be used in the Cause."

"That's a splendid offer. I'm sure there must be a way. Perhaps John may have a suggestion."

"I would be ever so grateful if you would ask him." Jackson May held out his hands and Mrs. Ewing handed him the flag.

"Mother, could I give this flag to one of the soldiers on the train?"

"That would be too dangerous for you to get that close to a moving train."

"But Mother, sometimes the train stops and waits. I could do it then."

"The flag belongs to Mrs. Ewing and the decision is hers."

"Harriet, if Jackson May can find a safe way to deliver the flag, I will be happy for him to do so." The look in his eyes told Harriet he would try his best to deliver the flag.

"I'll tell you what, Jackson May, you go find Martha and the three of us will talk about a plan." He returned shortly holding Martha's hand. Although they were almost three years apart in age, a recent growth spurt made him nearly her height. Regardless of age or size, Martha was always in charge.

"Martha, would you feel comfortable in going down to the train when it stops?"

"Mother, do you mean all the way down to the Overton Station?"

"No, down there," pointing in the direction of the Mary Overton's herb garden, "where the train stops that's loaded with soldiers."

"Yes, I believe we can do that."

Their chance came that afternoon. When the whistle blew, Harriet went to the window to watch her children disappear down past the tree line and out of sight. The underbrush was heavy, but Martha and Jackson May wiggled their way through the maze. He unfolded the flag, holding two corners while Martha held the other two. The train had slowed and then stopped. "We have a flag for you." Jackson May was almost yelling as he made the offer. Three soldiers jumped from the car platform and landed so forcefully the children were alarmed. Martha dropped her side of the flag and ran up the hill toward the house and safety. Her little brother was right behind her. They both were huffing and puffing when they reached the gallery. Harriet was there to meet them. "What happened? Why didn't you give the soldiers the flag?" Jackson May was unaware he was still holding it. As Mrs. Ewing stood in the doorway, she was disappointed to discover her wonderful flag had not made it to support the Cause. Harriet took the flag, folded it with care, and looked at her friend. "We will find another way to get your wonderful flag to the Cause." They returned to the large room to work on bandages, both touching the flag.

John's return to the plantation was met by those eager to search the contents of his mail pouch. Annie was anxious to hear from Thomas. She wanted to know where he was and that he was safe. She didn't want her daughters to lose touch with their father. In late September a letter arrived from Thomas, to the delight of Annie and the girls. With the letter in hand, Annie took Mollie and little Harriet to their makeshift bedchamber on the second floor. Each communication from Thomas was a special event for them. The girls sat next to their mother as she opened and read—

*My dearest Annie,*
*I am on the move. My health is good. I think of you and the girls*
*each day. I send a kiss for 'M' and one for 'H' on this paper. The*
*rest of the page is filled with kisses for you, my love. When you*
*embrace this paper, think of me. Pray for me as I do for you.*
*Your devoted husband,*
*Thomas*

Annie and her daughters sat a long time holding the letter. It was their only contact with their loved one far away. When they returned downstairs, the family was gathered in the large room. Harriet was intently reading the *Weekly*. She looked up when Annie entered the room. "I hope you have good news from Thomas."

"He is in good health and is on the move. He didn't—couldn't—say where."

"The *Weekly* reports a large portion of the Confederate Army is moving west."

"Do they report how?"

"Let me see. 'General Beauregard and his troops boarded the trains in Richmond heading west.' The article goes on to recount his victory at Bull Run. It appears he has become a hero of the battle and his troops are calling him 'Napoleon in Gray.'"

"Thomas is on General Beauregard's staff. That's wonderful. At least, he is not involved in a battle. I wonder what 'west' means. I need to look again at your map."

"There's a drawing of a General Grant who is occupying Paducah, Kentucky. The reporter questions, 'Does General Grant have a drinking problem?' That's all we need, a drunk in charge of
guns. I hope he stays where he is and doesn't have any ideas of coming south. John, what is the mood in the city?"

"Funny you should ask. I drove down by the hotel this morning and it is filled with troops. Someone made a hand-painted sign and nailed it over the front entrance. The Maxwell Hotel is now the Zollicoffer Barracks."

"I thought General Zollicoffer was in Knoxville."

"I believe he is, but part of his army must be in the hotel."

"I talked also to one of the officers at the recruitment station today. There is an infantry regiment being formed. I believed he said it was the 44th Tennessee. I know John wants to get involved."

"Are you sure the infantry is where he needs to be?"

"The recruiter indicated John's level of education and his horsemanship would be taken into consideration. He could join the 44th for training and then be transferred. John has not said anything to me recently about the army. I'll wait for him to broach the subject."

"Thank you for that. If you have to be away from the plantation for any length of time, I'd like to have John here to help me manage the place." Cynthia and Emily entered the room to announce dinner in one hour. Harriet noticed how frail Emily looked. She followed her to the kitchen. "Emily."

"Ya, Miz Harriet. What can I do fer ya?"

"Emily, how are you feeling?"

"Tolerable, jest tolerable."

"Why don't you go out to the weaving house with Matilda and rest a while?"

"Ya, ma'am. I's goin' to takes my rest."

Little did Harriet realize those would be the last words Emily would speak. The next morning Matilda knocked on the kitchen door. "Cynthia, come quick. Emily passed over in da night." The adult family members were gathered in the small dining room for breakfast. Cynthia whispered the sad message in Harriet's ear and then followed her to the weaving house. Matilda returned to the house, "Miz Mary and Miz Annie, please comes wid me." They heard Harriet sobbing before they entered the small room. Cynthia had her arm around Harriet. "What's the problem, Harriet?" Annie was the first through the door.

"Sweet Emily has taken her rest." The three sisters embraced as they gazed on the still body that reminded them of their past. Mary brushed away her tears. "She was a good person. She took good care of our family all these years."

Harriet made arrangements with the new owners of the Hall to bury Emily next to Julia. Emily had a new dress and a pair of Mary's shoes. Annie made a bonnet to match the dress. Claiborne built her wooden box. Harriet tried to locate the Reverend Merry to conduct the funeral, but he was out of town. Eli had agreed to say the final words, and that was fine with Harriet.

Winter was in the air the morning the last bit of dirt was placed on Emily's grave. The Maxwell sisters watched as Cynthia dropped pieces of broken earthenware on the fresh dirt. Harriet was left alone with her thoughts. *Goodbye, sweet Emily. Find your rest. You have been so faithful to me and the entire Maxwell family. I will miss your smile, your kind thoughts, and most of all, your walnut cookies.* Harriet smiled as she joined John in the carriage, never revealing her countenance reflected the memory of walnut cookies.

The death of Emily, the decision of young John to sign up for the 44<sup>th</sup> Tennessee Infantry, and the early snowfall weighed heavily on Harriet as she looked to the holiday season. The family had already decided there would be no overnight houseguests this year. The house was full of people and Harriet didn't want to disturb the established routine.

The governess took charge of the children as they prepared holiday decorations for their rooms. Archer brought a wagonload of greenery to the gallery. Harriet was delighted that Annie wanted to be in charge of decorating the house for the season. This would be her first time, in many years, to be home for the happy family events. She involved her daughters in decorating as the greenery—holly with red berries, small boughs of pine, ivy, and mistletoe—was cheerfully displayed throughout every room in the house.

Cynthia announced at breakfast, "Eli be comin' wid da fruits dis mornin' and da sugar off da boat." Mollie looked up from her breakfast, "Mother, what did Cynthia mean?"

"Well, maybe your cousins Martha and Jackson May can tell you." Martha wiped her mouth with her napkin; Jackson May continued to eat.

"When Eli returns he will have a wagon full of fruit. He will have oranges, lemons, grapes, shinny red apples, and . . ."

"Don't forget the pineapples!" Jackson May had a mouth full of food when he blurted out.

". . . and pineapples. Really, Jackson, must you be so rude? You know you never talk with your mouth full of food." Harriet made eye contact with her sister Mary, who had already hidden her quiet laughter behind her napkin. Harriet followed suit, as did Annie. Jackson May knew he was outnumbered at the table, so he concentrated on eating and not interrupting his sister.

"What are pine—apples?" Mollie knew the two words, but not put together. Martha continued to control the table conversation.

"A pineapple is a fruit grown in the islands way south of the United States. They have a dull yellow body and green tops with sharp points. When all of that is cut away, inside is a sweet, juicy, bright yellow fruit that can be eaten as a dessert, or sometimes it becomes part of a cake."

"Excellent. Martha, that was a good description." Harriet did not need to encourage Martha, but she did. "And what about the sugar?" Jackson May's hand went over his head and began to wave in his mother's direction.

"Yes, Jackson May. Would you like to talk about the sugar?"

"Yes, ma'am. Sugar is white and brown. It looks like little trees. The sugar comes from New Or— . . ." His delay with the last word was ample time for Martha to finish his sentence.

"New Orleans! And the sugar does not look like little trees. It is in the shape of cones." Martha had a wide smile on her face as she glared at her brother across the table.

"That doesn't sound like the holiday spirit to me. I believe you owe your brother an apology for interrupting him." Harriet and Martha's eyes were in locked position. "Martha, did you hear me?"

"Yes, ma'am. I heard you."

"Well?"

"I was correct and Jackson May was almost cor—." She stopped when Cynthia pushed the door open and announced, "Eli here wid da holiday supplies." Jackson May was the first to push his chair back and run to the window. All the children looked as Eli placed each crate of fruit on the gallery under the window where the children were watching. The last wooden box unloaded and placed with the others was marked, **New Orleans Sugar Company. Sugar Cones. Handle with Care.** Martha smiled as wide as she could, but didn't say a word.

Harriet remained in the room while the others left for various activities. She heard the stairsteps creak before young John Overton opened the door and entered the room. "I hope all the commotion didn't disturb you."

"No, not at all. I've been up for a while reading. I've been reading about Andrew Jackson and the Battle of New Orleans. I have testing at the University after the holidays."

"You know your grandfather and Andrew Jackson sat in this room, around this table, and talked about the Battle. This part of the house had just been built. Your father was about seven years old."

"Maybe I should bring my book down here and read. Maybe these walls have a message for me from the past."

"Some of the secrets these walls have heard will never be known. Do you realize those two men were just a couple of years older than you are now when they came to this area of the country?"

"Tennessee wasn't even a state when they came here."

"That's true. John, if you have a minute I'd like to talk with you about another subject. Do you realize that's the first time I've ever used your name without the word little or young in front of it? When you were six, I started tutoring you. Your grandmother asked me to call you John III. That didn't last very long."

"I know it's confusing. It's really funny to be in a room with my father, my Uncle John Lea, and me. We all answer to the same name."

"What I want to talk to you about is the decision you made to enlist in the army."

"Father told me I needed to talk with you about that."

"The day I married your father, I vowed to support him. I have not always agreed with some of his decisions, but I have supported him. I'm not sure I agree with him now about you and the military."

"Harriet, I was nearly the last in my class at the University to enlist. Some of my classmates have already gone and are in training. I never want anyone to

look at me and say I was a coward, that my family's money kept me out of the war."

"John, you are not a coward. Your father's money could honestly keep both of you out of the war. We could send you to Pass Christian, or Cuba, or Europe until this conflict is over."

"No, ma'am. That's not going to happen."

"All right, tell me about the 44th Tennessee."

"This unit is under the command of General Albert Sidney Johnston and we are to begin training soon to be ready for duty when ordered."

"What does training mean? What will you be doing?"

"On Saturdays and part of the day Sunday we will be learning to take orders, march in formation, fire rifles, and respond to field commands. At night, we'll camp out and eat army food."

"So you will be able to stay in school until you are needed for military responsibility."

"Yes, until we are called up."

"Where will all the training take place?"

"Father has arranged for us to the use the land around St. Cloud Hill. That's the property Grandfather Overton willed to Aunt Ann Brinkley."

"That's where I used to take you and your cousin Annie on picnics years ago."

"The very same."

"Well, John, I do feel a little better after hearing your explanation. Will you get a uniform?"

"Yes, but it will be a while."

Annie and her girls entered the room laden with greenery for the mantel and the windowsills.

"Excuse us. I didn't realize you were in here. Good morning, John."

"Good morning, ladies."

"John and I were just talking about his military responsibility. He's going to have a gun and a uniform."

"Oh, John," Annie blinked her eyelashes, "I just love a man in a military uniform."

"That's what I understand." With that said, he headed for the kitchen to find some breakfast. Annie and the girls busied themselves with decorating; Harriet went about the house checking on the warmth of the rooms.

The Twelfth Night celebration at Travellers Rest in 1861 was remembered as a somber time. The laughter and excitement of small children running about the house brought needed relief for the adults who were caught up in the daily reports about the war. John and Elizabeth Lea decided to forego an open house event because of the times. They did come to see the Overtons during the season, allowing Elizabeth to spend time with her mother. Mary Overton was feeling her age. At seventy-nine, age was taking its toll on her body. Most of her days were spent in her favorite rocking chair looking out the window and

remembering. She entertained guests in her room and most often had meals with them there. She joined the family for special occasions in the large room and was always honored as the matriarch of the family.

Elizabeth's visit with her mother was uplifting for both of them. They laughed together and remembered events that had taken place years ago. "Mother, you should come to Lealand and stay a while. I'd love to have you, and you could spend time with your other grandchildren. The boys adore you and love to hear your stories about the old days."

"I may do that in the spring, but in a couple of days Margaret Jane is coming to pick me up and I'm going to spend some time with her and Jesse." Elizabeth saw the twinkle in her mother's eye and knew the visit in the Phillips' home had priority. "And you would never guess in a hundred years what's going to happen while I'm there."

"No, you need to tell me."

"Mary is coming for a visit."

"How is Mary doing?"

"She still pines for Richard. His death took so much out of her. She really has never recovered."

"She should have taken a lesson from you. How old were you when your first husband died?"

"I was thirty-five when Francis passed. The year was 1817. We were married for seventeen years. He built us a wonderful house, which is still standing on the Granbery property. He practiced medicine and I took care of our five children." Tears filled Mary's eyes and her voice got softer. "After his death, I had to give up my home and move to Knoxville with my brother Hugh. Three years later, I met and married your father and moved to Travellers Rest. I've lived here forty-one years, Elizabeth; you and your brother and sister were born in this very room." Elizabeth had heard this same account many times but never tired of hearing it again.

"Mother, thank you for reminiscing with me. I'm going to leave now so I can get back home before dark. You have a wonderful stay with Margaret Jane and Mary. I'll want to hear all about it when you come and stay with me in the spring."

"Thank you for coming, Elizabeth, and you have a happy holiday season."

Elizabeth hugged and kissed her mother. She realized on her way home that each visit with her aging mother could be the last. She wiped away tears.

With snow still on the grass a light covering of ice fell, making everything sparkle in the sunlight. It was cold and slippery outside, but John still needed to make the trip to the city for a meeting with the railroad directors. Harriet insisted, "John, take a change of clothes with you in case you need to stay overnight. If the weather is bad, check into a hotel and stay safe. I can handle the plantation until you return. Remember that Eli needs lodging as well."

"Harriet, I know this plantation is in good shape with you here. I'll try to make it back this evening if the weather permits. I'll be back tomorrow by noon for certain."

"I will never understand what is so important that it can't wait until after the holidays."

"General Johnston is demanding we turn over to him the operation of the railroad. The directors and I want to be assured of compensation if that happens. Troops are moving in all directions, in and out of Nashville, and the General wants to control all of the traffic. There is still some civilian travel on our line and we are trying to protect it."

"I thought you told me everything you owned was at the disposal of the Confederacy."

"It is, but that's not the position of the other directors. I'm hoping they will listen to reason. If they become stiff-necked about the matter, the army will take everything. If we can talk to the General and he understands that we need the rail to get our goods to market, he may allow us to maintain control and compensate us for the military's use."

"Well, good fortune." She kissed him and gave him a hug. John was off to the city; Harriet returned to their bedchamber, sat by the fire, and read the latest edition of the *Weekly*.

When John arrived at the city square, the place was alive with commerce and activity. There was little evidence that the nation was at war. He noticed the usual military presence was gone. Since he had a little while before his meeting at the St. Cloud Hotel, he directed Eli, "Drive on down by our hotel." He was surprised to see only four soldiers standing at the entrance. The middle-aged soldier appeared to be in charge, as he ordered two of the others to find some wood for the open fire they needed for the cold weather. "Sir, where are all the soldiers?" John directed his question to the oldest man.

"They've headed east to meet up with General Zollicoffer. Big doings about to happen up in Kentucky. Those blue bellies are about to take another whippin' from us."

"Thank you." As Eli pulled the carriage away, John was surprised how easily he got information about troop movement. *I wonder what a Union spy would do with that information. How would a spy get information to the Union Generals? Troop movement to a specific location is very important information.*

General Johnston sent a staff aide to represent him at the meeting with the railroad directors. As the aide entered the room, he looked at the five directors. They had been there for some time discussing their strategy. "Which of you gentlemen is Colonel Overton?" That's the first time he had been addressed by a military person. John was a little embarrassed, but he liked hearing the title. All of his life he had heard his father addressed as Judge John Overton. Now he had a title—Colonel John Overton, CSA.

"I'm John Overton." He introduced the other directors and the meeting began.

"I'm Captain Cook of General Johnston's staff. He has instructed me to read his decision related to your railroad."

> *For the present time, the Nashville-Decatur railroad line will be managed by the current directors. The military will have priority use of the line and may, at any time, interrupt the schedule routine. Compensation to the Nashville-Decatur line for transporting military personnel will be a quarter of the normal rate. Payment for services will be approved in my office after proper forms have been received.*

"General Johnston has signed the order and has requested that you gentlemen sign and date a duplicate for his files."

John Overton was the first to sign the order. "Please convey to the General our appreciation for his willingness to allow the operation of the line to stay in our hands. We fully understand this arrangement may change at any time."

"I will do that, Colonel, upon my return to headquarters. If we are finished, gentlemen, I have personal business with Colonel Overton." The announcement surprised John, and he was anxious to know more about the personal business. After the other directors left the room, Captain Cook removed an envelope from his coat pocket and handed it to John. Colonel Overton, I must be getting back to headquarters."

"Captain, do you need a reply to his letter?"

"Sir, I was instructed to hand the letter to you. I will be happy to wait while you read it. If a reply is required, I will be glad to deliver it." When John turned the envelope over, he noticed it had a wax seal with initials CSA. The Captain smiled at John's reaction. "It looks official."

"It is official, sir. It came all the way from Richmond from the office of the President. Excuse me, sir, my chatter is keeping you from the letter." John glanced to the bottom of the page and found the signature of Jefferson Davis, President CSA. The message was brief but invaluable.

> *The bearer of this document is Colonel John Overton, CSA. He is under the command of General Albert S. Johnston and a personal aide to me. He is authorized to secure any items needed for military use. His signature will assure payment by the CSA in Richmond, Virginia.*
>
> *Jefferson Davis*
> *President CSA*

"Captain Cook, I have no reply."

"Very good, Colonel. I'll be on my way. It was very nice meeting you. I hope our paths will cross again."

John walked outside and watched the Captain ride toward the west. The sun provided enough heat to make the ice slushy. "Eli, do you think the carriage can make it home?"

"Oh ya, sir, Massa John."

"All right then, let's head for Travellers Rest."

The journey south allowed John another opportunity to examine the document in his coat pocket. He unfolded the page and looked at the signature a long time to be sure it was still there. He was still amazed as he thought, *He is authorized to secure any items needed for military use.* He mentally revisited places he had been in his life. He focused on years in New Orleans, the trips he had made to Memphis, traveling to Pass Christian with stops on the lower Mississippi River, and the one time he went with his father to Louisa County, Virginia to visit the Overton family. His most recent opportunity in Chattanooga had provided him contacts in the Carolinas and Georgia. The railroad venture gave him contacts at nearly every stop between Nashville and northern Alabama.

By the time he arrived at home, his mind was reeling with the thought of *authorized to secure any items needed for military use. I know where to find food and animals, but what about guns, ammunition, uniforms, blankets, shoes, tents, and medical supplies? Maybe Harriet will have some ideas.* He stood on the gallery and surveyed his property before going in the house. He could see for miles with the leaves off the trees. The sun had already slipped beyond the roofline, leaving the gallery a cold place in the shade.

Harriet was in the large room when she looked through the windows and spotted John. She walked over to the window, pecking on it several times and motioning for him to come in. She moved to the double door and opened one side. "John, come in the house where it's warm. You will catch your death out there in the cold." He removed his gloves, heavy coat, and floppy hat and placed them on the rack. "Go over by the fireplace and warm up." He leaned over, kissed Harriet, and patted her back. "Yes, ma'am, that's a good idea." He greeted the other ladies in the room.

"Would you like some hot tea or something stronger?" Harriet knew his answer and had sent the servant to the kitchen before John entered the house.

"Tea will be fine. Maybe a little touch of something stronger in the tea would be good."

"Son." John's mother was losing ground health-wise. Her voice was weak. She was dressed waiting for Margaret Jane to come and pick her up. "How did your meeting in town go this morning?"

"Quite well. The military is allowing the directors to run our railroad for the time being. The military will have priority use of the passenger cars and the flatcars. We will make some money from the CSA and still provide limited passenger and freight use for nonmilitary. The good thing is we will be able to work out hauling our products to market. Horses in this area are becoming so scarce that there is very little wagon traffic any more. I met with a Captain

Cook and he . . ." The knock on the door interrupted his sentence and he was glad. He glanced out the window and recognized his half-sister, Margaret Jane Phillips, sitting in her carriage. "Mother, it's Margaret Jane. Will she come in?"

"No, I expect she'll not get out in this cold. If you want to greet her, you'll need to go out there."

"Very well. I do want to speak with her."

"John, I'll help your mother get ready while you go to the carriage. Please give her my regards." John did not press Harriet to face Margaret Jane. Some words had passed between the two ladies early in their relationship, and they had been cool to each other ever since. He really didn't know the full account of the dispute but knew it was a matter Harriet never discussed. John greeted Margaret Jane and shared Harriet's regards. There was no response for Harriet. He helped his mother into the carriage and kissed her on the cheek. When Mary's trunk and valise was loaded, the carriage left. The second First Lady of Travellers Rest did not ask about Margaret Jane and John offered no comment.

The Twelfth Night celebration ended on January 6, 1862. The children in the house had enjoyed the special treats, especially the animal-shaped cake. The slaves stayed in their cabins resting, with extra food and a keg of the peach brandy they had produced. The house servants laughed and joked, watching the green Yule log they had selected as it spit and smoked in the large room fireplace. All seemed at peace within the walls of the plantation house. The white owners and their guests didn't say so aloud but knew life outside the walls was much different.

# 20. Separation and Challenge

Young John Overton left for Memphis the day after the holiday celebration. He was anxious to visit with his cousins Hugh and Ann. He had not seen Hugh for a while and he was eager to tell him about enlisting in the 44th Tennessee. Hugh's health continued to decline after they left school in Virginia. After a brief stay in Memphis, his father sent him to the warm springs in the west central mountains of Virginia, hoping the treatment would restore his health. Now he was back in Memphis for the holidays. The train ride was uneventful. John had hoped to see some soldiers and talk with them. He did make the trip with a couple of his classmates from the University. That was a surprise and made the trip pass quickly. One of his friends was met at the Decatur Station; the other stayed on the train all the way to Memphis. The train did not arrive until after dark. When it pulled into the station, John was fascinated to see the platform fully lighted by the recently installed gaslights. *I'll need to remember to tell Father about these lights. We need these in Nashville.* John saw Hugh first, then his Uncle Robert.

"Hugh! Hugh Brinkley! You old son-of-gun, how are you doing?" The cousins embraced and laughed. "Uncle Robert, so good to see you."

"It's good to see you again, John. How are things at Travellers Rest? I trust your father and Harriet are in good health."

"I bring you greetings from the Overton clan. Grandmother Overton sends her regards. She is still talking about her stay with you last year. Today she is visiting with her daughter, Margaret Jane."

"I remember her, a quiet sort."

"Yes, she has not changed."

"Come, gentlemen, the carriage is waiting for us." John noticed Hugh covering his mouth as he blocked a hacking cough.

"Hugh, are you all right?"

"Yes, it's just this damp, cold air." As they entered the carriage John continued to talk and he remembered some things Harriet had told him. *Remember to inquire quickly about Uncle Robert's wife. Call her Mrs. Brinkley. Ask about Ann, as well. Do not speak of the war until the subject is broached by your host. Remember, Hugh's health prevents him from taking an active part in the military.*

"Uncle Robert, how is Mrs. Brinkley?"

"Well, John, we have some good news about her. She is with child, which makes her very happy but quite uncomfortable."

"Congratulations to both of you! Am I at liberty to speak to Mrs. Brinkley about her health?"

"Oh, yes."

"And Ann, how is she?"

"Ann is well. She is no longer a little girl but a young lady with all the feelings and actions that go along with her age. She looks so much like her mother. She has the same maturity her mother displayed." Hugh uncovered his mouth and smiled as he spoke.

"She's looking for a husband. She has already asked Father about how you are related to the Brinkley family, so be prepared."

"Hugh, mind your tongue! Ann was just trying to get the family lines straight in her mind." All three were laughing as the carriage came to a stop in front of the house.

On the third day of his visit, a wire came to the house for John. He and Hugh had been in town early in the day for an appointment with the Overton family agent. Mary Overton had insisted John meet with the agent while he was in Memphis. She wanted him to be familiar with the family business and know the agent. The morning meeting was successful. He was handed a folio of papers containing updated figures on the Overton accounts. "How much land did our Grandfather Overton own in Memphis?" John thought the question from Hugh was strange.

"Grandmother told me the Judge had about 5,000 acres in the original purchase. He sold some of the land to Andrew Jackson and General Winchester."

"Do you know anything about the land in Nashville my mother inherited when Grandfather Overton died?" John wondered about that question also. Although Hugh was his blood cousin and they had been roommates at school in Virginia, John had really never considered Hugh to be an Overton until just that moment.

"My father, your Uncle John, told me the land where I've been drilling with the 44th Tennessee belongs to your family. The land is called St. Cloud Hill."

"What's the 44th Tennessee?" Hugh seemed completely surprised. "Have you signed up to fight in the war? Are you going to kill them dang Yankees if they invade Tennessee?" John was hearing the questions and remembering Harriet's instructions, *do not speak of the war until the subject is broached by your host.* John hesitated long enough for Hugh to continue. "John, talk to me."

"Yes, I've signed up and I'm a part of the 44th Tennessee Infantry. We've been drilling on the weekends. My captain gave us the holidays off, but we are on call if we are needed."

"Do you have a uniform? What kind of a gun do you have?"

"At this point, we don't have uniforms and we use sticks when we drill."

"Oh." There was disappointment in Hugh's voice. "Father has arranged for me to be deferred because of my health. I wanted to join, but he felt it best that I not."

"Hugh, your health is important, and I'm betting there will be plenty of time to get involved." John wanted to tell Hugh about his father's meeting

with President Davis and that his father was a colonel in the CSA, but he didn't mention it.

Robert Brinkley was waiting at the front door when John and Hugh entered the house. "John, this wire came for you this morning."

"Thank you, Uncle Robert." The envelope was not sealed but the flap was tucked in. John read the brief message:

JOHN OVERTON. THE 44TH IS CALLED TO ACTIVE DUTY. PLEASE RETURN TO NASHVILLE IMMEDITELY. CJO, CSA

John grabbed Hugh and patted him on the back. "I'm going to war! My unit has been called up. I must return to Nashville immediately." Hugh was in a position to see his father's eyes. He looked away and congratulated John, who was rereading the message. "John, are you sure this is what you want?"

"Yes, this is really what I want."

The two cousins went to the second-floor bedchamber to pack John's valise. Robert told the carriage driver to wait.

At the station platform, John told Hugh, "Don't stand out here in this dampness. Fortunately, I have only a little over an hour to wait for the afternoon train. I'll be fine. Go home and get out of this weather. It's not good for your health."

"John, I wish I could go with you."

"We've already talked about this. Your time will come."

"Please write to me. I'm going back to the warm springs before winter sets in. Maybe by spring I'll be fighting them dang Yankees myself."

"All right, that's the spirit. Get your health back and we'll go after them dang Yankees together." The cousins parted laughing and waving. Hugh was in better spirits than either thought he would be when they came to the station.

The train to Decatur was practically empty in the middle of the week. Robert Brinkley had sent his nephew off with a basket of food and drink hurriedly put together by his cook. John was too excited to eat, but the aromas coming from the basket were too much to resist. The conductor opened the door at the end of the car and came up the aisle toward John. "Excuse me, sir, will the train be on time for Decatur?"

"Son, this train will be on time all the way to Charleston, South Carolina. We'll make quick stops in Corinth and maybe Tuscumbia before we get to Decatur. You got a gal waiting for you in Decatur?"

"No, sir. I just need to get to Nashville as quickly as possible."

"Are you in the army, son?"

"Yes, sir. I'm reporting for duty."

"There is a train being held in Decatur for soldiers. We had a wire about it before we left Memphis. Our army seems to be on the move toward Nashville and beyond. You'll have plenty of company when you get to Decatur. Just sit back and enjoy what's in that basket. It smells really good."     John's hand found the first of two large ham biscuits. One was plain; the other was

smeared with apple butter. A medium-size jug of water helped wash the biscuits down. Two fried peach pies and a large ginger cookie were a welcome find in the bottom of the basket. One pie was broken in small pieces, and each morsel was consumed with not one crumb lost.

The conductor came back in the car to announce a stop at Corinth. John peered through the window as the train came to a stop. He watched four soldiers walk their horses to the back of the train. Shortly, they entered the car and sat in separate seats. Three of the soldiers quickly stretched out on their seats, apparently to take a nap. The fourth soldier, an officer, removed his hat, outer coat, and gloves. He sat facing John and spoke. "Good day to you, young man."

"Good day to you." John wanted to use the officer's rank, but he was not sure of the rank symbols on his gray jacket. The knee-high, leather boots and matching belt and holster also caught John's eye. He knew there must be a pistol in the holster, but he didn't want to stare. "Are you bound for Charleston?" John was hoping for some military conversation.

"Maybe."

"I noticed you and the other soldiers had horses. Are you in the cavalry?"

"Maybe." John thought those were strange answers coming from an officer. *Surely, he knows where he's going and what branch of the army he's in. Maybe if I tell him something, he'll tell me something.*

"I'm in the infantry. I'm headed to Nashville to muster in with the 44th Tennessee."

"Young man, how do you know I'm not a Yankee spy just hoping to hear information like you told me?" John glanced away several times. Each time he looked back the officer had a penetrating glare. Then a smile curled up the corners of his lips. "When we first met I was wondering about you. You were asking questions trying to get information out of me."

"Yes, and you were very . . ."

"Vague?"

"Yes, that's the word I needed."

"I was vague because you were asking for specific information."

"I was trying to make conversation with you."

"Yes, I noticed. That's exactly how spies get valuable information. What did I tell you in my answers?"

"Nothing. I still don't know where you are going or what branch of the army you're in."

"Now, on the other hand, what valuable information did you give me? I know where you're going, which unit you're in, and I know you're in the infantry. I also know your unit is getting ready to be involved. If I were a spy, which I'm not, the information you freely divulged would be a great help to my commander."

"I thought we were just talking and . . ."

"You were doing all the talking. I was picking up clues."

"How do you know I wasn't lying about all that stuff?"

"Well, I know the 44th is an infantry unit and it's being mustered in the Nashville area. I also know you have a Tennessee drawl. You've spent some time in Virginia, however, but Tennessee is your home."

"How did you know about Virginia?"

"I wager you spent some extended time in or near Charlottesville."

"You are unbelievable. Yes, I did. I went to school there a number of years, but I didn't realize my speech gave me away."

"By the way, I didn't get your name."

"I didn't give it." John laughed and hit his knee at the little victory.

"You are a quick learner. You are going to be a good soldier. Remember, if you are ever captured by the Yankees, don't give them any information. My name is Paul Cook and, by the way, my rank is captain." John extended his hand.

"I'm John Overton."

"Would you happen to be related to Colonel John Overton?" The question took him by surprise.

"Maybe."

"Excellent! Well done, soldier. I met the Colonel a few days ago. We talked about his railroad and some other matters."

"Was the Colonel a short man, about five feet four inches?"

"No, he was . . . ah . . . maybe. You did the spy thing to me again. You are really good at this."

John and Paul talked all the way to Decatur. John gave him the choice of the cookie or fried pie from the basket. Paul never did reveal his responsibilities in the army, where he had been, or where he was headed. When the train arrived, Paul and his men got off. The platform was filled with soldiers. Some of them were old, some were young, some were obviously officers, but most were standing in lines at attention. As John exited the train he spotted a young man about his age holding a handmade sign, **44th Tenn. Inf**. "What does your sign mean?"

"Are you with the 44th Tennessee Infantry?"

"Yes, I am. I'm headed for Nashville."

"Yeah, everyone on the platform is headed for Nashville. Wait over there by that big tree. We'll be going north shortly, and I don't want you to be left behind."

Harriet was standing by a window watching the smoke rise from a passing train as her husband entered the room. "Do you think he's on that train headed to war?" There was a sadness in her voice.

"He will be passing by here soon. I just hope he was able to get good train connections out of Memphis. His unit is forming as we speak. As the soldiers gather near our depot, they are being transported to Camp Trousdale for training."

"He's so young and his whole life is before him. How do you remain so calm?"

"I'm not really calm. I go to sleep thinking about him and some of my first thoughts of the day are about him."

"Are you prepared if he is taken prisoner, or wounded, or ki...?" Harriet couldn't say the word. She patted the tears on her cheeks with her handkerchief and buried her face in John's vest.

"He will be all right. He's a smart lad."

The train John was on stopped several times between Decatur and Nashville to take on passengers. He was so engaged in conversation with others he didn't realize he had passed Travellers Rest. *It's just as well,* he thought, *I don't want these men to get the wrong impression of me.*

The same young man with the **44ᵗʰ Tenn. Inf.** sign was standing on the platform as the train cars emptied. This time there was an older man, in uniform, standing with him. John went directly to the sign. He watched others walk right by asking, "Where's the 44ᵗʰ Tennessee?" The older man was yelling, "All you yahoos with the 44ᵗʰ Tennessee come right here!" In less than two minutes, two dozen men gathered around the sign. The crowd was thinning out on the platform so normal voices could be heard. "Can any of you read and write?" John raised his hand.

"I can, sir."

"What's your name, son?"

"Overton, sir."

"All right, Private Overton. Take these recruits over to the storage room, write their names and addresses in this book, label every piece of their luggage with their name and address, and wait for me there."

John didn't realize it at the time, but he had his first of many promotions. As he was performing his duty, he recalled the first time he met Harriet Virginia Maxwell. She was his first tutor and she challenged him with the thought, *if you will learn to read and write, you will become a smart man. You will be able to help others who don't know how.* He made a mental note to tell Harriet this story the next time they were together.

The relative silence of the storage room was disturbed by a demanding voice, "You yahoos line up in three lines. Private Overton, you come and stand by me. My name is Sarge. I'll be getting you ready to fight a war. All you farmhands, momma's boys, and schoolboys are members of the fighting 44ᵗʰ Tennessee Infantry. If you listen to me, I'll get you through this war and back home to your mommas. If you don't, you'll probably die on the battlefield. There are two wagons outside. Put your belongings in one wagon and find a seat in the other one. Private Overton, take the men to the wagons."

"Yes, sir, Sarge." A glancing smile passed between the two and John was on his way outside.

Camp Trousdale was a nightmare for some, an adventure for others. The first impression of the camp set the tone. There was a sea of eight men-sized tents. It looked like a hundred, at least, but there were only eighty. The tents were arranged in groups of ten with a large tent in the middle. Flapping in the winter wind was the regiment flag. It had a blue background with a wide red border, and in the center was a gold oval with two crossed guns and the letters, 44$^{th}$ Tenn. Reg. The sight of the flag brought tears to some, chills to others. The wagons pulled up to the assigned tents.

"Everybody out and line up! Private Overton, I want eight men in each tent. Some of the tents are already filled. After you finish, come to my tent over there."

"Yes, sir." In less than a day, John had become a leader with rank. He hadn't asked for it, but a number of his fellow soldiers in his unit looked to him for help. Uniforms and guns were issued to each soldier. John's uniform was issued with a Private's stripe already on the jacket.

The training was hard, Sarge saw to that. In a couple of days, other soldiers moved into the camp and the tent city swelled. That's when the competition began. Each of the ten companies in the regiment tried to be the best at marching and shooting. Toward the end of the week, all of the companies stood at attention on the parade ground. Sarge said something about "the General is coming to review the troops." Sure enough, three riders entered the parade ground and began making their way through the mass of men. John stood by Sarge as the riders approached. "Eyes front!" That was a new command from Sarge, but every soldier in his company knew what to do.

"Excellent, Sergeant." The general's words seemed to echo up and down the lines of soldiers. He turned his horse and Sarge ordered, "Company rest." Eyes darted this way and that hoping to catch sight of the general. As John turned his head, he made direct eye contact with the general's aide, Captain Paul Cook. John's eyes widened. Captain Cook smiled and pointed to his arm, making a sign of an upside down V, and gave John a quick salute. John's thoughts wandered and returned to his train ride. *No wonder Captain Cook was so indefinite on the train. He's a staff officer to General—. Who was that General anyway?* "Sarge, who was that general?

"That, son, is A. S. Johnston." Sarge spoke out of the corner of his mouth. "Private Overton, you are still at parade rest. No talking."

"Yes, sir." John tried to speak out of the side of his mouth but realized he needed more practice.

Sarge was gone the rest of the day and until the noon meal the next day. When he entered the tent there was a sense of urgency in his voice. He handed John a small box filled with pieces of paper, an inkpot, and several quills.

"Corporal Overton." The new rank was barked out with no recognition from John. "I want you to find me four of our men and make them privates."

"Sir, may I suggest I find the men and you make them privates?"

"Good idea, Corporal." He smiled and then saluted as Sarge handed him a second stripe for his uniform. He left and returned a few minutes later to Sarge's tent with four surprised men. "When Sarge hands you a stripe, salute and say thank you, sir." After a brief recognition ceremony, Sarge spoke with urgency in his voice. "We are moving out in the morning at daybreak." One of the new privates spoke up, "Where are we going?" John held his breath for the tongue-lashing he knew was coming.

"Private, when I want you to know something, I'll tell you." Sarge was nose-to-nose with the young private. Drops of spit landed on his cheeks as Sarge barked. John knew Sarge was looking at him, but he never made eye contact. "Corporal Overton!"

"Yes, sir!" John came to attention and braced himself. The four new privates followed his lead.

"I want you to go to the supply wagon and set out all the stuff the men brought with them from Nashville. Call them out. Let them take anything that will fit into their haversack. Whatever is left needs to be tagged and sent back to Nashville. Then I want each man to make and carry on his person a tag with his name and address. We will eat breakfast in the dark tomorrow and be ready to march at dawn. Any questions?"

"No, sir. Privates, you heard the orders. Why are you still standing here? Get your butts to the supply wagon and then to the tents. Move! Skedaddle!" Sarge was impressed with what he heard from John.

Sarge wrote in his journal the next morning,

> *January 19, '62. Cold rain falling. Overcast and foggy.*
> *44th Tenn. marching to Bowling Green. Recruits still very*
> *green. May need to fight to survive soon. Company*
> *count: one sergeant, one corporal, five privates, fifty*
> *recruits.*

Harriet decided to endure the cold weather and attend church services. Mary Maxwell went along, leaving Annie at home with the children. Eli drove the carriage to the downtown train depot where John got out. The ladies went on to church. Midway through the worship service loud voices could be heard outside the building. Newspaper boys stood at nearly every street corner. "Extra, extra, get your news here. General Zollicoffer killed in action." John bought a paper and was shocked to read the headline.

### Brigadier General Felix K. Zollicoffer Killed

Today, at the battle of Mill Springs in Kentucky, the Confederacy lost a great general. Brigadier General George H. Thomas and the Union Army defeated our soldiers and now control the eastern part of the Cumberland River.

This is the first major engagement where Tennesseans fought against Tennesseans. Soldiers from the 1st and 2ne Tennessee

wearing blue, fired on the 17th, 20th, and 29th Tennessee wearing
the gray of the Confederacy. Each regiment suffered casualties.

The newspaper extra with its headline and article had only a few brief words, but the impact was great. Some of the downtown churches received the sad news and closed their worship services with prayer for the Zollicoffer family and the other unnamed casualties.

During the carriage ride to Travellers Rest, Harriet and Mary were solemn. John did not say a single word but looked out the window in disbelief. When Harriet arrived home, she went immediately to her map to locate Mill Springs, Kentucky. John gave his mother and Annie the sad news. They joined Harriet but remained silent.

"John, Mill Springs is not on my map." She scanned the map without turning around.

"Do you see Somerset?"

"Yes."

"Come southwest along the Cumberland River until you find a major bend in the river. Mill Springs is on the south side of the river about a dozen miles from Somerset."

"Yes, I see the spot." She found a quill and ink and marked the map.

"Do you plan to mark every battle?"

"No, I just wanted to mark this one." They both knew she would return to the map many times.

The news from Mill Springs, Kentucky was unsettling for the citizens of Nashville. Many families left the city for points south and west. They emptied their bank accounts, boarded up homes, closed businesses, loaded wagons, and left. There was a constant flow of traffic on Franklin Pike heading south. Harriet could see the moving traffic from a second-floor window. She and Annie watched from the upper parlor. "Annie, do you think we will be safe here?"

"I really don't know. It would be hard for us to travel with our children. What would you do with the slaves? I guess we are as safe here as any place. When I lived in the fort, Thomas said we needed to be ready to move at a moment's notice. Twice while we were there, we had to practice leaving in a hurry. The girls and I had to leave our home and run to the wagons. I tried to make it a game for the girls, but it was scary. Harriet, do you have guns in the house?"

"Oh, Annie, you don't think it will come to that, do you?"

"Wartime does strange things to people. When there's a shortage of food, some folk will do most anything to get it. Animals and wagons are needed to get out of town. I just think it would be wise to be prepared."

"I'll ask John about the guns. Do you know how to shoot a gun?"

"Yes, and I can teach you and Mary. All three of us need to be prepared." Harriet continued looking out the window after Annie left to go downstairs.

She wondered, *Where is our Overton soldier today? We've not heard from him. I hope John is safe. I need to go about my routine. I need to go talk with Cynthia.*

Harriet didn't hear the carriage arrive, but she heard voices at the foot of the stairs as she started down. Mary Overton and her oldest living child, Mary, were back from their visit with Margaret Jane.

"Mary, I'm quite capable of removing my own coat." Mary was fumbling with the buttons on her mother's heavy coat. "Will you please stop!"

"Mother, I'm just trying to help you."

"You can help me most by getting out of my way. I'm going to my room." Harriet had reached the bottom of the stairs and saw the panic in the daughter's eyes.

"Mary, why don't you go into the large room by the fireplace, and I'll get your mother to her room." Mary was more than pleased to oblige. Harriet went over and released the door latch on Mary Overton's bedchamber.

"Welcome home. I'll send a servant in to help you."

"Thank you, Harriet. Thank you! Thank you!"

Harriet found Mary in front of the fireplace warming her hands. "May I get you something hot to drink? We'd love to have you stay for dinner."

"You are very kind, but no. I need to be getting home. It will be dark by the time I get there. Is Mother coming out?"

"No, she said she needed to rest before dinner."

"It's just as well. She is very cross today."

"Is there something I need to know?"

"She had some kind of spell at dinner last evening. Margaret Jane got all upset when Mother dropped a china cup and it broke. They had words. I tried to intervene but was caught in the middle. Mother got up this morning, packed her clothes, put her heavy coat and hat on, and told me she was going back to Travellers Rest. After being with Mother these past few days, I don't know how you do it."

"Do what, Mary?"

"How are you able to live under the same roof with Mother? Margaret Jane and I think you must be a saint."

"This is your mother's home. She shares it with me."

"Well, you're a saint nonetheless." Mary said her good-byes and left to go home. John passed her carriage, but had no idea she was inside. He entered the house carrying a large leather valise.

"John, you just missed seeing your sister Mary."

"Half-sister. I just passed a carriage. That must have been Mary. How is she and why was she here?"

"She came with your mother and she called me a saint."

"And that you are. I have some news about John."

"I was thinking about him earlier. How is he? Where is he?"

"Here, you can read for yourself." John pulled a folded sheet of paper out of the valise.

> *Dear CJO,*
>     *Your son is healthy. He is a proud soldier and on the*
> *move to CH in BGK. Greetings to all at TR. All for the Cause.*
>                                   *CJO*

"John, is he writing in some kind of code? I don't understand some of the initials. Let Annie read this when she comes in. Maybe she can understand the code. I need to go to the kitchen and talk with Cynthia."

Cynthia was humming as she scurried about the kitchen. She didn't see or hear Harriet. The window glass was sweating on three walls of the kitchen. The heat from the iron stove against the winter cold on the glass panes made the water beads. Julia used to tell Harriet the heat was crying to get outside. That thought flashed through Harriet's memory. She cleared her throat before she spoke, "Cynthia." Cynthia dropped the pan she was holding and it clanged as it hit the iron stove. She put both hands over her heart, "Lands a Goshen! Wow. I's didn't knows ya was in here, Miz Harriet."

"I've just been enjoying the music and looking at the crying windows."

"Ya, ma'am. Does ya needs somethin'?"

"I wanted to let you know Mrs. Overton is home. She may want to eat in her room. You can check with her servant before dinner."

"Ya, ma'am. I can do dat." Harriet turned to leave. "Miz Harriet, I's have a concern."

"What is it, Cynthia?"

"I heard, down in de cabins, 'bout da fightin'."

"Fighting?"

"Where young master John be."

"Oh, you mean the war between the Confederacy and the Union?"

"All dem trains comin' down da track wid army mens. Where dey be goin' and what dey be fightin' fer?"

"Do you know the meaning of states' rights?"

"Na, ma'am."

"A group of men in the north think they know what's best for the people who live in the south. But the people in the south like to do things their way. Cynthia, when you season a mess of greens, what do you use sow belly or ham hock?

"You knows I's uses ham hock. It da best fer greens."

"Suppose I told you to use sow belly. What would happen?"

"Is do it, but nobodies eat da greens. Dey be too salty. We jest throw 'em away."

"The south is gathering soldiers to fight for what we think is right."

"How comes, Miz Harriet, some of da slaves says da war 'bout us slaves?"

"Cynthia, the south needs slaves to work on the plantations, like Travellers Rest. The people up north think we don't need slaves, but we do."

"Eli says, Massa Lincoln goin' to free da slaves. What dat mean?"

"I don't know exactly what that means, Cynthia." Harriet was honest with her slave cook. At the moment she didn't know, but with the passing of time, an answer would become clear.

Slowly the reality of war took its toll on Nashville. No longer did those who gathered on street corners raise their voices for the victory at Bull Run. Now they were mourning the defeat at Mill Springs. As the wagons carrying the wounded made their way to the streets of Nashville, men removed their hats and ladies turned away.

The entire city was in deep mourning the day General Zollicoffer's flag-draped coffin was transported through the streets to the City cemetery. The turnout was massive as the minister recounted the many achievements of the first Confederate General in the west to fall in battle. There was a little confusion at the funeral. Harriet questioned in her mind when the minister mentioned, "This gallant soldier fell at Fishing Creek in the defense of his family, friends, and country." *I thought the newspaper reported Mill Springs as the place of the General's death. I'll need to ask John about that later.* Harriet lingered at the grave to offer her condolences to the Zollicoffer family. One family member commented, "He was such a smart businessman but had no military skills. He did not know how to protect himself."

Later in the carriage ride home, Harriet asked, "John, do you have any military skills?"

"No, you know I'm a businessman." She quickly changed the subject.

"Have you been able to discover any information about John?"

"He is, as far as I know, still at the camp in Bowling Green. Since the battle at Mill Springs was lost, I'm certain the planners are having to rethink their strategy for Kentucky. The Union army now has a path into Tennessee. They are in control of the eastern part of the Cumberland River. The Union army could march into Nashville."

"Do you think they will?" John waited a while to answer Harriet's question. He didn't want to alarm her unnecessarily.

"It seems to me the army would need to establish a supply line before they push south. Capturing Nashville would allow them to get supplies by using the rail and river systems."

"John, we have not talked about what we would do if the Union army captures Nashville. Will we stay or leave? Have you thought about it?"

"Yes, I've been thinking about it for the last couple of weeks. At this point, I don't have an answer. Maybe the decision will not need to be made."

"Is your reasoning realistic? Families are leaving Nashville by train, wagon, and horseback. The church service on Sunday had half its usual attendance. Some of the ladies were saying Adelicia Acklen had closed up

Belmont, hid most of her valuables in the city, freed some of her servants, and took the rest of them with her headed south."

"That's true, at least the part about heading south. I sold her all the seats on a passenger car to Decatur. She had eleven large trunks on wagons when she arrived at the depot."

"Do you know where she was going?"

"I would guess somewhere in Louisiana. She has a large plantation not far from New Orleans." Harriet looked directly at John, hoping to hear the plan for his family. He gave no response and left her to ponder.

Eli had picked up the mail pouch while the funeral was being conducted. John handed Harriet the *Weekly,* hoping it would occupy some of her time. He knew she was concerned about their children and the others living at Travellers Rest.

The front page of the *Weekly* displayed the headline, **Union Victory in Kentucky—Confederate General Zollicoffer Killed in Battle.** Harriet read the article under the headline, looking for Mill Springs. It was not there, but neither was Fishing Creek. She read three new names: Colonel Speed S. Frye of the 4th Kentucky Infantry, US; Major General George Bibb Crittenden, CSA; and Brigadier General George H. Thomas, US. The map on the bottom half of the paper caught her attention. She spotted Nashville on the map and traced the Cumberland River east to Somerset. Next she traced the river north to Dover.

"John, is there a fort at Dover?"

"Yes, Fort Donelson. It's about seventy miles north of Nashville and due west from there is Fort Henry on the Tennessee River." She found the Tennessee River and traced it north to Paducah. She glanced to the right and noticed the city of Bowling Green listed on the map. *I wonder how John is doing. I'd like to see him in his uniform. I hope he has enough clothing to keep him warm and enough food to keep him healthy.* Little did Harriet realize, or even guess, that hundreds of miles away orders were being finalized for General U. S. Grant to attack Fort Henry. The map she studied was a target with Nashville as the bull's eye.

The roofline of the Overton home nearly blocked the winter sun as the carriage pulled up to the house. Eli opened the carriage door to help Massa John to the ground. John then turned to help Harriet. The distance was much greater for her. Her heavy coat had been unbuttoned in the carriage. As she exited, with John's help, the cross necklace she was wearing swung forward and caught the sun's rays. The facets on the thirty small diamonds sparkled. "What a beautiful cross you are wearing, ma'am." John's smile was wider than usual.

"Thank you, sir. My sweetheart gave it to me for my birthday."

"And how many diamonds are on the cross?"

"Sir, you ask way too many questions." She was pleased John noticed she was wearing the diamond-lined cross. It was his birthday gift to celebrate her thirty years on January 8.

John Overton had lunch with his brother-in-law, John Lea, every Thursday they were in Nashville. It was a good time to talk business and stay current on each other's family. Since it was the first Thursday in the month, the two friends headed for the Nashville Inn for the lunch surprise. The headwaiter ushered them to John Lea's table and announced, "Gentlemen, the special today is black bear stew with gravy and vegetables, or I can bring you a menu."

"I'll have the special." John Lea agreed and ordered the same. "And bring a bottle of wine that goes with black bear." The two friends laughed as they were seated. Little did they know this would be their last Thursday luncheon for several years. John Overton looked across the room and saw William Driver smiling at him. He acknowledged the smile with one of his own.

By midafternoon, the city was in an uproar. The streets were filled with fast-moving wagons headed out of town. People were running in all directions. As Lea and Overton crossed the Square heading for John's office, the madness became apparent. "Extra! Extra! Read all about it!" The newsboys were at work at every intersection. "Fort Henry is captured by the Union Army." John Lea dropped a nickel in the newsboy's cup and took two sheets, handing one to his friend. He adjusted his glasses and read aloud,

> At eleven o'clock this morning, Fort Henry was captured. A
> combined force of land and naval troops pounded the fort.
> Confederate General Lloyd Tilghman waved a white flag after
> sending the major part of his command to Fort Donelson.
> Union General U. S. Grant sent 15,000 ground troops and
> a flotilla of seven federal gunboats, led by Flag Officer
> Andrew H. Foote, in the battle for Fort Henry. Union forces
> now have control of the fort and the Tennessee River.

Harriet's face and voice flashed in John's mind *What will we do if the Union Army captures Nashville?* John had not answered her question. Now, he had to take her the news, and he fully expected to hear her stomp her foot in reaction to his delay in making a vital decision. She was not happy to hear the news. She read and reread the newssheet John had handed her. He did not say a word but knew Harriet was fuming when she cut her eyes in his direction. She went to the foot of the staircase and called for her sisters. "Annie. Mary." When they did not respond, she sent a servant to find them. "Harriet, you sent for us?"

"Yes, we have something to discuss." Mary and Annie looked at each other as the three sisters went into the large room. Harriet dismissed the servant and then handed Annie the newssheet.

"It appears to me Nashville is in jeopardy. I don't see how our men can hold Fort Donelson. We need to decide what we are going to do if Nashville is captured." Harriet crossed her arms and sat back on the sofa.

"Mary and I were watching the troop trains pass by the house when you called for us. I'm guessing our men are getting ready to defend the city, if an attack comes."

"I hope your guess is correct, for our sakes." Annie was both right and wrong. The troops were gathering in Nashville, but General Johnston was sending them to Dover, under General John Floyd's command, to support Fort Donelson and hopefully, prevent the capture of Nashville. For days, news came from the battle zone that the fort was being held and Nashville appeared to be safe.

On Sunday morning, February 16, church congregations gathered to pray and give thanks. Church bells pealed and members greeted each other as they entered worship services. Their joy was shortlived. That very morning as they gathered, Fort Donelson was unconditionally surrendered to General Grant. Churchgoers on their way home met waves of soldiers—some on horseback, some in wagons, and others running— all with the same warning, "The Blue coats are coming!" Panic hit Nashville with a vengeance. By late afternoon, all Pikes heading south, east, and west were clogged. Traffic moved at a snail's pace. Those who did not have wagons and carriages crowded the railroad depots, hoping to find a way out of town. Some tried to find boats to float the Cumberland River, only to discover both ends of the river were controlled by Union troops.

The Overtons reached Travellers Rest a couple of hours ahead of the mass exodus moving south. Traffic on Franklin Pike was extra heavy all evening and early the next day. Harriet was pleased John did not attempt to ride into the city the entire week. He decided to gather the slaves near the barn and talk with them about the current situation. "I'm sure you are aware there is a war going on. For weeks the train cars have been filled with soldiers going into Nashville. In the last couple of days, the Pike has been crowded with wagons and carriages going south." Claiborne shifted his weight and then raised his hand.

"Yes, Claiborne."

"Massa John, what dis war all 'bout?" John realized the question was a test. He knew the slaves had a network of news that passed from plantation to plantation. The free blacks in the city kept the slaves aware and agitated. He had watched Eli wander down to the blacksmith's shop near the depot on several occasions.

"The war is about states' rights."

"What do dat mean?" The slaves moved closer to John, forming a half circle around him. They were eager to hear his answer.

"States like Tennessee, Mississippi, Georgia, Alabama—have the right to make decisions about what they want to do and not do."

"Ya means ta owns or not owns slaves?" The statement came from the middle of the crowd from a voice John recognized but could not find the person.

"Who said that?" John moved forward, the slaves parted, making room for him to move. He came face-to-face with Emmaline. She was holding a child, a mulatto. Her other children were scattered around her. Heads turned her way in anticipation of what Massa was going to say.

"It be me, Massa Overton. I axed da question. Ya means ta owns or not ta owns slaves?"

"Yes, that's part of it."

"Massa Lincoln say we be free soon." John was about to respond when a fast-moving horse came up the road, leaving a cloud of dust behind him. His slouch hat hid his face until he took it off and began waving it. He rode over to where the slaves were standing.

"Father! It's me, John. Corporal Overton reporting in, sir." The mere voice of his son brought a tear to John's eyes. The Corporal dismounted, John put his long arm over his son's shoulder, and they walked to the house.

"I can't stay. Sarge found this horse for me and told me to head for home. My unit is moving down Nolensville Pike, and I need to find them before dark."

"The ladies in the house will want to see you. I'm proud of you and what you're doing for the Cause."

"And I'm proud of you, Colonel, sir." The visit in the house was brief. The ladies—Harriet, Annie, Mary, and Grandmother Overton—smothered the Corporal with hugs and kisses. Even Cynthia hugged him and then returned to the kitchen. The children were impressed with his uniform. They all had to touch him.

"I really must be going." He was on his horse, waving to the family gathered on the gallery, when Cynthia appeared. "Massa Overton, here a little somethin' fer da trip." She handed him a napkin tied up with two ham biscuits inside. He was gone as quickly as he had appeared. Harriet put her arm around John's waist and they returned to the warmth of the large room. No words were spoken for several minutes. They were all busy struggling with the emotions they felt for their young soldier.

By the end of February, General Johnston had moved his troops out of Kentucky, sending part of them to Murfreesboro, Tennessee and the others to Corinth, Mississippi. Nashville was left abandoned and offered no resistance when Union General Don Carlos Buell captured the city on the 25th. The local newspaper reported,

> William Driver, a local resident of Nashville, welcomed the
> Union troops into the city and presented General Buell with
> a flag. Driver is a former sea captain. The flag he offered
> is an American flag he used on his ship. The flag has been

> in hiding, according to Driver, to prevent it being confiscated
> by the Confederates in the city. Driver referred to his flag as
> 'Old Glory' and suggested to the General it be flown atop the
> Capitol building. Old Glory is a sign of the times.

John smiled as he read the article and remembered Driver's sheepish smile at the Nashville Inn. Harriet was less charitable when she read the article. "I thought Nashville was a Confederate city, John. Who is this William Driver, anyway?"

"He's the old sea captain who used to fly his special flag on the Fourth of July. Since he was born in New England, I guess his allegiance is to the Union."

"It would appear so."

"Have you had any dealings with this man?"

"He wanted to sell me some items for the hotel, but at the time, I was not ready to buy. Speaking of the hotel, it is being used to house Confederate prisoners. Most of the churches downtown have received notice their buildings will be confiscated and used as hospitals."

"Can the Union Army do that? Will you or the churches receive any compensation?"

"Harriet, I don't really know about the compensation."

Tennessee was the last state to secede and join the Confederate States of America. By some stroke of fate, Nashville was the first Confederate state capital to be captured. Governor Harris moved his office and the State Legislature to Memphis. Abraham Lincoln used the capture to make the city and state an example of things to come. Andrew Johnson was sent from Washington to serve as Military Governor and lay plans for the state's reconstruction. The Greeneville, Tennessee tailor was not well received by the citizens of Nashville. Even his east Tennessee connection did not endear him to most of the state. His first speech to the citizens was made at the St. Cloud Hotel. John Overton was intentionally present to hear the speech. The only statement that stuck in his mind was the headline in the newspaper the next day, **Traitors Must Be Punished and Treason Crushed.**

The attitude of Johnson troubled all those who lived at Travellers Rest, especially Mary Overton. At an evening meal she recalled, "When Andrew Johnson was a rising politician in Greeneville, he supported my brother Hugh for President."

"Mary, I've never heard that story." Harriet placed her fork on her plate and gave Mary her full attention.

"Yes, it was in '36 when Hugh became a Whig and the Tennessee party encouraged him to make a run for the high office. Hugh was fully expecting that other Andrew to support him, but it didn't happen. Jackson threw his influence behind Van Buren and the rest is history."

"Mother, is that when you removed all the images of Andrew Jackson from the house and wouldn't allow his name to be spoken on the plantation?" John looked over at Harriet and smiled.

"Yes." Mary was half-serious and half-laughing. "And I would do it again. That Andrew Jackson was a rascal. He got too big for his britches." There was laughter all around the table.

By the spring of 1862, Military Governor Johnson was becoming dictatorial and making good on his threats. John received a summons to appear before Johnson to take the oath of allegiance to the United States. Before he explained the summons to Harriet, he needed legal advice from John Lea. The horseback ride to Lealand allowed John to collect his thoughts, mostly of Harriet and their children. *She was doing her part for the Cause by opening their home to the ladies in the community who gathered to roll bandages and knit socks and scarves. She had kept the family updated on the war events by sharing articles and drawings from the Weekly. She spent time with the children studying her war map. Her courage was an example for the entire family.*

Time with John Lea validated John Overton's own thoughts about the summons. If he responded to the summons and refused to sign the oath, he would be arrested on the spot and taken to prison with little or no recourse. If he refused to appear for the meeting, Johnson would send the military after him. The outcome would be the same. He had already determined not to sign the oath, regardless.

Harriet saw his furrowed brow when John walked into their bedchamber. He closed the door, walked over, took Harriet in his arms, and they held each other without speaking. "Harriet, the Military Governor has sent me a summons. He's going to require me to take an oath of allegiance."

"You can't do that!"

"If I don't, he will send me to prison. He's already sent several of the pastors in the city to prison. John Lea knows he's on the list and is planning to leave town before the summons arrives."

"John, listen to me. You are a Colonel in the CSA, commissioned by Governor Harris. You have special authority from President Davis. They expect you to do your duty for the Cause. What good are you to the Confederacy if you end up in prison somewhere? What would your son think if you take the oath?"

"What will happen to you and the children, to the others in the house, to the slaves, and to the plantation?"

"I've yet to read or hear of women and children being put in prison. The Union Army has not stooped to confiscating private homes. You have spoken to the slaves already. I will speak to them again. You, sir, have a duty. When you leave, where will you go?"

"You see things so clearly. I will go to Memphis and then on to Corinth, Mississippi to join General Johnston. I'll take Eli with me and our horses. If

possible, we'll travel by train to Memphis. If by chance we are stopped, I can always say I'm inspecting the train line or attending to business in Memphis."

"Now you are thinking like a Colonel in the CSA."

"I will stay in contact with you by using the train engineers who are loyal to the Cause and to me. They will deliver our messages."

Harriet tried to be brave, watching John ride away to war. Annie and Mary hugged her and tried to console her. John had spent many nights away from the plantation on business. Harriet always knew the separation was only temporary and that he would be back soon. Now she had to face double separations with two Overton men in the service of the Cause. Events had moved so quickly in the last twenty-four hours that she had little time to contemplate the challenge before her. Within minutes, John and Eli were out of sight. At that very second the weight of Travellers Rest—its residents, its slaves, the land itself—dropped squarely on the shoulders of a thirty-year-old female. A great challenge was before her.

# 21. War News Is Never Good

Harriet moved quickly to create some sense of normalcy for her family and the slaves. At dinner on the day John and Eli left, she shared John's dilemma and decision. "Military Governor Andrew Johnston has issued a decree that a number of folk in Nashville take an oath of allegiance to the United States." Martha, who sat next to her mother, raised her hand.

"What is a decree?"

"A decree is like a law, something one must obey. Your father decided not to obey."

"Will he get in trouble?" Jackson May felt no need to raise his hand to make a comment. "I know when I don't obey, I get in a lot of trouble."

"Would you please allow Mother to continue!" Martha glared at her brother as she spoke. "This is important; children should be seen and not heard." Harriet glanced at Annie and then Mary Overton. All three were laughing with their eyes. Harriet continued, "If someone should come to the door asking for John, please say he is on an extended business trip to check on the railroad system and property in Memphis." She looked directly across from her at John's empty chair and wondered, *When will this family be back together? Lord, keep my John safe and bring him back to his family. Let him sit in his chair once again.*

Annie noticed Harriet's distant look and felt sure she had finished with the subject. "What would you all think if I opened a school here on the plantation for the children in the surrounding area?" She took a bite of dessert and allowed the question to hang in midair.

"I read in the newspaper that the schools in the city have been closed. The Academy has also been closed. Ann Brinkley was so disappointed she could not come back to Nashville. What do you have in mind?" Harriet was inquisitive.

"I'll begin with our children and then expand to the children in the community."

"Have you thought of a place for the school?"

"Is the old law office used for anything?"

"Storage is the only thing I can think of offhand. I haven't been in that building for years." Mary Overton began to smile and then laugh.

"You may discover some images of Andrew Jackson out there. They can go in the cellar if need be, or you can throw them away."

"No," Annie responded, "if I discover anything in the office I can use in the school, I'll want to keep it."

"Annie, you may use my war map if you like. I also have a lot of copies of the *Weekly*. It covers a variety of subjects but mostly articles and drawings of the war. Martha has some early readers in her room. I'm certain she would like

to put them in the school for others to use. You might want to get Archer to check the fireplace and chimney."

"Well, it looks like we may soon have a school."

Before he left the plantation, John arranged to have mail left, including the *Weekly* and the *Daily Union*, at the Overton Station. When the weather was pleasant, Martha rode her horse to the station and picked up the mail. On other days, Claiborne did the task. Harriet was reminded each time she read the *Daily Union* how much information John brought home with him from the city. She missed it and found herself looking forward each day to the mail delivery.

On April 8, only one week after John had left, Harriet read about the terrible battle at Shiloh. The headline in the *Daily Union* sent chills down her back. She felt faint and had to be seated as she read,

### Bloodiest Battle Ever Fought in North America.

Estimates are over 23,000 men were killed, wounded, or declared missing. Sadly, one of those killed in battle was General Albert Sidney Johnston, Commander of the Confederate Army. He led his army to Shiloh from Corinth, Mississippi. . . .

Harriet could not read further. Her eyes stuck on Corinth. She heard herself utter, "Oh no! Corinth is where John was headed to meet General Johnston. Oh Lord, not John! Please, Lord, not John." She could not hold her tears back and sobbed for several minutes in the privacy of her bedchamber.

The following week the W*eekly* reported the full account with drawings of Shiloh Church, Bell's peach orchard, and the Hornet's Nest. With the paper in hand, Harriet walked to the law office, now schoolhouse. She handed the paper to Annie and watched as her eyes moved up and down the columns. Annie focused her eyes and said, "General Beauregard. Thomas was there at Shiloh. He's on Beauregard's staff."

"I'm wondering whether John was there. Annie, how can I find out where he is?"

"I guess you will have to wait until he contacts you. The only thing we can do is pray for his safety. That's what I do for Thomas. The soldiers are trained not to reveal any information that will help the enemy. Even if you get a letter from John, he will not give you any details."

"All I want to know is that he is safe. I'll read the details in the newspapers. How is school going?"

"Fine, being in this room helps us take our minds off the war during the day. Mollie and Harriet are worried about their father. They go to bed sad and wake up sad. Being here helps. Would you like to be involved in the school? I've asked Mary to come in during the day and help the children with creative writing."

"No, thank you. I have my hands full keeping the slaves busy and running the house."

"How are the slaves doing?"

"John talked to them before he left. I've talked to them a couple of times since. With planting and mending fences, they are staying busy. I know they're talking about the Union soldiers in the city. Claiborne has heard talk about some of the young ones escaping."

"What can you do if they run away?"

"I'll have to let them go. Andrew Johnson has already said he will not help the plantation owners in any way. With John under arrest, I'm certain I wouldn't even get a hearing in the city. I need to get back to the house. I just wanted you to see the report on Shiloh."

"Thanks for coming. I'll see you at dinner."

After the Battle of Shiloh, General William S. Rosecrans, Commander of the Army of the Cumberland, was given orders to gather men and stockpile supplies in Nashville. Those times he was in the city, chaos ruled. He was at odds with Andrew Johnson, who was busy at work trying to reconstruct the political systems of the state and dealing with the secessionist citizens.

Rosecrans made plans to defend Nashville. As the city burst at the seams with Federal troops and Confederate prisoners, he gave orders to confiscate church buildings, warehouses, and the uncompleted Maxwell House Hotel. He closed the Pikes into the city and required passes for all non-military travelers. Gun permits were required. Schools were closed, allowing children to run freely throughout the city. Prostitutes entered the city in large numbers. Vandals plagued the plantations and homes outside the city limits.

On Sunday evening, April 13, a train left Columbia for Nashville. Union troops crammed into the passenger cars; some were wounded at Shiloh, others with orders to report for new duties. As the engine passed Travellers Rest, it derailed, causing injury and panic in the passenger cars. Vandals had placed material on the tracks which caused the collision and derailment. As the cars emptied, the troops under direct command were being formed to march the last eight miles into the city in the dark. Several of the remaining troops scampered up the steep bank to the large, two-story plantation house. Annie heard the crash, quickly put on her robe, and went to Harriet's room. "Did you hear that loud noise?" Claiborne ran from the barn to the house, meeting Cynthia on the gallery. "What was dat?"

"Cynthia, it sounds likes da train been hit."

"Knock on da door, Claiborne. We needs ta check on da ladies and chilins' inside." He didn't have to knock because, at that moment, Harriet opened the door and walked out with Annie. Both had put on robes, Cynthia was trying to button her dress, and Claiborne apparently had slept in his clothes. "Cynthia and Claiborne, did you hear the loud sound?" Both nodded yes.

"Here, take these candles. Let's walk on the other side of the house, down by the herb garden." Before they reached their destination, they could hear voices and the hissing of the steam escaping the engine. In a very soft voice Annie asked, "Harriet, do we have any guns in the house?"

"No!"

Annie turned to Claiborne. "Do you have a gun in the barn?"

"I's got a rifle but no black powder. It be da one young Master John axed me to keeps fer him."

"Harriet, I think it is best we go back in the house and prepare the children."

"Prepare them for what?"

"Prepare them for the visitors we are about to have."

"Claiborne, you come with us into the house. Cynthia, go to the cabins and tell the slaves to stay indoors and then come back to the kitchen."

"Ya, ma'am. Is we goin' ta be alright, Miz Harriet?"

"Yes, but pray hard for the Lord to protect us."

No sooner had Harriet, Annie, and Claiborne entered the side door and closed it, when they heard loud banging on the front door. The door rattled from the force. "Open this door or we'll break it down!" The banging roused Mary Overton. Annie went through her room and up the staircase to gather the children. She found them huddled in bed with Mary Maxwell.

When the demand was made, Claiborne stepped to the door and yelled in a strong masculine voice, "Who's out there?" Harriet was surprised. He sounded just like a white man.

"We're in the Union army. There's been a train wreck and we have two injured men."

"Go around the house to the back door." There was silence and the sounds of movement.

"Miz Harriet," Claiborne said softly, "when we gets to da back, ya tells me to gets a dozen men." Harriet thought that was a strange request. They walked on to the gallery to discover six young soldiers. Two of them were supported on crutches. Harriet was holding two candles. One flickered when Claiborne bumped her arm. She saw him roll his eyes toward the barn. "Claiborne, go down to the cabins and get a dozen men." The young soldiers watched Claiborne leave and looked at each other.

"You may wait on the gallery." Harriet tried to use her directing voice. "I'll have the cook prepare you some food. Four of you may sleep the rest of the night in the house; two of you will sleep in the barn." The closer she looked at the six visitors, she realized they were about young John's age. "Where is your home?"

"We are from Ohio, ma'am."

Harriet did not sleep the rest of the night but stayed in her bedchamber looking out the east window. *John Overton, why have you left us in this peril? We may yet be killed by these soldiers who sleep under our roof.* When the sun

broke on the horizon Harriet's mood changed. She dressed and walked into the large room where her visitors were already up looking around the room. "Ma'am, this is a very nice house."

"Thank you. This part of the house was built the same year Andrew Jackson went to Washington to be President."

"Did he ever visit in this room?"

"Yes, he did, on a number of occasions." Seeing the soldiers in the morning light revealed their youthful age even more than last evening. Harriet could not help but think of young John on crutches in a strange house somewhere. "We will be having breakfast on the gallery. The necessary is down below the house. I'll have a servant place a basin of water and towels on the gallery. I will appreciate it if one of you would go to the barn and instruct the others."

"Yes, ma'am, I'll be happy to do that." Before the young soldier left the gallery, Harriet heard the outside bell ringing. Claiborne was pulling the rope and yelling, "Fire! Fire in da barn!"

The sound of the bell brought everyone in the house to the gallery. Harriet was already on her way when Claiborne stopped her. "Ya stays here, Miz Harriet. We takes care of da fire." She watched as Claiborne and three of the other slaves led the horses out of the barn and returned to push the carriage and buckboard out. Two other slaves were in the barn trying to smother the flames. Smoke rolled out the double door and the broken windows. Harriet moved closer to the barn and met Claiborne and the other slaves coming out. They were coughing and eager for fresh air. "What happened, Claiborne?"

"Dem two soldiers put fire in da straw."

"Where are they? I want to see them this very minute!" Her foot stomp and her hand gestures were visible to all that morning.

"Dem runned away."

"Claiborne, how much damage is there to the barn?"

"It looks like da windows all broke. Da side wall gone by da fire. Archer lookin' at it now."

"Can it be repaired?"

"I believes so, but Archer gots ta say."

"You did a good deed in saving the barn. Thank you. Please bring the other men to the gallery. It's time for breakfast." Claiborne had never heard any white person say "thank you" to him.

Breakfast was being served and enjoyed when Harriet returned from her bedchamber. She found her family and the soldiers sitting at the table. Jackson May was the only child near the soldiers. The slaves were sitting on the steps. She worked her way down the steps and faced the slaves. "You men," they stood as she spoke, "did a good deed this morning. You each deserve a reward. Here is a greenback for each of you." Annie smiled as she heard Harriet talk to the slaves. The soldiers stopped eating and talking and watched their hostess.

The sound of horse hooves and the rattle of a heavy wagon took all of them by surprise. The four soldiers stood, braced, and came to attention. The officer on the chestnut colored horse ordered, "At ease, rest." He dismounted, removed his wide-brimmed hat, and pulled out a piece of paper from his coat. Jackson May scooted his chair back and went to the gallery rail to get a better look at the officer. Harriet was still standing at the foot of the steps. As he looked at his paper he said, "I'm looking for Mrs. John Overton."

"And who are you, sir?" Harriet had to look up at the rather tall soldier.

"Ma'am, my name is Captain Henry Smith from General Rosecrans' staff. Is there a Mrs. John Overton here on the property?"

"Yes, Captain, in fact there are two of us. Which one do you want?"

"The owner's wife, ma'am. John Overton's wife."

"That would be me." Captain Smith focused on Harriet.

"Last evening there was a train wreck on your property. A number of our soldiers on that train have not reported in, and I'm looking for them."

"As you can see, four of your soldiers were my houseguests. Two others were offered hospitality and repaid my kindness by trying to burn down my barn."

"I am disappointed to hear about your barn. You have my and General Rosecrans' deepest apology. I will put the incident in my report to the General, and I will take these four soldiers with me. I will leave an inspection team at the site of the wreck for the rest of the day. They will be gone before dark."

"About your report, Captain Smith."

"Yes, ma'am."

"Please add a line indicating Mrs. John Overton desires an audience with the General."

"An audience, ma'am?"

"Captain, I wish to speak directly with your General."

"May I tell General Rosecrans when he may expect you?"

"At my convenience, Captain." Mary Maxwell smiled at Harriet as they passed on the gallery.

Later in the afternoon, a soldier rode up to the gallery and handed Harriet a folded piece of paper. "Ma'am, this is from Captain Smith." As the soldier rode away, she unfolded the paper and read,

> Line Passage—Please allow Mrs. John Overton to pass at her
> convenience. She has an audience with General Rosecrans.
> Captain Henry Smith
> Staff to General Rosecrans

Harriet smiled as she refolded the note, thinking how important a piece of paper was when it had the right signature on it.

Harriet chatted with Annie and Mary, trying to determine the proper approach to take when she met with General Rosecrans. "Harriet, the thing about generals is that they feel their rank. If General Rosecrans is old army

and worked himself up through the ranks, he is proud of his accomplishments and wants to be recognized for his efforts. If he is a politically appointed general, he is interested in power and his ego comes into play."

"The *Weekly* describes him as a West Point graduate from Ohio. He is an engineer and businessman. He was appointed a general when the war began."

"He sounds like a mixture of what you described, Annie." Mary was happy to be included in the discussion.

"Harriet," Annie continued, "always address him as General. Work into your conversation his home state. Stay on the subject and don't engage him in small talk. If John's name is mentioned, just say John's work is as a businessman. Mention the railroad, the hotel, and the land holdings. Do not, under any circumstances, mention slavery or President Jefferson Davis."

"What should I say about the fire in the barn?"

"You may want to use the word *accident*."

"But Annie, Claiborne thinks the Bluecoats set the fire intentionally."

"That may well be true, but you have no direct proof."

Harriet thought about the advice that night before she went to sleep. The next morning her mind was clear, and her goal was to meet General William S. Rosecrans. Claiborne prepared the carriage, and shortly after breakfast they drove to the city. Travel down Franklin Pike was pleasant until they reached a checkpoint near the city limits. A barrier had been erected to stop all traffic. Claiborne pulled on the reins and the carriage came to a stop. "And where do you think you're going?" The soldier's voice was gruff. Claiborne looked straight ahead as the soldiers approached Harriet. "Good morning, ma'am. Do you have business in town?"

"Yes, I do, sir."

"You will need to show a pass to enter the city." Harriet had her pass in hand. "We've got to be extra careful these days with all these secessionist citizens wanting to do us harm."

"Do I look like a secessionist? What is your name, soldier?"

"Why do you need to know my name?" Harriet handed him the pass. As he read it, she watched the expression on his face change. "Private Lawrence, ma'am. Private Robert Lawrence. I beg your pardon. I didn't realize you . . ."

"Private Robert Lawrence, even in wartime, one needs to be civil. I know you have a duty to perform, but you need to learn to be tolerant. Now, remove the barrier and allow me to pass."

"Yes, ma'am!" Private Lawrence removed his hat, did a little bow, returned the pass, and quickly removed the barrier.

"Thank you. I will say a kind word about you to the General this morning."

"Thank you, ma'am." He stood at attention as Harriet passed. Claiborne smiled and shook his head as he drove away toward High Street.

The George W. Cunningham house sat on High Street facing west. It was located with other elegant homes between Spring and Union Streets. This

house, like others, had been abandoned when the Union troops captured Nashville. General Buell had his pick and he chose this renaissance-revival home as his headquarters. When General Rosecrans was in the city, this was his headquarters.

When the carriage was parked in front of the military headquarters, Harriet walked up the steps. A polite soldier opened the door and greeted her with a smile. "Good morning, ma'am, may I help you?"

"I'm here to see the General. My name is Mrs. John Overton."

"Yes, ma'am. The General has been expecting you. Please follow me."

"General, Sir, Mrs. John Overton is here for her audience with you." Harriet was guided to a chair facing an oversized desk filled with stacks of paper. General Rosecrans stood, still holding several papers. "I've read Captain Smith's report about the train wreck on your property and a note about your barn. I guess you are here to apply for damages."

"General, we are fine at Travellers Rest. I trust you are having a good day." Harriet remained calm, spoke in a strong voice, and looked the General directly in the eyes." He quickly realized he was not talking to a soldier under his command. He dropped the papers on his desk.

"My deepest apologies. May I begin again?"

"If you choose to, sir."

"Welcome to my headquarters. I trust your travel was uneventful. May I offer you some refreshments?"

"No, thank you, General."

"You are the first lady to visit my office. I spend most of my day, when I'm in town, barking orders and signing papers."

"I fully understand the pressure of command."

"And how is Mr. Overton?"

"My husband is out of town on business. General, I understand you have a business background."

"It's more in the area of engineering, but yes, you could call it business. I've read, with interest, about your grandfather Maxwell. He fought in the Revolution." Harriet was surprised. *How would he know about my Maxwell family?* "You look surprised."

"Yes, I am surprised."

"At West Point I studied about the tactics used at the Battle of King's Mountain. Your grandfather and his brother David had a role in the battle."

"General, I'm impressed."

"And there is a hotel project underway in the city to honor the Maxwell name."

"Again, you are well informed. However, the hotel project is currently being used for military purposes." The conversation continued about many subjects for the next twenty minutes. A tap on the door interrupted them. "General, sir, a wire has just come that needs your attention."

"Excuse me, Mrs. Overton." General Rosecrans read the wire and placed it on his desk. "I'm sorry; I must end our wonderful conversation. This has been a delightful morning. Thank you for coming. If you will leave your name and your sisters' names with the sergeant, I will issue a line pass and an authorization for gun permits for each of you. You may pick them up the next time you are in the city."

"Thank you so much for your time, General." She extended her hand, which she had not done upon meeting him.

"I hope you will come again. Perhaps next time we could dine together."

"Perhaps." She left his office feeling good about the morning visit. Annie had prepared her well. She felt she received much more than she gave.

Annie and Mary gave Harriet a chance to catch her breath before they plied her with questions about her visit with the General. The three sisters ate dinner together. Mary Overton ate in her room; the children had eaten earlier. Harriet began the dinner conversation by reporting, "General Rosecrans knew about our grandfather Maxwell being at the Battle of King's Mountain. He also knew about the Maxwell House hotel downtown."

"Did he mention John?"

"Annie, you prepared me well to truthfully talk about John. I said he was out of the city on business. Talking about business was a helpful clue. I'm certain he knows everything about John and why he's out of the area." Annie was pleased and then asked, "Did he look like a military man?"

"He looks just like the drawing of him in the *Weekly*. He has a sharp nose and a well-kept beard. He looked very handsome in his uniform and leather boots. At one point, he said he'd like to visit Travellers Rest. I told him he could come, but he would have to wear a gray uniform. We laughed about that. He will be issuing both of you a pass through the lines if you would like to go into the city. He even offered to issue us gun permits."

"He sounds," Mary added, "like a considerate person."

"He is, I believe. It may be because he's worried about his own wife and family back in Ohio." Annie stood to go check on her daughters.

"Harriet, it might be good to follow up your visit with a note of appreciation. You want to stay in the good graces of General Rosecrans."

"Excellent idea." She prepared the note and mentioned the fine treatment she had received from Captain Henry Smith and Private Robert Lawrence. She sealed the note and left it on the desk. She raised the windows to allow the spring air in and then settled in bed. As Harriet drifted off to sleep, after her busy and eventful day, she had thoughts about people she didn't know. She prayed for the safety of Mrs. Rosecrans and her children in Ohio.

Routine had become Harriet's welcome friend. She found herself following a familiar path each day. Regardless of the time her eyes popped open to begin a new day, she prayed for her husband and young soldier. *Lord, keep my men safe today. Shield them from harm and return them to me at the*

*appropriate time.* There were times in these early moments she thought about her longheld Presbyterian beliefs about predestination. She didn't linger long, but she did have doubts. *Why would God promise to hear my prayers if He already knows the outcome?*

At mealtimes, either Martha or Mollie read the Bible and the family prayed. The adults talked about current affairs; the children talked about school and playing games. Sometimes they stayed while the ladies talked about the war and any news they received from John or Thomas. Harriet mentioned an item she discovered in the *Weekly* about the "Great Locomotive Chase in Georgia." She handed the paper, with the drawing of the trains, to Jackson May.

"Mother, these look like Father's trains. What is a lo-co-mo-tive?"

"Some people call them locomotives and some call them trains. Hold the paper up for all to see. A group of Union soldiers, calling themselves Andrews' Raiders, captured a train called the General. A group of Confederate soldiers jumped on a train called Texas and chased them." Mollie's eyes were very wide when she heard the word *Texas.*

"Did they catch them, Aunt Harriet?"

"Yes they did! Texas did its job."

"Hooray for Texas! It did the job." Annie was pleased and smiled.

Mary mentioned one morning, "We made the news." She was holding a copy of the *Daily Union.*

"What does it say?" Harriet was excited.

"It talks about the April 13 train wreck and the soldiers staying the night at Travellers Rest. It reports the barn being burned. It states, and I quote, 'No arrest has been made, and the matter will doubtless be fully investigated.'"

"Are any names mentioned in the article?" Annie was standing and about to leave.

"No names. Just Travellers Rest."

"It's just as well." Before Harriet could leave the room, there was a knock on the door near the kitchen.

"Yes, who is it?"

"Alexander Gray, ma'am." Harriet never liked their overseer, but he did a good job with the slaves. He was the only white male on the property. John trusted Alexander; Harriet tolerated him.

"Do we need to talk this morning?"

"Yes, ma'am, we do."

"Please come in." He stood until Harriet offered him a seat. "Would you like some breakfast?"

"No, ma'am. I ate in the kitchen earlier."

"So, Mr. Gray, what do we need to talk about?"

"We have a runaway."

"Who?"

"Zeke. Ezekiel. That was Big Sam's son, I understand. He was born here back in the 30s."

"Was Ezekiel the one training to be a driver?"

"The very same."

"How did he escape?"

"Claiborne had him out late last evening driving one of the wagons. They were on the Pike. At some point, Ezekiel had to relieve himself. Claiborne sent him to the woods and he never came back. Claiborne looked for him until after dark but he's gone. Most likely, he's headed for contraband camp in the city."

"Did you say, contraband camp?"

"Yes, ma'am. The Union Army has the camp set up to keep runaway slaves. They put them to work."

"Can we get Ezekiel back?"

"I doubt it. Even if we could, he would be trouble for us. We could whip him or cut off his toes, but he would run again. When a slave gets a taste of freedom, that's all he can think about."

"Is there anything else, Mr. Gray?"

"Yes, ma'am. You were exactly right about the crops."

"How's that?"

"You told me to plant more corn and less cotton and tobacco."

"And you went to Mr. Overton!"

"Yes, ma'am. He told me to follow your orders. The cotton and tobacco we did plant is doing poorly, but the corn is going to be a bumper crop. How did you know about the crops?"

"There's a biblical principle about resting the land. The Jewish people in the Old Testament had the right idea."

"I don't know about the Jewish people, but you were right."

"When the corn is ready to pull, you let me know. I want you to figure out how much we will need and then I plan to sell the rest to the Union Army."

"Yes, ma'am." Mr. Gray left the room still unable to understand how Harriet, at her age, knew exactly what to do.

Harriet counted on her sisters to help run the plantation. Annie had closed the school for the summer but continued to direct activities for the children on the lawns around the house and on the galleries. Sometimes she took the children to the upper gallery where they could see for miles. They could watch the slaves going to and coming from the fields. Traffic on Franklin Pike was always on the move it seemed. Martha and Jackson May counted the wagons and the horses as they passed by. It was not unusual to see soldiers on horseback near the house. The children commented on how the sun's rays made little flashes of light when they hit the metal buckles and sabers. One day they noticed a row of white tents sitting in the meadow between the peach orchard and the Glen Leven plantation.

"Are those our soldiers, Aunt Annie?"

"No, Jackson May, those are Union soldiers under the command of General Negley. He's trying to intimidate us and scare the slaves in the fields."

"What does in-tim-i-date mean?"

"He wants to make us afraid to stay here on the plantation. He'd like for us to leave."

"I'm not afraid! I'm not leaving!" Jackson May pulled in his stomach and squared his shoulders.

"You are brave, but I don't want you to do anything foolish." Martha and Mollie were standing with Jackson May as he made his declaration of bravery.

"Foolish . . . like Aunt Mary in the corn field." Martha had heard her Aunt Mary tell the story. "She was brave to stand up to the soldiers. She saved our corn. The soldiers had no right tearing down our fence and then helping themselves to our corn. They were just outright stealing."

"I don't disagree with you, but think about this. Would you try to get something to eat if you were really hungry? How about getting food for your hungry horse?"

"Well . . . yes, but I wouldn't tear down a fence to do it."

"Your Aunt Mary is a brave person. She did what she thought was right. However, I don't want any of us to take chances that will bring harm to us."

"But, Mother," Mollie added, "If Aunt Mary had not taken a chance, those Bluebellies would have taken our forty hogs."

"Who told you about the hogs?"

"Cynthia told Martha and me Aunt Mary Maxwell was very brave. She's a hero."

"You mean heroine. Yes indeed she is. I'm very proud of her. Her plan and action saved those hogs for us."

"So next winter when we are enjoying pieces of ham, we can thank Aunt Mary."

"Yes, we can. She had those hogs herded nearly thirty miles into Williamson County. It's a miracle the slaves were not caught and the hogs lost. We will be able to thank Aunt Mary each time we eat ham, bacon, sausage, and those wonderful pork roasts Cynthia cooks for us. Children, you may stay up here or go on the lower gallery, but don't go on the lawn without an adult with you. I have some things to do in the house, so enjoy your day. And Jackson May, no climbing on the rail."

"Yes, ma'am." The children continued to watch events unfold before their eyes. They watched the afternoon train, filled with Union troops, headed south.

Harriet was pleased she was able to sell most of the corn crop to the Union army. She was sure General Rosecrans had something to do with the arrangements, but nothing was said about it the morning the wagons came. The officer in charge gave her a receipt for the corn indicating, "Ma'am, this receipt can be redeemed for cash when you present it at headquarters."

"Thank you. I will see to it the next time I'm in the city. Please give my regards to General Rosecrans." The officer tipped his hat to Harriet and to Mary Maxwell, sitting in a rocker on the gallery. Little did he know it was Mary who had saved the corn crop he had just bought. Harriet sat next to Mary as the officer turned and rode away. "Thank you, Mary, for making this sale possible." Harriet handed her the receipt. Mary was surprised to see the amount. "I didn't realize corn was so valuable."

"A number on a piece of paper is not money in the bank. I will feel better when we have the money in hand." Harriet's nature was to trust, but she had a funny feeling about this sale. She would discover, as did others, that few receipts for goods were ever paid in full by the government during or after the war.

July 1862 brought not only unforgiving heat but a wonderful surprise to Travellers Rest. The windows in the house were always raised in the summer months to capture a cross-flow of air. The night sounds of birds and insects brought a calming comfort to those in the house. Harriet slept an uneasy sleep since John was gone. She heard every little sound, but did not rouse to investigate. The pistol she purchased gave her some comfort. She kept a loaded gun in her dresser hidden from the children. Annie kept the shotgun in her room. Harriet's eyes opened when she heard the sound of horse hooves outside her bedchamber window. The sounds stopped and then started again. Scalawags in the community usually traveled in packs. This sound was a lone rider. The horse whinnied when the rider dismounted. There was enough of the morning sun against the darkness to cast a shadow of the figure outside the window near the steps. Harriet rolled out of bed and found her pistol. She rethought Annie's instructions, *Place both hands on the gun. Cock the gun with your left thumb until you hear the click and keep your right index finger on the trigger. Put the gun in front of you with your elbows bent. Point the gun at the target and use the sight if possible. Take a deep breath before you pull the trigger.* She eased her body to the open window and pointed the gun. "Who are you? I have a gun!" The figure turned toward Harriet's voice and saw the barrel of the gun through the raised window. Eli threw his hat on the gallery and stood straight up, although doing so caused him great pain.

"Miz Harriet! Miz Harriet Overton! It be me, Eli! Eli Overton of Travellers Rest. Plez don't shoot me. I's Eli! Eli, Miz Harriet." Eli fell to his knees and then to a prostrate position in front of the window. Harriet could feel a huge smile on her face and then a chuckle from deep within.

"Eli! Eli!" She uncocked the gun, threw it on the bed, wrapped a light robe around herself, and went to the side door. After fumbling with the key, she pulled the door open. Eli was still face down on the gallery. At the moment, Harriet feared fright had done Eli in rather than a bullet.

"Eli, are you all right?" She dropped to her knees and rolled Eli over. She lifted his head and patted his cheek. Annie watched the scene from the window

in the large room. When she identified Harriet, she unlocked the double doors and stood there with the shotgun, cocked and ready to shoot.

"Harriet, are you all right?"

"Yes, but I may have killed Eli." All the commotion brought Cynthia out of the kitchen.

"Cynthia, bring me a basin of cold water and a towel."

"Harriet, put your hand on his chest," Annie directed, still standing over Eli with the shotgun. Eli blinked his eyes and slowly opened them, only to see the barrel of the shotgun pointing directly at him. He was out again. This time Harriet realized she had not killed Eli; he had just fainted. Cynthia arrived with the water and towel.

"Cynthia, I believe Eli has fainted."

"Miz Harriet, ya stand free of Eli. I brings him back." She poured the basin of water directly on Eli's face, some of it squarely in his mouth. She had not finished pouring before Eli roused, shaking his head and gasping for air. He flayed his arms and legs to the delight of Cynthia. She laughed aloud.

"Gets up off da flo, ya black fool! Ya should be ashamed what ya puts Miz Harriet through." Eli propped himself on one elbow and then slid, putting his back against the side of the house. Cynthia laughed so hard she jiggled. Eli was soaked. Water dripped off the end of his nose and chin. Harriet and Annie joined in the laughter. Finally, Eli joined them as well. He was breathing better and smiling. "Miz Harriet, I jest knew yous gonna kilt me. Massa John tell me not to scares ya when I gets home. He was sure rite."

"Eli, you did scare me a bit. When I looked out the window there wasn't enough light to tell who you were. I wasn't taking any chances."

"Massa John say da first thang I needed ta do is gives ya da saddle bag on da harse." He pointed to the horse. Cynthia brought the saddlebag to Harriet. Inside she discovered four envelopes. She doubled checked and then began to flip through them. Harriet handed two envelopes to Annie; the other two she placed next to her cheek. Annie read aloud, "AMC." Then looking at the second, "M and H C."

"Eli, go with Cynthia and get some breakfast. When you finish, come to the table and let's talk about your adventures. Cynthia, Annie and I are going to the dining room. Please bring us some hot coffee. We'll wait for the children to get up and then have breakfast."

"Ya, ma'am."

In the dining room, Harriet and Annie read their letters and then talked.

"How is Thomas?" Harriet gave her full attention to Annie.

"He's well. He has seen terrible things. He is on the move. He had to replace his horse. He needs a pair of knee-length leather boots and a new uniform."

"Do you think he wants you to send the boots and uniform?"

"I don't really know. He just indicated he needed new ones. What are you thinking?"

"I'm thinking we could go into town and find what he needs and then let Eli take them back with him."

"How would Eli know where Thomas is?"

"He won't, but John will."

"How is John?"

"He is well also. He sent me a coded letter."

"What did he write?"

"Cm in tw wks. Sty fr tw mnths. Lv wth GE."

"May I see your letter?" Annie was concentrating when Cynthia walked in the room with coffee. Eli was right behind her, still chewing a mouthful of his breakfast.

"Eli," Harriet questioned, "have you recovered from your bath?" He nodded. "Where did you last see Mr. Overton?"

"We be in Columbie. He goin' to Pul . . . Pul."

"Pulaski?

"Ya, ma'am. Dat place."

"When you go back, where are you to meet Mr. Overton?"

"He says, yous know where." Harriet looked at Annie and smiled. Annie nodded as if to say the code is broken.

"Eli," Annie interrupted, "where did you see Thomas?"

"We sees Massa Claiborne after da killins."

"You mean the Battle at Shiloh?"

"Ya, ma'am. Den we goes south fer a spell."

"Eli, you look tired. Go down to the barn and get some sleep. We'll talk later."

"Ya, ma'am, Miz Harriet. It sur feel good ta be home." Eli was no sooner out the door when Annie handed the letter back to Harriet.

"I know part of the code. John wants you to come to Pulaski in two weeks and stay for two months. He wants you to live with GE. I don't understand the GE part. He sent part of the message in writing and the other part he gave to Eli."

"I know the GE part. That's Grace Evans. She has a dress shop in Pulaski. Did you notice the line at the bottom of the page? It seems to be an add on. Same as TC for YJo."

"Young John needs a new uniform and boots just like Thomas."

"You are right. Annie, you are exactly right. You are so smart."

When the children came in for breakfast, Harriet and Annie handed them their envelopes. Martha read through her father's letter silently first, then she directed, "Jackson May, Mary, and Elizabeth, come over here. Father has sent us a letter." They gathered around Martha and hung on every word she read. Mollie waited at the other end of the table. She put her arm around young Harriet's shoulder and read,

> *Dear M & H,*
> *I hope you will remember my face as you read these words. I am*
> *seeing your faces as I write. I miss you both very much. One of*

*these days all four of us will be back together again. Stay sweet
and listen to your mother. I love you both.*

*Father*

Annie and Harriet were wiping tears when Mollie finished. Breakfast was served. There was laughter in the room. A special joy had come that day to Travellers Rest on four sheets of writing paper.

# 22. Surviving in Hard Times

"We need to be in the city early." Harriet explained her plans for the next day's adventure. "I need to be at the depot before the midmorning train leaves. Mary, I want you and Annie to wear your hoops tomorrow. I know you will be hot, but it's for the Cause." The sisters had their plan and knew their responsibilities.

The next day the sky was overcast with dark clouds. There was a smell of rain in the air but so far, it was dry. Harriet took no chances. She instructed Claiborne and Eli to use the carriage with the pull-down top. Her plans didn't allow for rain, but it came anyway. Before Claiborne reached Franklin Pike, he had to stop and put the top up. The brief shower stopped by the time he reached Glen Leven. Hundreds of blue-clad soldiers were milling around on both sides of the Pike. Some of the soldiers yelled as the carriage passed.

"Did you hear what that young soldier yelled at us?" Mary was shifting in her seat to get a better look.

"Mary, they apparently haven't seen ladies in a while. They are just being soldiers." Annie's comments carried weight with her sisters, since she knew about military matters.

"Mary, just ignore them." Harriet was laughing as she spoke.

Passage through the line did not take long after Harriet flashed her pass with General Rosecrans' name on it. "Well," Harriet said, "we live in a day when it's who you know and not what you know that counts." She slid her pass back into her purse. The three sisters were still chatting when the carriage pulled into the depot.

"Eli, come with me," Harriet directed, "I need your help."

"Ya, ma'am."

"Where does the train engineer stay here at the depot?"

"He be in da office, rite up dere."

"Very well. You may go back to the carriage." Harriet walked into the office and just as Eli had said, she found the engineer.

"Sir, we have not met, but I do appreciate hearing you blow the train whistle as you pass my home." The engineer, smiling, tipped his hat.

"Yes, ma'am, Mrs. Overton, how may I be of service?"

"You know my name. That puts me at a disadvantage because I do not know yours."

"My name is Scott Harris. I am the first engineer your husband hired for his railroad."

"Mr. Harris, I knew of you but did not know your name. On behalf of my husband, we appreciate your faithful service to the railroad. He told me if I ever needed information about what is happening in Nashville, you were the person to see."

"Yes, ma'am. I do hear a lot of things working here. What kind of information do you need?"

"Mr. Harris, if you needed to purchase a uniform, say a CSA uniform and officer's riding boots, where would you go?" He went over and closed the office door.

"I would go to the market on the Public Square. I would look for a young man named Edward Conn."

"Thank you, Mr. Harris. Mr. Overton will know of your loyalty. Good day."

"Be very careful, Mrs. Overton. This city is full of spies and snitches. They will turn you over to the authorities at the drop of a hat." Harriet nodded to acknowledge the warning and went to the carriage.

"Claiborne, take us to the Public Square. Ladies, when we get to the Square, we need to find an Edward Conn."

When they arrived at the Square, Mary saw a young man standing next to a flatbed wagon filled with baskets of vegetables.

"Excuse me, young man. Would you happen to know an Edward Conn?"

"As a matter of fact, I do know him. He's about my height and weight. He's quite handsome." Mary was beginning to blush.

"Could you direct me to him? It's very important that I talk with him." Edward was leery and turned away from her. *Is this a trick? Is she a spy for the Bluecoats? She's not wearing any face paint, so she's not a hired woman. Why would she want to find me?* After a moment of visually searching the Square, he cleared his throat.

"What do you want with Edward?"

"My sister, Harriet Overton, is looking for him."

"Is she from Travellers Rest?"

"Yes she is." Edward heard Mary's voice, but his thoughts went back to a day, nearly ten years ago, when he made a delivery to the plantation. *When you are a successful businessman, you can return the kindness. She was the tallest lady I'd ever seen. I appreciated her kindness.*

"Ma'am, is your sister in the Square?"

"Yes she is. Can you help us find Edward?"

"Yes, ma'am, I certainly can." In a few minutes, Mary returned to the vegetable wagon with Harriet and Annie. Edward had not moved from his spot, but he continued to scan the Square.

"Sir, this is my sister, Mrs. Harriet Overton, and my other sister, Mrs. Annie Claiborne."

"I'm pleased to meet you ladies. Mrs. Overton, have you enjoyed your silver pitcher?"

"I beg your pardon." Harriet moved closer to Edward.

"About ten years ago I delivered a gift to your home. A very tall lady was very kind to me and told me, someday I could 'return the kindness.' It appears this is the day."

"You are remembering my mother-in-law. The pitcher was a gift from her. I will tell her about you. Now, about Edward Conn."

"At your service, ma'am. How may I help you?" Mary's mouth dropped open. Edward smiled broadly at her. She blushed again. He then gave his full attention to Harriet.

"Mr. Scott Harris gave me your name and where to find you."

"Oh yes. Mr. Harris is a friend, a very trusted friend. Please follow me."

By the time Harriet and her sisters returned to the carriage, flashes of lightening broke through the dark forming clouds. Claiborne had secured the fold-down top and helped them up the step and into the carriage. Their entry was a struggle. Each sister, Claiborne felt, was weighted down and a little shaky. When the carriage reached the checkpoint, the rain was in full storm mode. The guard ran from his tent, pulled the barrier back, and waved the carriage through. Normal procedure at the checkpoint was to check carefully each person and conveyance. Not today; the hard rain provided free passage.

"Mary, I thought Edward Conn was flirting with you earlier." Annie glanced over at Harriet as she spoke.

"I felt he was just being careful. After all, he is a criminal and so are we."

"Mary, what you are doing today is for the Cause." Harriet reached under her hoop skirt and revealed one of the boots she had tied there earlier.

"If we are stopped and searched, all three of us will go to prison. What will become of your children? Did you think about them when you were planning this secret adventure?" Mary crossed her arms and looked out at the rain.

"Mary, how did you feel the day you caught those soldiers in the corn field?" Annie was patting Mary on the knee. Mary did not respond. "You took the action you did for the Cause. You were fighting the enemy. That's what we are doing today. We have these uniforms and boots under our skirts because someone fighting for the Cause can use them."

"And besides," Harriet said in a teasing voice, "if you had not found Edward Conn this morning, we would not be having this conversation."

"Harriet, I've never had the courage you possess. What we are doing scares me."

"We are all scared. Our house has been invaded by the enemy. The Union soldiers use our land as a training ground. They tried to burn down our barn. Yes indeed, we are all scared. I need for you to be brave. I'm leaving tomorrow to meet John, and I need to know you will care for my children."

"I can do that. Your children will be safe with me. Those Bluebellies will have to kill me before . . ." Mary began to tear up. Harriet put her hands on Mary's cheeks and cupped her face.

"That, Mary, is courage of the highest order." The rain continued all the way to Travellers Rest.

That evening at dinner, the entire family gathered. Harriet took the occasion to explain to the children why she would be gone from the plantation.

After the meal, each child wrote a note to their father. Even Elizabeth, who just turned two in June, scratched on a piece of paper with a quill pen. The Claiborne girls, Mollie and Harriet, decided to write a note but ended up using two sheets of paper. When the notes were finished, they were placed in envelopes with the appropriate father's name added. Mary Overton wrote separate letters to her son and grandson. Mary Maxwell added her notes to John and Thomas.

"Harriet, may I give you my letter for Thomas in the morning?" Annie questioned. "I'll work on it this evening after the girls are in bed."

"Yes, of course." The children gave hugs and kisses all around before going to bed. Jackson May waited to be the last one to hug his mother.

"I will miss you, but I will take care of this family." For a six-and-a-half-year-old, he sounded very mature.

"Yes, I'm counting on you being the Overton man of the house. Each day, after the train passes the house, I want you to check on the station platform for the mail. You may bring the mail to Aunt Annie, Aunt Mary, or Grandmother Overton. School will begin before I get back. I expect you to sit on the front row and be an excellent student."

"Yes, Mother." Harriet saw his chin quiver and she held him close.

"Now, off to bed with you."

The ladies in the house remained in the large room for another hour, making plans for Harriet's departure in the morning and saying goodbye for a while.

"If you will excuse me," Harriet stood, "I want to say good night to the children." Elizabeth and Mary slept in the same bed. She pulled back the netting, kissed each daughter on the forehead, and pulled the light sheet over them. When she got to Jackson May's bed, he had already pulled up the netting, allowing his mother to hug and kiss him. She patted him on the chest and blew him a kiss as she left the room. Martha had been sleeping in the room with her Aunt Mary for nearly a year.

"Martha, are you sleeping?" Harriet moved slowly on the wood-planked floor.

"No, Mother. Please come in." Martha had not yet dropped the netting around her bed.

"May I sit on your bed?"

"Yes, I would like that."

"I wanted to talk with you about my leaving for a while. Do you know why I'm going?"

"You miss Father and he misses you."

"Martha, you are so wise for a nine-year-old. I have something for you." Harriet removed a ribbon from her neck on which was a black key. "This is the key to my treasure box on the top shelf in my clothes press. I want you to keep the key for me and return it to me when I come home." Martha leaned over, hugged her mother, and began to cry.

"Mother, please, please, please come home." Harriet held her until the crying stopped.

"You can count on it. I'm planning to dance with your father at your wedding." She stretched out the netting over the bed of her oldest child and left the room.

The full moon provided enough light the next morning for Eli to pull the buckboard up next to the steps on the gallery to load Harriet's trunks. Cynthia came from the kitchen with a basket and walked over to where the ladies were gathered.

"Here some food fer da day." She handed it to Eli.

"Harriet, have a safe trip and greet John for us. If by chance you see Thomas, give him a hug." Annie handed her the letter for Thomas. After Harriet was seated, she looked up to the second gallery to see Jackson May with his arms over the rail. In a very loud whisper, she heard him say, "Bye, Mother, I love you. Come back soon." That vision stayed with her for weeks.

The weather was ideal with a beautiful blue sky. By midmorning, the sun was so bright that Harriet unfolded the parasol she brought along for the trip. The buckboard was moving fast enough to create a helpful airflow. On the outskirts of Franklin, Harriet noticed several soldiers on horses. They were Union soldiers, much to her displeasure. She had already decided the story she would tell if she was stopped for questioning.

"Dem soldiers be Union cavalry on patrol."

"Eli, in case we are stopped, I plan to say we are on our way to help a sick friend."

"Ya, ma'am. Ifin' we stopped, yous do all da talkin'. By da ways, where we be goin'?"

"Tonight we'll stay this side of Columbia. Some of the Hogan kin live down there, and I've arranged to stay with them. Then, tomorrow, we'll go on to Pulaski. The Hogans also have kin there. Hopefully, we'll meet Mr. Overton in Pulaski. Are you getting hungry?"

"I's always hungry fer anythings Cynthia makes."

"Let's get through Franklin, and we can pull off the road near the Carnton plantation for lunch. We should be able to make it to the Hogan's place before dark."

The night's stay was refreshing and made the trip to Pulaski the next day so much easier.

Grace Evans was so excited her friend, Harriet Overton, was coming for a long visit. When Harriet decided to make the trip, they exchanged notes. Grace had arranged for the Overtons to have one of the rooms above her shop. In her last letter, Grace had written,

> *Dear Harriet,*
> *Thank you so much for asking me to help. My shop is*
> *downtown in a two-story building. I will place a sign in the*

> *window that only the two of us will understand. See you soon.*
> GE

Harriet was fascinated at how letters were sent these days without giving any information away. John wrote in code. Now Grace gave secret directions. She thought, *will life ever be normal again? I wonder what Grace's sign will be?*

Pulaski was not large by anyone's standards. The main street had a dozen or so buildings. Five of them were two-story. *That narrows down the search for Grace.*

"Eli, drive slowly, I'm looking for a special sign."

"What it be?"

"I don't know, but I'll recognize it when I see it. There it is, pull in here." Harriet was all smiles and half laughing when she saw, in bold letters, NFA. They had no sooner stopped, than Grace appeared in the doorway of her shop.

"Do you like my sign?"

"Grace, you are so clever. Only you would have thought of the Nashville Female Academy."

"Well, you found me, didn't you? You may want to pull the buckboard behind the shop. We occasionally have a cavalry patrol in town. I don't want them to get suspicious."

"Is John here?"

"No, he came by yesterday and left you a note. It's inside the shop."

> *HMO, welcome to P. I will be back in one day. Renew your*
> *Friendship with GE. I'll see you soon. JO*

"How does he look, Grace?"

"He is as handsome as ever. His beard and mustache make him look distinguished. He is a taller version of General Robert E. Lee."

"What? Who? Are you sure it was John Overton you talked with yesterday?"

"Yes," Grace was laughing, "he said you may not recognize him."

The two friends stayed up late that evening talking. Grace was eager to hear about the changes in Nashville, and they made plans for Harriet's stay.

"Harriet, do you know how to sew?"

"I haven't done any in quite a while, but I do remember some things from the Academy."

"Good. While you're here and John is gone, you can pretend to work in my shop. In case the soldiers come by checking, I'll call you Harriet Maxwell."

"That should be easy to remember."

The General Lee lookalike appeared the next day a little before lunch. Grace spotted him through the shop window.

"Harriet, I believe your John is here." Grace disappeared behind a curtain into the supply room.

"Thank you, Grace." Harriet was surprisingly nervous. She had not seen John in over four months. She only knew he was alive when she received his brief notes. When the door opened, they were both speechless. For a moment, they stood motionless looking at each other. Then John moved forward and wrapped her in his arms. She joined her hands around his waist and squeezed. The hug and squeeze made the four months disappear in an instant. He bent over and kissed her long and passionately. They were like newlyweds again.

"Sir, what are your intentions toward me? I'm a happily married woman. And you, sir, are General Lee in disguise."

"General who?"

"John, it is so good to see you. I've missed you every second you've been gone. Army life has slimmed you down and added weight to your face." Harriet stroked his beard.

"Do you like my beard and mustache?"

"Yes, it makes you look refined, kind of like a politician."

"Oh my, I can shave it off immediately."

"Have you seen John or Thomas?

"As a matter of fact, I have. John is now functioning as an officer. He is a volunteer aide-de-camp to General Bushrod Johnson."

"What does that mean exactly?"

"He runs errands for the General. His promotion has been requested. When it is approved, he will need a new uniform and boots."

"I have those in my trunk."

"How did you . . .?"

"It's a long story. I'll tell you later. And Thomas . . ."

"He, too, is up for promotion. He is still on General Beauregard's staff. He has something to do with troop movement. How are the folk at Travellers Rest? Our children? Mother? Your sisters?"

"Let's see. I'll begin with your mother. In November, she will be eighty years old. She is showing her age. Her mind is as sharp as ever, but her health is declining. She spends a lot of her day in bed. Our Martha is nine and very much a young lady. She is a take-charge person, especially with her siblings. Jackson May sits in your chair for meals. He is the lone man in the house and reminds the rest of us frequently of that fact. He wants to go to Robertson Academy this fall. I believe he just wants to get away from all the girls on the plantation. Mary turned five the month you left for the war. Elizabeth is two and very independent, almost to the point of being headstrong. All your children and your mother sent letters. I'll get those for you later. Annie is busy with Mollie and Harriet. She is planning to reopen the school in the fall. Several of the neighbor families have asked her to include their children. That, in a nutshell, is an answer to your questions. And by the way, we have lost only one slave since you've been gone."

"Which one?"

"Ezekiel. Claiborne had him out on the Pike practicing his driving. He went to the woods to the necessary and never came back. We think he went to a contraband camp in the city."

"Zeke will get tired of digging those open latrines for the military and sleeping in tents. He may run back to the plantation."

"I sold the corn crop to the Union Army. They gave me a voucher for the cost. The cotton and tobacco crops were smaller this year. The peaches were nearly picked clean by the soldiers training down near Glen Leven. We did get enough to make three kegs of brandy. My sister Mary had the hogs driven off the property, and they ended up somewhere in Franklin or Nolensville."

"Why did she do that?"

"She heard some of the Union soldiers talking about 'getting those hogs' for army use. She found someone to keep the hogs 'till winter."

"I heard you had a train wreck near the house."

"It happened several days after you left. I actually had some Union soldiers stay in the house. Two of the young men had been wounded at Shiloh. They were on their way to Nashville. Two others tried to burn down the barn. Archer and his crew have the barn back in working order. Because of that ordeal, I had a meeting with General Rosecrans at his headquarters."

"You mean Rosy?"

"I mean General Rosecrans. He is a very nice man. He has a family, and just like you, he's forced to be away from them."

"Harriet, you are always thinking about family—ours or others'. That's one of the things I love about you."

The time in Pulaski passed quickly. There were days when Harriet and John were together. They took rides in the countryside. They enjoyed quiet picnics by a small stream under a shade tree. They went horseback riding. Each time they left Grace's shop, Harriet realized John was a man with a price on his head. Andrew Johnson would like nothing better than to arrest John and send him off to a prison somewhere. Yet they seemed to live in a prison already, having to take care not to be seen in town. Many of the days in Pulaski Harriet stayed in the shop helping Grace. John had duties which required him to travel and be gone. He commented to Harriet before one of his absences, "You know the war did not stop just to allow us some time together."

"I know, John. I just miss you when you're gone. I have cherished each moment we've had in the last weeks. I know sooner or later this time, too, will cease."

Harriet tried to be at the train station at least three days a week, hoping to see Scott Harris. He had become her personal mailman, since she had been away from Travellers Rest. He picked up mail at the Overton Station when he could and dropped mail off at the station when he felt it was safe to do so.

Those times when he had soldiers or others he deemed unsafe on his train, he would skip a delivery. There were times in Pulaski when he spotted someone in the station who was questionable and he would not make any contact with Harriet, although she was fully visible to him. She trusted Scott.

There were days at the shop when she had to scurry behind the curtain for fear of being found out. Then there was the day she was in the shop alone while Grace was running an errand. She was looking through the window when three soldiers on horseback stopped. One dismounted and entered the shop. Harriet was frozen with fear.

"Ma'am, I'm here to pick up a package for Captain Smith. Are you Grace Evans?"

"Grace is out running an errand. Let me look in the back for your package." Harriet's first instinct was to go out the back door. *If I leave, the soldier will become suspicious. He may even go and report me to his Captain. Lord, help me to be calm. Allow me to act normal.* She returned with a package.

"Here you are. Is Captain Henry Smith the one? It looks like payment has already been made. Thank you, sir. Do come again." As she handed the package over, she glanced out the window and had a full view of Captain Henry Smith's face. She took a deep breath and closed her eyes. *Good Lord, Captain Henry Smith is the very same officer who wrote me a pass to cross the lines and have an audience with General Rosecrans. I don't believe it! Lord, please protect me.* The horses walked away. Harriet went to the door, hung the CLOSED sign, and locked the door. She hid behind the curtain until Grace returned.

John periodically returned to Pulaski, which brought much joy to Harriet. She knew soon she would hear the words she dreaded. They came while John held her tight.

"Harriet, my sweet, the army is moving out of this area. I will not be coming back to Pulaski."

"Should I go home?"

"Yes, that would be best." They spent the evening as lovers with their passions high. When the sun's rays broke through the windows, Harriet found John had gone. She discovered five envelopes on the table. The first was addressed to her, the second to their children, another to his mother, one for Annie and children, and the last to Grace.

Breakfast was sad to begin with but then turned to happiness, when Grace read the note from John and discovered the gift he left.

"Harriet, John didn't need to do this. He's given me money for a full year's rent on the shop."

"Believe me, Grace, the money is only a small thank-you for your hospitality."

Harriet saved her envelope for the train ride home. She packed, said a tearful farewell to Grace, boarded the train, and left for Travellers Rest. John

had made plans for Eli to return the horse and buckboard to the plantation. Eli would arrange for Harriet's homecoming and then join Massa John at an appointed location near Shelbyville.

Harriet settled in a seat next to the window. The passenger car was empty, which she didn't really mind. She was anxious to read John's letter.

> *Dearest H,*
> *These past weeks have been wonderful. I looked forward to*
> *seeing you each time I returned. The rides, walks, picnics—all are*
> *memories I will cherish for a long time. Miles may separate us*
> *for a while but our spirits will always be together. I will stay in*
> *touch with you by the usual method. Both packages have been*
> *delivered. I am very proud of both who received a package. H, do*
> *not take any unnecessary chances. All of the family needs you.*
> *You have my heart and all the love contained in it. J.*

Harriet placed the sheet in the envelope and held it to her lips for a long time. John's image flashed in her mind. *You have my heart and all the love contained in it. Yes, John, you have my heart also and all the love contained in it.*

The train stopped in Columbia and Franklin to take on passengers. One lady and two small children entered the car at the first stop. She smiled politely as she passed Harriet. The little boy reminded Harriet of Jackson May when he was small. The boy's manner made her realize how much she missed her children. The platform in Franklin was filled with blue-coated soldiers. An officer stuck his head in the car, looked around, and then left. Harriet watched the officer point to his right and the soldiers moved in that direction. As the train passed south Brentwood, Harriet noticed a number of wagons filled with logs and then stacks of logs piled between the railroad tracks and Franklin Pike. It was interesting to see, but she had no idea why they were there. When the train passed Brentwood proper, Harriet knew the next stop was Overton Station. A smile came to her face when she saw Claiborne. He was holding the reins to keep the horse from bolting when the train whistle sounded. The conductor placed a stepstool for Harriet to use while he went back to the baggage car to unload her trunks.

The homecoming could not have been happier. Two months was a long time to be gone, especially from the children. Martha had placed her siblings—Jackson May, Mary, and Elizabeth—on the gallery steps. When the buckboard arrived, the children stood on cue and shouted, "Welcome home, Mother!" They ran to their mother, formed a circle around her, and then surrounded her with hugs. She turned slowly to greet each child with a kiss.

"I'm so glad you're home." Jackson May appeared to have grown two inches.

"I'm happy to be home. Your father is in good health and sends his love. In fact, he sent you a letter." Harriet found the letter in her purse and handed it to Martha. "Find a quiet place and read it to the others." Harriet made her way

onto the gallery and greeted the ladies waiting there. Her mother-in-law, Mary Overton, was greeted first.

"John is in good health. He asked about you often. He has grown a beard and mustache. Here is a letter he sent you." Harriet was surprised to find Mary looking pale. *Her eyes look weak, and she has dark circles under them. I wonder whether she has been eating properly.*

"Oh, my. How does he look?"

"It was strange at first, but I got used to them."

"Where is John off to now?"

"I don't really know, other than he stated he was moving out of the area."

"When Eli was here briefly, he said something about meeting John in Shelbyville." They hugged and patted each other. Annie was waiting her turn. Her daughters broke the protocol and hugged their Aunt Harriet.

"Girls, I've missed you. I have a letter for you from your father. Your Uncle John sees your father occasionally in his travels. He is in good health and misses you both very much." Grandmother Overton went into the house and to her room.

"Did you get to see Thomas?" Annie asked her important question as she embraced Harriet.

"No, John saw him a couple of times in Mississippi. He gave him the package. Thomas' responsibilities keep him moving among the troops. But he is healthy." Harriet handed her Thomas' letter.

"Go, take the girls, and read your letter." Harriet held out her arms and waited for her sister Mary to approach.

"Mary, how can I ever repay you?" Harriet felt tears on her cheeks as they embraced. Mary tried to break away, but Harriet would not let her go.

"Martha has mothered Mary and Elizabeth. Jackson May has been my protector and the man of the plantation. He is riding his horse quite well. In fact, he rides down to the station every day but Sunday to check on the mail. We have named him General Mail."

"Each thought I had of the children while I was away, I also thought of you."

"Harriet, knowing you were coming home soon, we kept some of your mail here. It's in your bedchamber. I believe there is a letter from Ann in Memphis. We didn't open it, but we were anxious to know whether she's all right."

"I'll go look at the mail now and bring it to the large room later."

Dinner that evening was a reunion for the family. Mary Overton stayed in her room, but the rest of the family laughed and recounted stories from the past two months. Harriet brought with her the letter from Ann Brinkley. Her letter was newsy with mention of the Union occupation of Memphis and all the hardships that was causing. She also wrote about Hugh's health problems, her father and stepmother's growing family, and her personal sadness of not

being able to attend the Academy. Mary and Annie smiled when Harriet mentioned the Academy.

"Are either of you familiar with the names Kate Galloway and Elizabeth Meriwether?"

"Yes," Annie replied, "Kate Galloway was banished from the city of Memphis by General Grant after the Union army captured the city. He said something about making her an example."

"An example of what?"

"Her husband was the editor of a Memphis newspaper, the *Avalanche*. Our local newspaper called it pro-Southern. It seems he fled the city and joined the staff of General Nathan Bedford Forrest. Kate remained in the city and continued to stay in touch with him. She was very vocal about her support of the Confederacy. General Grant issued an order about not giving aid or comfort to the enemy." Annie paused to sip from her glass of water. Mary jumped into the conversation.

"Kate did not comply with the order and was banished from Memphis."

"When did all this happen?"

"While you were away giving aid and comfort to the enemy." The three sisters laughed.

"Ann also sent a clipping from the *Memphis Appeal* about an Elizabeth Meriwether. Now, who is she?"

"Kate and Elizabeth are friends. When Kate was banished, Elizabeth took up the cause and has also become very vocal. General William Sherman, who took over from Grant, has issued his own warning about giving aid and comfort to the enemy. I guess she'll be banished as well." Harriet passed the two articles and Ann's letter to Annie and then reached for her water glass. Her thoughts were far away. First, she thought about Kate and Elizabeth. *I have been doing the same thing for the past two months. I wonder whether I'm on someone's banishment list?* Her thoughts focused on John but were interrupted by a question from Martha.

"How is Miss Grace?"

"She is fine. In fact, she wanted to know if you still had your doll with the black velvet dress."

"And what did you tell her?"

"I told her the doll sits on your dresser and is an important part of your early childhood."

"Tell me about her shop."

"It is a little larger than this room. She has a portion of it divided off by a curtain. The shop has a front door and three large windows. She has displays in the windows and lots of material on tables. Upstairs are several rooms. That's where your father and I stayed."

"What did you do when Father was gone?" Martha was not pleased that Jackson May had butted in.

"I worked in the shop as Grace's assistant. She always introduced me to her clients as Harriet Maxwell."

"What's a client?" Martha released a huge sigh. Harriet patted her on the arm.

"A client is someone who comes in the shop to buy something."

"Oh. Like a dress or a bonnet or something."

"Yes, that's right. We can talk more later. Right now, it's time for bed. Off you go." Harriet kissed and hugged each of her four children, followed them to the staircase, and watched them disappear out of sight. She bid good evening to her sisters and walked to her bedchamber.

General James S. Negley was a man on a mission. He had orders from Washington to fortify and secure Nashville against a possible Confederate attack. Military Governor Andrew Johnson was fearful of being kidnapped and was not convinced the 6,000 men under Negley's command were adequate to protect him or the city. Army engineers, led by James Morton, were brought to the city to plan and erect the needed fortifications. By the fall of 1862, St. Cloud Hill, south of the city, was selected for the first of several forts to be built.

Harriet and Jackson May were standing on the gallery, after breakfast, the morning General Negley and his troops arrived.

"Good morning, ma'am. Are you Mrs. Overton?" He removed his hat.

"I am, and who are you?" Harriet coaxed her son closer to her side and put her arm around his shoulder.

"My name is General James Negley. I command the Union Army in Nashville."

"Sir, how do you relate to my friend, General Rosecrans?" The question was unexpected. Harriet watched as General Negley squirmed in his saddle.

"I report to General Rosecrans in this theater of the war. This is my third visit to Travellers Rest to see you."

"Yes, General, I've been told you were here before. I've been away helping a friend. How may I help you?"

"I am in need of skilled craftsmen for the project on St. Cloud Hill. I'm hiring slaves to work as carpenters, coopers, stonemasons, blacksmiths, wagonmakers, and cooks. Might some of your slaves qualify?"

"General Negley, I have a cook, who serves the family. When I need the skills you mentioned, I must hire those just like you. The slaves here are field laborers. They plant and harvest the fields. In fact, their labor provides food for your soldiers. I need the slaves here, and you need my slaves to work here."

"I see . . ." He turned and handed a piece of paper to the soldier at his side.

"Is there anything else, General? My son and I need to be inside out of this cold weather."

"Ma'am, thank you for your time and the information. Please give my regards to Mr. Overton."

"Thank you, sir, and give my greetings to General Rosecrans." Harriet smiled as she guided Jackson May to the double doors. General Negley knew he had been outmaneuvered by a very skillful female. He took the lead position as he and the troopers left the plantation.

"What was that all about?" Mary Overton was standing in the doorway to her bedchamber. She was still in her nightclothes, complete with cap and heavy shawl. Jackson May spoke to her as he headed up the stairs.

"That was General Negley. He wanted to hire our slaves to help in building the large fort on St. Cloud Hill."

"What did you tell him, Harriet?"

"I told him we needed the slaves here."

"He has no right to use St. Cloud Hill. The Judge left that property to our daughter in his will. That land belongs to the Brinkleys. Years ago, you took little Ann and young John there for picnics."

"I remember those outings. Mary, how are you feeling this morning?"

"I've not been sleeping well with the colder weather. I have a heaviness in my chest."

"I'll get Cynthia to make you a pot of herb tea and we can visit." The two Mrs. John Overtons sipped their tea and chatted by the fireplace.

"Harriet, do you remember the first time we had herb tea together?"

"No, I don't. Do you?"

"You, Annie, and Mary came here for a visit. You requested herb tea and honey. I was impressed. You must have been around fifteen years old." Harriet nodded. "You have been very good for Travellers Rest. You have taken good care of John. He is so proud of you. You have given him four wonderful children. In many ways, you are more like a daughter to me than a daughter-in-law."

"You are very kind."

"In less than a month I will be eighty years old. I have lived well beyond my allotted time."

"You still have a lot of living to do."

"No, I believe my time on earth is coming to a close. I have some things I would like for you to do for me when that time comes."

"We don't need to be talking about this right now."

"Yes, we do. I want a simple funeral at the church, but no wake. I want to be buried next to the Judge. After all this war stuff ends, I want you and John to place our remains in the new cemetery downtown. Don't put us in the City cemetery but the new one."

"Mary . . ."

"I've made out a list of things I want my daughters to have, and that's all they get. The rest of my possessions I leave to you. The list is in my

nightstand. One other thing. I have a little box under my bed. I want you and John to take it to Mayfield and bury it near the house."

"Where is Mayfield?"

"Mayfield is the home Francis built for us after we were married."

"I've never heard it called Mayfield."

"Harriet, I need to go back to bed. Please help me."

That evening Harriet wrote a letter to John, telling him of her conversation with his mother. She encouraged him, if at all possible, to come home to see her. The letter reached him, but it was too late. A month and a day after her eightieth birthday, Mary McConnell White May Overton died in her sleep.

On Friday morning, December 12, 1862, Harriet announced the death. She tried, with no success, to locate Mary's daughters and then sent them brief notes. She sent a brief note to John. The war had scattered the May and Overton families, so Harriet, her sisters, John and Elizabeth Lea, the children, and a few of the old slaves carried out Mary's wishes. John Lea arranged passage through the lines and to the First Presbyterian Church for the brief service. At Travellers Rest, the winter's hard ground was opened next to the Judge. The cold December wind blew hard against those who gathered a hundred yards south of the front of the house.

John Overton wept in the privacy of a soldier's tent, miles from home, when he read Harriet's note. Not even Eli could take away the emotional hurt.

## 23. Holding Things Together

Harriet's grief for Mary was deep but necessarily short-lived. She had a plantation to run and protect. She was on constant guard with Union patrols on the plantation. Supplies had to be secured, which meant trips into the city for open- and black-market purchases. On her first trip to the city in the new year, 1863, she purchased copies of the January 3$^{rd}$ issues of the *Daily Union,* the *Dispatch,* and the *Banner.* The newspapers were consistent in their reporting. The Battle of Stones River had cost nearly 24,000 lives. The number was staggering for Harriet to comprehend. The battle was reported as a draw. Each side won some and lost a lot. Murfreesboro was not that far away, and she had friends in that community. She could not dismiss the thought all the way home that afternoon, *Where are my Overton men?*

The pall hovering over Travellers Rest caused by Mary Overton's death continued. Harriet was surprised at the sadness of the children. They talked about Grandmother Overton. They told happy and sad stories. They delighted in hearing their mother's accounts of events that happened when she married into the Overton family. Even Annie's children missed her.

When the letters Harriet had sent to Mary Overton's daughters finally arrived, they were overtaken with grief. Mary May Barry was the first to come to the house. She stayed long enough to thank Harriet, visit the gravesite, read her mother's final letter and will, and collect the items Mary had left her.

"Mary, do you remember living at Mayfield?" Her facial expression did not change when Harriet mentioned the name.

"I remember it was brick and had two rooms originally. Two more rooms were added as the family grew. Our bedroom was upstairs. Mother had a walled-in herb garden. That was her treasure. She said it would always be a part of her. We also lived downtown near Father's office for a while, and then we moved to Knoxville after his death. I was about fourteen years old when we came here to live."

"You are blessed with a clear memory just like your mother."

"I must be going. Harriet, thank you for all your kindness to Mother. I admire your courage."

"Thank you, Mary. You are very kind. Please know you are always welcome to come back."

A few nights later, as the winter wind rattled the glass in the windows and the full moon was shining brightly, the family gathered in the small dining room for the evening meal together. Sometime midway through the meal, a heavy peck came on the window and a dark shadow stood outside looking in. Jackson May ran to the window. "Go away! Get out of here! And be quick about it!" Annie was out of her seat and reaching for the unloaded shotgun that

hung on the side of the fireplace. Harriet had moved to the side of the window and pushed Jackson May away from the window.

"Who's out there?" Harriet's voice was directive and demanding.

"It be Moses, Miz Overton. Massa and Miz Phillips be here to see ya."

"Tell them to come in." Harriet ordered. "It's Jesse and Mary Jane Phillips. Children, please finish your food and then you may be excused." By the time they finished eating, the Phillipses were in the house, removing their heavy coats.

"Welcome! Your Moses gave us a fright. These are my sisters, Annie and Mary. May I get you something hot to drink? Jesse, would you like a brandy?"

"No, thank you, Harriet. We can't stay long. I told Margaret Jane we needed to come in the daylight. I told Moses to tap lightly on the side door. I guess he misunderstood."

"Harriet, I must apologize to you." Margaret Jane was adjusting her heavy shawl. "Our neighbor told us one of your slaves came to the house with the news about Mother. I appreciate your note, but we were away from the house for a while. I don't travel on the roads in daylight because there are soldiers everywhere."

"I completely understand. As I wrote you, your mother died peacefully in her sleep. Let's go to her bedchamber. She left a letter for you and some personal items she wanted you to have." Harriet and Margaret Jane held candles as they walked through the house to the empty and dark bedchamber. Margaret Jane cried as she read the letter.

"Harriet, I have not been a very good daughter these last few years."

"Yes, you have. Your mother knew you had your own life to live. These last couple of years have been hard on all of us. Your mother loved you very much."

"Harriet, you are a saint."

"Your mother wanted you to have some specific items." Harriet pointed to the collection on the table in the corner of the room. She lit a wide-wicked lamp for more light. "If there are other things of hers you would like, I'll try to find them for you and have them sent to your home."

"No, these will be fine. Mother chose them for me. Did she do the same for Mary?"

"Yes, she did. She also had some items for Elizabeth, but she has not been by yet to get them."

"Harriet, I can never repay you for all you did for Mother. When this war is over, I'd like to sit down and talk for a spell."

"I will look forward to that time."

"I guess it's best Jesse and I be going while there is still darkness to protect us. I hope Moses didn't scare the children too much." Harriet picked up one of Mary's shawls and placed it around her shoulders. She waved from the gallery as the carriage disappeared into the night.

Jackson May was covered with snow when he walked up from the barn. Harriet saw him coming.

"Son, where on earth have you been?"

"I rode down to the station to pick up the mail, and then I put my horse away. I'm doing my duty."

"Yes, you are, and the whole family appreciates what you do. Now, go to the kitchen and get something hot to drink." Harriet looked forward to the mail. Today she had a copy of the *Weekly;* an envelope addressed to her with a recognizable script; another envelope addressed to Travellers Rest, Nashville, Tennessee; and a letter for Annie. She dropped Annie's letter on a table near the staircase and went to her bedchamber. She didn't use her reading glasses in public but liked to use them when she had a lot of reading to do. She settled in her chair near the window, adjusted the blind to allow more light, and broke the seal on her letter from John.

> *My Dearest Love,*
>
> *I am deeply saddened I was not with you at Mother's death. How awful of me. I have been busy doing my part for the Cause. The events at S.R. were unspeakable. Our young soldier was wounded but is recovering and back in the saddle. I am headed back to where we last met and then south. Your face is ever before me and my love for you is unending. Hug and kiss our children for me. Regards to the family. JO*

Harriet closed her eyes and held the letter near her nose. She tried to smell the scent of John on the paper and visualize his hand writing the letter. She wept for several minutes. The second letter was a mystery until she found Elizabeth Lea's name at the bottom of the page.

> *Dear Beloved Harriet,*
>
> *I am truly sorry not to be standing at your side this very moment. The news of Mother's death struck me to the very core of my being. This war is robbing us of our family ties and personal relationships. We are in Kentucky on business. John is struggling with the oath. I fear Lealand is lost forever. I pray each day you will have the courage for living. I will see you as soon as we return.*
>
> > *Affectionately, I am*
> > *Elizabeth Lea*

Several thoughts flooded Harriet's mind as she returned Elizabeth's letter to its envelope. *I'm sorry the Leas are struggling. I'm certain John will make the right decision about the oath. Elizabeth is so right. This war is "robbing us" in so many ways.* Harriet shifted her weight in the chair and felt an all-too-familiar pain in her lower back. When she focused on the pain, she tried to remember her last woman time. *Oh my,* she thought, as she placed her hand on

her midsection, *could I be with child again? Did I bring back this surprise from my Pulaski visit?*

"Mother! Mother, are you in your bedchamber?" Jackson May's voice interrupted her thoughts.

"Yes, I am, and I would love to have you come in." She did not stand but stretched out her arms to enfold her son.

"Did you have a letter from Father in the mail pouch?"

"Yes, I did, and I think you need to read it."

"You mean before Martha reads it?"

"Yes, before Martha reads it. Here you are. I'll help you with the words you don't know." Jackson May sounded out the syllables as he read and stopped to ask questions.

"Is Father talking about Grandmother Overton?

"Yes he is. He is very sad, just like us."

"What does 'S.R.' mean?"

"I believe that's your father's code for Stones River. The 'young soldier' he mentioned is your half-brother, John. He got hurt, but he's better now and riding his horse."

"I think Father loves you."

"Yes, he does, very much." He folded the letter and handed it back to his mother.

"Well!"

"Well? Well what, son?"

"Where's my hug and kiss, young lady?" Harriet was laughing aloud as she stood, still feeling the pain in her back. The *Weekly* dropped to the floor. She gave her son a bear hug and would not let him go until she felt him push against her. *I wonder, Jackson May, will you have a little brother or another sister this year?* Jackson May had been gone long enough to have said something to his sister, Martha, before she appeared in the doorway of Harriet's room.

"I understand you have a letter from Father."

"News travels fast. Yes, here's your father's letter." Martha read it quickly.

"Mother, I hope someday to find someone who loves me as much as Father loves you."

"Martha, you are only nine years old."

"I'm nearer ten than nine, Mother."

"Come here and sit in my lap. I need to give you your father's hug and kiss." Martha responded and returned the hug and kiss.

"Mother, I brought you something."

"What is it?"

"The key to your treasure box. You asked me to keep it while you were away." Martha picked up the *Weekly*, handing it and the key to her mother.

The issue of the *Weekly* felt extra thick to Harriet. The headline on the front page caught her attention, **The Battle of Stones River is Costly to Both Sides**. On the second page, she was surprised to see a drawing of General Bragg and her friend, General Rosecrans. There were several smaller drawings showing stages of the battle and some maps indicating troop movements during the battle. Harriet studied the maps carefully. *I wonder where our young soldier was during the battle. I hope he is recovering as John said.* The report went on for several more pages, but she was not interested in the blood and gore being reported. Midway through the *Weekly*, Harriet's eyes focused on an article describing the largest inland masonry fortification built thus far in the war. There was a drawing of General Negley. She folded the *Weekly* and went looking for Annie.

"Annie, look at this." Harriet handed her the *Weekly* opened to the drawing of General Negley. "He's the general who was out here looking for slaves to help with the fortifications on St. Cloud Hill. There a bird's-eye view drawing of the fort."

"That's huge!"

"Read the description of the size." Annie read the article and looked closely at the drawing.

"The Army engineers said Nashville was six square miles, three miles long by two miles wide. In addition to Fort Negley, the engineers plan a series of smaller forts to protect the city." Harriet pointed to the size of Fort Negley.

"The fort itself is 600 feet long and 300 feet wide and has additional earthworks around it. Somewhere it states the entire area covers four acres."

"Nashville is being heavily fortified for some reason." Annie continued reading the *Weekly* and in a moment gasped.

"Harriet, did you read the proclamation by Lincoln? It was issued on September 22, 1862 but became official on January 1, 1863. He has freed the slaves. Listen,

> 'That on the 1st day of January, A.D. 1863, all persons held as slaves within any State or designated part of a State the people whereof shall then be in rebellion against the United States shall be then, thenceforward, and forever free; and the executive government of the United States, including the military and naval authority thereof, will recognize and maintain the freedom of such persons and will do no act or acts to repress such persons, or any of them, in any efforts they may make for their actual freedom.'

"There's a list of states in rebellion, but Tennessee is not listed."

"What does that mean? Tennessee is not in rebellion. The proclamation does not apply to us. Our slaves are not free."

"I'm not really sure, Harriet."

"If John Lea had not left the city, I could ask him. He'll need to respond to the proclamation just like us."

"What about our neighbors, the Hogans and the Ewings? They may not even know about the proclamation." Harriet grimaced and grabbed her lower back. She made her way to a chair and sat. "Are you all right?" Annie questioned. Harriet nodded.

"I'll bet our slaves know what it means. Annie, we may need to make a trip into the city and get some information about this." Harriet sent a letter to John that evening asking him about the proclamation and what to do about their slaves.

The city had changed since Harriet last made the trip in for supplies—black market at that. She was surprised to find soldiers sitting on the steps of all the churches. It looked like many of the young soldiers were convalescing from battle. All the shops were closed and boarded up except those on the Square.

"Claiborne, drive down by Mr. Overton's hotel." What she saw made her sad. What had begun as a grand project was now in shambles. *I cannot tell John about his hotel. He will need to discover it for himself. It is in a sad state of affairs. The building looks awful.* Harriet had read in the local paper about the Grand Staircase collapsing and killing several Confederate prisoners. She really wanted to confirm the story but did not feel safe entering the building.

"I've seen enough. Claiborne, take us to High Street. I need to stop in at the army headquarters. Annie, do we need anything from the Square?"

"No, not the way these soldiers are looking at us. I believe we are safer at Travellers Rest than on the streets here."

"I agree. I'll only be a minute. I need to ask General Negley about the proclamation." Finding the General out of the office, Harriet did not stay long. She was red in the face and exhaling heavily when she slammed the door to the carriage.

"Claiborne, take me home as fast as you can. I need to get out of this hell hole!"

"What on earth, Harriet! Your face is flushed. Are you all right?"

"The nerve of those Yankee Bluebellies. One of the soldiers in the office wanted to know if I was the Madam of a whorehouse. The very nerve! Do I look like a Madam?" Harriet settled back in her seat and looked out the window. Annie remained silent until they were past the checkpoint and on the road for home. She did wonder, *I bet that was a sight to see. Harriet stomping her foot. The young soldier fearing for his life and wondering whether this little lady was going to attack him.* Annie broke the silence.

"What did he say about the proclamation?"

"General Negley was not in, but a young officer came out and suggested I write Governor Johnson. He thought that in Tennessee, the slave question was a political matter and not a military concern." Annie responded with a nod and then gazed out the window of the carriage. Harriet began to laugh. "The very idea. Me a Madam. A whorehouse. Wait till Mary hears what her little sister has been up to now." Annie joined in the laughter. The sounds floated up to

Claiborne in the driver's seat. He didn't understand all the commotion, but he smiled at what he heard. About the time Claiborne turned off Franklin Pike, Harriet said in a serious tone, "Annie, I am with child again."

"Are you certain?"

"Yes, I've been having the feelings and pains like the other times."

"When . . . did . . ."

"When did it happen? It happened in Pulaski."

"Were you and John planning on another child?"

"Planning? No, we've always just taken our children as gifts from God. So I guess God planned for us to have another child."

"Harriet, I'm so happy for you—and John. Does he know?"

"I've written him and used our usual mail delivery system, but I have no idea when the news will reach him. I don't even know where he is."

"We need to make plans for you and the birth of your child. I think it would be wise for you to be away from Travellers Rest for the birth. You don't need the stress of dealing with this war any more than you have to."

"Why do you think that?"

"John cannot come home. You must go to a safe place where he can come to you."

"What about Pulaski? Grace can help with the arrangements."

"Yes. You can take Cynthia or one of the other slaves with you."

Harriet made her plans. She told her sister Mary, who was thrilled at the prospect of helping with a new baby. She hugged Harriet and they talked about names for the baby.

"John had a name in mind before Jackson May was born. I told him in my last letter he needs to be thinking again. We could have another son and he needs to have the name ready.

"And if it's another girl?"

"What do you think of Julia for a girl's name?"

"That name would bring back lots of memories of our childhood."

Harriet gathered her children and told them the news and her plans. Martha was silent. She looked away from her mother and closed her eyes. Mary and Elizabeth clapped their hands and laughed. Harriet was pleased with their reaction and looked in Martha's direction. Jackson May was excited too. He hugged his mother.

"Mother, may I help name my new brother?" That brought Martha back into the family circle.

"No!" Martha growled in her motherly tone, "Father will name the baby if it's a boy."

"Maybe," Harriet said calmly, looking at her son, "you can help your father with the name."

"All right!"

"Jackson May, I need a favor from you."

"Yes, ma'am."

"Please take Mary and Elizabeth to their room and play with them for a while."

"I can do that." He left with his little sisters. Martha started to leave as well.

"Martha, please stay with me. We need to talk."

"Yes, ma'am."

"I sense you are not happy about my announcement. What are you feeling inside?"

"Mother, I'm not really unhappy. I'm just concerned about you. You have had four babies already. Is it wise to have more than four babies? With the war all around us, can you get proper medical care for yourself and the baby if you need it?"

"Martha, do you know the Bible story of Mary, Martha, and Lazarus?"

"Isn't Lazarus the man Jesus raised from the dead?"

"Yes, that's the story. Well, Martha was his sister. She always wanted everything 'just so' in her home and in her life. She was very anxious about lots of things. The two of you have some similar traits."

"Just the same, I'm concerned about you."

"I know you are, and I love you for it. By the time this baby is born, you will be ten years old. Martha, you are so mature and wise for your age. Can I count on you to care for our family while I'm gone?"

"Yes, ma'am."

After wintering to rest and resupply the troops, the Union and Confederate Armies were on the move again by the spring of 1863. Newspapers reported that Lincoln had to replace his top general. General Ambrose Burnside was replaced by General Joseph "Fighting Joe" Hooker. He commanded the Army of the Potomac until June and was replaced by General George Meade. Names like the Wilderness, Chancellorsville, and Fredericksburg became a regular part of the adult conversation at mealtimes. Harriet marked these places on her map after reading the *Weekly*. Spirits were riding high at the success of the Confederate Army until word came that General Thomas "Stonewall" Jackson had died of his wounds from Chancellorsville. Annie draped the drawing of him with a black hair ribbon.

Troops moved out of Nashville in large numbers, not by train, but using the Murfreesboro Pike. The dust created by their movement blew all the way to Travellers Rest. A newspaper article told of the troops going to join General Rosecrans. By late June, he had maneuvered Confederate General Bragg out of Tennessee. Except for the occasional raiding party, the Confederate Army presence in the Nashville area was gone. Vicksburg was under siege. Harriet became stoic with each report she read. It got so bad Annie was worried about Harriet in her condition.

"Harriet, Thomas used to tell me 'no news is good news'."

"I know, Annie. I just need some word from John before I leave for Giles County to have this baby. My time is getting short. I'm guessing he is headed for Chattanooga with General Bragg, but I don't know for certain."

"John will get word to you, and he will be in Pulaski when the baby comes. I want you to cheer up."

"I need to talk with the slaves before I leave. I want them to know about the proclamation. By law, I don't need to do anything right now, but I just know it's only a matter of time. I want to tell them they are free."

"How do you plan to do it?"

"I'll tell them what I know and what we plan to do from this point on."

"Which is . . .?"

"We will pay them a fair wage to work the crops, or they can sharecrop our land on a contract basis. Those who have special skills, like Archer and Matilda, will be paid a wage accordingly. They are free to come and go. They will take care of all their other needs. They can live on the plantation and rent housing, or they can provide their own housing."

"What about food, Harriet?"

"They will provide their own food."

"You've given this serious thought, haven't you?"

"Yes, I'm trying to do what is fair for them and us. I haven't even mentioned what the Overtons paid for the slaves originally. That money is lost in the system of freedom."

The following week, Harriet gathered all the slaves around the gallery. She repeated to them what she had said earlier to Annie. She waited for a response.

"Miz Harriet," a voice came from the middle of the crowd, "did ya say we free ta leaves da plantation?"

"Yes, you are free to go."

"Where we gos ifin' we leaves?"

"That is your choice."

"Spose we leaves," a female voice asked, "and wants ta comes back later?"

"If there's a job available when you come back and you're qualified, we may hire you to work for us."

"Miz Overton," Archer put his hand up, "what do we owe you, if we leave?"

"Archer, you do not, nor any of you, owe us anything if you choose to leave. I would like to know by this time next week if you plan to stay. I will give Mr. Gray a list of the jobs available on the plantation and what the wage is for each job."

"Harriet," Emmaline was sharp-tongued as usual. Heads turned in her direction. They didn't like the tone of her voice or her lack of courtesy toward Mrs. Overton. "What happen ta us and our chillin' if we do not qualifies for any of da jobs on da list?"

"Is your name Emmaline?"

"Ya." Some in the crowd wondered whether Harriet was about to challenge her. They wondered whether Harriet knew the secret about Emmaline.

"Emmaline, if you qualify, you may work here. If you don't, you will need to leave the plantation."

The slaves headed back to their cabins, talking as they went. Harriet went inside the house, wondering whether she had done the correct thing. *What would John have done in the same situation?* The week passed in a hurry. Mr. Gray returned with the slave list telling Harriet, "It looks like Emmaline and her children are the only ones leaving."

"Mr. Gray, give her a week's worth of food and thirty dollars in cash."

"Are you sure that's what you want to do? You do know she . . ."

"Mr. Gray, I know she is a mother with small children to care for and although she may have made the wrong decision, she has made her choice."

"Yes, ma'am. I will see to it this morning."

"Mr. Gray, while I'm away, my sisters, Mrs. Claiborne and Miss Maxwell, will make decisions related to Travellers Rest. If you have a concern about anything, please talk with them."

"Yes, ma'am." Even though Harriet still did not like or trust Mr. Gray, under the present circumstances, she was left with no choice but to keep him in his position.

On the day Harriet and Cynthia boarded the train at Overton Station, Scott Harris was standing near the engine. He waved at Harriet and walked in her direction.

"So good to see you today, Mrs. Overton."

"And the same to you, Mr. Harris. I'm indebted to you for transporting my mail."

"At your service, ma'am. I saw Mr. Overton earlier in the week. He was headed to Memphis on some business." Scott winked at Harriet; she smiled.

"How did he look?"

"He is the spitting image of General Lee, but a lot taller." Harriet laughed. "By the way, he gave me a message for you." Harriet's face lit up as she moved closer to Scott.

"What is the message?"

"I may need a button sewn on my shirt in mid-July."

"Thank you, Mr. Harris. That is a wonderful message and you delivered it perfectly."

"Do you know what it means? It is a strange message." Harriet nodded and turned to leave.

"Mrs. Overton, have you heard any other news about the incident at Ferguson Hall?"

"You mean Ferguson Hall in Spring Hill?

"Yes. Has the sheriff found Dr. Peters yet?" Harriet shrugged her shoulders as a nonanswer. She was aware of the newspaper account. Dr.

Peters' wife, Jessie, was having an affair with Confederate General Earl Van Dorn. The Doctor confronted the General at Ferguson Hall and demanded he write a statement saying he had seduced Jessie. In the process of writing, Dr. Peters shot and killed the General.

"Personally, Mrs. Overton, I support the doctor."

"I guess it will be up to the courts to determine his fate."

The train trip to Pulaski was pleasant. Harriet thought how secretive John had been with his message and how she knew exactly what he meant. She gave no more thought to the Van Dorn matter. Grace met the train. She was waiting in a buckboard. After the trunks were loaded, she headed for her shop and parked in the back, out of sight.

"John has found a house for you for your stay here. An older couple live there and you will be safe with them. There are only a few troops in the city a couple times a week. Most of them have gone east toward Chattanooga. You will be close enough to come to the shop anytime you feel like it. Harriet, it is so good to see you again."

"Thank you, Grace. I want you to know Cynthia. I hired her to come and help me with the baby. She is also an excellent cook. In fact, she has been doing the cooking at Travellers Rest for years."

"Cynthia, welcome to Pulaski. You are welcome to come to the shop with Harriet if you like."

"Thank ya, Miz Grace."

Grace waited until dusk to deliver Harriet and Cynthia to their temporary home. They traveled several miles to the Bradshaw community. The houses sat off the road, protected by split-rail and, occasionally, rock fences. Grace turned off the main road and followed a winding smaller road to a large house. She halted the horse.

"Here we are. Paul and Lucinda Chiles live here."

"Hello, Grace." A cheery voice greeted them.. "We've been looking for you. Please come in. Dinner's on the table." Harriet eased herself down from the buckboard and fluffed her dress. She waited for Cynthia and they followed Grace up a path and into the house.

"Lucinda, it is good to see you again. This is Harriet and Cynthia."

"It's nice to meet you. Welcome to our home. Paul is in the kitchen. I have your room ready. You may want to freshen up after that dusty ride from town. Please follow me." Inside the large bedchamber was two of everything—beds, chairs, dressers, and washstands. It struck Harriet for the first time, *Cynthia is just like me*.

"If this is not suitable, I can arrange something else."

"Mrs. Chiles," Harriet looked at Cynthia, "this will be just fine." Cynthia nodded her approval.

"And please, call me Lucinda. Paul will get your trunks after dinner. When you are ready, come to the dining room."

"Thank you, Lucinda. We will be right there."

In the dining room, Paul was introduced. He and the ladies were seated. Harriet and Cynthia had two new experiences that evening. Paul put all the food he had prepared on the table at the same time. Bowls and platters were passed and each person took portions of food. Cynthia was seated, passing food to Harriet rather than serving her. Both of them were uncomfortable. Harriet knew this was the cost of freedom for the slaves; Cynthia didn't know what to think.

Nine days later, when John arrived at the Chiles' home, Lucinda realized the fallacy of her sleeping arrangements and made a correction. Cynthia was moved to an upstairs bedchamber, which pleased her. John was surprised to discover Cynthia eating at the table with him. He caught Harriet looking and smiling at him. That evening in their bedchamber, Harriet told him how she had handled the slaves at home. John congratulated her on her wise decision.

"Harriet, you did exactly what I would have done." His facial expression was unchanged when she mentioned the encounter with Emmaline and the resulting provisions. "You are a very giving person. I'm pleased to hear of your actions."

"I could not allow her to leave without some means of support. To change the subject, have you selected a name, if our new child is a son?"

"Yes, I have. At least I have a first name."

"I must tell you, Jackson May is insistent on naming his new brother, Maxwell."

"That solves my dilemma perfectly. I could not think of a middle name, but Maxwell is a perfect match for Jesse. His name will be Jesse Maxwell Overton." Harriet said a silent prayer in the midst of the conversation. *Dear Lord, I need very much for my new child to be a son. If you will grant my desire, I will do everything in my power to make him a God-fearing man.*

"John, you and Jackson May are wonderful. The two of you have been cut from the same cloth. I am very pleased with the name."

Saturday morning, July 11, was pleasant. It had rained the evening before and settled the dust on the road to downtown Pulaski.

"Harriet, after breakfast, would you like to ride to the train station with me?"

"That would be delightful." Something at breakfast made Harriet sick to her stomach. Back in their bedchamber, she begged off the morning buckboard ride. John understood.

"I need to pick up some messages at the train station. You stay here and rest. I should be back in an hour."

"John, thank you for understanding. I wouldn't be very good company this morning. You take your time."

"Good-bye, my sweet. Get some rest. I'll have Cynthia look in on you shortly."

John passed one man on horseback as he made his way through the streets of Pulaski to the train station.

"Good morning, sir." The stationmaster put down the newspaper he was reading.

"Yes, how may I help you?"

"I'm expecting a wire. My name is Overton."

"Yes, a wire came for you yesterday. Strange wire. Here it is. That will be thirty-five cents." John paid the cost and then read the message.

> J. OVERTON. PULASKI, TENN. 10 JULY, 1863 C 3 FROM 10.
> G-P LOSS. V-M LOSS. BVC.

John intentionally did not wear an army uniform. He found it easier to do his work for the Cause looking like a businessman. The stationmaster had watched John read the wire and then put it in his shirt pocket. He was curious about the message. He had spent time rereading the message when it arrived, but it made no sense. He was suspicious of John.

"Say, Overton, have you run into Forrest lately?" The past couple of years had made John suspicious of leading questions. *That's a strange question. Is this guy a Yankee spy? Is he a home guard? I'd better check him out.*

"Which Forrest is that? You mean the man who owns the blacksmith's shop in Franklin?"

"No! I'm talking about General Nathan Bedford Forrest."

"Oh, you mean the cavalry general. The one who rides a horse named King Philip."

"King Philip and sometimes Roderick." Only a true Confederate soldier could have followed the line of conversation. The stationmaster stuck his hand out and smiled at John.

"Captain Edward Chiles, Special Services, CSA, at your service. It's an honor to meet you Colonel Overton, sir." John was surprised and moved back a step to view the Captain.

"You knew my identity all along?"

"No, sir. I was told you were in the area and to be on the lookout for a tall Robert E. Lee." John laughed aloud.

"You are not the first person to say that. Someday I hope to meet General Lee."

"I hope you are enjoying your stay with my parents."

"So Paul and Lucinda are your parents. They are lovely people. My wife, Harriet, came here to have our baby."

"Yes, I know. I helped make the arrangements."

"Well, Edward, we will always be indebted to you for your planning and hospitality."

"Only too happy to help, sir. Have you read the latest war news? We took a beating at Gettysburg and Grant took Vicksburg. Here, take my newspaper.

It's really depressing." John took the paper, folded it, and returned to the Chiles farm.

Harriet was on the shady side of the gallery in a rocking chair when John arrived. He handed her the wire.

"I know how much you like decoding messages. Here's one for you to work on." Lucinda was coming out the door. She was in a long-sleeve day dress and sporting a bonnet.

"Hello, Lucinda. How are you this fine day? I just came from meeting your son Edward."

"Well, how are things in the train business today?" Harriet was working on the code but listening to the conversation.

"The train business is doing just fine."

"Edward told me you had something to do with the railroad line."

"Yes, ma'am. I've been in the railroad business for over ten years now." Harriet smiled and felt a sense of pride in John's accomplishments.

"Have you figured out the code? Here, some of the answers are in this newspaper." Harriet shook her head. Three minutes passed. Harriet stopped rocking and looked at John.

"Gettysburg and Vicksburg lost on the same day."

"That's terrible news for the Cause. I'll need to be in Chattanooga in three weeks from yesterday."

"All right, John, what does BVC mean?"

"Be very careful. Those are my orders."

"And those are my orders to you as well."

The hot, humid days of July were moving too quickly. John was constantly checking with Harriet about her condition. He was concerned August 1 would arrive before their child was born.

"John, our baby will come when it's ready. Your worrying will not change one thing. You go on to dinner. All I want is something cool to drink and a wet towel for my head. Ask Cynthia to check on me after dinner."

"I'll send her in to you now."

"John, you must remember to ask Cynthia and not tell her what to do. She works for us now. We do not own her."

"Harriet, you will need to constantly remind me of that fact. It's a hard adjustment for me. Remind me also, when I leave, to tell Eli he's a free man."

"Where is Eli while you're away?"

"He is staying with our John."

"That's good. Now go on and get your dinner."

John had almost forgotten what a country dinner was like. The Chiles' table that evening was spread with a platter of fried chicken, mashed potatoes and gravy, snap beans, white corn, applesauce, apple butter, huge biscuits, corn bread, and butter.

"Lucinda, this is the best meal I've had since I left Travellers Rest."

"This is the best fried chicken I've ever had in all my seventy-three years." Paul Chiles was smiling as he spoke. "You can thank Cynthia for this meal. She did it all. I may have to hire her to stay with us."

"Thank you, Cynthia. This is a wonderful dinner. It truly is like being back at Travellers Rest. Paul, you will have to deal with Harriet about keeping Cynthia, and that will be a hard battle that you will not win."

"Thank ya Massa . . . uh . . . Mr. Overton." John did not respond; just stared into his plate of food.

"John! Cynthia! Come . . ." Harriet's scream trailed off, but echoed throughout the house. Everyone moved quickly to Harriet's bedchamber. Cynthia took charge of the situation when she saw evidence the birthing process had begun.

"Ya mens gets out of here! Mr. Overton, brings me some hot water. Miz Lucinda, gets some clean cloths." There was a scurry in the room and instructions were followed.

"Miz Harriet, ya not ready yet. Stand up and let's gets ya into some bedclothes."

"Cynthia, you are in charge."

"No, ma'am. Dis here child be in charge!"

July 25, 1863 was not the best day to give birth, but Jesse Maxwell Overton chose that uncomfortably hot day to make his appearance. Harriet was exhausted. So were Cynthia and Lucinda. John was proud and accepted congratulations from his host, Paul.

"Is this your first child?" Paul thought he was putting John at ease.

"No. This is our fifth child. We have three girls and a boy. Now we have another son."

"John," Harriet's voice was weak, "send a note to our family."

"All right. What do you want to say?"

"Jesse Maxwell Overton has arrived. Mother and child are well. Father is like a proud rooster. Address the envelope to Master Jackson May Overton. John, I need to rest while Jesse is asleep. He'll be hungry soon and I need to be ready."

"I'll get this note on the next train north. You rest now. I love you, Harriet Virginia Maxwell Overton." Harriet smiled and closed her eyes.

John was humming when he reached the railroad station.

"Good morning, stationmaster Chiles."

"Sir, you are in a happy mood."

"I have a new son. I want to get this envelope to engineer Harris on the next train north."

"Well done, sir. I'm pleased for you and the missus. He is a special gift to Giles County." John made his way to the dress shop to find Grace. His wide smile gave his announcement away before he could say a word.

"Congratulations, John Overton! How is Harriet doing?"

"She had a long labor with our son, but she's doing well, thank you." He turned to leave.

"And what did you name your son?"

"Jesse Maxwell."

"That's wonderful. You are keeping the Maxwell name alive."

Cynthia made Harriet stay in bed for several days. When Harriet wasn't nursing Jesse, she was trying to regain her strength. John walked her around the room under the watchful eye of Cynthia. She and John ate their meals together in the bedchamber. He held her hand at night until she went to sleep. During the day, they talked about their family and the new addition. They both wondered how Jackson May received the news about his new brother.

On the evening before John was to leave the next morning, their words were few. The expressions on their faces spoke of their deep love for each other. Their tears intermingled as John brought Jesse to his mother and positioned him to be fed. John ran his hand over Harriet's forehead.

"My love, rest well this night. Always know you are my dearest love."

"John, my beloved, BVC." John laughed and left the room; Harriet turned her attention to Jesse. John was gone the next morning—back to the war and back to serving the Cause. Harriet stayed with the Chiles family for two more weeks. She was able to get Jesse on a feeding schedule. She asked Cynthia, "Are you ready to go to Travellers Rest?"

"Ya, ma'am, I sure is."

"All right, I'll send a note and tell them we're coming home. We'll leave here on Friday. We'll sleep here three more nights."

"I's be ready."

"I'll tell Lucinda and Paul our plans this evening."

Lucinda urged Harriet to stay longer but fully understood Harriet's need to see her other children and for them to see their new brother.

Jackson May was sitting on his pony. Claiborne was in the buckboard when the train came to a full stop at Overton Station. Before Harriet, Cynthia, and Jesse departed the passenger car, Martha rode up to the platform on her horse. Jackson May was running, hoping to see Jesse before Martha. He won the race because Martha thought herself a lady and was too old to play childish games like running races.

"Welcome home, Mother! I've missed you. May I see Jesse Maxwell?" Harriet turned the baby to give his brother a full view. "He's nice, Mother. Thank you for bringing him home. I'll go help Claiborne with your trunks." Harriet smiled, placed the light cloth over Jesse's head to protect him from the engine smoke, and looked up to see Martha slowly moving toward her.

"Welcome home, Mother." There was a sadness to her voice. It concerned Harriet. She kissed her oldest child on the cheek.

"I missed you so much, Martha. I stayed awake some nights wondering about you. How have you been?" Martha had a frown on her face. "Martha, I need a favor from you."

"Yes, Mother?"

"Would you please hold Jesse Maxwell while I go and make certain all my trunks are found?" Harriet handed her youngest child to her oldest and walked away. Transformation took place the very second Martha took a peek at her new brother. Bonding began. The moment was magic. Harriet watched from a distance and just knew the two would always be close.

The homecoming continued on the gallery. Everyone was waiting to see Harriet and hold Jesse Maxwell for the first time. Harriet sensed, in the scene unfolding before her, that a new day had come to the plantation. The Overton family circle was expanded. The bloodline had another male heir.

The city had been stripped of hundreds of Union soldiers. They were on their way to Chattanooga. The tents were gone from the fields at Glen Leven. There was little or no military presence on or near Travellers Rest. Harriet commented on the situation and was cautioned by Mary.

"Harriet, something big is happening east of us. Rumor in the newspapers is that the Yankees are planning to attack Knoxville, then Chattanooga, and then Georgia. Annie had a letter from Thomas indicating he was headed for Chattanooga."

"That's where John is going as well."

"But the more pressing matter for us is the home guard. They call themselves guerrillas. I'll say one thing for them, they are acting like wild animals. The newspaper has labeled them the Civilian Resistance. A week or so ago a Yankee patrol came right up to the gallery and wanted to know whether we'd seen any of the rebel bushwhackers around these parts."

"What did you tell them? Have you seen any?"

"We told them no. It wasn't twenty minutes later a band of riders came up to the same spot and wanted to know what we told the Yankees. They must have been watching us."

"Who were they?"

"They said they were the Civilian Resistance. Annie came out of the house and got involved in the conversation. She told them there were three CSA officers from this house fighting for the Cause. They wanted to know who owned the house. When she said, 'John Overton' every man removed his hat. The leader of the group apologized to us and told us, 'Ladies, the CR will protect this home from the Yankees.' Then they rode off."

"Have you seen any of them since?"

"No, but some nights at bedtime, with the windows up, you can hear low voices and horses walking near the house."

"Are you frightened?"

"Yes, and I'm planning to request a gun permit from the state government the next time I'm in the city. I know your permit is from the military. I want one from Andrew Johnson." Mary was adamant.

Mary Maxwell's understanding of the war events was eerily precise. Knoxville was captured and occupied by the Union Army. General James

Longstreet moved his troops from the east to support General Braxton Bragg in the Chattanooga area. General Rosecrans pushed Bragg out of Middle Tennessee and made plans to crush his army in Chattanooga. The Battle of Chickamauga on September 19-20 proved otherwise, and Rosecrans was forced to retreat. Union General U. S. Grant was given command of the Division of the Mississippi and moved to the Chattanooga area in late November. By November 25th his troops captured Missionary Ridge and defeated General Bragg at the Battle of Lookout Mountain.

Harriet read the accounts of the battles in the newspapers and reviewed drawings in her copy of the *Weekly*. Two side articles related to the battles caught her attention. **The 'Rock of Chickamauga'** featured General George H. Thomas and his heroics at the Battle of Missionary Ridge. Harriet clipped the article and his picture for her war map.

The second article was a listing of Confederate soldiers injured in the Battle of Chickamauga. She was always hopeful she would not find the name of anyone she knew. In the second paragraph was a name she did not recognize, General John Bell Hood. He was listed as a native of Kentucky, serving under the command of General Longstreet. He fought in the battle with a previous arm wound he had received at Gettysburg. She wondered, *Why would General Hood be required to fight in another battle after being wounded? Why not give him other responsibilities? Why does he need to be on the front line? I need to ask Annie. I'm sure there must be a good reason.*

By the end of the year, General Joseph E. Johnston was given command of the Army of Tennessee, replacing General Bragg. There were minor engagements in both the Western and Eastern Theater of the war. The newspapers reported no major troop movements during the winter. The armies rested, restocked their supplies, and made plans for 1864. Each side was hopeful that the next year would be the last. The foot soldiers hoped the generals would find a way to end the conflict. The generals hoped the two presidents would find a way to a truce. Prayers were lifted to The Almighty asking Him to intervene. The men in Gray and the men in Blue waited—with guns loaded.

At the same time at Travellers Rest, life went on. The freed slaves tried to comprehend fully their freedom. Mary Maxwell wrote her thoughts in a journal, hoping one day she would be a published author. Annie Claiborne and her daughters passed the time in school or waiting for the mail to bring news of Thomas. Harriet continued to manage the plantation and nurture her children, reminding herself almost daily, *I need to remember what happened today so I can tell John when he comes home.* She would not allow herself to think of John not coming home.

# 24. A Year to Remember

Harriet and her sisters did not plan any formal dinners for the holiday season. Food in Nashville was becoming scarce. There was no smell of citrus—lemons or oranges—no pineapples, no sugar for cookies and syllabub. Food for the table came from their fields, orchards, and smokehouse. A lone keg of peach brandy was found in the cellar, but Harriet decided to keep it for John when he returned. Then they would celebrate.

Some relatives came and stayed for a night or two. Friends came by to wish them a holiday greeting, but nothing extravagant was planned as in years past. The whole season felt tentative.

"Mother," Martha commented at breakfast, "I know we are not having a big party this year, but we can still make the house look and smell festive."

"What do you suggest?"

"We can cut and display some greenery and holly in the house. We can make hanky dolls. We can string some berries and popcorn and make some paper snowflakes for the windows."

"That is a grand idea. Why don't you and Mollie be in charge of decorating the house for the holiday season? You must find something each child can do to feel a part of the decorating. You may ask Claiborne to find the greenery and holly." Martha and Mollie went about their planning. Watching the girls move about the house reminded Harriet of a thought she had while in Pulaski.

"Annie and Mary, what would you think if we turned Mary Overton's bedchamber into a parlor? We could move some of the furniture out of the large room, put a rug on the floor, and add some small tables. That would create a better flow to the downstairs."

"Harriet," Mary was excited, "how about replacing the curtains with some heavy drapes?
There's a shop on the Square in town that sells used items like furniture and furnishings."

"Why would we want used things, Mary?"

"I doubt there's anything new in town to buy. The items in the shop are quality. The folk leaving the city sold what they couldn't take with them."

"All right, I'll put you in charge of the parlor. You can use what we have and purchase some other *used* items. Annie, you haven't said a word."

"Mary has a good idea. I think that room would make a fine parlor. I guess I was daydreaming about the parlor Mother had. Father never saw the need for one. Mother insisted, "Jesse, I want a proper room at the Hall where we can receive guests. Our daughters need to be reared with social etiquette. I intend for them to be proper young ladies."

"I don't remember a parlor at the Hall. Was I ever in the parlor?" Harriet queried.

"Oh, yes. You were a babe in Mother's arms. You were properly dressed and well behaved. Mother taught us how to sit and how to hold a teacup and saucer."

"Annie and Harriet," Mary gestured with her index finger, "when we get the parlor, you need to train your daughters the same way."

"All the more reason to have a parlor." Harriet was standing as she spoke. "I need to check on Jesse and then see how the house decorations are coming along. You'll excuse me, please."

"You're excused." The sisters laughed as Harriet left the room.

Harriet could hear the girl cousins laughing and giggling upstairs. She found Jackson May sitting cross-legged in the foyer.

"Son, why aren't you upstairs helping with the decorating?"

"Martha told me to bring in the greenery and holly and put them under the steps." He pointed to the pile he had created.

"That was a lot of work. Why don't you go upstairs?"

"I was told to wait down here." He stood and moved over to the bedchamber door facing and began to run his hand up and down it. Harriet stood at the foot of the steps with her hands on her hips.

"Martha! Martha Maxwell Overton, I need to speak with you, now!"

"Coming, Mother. Yes, ma'am?"

"Why is Jackson May not helping with the decorations?"

"Oh, he is, Mother. We gave him the most important job. Mollie and I knew the girls couldn't carry the heavy greenery, but Jackson May could. He is the strongest male we have in the family. We could not complete decorating the house without his help." Harriet turned away from Jackson May to hide her smile.

"That was good planning and very thoughtful." Martha was very pleased with herself and Harriet knew it. Harriet moved over to Jackson May and placed her hands on his shoulders.

"You are the strongest male in the house and we all depend on you. Thank you for what you do for this family."

"How strong is Jesse?"

"He's just a baby and he's not as strong as you. I'm counting on you to help him become strong. Will you do that for him—and me?"

"Yes, ma'am. When can we measure him and mark it here?"

"I don't understand. What do you mean?" Jackson May pointed to the marks and names on the door facing. All of the children's names were there— Martha, Mollie, Jackson May, Harriet, Mary, and Elizabeth. Harriet moved closer to examine the display.

"Who are Charles and Lavinia?"

"That's Charles Stratton and Lavinia Warren. They are General and Mrs. Tom Thumb." Martha was talking and laughing at the same time. "There's a story about their marriage in one of your *Weekly* papers."

"Mother," Jackson May joined in the laughter, "they were married in New York City."

"Are you certain?"

"Yes, they're little people—dwarfs."

"Oh, my." The laughter brought the other children to the steps and they joined in.

The war, news of the war, thinking about the war—all brought a gloom over the holiday season. Somehow Elizabeth came down with a chest cold and had to be confined in bed. Harriet moved the other children out of her room to protect them. As hard as she tried to shield him, Jesse became ill also. His breathing was labored, he lost his appetite, and nothing satisfied him. Harriet and the house servant walked the floor with him. Finally, Harriet consented to using a poultice on his chest to break up the congestion. The poultice had worked on Elizabeth. Harriet stayed up to the wee hours of the morning rocking Jesse. His fever broke and he fell asleep. When the light of day came, Harriet had to shake him from a deep sleep. She fed him and he went right back to sleep. She mouthed a prayer of thanksgiving as she placed him in his bed and covered him.

Copies of the *Harper's Weekly* had stacked up while Harriet was in Pulaski. When they arrived, she would review them, stopping to read only headlines that captured her attention. Jesse had been a full-time job even with the help of her house servants. Now that he was on a routine, she set aside some time each day after breakfast to thumb through each back issue. When she read an article she felt would add to the children's education, she cut it out and shared it with Annie.

One morning she discovered an article about a strange floating vessel the reporter called a submarine. The *Hunley* had seen action in Charleston, but the eight-man crew lost their lives when the vessel sank. On another morning, she read an article reporting that President Lincoln had declared the last Thursday in November as a national holiday of thanksgiving. She wondered, *This nation is being torn apart by war. Men are dying. Families will be in sorrow for generations. For what do we give thanks? We are alive—barely. President Abraham Lincoln, for what do we give thanks? Please tell me one single thing.* Harriet threw the paper in the basket with the rest of the papers. She felt a tear roll down her cheek. *Lord, why couldn't we just live in peace? Why is there so much death and destruction? Are we living in the last days?*

Harriet watched out the window as Jackson May shielded his face against the February cold. He was riding his new horse, a birthday present for his eighth birthday. She held Jesse, who in a few days would be seven months old. She heard her own words, "My, how time flies." She caught herself thinking, *John, I have not seen you in nearly seven months. You have held your new son only one time. You have not seen your other children in nearly two years. John Overton, where are you? Are you healthy? Have you been wounded? Are you*

*still alive? Oh God, please protect John and bring him home.* Harriet put Jesse in his crib and went to meet Jackson May in the foyer.

"Did we get mail today?"

"We got something. This pouch is heavy." He handed it to his mother.

"Thank you, son, for riding all the way down to the station to get our mail."

"It's really cold out there."

"Why don't you go the kitchen and let Cynthia make you something hot? Be sure to thank her."

"Yes, ma'am." Harriet took the pouch into the new parlor. She stoked the fire before she sat in the chair near the window. She dumped the mail in her lap and had to pick up two envelopes that had fallen. Annie and Mary entered the room and were seated.

"I hope there's a letter from Thomas in that pile."

"Let me see." Harriet shuffled the mail. "As a matter of fact, there are two envelopes with your name on them. This one looks like it's been around the world." Annie studied the strange envelope. The original address was her Texas home. Under that address was the Memphis military mail drop that had been marked through, and TRAVELLERS REST, NASHVILLE, TENNESSEE had been added.

"Who's it from?" Mary watched the puzzled looks on Annie's face. "Why don't you open it?"

"I don't believe it! It's signed William Elliot."

"Who's William Elliot?"

"You remember him, Mary. He escorted you on the paddleboat we rode on up the Mississippi River. He's Thomas' friend. We were in Texas together." Annie smiled as she finished the letter and handed it to Mary. "He asked about you, Mary."

"Annie, are William and Thomas still soldiers together?" Harriet was taking her reading glasses out of the case.

"They are both soldiers but on different sides."

"Annie," Mary said, "this letter was written nearly two years ago. William is sad, 'knowing one day he may be shooting at Thomas.' He's asking for your forgiveness if that happens. 'Please do not think ill of me, Annie. You are my forever friend.'"

"That is the last thing William said to me before he left the fort."

"That is so . . . so . . . poetic, Annie." Mary folded the letter and handed it back. Annie carefully broke the wax seal on the envelope she knew was from Thomas. Harriet was already reading her letter from John.

> *My Dearest Wife,*
> *The miles that separate us are shortened, I hope, by this brief*
> *note. I am on my way south to check on supplies. My health is*
> *good. Have not seen young John for several months. I am pleased*
> *to learn from your letter that baby Jesse is doing well.*

*How I long to hug and kiss you. I miss you to the very depth*
*of my soul. I am sending Eli home on a special mission. Look for*
*him. My love to you, our children, and all at TR.*

*JO*

*P.S. Thank you for saving the peach brandy. I look forward to*
*the celebration!*

"I trust John is all right." Mary didn't want to intrude on her sisters, but she felt she needed to say something.

"Yes, he's on his way south. He thanked me for saving the peach brandy."

"Are you kidding?"

"No, that's what he wrote." Harriet was laughing as she folded the letter.

"Annie, how is Thomas?"

"He misses us. He didn't say where he was. He feels the war will get worse before it gets better. He said, 'Our soldiers are very tired and want to go home.' Supplies are hard to come by. 'Each time I see a rolled bandage, I think maybe it came from the ladies at Travellers Rest.'" Annie held the letter close to her breast. She could not hold back her tears. Harriet moved to the sofa. She put her arm around Annie, as did Mary. The Maxwell sisters wept together.

While the two armies wintered, the early months of 1864 brought challenges for the leaders in Richmond and Washington. Jefferson Davis had high hopes for his new military leader, General Joseph Johnston.

"General, I want you to dig in and hold northern Georgia. I don't want the Union Army to advance further south than Chattanooga."

"I can defend the line."

"Good, that will free General Lee to be offensive. He might even be able to challenge Old Abe at his big White House."

"Sir, will I have the services of General Forrest?"

"Eventually, but for the time being, I want to free him up to create havoc where and when possible. When he has recuperated, I'm planning to send John Bell Hood to join you. You'll need him if the Yankees head for Georgia."

"Very good, sir."

Many in the Confederate ranks, Johnston included, felt attrition was a viable strategy. If they could hold out until the November election in the North, Lincoln would be defeated. Then pressure would be placed on the new president to seek peace. In the meantime, General Robert E. Lee was positioning his dwindling troops. Permission had been granted from President Davis to allow General Forrest and General J.E.B. Stuart's cavalries to run free.

Abraham Lincoln was not sitting idly by, waiting for peace. He had taken his stand on slavery. Already he was hearing gossip and threats about the November election. He was concerned about a second term, but his more immediate concern was to find a general who could create a strategy to bring

closure to this awful war. By the second week of April, Lincoln convinced his Cabinet he had found the man—General Ulysses Simpson Grant.

Harriet read of Grant's appointment as general-in-chief in the *Weekly*. The interview article quoted Grant: "I propose total war." She and the Confederacy would come to understand the horror of total war. General Philip Sheridan was given command of the Union Army's cavalry and would operate independently. General William Tecumseh Sherman was sent south to Georgia. The third part of total war was General Grant's challenge to defeat Lee.

As spring and summer unfolded, table conversations, including those at Travellers Rest, were dominated by names like Fort Pillow, the Rapidan River, the Wilderness, Spotsylvania Court House, Drewry's Bluff, Cold Harbor, Petersburg, and Kennesaw Mountain. Harriet added the locations to her war map.

"Mother, can you show me on the map where Father is?" Jackson May questioned.

"As best I can tell, your father is in the Atlanta area." She pointed to Nashville on the map and traced the route all the way to Atlanta, pointing out Chattanooga and Kennesaw Mountain. Jackson May's attention to the war was totally focused on where his father was at the time. Harriet located a spot on the map northwest of Richmond and made a dot with a pencil.

"This is the area in Virginia where your Grandfather Overton's family lives. There's been a lot of fighting there. This is the Shenandoah Valley in Virginia. Cavalry, the soldiers on horses, are fighting here. And here, south of Richmond, is a place called Petersburg where our Confederate soldiers are making a stand."

"Mother, do you think the war will last long enough for me to be in the cavalry?"

"I hope not."

"I could ride my horse for the Cause." Harriet could not believe what she just heard. *I could ride my horse for the Cause. . . . For the Cause!*

"I believe your father and your uncle Thomas want you to be a good student in school and let them fight for the Cause." Harriet was not certain her son heard her on his way out the door. In the quietness of the room, looking at the map, she pondered. . . . *for the Cause. Have I talked too much about the Cause in front of the children? Is this really their war? Have I had too many ladies here at the house rolling bandages for the Cause? I don't know. I really don't know. My life is here, but a part of me is with John.*

In the back of her mind, Harriet knew Eli would show up one day at the plantation unannounced. John had written in his last note, "Look for him." The trees in the meadow south of the house were vibrant with color, almost as if an artist had painted them that way on purpose.

Harriet and Martha walked to the meadow.

"Martha, this is my favorite time of the year. The weather is mild and the colors of the trees are breathtaking."

"I like it when there's snow on the ground. I like riding the sleigh in the snow."

"Thanks for walking with me. You have been a big help to me. Your care of Mary and Elizabeth has allowed me to give attention to Jackson May and Jesse. I appreciate your help. This war has robbed you of some of the opportunities your father and I planned for you."

"Like what?"

"We wanted you to attend a school like the Academy. We wanted you to travel. Next year you will be twelve years old. What special present would you like to have?"

"I'd like to have Father home, so we can be a family again."

"That would be a present for the whole family and a wonderful gift." Mother and daughter continued to talk and enjoy the scenery, as they turned and headed back to the house.

"Mother, do not turn around," Martha directed in a near whisper. Harriet complied and they picked up their pace. "There is a man and a horse in the stand of pine trees to our right." Harriet instinctively felt for her pistol, but she knew it was not there. She could see the top of the house in the distance but realized the person in the trees was closer to her than the house.

"Martha, when I let go of your hand, I want you to run as fast as you can to the house and get Annie."

"What are you going to do?" Harriet released her hand and gave Martha a gentle shove.

"Go! Run fast and bring my gun!" Harriet turned to face the challenge.

"Whoever you are, make yourself known." Stomping her foot gave Harriet courage. The figure stepped forward.

"Miz Harriet, it's me, Eli. Don't shoot!" Eli remembered the last encounter he had with Harriet. All he heard her say a few seconds ago was "gun." He pulled his hat off to give her a full view of his face. He did not move another step, hoping the distance between them would save his life.

"Eli, you gave us a fright. How are you? Come on over here and let's go to the house."

"I sees ya and young Miz Martha from da trees. I's feared ta show myself. I's plannin' ta lets yous gets home afore I's rides in."

"Eli, you look like you've lost weight and there's some gray in your hair."

"Ya, ma'am. Da war dos dat." They were approaching the little law office, turned schoolhouse, when Annie appeared holding her shotgun. Eli spotted her and stepped behind Harriet.

"It's all right Annie. Eli has come home."

"Thank God! The way Martha talked, I thought you had been kidnapped."

"No, everything is just fine. Eli, go take care of your horse. Go see Cynthia, get some food, and then come to the house. We want to hear from you."

"Oh, Harriet, when Martha found me in the schoolhouse, she was out of breath and could hardly speak. All I could make out was, 'Mother . . . take gun!' and she was pointing in the direction of the meadow. I saw the two of you coming, so I waited."

"Annie, you did the right thing. I'm glad Martha thought to look first in the schoolhouse. Where is she now?"

"I sent her to the house and told her to put everyone in the cellar."

"That was a smart thing to do. I'll need to remember that." Harriet and Annie walked to the house and found Eli standing at the open kitchen door.

"Cynthia not here. Nobodies here." The house appeared to be empty. Harriet pushed open the double door and entered the foyer.

"Hello, is anyone home!" She did not hear a sound but heard the echo of her voice. Annie went around the house to the cellar door and pushed against it.

"Mary, can you hear me? We are safe. You can come out." Slowly the door cracked opened.

"Is that you, Annie?"

"Yes. You can come out." The little troop of females and Jackson May huddled together as they exited the cellar and went to the gallery. The children were holding hands and being coaxed along by their Aunt Mary.

"Let's all go into the parlor and hear what Eli has come to tell us." Harriet touched each of her children as they passed. She had a special hug for Martha.

"Martha, you were so brave."

"No, Mother, you were the brave one. All I had to do was run to safety. You had to have courage to face the challenge." Seated in the parlor, the family waited to hear from Eli. He held up his hand and began pointing to his fingers.

"I's gots five thangs to tells yous." This was a new experience for Eli. Normally, when he came inside the house, he listened. Now he was doing the talking. He looked directly at Harriet and then each Overton child as he mentioned their names.

"First," pointing to his thumb, "Massa Overton send his loves fer y'all."

"How is Father?" Martha waited to hear her mother's voice for the interruption. Nothing was said.

"Yous father be well. He be eatin' and sleepin' good." The report made Martha and Jackson May smile at each other. Eli held up his index finger.

"Next, we talks with Massa Thomas." Annie and her daughters were seated on the sofa. "He be well and says, 'I loves my girls—all three of dems—Miz Annie, little Mollie, and little Harriet.'"

"Eli, when did you talk with Thomas?"

"It be late spring. He be off ta Virginny."

"Next." It was apparent to Harriet that Eli had been practicing what he had been told. He tried, as best he could, to deliver the messages in the proper order. "Young Master John Overton be goin' ta Mississippi ta join up with General Forrest." Jackson May looked at his mother and then back at Eli.

"Is he going to ride with the cavalry?"

"Ya, I 'spose dat be rite. Next, da war in Georgie be bad. And da last thang be only fer Miz Harriet." Eli was finished except for the last message. He looked at Harriet with a questioning look. She asked to be left alone with Eli. In a moment, she was alone, facing this faithful servant of the Overton family for so many years.

"Now, Eli, what is the special message?"

"Da war," he spoke in a soft voice as if to protect the message he'd brought, "be coming to Nashville."

"What?" Flashing before Harriet's eyes were the drawings in the *Weekly* of the ruined cities. "Oh, my God!"

"Massa John and me be comin' home."

"When? When is he coming?"

"I dosen't knows. He jest be comin'. He want ya ta put a special box on da train fer Pulaski. Ya is ta sends it ta Mr. Chiles at da station."

"What box? What's in the box, Eli?"

"Befores Massa Overton and me leaves fer da war, we puts a box in da earth in da orchard."

"What's in the box?" Eli hesitated and looked down at his feet. "Mr. Overton doesn't want me to know what's in the box, does he?"

"He says, it best ya not knows."

"Do you remember where you put the box in the orchard?"

"Ya, ma'am."

"We haven't had many patrols on the plantation recently. However, just to be safe, Eli, wait until dawn to recover the box."

"Dere be one mo thang. We needs to puts da box on da train at a spot 'tween here and Franklin. Massa John says da Yankees may be watchin'. Massa John says if anyone can gets da box on da train, it be ya, Miz Harriet."

"All right, if the box is that important, I'll go with you tomorrow. We'll find the spot." Harriet was ready the next morning to meet the early train at the secret spot. This time she had her pistol hidden away. All went well until the buckboard came within sight of the new fort. As they passed, a lone horse soldier yelled at them. Harriet waved in a friendly manner. She put her free hand on the hidden pistol.

"Eli, look straight ahead and keep going. Do not slow down." They were in the clear. By the time they reached the secret place, she could hear the train whistle.

"The train must be passing the fort." Harriet and Eli waited at a clearing in a heavily wooded area. The engine passed and began to slow. By the time the train came to a complete stop, the empty passenger car had passed and the freight car stopped in front of them. The large door slid open and out jumped two Confederate soldiers. One handed Harriet an envelope and then they loaded the box on the train. Eli handed Harriet the leather reins. "I's be takin' my leave and gettin' back to da war. I's sees ya next time."

"I'll see you next time." The door slid shut, the train pulled away slowly, and Harriet was alone, miles away from Travellers Rest. She watched the train fade into the distance and then read the brief note in the handwriting she loved.

> *My Dear Courageous Love,*
> *Thank you for delivering the box of gold bars. They will*
> *be used to purchase needed supplies, as the army makes its way*
> *to Nashville. See you soon. The day cannot come fast enough.*
> *Destroy this note after you have read it.*
> > *Your loving husband,*
> > *JO*

Harriet retraced the buckboard's wheel tracks back home. She waved as she passed the fort in Brentwood, but no one responded.

Eli's brief comment on the war being bad in Georgia seemed an understatement. As Annie read the Nashville newspaper she thought to herself, *I don't know which is worse, thinking Thomas could be in Georgia or not knowing what is happening to him in Virginia.* The article she was reading was reporting on battle events that had taken place in mid-May. There were two lines of encouragement for her, "after the May 16 engagement at Drewry's Bluff, General Beauregard moved his troops south." Thomas was with the General. There was no listing of names. The casualty numbers were not included in the report. She breathed a sigh of relief and thought, *in wartime, no news is good news.*

"Is there any news in the paper about the war in Georgia?" It had been a week since Harriet had made her early morning mystery ride with Eli. She had not said anything and no one had asked.

"According to this article, General Johnston has been relieved of his command and replaced by General John Bell Hood. 'Hood has a reputation as a bold, aggressive fighter.' It looks like General Hood and General Sherman have been in a chess match. One general makes a move and the other countermoves. The two armies have been at each other for two months. Sherman keeps pushing south and Hood keeps trying to cut off his supply lines. The Confederate cavalry defeated Yankee divisions attempting to free their prisoners in Andersonville and Macon."

"If the *Weekly* is to be believed, General Sherman sent a telegraphed message to Lincoln on September 2, bragging, ATLANTA IS OURS, AND FAIRLY WON."

"What's so great about winning Atlanta?" Mary continued to write in her journal as she raised the question.

"I guess it's just one more step deeper into the Confederate States. John believes the Army of Tennessee is coming to Nashville."

"How do you know that?

"He sent me a note." Annie looked up from the newspaper she was reading.

"Did he say in which direction they were coming?"

"No, he didn't."

"The reason I asked is, if General Sherman is moving south, General Hood could come back through Chattanooga and Murfreesboro to Nashville."

"Then how come the trains coming by the house, going south, have been filled with Yankee troops for the past week? Franklin Pike has been filled with a steady stream of wagons going south." Mary's question caused concern for Harriet. She was fearful. If the army came from the south, Travellers Rest sat on the direct path to Nashville.

Two weeks later, Harriet received a letter from her friend Grace. Three lines in the letter confirmed her fear.

*November 15, 1864*

*Dear Friend Harriet,*
*I regret to inform you of Mr. Chiles' passing. He went to*
*meet the Lord in his sleep. I have closed the shop and have*
*gone to stay a while with Mrs. Chiles.*
*Great fear has gripped Pulaski. Only a few miles away*
*in Columbia, the Yankees have moved in 20,000 troops. We*
*fear they will be coming our way. General Schofield has spread*
*them all the way to Lawrenceburg. It has been nearly a year since*
*the tragedy of Sam Davis' hanging. Pulaski and Giles County are*
*still in mourning. What is happening to our lives? I trust all is*
*well with you. Hugs and kisses to Jesse.*

*With love to my dear friend,*
*Grace*

At dinner that evening, Harriet shared Grace's letter with her sisters. Annie looked up after reading the letter.

"Harriet, we need a plan. What are we going to do if the plantation becomes a battlefield? With war, anything is possible. Thomas says, 'It's better to be prepared than to be sorry.' Are we planning to stay in the house? What are we going to do with the children? What are we going to do with the slaves . . . uh, workers?"

"My plan is to stay here. We can stay in the cellar. Do you really think we are in danger?"

"I would feel a little safer with a military presence on the plantation. Maybe the new commander in Nashville, General George Thomas, would help us. We need to stockpile some food supplies in case we get cut off from Nashville. Mary and I will make a trip into the city for supplies and stop by the headquarters. In the meantime, you can deal with the workers and their safety."

As fate would have it, Annie was wise in her concerns and planning. She smiled as she reported to Harriet.

"It appears we have not lost all of our womanly charm. Mary and I were able to get a wagon full of supplies. Please don't even ask where some of the stuff came from. Cynthia is filling the smokehouse and the cellar as we speak. Before dark, we will have two armed soldiers on the plantation."

"What did you tell the General to convince him?" Harriet was proud of Annie.

"I told him we had three ladies, seven children, and fifty workers to protect. But he really responded when Mary told him about all the corn the Union Army had bought from us. He was also interested to hear about the guerrillas in the area."

"We don't have guerrillas on the plantations."

"No, Harriet, guerrillas are what military people call the home guard."

"Anyway, we have supplies and soldiers coming for protection. I have asked Claiborne to bring our trunks to the house and move all our wagons near the barn. I've talked to the workers. They want to stay where they are but will come to the cellar later, if necessary."

"I bought a couple of newspaper in town. Your friend, Grace, was correct about the troops in Columbia, but it looks like the fighting is coming our way."

"Well, Annie, it appears we have heeded Thomas' warning. We are prepared. I just hope we will not need to be sorry." That evening at dinner, the family gathered for food, conversation, and prayer.

# 25. November 29, 1864

*This land looks so familiar, but it's a strange route to take to get to Spring Hill,* John was thinking when he heard Eli's voice. "Colonel Overton, could I's lags back a bit and rides wid Martin?"

"Martin who?"

"It be jest Martin, sir. He don't has no last name. He's jest Martin. Ya knows Martin. He use ta belongs ta de Judge. And right befores de Judge dies, Martin am sold south. Ya am jest a youngin whens ya, me, and de Judge brings Martin to Columbie."

"Do you mean Columbia, Eli?"

"Ya, sir—Columbie."

"Martin lived with us at Travellers Rest?"

"Ya. He am a child when he comes and he am a child when he sold south. De Judge got dat crazy bull ya names Ferd and we leaves Martin."

"Yes, I do remember Ferd. He's the bull that kept breaking down the fence, and one morning he was gone forever."

"Ya, sir. Dats de one—crazy Ferd!"

"Eli, it's fine for you to ride with Martin for a while, but keep a sharp eye on me. If I move away from this group of riders, you need to come with me."

"Thank ya, Colonel. I keeps a sharp eye on yous."

Colonel Overton pulled his horse back into the flow of soldiers and enjoyed the warmth of the morning sun on his face. The balmy weather yesterday and today was making up for the last three days of rain in Columbia. Apparently, the rain had fallen here as well, as evidenced from the ditches filled with water.

"Colonel Overton," the voice came with no recognition and sounding strangely un-Tennessean. "It's good to see you again. It's been a few years."

"Sir, you have an advantage over me."

"My name is Quintard."

"You must forgive me. Have we met before?""

"I'm Bishop Quintard from Nashville. I assisted in a funeral at the Downtown Presbyterian Church. You were one of the pallbearers."

"My humble apologies, sir—Bishop. Yes, I do know you. However, at the funeral, you were not in a military uniform and did not have a beard, as I recall."

"Your memory is correct. I also had a few more pounds on me at the time."

"I see you're a chaplain."

"Yes, my assignment is with the Army of Tennessee. I normally ride with General Hood and his staff, but his battle staff has become so large it's a little easier to ride with this group and then join him when he stops for the day."

"And where will you spend this evening?"

"I will join the General and his personal staff at the Absalom Thompson home in Spring Hill."

In most cases when the army is traveling in open country, private homes are used as headquarters. Advance parties are sent ahead to secure housing for the Commanding General and his small personal staff. The staff consists of the General's personal aide, several low-ranking officers who deliver and receive messages, a chaplain, and a medical doctor. There will also be a guard detail assigned for protection and a telegraph wagon. If the General is lucky, he may even have a personal cook. The army compensates the host family, but most often, they count the request as an honor. Not only is the General and his staff housed, but his Corps Generals and their staffs are offered accommodations nearby.

"Chaplain Quintard, do I recall correctly that you are also a trained medical doctor?"

"Yes, I am. I'm able to do double duty for the General. For a while I was on General Lee's staff."

"The General Lee in Richmond?"

"Yes, the very same. I'm here at his request. When General Hood was promoted to lead the Army of Tennessee, General Lee felt my training could best be used here."

"Your medical training or your religious training?"

"Some of both. It depends on the day and the situation. General Hood is having a terrible time with his health. He suffers from the two wounds he received in battle. He doesn't sleep well. His aide has to strap him into the saddle when he rides."

"Why doesn't he take a medical leave? I understand his wound at Chickamauga nearly took his life."

"Your question is one I've raised with him on a number of occasions. He is a determined soldier. His leg wound keeps him up many a night with no sleep, and he's right back in the saddle the next day. I really think he has something to prove—to himself and to the Cause."

Colonel Overton glanced over his shoulder to check on Eli. He was right where he said he would be. He and his friend Martin appeared to be in serious conversation but was keeping pace with the group, as they continued in a westward direction. The Colonel shifted his weight in the saddle and adjusted his hat against the bright sun.

"Chaplain Quintard, are you at liberty to tell me why we are not taking a more direct route to Spring Hill?"

"My impression, sir, from the briefing last evening in Columbia, is that General Hood feels his army is in a position to flank and trap the Yankees somewhere before they reach Nashville. He's hoping the Yankees will stay on the Columbia to Franklin Pike, allowing his army to split on either side of the Pike and get ahead of them—thus the trap."

"Not being a military man myself, do you think the Yankees will allow themselves to be trapped?"

"Colonel, I don't make the plans, I just bless them after they have been determined."

The slow-moving, westward-bound soldiers began to slow down even more. The soldiers in front, a quarter of a mile ahead, were in a dead stop, causing the same reaction behind them. Colonel Overton and Chaplain Quintard pulled their horses to a stop and dismounted, allowing their mounts to move quickly to some nearby grass. Shortly, Eli walked up to them leading his horse. He made eye contact with the Colonel but did not speak.

Officers on horseback were making their way through the mass of soldiers, barking orders to break rank but stay in their assigned units. This was a rest, eating, smoking, and a take-care-of-your-personal-needs break—but still a time to stay together. The Colonel looked behind and could not believe the mass of soldiers. There must have been at least 3,000. He had not realized, in the brief time he had been talking with Chaplain Quintard, that such a mass of soldiers had gathered. Scattered throughout the throng were supply wagons but no heavy cannons. That was strange, *but I'm not a military man,* the Colonel pondered, taking in the scene.

He remembered one other time in his life when he had been in the middle of a large crowd of people. His father, the Judge, had taken him down to the boat dock to watch President Andrew Jackson begin his journey to Washington. He had told Harriet about the event, and now he would have another story to tell her when next they met. The Colonel caught Eli's movement out of the corner of his eye. Eli had unbuckled one strap on his saddlebag and was working on the second strap. "Eli, what are you doing?"

"I's looking for one of dem ham biscuits."

"Where did you get ham biscuits?"

"We be leavin' Colombie dis mornin' and out of de kitchen come de cook with a napkin full of biscuits. She asks me would I likes ta have 'em fer my trip. And I says 'yep,' and here dey is." Eli released the second strap, pulled out a grease-stained napkin, and unfolded it. To his and the Colonel's delight and amazement, six palm-sized biscuits were wrapped around protruding pieces of ham. "Has ya ever in alls ya born days sees anythin' likes dat?" Eli was smiling so wide, it was hard for him to chuckle at the same time—but he did. The Colonel noticed Eli's expression and began to laugh.

"Eli, maybe General Hood should assign you to the quartermaster corps. You have the ability to come up with just the right supplies."

"No suh, Colonel, I's goin' ta fights dis here war at ya side, not behinds a gun." Holding out the napkin filled with lunch, Eli quizzed, "Is I a free man?"

"Yes indeed, Eli, you are a free man."

"What do it mean, I's a free man?"

"It means I no longer own you. You are free to go or stay. Why are you asking the question?"

"When I's ridin' wid Martin, he say he a free man. I's telled him he not free. De Judge done sold him south. He tell me, 'Don't matter now fer President Lincoln make him free.' How Lincoln do dis, Colonel?"

"He's the man the Yankees call the President of the United States. He's the man who has the same job Andrew Jackson had. His office is in Washington."

"If he be likes Massa Jackson, he be a good man. I's remember when Massa Jackson come visit de Judge at Travellers Rest. He a good man."

"Well, Eli, Mr. Lincoln and Mr. Jackson had the same job, but they are not alike."

"How they be different?"

"Mr. Lincoln doesn't know how life is lived in the south, and Mr. Jackson lived his life and had his home in the south. Mr. Lincoln gets advice from a lot of people, and Mr. Jackson made a lot of his decisions without advice from others. Mr. Jackson. . ." Chaplain Quintard's return from tending his horse brought a halt to Lincoln-Jackson differences in mid sentence.

"My humble apologies, gentlemen. I did not realize you were in conversation. Please continue. I'll. . ."

"No, Chaplain. We were talking about Eli's freedom. He had some questions, and I was trying to give him some answers. Perhaps you have some advice for Eli about his freedom."

"I don't really have advice, but maybe some words of encouragement. Tell me about yourself."

"Well . . . well . . . Colonel, maybe yous needs to tell him 'bout me."

"My father brought Eli to the plantation shortly after I was born. That was in 1821. He was about ten years old at the time. He was born in Virginia. He stayed in the cabins for about two years, and then my father brought him into the main house to be my companion. In 1831, the two of us went to New Orleans for my manly training. We stayed there until my father's death in 1833. My mother thought it best I spend some more time away. So Eli and I returned to New Orleans. Although he was my servant, he lived with the other house servants while we were there. Eli has been like a brother to me all these years."

"You two have been companions for over forty years?"

"Yes, that's true.

"Ya, suh, dats rite."

"Eli," the Chaplain patted him on the back, "in one sense you have been a slave all your life, but in another sense, you have been free all your life. The real difference, as I see it, is in the area of responsibility. For all these years the Colonel has been responsible for you and now that you are free, you are responsible for yourself."

"How I's be responsible for me?"

"Well, you will need to buy your own food, clothes, and find a place to stay. When you're sick, you'll need to get well by yourself. Those things have been provided for you all your life."

Before Eli could respond, the three men spotted a cloud of dust rising to their left toward the south. Chaplain Quintard had an idea what was causing the dust, but it remained a mystery for the Colonel and Eli until the horsemen were about a hundred yards away. The Calvary always created attention when they rode, but General Forrest's men created dust. It seemed to be their trademark. For some unknown reason the horses began to slow down to a trot and then to a walk as they approached. They were a sight to see, and the soldiers in the surrounding fields stopped what they were doing to view the spectacle. The lead rider raised his hand and halted the unit. He dismounted, adjusted his saber, removed his hat, and in a strong voice said, "John." The Colonel was surprised, but delighted to hear Thomas' voice.

"Thomas, it's wonderful to see you again!"

"Eli." Still holding his ham biscuit, Eli smiled at Thomas.

"Massa Claiborne, tis good ta see ya, suh."

"Thomas, do you know Chaplain Quintard?" The Colonel turned in his direction.

"Yes, we have met on a number of occasions at headquarters. I must admit, however, I've not been to Sunday service since Alabama. Inspecting the troops in this army keeps me quite busy."

"Captain, it's good to see you again," the Chaplain replied.

"Chaplain, did you know John and I are brothers-in-law? We married the Maxwell sisters—at least, two of them, anyway. John, have you been back to Travellers Rest in recent days?"

"No, Eli and I have been on a sweep through Tupelo, Jackson, and Hattiesburg. We spent a couple of days in Pass Christian, and then we headed for Nashville by way of Alabama. I heard the Army of Tennessee was headed north, so we have been waiting in Pulaski for about a week. Eli has been back about three days from the plantation."

"Eli, did you, by chance, see Mrs. Claiborne while you were there?" questioned Thomas hopefully.

"Ya, suh. I's gives ya three ladies ya message. Dey smiles and says dey loves ya, too. Miz Annie looks fine and ya chillins be happy."

"Eli will be going to the plantation shortly with a message for Mrs. Overton. He'll be glad to take a note to your wife."

"Thanks for the offer, John, but I need to complete an assignment for the General. Big things may be happening by this time tomorrow. See you soon." In a flash, Captain Claiborne was back in his saddle and giving the order for the unit to move forward. They began in a walk, then a trot, and then in full gallop. In ten minutes, the entire unit was making dust.

"Eli, are you ready to ride to the plantation?"

"Ya, suh."

"I need to add one additional line to the note." Since visiting with Thomas, the Colonel added, "Had a brief visit with Thomas. He is well. He said, 'Big things may be happening by this time tomorrow.'"

"There, the note is ready to go with you, Eli, to the hands of Mrs. Overton. Remember to stay near the railroad. After you cross the river in Franklin, rest your horse and eat another of your ham biscuits. Make the rest of the trip at an easy trot. You should be at Travellers Rest by sunup. If by chance you are stopped, represent yourself as a free man headed for Nashville."

"Ya, suh. I's be a free man headin' for Nashville."

# 26. Sadness and Joy

The L-shaped upper gallery was a wonderful place to begin the morning. The winds from the north greeted one with a crisp, "Welcome to a new day." Harriet took the opportunity to visit the gallery while the others in the family slept. When the first child's feet hit the floor, the day had begun. There would be no time for quiet reflection. The winter sun's rays coming through the spindles covered the wood floor, making it dance with shadows. Closing the door behind her, Harriet hoped a gust of wind whipping around the gallery would not slam the door and wake the others inside the house.

She was anxious about the day ahead. As she moved to the north end of the gallery, she saw the smoke rising from the fireplaces in the cabins beyond the tree line. She had seen this sight so many times but now wondered how much longer she would have the field hands and the house helpers. A few months ago, the hands and helpers were slaves owned by her husband. Now, thanks to Abe Lincoln, they were free. A completely new vocabulary had to be used for the current situation. Whatever the feelings were of those living in the cabin community, they would have to wait. Harriet had more pressing matters to attend to.

To the north, the Union Army was making its presence known. They sent out small patrols nearly every day to the peach orchard ridge to spy on the house. For the last few days, Franklin Pike was filled with soldiers and supply wagons moving north and south. Even at this early hour of the morning, the sounds of war filled the gallery. The faint sounds of cannon fire from Fort Negley bounced off the brick walls of the house. *Why must they fire those cannons so early in the morning?* She knew the answer to her question but posed it anyway—to keep the enemy on the defensive. Anything she could do to put them in jeopardy was well worth her mental effort.

The elevation of the gallery and the season of the year allowed Harriet a brief pause as she viewed the rising of the sun. Standing here with the leafless trees not blocking her sight, she could almost magically see the old Maxwell Hall. The memory of that house, her home, was refreshing, even though it burned to the ground when she was a child. She breathed deeply, remembering fond moments of her childhood, her parents, her sisters, and the way things used to be. *That time is gone. As wonderful as it was, it's gone. That was my life then.* Harriet gripped the top of the railing, arched her back, and reminded herself as she verbalized her thoughts, "I was there yesterday, but I'm here today!"

"Who are you talking to?" Annie questioned as she neared Harriet. Annie glanced over the rail into the yard below to be sure she was not intruding into her sister's conversation.

"Good morning, Annie." Harriet was chuckling as she turned in Annie's direction. "What are you doing up so early?"

"Those cannons. I thought maybe. . ."

"Maybe the Yankees were headed this way. Is that what you thought?"

"Well, yes, that thought is ever present . . . Harriet, what are we going to do with the children if the Yankees come?"

"Do you remember what Mother would do when you, Mary, and I were frightened by the lightning and thunder?"

"Yes, I do. Mother would say, 'Annie, get your little sister Harriet and I'll get Mary.' Then off we would go to the cellar."

"That's right. The cellar at Maxwell Hall was a safe place. We'll do the same thing here at Travellers Rest, if the time comes."

"Harriet, I'm wondering if we would not be wise to leave here and go south, maybe to Pass Christian."

"You mean leave my home and this land to the Yankees? That will never happen!" Harriet stomped the wooden floor so hard, Annie took a step back. "They may shoot this rebel gal. They may put this rebel gal in chains. But nothing will ever change my Southern heritage." Harriet stomped again and it reminded Annie of other times when her little sister had exhibited her strong, unchangeable will. A Maxwell trait had found a generational resting place.

"Annie, we could not leave now, even if we wanted to. We cannot go north. We cannot go east or west. General Thomas has blocked the way in those directions. The war is coming to us—from the south."

The sound of Harriet's stomping was not confined to the upper gallery. The sound had carried to the barn where Claiborne was preparing for the day. He came running up the hill and saw the two sisters. "Is ya all right, Miz Overton?"

"Yes, Claiborne. we're fine. And how are you this fine morning?"

"Tolerable, just tolerable, thank ya."

Annie stepped forward, close enough to the rail to view Claiborne below. "Harriet, were you talking to Claiborne when I first came onto the gallery?"

"No."

"Then who were you talking to?"

"I guess I was talking to myself, remembering yesterdays at Maxwell Hall."

"Oh."

"I was there for a few brief moments, but I'm here now." Harriet glanced past Annie to their right, shielding her eyes against the morning sun and hoping this would be the day Eli would come.

Claiborne started back to the barn when Harriet directed, "Claiborne, tell Cynthia to prepare breakfast. We should be ready to eat in about an hour."

"Ya, ma'am. I's goin' to de kitchen rite now."

Harriet and Annie entered the house to find their sister Mary, already dressed in her day clothes, moving toward the staircase. "Good morning, what are the two of you doing on the gallery this time of morning?" Mary questioned.

"Would you believe we were reliving our childhood days at Maxwell Hall when Mother took the three of us to the cellar?" Annie said, turning to smile at Harriet.

"Harriet, you were so small. How do you recall those days?" quizzed Mary.

"A lot of our childhood experiences come back to me when I watch my Martha, Mary, and Elizabeth. My girls are similar in many ways to us when we were children. Our ages were closer together than theirs, but they have the same sense of sisterhood."

"What do you mean by sisterhood?" Mary was not familiar with the term.

"Do you remember the time Mother came here to visit Mrs. Overton? We came with her, and we had on our Sunday clothes. In fact," Harriett remembered, "we were on our way home from church. I was eight years old. Annie was about twelve; you were eleven. Mother and Mrs. Overton were visiting in the sitting room. Mother excused us and we went downstairs. When we got to the bottom of the steps, John Overton Junior greeted us. He was so tall and handsome. We giggled when he spoke to us. Later that night in our bedroom, we took a pledge. We pledged that one of us would marry John some day." Annie's smile turned into a laugh. "Harriet, that night you said it would be me."

"Yes, Harriet," Mary chimed in, "little did we know that you would be the one."

"Well, Mary, that's sisterhood."

The three sisters laughed and hugged as they had not done in years. It was good to laugh in stressful times like these. It was fun to surface memories of days gone by. *John should have been here to enjoy the sisterhood story, since he was the main character in the drama of life,* the sisters thought silently without saying a word to each other.

Waking-up sounds were coming from the rooms where the children slept. Harriet's four younger children slept in the room near the grand staircase. Annie's two girls stayed with her in her bedchamber.

Mary was making her way down the staircase when she was stopped by Harriet's voice. "Would you step into the kitchen and tell Eliza the children need to get up and get ready for breakfast?"

"Yes, I will."

Annie turned and headed for her room and then turned again. She walked back to Harriet and took her hands in hers. "Harriet, the girls and I appreciate your kindness in allowing us to stay here with you and your family. Living in Texas with the girls was no fun without Thomas around. He was determined to get involved in the war, and thanks to your wonderful John, he has found his place riding with General Forrest."

"The Cause needs every able-bodied, fighting man available, and your husband's cavalry experience was a natural match for the General. I'm happy you and the girls are here. One never gets too old to need a big sister, and

you'll always be mine. Your training as a teacher and your willingness to teach the children has been a Godsend."

The sisters parted and went about their morning routines.

Eliza had been with the Overton family for a long time. She had been purchased by Judge Overton to help rear his children—John Junior, Ann, and Elizabeth. Eliza was just twenty years old when she came to live at Travellers Rest. Sometimes it was hard for her to remember. Last year when Harriet gathered all the slaves at the gallery steps to tell them they were free and could leave if they chose, Eliza began to cry. She didn't know if the news of her freedom was good news or bad news. She had felt free for many years, working for the Overtons, but remembered all too well her feelings when she arrived. She had been born into slavery and as a child had witnessed what had happened to her mother and older sisters. That had not been her experience personally, but sights and sounds become a part of one's personal history. There had been challenges from houseguests in the past, men who looked at her as property and not as a person. But now that she was in her late sixties, the challenges were not a problem. Now her only worry was whether she could make it up and down the staircase one more time.

"Eliza," came the voice from the top of the stairs, "are you coming?"

"Yes, Miz Overton, I be thar directly." Eliza had known other Mrs. Overtons through the years, but this was one was the best and the worst.

"I want Martha, Jackson May, and Mary to have some playtime outside this morning before they go with Mrs. Claiborne for schooling. You will need to check with Mrs. Claiborne about Mollie. The girls will need long stockings underneath their dresses, and Jackson May can wear his heavy, long pants. Their coats are still in the hall closet downstairs."

"Yes, ma'am."

"Elizabeth will be staying inside today. So just dress her in day clothes. It might be good for Harriet Overton to stay in with Elizabeth, but ask Mrs. Claiborne about that."

"Yes, ma'am." Eliza really knew the morning routine by heart, but she also knew Mrs. Overton had to be in charge.

"I'll manage little Jesse and take him with me when I go downstairs. And one more thing, Eliza, stand over Jackson May while he washes his face. And comb his hair. He is the man of the house and he needs to look the part." Jackson May was just waking up, but he came to attention when he heard the last part of the conversation—*man of the house.*

In the other bedchamber, Annie's oldest, Mary Maxwell, better known as "Mollie," was up and out of bed at the first sound of her mother's voice. For her sister Harriet Overton, it was another matter. She was a sleepyhead and needed extra coaxing to get out of bed.

Cynthia had breakfast on the table when the adults and children came into the room. This morning the family was eating in what Mrs. Mary Overton

used to call the men's sitting room. Since that social function was no longer needed, Harriet used the room as an office and also as a dining room where the family gathered for meals. It was a perfect size for the three adults and seven children who ate there. The fire in the fireplace made the room nice and warm when the three doors in the room were closed. The two large windows allowed an abundance of light. From her vantage point at the table, Harriet could view the outside from either window. Sally, Cynthia's helper, used the north door, which led to the kitchen. To Harriet's right was the door that connected this room to the rest of the house. The third door opened to a narrow staircase to the second floor.

When all had gathered, Harriet looked around the table. "Let's see, who would like to say grace?" Her strong Presbyterian background served in all aspects of her life, and grace at mealtime was always important. Before Annie or Mary could respond, Jackson May scooted his chair, making a scraping noise against the wood floor. Standing as tall as he could and looking directly at his mother, he announced, "Since I am now the man of the house, I feel it is my duty to say grace." Harriet took in every word of the request but pondered the phrase, "my duty." Painfully, she had heard that phrase from another Overton male, and against her wishes and pleading, her John felt it was "my duty" to support the Cause. Because of his "my duty" she had the full responsibility of Travellers Rest.

"Do your duty young man."

Although he stammered and gasped for air, Jackson May's first attempt at saying grace was completed, having made mention of the food, his family, and the Cause. As his mother nodded approval, Annie passed the first platter of food to him.

Harriet and Jackson May were the only ones at the table to see Eli pass by the window. The knock on the door was strong and rattled it from top to bottom. Since Cynthia was not in the room, Harriet turned to Jackson May and said, "Please go to the door and ask Eli to come in." All eyes at the table followed Jackson May's every move. He twisted the silver doorknob and yanked the door open, revealing Eli to all in the room.

Eli went directly to Harriet. Already Eli's hat was in his hand as he fumbled about his vest, trying to find the written message he was to deliver only to Mrs. Overton. "I's has a message fer ya from de Colonel." Eli bowed and backed up at the same time, as he extended his arm toward Harriet. She took the envelope from Eli's hand, placed it next to her plate, and directed him to see Cynthia in the kitchen for some breakfast. "Eli, after you've had breakfast, please come find me. I need to ask you some questions."

"Ya, Miz Overton."

The timing was perfect. Jesse began squirming in his crib and was working up a little cry about the time Eliza walked into the room. "Eliza, please tend to Jesse," directed Harriet. "And when you get upstairs, send Emily Jane to me immediately."

The children around the table waited to be excused. Emily Jane appeared and took charge of Elizabeth and Harriet Overton. They would stay in the house this morning. The older children would put on their coats and hats for a time of play outside before going for lessons with Annie. Mary Maxwell would supervise the outside play. With assignments made and agreed to by nodding heads, the blended family was off to the adventures of the day.

Annie stared at the obvious envelope at Harriet's plate and said, "Harriet, the envelope."

"Oh, yes. The envelope. Thank you." Harriet gently lifted the envelope flap and slid the folded note out. In a way, she was hoping to catch the scent of her beloved John. She read each word almost letter-by-letter to increase the joy she felt.

*November 1864*

*My Dearest Wife Harriet,*
*We are headed for C, SH, F, B, and then home. I do not have any*
*idea about the time involved. I have been gone from you and the children*
*far too long, but I must do what I can for the Cause. The men in the A of*
*T are in good spirits. They have a strong leader, JBH, and seem eager to*
*follow him. It appears, from what I hear, the A is headed for N. That*
*being said, keep the field hands off FP and out of the west fields. Be*
*sure to secure all the buildings. The two armies will be moving across*
*our land in large numbers.*
*I am forever your loving husband and looking forward to being*
*home soon.*

*As always I am,*
*JO*

A message for Annie

*I had a brief visit with Thomas. He is well and loves you. He*
*said big things may be happening soon.*

After reading the letter, Harriet read it to her sisters. She was even able to decode it. She smiled at both of them but made eye contact with Annie. "There is a brief note about Thomas." Harriet handed the letter to Annie. "What do you think Thomas meant by 'happening soon'?"

Annie paused, then answered, "I'm guessing from the other information that General Hood is moving the Army of Tennessee toward Nashville. There may be fighting in Columbia, Spring Hill, Franklin, and Brentwood. One thing is for certain; we need to be prepared."

Harriet was on her way to the weaving house when she approached the two young Yankee soldiers sitting with their backs to the side of the smokehouse. *I'm glad these soldiers are here to protect us against scallywags.*

One was smoking a pipe; the other had his eyes closed, letting the winter sun warm his face. They did not stand when Harriet stopped.

"Are you old enough to smoke?" Harriet was holding tightly to a heavy shawl.

"Lady, if I'm old enough to die, I'm old enough to smoke." She was tempted to snatch the pipe out of his mouth but withheld any other comment about it.

"Is your lodging satisfactory?" Claiborne had made a place for the soldiers in the barn, when he noticed they were setting up a tent near the smokehouse.

"Yes, ma'am. It's like being at home in Ohio." Harriet wasn't sure the comment was truth or sarcasm. She walked over to the weaving house to check on Matilda and then went back to the kitchen.

"Cynthia, please prepare enough food each meal for the two young soldiers to have something hot."

"Ya, ma'am. Ya knows, one of dem youngins gots a smart mouth."

"I know, but he's still a human being and needs to eat. He's far from home and he may never get back there. His mother loves him and is praying he gets enough to eat. You are helping God answer her prayers."

"Miz Harriet, yous a mighty fine Christian lady."

"I'm just returning a kindness." Harriet walked on the gallery and was met by a puffing Jackson May.

"Mother, Aunt Annie wants you and Aunt Mary to meet her at the schoolhouse."

"Thank you, kind sir. I'll head that way. You go tell your Aunt Mary." She looked at her watch as she started down the path. It was a few minutes after four o'clock. She passed the girls and they exchanged greetings. Annie and Eli were standing next to the schoolhouse.

"Harriet, I've been hearing cannon fire south of us, and the children are frightened."

"Are you sure? Maybe they are firing the cannons at the fort in Brentwood. Or maybe the sound is coming from Fort Negley."

"No, it sounds more distant than either of those. There, did you hear that?"

"Yes, I did. Surely we couldn't hear anything from as far as Columbia."

"No, ma'am." Eli had cupped his hands on his ears. "Theys be fightin' in Franklin."

"Eli, will Mr. Overton be in danger?"

"No, ma'am. Massa John be a ways from the fightin'."

"Could the sound be coming from Fort Granger?"

"Yes, Fort Granger is a possibility." The sounds continued until nightfall. At times, the booms rattled the glass windows in the parlor. Each time it happened, everyone in the household was aware and anxious. Annie wondered silently, *Is this the 'big happening' Thomas was talking about?*

On Thursday morning, December 1, the sounds of wagons rolling fast and the loud voices of men outside woke the household at Travellers Rest. Annie

went to her trunk and found Thomas' officer shoulder boards. She dressed and left the house to find the two soldiers providing them protection.

"I want you to wear these boards on your uniform."

"But ma'am, we might get shot for impersonating an officer."

"These boards just might save your life." As the morning progressed, Annie's prediction proved correct. A number of times Union soldiers, staggering back to Nashville, passed by the house only to encounter youthful officers near the smokehouse. The two sentries found the encounters funny and laughed when older soldiers passed by. About noon, gray-clad soldiers began to appear on the plantation. Dropping the officer boards by the smokehouse door, the two Union guards joined their fellow soldiers and headed for Nashville.

As Harriet and Annie stood on the gallery watching, three riders approached from beyond the schoolhouse. It was difficult to tell the color of their uniforms from a distance. Halfway between the schoolhouse and the house, the riders slowed. The horses were breathing hard, blowing hot air into the crisp December day.

"Harriet, I believe their blankets are Confederate gray. We'll soon know if they bring sad news or unspeakable joy."

"Annie, I hope it's joy."

The lead rider removed his hat as he approached the gallery. The other two followed his actions.

"I am looking for Mrs. John Overton."

"Yes, how may I be of service to you?"

"Ma'am, I bring you greetings from Colonel Overton. He wants you to know he will be here tomorrow and . . . he has made a request." Harriet turned to Annie and they embraced. She did not hear the last phrase.

"Harriet, there's more. There's something else the officer is saying."

"Please forgive me, sir. I am so overtaken with joy that I did not hear all you said."

"Colonel Overton has requested you prepare the house to receive guests."

"Who might they be?"

"Ma'am, General John Bell Hood and his staff will be using your home as his headquarters."

"When may I expect them?"

"The General will be here tomorrow near dusk. Several wagons and several riders will arrive after sunset."

"Should I prepare dinner for General Hood and his staff?"

"Since the exact arrival time is uncertain, I will say no. I will advise the General of your offer and of my decision."

"Very well, young man. We look forward to tomorrow." The three riders saluted, donned their hats, and spurred their horses to full gallop. Harriet and Annie walked into the parlor where they found Mary, who had been watching the riders through the window.

"What did they want?"

"Mary, we have news that is almost unspeakable."

"What on earth would that be?"

"Tomorrow night our home will be filled with Confederate officers. Travellers Rest is to be turned into General Hood's headquarters." Annie added to Harriet's joy.

"If that wasn't good news enough, the best news is John is coming home with the officers." Mary clapped her hands and walked around the chair to give Harriet a hug.

"Ladies, we only have one day to get this house ready for guests." Harriet was already making mental notes of things that needed to be done. "Mary, I want you to find Claiborne, Archer, and Cynthia. Bring them to the gallery. Annie, bring the children to the parlor. We need to tell them what is about to take place."

Mary was out the door, wrapping a heavy shawl around herself as she headed to the kitchen. "Annie, do you think all of us could squeeze into the upstairs parlor?"

"It would be tight, but we could do it. Could we use the empty room above the small dining room?"

"I thought we had some furniture in that room."

"We do, but some of it could be moved to the upper gallery. Harriet, are you thinking of moving all of us into the upper parlor?"

"Yes."

" Why don't you and John take the room we clean out upstairs? Maybe we could put a cot in the small dining room for Jackson May. That would leave Mary, our five girls, Jesse, and me in the parlor."

A short while later, they told the children about the coming situation and the changes involved.

"Jackson May, why are you so happy?" questioned Harriet.

"Because Father will be here tomorrow, and I don't have to sleep in the room with all the girls."

"That's reason enough." She put her hand on his head and ruffled his hair. *Jackson May, you may have had to sacrifice the most of all of us. The Cause has forced you to be the man of the house. You've had to grow up without your father around. Son, I'm happy for you.*

"Children, go about your day, but stay inside the house. You can watch the soldiers through the windows. Mary, ask Cynthia, Archer, and Claiborne to come into the parlor." Harriet motioned for everyone to find a seat. Archer hesitated momentarily and then sat in a chair next to Claiborne.

"I've asked you to come because I need your help. By tomorrow evening this house will be filled with guests—all of them men. So we need to do some rearranging. Archer, a couple of years ago you built dividers that we used in the upstairs parlor."

"Yes, they are in the cellar."

"Good. I want you to recruit a dozen workers to help rearrange some of the rooms. We need to begin within the hour. There will be extra pay for all. Cynthia, I want you to find two more people to help you in the kitchen, and we need six more people to work in the house for a spell. There is also extra pay for them. Claiborne, I want you to hire men to cut firewood and keep the fireplaces working. You will also need to locate more hay for the extra horses. All three of you need to know there will be soldiers putting up tents and building fires on the plantation. Do not be afraid. These men are Confederate soldiers. Do you have any questions? By the way, as you move among the workers, my offer still stands. They can come and stay in the cellar, if they desire." As everyone left the parlor, Harriet, Annie, and Mary stopped in the foyer.

"Ladies, we need to take some assignments." Harriet felt the need to be directive.

"What can we do to help?" Annie knew time was a priority.

"Annie, I want you to work with Archer to get the dividers in place and arrange the upstairs parlor. Assign a couple of the workers to clean out the other room upstairs. Mary, ask someone to search the cellar and barn for extra beds. Bring them to the lower gallery. Then help the children get their things together. I'll need for you and Martha to move into the upstairs parlor with the rest of us. What do you think of making our new parlor a bedchamber and my bedchamber the parlor?" Mary gave Harriet a questioning look.

"Why would you want to do that?"

"Annie, didn't you tell me General Hood had lost a leg in battle?"

"Yes, he has an artificial leg. I understand your plan. By changing the two rooms, he would be closer to the large room for meals."

"Exactly."

The workers were fast and hard working. They accomplished everything Harriet had planned. She and John would have the single room upstairs. The rest of the family would live in the large upstairs parlor. Jackson May arranged his cot in the corner of the small dining room. Hay and firewood had been gathered and stacked. Cynthia had picked some of the older young adults to work in the house and added help for the kitchen. Harriet met with the helpers to explain their duties. When they left, Harriet had to smile as she thought, *Things are moving so smoothly that I'm glad Mr. Gray left the plantation when he did. He would have only been in the way.*

The residents of Travellers Rest awoke on Friday, December 2, to an unseasonably warm day. During the night large numbers of Confederate soldiers came to the plantation. As Harriet, Annie, and Mary met on the upper gallery before breakfast, they were amazed at the number of small fires dotted all over the property.

"I guess the soldiers are eating breakfast." Mary walked to the north end of the gallery.

"Harriet, I suggest we stay up here today with the children. They can play while we finish rearranging the inside. We can put Martha and Mollie in charge of the younger children. In fact, if the weather stays this warm, we can have school up here."

"That's fine with me. I need to go check on breakfast and talk to the house servants."

"If Jackson May would like to join us, he's welcome to come," Annie suggested.

On her way to the kitchen, Harriet found Jackson May sitting on the steps.

"Good morning, son."

"Good morning, Mother."

"After breakfast, Aunt Annie will be having school lessons on the upper gallery. Would you like to join them?"

"No, ma'am. I'm waiting for Father to come."

"It may be dark before your father arrives. Maybe some school lessons would make the time pass." Jackson May stood, faced his mother, and stomped his foot.

"Mother, I prefer to wait on the gallery for Father." His voice was firm but controlled. Harriet locked her eyes on her son. *You may have your father's features, but you have Maxwell blood flowing through your veins. Apparently, you have my temper—at least in your foot.*

"Very well. I will ask you to stay on the gallery."

"Yes, ma'am. Thank you, Mother. This is a wonderful day for our family."

"Indeed it is . . . a wonderful day."

At breakfast, Jackson May stood behind Harriet's chair and helped her be seated. His polite actions did not go unnoticed by his Aunt Annie.

"Harriet," Mary handed her a book, "would it be all right for me to place that book in the large room? It's one of my new, unused journal books. I'd like to collect autographs from our guests."

"Yes, but you will need to keep up with it." Harriet glanced out of the window.

"They're here!" Jackson May was out of his chair and on the gallery while the others continued to eat. Harriet joined her son, holding him by the back of his shirt to keep him on the gallery.

"Good morning, ma'am. We are the advance security troops for General Hood. We need to secure the house, and then we'll be putting up a signal station." The officer in charge began giving orders and directing his men to different tasks. When he finished, they headed in different directions. "Ma'am, I will appreciate your help in seeing each room in your home."

"I'm at your service, sir." The officer dismounted and watched as Jackson May said something to his mother. Harriet shook her head from side to side indicating no.

"Ma'am," the officer unhooked his sword, "I sure could use another trooper to watch my sword and horse while we tour the house. Young man,

could you help me?" Harriet smiled and nodded her approval. Sisters, cousins, and aunts watched through the window as Jackson May performed his assigned tasks.

The officer seemed pleased as he walked through the house ending back on the gallery. He asked questions and make mental notes.

"Mrs. Overton, when the General arrives and enters the house, he will use the front door. All the doors to the house, including the cellar, will have two security guards at all times. The drapes in the General's bedchamber and the parlor will be closed, and no one will be allowed in that part of the house. At times, the General may want to entertain in the parlor. He may want to eat alone, but mostly, he will take his meals in the large room with the family. Before the General arrives, several more wagons will be coming. There will be a telegraph wagon, a couple of supply wagons, a furnishings wagon, and some other wagons. Your home, unfortunately, is about to become a beehive and the bees will be coming from all directions."

"My home and everything I have is available to the Cause."

"Ma'am, those are the exact words Colonel Overton said when he offered your home to the General."

"You know my husband?" Harriet's smile lit up the conversation.

"Very well. He is a remarkable man. He has filled more of my requests for supplies than I can count. I believe he knows everyone in the south."

"Yes, you are probably correct. He has lots of friends and associates." They continued to talk as a carriage pulled up next to the house. Harriet could not believe her eyes. Waving at her were White May, Becky Allison, and two young ladies she did not recognize.

"Mrs. Overton, if you will excuse me, I need to retrieve my sword and horse and then, check on my troops."

"Captain, if you need anything else, please ask."

"Thank you, ma'am." By the time he thanked Jackson May, rehooked his sword, and took the reins to his horse, the four ladies were on the gallery.

"White, what on earth are you doing here? Don't you know we are in the middle of a war?"

"We are out this morning encouraging our troops."

"Don't you think it's a little dangerous for four ladies to be out encouraging men who have been away from their wives and sweethearts for so long?"

"Well . . . ah, well . . . Harriet, you know Becky. This is Mary Bradford and Mary Hadley."

"Nice to meet you both. Becky, it's good to see you. I have the time for tea, if you would like some."

"No. We have come to see whether General Hood's staff has arrived. Mary Hadley is engaged to marry Major William Clare and had a note from him. I also have a favor to ask, Harriet."

"We are expecting the General and his staff near dark. It might be best, Mary, if you came back in a few days for a visit. White, you need a favor?"

"I need a place to stay until all this troop movement settles down. Could I stay with you?"

"Yes, you are welcome to stay. But, you need to understand, we are all sleeping upstairs to accommodate the soldiers who are coming."

"That will be fine. While I'm here, I'll be glad to help in any way I can."

"I hope you brought some clothes with you." Harriet was as polite as she could be under the circumstances, but she was thinking, *I do not have the time to be a chaperone for a twenty-seven-year-old single female in a house full of soldiers. Oh well, maybe the soldiers will be so occupied they won't notice her. The children will enjoy having Aunt White for a visit. John will also enjoy seeing White again.*

"Mrs. Overton," Mary Hadley was heading for the carriage, "when William arrives, will you tell him I was here and will be back next week?"

"I most certainly will, and all three of you come back anytime." The carriage left with the three young ladies jabbering to each other.

"White, let's go inside and get you settled. The children will be happy to see you. By the way, my two sisters, Annie and Mary, are here as well. We have a busy evening ahead of us."

The last rays of the winter sun were disappearing, when the sounds of horses' hooves and wagon wheels filled the air. Jackson May was looking out the window of the new parlor. The soldiers rode in twos; eight of them passed by the house. A single rider dismounted and walked to the gallery. His boots made a heavy sound on the wood planks. Jackson May opened the side door to see the visitor. He did not recognize his father. John did not recognize his son. They each stood with a fixed stare.

"Jackson May, is that you?"

"Yes, sir, I'm Jackson May Overton. What's your name?" He saw before him a man with white hair and a white beard. The man knelt down, removed his hat, and stretched out his arms.

"My name is John Overton." Jackson May shut the door, ran threw the new bedchamber, and stopped in the foyer. At the top of his lungs he yelled for his mother.

"Mother! Mother! Come quick! Quick!" Harriet appeared on the landing of the stairs.

"Jackson May, what on earth is the matter with you? You know you're not to yell in the house."

"There's some old man on the gallery and he says his name is John Overton." Harriet held tightly to the handrail as she descended the staircase. She opened the double door and looked up and down the gallery.

"Mother, he was here a moment ago. I'm telling the truth." John was standing behind them in the foyer.

"My name is John Overton. Are you looking for me?" Harriet fell into his waiting arms. She hugged him, burying her head in his chest. "Oh my love, you are home at last!" She was crying. Jackson May watched this strange man holding his mother. "Jackson May, go upstairs and get your sisters and ask the governess to bring Jesse. But first, give your father a hug." He followed his mother's instructions but really didn't feel comfortable hugging another male.

"John, he has been looking for you for days. You will need to give him time to adjust. You have been gone since February of '62. Both of you have changed a lot in that time."

"We will need to get reacquainted." Jackson May did not share the news of their father's arrival with his siblings. He wanted to observe their reaction. Martha held Mary's hand as they came down the steps. Elizabeth held tightly to the rail and took one step at a time. Jesse was in the arms of the governess. Jackson May waited on the upper landing.

"Children, your father has returned. He is back home."

Martha responded politely, "Father, we are so pleased you have returned safely. Our prayers have been answered." She was very formal and reserved in her greeting. The other children did not respond. John was hurting inside, and Harriet knew it.

"Your father is tired from riding. Let's go to the family dining room and have some cookies and milk."

"Before we do that," John directed, "I want you to see someone. Get your coats and meet me on the gallery." As the Overtons gathered, seven riders walked their horses by the gallery, heading south. The second rider on the inside tipped his hat and continued with the others.

"That rider, children, was Captain John Overton, special aide to General Forrest."

"Wow! He's my older brother." Martha waved, but Captain Overton did not see it and rode on. "Father, did you see his sword and gun? He looked very brave."

"Yes, he did, Jackson May. But I also have two other brave sons." Jackson May put his arm around his father; John did the same for his son.

"Father, I'm so happy you're home. I've missed you."

The riders returned. This time they escorted six wagons. The first three were open and filled with soldiers who jumped to the ground and quickly encircled the house, barn, and outbuildings. The next was an ambulance followed by a covered wagon. Both were pulled to the front door. The last wagon turned to the outside of the ambulance, blocking it from view. A dozen heavily armed soldiers surrounded the ambulance.

"Children, it might be best if we went to have some cookies and milk." Mary knew what those words meant and darted down the gallery. Elizabeth followed closely behind her. Martha took her father's hand as the family headed to the dining room. While the family reunion continued, the other end of the house was being turned into a military headquarters. Beds and

mattresses were moved in on both floors. The parlor was transformed into an office and map room. The lay of the house was explained to General Hood and his staff.

In the kitchen, Cynthia had her first introduction to Sergeant Goodson, the general's cook. He pushed the kitchen door open and announced, "My name's Goodson. I'll be taking over this kitchen."

"My name be Miz Cynthia and yous not be takin' over my kitchen. Yous take one mo step and yous be drinkin' dis hot coffee widout a cup."

"Allow me to begin again. My name is Sergeant Goodson. I am General Hood's cook. I would like to cook his meals in this kitchen."

"Dat be better. I's be happy to share my kitchen wid yous."

"Thank you kindly, Miss Cynthia."

Saturday was a leisurely day in the house. The family gathered for breakfast in the family dining room. Jackson May had to fold his cot and bedcoverings to make room for everyone. Even Jesse was propped up and sitting in a highchair next to Harriet. When the food was on the table, John bowed his head and offered thanks for the food. Harriet touched his hand as he prayed.

"Jackson May has been offering thanks since you've been gone." Harriet turned to check on Jesse while the food was being passed around the table.

"I should have called on you, Jackson May. I'm sorry. The next meal will be your turn."

"Father, you can have the duty. It's good to hear your voice."

"Family," John said while helping his plate, "this might be a good time to talk about General Hood." Jackson May delayed his usual feasting at mealtime and looked at his father. "General Hood was born in Kentucky. He graduated from West Point Military Academy. Annie, he served in Texas and I believe he said he knew Thomas."

"Yes, John. General Hood encouraged Thomas to join the Confederate Army. That's why Thomas traveled all the way to Richmond to receive his commission."

"General Hood is the youngest man at his rank. He has fought in many battles. In two of those battles, Gettysburg and Chickamauga, he was wounded. He has no use of his left arm and has no right leg." Martha dropped her fork and swallowed her mouthful of food.

"Father, what do you mean he has no right leg?" Jackson May was on the edge of his chair. He looked down the table at Martha.

"He got shot in the leg, Martha. And the doctor had to chop his leg off with an axe."

"No, the doctor did not!"

"Tell her, Father. The doctor used an axe." Harriet cut her eyes at Jackson May, and he knew he was in dangerous territory.

"Son, I believe the doctor used his medical tools for the operation. The point I was trying to make by mentioning General Hood's condition was to

help you understand when you see him for the first time. I don't want you to be afraid of him."

"Father, can you see the axe marks where his leg used to be?" Harriet jumped into the conversation.

"Young man! That will be enough talk about an axe."

"Yes, ma'am." He enjoyed the rest of his breakfast, refusing to acknowledge Martha's glare.

"Children," Harriet directed, "when you see General Hood, look into his face and notice his blue eyes. I've read they're one of his outstanding features." Cynthia entered the room with a pot of hot water and more tea.

"Youins needs some mo tea? Dat Sergeant Goodson gots a whole wagon of supplies out dere next to da kitchen. Ya jest names it and he gots it."

"No, Cynthia. I believe we're finished in here."

"Sergeant says da general and his mens be eatin' in da parlor today. Den on Sunday, da general be ready to eats wid yous."

"That will be fine," Harriet's voice became high pitched, "but we'll wait for an official word from the general." Harriet and John walked on the gallery and enjoyed the spring-like weather.

"Harriet, would it be all right to take Martha and Jackson May horseback riding?"

"John, you are their father. That's a decision you can make."

"The reason I asked is, I know you and Annie wanted the children to stay in the house or on the upper gallery, and I did not want to go against that."

"I appreciate your thoughtfulness, but please understand when you are present in the house, all of us look to you for decisions. However, I will check with the children."

"I'll go down to the barn and visit with Claiborne." Harriet was headed up the staircase when she heard her name. "Mrs. Overton? Mrs. Overton, excuse me. May I have a moment of your time?" Harriet turned to see a very handsome young officer.

"Yes, you may, sir but first I have a task upstairs. I will be back in two minutes. Please go into the large room and have a seat."

"Yes, ma'am." Harriet found Martha, Jackson May, and Aunt White on the upper gallery, looking down at several soldiers eating breakfast.

"Children, I would like for you to dress appropriately and go horseback riding with your father."

"But Mother," Martha was twirling her hair around her finger, "I thought you wanted us to stay upstairs."

"I do, but this is a special occasion with your father and I don't want you to miss it. Now, get into your riding clothes and meet your father at the barn. It's warm enough today for a light jacket. I want you to wait for each other and go to the barn together."

"Thank you, Mother." Jackson May was moving toward the door as he spoke.

Harriet and White descended the stairs. Harriet stopped on the last step, patted her hair, and then entered the large room. The young officer stood and braced to attention when Harriet and White entered and were seated. He sat in a chair directly across from them.

"Miss May is one of my houseguests." The officer nodded; White returned his gesture. "Now, how may I be of service to you?"

"Ma'am, I was wondering whether you recognize the name Mary Hadley." Harriet smiled at White.

"Let me guess. Your name is Major William Clare, and your bride-to-be is Miss Mary Hadley."

"Yes, ma'am. You are correct." William was all smiles.

"Miss Hadley was here inquiring about you. Perhaps I should tell you more about Miss May. Her full name is White May."

"I know that name. Mary wrote me about you. You are going to be in our wedding."

"Yes, William, along with Becky Allison."

"Yes, along with Becky. It is so good to finally meet you."

"The feeling is mutual." Harriet noticed William's eyes were focusing on White.

"William, have you and Mary chosen a date for your wedding?"

"We were hoping for December 12, but we may need to delay."

"I asked Chaplain Quintard to perform the ceremony, but he's been very busy with funerals."

"Funerals?"

"We lost several Generals at Franklin. He was in Columbia yesterday conducting funerals for General Strahl, General Cleburne, and General Granbury. He's due to be here tomorrow. Oh, Mrs. Overton, I've been so caught up in my own affairs I have forgotten to deliver an important message."

"Yes?"

"General Hood wanted me to express his apology for not greeting you and your family. He met last evening and all of today with his corps commanders. In fact, General Benjamin Cheatham is with him now. General Hood would like to dine with your family tomorrow—Sunday."

"Yes. Please report to him that we will be honored. Will others join us?"

"Yes. He will be joined by Chaplain Quintard and me, if that is suitable for you." Harriet looked at White.

"White, please get a note to Mary Hadley this morning inviting her for dinner Sunday evening." Harriet turned to William and smiled.

"I assume those arrangements are suitable for you."

He stood at attention and responded, "Oh, Mrs. Overton, that would be wonderful! Ma'am, may I be excused to report to the General?"

"Yes, Major, you are excused." Harriet held her composure until William left the room, and then she and White laughed together.

John, Martha, and Jackson May noticed several horses tethered to the gallery as they rode past the house. John was enjoying the peaceful morning with his children. When they approached the law office, Martha pointed to the building.

"Father, Aunt Annie has opened a school here. Most of the neighborhood children come. Jackson May, Mollie and I also attend. All of the schools in the city have been closed, even the Academy."

"But," Jackson May added, "the Robertson Academy is not closed, Father." John did not follow up on the comment, but suggested they pick up the pace and ride to the Overton Station. As they rode, they passed a group of soldiers cutting down trees.

"Why are they cutting down our trees?" There was an air of concern in Jackson May's voice.

"They will stack some of the larger pieces for protection and the smaller ones for their fires. We have plenty of trees to share."

"Father, how do the soldiers get their food?" Jackson May was interested in every facet of the military. He had secret hopes that the war would last long enough for him to be a part.

"The army has supply wagons that carry food for the soldiers. A part of what I do is to find food for the wagons. I go to farmers and buy food." Martha was listening intently to the conversation.

"So, Father, every soldier is counting on you doing your job."

"Yes. But, Martha, I'm only one of many men finding food for the soldiers. We also must find clothing and ammunition."

"What's the hardest thing to find for the soldiers?"

"Shoes and medicine are the hardest."

"Did you know I help Mother and her friends roll bandages for the soldiers?"

"Yes, and that is a very important task for the Cause."

Not to be outdone by Martha, Jackson May added, "Mother gave me the task of getting and sending the mail. Each day, rain or shine, I make a trip to the Station for the mail."

"That, too, is an important task for the Cause. Both of you have performed your duties well." They arrived at the Station and turned around to go back to the house. Martha gave her horse a smack on the rump and yelled, "The race is on. The last one back to the barn is a frog." Martha did not look back but bent over in her racing position.

"Just let her go," Jackson May sighed. "She has to win every horse race. If she loses, she always has an excuse. So I don't race her anymore. Anyway, I need to ask you a question."

"What's your question?"

"Would it be hard for you and Mother to call me May?"

"No, as a matter of fact, in your early years we called you May. I believe it was your Aunt Elizabeth who insisted on calling you Jackson May. From this day on, we will call you May."

"I'm the only one of the children who has a double name and now, I'll be just like everyone else." When they returned to the house, Major Clare was standing on the gallery.

"Colonel Overton, General Hood would like a guided tour of the area. Would you be available?"

"Yes. When would he like to go?"

"The General is ready now, sir."

"I have a buckboard in the barn, if that would be more comfortable for the General."

"That would be ideal, sir."

"May, you wait here. I want you to meet General Hood." John walked through the garden to the necessary and then to the barn. When he returned to the house, the General and six troopers were waiting.

"Good day, Colonel. I appreciate you being available on such short notice. My maps show a peach orchard on your property. I would like to begin there."

"Yes, sir. Have you met our son, May?" General Hood was being helped onto the buckboard.

"Yes, he was telling me about his older brother John, riding with General Forrest."

The troopers surrounded the buckboard as they traveled to the orchard. John pulled up to the highest point in the orchard. From that vantage point, John pointed east to Nolensville Pike. In the center was the town of Nashville, eight miles away. To the west were Franklin Pike, Granny White Pike, and Compton Hill.

"Colonel, how close from here is the Lealand plantation?"

"There is a dirt road that begins at Franklin Pike, crosses Granny White Pike, and connects with Hillsboro Pike. Going that way, it's about at a mile and a half. There is a shorter way to Lealand by going down the road by Robertson Academy." John pointed to the map General Hood was holding.

"I would like to see both ways. What is the elevation of Compton Hill?"

"I would judge it to be as high as, if not higher than, the orchard."

"Very good. I understand your father owned all this land."

"Yes, his plantation stretched all the way to Granny White Pike at one time. He willed the land we are on to me. Where Lealand sits, he willed to my sister, Elizabeth. She's married to John Lea. And interestingly enough, the land where Fort Negley has been built was willed to my sister, Ann."

"Are the Leas still living at Lealand?"

"No, sir. However, there are still some workers on the property. I understand from my wife that John is back in the area every three or four months."

"Tell me about the Pikes. Where do they begin?"

"The Pikes are like spokes in a wagon wheel, with the hub being the State Capitol building in the city. If you notice on your map, there's probably a listing for Richland, Lebanon, Chicken, Charlotte and Murfreesboro Pikes. Most of the Pikes lead to a neighboring community."

"Are most of the Pikes able to take two-way traffic?"

"Yes, General."

"Colonel Overton, do you have any information on the forts being built in Nashville?"

"My wife told me about Fort Negley. She even has a drawing of it from the *Weekly.* She or her sisters may be able to tell you about any other fortifications." John pulled the buckboard to the back of Lealand and stopped.

"Would you be offended if I took off this artificial leg? It is a constant worry of mine."

"No, General. This is the backside of Lealand. The plantation spreads in all directions." The General unbuckled the straps, gave a heavy pull, and the leg was on the floorboard. An aide approached and took the leg.

"I'd like to see the front of the house. How far does that stone wall extend?"

"Somewhere between a half and a quarter of a mile, sir. We are about a mile from Franklin Pike." General Hood called to one of the troopers and pointed to the wall.

"I need to know the length of that wall."

"Yes, sir."

"The road back to Franklin Pike passes in front of the wall, correct? And the rise to our left is . . .?" He focused on his map.

"That is Compton Hill."

"Colonel, I'm ready to return to Travellers Rest." He glanced at the winter sun and then flipped the lid on his pocket watch to check the time. He did not say another word. He spent his time looking at both sides of the road and making notes on his map. By the time they reached the house, the General had reattached his leg.

"I thank you, Colonel, for the tour. I'd like to come back someday after this war and have another tour."

"Sir, you have an open invitation to return." Hood swung his legs around and steadied himself on the ground, holding on to the side of the buckboard. A trooper brought him a crutch.

"Say, Colonel, how far can one see from the north end of the upper gallery?" Before he could answer, a familiar voice to both of them answered.

"General Hood, one can see into the face of the enemy from this vantage point."

"Well, General Lee, I'm delighted you're here. You know Colonel Overton."

"Yes, sir, he has fed and clothed my Corps many times in the last month."

"It's good to have you at my home, General Lee." Another familiar voice came from the upper gallery.

"Father, he's not the real General Lee. He just has the same name." General Hood was the first to laugh. He was joined by General Lee. John was embarrassed at what he heard and felt.

"May, I need to see you immediately in the barn!"

"With all due respect, Colonel, May did not approach me; I approached him. I came up here to get a view of the landscape. He was playing and I asked him the direction of Nashville. He is quite clear in his directions. He told me the highest point on the plantation is the peach orchard. He knows about Fort Negley, Compton Hill, and the Pike system. If he were a few years older, I'd have him on my staff." John was happy that May did not hear that last comment. May appeared on the lower gallery.

"Son, I have a job for you."

"Yes, sir."

"Please take the horse and buckboard to the barn. The horse needs some water."

"Yes, sir." May was relieved to have the task. He had different thoughts on the way down the stairs. "Father, will you be coming to the barn?"

"No, I trust you to do your duty." May was off to the barn with a smile on his face.

"Well done, Colonel. You are a master of thinking on your feet." Hood made his way onto the gallery. He was joined by General Stephen Lee, and they entered the house together.

# 27. My Proudest Day

Harriet made every effort to see General Hood. When he and John left to survey the property, she was tending to Jesse. Upon their return, she was in the kitchen planning the menu for Sunday's dinner. She was even a little jealous of May when he told her about meeting not only General Hood, but General Stephen Lee as well.

"Mother, I was on the upper gallery, minding my own business, when this General asked me if I knew the direction to Nashville. He said his name was General Lee. He didn't look anything like the General Lee from the *Weekly*. He was young and had black hair."

"Jackson May! Are you making this story up?"

"No, Mother, and remember, Father wants everyone to call me May."

"Yes, I forgot. May, where did you meet General Lee?"

"I told you. He came on the upper gallery and wanted to know the direction to Nashville. We walked down to the end of the gallery and I pointed toward Nashville. He was able to see Fort Negley through this long, metal thing."

"Do you mean a telescope?"

"Yes, that was it, a tell-er-scope."

"A tel-e-scope."

"Yes. Anyway, he handed me that thing, and I could see the blue bellies at the fort. I had to squint my eye like this and hold the tell-er-scope with both hands."

"Can you remember the word *spyglass*?"

"Yes, Mother."

"All right. When you tell this story to someone else, say spyglass."

"And then I talked with General Hood before he and Father went for a ride."

"Are you sure it was General Hood?"

"Yes, ma'am, it was General Hood all right. He had a crutch to help him to walk. He had a hard time getting into the buckboard 'cause of his funny leg. You remember the one the doctor cut off with an axe."

"May, General Hood has an artificial leg, not a funny leg. And he did not have his leg removed with an axe. I wish you would stop saying that."

"Anyway, I seen both generals."

"You did not 'seen' anything. You saw both generals."

"Yep, I sure did."

"Well, since you are so well acquainted with General Hood, would you like to join us for dinner tomorrow evening? You will be the youngest one there, but you are welcome to come."

"May I sit at the big table?"

"Yes, you may. Don't forget, I want you to stay on the upper gallery while the soldiers are in the house."

Elizabeth, Mary, and young Harriet were sitting on Aunt White's bed reading their books. White was holding Jesse while she watched Martha and Mollie doing their cross-stitch. Martha pushed a needle through the material and pricked her finger. She let out a yell and stuck her finger in her mouth.

"Martha," White was laughing, "here, put this thimble on your finger." Harriet stepped into the room and watched Martha maneuver the thimble from one finger to the other. *Martha is so much like me in so many ways. I was at the Academy before I really understood the concept of using a thimble. I haven't done cross-stitch in years.*

"Good job, Martha. Thank you, White, for showing Martha how to cross-stitch. Watching you both brings back pleasant memories of my girlhood. I want you both at the evening meal tomorrow. We will dress for dinner and officially welcome General Hood to our home."

"Mother, what should I wear?"

"I want you to dress as though you were going to church."

"Yes, ma'am."

"I was hoping to find Annie up here."

"She said she and Mary were going to get some fresh air and walk down to the schoolhouse and back before dark."

"Good, I'll try and see them when they return."

Harriet went to the large room to wait for her sisters and catch up on some back issues of the *Weekly*. Mathew Brady's photos of the war were appearing in nearly every issue. The photos of Atlanta, after being burned, were depressing. *Could this same thing happen to Nashville? Would the city survive?* Harriet was still pondering over this when Annie and Mary entered the room.

"Annie, have you read about the devastation in Georgia?" Harriet handed her the *Weekly*.

"I just know Sherman is waging total war as he moves to the coast. His army is burning and destroying everything in its path." Mary was looking over Annie's shoulder as she studied the photos.

"I need to talk to both of you about Sunday evening. Annie, do you want Mollie and Harriet to dine with us?"

"I want them to meet General Hood, but I don't want them to stay for the meal. I feel sure some of the conversation will be about the war, and I'm trying to protect the girls. Seeing the General may be traumatic enough."

"I know May wants to be there, and I've invited Martha. There should be eleven of us at the table. I'm having twelve places set, just in case. One of the things I want to talk about at the table is the wedding of Major Clare and Mary Hadley. Please help me remember and bring the subject up sometime during the evening, if I forget."

Sunday, December 4, was an exciting day for May Overton. He had placed his Sunday clothes on the chair near his cot before he went to bed. The rays of the rising sun woke him. He threw the covers back, put his bare feet on the cold floor, and walked over to the window. Nothing was moving outside. The soldiers were still sleeping; their fires were down to embers. He glanced at the barn. The doors were still closed. There was not a sound in the house. The only thing May heard was his own breathing and yawning. He folded his nightclothes, bedding, and dressed in his Sunday clothes. Surely, he thought, *Cynthia will be up and getting breakfast ready for the family. I'll just go out there and check on her.* May pushed against the kitchen door only to find it blocked from the inside.

"Who be thar?"

"It's May, is it time for breakfast?"

"No, go back to bed. I's bring in breakfast later." The sun was up and a warm breeze was blowing when May headed for the gallery. He had forgotten about the soldiers on the gallery guarding the doors to the house. He was surprised when he saw them and they, too, were surprised. He quickly moved away from the door and went back to the small dining room. Now there was enough light in the room to see his mother's map and the drawings she had clipped from the *Weekly*. To his delight, he discovered drawings of General Hood and General Lee. He heard footsteps in his parents' room above him. The footsteps moved to the staircase and then the door opened.

"May, what are you doing out of bed? Why are you dressed in your Sunday clothes?"

"Mother, today's the day we have dinner with General Hood. Have you forgotten?"

"No, May, I've not forgotten, but we won't be dining with the General until this evening. Why don't you put on your day clothes, and later you can dress for dinner. By the way, you look very handsome. While you change your clothes, I'll go check with Cynthia about breakfast."

"She's still in bed."

"Well, it's time for her to be up and start breakfast for the family."

May changed his clothes and was looking at her map when she returned to the room.

"Have I told you how proud I am of you?" She put her arm around his shoulders and pulled him to her. He did not respond to her question. "You have been the man of the house while your father was gone. I truly appreciate everything you've done for me and the family." She hugged him even tighter.

"Who will be at the dinner this evening?"

"Well, let me count them. Better yet, I'll name them and you can tell me how many. There will be General Hood, your father, your three aunts, Martha, Major Clare, Mary Hadley, Chaplain Quintard, you, and me."

"I counted eleven. Will Martha and I be at the big table? Where will I be at the table?"

"I have not decided on the seating arrangement, but you can help me after breakfast."

"Good."

"I need to go upstairs and dress for the day and get the family up for breakfast. Cynthia will be in shortly to set the table. You may help her, if you like."

"Yes, ma'am. I can do that."

"By the way, I'm pleased about your name. It sounds so grown up." Harriet smiled as she approached the door. May was happy—very happy.

After breakfast Cynthia had placed pieces of the family china on the table and was bringing some glassware when Harriet and May entered the large room.

"Cynthia, I want the table set for twelve for the evening meal."

"Ya, ma'am."

"But Mother, I counted only eleven."

"You are correct, but I want to be ready in case General Hood has another guest."

"What about the seating arrangement? Have you decided where I will be?"

"Suppose we put two at each end and four on each side of the table." May did a mental count and his mother's plan was just right. He waited for his name as his mother began walking around the table assigning places. "And this will be your place, on your father's right side." May's smile lit up the room. Harriet glanced through the window and saw Major Clare on the gallery. He bent over the rail, looking down the driveway leading to the front of the house.

"Major, are you looking for anything or anyone in particular?"

"Ma'am, I was . . . ah . . . ah . . . checking the weather. Yes, I was checking the weather."

"I don't believe it will rain on Miss Hadley today. There's not a cloud in the sky."

"Very good, ma'am. You caught me. I was looking for Mary."

"I know, Major. You are very much in love. I can see it in your eyes. You are concerned about her safety."

"Yes, I am."

"She'll be safe. She's traveling in Confederate territory."

"Mrs. Overton, I have a verbal message from Chaplain Quintard. He regrets he will not be at your dinner this evening. He feels compelled to minister to the dying in the Franklin area."

"That's understandable. He is a man of the cloth, and he is giving comfort to those in need. One must appreciate that kind of dedication."

"Yes, ma'am. I talked with him briefly this morning about the wedding. He assured me the ceremony will be on the morning of Monday next."

"What date is that, Major?"

"That would be the 12<sup>th</sup>, ma'am. He knows of a church in the Brentwood area we can use, not too far from here."

"Yes, I'm certain that would be the Brentwood Methodist Meeting House. That's what I needed to know. After the wedding, we will come back here to the house for a grand dinner. Well, Major, I have some work to do. I trust your wait will not be long—for the weather to change, that is."

"Mrs. Overton, you have a wonderful sense of humor. It has been an honor getting to know you."

"Thank you. The feeling is mutual." Harriet left and went to the kitchen.

The evening was warm enough to have the four large windows in the room raised several inches. The cool air was welcome. Two large candelabra provided enough light for the table, but Harriet had additional candles around the room. The china and crystal caught the flickering of the candles and provided a magical appearance. Harriet had arranged with Cynthia to bring up from the cellar the last small keg of peach brandy. It was placed on one of the pier tables and covered. This would be used as the last activity of the evening and a special surprise for John.

Major Clare had inquired about the seating arrangement for the evening. He shared the information with General Hood. The General wanted to know the ages of the children coming to dinner.

"Sir, you have already met May. His sister, Martha, is eleven. There are five other children in the house. They will be presented but will not stay for dinner."

"And how are they related to the Overtons?" The Major pulled a small piece of paper from his coat and read the information.

"Colonel and Mrs. Overton have five children—Martha, May, Mary, Elizabeth, and Jesse."

"And the other two?"

"The other two are the daughters of Colonel and Mrs. Thomas Claiborne. Their names are Mollie and Harriet."

"Major, what do you know about Colonel Claiborne?"

"According to Mrs. Claiborne, you and the Colonel have met. He was stationed in Texas at the outbreak of the war, and you encouraged him to side with the Confederacy. He rode with your Texas Brigade for a while and then went to Richmond. He's currently on General Beauregard's staff, serving as an Inspector."

"It is truly a small world, isn't it?"

"Yes, sir."

"Is there anything else I need to know about this evening's activities?"

"Well, sir, Mrs. Overton has invited my bride-to-be, Miss Mary Hadley, to the dinner."

"I look forward to meeting her, Major. One other thing about this evening."

"Yes, General?"

"I would like to be in the dining room early, before the small children arrive, and be seated behind the table. I don't want my appearance to frighten them in any way."

"General, that will not be a concern."

"My appearance, with this fake leg, is a concern for adults. I do not want the children to have a bad memory of me."

"I will see to it immediately and report back to you."

Harriet made one last visit to the large room and was surprised to find General Hood already seated.

"General, we have not met. I'm Mrs. John Overton. My friends call me Harriet."

"Mrs. Joh . . . ah . . . Harriet, my name is John Hood and my friends call me Sam. Please excuse me for not standing."

"Sam?"

"Yes, it's a long story and not very interesting. Take my word for it."

"Sir, we count it an honor for you to be at Travellers Rest."

" I apologize for any problems to your family that my stay has created."

"This family stands ready to help the Cause in any and every way possible."

"Yes, I know of no family who has or is contributing more to the Cause." Tears came to Harriet's eyes. She had to turn away and pat them dry. As she turned again to face the General, Major Clare and Miss Mary Hadley entered the room.

"Mrs. Overton, I believe you know Mary."

"Mary, I'm delighted you could come this evening. And I noticed Miss Becky Allison came with you."

"Yes, ma'am. I hope I did not overstep my bounds by asking her."

"There is always a place for one more at Travellers Rest. And where is Becky?"

"She's upstairs with White."

"Mary, this is General John Hood."

"It is my pleasure to meet you. Major Clare has been pushing my army hard to get here in time for your wedding." The General cut his eyes at Harriet and smiled.

"Yes, sir, William is persistent."

Sunday evening's dinner exceeded Harriet's expectations. The conversations at the table were light and only occasionally about the war. As promised, Annie brought up the subject of the impending wedding and quickly guided her question to Mary Hadley.

"Mary, did you know I was a military bride? My husband, Thomas, was in the army when I met him, fell in love, and married."

"I may need to spend some extended time with you. How do you handle not knowing where he is or what he doing?" It seemed everyone heard the question and waited for Annie's answer.

"I pray for his safety all during the day and think of him constantly. Our daughters and I talk about him all the time. We are eager for the mail to come, hoping there is a letter from him. I trust our leaders not to put him in harm's way. He is dedicated to the Cause, and I fully support him in what he's doing." There was a deadly silence in the room. People cleared their throats and sipped from their glasses. They tried to focus on anything in the room but each other. Harriet broke the silence.

"I suggest we have another grand dinner, in this room, after your wedding ceremony." Glasses were lifted in support of the suggestion.

"Mrs. Overton," Major Clare stood, "I would like to propose a toast."

"Major, can you hold that thought for a few minutes?" The servants were moving about the table removing the china and crystal. "I have a surprise for my husband that will go well with your toast. John, under the cover on the pier table is your surprise." John moved to the table, removed the cover, and laughed. He lifted the small keg of peach brandy and brought it to the dinning table.

"General, this is a labor of love started by my father. One of the first ventures he started when he built this house in 1799 was to plant a peach orchard. He learned how to make peach brandy. He, Andrew Jackson, and Sam Houston drank peach brandy in your parlor. The orchard is mostly gone now, but this treat remains. I'm happy to share this final keg on this occasion." Glasses were filled for the adults.

"Now, Major Clare, you were about to propose a toast."

"Yes, I rise to salute a wonderful family, who is fully dedicated to the Cause and to the First Lady of Travellers Rest, Mrs. Harriet Overton." Harriet cut her eyes to John to see his reaction. He smiled, joined in the clinking of glasses, and led the chorus of "Here! Here! To the First Lady of Travellers Rest." Harriet saw no need to correct the second part of the toast. She understood it was given by one who knew little of the Overton family history. Harriet excused Martha and May after the toast. Annie followed them upstairs and checked on the other children before returning.

"This has been a delightful evening." General Hood made eye contact with each person at the table. "If you will excuse me, I have some work to do in my room." His announcement was Major Clare's clue to find the crutch. The General struggled to his feet, fitted the crutch under his arm, and left the room.

"Mary and Becky," White directed, "we have made a place for you to stay the night. You can travel home tomorrow in the light of day. Your parents will understand. It's a matter of safety."

Later, when John and Harriet were alone, he said, "Harriet, this was a grand event. My surprise was extra special. Thank you for being so thoughtful." Harriet smiled and hugged John around his waist. The next couple of days were uneventful on the plantation.

When Harriet got out of bed on Thursday, December 8, she could tell the weather had changed. She stepped out on the upper gallery and was greeted by a blast of cold wind and rain. She returned to her room, dressed warmly, and then went to find the governess.

"The children will need to stay inside today. Please dress them in warm clothing. If May wants to go check on the mail drop at the Station, tell him to see me first."

"Yes, Mrs. Overton. Why would anyone want to be out in this weather?"

"May will tell you it's his duty, but I still want to see him before he goes."

"Yes, ma'am."

At breakfast, the children were more interested in watching the snowfall than eating. "John, would you check with Eli or Claiborne and get some more firewood cut and split? It won't take long for the stacks to go down in this cold weather."

"Yes, I'll check on that after breakfast. Harriet, I need to make a trip south for a few days to check on some supplies."

"Have you looked outside this morning? You may want to think about delaying your travel until this snowstorm passes. The wind is blowing out of the north and I'm sure it's going to get colder." By noon the weather was intensely cold with sleet and blowing snow.

By Sunday three inches of snow had fallen, and the temperature had dropped to ten degrees. The upstairs bedchambers had been empty most of the week. General Hood's Corps commanders preferred staying with their men as much as possible and only stayed in the house when there was a planning meeting or some special event scheduled. Major Clare had told Harriet the rooms would be full on Sunday evening. Harriet took the opportunity to do a quick check of the area. She knew using the fireplaces created dust in the rooms. It would also be a good time to change the bedding and pick up any trash lying around.

The middle space between the two bedchambers was known, in the family, as the passageway. This area had no source of heat, and the room temperature was only a few degrees warmer than the outside. As she walked through the passageway, she discovered, to her amazement, a washing bowl half full of frozen water on a stand next to the bed. As she inspected the bowl, she thought, *This is appropriate. The water is showing us how cold it is on this Sunday.* She found the servants and reminded them, "The bedding in the bedchambers upstairs needs to be changed. Make certain we have extra covers on each bed this evening. The fireplaces need to be cleaned and a large supply of logs placed in each room. Put extra candles on each stand."

Harriet found the children playing in the large room, gathered near the fireplace. "Martha, make sure no one gets too close to the fire. We don't need any accidents." Harriet looked for Mollie.

"There you are." Mollie looked up from her diary and closed it as her aunt approached.

"Yes, ma'am."

"Are you staying warm?"

"Yes, Aunt Harriet. I'm very comfortable."

"How are you coming with your writing?" Mollie's Aunt Mary had given her a diary, and Mollie had faithfully written her thoughts in it every day since her birthday in July.

"I was telling my diary how cold it is and about the snow."

"I discovered something in the passageway upstairs you might find interesting. It's in the bowl next to the bed."

"May I go see?"

"Yes, I think you should." Mollie was on her feet, out the door, and up the steps. When she entered the passageway, she spotted the bowl on the stand. From a distance, she didn't notice anything special. Upon closer inspection, she discovered the ice. She put her hand on the ice and pushed. It was solid. As she passed the window in the adjacent bedchamber, she caught a movement outside through the corner of her eye. She backed up and watched. The wind had blown open half of the window shutter. She watched a lone soldier parching corn over a fire. Soon two other solders joined him. They all had ears of corn over the fire. All three soldiers were hatless. The snow was caking on their hair. Two had coats but one was wrapped in a blanket. Mollie knew they were talking because she watched the white vapors come from their mouths. She gasped as she watched the soldier with the blanket walk away from the tiny fire. He was gnawing on his corn and making tracks in the deep snow—crimson tracks. Mollie tucked her diary under her arm and headed for the steps. When she found her mother in the small dining room, Mollie was bawling and sniffling.

"Mollie, what has happened? Are you hurt? Is it your sister? What is it, Mollie?" She took her mother's hand and they both returned to the upstairs bedchamber. When she got to the window, Mollie pointed to the two soldiers eating their corn. She was still sniffling.

"Yes, I see the two soldiers eating by the fire. What is the problem?" Mollie pointed to the tracks in the snow.

"Yes, I see the tracks. They are covered with blo . . . . Oh, sweetie, I understand. That's something no nine-year-old should see. I'm so sorry you had to see it." Annie hugged her daughter and watched as the soldier made a second set of tracks, these bloodier than the first.

"Mother, that poor soldier doesn't have any shoes and his feet are hurt."

"Yes I know, dear."

"Can I give him a pair of my shoes?"

"Oh Mollie, how thoughtful you are. I don't believe your small shoes would fit him."

"Suppose that was Father down there. Wouldn't we do something?"

"Yes, we would. And I promise you I will talk to Major Clare about this."

"Promise?"

"Yes, I promise." Annie wiped the tears from Mollie's eyes and cheeks, led her back to the large room, and then went looking for the Major. He was behind closed doors with General Hood and his staff. She returned to the large room and found Harriet reading a copy of the *Weekly*.

"Did Mollie tell you about the soldier with no shoes?" Annie crossed her arms as she sat no the sofa with Harriet.

"No. She has been very intent on writing in her diary." Annie's voice became very soft, almost a whisper.

"She was in the upstairs bedchamber looking out the window. She saw some soldiers parching corn. One of them had no shoes and no coat, only a blanket wrapped around him. When he walked away, he left bloody footprints in the snow. I tried to find Major Clare to tell him, but he must be in a meeting."

"I saw some of the soldiers early this morning. I was having breakfast with some of the officers and commented to General Cheatham about food for them. He told me, 'Give yourself no concern, I have just issued them four ears of corn apiece.' However, I did not see the soldiers without shoes. That's terrible. Is Mollie going to be all right?"

"I'd love to know what she's writing in her diary." As Annie focused her gaze on her daughter, she wondered, *Is Mollie at the early stage of becoming a writer? Will this one experience mold her future?*

The snow continued to fall as the house began to fill up on Sunday evening. The large room became the central gathering place for the guests. Mary Hadley and Becky Allison had arrived earlier in the late afternoon. Becky brought her harp and began playing it for the guests. She encouraged Martha and Mollie to join her in the activity. The room was filled with songs from happy voices. General Hood heard the music and joined them. Chaplain Quintard entered the room unannounced and sat down next to General Hood. They chatted for a brief moment and then joined in the singing. A large log was added to the fireplace. As it blazed, the side door opened to reveal Generals Lee, Cheatham, and Steward. They handed hats and overcoats to the servant as they made their way to the warmth of the fireplace. General Hood acknowledged their presence and continued to enjoy the evening. Dinner was served and a light-hearted feeling continued to pervade the room and its guests. There was a pause in the many conversations around the table when John Overton stood.

"Chaplain Quintard, I wonder if we could prevail on you to offer a vesper thought and prayer. Thank you again for sharing Holy Communion with us this morning."

"It would be my pleasure to do so." Harriet was thrilled and held John's hand when he sat down.

"I call your attention to a time in the life of our Lord. He had been in Galilee ministering, and the Scripture states, 'and He turned eyes toward Jerusalem.' Jesus had a responsibility in Jerusalem. He had a date with his

reason for coming to earth. He knew what was ahead of him. He did not delay his mission." The room was silent. The Chaplain continued for another few minutes and concluded with, "The world saw the death of Jesus as defeat; God knew it was victory." He offered a prayer. As heads were bowed, everyone listened intently to the Chaplain's words. The reverence of the moment was shattered by loud voices outside on the gallery.

"Get those horses some food and water before you sleep. Double the guard around the house tonight. I don't want any of those dang Yankees sneaking around here."

"Yes, sir, General." Nathan Bedford Forrest pushed the double doors open, stuck his head in the room, and threw off his coat. He sat on the steps and loosened his spurs, allowing them to drop to the floor with a clang. May left his father's side. He was anxious to see who had arrived.

"Good evening, young man. Who might you be?" May came to attention and braced.

"Sir, my name is Jackson May Overton. My father is Colonel John Overton, CSA, of the Army of Tennessee." He pressed his lips together and looked straight ahead.

"At ease, soldier." May relaxed his body but did not change the solemn expression on his face.

"Yes, sir!" John turned the corner and entered the foyer. As soon as he saw General Forrest, he extended his hand and the General stood up.

"General Forrest, it is good to have you at Travellers Rest."

"Thank you, Colonel."

"Have you met my son?"

"Yes. He is an impressive young man."

"General, have you eaten?"

"Yes, we stopped about an hour ago in Brentwood. I'm about ready for bed. I need to make one more check with my men before I retire for the evening."

" I'll tell the servant to get your bed ready. There will be fresh water in the basin and a decanter of brandy. Would you like to have the hip tub set up?"

"No, what you have prepared will be fine."

"You will have a bedmate. Chaplain Quintard said he would be happy to share the bed."

"Excellent. We have shared a bed on other occasions. We joke about the lion and the lamb lying down together." May watched as General Forrest adjusted his saber, picked up his spurs, and went onto the gallery, closing the door behind him.

"Father, that was General Nathan Bedford Forrest. He's the one who whipped the Yankees in Brentwood." May finally allowed a smile on his face. "And he's staying in our home."

"Yes, some folk call him the Wizard of the Saddle. You remember your brother, John, rides in his cavalry."

"Yes, I do. Mother told me he helped General Forrest run the Yankees out of Brentwood."

"Well, he did challenge them. May, tomorrow is going to be a big day. It's time for you to go to bed. Go find your mother and bid her good evening."

"Yes, sir." Houseguests and family members found their way to sleeping quarters, fires were banked, candles were snuffed, and all became quiet at Travellers Rest.

Harriet decided not to attend the wedding ceremony on Monday. She spoke to Major Clare.

"Sir, you will forgive me for not attending your wedding ceremony this morning?"

"Yes, ma'am. I think you are wise staying out of this extremely cold weather. There is also a layer of ice under the snow. Travel will be tricky this morning."

"I want to oversee the preparations for your wedding dinner. I will celebrate with you and your new bride when you return."

"I look forward to returning, ma'am."

Eli pulled the carriage as close as possible to the steps on the gallery. When the ladies left the house, they were bundled in heavy coats and blankets. They did appear dressed for a wedding. The cold weather did not hinder their excitement. Harriet and her sisters watched through the windows as the wedding party left.

"Ladies, we have work to do before our guests return." Harriet surveyed the room.

"Harriet, how many guests are you expecting for dinner?" Annie had mentally counted the chairs.

"I told Cynthia to set twenty-four places. She probably has food for fifty. I'm certain John will invite all who attend the wedding ceremony."

"Have you made plans for where the Major and Mary will spend their honeymoon?"

"I was thinking of putting them in the guest room upstairs. I could take out one of the beds in there. The Major told me most of the officers would be leaving after dinner. Did you know that's the bedchamber where Sam Houston and Eliza Allen spent part of their honeymoon?"

"I remember you saying something about it. Won't that be something for the Clares to remember!"

"Mary Overton told me it was an interesting time in the house. Sam was upset. Eliza never spoke to him in public after their honeymoon. She finally went home to Gallatin and her relatives ran Sam out of Nashville."

"Hopefully, the Clares will have a better marriage."

Harriet and Annie busied themselves in the room. Mary was trying to find an appropriate place to display her autograph book and quills. Harriet wanted to tell her to forget the book at dinner but knew it was important to her.

"Annie, what time do you judge our guests will be arriving?" Harriet was mentally thinking about the seating arrangement.

"The ceremony is at ten o'clock. The ride back from Brentwood will be slower than usual due to the weather. I would judge they will all arrive by one o'clock."

"Perfect. I need to tell Cynthia and the General's cook."

Harriet returned from the kitchen and again tried to think through the seating. *I will seat General Hood and John together at one end of the table and the Clares at the other end. I know May wants to be near one of the generals. That is all I will concern myself with right now. The remainder of the seating will just happen naturally when the time comes.* She went upstairs to her room and dressed for dinner.

The cold temperature outside had not improved. It was still below the 20-degree mark. The north winds had magically stopped blowing. The icicles hanging from the roof were not melting. The sun was high overhead when the wedding party arrived. It was a few minutes before one o'clock. Harriet, Annie, Mary, Martha, and May waited in the large room. Extra logs had been added to the fireplace and the room was comfortable. Sergeant Goodson sat several bottles of whiskey and glasses on one of the pier tables. He knew from past experience some of the guests would be looking for the libation before eating. Harriet watched him and caught Annie's eye. She nodded her head and mouthed, "It's the army way." The guards on the gallery came to attention as General Hood passed them. He entered the double doors and went straight to his room. Harriet watched through the window as John pointed in the direction of the necessary. White, Becky, and Mary Hadley Clare moved quickly up the steps, holding long skirts and unbuttoning their heavy coats. Chaplain Quintard entered the room, removing his hat when he saw the ladies.

"Good afternoon, ladies." He backed up to the fireplace. "This fire is wonderful. The ride from Brentwood was really cold."

"I trust all went well with the ceremony." Harriet was moving across the room as she spoke.

"Yes, the wedding guests passed the hat, and I now have a tidy sum for my mission work."

"Chaplain," Mary added, "you should spend some of that money on your family."

"You are right. I will send some of this money to them. I'm sure there are some needs to be met at home."

"Chaplain Quintard, have you signed my autograph book?"

"No, I don't believe I have."

"Well, sir, you need to do that before you leave the house today." As the dinner guests entered the large room, they passed by the fireplace and then congregated around the table where the whiskey had been placed. John followed General Hood into the room and closed the door behind him. Harriet stepped to the center of the room and looked at John.

"Ladies and gentlemen, welcome to Travellers Rest. This is a wonderful day and a proud one for us. We are here to honor our new bride and groom. Major and Mrs. William Clare, these two places are for you." Harriet directed them to the assigned seats at the table. She walked to the head of the table and instructed, "John, you and General Hood sit here. The rest of us will fill in around the tables. When we are seated, General Hood, please introduce your officers, and John, please introduce our family members. Friends and family, be seated." May made his way to a seat near General Forrest. Martha stayed near her mother, hoping there would be a seat available next to her. The various officers escorted Annie, Mary, White, and Becky to their seats. Harriet watched as the tables filled. John helped her and Martha in their chairs and then returned to the head of the table. General Hood struggled to stand and balance his weight. His one good hand gripped the back of his chair.

"What a delightful day this is. In the midst of war, we can find serenity in such an occasion as this. The event is made even more special by gathering in this fine home. This brief respite surely will long be remembered by us who gather here. My congratulations to the bride and groom. May your love for each other grow stronger each day. Now, to my orders." He smiled at Harriet; she nodded and smiled in response. "May I present, to my right, Governor Harris. Next to him is General Edmund Pettis. Then, Generals James Chambers and W.H. Jackson. Next to Master May Overton is General Nathan Bedford Forrest. At the far end of the table are Generals Stephen Lee and Benjamin Cheatham. And here is my highly trusted spiritual counselor, Chaplain Charles Todd Quintard." John waited for General Hood to be seated.

"Thank you, General Hood, and to all your officers for being here. My best wishes to William and Mary. Gentlemen, I want you to know Annie Maxwell Claiborne. Some of you have met her husband, Colonel Thomas Claiborne, who is on staff to General Beauregard. Her sister, Mary Maxwell, is next. She's the lady with the autograph book. Becky Allison and White May are the lovely bride's attendants. Sitting by her mother is our oldest child, Martha. Our oldest son, May, is the man of the house in my absence. The second First Lady of Travellers Rest is my wonderful wife, Harriet Virginia Maxwell Overton." The gentlemen stood, faced Harriet, and bowed. She acknowledged their tribute by standing. Then she blew a kiss to John as all returned to their seats. As the food was served and glasses filled, Harriet glanced around the table and thought, *This is my finest hour.*

There was happiness in the room. Little conversations were going on all around the table. Cynthia and Sergeant Goodson had prepared a bounty of food for the guests. Harriet was pleased to notice her sisters and White were enjoying themselves. She tried to get May's attention, but he was too busy eating and talking to look her way. Martha didn't like being in the room. Becky Allison tried to engage Martha in conversation but found that topics were limited.

"Mother, may I be excused? I've had all I want to eat."

"Yes, I think that's a good idea. I'd prefer you stay in the house, since the weather is so cold."

"Yes, ma'am." Martha was closing the door behind her when Major Clare stood.

"Ladies and gentlemen, on behalf of Mary and me, I want to offer a toast," and he lifted his glass. "We thank you, Mrs. Overton, for your gracious hospitality." Glasses were lifted in agreement. Mary stood by her new husband. She had a package in her hands. When the toasting quieted, she turned to Harriet.

"Mrs. Overton, William and I have a gift for you. We can never repay you for all your kindness, but we wanted you to have something to remember us by." Mary walked around the table and gave Harriet the package.

"Thank you, Mary. Thank you, William. Should I open it now?"

"Yes, I think it will be very appropriate." The ribbon came off first and then the paper wrapping was pulled back. The red material was the first thing Harriet saw and she was puzzled. As she unfolded the cloth, the blue bars and white stars were reveled to all in the room. May came near his mother to get a better look at the flag—the battle flag of the Confederacy. He took two corners, as did Harriet. The full display was met with loud hand clapping and smiles. Harriet was in tears.

"Thank you ever so much. I can now proudly display the flag of my country. I will place this flag in this room and will defend it to my last breath." The cheering and clapping began again.

"Mary, I have a gift for you and William. The upstairs guest bedchamber has been prepared for your honeymoon. The windows and the door—lock from the inside." Cheers and clapping erupted again.

The ladies moved and gathered around Mary. The men shook William's hand and slapped him on the back, making statements that made him laugh. William and Mary excused themselves and went upstairs. One by one, the guests left the room, leaving Harriet and John standing together near the fireplace.

"Harriet, this has been an exciting day. The wedding, the dinner, your special gift—it has all been wonderful."

"Now, Colonel John Overton, about this flag. I would like to display it between these two windows."

"Yes, ma'am, General Harriet Overton. I will see to it immediately, ma'am." They hugged and laughed by the warmth of the fire.

# 28. Battleground—December 15-16, 1864

Harriet did not realize her remarkable dinner would be the last time she would see General Hood.

Afterward he stayed in his room. That area of the house was like a beehive. Staff members constantly received and sent telegraph messages at the telegraph wagon. Officers rode in on horseback in a hurry and departed the same way. Lookouts were stationed on the north end of the upper gallery, just outside John and Harriet's bedchamber. The temperature outside began to moderate somewhat, but it was still cold. The wind had shifted from the north to the east. Sometime during the early hours of Thursday, December 14, warmer air arrived, bringing with it a thick fog. As Harriet waited for the family to gather for breakfast, she looked out the window and could not see the barn. A misty rain began to fall, melting the snow and ice and creating a massive mud problem. Some of the soldiers tried to get on the gallery, but were chased off by the guards. There was yelling and cursing, but the guards did their duty.

When Harriet returned to the family dining room from her visit to the kitchen, she found the newlyweds—William and Mary—standing in the doorway.

"Mrs. Overton, may we join you for breakfast?" Mary's soft voice could hardly be heard.

"I would count it an honor to have you join us. I just told Cynthia to prepare your breakfast and send it up to your room." Cynthia entered the room with an armful of plates and napkins.

"Look who's here, Cynthia."

"I do declare. It be da newlyweds."

"Major and Mrs. Clare will be joining us for breakfast. Please set a place for them."

"It be my joy." The sound of the voices woke May, who was sleeping in the corner of the room. He pulled the covers over his head and curled up.

"May, it's time to get up. I have two surprises for you this morning." May pushed the covers down and stretched his arms over his head. He was finishing a yawn when he spoke.

"Mother, are you teasing me? What are the surprises?"

"The first surprise is our special guests for breakfast." May rubbed his eyes and then opened them wide.

"Who?"

"Major and Mrs. Clare are here." Hearing the word Major, May was on his feet.

"Good morning, sir! We are happy to have you and your wife join us for breakfast."

"Soldier," Harriet was laughing at her son standing at attention in his nightclothes. "It might be good for you to step behind the door and put on your day clothes."

"Yes, ma'am!" William and Mary smiled broadly. May dressed, folded his nightclothes and the bedcovering, and walked over to his mother and gave her a hug.

"Mother, what is the second surprise?"

"Go look out the window."

"Wow! What is that?" May had his nose pressed against the window.

"It's fog. My father used to call it a Scotch mist."

"May I go outside on the gallery?"

"Yes, but just for a few minutes. Cynthia will have breakfast ready shortly. While you're out on the gallery, look for the barn." The family made their way through the house and had not noticed the fog. When May reentered the house, he made an announcement.

"Father, someone took our barn. It's gone!"

"May, what are you talking about? The barn is where it has always been."

"No, sir! It's gone! Go out on the gallery and look." His announcement made all in the room curious. Some went to the window to see for themselves. John walked out on to the gallery and looked in the direction of the barn.

"Well, I'll be darned. It sure looks like the barn is gone."

"Mother told me some man named Scotty Mist took it." John put his arm around his son and laughed loud enough to bring Harriet to the doorway.

"What are you gentlemen laughing about? Come inside. It's time for breakfast and we have guests."

"Harriet, tell me more about this man, Scotty Mist."

"Who?"

"The man who took our barn—Scotty Mist." John began laughing again as he sat down at the table.

"I told May my father called the fog a Scotch mist. I didn't say anything about Scotty Mist. May must get his hearing problem from your side of the family." Harriet placed her hand on top of John's and smiled at him. "John, before you bless the food, allow me to say again how pleased I am to have William and Mary join us." The conversation around the table was light and cheery. No mention was made of the war. After breakfast, William and Mary remained at the table with John and Harriet.

"Mrs. Overton," William was pushing his chair away from the table, "I have some duties to perform for the next couple of days. Would it be all right for Mary to stay with you until I return?"

"Yes, that will be fine. That will give Mary some more time to visit with White."

"I will be happy to help with the household duties in any way I can." Mary's smile spoke volumes.

"The only thing I ask is that you fit into the routine of the house."

"Yes, ma'am. I can do that."

"There is one more very important matter about you staying here."

"Yes?"

"I want you to call me Harriet."

"Yes, ma'am . . . ah . . . Harriet." William and Mary left the dining room hand in hand, leaving only John and Harriet.

"Harriet, I will be leaving this morning. There are some important army duties needing my attention."

"But John, it's so muddy on the roads. Is it safe?"

"Safe or not, I've got to go. General Hood is expecting more troops to come, and I need to find supplies for them. Please ask Cynthia to prepare some food for Eli and me to take with us. I need to walk down to the barn and find Eli. We will be leaving as soon as he can get the horses ready."

"Please don't leave without saying good-bye to the children. They miss you so much when you're gone. How long will you be gone this time?"

"It depends on how far south and west I need to go. The extra troops could be coming from either direction. I'll stay in touch by our usual method. Please hand this letter for Colonel Edmund Rucker to one of the officers. It needs to be delivered to him."

By sunset, the house was eerily quiet. The wagons, the horses, the soldiers—all were gone. Harriet knocked on the door leading to the bedchamber used by General Hood. There was no response. She turned to see Mary Clare coming down the staircase. She was sobbing.

"What's the matter, dear?"

"I miss William. I fear for his life. He rides so close to the front lines to check on the position of the troops. Being an officer, he is a prime target for a Yankee sniper." She continued to sob.

"Mary," Harriet took her by the hand and led her into the large room. "The best we can do for our men is pray for them. John left again this morning, and I don't know when I'll see him again. You must be strong for William and the Cause. Did you see the flag you and William gave me?" She pointed to the battle flag hanging between the windows. "Mary, that flag brings me comfort."

"Harriet, I wish I had your courage. I'm just so afraid of what might happen."

"I'll tell you what. After dinner, I'll teach you how to knit and you can start on a scarf for William. And then tomorrow, the ladies are coming to roll bandages and you can join us. Courage for living sometimes is in staying busy at home and knowing our men are out there somewhere protecting us."

"William told me he would not be coming back here. He'll be reporting to General Hood over at the Lealand house." Harriet had a troubling thought: *I hope the Leas will be safe.*

"I guess that's why the house is so quiet. General Hood has gone and taken all the soldiers with him." *I didn't even have an opportunity to tell Sam good-bye.* Harriet and Mary sat on the sofa looking into the fire. Their silence

was interrupted by a knock on the door. Annie was descending the staircase about to enter the room to speak to Harriet but instead answered the knock.

"Yes, Claiborne?"

"Miz Annie, I needs to talks wid Miz Harriet."

"You wait here, I'll get her for you." Annie stepped into the room.

"Harriet, Claiborne is at the door and needs to talk with you."

"Ask him to come in, please."

"Do I need to leave?" Mary appeared to be calming down from her crying spell.

"No, please stay." Claiborne entered the room and stood in front of Harriet.

"Claiborne, you need to talk with me?"

"Ya, ma'am. It be abouts the black folk. Dey would likes ta comes and stay in da cellar."

"That will be fine. Some can stay in the cellar and some can stay with Cynthia in the kitchen."

"Ya, ma'am. I done talks ta Cynthia abouts da chilins stayin' dere. Miz Harriet, is dar goin' be a fightin'?"

"Why do you ask that, Claiborne?"

"Well, ma'am, all dem soldiers leaves da house in a big hurry pointin' dere guns at da city." Annie was listening to the conversation with interest.

"Claiborne, how many wagons do we have in the barn?" Annie was talking to Claiborne but looking straight at Harriet.

"Dere be twos haulin' wagons, da carriage, and da buckboard." Harriet looked puzzled.

"And how hard would it be to put our big trunks in the two wagons?"

"Da trunks be in da wagons now, ta save space in da barn."

"Do we have horses and drivers for the wagons?"

"Ya, ma'am. Is ya goin' somewheres?" Harriet had the same question.

"I's be goin' ta gets da black folk up heah." The door closed behind Claiborne and Harriet was on her feet.

"Annie, what are you thinking?"

"I'm thinking the workers know something. They sense the armies are about to fight. They have stayed in their cabins through all this cold weather and now, they want to come and stay in the cellar. They could leave the plantation if they wanted to, but no, they want to come to the house. Why? They sense something. Harriet, we may need to leave here for the safety of the children."

"I'm not leaving my home empty for some band of no-goods to plunder."

All Wednesday night and the early of hours of Thursday, Harriet could hear the sound of boots walking back and forth on the upper gallery. *Maybe General Hood and his men have come back to the house.* She closed her eyes but only for brief moments. The sounds of whispering voices penetrated the window in her bedchamber. Before sunup, the voices became louder and more

urgent. She heard the siege guns announce the sunrise. *Maybe the guns are being fired to scare us. I hope they are no closer than Fort Negley.* At times, the windows rattled.

"Take a message to General Hood," the officer's voice was demanding. Harriet looked at her watch. It was a few minutes after six o'clock. *What's happening out there? What's the message?* She went to the window and saw an officer leaning over the rail with his hands cupped around his mouth. "Report, the enemy appears to be on the move in the East Sector, coming down Murfreesboro Pike, and may be heading for Granbury's Lunette. From the light of the torches, I'd judge at least two divisions."

"What about the West Sector? What do you see?"

"I don't see anything moving. The fog is too dense. I can't see much of Franklin Pike from here."

Harriet dressed and went to wake Annie and Mary. When she arrived at the upper parlor, her sisters were already dressed and standing on the landing.

"Good morning, ladies."

"I'm not certain it's a good morning." Annie was blowing on her fists to warm them.

"Let's go get some breakfast before the children get up. We can talk about our plans. Annie, how many men are in a division?" Annie and Mary followed Harriet down the staircase.

"A full division would be about five thousand men. Why do you ask?"

"I heard the officer outside my window say, 'I'd judge at least two divisions.' He was sending the message to General Hood."

"Did you hear a direction? Did he say where the two divisions are?"

"He said something about an East Sector."

"All right, that would be on our right flank."

"What does all this mean for us?" There was concern in Mary's question.

"It means, the armies are about to do battle, and we could be right in the middle of it." Harriet had opened the door leading to the kitchen and stopped.

"Annie, do you think we could be involved in a battle?"

"You read about what happened at Franklin. That could very easily be our fate."

"Mary, give May a shake and tell him to get up and dress for the day. I'll check with Cynthia about breakfast." Annie and Mary were at the table when Harriet returned.

"Breakfast will be on the table in about ten minutes. May, are you about finished dressing?"

"Yes, ma'am."

"Come over to the table and join us. We need to talk about the day before us." Breakfast was served. May prayed for the food and for the safety of their loved ones.

"May, after you eat, I want you to go to the barn and tell Claiborne to bring the wagons to the steps on the gallery."

"Are we going somewhere?"

"Son, we need to be ready for anything today."

"Mary, I want you to pack the children's clothes. Ask White and our new bride to help you. The trunks are already in the wagons. Annie, talk with the officer on the upper gallery. You are the only one of us who speaks and understands the military language. I will go to the cellar and talk to the workers. Let's meet back here in the dining room in one hour." Harriet finished the last few bites of her breakfast and headed for the cellar. She looked at her watch; it was eight o'clock.

The cellar supported the entire house. The fireplace was massive. Wall supports divided the space into rooms. There were small iron vents on the outer walls, which allowed air and light in and provided a limited view of the outside. The sounds of the guns from Fort Negley were somewhat muffled but still very much noticeable. Harriet asked Archer to gather the workers in the kitchen part of the cellar. Harriet stood on the hearth to speak.

"As you are aware from the sounds outside, the armies are about to do battle. That's about all I know to tell you. I believe this cellar is a safe place to be. There's plenty of food here and it is warm and dry. You are welcome to use anything you find down here. Archer, I'll put you in charge of the wine. There are two wagons in the driveway. Mrs. Claiborne thinks it might be best to take the children away from the battle. If the children are taken away, there will be room in the wagons also for your children. Archer cleared his throat and raised his hand.

"Miz Harriet, will you be staying or leaving?"

"This is my home. I will be staying, no matter what. You are welcome to stay." The workers began to talk in small groups. Harriet felt they had all the information she could give them. As she left the cellar, she heard the sound of a fiddle. It brought a smile to her face.

"Mother, good morning." Martha greeted her mother with a smile. "Have you been outside?"

"Yes, I was talking to the workers in the cellar." Harriet made a circle around the table greeting each child with a hug and a kiss.

"Aunt Mary and Aunt White are collecting our clothes. Are we going on a trip?"

"Martha, we are making preparations to leave, if the fighting gets too close to the house."

"Is Father coming to take us?"

"No, if we leave, it will be on our own."

"Mother, I'm afraid."

"So am I, but I need for you to be brave for your brothers and sisters. If you are brave, they will be brave."

"Yes, Mother. This is the time for courage."

"Yes, that is the very word we need for this day—courage. When everyone finishes breakfast, I want you and Mollie to take the children back upstairs.

You can use the small staircase." The room emptied. Harriet was staring out the window when Annie and Mary came in.

"It looks like the fog is clearing. Annie, what did you find out from the officer?"

"If you are looking toward Nashville, a lot of troops are gathering not far from the Thompson's home at Glen Leven. The officer told me over to the left toward Hillsborough Pike are five redoubts."

"What's a redoubt?"

"It's like an enclosure. The soldiers cut down trees, stack them, and then pack dirt around them. If they find large rocks, those are placed around the enclosure. They try to select a place on top of a hill or high ground. They roll large guns in the redoubt and fire on the enemy when they are coming up the hill. The redoubt is usually large enough to protect lots of riflemen. The officer was really concerned about all the troop movement on the right. He sent two verbal messages to General Hood while I was standing up there."

"Did you ask him how safe we are here in the house?"

"He thinks we are safe, if the soldiers and fighting stay where they are."

"And if they don't stay where they are?"

"All of us may need to get in the wagons and go someplace safe."

"Annie, I need to tell you now, I'm not leaving this house. I told John I would be here when he got back, and I will be here!"

Harriet and those staying at Travellers Rest did not know what was happening on the battlefront. She would learn later that the redoubts fell like dominoes. Somewhere between four and five o'clock in the afternoon, the last redoubt, Number 1, was overrun by Federal soldiers. The Army of Tennessee was on its last leg for the day. As darkness covered the battlefield, Confederate troops were repositioned in an east-west line, stretching two and a half miles, and anchored on either end by Peach Orchard Hill and Compton Hill. Orders were sent to the three commanders to regroup, dig in, rest, and prepare to fight a battle the next day. General Hood retired for the night, knowing he had the high ground, if General Thomas chose to do battle the next day. On the map, the two hills appeared impregnable.

Harriet made one trip to the wagons and packed several dresses in a trunk. She slept in her day dress and high-top shoes. She thought, as she pulled the heavy covers over her, *I need to be ready to move quickly in the morning.* She prayed for John and fell into a deep sleep.

The fog, or as Harriet called it, Scottish mist, was not quite so thick on Thursday morning. She rolled over in bed and faced the window. It appeared to be dark outside. She was tempted to close her eyes and try to sleep more, but she felt rested. The sound of a female voice outside her window prompted Harriet to get up and investigate. Peering through a space in the curtains allowed her see only three silhouettes. *Who is that?* She went to the door and opened it slightly. She heard the female voice again and discovered Annie was talking to two officers.

"Annie," Harriet spoke in a whisper. "What's happening?" Annie stepped inside.

"If there is a battle today, it will be in the peach orchard. The officers told me the Confederate line stretches from the orchard to Compton Hill."

"What does that mean?"

"We will know for sure a little after sunup. The officers know where our troops are, but they are not certain where the Yankees are. They can use their scopes as soon as the sun comes up."

"And then what?"

"They will be able to see the enemy's location. I'd suggest we feed the children and get them into the cellar."

"Annie, are you leaving?"

"No, we are staying. Harriet, we are a family and we need to stay together." Harriet hugged Annie and kissed her on the cheek.

"Thank you!"

By eight-thirty the children were dressed, had eaten breakfast, and were taken to the cellar. Just as the door was closed, the artillery bombardment started along the battle line. Aunt White and Mary Hadley Clare seated the children on a bench backed up to the foundation wall. Martha and Mollie were scared but tried to be brave for their sisters. They held each other close. May was holding Jesse and patting him on his foot.

"Jesse, the sound you hear outside are big guns called cannons." Jesse's only response was to hold tight to his big brother. Mary was peering through an air grate in the foundation, looking toward the garden, when she put her hand over her mouth.

"Oh, my God." White moved over next to her.

"What is it, Mary?"

"I thought I saw a Yankee soldier on the other side of the garden wall. Take a look. He was wearing a blue coat and a little blue cap." White looked but did not spot anything but the garden wall. She and Mary moved back closer to the children.

Harriet, Annie, and Mary were upstairs moving in and out of different rooms.

"Mary," Harriet instructed, "check in the kitchen, weaving house, and the barn. Make certain all the workers are in the cellar." On the way to the barn, Mary saw the Confederate troops gathered in the peach orchard. No sooner had she reached the barn than she heard the sounds of the cannons. From the clouds of smoke drifting back toward the house, she told herself, *Our boys are getting after the Yankees.*

Mary reported to Harriet, "The workers are in the cellar. I did find about ten of them in the kitchen huddled in the corner, and I sent them to the cellar. Have you heard the cannon fire in the orchard?" Harriet had not answered her when the first shell exploded, sending shrapnel against the outside wall of the small dining room, breaking one of the lower panes of glass in the window.

The glass fell where May's cot had sat only a few hours ago. The barrage continued all morning—some shells exploding; some cannon balls hitting the ground and rolling against the foundation of the house. Fearful eyes peered through the grates watching and reacting to each ball that landed. The fiddle music in the cellar seemed to keep time to the thuds on the lawn outside.

"Annie," Harriet hurried her two sisters into the pantry area, "why are the shells coming so close to the house?"

"They are adjusting the elevation and range of their cannons. I'm certain they are trying to hit our troops on the high ground around the orchard."

"We'd better stay away from the windows until someone finds the range. Let's make sure all the doors are locked."

"Good idea, and we'd better have our guns handy." Harriet and Annie locked all the doors and returned to the pantry area.

"Where's Mary?" There was a touch of fear in Harriet's voice.

"She went to lock the front and side doors. Maybe she's having trouble with the doors."

"Harriet, let me go to the front of the house and check." As she walked through the large room, she looked through the windows and spotted Mary placing a valise in the wagon. Annie pecked on the window, getting Mary's attention and motioning for her to get in the house. Mary had no sooner reentered the side door, locking it behind her, than a loud blast was heard. An exploding shell hit the kitchen, creating a large hole in the wall and throwing bricks all around the yard. Flying bricks hit the weaving house, the smokehouse, and made the door into the family dining room rattle. Harriet could smell black powder and burning grease wafting under the door. The sisters went back to the pantry area.

"Mary, what were you thinking? You could have been killed by one of the exploding shells." Annie was using her schoolteacher voice. Mary did not respond.

"Ladies, do you smell grease fumes? I think the kitchen is on fire."

"Harriet, do you want me to check?" Mary was trying to find a way to redeem herself.

"No, the kitchen is brick and the fire will surely burn itself out."

"Maybe the rain will help. I felt the rain when I was out at the wagons."

"Let's open the trapdoor and check on the people in the cellar." The rising heat from the cellar was a welcome surprise. Harriet's voice echoed through the vast cellar.

"Claiborne! Claiborne, can you hear me?"

"Ya, ma'am. I's hears ya."

"How are things down there?"

"Fearful, Miz Harriet, fearful. How be thangs in da house? What time it be, ma'am?"

"It's a little after two-thirty. Why do you need to know the time?"

"It be dark in a couple of hours and da guns will stop."

"I sure hope so. Go to the front cellar and ask Miss White May to come. I need to speak with her."

"Ya, ma'am." Harriet waited looking down through the opening. Annie was holding Harriet's hand.

"Yes, Harriet, you wanted to speak to me?" White put one foot on the ladder as she looked up.

"How are the children doing?"

"Other than not liking the musty smell down here, they are doing fine. May has been explaining to us about the shells bursting. Martha and Mollie are being very brave and helping with their sisters."

"And how is Jesse doing?"

"Right now he's taking a nap. Mary Clare has him." Annie stepped forward and looked down the opening.

"Is there anything you need?"

"No. We are warm and we have food. We have a chamber pot. So, all is good—so far. Are we going to be leaving the house today?"

"No. The safest place we can be right now is here." Harriet smiled on hearing Annie speak.

"I'd better get back to the children. Talk to you later." Annie closed the trapdoor and looked at Harriet.

"We are in the safest place we can be right now," Annie reiterated.

"I'll take your word for it, big sister."

The rain that began gently, now beat against the windowpanes with such force that Harriet peeked around the corner into the large room to see the rain dripping outside. *I wish I had closed the shutters. It's too late now. At least the shelling has stopped. Maybe that's a good sign.* The rain seemed to come in sheets and then slowed to a mere drizzle. It dripped through the broken pane and puddled near May's cot, unnoticed.

Harriet was unaware of the battle in progress along the road that passed Lealand and wound its way to the home of her friends, the Comptons. Every sound outside made her heart beat faster. Her ears became overly sensitive. She wondered about life on the other side of the door but was afraid to venture out onto the gallery.

"Harriet, did you hear that voice?" Annie turned in the direction of the door.

"Yes, I did. What did you hear?"

"It sounded like someone yelled, 'On the hill' or something like that."

"That's what I heard." Harriet looked at her watch. It was nearly four o'clock. The cannons firing on the hill in the orchard had been so loud and prolonged that when they stopped, Harriet felt she could hear her heart beating. She looked at Annie but didn't say a word.

A loud thud on the gallery caused Harriet, Annie, and Mary to turn in the direction of the door. They heard the two doors rattle and saw the doorknob turn. Annie pushed her sisters behind her and leveled the shotgun she was

holding. Her thumb cocked the hammer. Someone ran down the gallery trying each door before going down the steps. Whoever it was was in a hurry.

"Who was that?" Mary spoke directly into Annie's ear.

"I have no idea, Mary."

"Were you really going to shoot someone?"

"If I saw a blue uniform come through that door, I was ready." There were more voices outside, but no more thuds on the gallery. Men were yelling; men were crying. All of them sounded like they were anxious to be anywhere but where they were. Harriet and her sisters huddled together and remained silent. It reminded them of when they were girls at the Hall. The spring winds would blow, the thunder and lighting would shake the house, and they would huddle together in silence.

The first cannonball to hit the west side of the house shocked Harriet. The ladies could hear the bricks falling to the ground. The screams from the cellar were full of fear. Harriet opened the trapdoor.

"What's happening down there? Claiborne, can you hear me?"

"Miz Harriet, is da house fallin' down?" Before she could answer, two more cannonballs hit the house. One hit a window frame, shattering all the glass and falling to the ground. The second hit near one of the metal grates, causing more screams from the cellar. The balls kept coming, doing more and more damage to the windows and the bricks on the side of the house.

"Claiborne, move everyone away from the west side of the house. Then go find Miss May."

"Ya, ma'am."

Harriet stuck her head around the doorway to the large room. Both windows were broken, glass was everywhere. A cannonball had rolled to the middle of the room and stopped under one of the chairs. Rain was blowing in where the windows had been. As she turned, she glanced at her flag. She slid her hand into the pocket of her dress and located her pistol. *Lord, please protect us in this house. Keep us from harm. The bricks and windows can be replaced, but your people cannot. And Lord, if a Yankee tries to get in this house, please forgive me for my actions.* Harriet's brief talk with the Divine was interrupted by White's voice.

"Harriet, you need me up there?"

"No, how are the children?"

"We are doing all right under the circumstances. The cellar walls are shaking. What's happening to the house?"

"The cannon fire has hit the west side of the house several times. Windows are broken and bricks are falling off the side of the house." Harriet could not hear any more cannon fire. "Maybe the worst is over. It will be dark soon. Annie and I will try to get into the cellar later. Thanks for protecting the children."

Darkness was setting in. The rain continued. The sounds of wagons, horses, and men moving through the yard had stopped. Annie, Mary, and

Harriet lit candles and ventured into the large room and the small family dining room. They were speechless. The damage was overwhelming. Pieces of glass were everywhere. The furniture near the windows was covered with beads of rainwater. The carpet was soaked and left shoeprints as the ladies walked around the room.

"Mary, would you check upstairs for damage?" Harriet spoke in a quiet voice, not wanting to tell anyone on the outside that the house was occupied. Mary returned with her hand over her mouth.

"Well, what did you find?" Mary hesitated, trying to find the right words.

"Both windows are gone and the bricks are in disarray. Rain is blowing into the room." All three sisters turned toward the pantry area when they heard White's voice.

"Your children are asking for you, Annie and Harriet. They want to know you are safe."

"Harriet," Annie directed, "you go on and check on the children. I'll go when you get back. White, you can stay up here with us for a while. I know the cellar is a frightful place."

"Thank you, Annie. The outside sounds have been the worst part. Not knowing what's happening is hard." Harriet returned and was straightening her dress when a knock came to the front door. All four ladies shielded their candles, redirecting the light. A second knock came. Mary walked to the door.

"Who's there? What do you want?" Annie moved behind Mary and leveled her shotgun at the door. She had already cocked the hammer when she heard a man's voice.

"My name is William Elliot. I'm looking for Annie Maxwell Claiborne. Is she in the house?"

"Are you alone? Tell me your name again. How do you know Annie?"

"Annie and I are friends from Texas. I was in her wedding in this house." Harriet moved across the large room on her way to the front of the house but was not able to see anything outside due to the darkness. She had found her pistol and had it in hand when she joined Mary and Annie. She handed Mary the door key.

"Mister," Harriet projected her voice, "remove your hat and move away from the door. If you are truly William Elliot, you are welcome. If you are not, you are a dead man. Mary, open the door and get behind it." Annie could feel her right hand tighten. She was prepared to pull the trigger. When the door opened, William stood with his hat in his hand. He was wearing a rain slicker over his uniform and it was dripping.

"Annie?" Annie could not mistake that voice. She had heard it so many times before in Texas. She uncocked the shotgun and laid it on the floor.

"William Elliot, I am so happy to see you after all this time!" She put her arms around him, forgetting he had been in the rain most of the day. "Come in and take that slicker off."

"I was riding on Franklin Pike and remembered Travellers Rest was on this road and there was a peach orchard. I checked my map and sure enough, there it was. I was concerned about your safety. That's why I'm here." Harriet was listening to this Yankee officer and thinking, *Why didn't you come early in the day and stop those big guns that were aimed at my home? Maybe you'd like to stay and help rebuild my house.*

"William, can you stay?" Annie glanced at Harriet for some clue as to her feelings. Harriet nodded, then she spoke.

"William, we have only one bed for you to sleep in tonight. You will have the rare privilege to sleep in the same bed General John Bell Hood used only two nights ago. Did you know he stayed here?"

"Yes, ma'am. We knew when he came and when he left. We had hoped to capture him and his staff when they went to the wedding last Monday."

"Really! How did you Yankees know all that?" Annie smiled at the interchange.

"Harriet, every army has spies and informants."

"I'm certain they do." Turning to White, Harriet requested, "White, check in the cellar and find some food for our guest." That was hard for Harriet to say. She felt she was aiding the enemy.

"William," Annie gestured toward the bedchamber door. "Let me show you General Hood's room." Harriet knew that offer was made for her benefit, but she was pleased, nonetheless, with the wording.

Dinner at the Overtons that evening was substandard. Harriet did not apologize for the beans, greens, and cornbread. *After all*, she thought as they sat at the table, *we are using the same china I used for General Hood. That should be good enough for any Yankee, no matter his rank.*

"Mrs. Overton, this is a wonderful meal. I don't know how you cook the greens, but they are the best I've ever eaten." Harriet was leery of any compliment coming from a Yankee, but she took it as being genuine.

"In the true south, we highly season all of our vegetables." The candlelight at the table was very dim, but Annie could tell from William's expression that she needed to change the subject.

"William, where have you been since Texas?"

"Well, let's see. You remember I left Texas not long after Thomas. I was in Baltimore for a while training new recruits. Then a number of us from the old army were assigned to keep track of troop movements. I was scheduled to be at Shiloh but only got as far as Kentucky. When General Thomas started building up the troops in Nashville, I came here. I've been in the area for a while."

"Did you know Thomas is also a troop inspector?"

"I did read a report with his name listed." He pushed his chair back from the table. "Ladies, I've enjoyed this opportunity to dine with you. Mrs. Overton, I appreciate your wonderful hospitality. The meal was excellent. I'll be leaving before sunup, so I'd better retire for the evening."

Harriet responded with a nod and addressed Annie, "I'll go and check on the children. Be sure to show William my special gift." He made no comment as he passed Harriet's Confederate flag hanging in the large room. Annie realized he saw the flag.

"I guess my sister will put the gift flag in her coffin when the time comes."

"I'm finding the longer this war goes on, that both sides of the conflict have people of courage. You and your sisters are incredibly brave. You do know, Annie, this house was on the battlefield." William pushed open the door to the bedchamber. "Give my regards to Thomas. Please know our friendship is bigger than this blue and gray struggle."

"Thank you, William, for coming to check on us. This visit has been all too brief, but I understand duty calls. May God protect you from harm. Come back and visit us when this war is over."

"You can count on it. Good evening." When the door closed, a chapter of Travellers Rest history was finished.

The days and weeks came and went with no word from John. Harriet didn't know where he was or if he was still alive. She was fearful to send May to the Overton Station to check for mail. The plantation and the larger community continued to be harassed by Union troops on patrols. The rails had been destroyed in places, and the train did not have a regular schedule. The local newspapers stopped listing Confederate dead and MIA soldiers, even though Harriet ran her finger down each column on every page searching for any word about John.

The black workers moved back to their cabins down below the barn. They were surprised to find little damage. They did, however, find dried blood on several porches. Those cabins remained vacant for several months. Archer put a work crew together to begin making repairs on the west side of the plantation house. No windows were available to replace the broken ones, so Harriet had them boarded up. The bricks from the destroyed kitchen were cleaned and stacked behind the weaving house. Harriet put the older children of the black workers to work stacking cannonballs. She indicated the design she wanted and where she wanted the stacks placed. The family, once again, occupied every room in the house. For all practical purposes, a sense of normalcy had returned to Travellers Rest.

One day in late January 1865, a wagon appeared at the side of the house. It was covered in canvas with the large initials, USA, painted on it. The driver, in a Union uniform, walked to the side door and knocked. Harriet and Mary appeared at the same time and opened the door.

"May I help you?" The soldier removed his hat and retrieved an envelope from his coat.

"I'm looking for Mrs. John Harriet Overton." Harriet turned and smiled at Mary.

"Yes, I'm Mrs. John Harriet Overton. May I help you?"

"This here wagon of supplies is fer yous." His speech was curt and funny sounding. "This here note goes with the wagon. I'll be taking one of the horses with me, the other one stays with yous." Harriet took the note and watched as the soldier unhitched a horse and rode away.

"Who was that?" Annie stood behind Harriet and Mary in the doorway.

"I don't really know. He didn't stay long enough for me to find out his name." Mary reached for the note in Harriet's hand. She removed the sheet of paper and read its contents.

> *My Dear Friends at TR,*
> *Our army is being reduced in size. These supplies will not be*
> *moved. Although there are no greens to compare with yours, I trust*
> *you can use what I have sent. Our friendship is bigger than this blue*
> *and gray struggle.. Until our paths cross again, I am—*
> > *W.E.*

Mary questioned, "Who is W.E.?"

Annie and Harriet answered in unison.

"William Elliot!"

"How did you two know?"

"The greens!" Harriet was laughing.

"The part about friendship." Annie had tears in her eyes and silently said a prayer, *Lord, please protect my friend William from harm. Keep him safe and return him whole to his loved ones when this war is over.*

Harriet was surprised and pleased as she and her sisters inventoried the contents of the wagon. Claiborne had walked up from the barn when the wagon arrived.

"Claiborne," Harriet was direct, "take this canvas off the wagon and store it in the barn." The more canvas Claiborne removed, the larger the volume of supplies appeared.

"Get some help, Claiborne, and put half of the supplies in the cellar near the kitchen and . . ." Harriet hesitated. Annie noticed and looked directly at her. ". . . and take the other half and distribute them among the workers. I'll count on you being fair."

"Ya, ma'am. Thank ya fer ya kindness." Annie and Mary watched Harriet climb the steps, walk the gallery, and disappear into the house.

"You know, Mary, our sister is such a strong person in so many ways. Her small body has a giant portion of fairness, compassion, and courage. During this struggle she has been more like our mother than our younger sister."

"Oh my goodness!" Mary's mouth was wide open. "Do you know what we have done?"

"What?"

"In all the confusion around here, we have forgotten Harriet's birthday."

"That's right. January eighth came and went."

"Mary, go tell Cynthia we need a special dessert for dinner. I'll work with the children today on a birthday gift, and we will celebrate this evening." And the family celebrated with a large dried apple cobbler that Cynthia prepared.

"Happy birthday, Harriet! Happy birthday, Mother! Happy birthday, Aunt Harriet! Happy birthday, Miz Overton!" The voices were of one accord. Annie placed the children in two lines facing Harriet. Even baby Jesse stood in line with the help of May.

"Harriet, the children have a birthday gift for you. They have prepared a Scottish folk song for you." Annie gave the pitch and the children began.

"Oh, I wish I was in the land of cotton, old times there . . ." Harriet stood and clapped her hands.

"Yes children, sing, sing, sing!" She joined them as they finished the song. "Thank you ever so much. What a wonderful gift and a lovely party. Now, who would like some cobbler?"

Harriet Virginia Maxwell Overton was thirty-three years old.

## 29. A New Beginning

By early February 1865, the regular mail was reestablished in Nashville. Harriet received a large stack of newspapers, magazines, and a few letters. Several of the magazines predated the Battle of Nashville. She sorted the delivery, with Annie's help, making stacks for the various categories. They sorted quickly, hoping to find an envelope from John or Thomas. Harriet sighed and began to cry.

"Where is my John? Where is he!" Annie scooted her chair next to Harriet and gave her a hug.

"Do you remember Father telling us, 'no news is good news'?" Harriet nodded and dried her eyes. "I guess that applies to us now." No sooner had she spoken than she spotted an envelope on the table. Printed in large letters was OFFICAL BUSINESS, USA. The envelope was addressed to MRS. THOMAS (ANNIE) CLAIBORNE. TRAVELLERS REST. NASHVILLE, TENNESSEE. She gasped and looked at Harriet. Harriet saw fear in Annie's eyes.

"Open the letter!" The two sisters interlocked their arms.

> *I have been captured. I am not hurt and am in good health.*
> *Our friend, W.E., is sending this message through the lines.*
> *All my love to you dearest. T.C.*

Annie flipped the envelope over in her hand, looking for any clue to where Thomas might be. She found nothing. She knew he had written the brief note. *At least*, she thought, *I know he is safe and he is in contact with William—wonderful friend William.*

"Annie, can you share the information with your daughters?"

"Yes, at an appropriate time, I think. I need to go give them a hug."

Harriet spread out the back issues of the *Weekly* until she found the issue reporting on the Battle of Nashville. She settled in her chair and put on her reading glasses. The front page had a line drawing of the Capitol building and the headline under it stated, **Federal Troops Defend Nashville**. *The battle never got that far. The Capitol building was never in danger. They should have a drawing of my home with all the damage.* The report was divided into three parts: The First Day, The Second Day, and The Aftermath. She was surprised to read that 22,000 Confederate troops were outnumbered by 66,000 Union soldiers. *That's three-to-one. No wonder our boys had such a difficult time. That wasn't a fair fight.* She skimmed over the accounts of the redoubts falling to the Yankees.

The first line of The Second Day captured her full attention. "General Hood reset his line overnight with his right flank on Overton Hill (also known as Peach Orchard Hill) and the left on Compton Hill." *Well, what do you think of that? Overton Hill is a part of history.* As she continued she was certain

there would be some mention of Travellers Rest, but there was none. She was disappointed.

She learned toward the end of the article that General Hood had resigned, and many of the soldiers in the Army of Tennessee had gone to fight under General Johnston in North Carolina. *Maybe that's why I've not heard from John. He has no way to contact me. Oh, Lord, take care of my John and his son.*

An image of Abraham Lincoln caught Harriet's eye. It filled nearly the entire page of the November 1864 issue of the *Weekly*. The cut line under the image read "photograph taken by Mathew Brady." She studied the image of Lincoln and wondered, *What is he thinking? He looks tired. Does he know what his soldiers did to my home?* She turned the page and immediately spotted a photograph of Andrew Johnson. That was her clue not to read about Lincoln's second term as President. *Anyone dumb enough to pick a traitor like Johnson as a running mate couldn't be too smart.*

She tossed the *Weekly* on the table, wrapped her shawl around her shoulders, and went to the cellar to find Cynthia. For some reason Cynthia had emerged as a spokesperson for the black workers. Archer had attained that role as well. When Harriet needed information about the mood of the workers, she talked to Archer or Cynthia. Since Mr. Gray, the plantation overseer, had left rather abruptly, Harriet had taken on his duties with the workers.

"Cynthia, do you have a few minutes to talk to me?" Cynthia wiped her hands on her apron and smiled.

"Do dis be a standin' talk or a sittin' talk?"

"Why don't we sit over at the table?"

"Would ya likes some herb tea while we talks?"

"Yes. Cynthia, I'm not going to rebuild the kitchen until Mr. Overton comes home from the war."

"Dat be fine. Now dat da others gone ta da cabins, dis place works fine."

"How are the workers doing?"

"Dey be mighty thankful ta ya fer lettin' dem stays here in da cellar durin' da fightin'."

"That was a couple of frightening days for all of us."

"Dere's one mo thing. We thanks ya fer da food supplies. Ya could have keeps all da food fer ya family, but ya treats us in a Christian way. Ya a good person, Miz Harriet." Harriet felt her face flush. She didn't want to appear embarrassed.

"Cynthia, did any of the workers leave after the battle? Did any of them go to the contraband camps in the city?"

"Na, ma'am, Archer talks ta dem 'bout workin' here on da plantation."

"Good. It's going to be planting season soon. I fear it's going to be a hard year in the fields. I'm certain there must be dead animals, broken wagons, and loads of cannonballs in our fields. The fences will need to be mended. I would

not be surprised to find some dead bodies, or what's left of them, in our fields."

"Oh, Miz Harriet! Does ya really thinks dere's dead bodies in da fields?"

"Let's keep that as our little secret." Cynthia nodded and covered her face with her apron. Harriet patted her trusted cook on the arm and went back upstairs. She spotted Archer and Claiborne looking at the brickwork on the west side of the house.

"I hope the house will hold together until Mr. Overton comes home." Archer and Claiborne removed their hats and held them in their hands.

"Yes, ma'am," Archer responded, "the house is solid."

"You should know if anyone does. You helped build it back in '28. In fact, you helped make the bricks, isn't that correct?"

"Yes, ma'am, I was just a lad."

"Archer, I need the labor costs for this reconstruction."

"There are none, ma'am. This is our gift to you."

"Nonsense, the Book says, 'A workman is worth his hire.' I'll tell you what. When Mr. Overton comes home from the war, he will settle with you."

"Yes, ma'am."

"By the way, Archer, can you get to the seed store in the city?"

"Yes, ma'am. We blacks can go pretty much where we want to go these days."

"Good. I need for you and Claiborne to pick up our seed in the next week or so. While you're there, ask whether they have any peach and apple tree saplings. If they do, get some. I'd like to surprise Mr. Overton when he comes home." Harriet realized as she spoke the last sentence, *I've said four or five times, "when Mr. Overton comes home" in the last fifteen minutes. My mind is preoccupied with him coming home. Could he be on his way?* Little did she know, but would learn later, on that very day her precious John was on his way to Louisville, Kentucky to take the oath of allegiance.

On Thursday afternoon, February 16, a wire message was delivered to Travellers Rest. The delivery boy knocked on the front door. When it opened, he faced a grim-faced Harriet.

"I have a wire for Mrs. John Overton. Is she here?"

"Yes, young man, I'm Mrs. John Overton."

"Please sign your name on this sheet," as he handed her the sheet and a pencil.

"Thank you, ma'am." Harriet pushed the door shut and looked down at the sealed envelope. She quickly pulled the door open. The delivery boy was adjusting his weight in the saddle.

"Young man. Wait!" Harriet went to her bedchamber, found a coin, and walked outside. "I forgot my manners." She handed him the coin.

"Thank you, ma'am." He tipped his hat and rode off.

Back inside, Harriet held the envelope with both hands. A feeling of fear came over her as she stared at the envelope. *Oh Lord, I ask that this message*

*be good news. If it is not, give me the grace and courage to handle it.* Harriet faced her fear and read:

> LOUISVILLE, KENTUCKY
> FEBRUARY 15, 1865
>
> DEAREST HARRIET. TODAY I TOOK THE OATH. I AM
> COMING HOME. LOVE. JOHN

Harriet held the wire to her heart. For a second, she felt faint. She sat in a chair and reread the wire slowly, "I am coming home." Tears of joy flooded her eyes. She searched for a handkerchief in her dress pocket. She read the wonderful news again. She bowed her head and slowly mouthed a prayer. *My dear God, your kindness toward me and my family is greatly appreciated. You have answered my prayers and I thank you. Amen.* As she remained silent for several minutes, the thought struck her, *How can I share this wonderful news with Annie while Thomas is a prisoner? How will she feel? What do I tell my children?*

Harriet walked through the house until she found Mary in the family dining room, sitting next to the window, thumbing through a magazine. She looked up when Harriet entered the room.

"I should write an article for this magazine."

"Yes, you have the ability. What would you write about?"

"I'll need to give that some thought. What have you been doing this morning?"

"Mary, I have some wonderful news to share with you. Then I need your advice."

"What's your good news?"

"John is coming home soon!" Mary stood up, grabbed Harriet, and they began to dance around the room. They were both laughing when Annie walked in.

"Why are the two of you so happy?"

Without hesitation Mary blurted out, "John is coming home soon!"

Harriet looked squarely into Annie's face. For a few seconds Annie's expression froze; then she began to shout, "John's coming home! John's coming home! Praise the Lord, he's coming home!" She joined her sisters in a dance of joy.

"Oh, Harriet, that is wonderful news! How did you find out?"

"John sent a wire message from Louisville, Kentucky." Harriet handed the wire to Annie.

"He's taken the oath and he's coming home." Annie held the wire over her head and the sisters continued to dance. They were breathless when they plopped in chairs facing each other.

"Harriet," Mary questioned, "what advice do you want from me?"

"I already have my answer; you are very wise."

Mary looked confused as she stood. "All this jumping has made me need the necessary. Excuse me."

"Annie," Harriet spoke softly, "I did not know how to share my good news with you. I was concerned. Your news about Thomas . . ."

"Army life has taught me to be happy for any good news. The fact I know Thomas is alive and well is good news for me. I am so happy for you and the children. It will be wonderful having John home." The two sisters held each other without saying a word.

At bedtime that evening, Harriet gathered her children around her in the room Martha shared with her Aunt Mary.

"I have some wonderful news! We have been praying together for a long time about your father. God has answered our prayers." She held up the wire and then handed it to Martha.

"Martha, please read this."

"Oh my, Mother! Father is coming home!" Harriet and her five children hugged each other. She took Mary, Elizabeth, and Jesse to their room, put them in bed, and kissed them good night. Jesse was not sure why everyone was so happy, but he enjoyed the happy feeling. Harriet returned to Martha's room and said good night. She walked down the stairs and met May on the landing.

"Do we know exactly when Father is coming home?"

"Today is Thursday. I would think by next Monday or Tuesday he will be here."

That night as eyes closed and before sleep came, visions of John Overton coming home captured thoughts throughout the house. All, that is, except Jesse. He went to sleep thinking about how happy everyone was and not really knowing why.

February 20, 1865 was a day when people were born and people died. The sun in the sky that day shone on the just and the unjust alike. At Travellers Rest, it was the day for a family to be reunited. It was a day of joy, tears, hugs, and celebration—John Overton was home from the war.

May had positioned himself on the stack of bricks behind the house. From his vantage point, he could see all the paths his father could take to reach the house. For two days, he visited his post, casting his vision in several directions. Harriet wasn't too keen on his being out in the cold weather, but she trusted his judgment. *He will know,* she thought as they talked, *when he's cold and when he's not. I have counted on his help these past years; I will count on him now.* He was nine years old and amazed Harriet, at times, with his maturity.

Eager to share the good news with his family, May's diligence was rewarded. He had spotted a six-man patrol riding south on Franklin Pike. The blue of their heavy coats was broken by a rider wearing gray. The patrol stopped, turned around, and rode away back toward the city. The rider in gray

watched for a moment, then turned his horse in May's direction. He watched with high expectation as the rider meandered around broken fences and partially burned military wagons. He was coming up the shortcut. May ran to the house.

"Mother! Mother, it's him! I think Father is coming." Harriet followed May, who had run ahead, to the brick pile. In a few moments, John Overton appeared in full view. He was leading his horse. He was wearing an unmarked officer's winter coat with high leather boots spattered with mud. John stopped to catch his breath in full view, now, of his homecoming committee. He doffed his hat, revealing his full head of white hair to match his beard.

"Happy birthday, son. I'm sorry to be late." May ran to his father and they hugged. Both were crying. John handed the reins to May and placed his floppy hat on his son's head. Harriet's outstretched arms welcomed her hero back home. The three of them walked toward the house. When they turned the corner and were in full view of the gallery, a cheer went up led by Martha. "Father's home! Father's home!" The chorus brought a wide smile to John's tired face. He greeted each of his children with hugs and kisses. He picked Jesse up and held him tight until Jesse began to cry. Harriet rescued her youngest into her arms.

"He doesn't know you, John. You'll need to give him some time to connect with you." They walked into the family dining room where the other house residents were waiting to greet John. Cynthia brought in a tray of cookies and a pitcher of milk for the children.

"Welcome home, Mr. Overton." Harriet noted the greeting and watched John's face for a reaction. Cynthia had adjusted to her freedom. Harriet was hopeful John had done the same.

"Thank you, Cynthia. It's good to be home." His response was encouraging. Harriet had never heard him say "thank you" to a black person. She was pleased. The family celebrated for nearly an hour, and finally, Annie felt it was time for Harriet and John to have some time together.

"Why don't we go about our usual activities? We can visit as a family at dinner." Harriet flashed an approving smile in Annie's direction. After everyone left, Harriet and John sat at the table alone.

"John, it's so good to have you home."

"I'm so happy to be home. Do you have any word from John or Thomas?"

"Annie received a brief note indicating Thomas had been captured. We have no idea where he is. The one good bit of news we do have is that William Elliot has been in touch with him."

"William Elliot?"

"Yankee! He and Thomas were fellow officers in Texas. William came and stayed in the house after the second day of battle last December."

"Was he the best man at Thomas and Annie's wedding?"

"Yes, he was. I was about to remind you of that fact. A week after the battle, he sent us a wagon filled with food supplies."

"How was the battle? I understand from reports that it was very close to our home." Harriet wanted to change the subject. She didn't want the condition of the house to be a shock. "I noticed the kitchen is gone and there is damage to the west side of the house." *He's already noticed the damage, so I might just as well tell him the whole story.*

"Let's go outside and walk around the house."

John saw the damage and sighed. "And Harriet, what about you and the children? Where were all of you during the shelling?"

"Annie and I put the children in the cellar below our bedchamber. White and Mary Claire stayed with them. The black workers were also in the cellar. Annie, Mary, and I stayed upstairs. Frequently, Annie and I checked on the children. We locked all the doors but forgot to close the shutters. Annie had her shotgun, and I had my pistol at the ready nearly all day on the sixteenth."

"And I presume you were in charge." John laughed as he spoke.

"This is our home. No Bluebelly was getting in without a fight. We heard the doorknob turn and the doors rattle a couple of times. There were heavy footsteps on the gallery. We think we heard a Yankee out near the garden. There are some bloodstains on some of the steps to the workers' cabins."

"Harriet, you have so much courage. I am so proud of you. I will never be able to repay you for keeping our family safe."

"Our children are fighters. They are strong. After all, they have Overton and Maxwell blood running through their veins. It would take more than a silly war to get them down." Harriet smiled up at John and held tightly to his arm.

"What about the upstairs? Is there damage up there as well?"

"The windows in the upper parlor are gone, and a lot of bricks were knocked out. Archer and some of his helpers repositioned the bricks and boarded up the windows. Enough has been done to keep the rain and cold wind out. I had no idea how to replace the windows. That's your responsibility. You need also to think about the kitchen. Cynthia told me the cellar kitchen will do for a while."

"It looks like you had your hands full with the family and the house."

"And don't forget the Yankees!"

"Have you heard from John and Elizabeth and their boys?"

"Not a word. I've been afraid to stray too far from the house. There are still Yankee patrols in the area but not as many as before the battle. John, how were you and Eli able to ride through the Yankee lines around the city? By the way, where is Eli? Did he come back with you?"

"No, Eli is on his way to Virginia. When we left Louisville, I gave him his freedom. He knew about the Emancipation. He talked about being a free man. So I gave him his horse, some money, and directions to Louisa County."

"He's been with you for so many years."

"My father bought him for me before I went to New Orleans. Both of us were just boys. I think he was three or four years older than I."

"You know you didn't have to do it—I mean, set him free. The Emancipation was not meant for Tennessee."

"But Andrew Johnson was enforcing it nonetheless. It's coming anyway."

"Yes, that's why I went ahead and gave all our slaves their freedom early. That way I had the opportunity to hire them back as workers. I believe it was a wise decision."

"I agree. You did a wise thing at the right time."

"Now, how were you able to ride through the Yankee lines?" John put his hand in his inside coat pocket and handed Harriet a folded sheet of paper.

"This is a copy of the oath I signed. I had signed one in Memphis, but there was some mix up. So the next closest place for me to go was Louisville." Harriet put her reading glasses on, glanced down the paper, and recognized John's signature. She read in silence without changing the expression on her face.

> I do solemnly swear that I will support, protect and defend the Constitution and Government of the United States against all enemies, whether domestic or foreign, and that I will bear true faith, allegiance and loyalty to the same, any laws, ordinances, resolution or convention to the contrary notwithstanding; and further, that I do this with a full determination, pledge and purpose without any mental reservation or evasion whatsoever; and further, that I will well and faithfully perform all the duties which may be required of me by law. So help me God.

Harriet folded the sheet and handed it back to John.

"How do you feel about signing the oath?"

"This one is much more palatable than the one I signed in Memphis. That one had the phrase, 'the Rebellious League known as the Confederate States of America.' I didn't even request a copy."

"Why did you sign it?" Harriet's eyes narrowed and her voice was demanding.

"It was the only way I could recover our property in Memphis." John realized it was time to change the subject. He knew Harriet was not pleased. "Is Andrew Johnson still in the city?"

"No! That traitor has gone to Washington to become Vice President. He has been a nemesis to every loyal Tennessean. He left us with a Unionist governor, William Brownlow. We may never recover." John was trying to find a subject that did not upset Harriet.

"Have you talked to anyone who's been to our hotel?"

"No, but if the Yankees treated it like they have the churches in the city, expect the worst. I think the only building or private home the Yankees did not confiscate was Mrs. Polk's."

"Harriet, maybe we should go inside." John put the oath back in his pocket. "Anytime I leave the plantation, ask me whether I have my oath. Attorney Waddell told me I would be safe as long as I have it with me."

"Who is Waddell?"

"He's the attorney I hired in Memphis to help me with the oath and the property. He's a good man." As they came near the back steps, John remarked, "Did all these cannonballs land on our lawn?"

"Yes, there are stacks of them all around the house."

"Do you plan to leave them where they are?"

"Most certainly. One of these days, I'll find a use for them. One thing for sure, the Yankees will never fire these at me again." John shook his head and laughed as he opened the door for Harriet.

On March 4, Abraham Lincoln was sworn in for a second term as President. Harriet read his speech in the *Weekly*. There was a photo showing the new Capitol building and those who gathered for the inaugural ceremony. She read the entire speech and gave extra thought to some of the phrases. *With malice toward none; with charity for all . . . to do all which may achieve a just, and a lasting peace, among ourselves, and with all nations.* Harriet placed the *Weekly* on the small table where she knew John would see it. It remained on the table, unmoved, for several days.

John played with the children on the gallery and in the yard. He carried Jesse in his arms until they both needed relief. Mary and Elizabeth tended to Jesse while their father rode horses with Martha and May. Harriet was pleased with the adjustment John was making to a slower pace of life but knew it would not last. He had mentioned three times in the last few days about needing to go into the city—to see about things. He was never specific, but Harriet knew he was restless. He needed a project.

Annie announced at dinner one evening, "With the coming of warmer weather, I'm ready to reopen the school. We have been out of school far too long."

"Who has to . . . ah . . . gets to go?" Harriet was pleased with May's apparent positive attitude for school. Annie was surprised but pleased with May's question.

"May, I sure could use your help. You will be the only male student with the five young ladies." Martha was itching to say something, and she did.

"Yes, May. Aunt Annie needs someone to sit in the dunce chair and you'll do just fine." May scooted his chair away from the table, stood up, and clenched his fists. He looked straight at his big sister. Although he was nine and Martha was 12, he was as tall as and weighed more than she did.

"Martha, Martha . . . you . . . you better . . ." The room became deathly silent. John cleared his throat, preparing to put a stop to May's actions. Harriet put her hand on John's arm and shook her head. She was anxious to see how May handled the situation.

"May, do you have something to say to me?"

May took time to compose himself and then responded, "I don't like what you just said." He sat down. "And another thing, 'A soft answer turneth away

wrath.'" Away from the confrontation, at the other end of the table, Aunt Mary added, "but grievous words stir up anger—Proverbs 15:1."

"Well, I believe," Harriet used her calming voice, "we've had our devotions for the evening. Children, you are excused from the table." Harriet looked over at May. When he glanced at her, she smiled approvingly at him. The adults remained at the table.

"It appears," John put his napkin on his plate, "I have a lot to catch up on with the children."

"You are doing fine. I just wanted May to stand his ground. Martha is too bossy."

"Where does he get his ability to control his anger? He doesn't get it from me."

"Our blessed mother," Annie added, "had that gift."

"John," Harriet patted his hand, "tomorrow, if the weather is suitable, I'd like to ride into the city. Would you take me?" She knew the answer, but she posed the question anyway.

The next morning after breakfast, Claiborne pulled the buckboard up by the house and waited for John and Harriet to appear.

"Claiborne, I'll be driving today." John walked to the buckboard. Harriet was still in the house giving last minute instructions to Martha and May.

"Is ya sure? I's be happy ta drive." Harriet was surprised to find John in the seat and Claiborne walking away.

"Isn't Claiborne driving us?"

"No, I'm driving."

"Why?"

"For appearances. If we take the carriage with a black driver, some folk in the city might not understand. If we appear too prosperous, we'll create problems for ourselves."

"Am I overdressed for the visit to the city?"

"Did you wear your pearls?"

"No."

"You look fine. Are you ready to go?"

The trip down Franklin Pike was depressing. The trees that once lined the Pike were gone. The roadway was rutted from heavy wagon traffic. All the split-rail fences were gone and most of the rock fences were in disarray. Houses looked abandoned with no sign of life anywhere. At one point John had to pull the buckboard over to allow a patrol to pass. He tipped his hat; the officer responded in like manner. Harriet looked straight ahead with a locked frown on her face. As they approached the city limits, Harriet handed John her "pass through the lines" permit.

"What is this?" John couldn't hold on to the reins and unfold the paper.

"That's the permit signed by General Rosecrans."

"How did you get this?"

"I stomped my foot and he said, 'Yes, ma'am!'"

"No. Really, how did you get this permit?"

"A young officer was on the plantation for official business and he came to the house. It was after some of those Yankees had tried to burn down our barn. He wanted to know what he could do to help my situation. He arranged for me to get the pass."

"But the permit is signed by General Rosecrans. Generals don't sign permits."

"Apparently they do! You see his signature, right there. When I needed something from the city, I pulled out the permit and the guard passed me through the line. There should be a checkpoint just ahead." However, the checkpoint was no longer there, and they drove across Broad to Spring Street.

"I thought you would go by the depot and check on the train." Harriet was trying to remember the city as it was.

"No. I'd like to see the hotel and then go by the military headquarters."

"The headquarters is in the Cunningham House on High Street. Do you think General Thomas will see you?"

"I hope so. I have my oath with me. I'm no threat to the Union. I just want to complete the hotel and move on with life." John drove down Spring Street, passing the St. Cloud Hotel and their church. Harriet could see the hotel was in really bad condition even before it was in full view. She was hoping John would stop at their church and turn around. He was determined, however, to see the hotel. He gasped aloud as they pulled alongside the structure. He did not say a word—he didn't need to. Harriet felt a lump in her throat and her eyes moistened. John wiped tears from both eyes on the sleeve of his coat. He took a left turn on Cherry Street and stopped the buckboard. He looked up at the building and shook his head.

"Harriet, oh Harriet. My, my, my . . ." Three Yankee soldiers walked out of the hotel and waved. John waved back.

"Those are the only soldiers I've seen all morning."

"That's three too many! Damn Yankees!" There was a sharpness to Harriet's voice. She was visibly upset. She repositioned herself in her seat and stomped her foot against the floorboard.

"Maybe we should go check at headquarters."

"Whatever you want." As they retraced their route up Spring Street, Harriet felt in her dress pocket, hoping she had brought her pistol. *If one of these Yankees looks at me crossways, I may just shoot him. The very idea of them practically destroying our wonderful hotel.* John was normally a quiet person, but Harriet was concerned what the sight of the hotel would do to him. He didn't say another word until they stopped in front of the headquarters.

"Is this the house?"

"Yes. Do you want me to go inside with you?"

"Yes, you better. It may take a while to see the General." Once inside, the young soldier was different, but everything else looked as it had the last time

Harriet was here. She knew where the General would be if he was here. The soldier behind the desk looked at John and Harriet.

"Yes. May I help you?"

"We would like to see General Thomas." John had removed his hat revealing his white hair.

"Do you have an appointment?"

"We were not aware one was needed." There was a sharpness in Harriet's voice.

"Names?" He was preparing to write their response.

"Mr. and Mrs. John Overton." The soldier stopped writing.

"The John Overton of the Maxwell Hotel?"

"Yes, does that make a difference?" The soldier stood up and extended his hand.

"Sir, you don't know me but I know you. I came to Nashville back before the war in '61. I was fresh off my Pappy's farm in Alabama and needed a job. I came to the hotel and you put me to work. I'm real sorry about what's happened to that fine building." He continued to shake John's hand and finally let go.

"Now, Mr. and Mrs. Overton, why do you need to see the General?" John looked at Harriet, hoping she would have a reason in mind.

"Oh, never mind. I'll just put down 'Private.' If you will have a seat, I'll check with the General and be right back." Harriet thought, as she looked around the room, *I probably would not shoot that Yankee. However, he is an Alabama man in a Bluebelly uniform.*

"The General needs about a quarter of an hour to finish a report and then he can talk with you."

"That will be fine. We'll wait right here."

"Mr. Overton, I'm required to check. Do you have a gun or a knife on your person?"

"No."

Harriet did another quick check in her dress pocket and was ready to answer, but the question never came. The soldier left and went upstairs, returning a few minutes later with a large envelope. He walked past John and Harriet and delivered the envelope to the General's office. At the precise time suggested, an officer appeared in the hallway leading to the General's office.

"Mr. and Mrs. Overton, the General will see you now." Three rifle-bearing soldiers sat in chairs just outside the General's office. John and Harriet followed the officer.

"Sir, this is Mr. and Mrs. John Overton." John noticed immediately the contents of the large envelope spread on the General's desk. General Thomas extended his hand toward John.

"Welcome to headquarters. How may I help you?" Harriet had some ideas she didn't voice. John handed the General his signed oath. The General glanced down the page and placed it on his desk.

"I'm sorry about the mixup in Memphis with your oath. It was not good that you had to go all the way to Louisville for another oath." General Thomas detected the surprise on John's face. "Mr. Overton, we are having difficulty with these oaths, getting them uniform and all."

"I understand."

"Mrs. Overton," the General looked straight at Harriet, "I rode by your home the morning after the battle. I deeply apologize for the damage to your beautiful home. Destruction of private homes is one of the tragedies of war." Harriet smiled and nodded to acknowledge the words, but thought, *If you had come inside my home, you would have seen my battle flag.*

"I read in his report that General Elliot stopped and spent the evening on the sixteenth."

"He did. Our family appreciated his kindness." *And did his report say that he slept soundly in the bed of General John Bell Hood?*

"Both of you come from very interesting families. The Overton and Maxwell families played historic roles in the Nashville area. Mr. Overton, do you remember meeting President Andrew Jackson and President Polk?"

"Oh, yes. They were both fine southern gentlemen. And don't forget Sam Houston."

"Tell me about the Maxwell Hotel. By the way, after the war, you need to apply for reparations to cover the damage done to the hotel. The United States government will pay for the damages it caused." Harriet wanted to shout for all to hear, *What about the damages to my home? Will the United States government pay for those?* but she held her peace.

"I will have my lawyer look into the matter."

"Now, what is the purpose for your visit today?"

"I would like to move freely about the city. Will my oath allow me to do that?"

"Yes, sir. That's its purpose. If it will put your mind at ease, let me put my signature on the document." He signed it and handed it back to John.

"Is there anything else?"

"No, General, I just needed the information from you." John stood and Harriet followed. He extended his hand to the General. They shook hands as gentlemen.

"Mr. Overton, I'm sure there are men like you who are supporting the Union troops. There's a note in your file stating, 'He has placed himself and his fortune at the disposal of the Cause.' Is that true?" Harriet glanced down at the papers on the General's desk.

"Yes, General. That is a true statement. In addition, my oldest son is a Confederate officer."

"Yes, I believe he served with Rucker's Brigade." John could not hide his surprise. His mouth dropped open.

"How . . .?" John was so shaken he could not finish the sentence.

"There's a note that you wrote here in your file. It's the note you sent to Rucker about your son John."

"General Thomas," Harriet inquired, "what other information do you have in my husband's file?" The General stepped behind his desk and shuffled the papers from the envelope.

"Mrs. Overton, I'm not at liberty to divulge everything in the file. Maybe I've said too much already." He held up a page and glanced at its contents. "You have a gun permit and a line pass in and out of the city authorized by General Rosecrans. He was very impressed with your demeanor."

"The officers I've met in this office have been very kind to me under the circumstances."

"Thank you for that good word. I will make a note of our conversation and place it in your folder."

"General Thomas," Harriet continued, "is there a file on every person in the Nashville community?"

"Only if there is an incident worth noting, having to do with military or state government matters."

"And sir, are you at liberty to say what prompted the Overton file?" The General turned the envelope over to check the first entry.

"It looks like Andrew Johnson issued an arrest warrant for Mr. Overton in March of '62."

"General," John said with interest, "is the arrest warrant still in effect?"

"No, your oath statement makes the warrant void. Just in case, I'll make a notation in the file that the warrant is not valid. I hope you will come back for a visit again."

"Thank you again, General Thomas." John spoke as he escorted Harriet out of the office. John waved at his former hotel employee behind the desk as he left the building.

"Mr. and Mrs. Overton, it was good to see you."

"When this war is over, come see me. I'll have a job for you at the hotel." Harriet took John's offer as a clue he was thinking of finishing it. She was pleased.

As John headed the buckboard in the direction of Spring Street, he turned to Harriet. " I have two stops to make before heading home. I want to check at the Public Square for replacement windows for our home and then go to the City Hotel for a late lunch."

"That will be fine." Harriet now knew John was looking for a project. She smiled and locked her arm around his and squeezed.

The black workers had been in the fields for nearly a month, clearing the debris left from the battle in December. The rock fences were repaired to some degree. There were no trees to fell for making rails. Both sides of the conflict left broken wagons and cannon wheels. Dead animals had been buried in ditches. The workers shied away from any man-sized mounds of dirt for fear

of finding a corpse. John inspected the seed and pointed out to the workers where to plant.

In early April he met with Archer to discuss the repair on the house.

"I've ordered replacement windows for the west side of the house."

"Yes, sir."

"Can you and your crew put this house back together, or do I need to find you some help?"

"We can make the repairs. The old bricks are stacked. We also have the bricks from the kitchen. There are some charred ones, but we can turn those around and no one will know."

"Very well. I'll let you know, as soon as I can, about the delivery of the windows."

"Mr. Overton, do you plan to rebuild the kitchen?"

"Not right away."

"Have you given any thought of putting a second story on the weaving house?"

"No, I haven't. Would it be very difficult to do?"

"We'd have to search on the property for the proper timbers."

"Archer, try to locate the timbers, estimate the cost, sketch out some plans, and then let's talk. How much time do you guess it would take?"

"That would depend, Mr. Overton. Just as soon as the planting is finished, I could put a crew together; that is, if they want to work. You know, some do and some don't. Freedom has not changed attitudes."

"I understand." John walked away and then turned back to Archer. "I'm planning on finishing the hotel in the city. Are you interested in working there?" Archer flashed a smile showing his perfect teeth.

"Yes, sir, I would count it a privilege." John could hear him whistling as he walked toward the cabins.

John Overton had been taught by his mother to keep the Sabbath holy. When he was a boy, activities were limited on the Sabbath and that training had carried over to his adult life. Since the churches had been closed due to the war, the Overton family and their guests sat on the gallery reading, writing, singing, talking, and sometimes napping in the fresh spring weather. That's the way it was on Sunday, April 9, until gunfire rang out.

"Harriet, get everyone inside. I'll walk down toward the Pike and find out what's happening."

"Do you need to take a gun?"

"No, I'll not get that close. I promise. I've learned how to stay away from gunfire." John walked to the highest point in what used to be the orchard. He could see three men on horseback and the smoke from their guns. One rider was in union blue; the other two appeared to be in farmer's clothes. John cupped his hands around his mouth.

"Sirs, what's happening down there?" The riders turned in John's direction.

"The war is over! A wire message came an hour ago. Bobby Lee has surrendered. The Confederacy is whipped!" John's hands dropped to his side. He turned and headed home. His feet became heavy. Each step he took became an effort. He felt sick to his stomach. His mind was flooded with scenes of dying soldiers. He wondered about his son John and Thomas Claiborne. As the ground leveled off, he stopped to catch his breath. He closed his eyes and bowed his head. *Almighty God, what has this war accomplished? Men are dead on both sides. Cities and homes have been destroyed. A generation has been lost forever. Families will never be reunited. What happens now?* John didn't close his prayer. He had more to say, but he just didn't have the strength. He wiped the tears from his eyes and continued his walk home. The side door was locked. He held the doorknob and shook the door.

"Who's at the door? Identify yourself."

"Harriet, it's me. Please unlock the door." When Harriet looked into his eyes, she was alarmed.

"What is it, John? What was the shooting all about?"

"The war is over. General Lee has surrendered." Harriet called the servant to take the children upstairs. She sent Annie to gather the adults on the gallery.

"What does the surrender mean? What will happen now?"

"Fighting will continue until the word gets to all the troops in both armies. The soldiers who know about the surrender will begin going home."

"John," Annie grabbed his arm, "do you think the prison camps will be opened and the men free to go?"

"That's how it should work, but I'm certain a release plan will need to be developed. I guess the federal government will decide how things are done now. I fear we, in the south, will be taking orders for a long time."

"What does that mean?" Harriet motioned for chairs to be pulled into a circle.

"The President and his cabinet will need to determine how the Union is to be reconstructed. The Confederate states will be told what they need to do to rejoin the Union."

"How long will that take?"

"I have no idea, but it's a new beginning for us. I'm sure the local newspapers will have all the information."

"I'll be anxious to get my copy of the *Weekly*."

The local newspapers arrived before the *Weekly* and covered the surrender, not missing a single detail. Appomattox was located on a crudely drawn map with arrows leading out of Petersburg. When the *Weekly* finally arrived, Harriet studied each photo and drawing of the event before she read a word. The photo of the McLean house had a caption under it, **Home Owner Moves Away from Manassas Battlefield and the War Follows Him.** Harriet thought, *How ironic is that? At least cannon fire didn't destroy his home.* The photo of General Robert E. Lee was worth keeping. Seeing him with his hat off did reveal what others had said about John. "Your husband is a larger

version of General Lee." Harriet had to smile and wondered whether her John was aware of the comparison.

Nashville newspapers all seemed to be biased in their reporting of the surrender. Harriet had little interest in reading about how gracious General U. S. Grant was to the Confederate army. She put the paper down when his name appeared in an article. The surrender announcement cast a pall over the entire household, with the exception of Annie. She took the gloomy news as a positive sign that Thomas would soon be released. At dinner, she quickly engaged John in conversation..

"John, is there any way you could find out where my husband is? Do you think General Thomas has a list of captured officers?"

"We could ride into the city and ask. Nothing ventured, nothing gained."

"I like to keep the children in school during weekdays. Do you think General Thomas would be in his office on Saturday?"

"If we miss him in his office, we can always leave a request. Now that the war is over, he may not be so protective of information."

"Harriet, do you have a problem with John taking me to the city to find out some information about Thomas?" Annie questioned.

"As long as you return him, I have no concern." Harriet laughed. John and Annie joined her.

The conversation was light and cheery as John and Annie rode down Franklin Pike. As they entered the city, the shrill voice of a child caught their attention. They saw the lad a block away but could not detect what he was yelling. When John turned the horse, right off of Spruce Street onto Spring, they heard the dreadful news. "Extra! Extra! Get your news here, President Lincoln shot and killed." John handed the child a coin and received two sheets. He brought the horse to a stop and read the brief account.

> President and Mrs. Lincoln were in their box at the Ford Theater on Friday evening last, enjoying the stage play, **Our American Cousin.**
> About 10:15 an assassin broke into the box and shot the President in the back of the head. He died this morning at 7:22 of the mortal wound.
> Full details in the Monday edition.

Annie gasped as she reread the brief report. John folded the paper and placed it in his coat pocket. He encouraged the horse to move again.

"We are so close to army headquarters, I suggest we make our visit and return to the plantation."

"You do what you think is best."

As they approached headquarters, the American flag had already been lowered to half mast. Two guards stood at attention at the top of the steps. John stopped the buckboard and was swinging his legs around to step down. He knew the click a gun made when it was being prepared to fire.

"Halt! Do not step down. Move along. The headquarters is closed. No one is allowed in. Move along." John understood the seriousness of the moment, turned the buckboard around, and headed for home.

"I'm sorry, Annie. We'll try another time. The Union soldiers still in the city may not be too open to us under the circumstances."

Harriet immersed herself totally in the national events surrounding the assassination of President Lincoln. She felt deeply for Mrs. Mary Lincoln and her family. The newspapers and the *Weekly* she read published the actual assassination and death but seemed to concentrate on the followup of the events. The local newspaper played up the fact that John Wilkes Booth had been in Nashville for a stage performance. The national news articles reported on the identification, capture, trial, and hanging of those involved in the assassination.

Scattered throughout the summer months of 1865 were emotional highs and lows for Harriet. She cried privately when she read of Jefferson Davis' capture. *How humiliating,* she thought as she read the report, *to be captured disguised as a woman.* She cried again, this time tears of joy, when Annie received a wire from Thomas. He was released from a military prison on June 6 and was coming home. She held John's hand the evening she announced to the family, the news she and John had known for weeks, that she was with child for the sixth time.

"Mother," Martha blurted, "when will the baby arrive?"

"The baby will be a special gift to the Overton family early in the new year."

"Mother," May had moved to stand next to Harriet, "may I help name the new Overton?"

"If it is a male, your father may need your help. If we have another female, I will let your sisters choose a name." Martha was surprised but pleased. She looked directly at May and stuck out her tongue.

Harriet gave her full attention to preparing her children for another sibling. Martha was past her twelfth birthday and had a keen interest in what was happening to her mother. Harriet took advantage of the opportunity to tell her oldest child about the baby process from start to finish. There were visits from neighbors and the Leas during the latter months of the year before the cold weather set in. Harriet stayed warm, rested, read, corresponded with the Brinkleys in Memphis, and waited for the New Year.

# 30. Post War Plans

The Ku Klux Klan was growing in the old Confederacy, the Freeman's Bureau was working with the emancipated slaves, the local newspaper ran an excerpt from a new writer named Mark Twain, and the Overton family welcomed a new son on January 15, 1866. Harriet was not at all surprised at the name chosen for the new addition by John with the help of May. The children gathered around their mother's bed while John held Robert Lee for the first time. May grinned from ear to ear. He was so excited. Martha forced a smile when her mother looked at her. Mary, Elizabeth, and Jesse just enjoyed the experience. Jesse, who was now two and a half, took his mother's hand.

"Now, I not the baby."

"That's right," Harriet ran her fingers through his hair, "now you are a big brother."

"Children," John ordered, "let's leave and give your mother and Robert Lee a chance to rest. We can see them later." John handed the baby to Martha.

"Mother, now there's three girls and three boys. Everything is all even. Are you going to have any more babies?" Harriet and Martha exchanged smiles.

"No, I think I'll let you have the next one." Martha did not respond.

Harriet's care of Robert Lee kept her from attending the wedding of her stepson, John. Captain John, as Harriet called him, married Matilda Watkins a few days after Robert Lee's birth. He and his bride moved to Memphis, where he became involved in the Overton real estate holdings. A good business sense was in his genes. He was successful in various ventures, including working in a brokerage firm and also promoting railroads.

Colonel Overton was busy in Nashville trying to get some answers. He was troubled when he returned from the city, and Harriet knew it from the solemn look on his face.

"What's troubling you, John?"

"I'm not getting any satisfactory answers to my questions. I put in a request for reparations on the hotel, just as General Thomas suggested. That was several weeks ago. Now they tell me my file has been sent to Washington. There's something about my file and my request being together. It's just a mess."

"How long has it been since you were in Virginia—Louisa County?"

"What does that have to do with the reparations?"

"On your way to Washington, you could stop in Virginia and visit some of your relatives."

"How did you know I was thinking of going to Washington?"

"Because the answers you need are in Washington. If you are going to finish your hotel, you need the answers. If the United States Government is not going to pay the reparations, you will need to find the money elsewhere."

"Well, I'll be danged! I should put an advertisement in the newspaper, *Come to Travellers Rest and have your mind read by H. V. M. O.* They both laughed at the suggestion.

Harriet prepared the children for their father's trip to Washington. She used the map in the family dining room to trace the route John would take. She gave Martha three stickpins, a thin strip of red ribbon, and instructed her where to place the pins. One went in Nashville, the second in a space just a little east of Charlottesville, and the final pin in Washington.

A week later Harriet received a wire from John which she read to the children at dinner.

> DEAR HARRIET AND CHILDREN. IN RICHMOND. CITY SLOW
> TO RECOVER FROM WAR. GOOD VISIT WITH OVERTONS.
> VISITED JOHN'S SCHOOL. GOING TO WASHINGTON
> TOMORROW. PRAY ALL GOES WELL.      LOVE TO ALL. J.O.

Harriet had a feeling about John's visit to Washington. *I doubt John will get a very good reception from President Andrew Johnson.* She was correct.

John reported on his meeting with the President when he returned home. "Johnson made me feel like a criminal. He told me I didn't deserve anything from the government."

"What did you say?"

"I held my peace. I extended my hand in friendship, but he did not respond. He called me a southern aristocrat and an Elitist. He pulled out of a file the note I'd sent to Rucker. He started to read it aloud. That's when I left."

"You just walked out of the room?"

"Harriet, it's hard to respect a person when he has done nothing to deserve it. He doesn't like me. He didn't like the Confederacy. His plans for reconstruction will wreck the economy." John noticed the gleam in Harriet's eyes and a mischievous smile on her face.

"Maybe he could make you a suit of clothes. I understand he's pretty handy with a needle and thread." John laughed aloud and hugged Harriet.

"The one thing I learned in Washington is that the city is too big for my liking."

"Did you find out any information on reparation funds for the hotel?"

"I got no satisfaction from meeting with Johnson. So I left a request in the Army Department and addressed it to General George Thomas. I'm hoping he'll remember our conversation and his suggestion."

"Does this mean you are going to wait on the funds to restore the hotel?"

"No, I've located enough funds to begin, and if any come in from the government, it will be a bonus. While I was in Washington, I noticed tall

columns on several of the buildings. How do you think the hotel would look with six or eight Corinthian columns at the entrance?" Harriet could tell by the smile on his face he had already made the decision, but she responded anyway.

"It would be a grand entrance for a wonderful hotel."

No bricks had been ordered, no wooden beams had been cut, but Harriet knew work was underway to restore the Maxwell Hotel. John had his project and Harriet had a contented husband. He hired a number of supervisors and they, in turn, hired laborers. Building materials began arriving, and the hotel project was underway. Some businessmen new to the city thought John Overton was foolish to attempt such a grand building. *How can such a large hotel,* they thought, *make a profit in this little southern city?*

Harriet remained involved in the hotel project by quizzing John about any progress. Each Sunday after worship at church, she had a visual update, as the family rode by the hotel. Seeing the size of the columns was a special surprise for her. John was anxious for her reaction and was not disappointed.

"John, you were so right. The columns are breathtaking. You made a very wise decision."

"We made a very wise decision, and we have lots more to make. Soon I'll have some samples of the room furnishings. I will need your opinion on those. After that, the samples of the furnishings for the dinning room will arrive. I can pick out the tables and chairs, but you need to choose the china, silver, and crystal."

"I will be delighted to help. You just let me know when I'm needed." The rest of the year was a time for making choices for the hotel and Harriet enjoyed her involvement. She needed time away from the responsibilities of the plantation, but more importantly, she needed time with John.

The year 1867 began with wonderful news for John and Harriet. A wire was delivered to the house from Memphis, stating that Matilda Watkins Overton had delivered her first child, Samuel Watkins Overton. Harriet told her friends, "Grandfather Overton is so proud. He had an announcement placed in our church bulletin. He acts like we are the only grandparents in Nashville." The day the news arrived, Harriet located her treasure box and found the piece of white ribbon Rachel Harding had given her from her wedding dress. In the quiet of her bedchamber, she thought about Rachel and wondered whether good news on earth was known in heaven. She hoped Rachel knew about their new grandson Samuel.

The Colonel was anxious to make a trip to Memphis to see their new grandson. Harriet prided herself in being perceptive when it came to her husband. At breakfast, a week or so after the announcement, she looked at John.

"Could you learn anything about the furnishings for our hotel by making a trip to Memphis? You could see what the hotels there are using. You could

also check on the Brinkleys, and you may even have time to visit Samuel Watkins," Harriet teased.

"Those are excellent ideas! I could be there and back in a week's time. Would you like to go?"

"Maybe another time. Martha would probably like to go with you. Aunt Mary will be here to help with the children. We will be just fine if Martha wants to go."

Martha, however, did not want to go and was clear in her decision. She was enjoying her time at Robertson Academy and did not want anything to interrupt that experience.

The windows arrived for the plantation house by early spring and Archer and his crew went to work making the repairs. Harriet watched, with interest, the work being done but did not notice the additional work under construction.

"The house is beginning to look like its old self again." Harriet watched as the bricks were placed around the new windows.

"Yes, ma'am. The work is going fine." Archer had an extra wide smile as he responded. The smile puzzled Harriet because this reaction was new for Archer. "All the work is fine." This time he cut his very expressive eyes to three men working on another project. Harriet followed the direction of his eyes and discovered a small structure being built in plain sight.

"What are those men working on, Archer?"

"Ma'am, I'm not at liberty to say. You'll need to ask the Colonel."

"What do you mean, 'not at liberty to say'?" He smiled again and went about his work. Harriet went inside the house perplexed at Archer's attitude. *Maybe Archer has forgotten he was once an Overton slave. The very idea of not answering me when I ask him a direct question.* Harriet did not allow her inquiry to fade away. That evening at dinner, she broached the subject with John.

"What is Archer's crew doing in addition to working on the house?" John knew from the tone of her voice she had discovered his surprise.

"Harriet, do you remember how many of your birthdays I missed while I was away?"

"Yes, but what does that have to do with my question?" John was smiling.

"During my travels, I noticed that many of the plantations south of us had a structure called a greenhouse. I thought it would be nice for you to have one. You can order seeds and start the plants early. You can have flowers year around. I know how much you like roses for the house. So happy birthday— late!"

"That is so thoughtful. I can have fresh flowers for the church, too. Having flowers reminds me of an article I read in the *Weekly*. Some ladies in Georgia and Mississippi take flowers to the graves of Confederate soldiers to pay tribute for their service to the Cause. Maybe the ladies of Nashville would like to consider a similar tribute. Goodness knows, we have lots of Confederate soldiers' graves. There must be hundreds in Mount Olivet alone. If the

government follows through with plans for a National Cemetery, that will be hundreds more. Don't you think we need a Confederate monument at Mount Olivet?"

"That would be a nice way of honoring our dead soldiers. Another thing someone needs to think about is a rest home for our soldiers as they get older and have no place to go."

"Sounds like some more projects for someone."

"Don't look at me that way. You know I'm involved with the hotel and that's enough for now. I will support you totally, wherever you want to be involved. I know you have a deep respect for the Confederate veterans. Do you think the ladies at church would take on some more projects?"

"John, that's a good idea. I'll ask some of my friends at church."

One late spring evening, John came home from inspecting the hotel with good news. He was eager to tell Harriet, but she was fuming when he arrived. She was waving the latest edition of the *Weekly*.

"Would you just look at what those nincompoops in Washington have done?" She was red in the face.

"Why are you so upset, Harriet?" She handed him the paper.

"The United States government has spent over seven million dollars to buy a place called A-las-ka. William Seward is out of his mind. Why doesn't the government use that money to rebuild the southern cities destroyed during the war? They spend that kind of money and then send you a piddling amount for nearly ruining your hotel." He led her over to a rocking chair.

"You need to calm down. I personally think it was a proper purchase. We bought the land for two cents an acre. The reports suggest there is a wealth of natural resources there that will provide for our growing nation."

"Well, you're entitled to your opinion. I still think it's outlandish!" Harriet handed John an envelope. He held it without looking inside.

"I have some good news. A while back, I told you I needed your help in selecting the furnishings for the hotel. The samples will be arriving next week." Harriet's mood changed completely. She dropped her paper on the table and gave John her full attention. "I have another bit of good news. The two Pullman cars I ordered for the railroad arrived today. The beds on the cars are actually long enough for my frame. Now you can travel on the rails while you sleep." Harriet realized John had come bearing good news, and she had nearly ruined it.

"I apologize for my bad attitude. I'm happy to hear the good news you brought. That envelope you're holding is an invitation to Adelicia Acklen's marriage." John sighed as he read the contents. *I hope Dr. William A. Cheatham knows what he's doing.*

"I guess you want to attend the wedding."

"John! Yes, we will attend. Keep June 18 free of other commitments. It will be the social event of the season. All of our friends will be there."

"That reminds me, I had lunch today with John Lea."

"How are they doing?"

"John is suffering. One of our mutual old friends came by the table and spoke to me but didn't even acknowledge John. After he left, I questioned John. He is being shunned by a number of his pre-war friends and associates."

"I'm not surprised. He never said so, but he sure did lean toward the Unionists in Nashville. I guess that's why he has not set foot in our home since the war."

"He is still my friend and my lawyer. It's time we put the past behind us and move on." She stood up and arched her back. John knew what was coming. She stomped the wood floor of the gallery, causing an echo off the brick wall.

"John Overton, you are the love of my life and I respect you fully in all aspects of life, except one. I will never put the past behind me! Those stacks of cannonballs, that flag hanging in the house, and our graveyards filled with Confederate dead will always remind me of my past. Sir, this matter is closed for discussion." Harriet turned and went into the house. John closed his eyes and shook his head. He knew not to raise that subject again.

Harriet was busy with all the routine activities on the plantation. She nurtured her children, keeping them healthy through the cholera scares that claimed the lives of so many Nashvillians. She worked with John on many decisions related to the furnishings for the hotel. Her new greenhouse occupied many hours of her time while the children were in school or busy with other activities. Days turned into weeks and weeks into years. Seasons came and went, but the flowers from the greenhouse remained a constant reminder of new growth and beauty. Harriet shared her flowers with family and friends. She beamed with pride on those occasions when her flowers decorated the gravesites of her beloved Confederate soldiers.

Early in 1868, the Overtons received two pieces of mail from Memphis. The first was from Ann Overton Brinkley telling of her engagement to Robert B. Snowden. As Harriet read the wonderful news, she envisioned Ann as a child running on the gallery of Travellers Rest. *Is she really old enough to be getting married? It seems only yesterday I was teaching her how to read.* Harriet handed the note to John.

"I plan for us to make a trip to Memphis for the wedding."

"When is the wedding?"

"May 5. The trip will also give us some time with our grandson Samuel."

"By all means, let's plan to go."

John had not yet opened the second letter which was addressed to him. He noticed on the envelope his title had been changed from Colonel John Overton to John Overton, Sr.. He recognized his son's handwriting as he unsealed the envelope.

"Well, that's interesting." He continued to read.

"What's interesting?"

"First, I have a new title. I'm now John Overton, Senior. Second, our son John wants to be addressed as John Overton, Junior."

"Well, that will be a lot easier. And your father will still be the Judge."

"John thinks it's best to move on and forget the military titles. Here's something else interesting. Jefferson Davis has bought a house in Memphis."

"I wondered where he would go after being released from prison last year. That's another reason to make a trip to Memphis. You can visit your friend."

"This might be a good family trip."

"Maybe we can take Martha. I doubt our other children would be interested in going."

"Maybe your sister Mary would like to go."

"I can ask, but she seems content staying here with the children."

Harriet looked forward to the trip to Memphis, and it was rewarding for her. Martha went to visit John Jr. and Matilda and spent time with Samuel. John went with his son to the home of Jefferson Davis, only to find him on a vacation trip south. John Sr. left his calling card and a note. He was hopeful that on a future trip he would have time to spend with the former Confederate president. Harriet was more productive with her time before the wedding. She spent a couple of hours in private with the bride-to-be.

"Aunt Harriet, I'm so glad you could come for my wedding."

"Ann, why don't you just call me Harriet?"

"But, but . . . ."

"I insist."

"Very well. Harriet, since you are the only mother figure I've had, I need some motherly advice."

"About what?"

"I need to know about my womanly responsibilities on my wedding night." The expression on Harriet's face was evidence she was not prepared for Ann's query. She took a moment to compose her thoughts.

"Ann, I will tell you what was told to me by my mother-in-law. No one can really prepare you for your wedding night. When the time comes, follow the lead of your husband, and try to find some enjoyment in the experience."

"And . . . and . . . that's all?"

"What happens will be a secret between you and your husband."

Ann made a beautiful bride. The ceremony was flawless and the reception was exquisite. Robert Brinkley spared no expense. Martha Overton took in every detail and stored the entire experience in her memory. She and Harriet talked about the wedding all the way home on the train and for weeks afterwards. Martha was fifteen years old and was quickly moving from being a little girl to becoming a beautiful young lady. Harriet made a mental note, *I must talk with John about a formal way to present Martha to society. Perhaps when the hotel opens we can find a suitable occasion.*

John had been disappointed that Jefferson Davis was out of town, but found great joy in visiting with John Jr. and his family. He was anxious for Harriet to hear about their son's plans.

"John told me he is thinking about getting into politics."

"Is this a good time for a venture like that?"

"Not now. He plans to wait until the Democrats regain control of Tennessee politics. He was eager to know all about our hotel. He wants to bring his family for a visit and be in Nashville when we have the grand opening."

"It will be lovely to have him and his family for a visit."

"He's been talking with some other businessmen in Memphis about building a grand hotel there."

"That's interesting. Robert Brinkley mentioned the same thing to me."

The trip to Memphis energized John and Harriet. John was ready to push the hotel project to completion. Harriet realized, after being with Ann, that her own children would quickly be coming of age. Although many matters of importance filled her life, she turned her focus on the socialization of her children. She looked for social events where Martha could be involved. She encouraged her in schoolwork. They spent long hours in the greenhouse talking about the future.

By the spring of 1869, the furnishings for the hotel began to arrive. John was excited to share the details with Harriet. She listened intently.

"John, I'm so pleased for you. Your dream is coming true." He handed her a stack of papers. "What is this?" She shuffled through the pages.

"That is the beginning of a guest list for the grand opening of the Maxwell House Hotel."

"Have you decided on a date?"

"This fall, before bad weather sets in." Harriet held up a sheet with a line drawing of the hotel.

"And this. What is this for?"

"That's for the newspaper article about the hotel."

"Don't you think it would be more impressive to have a photograph of the hotel?"

"Harriet, that's exactly why I brought that stack of pages home for you to see. Yes, a photograph would be better. That's an excellent idea. Read the description of the hotel on the next page and tell me what you think." She adjusted her glasses and continued reading.

> The Maxwell House Hotel will offer steam heat and gas lighting in each of its 240 guest rooms. The structure has five floors and a grand staircase leading to an elegant dining room.

"Is this all you plan to say about the hotel?"

"Do you have some suggestions?"

"The public needs to know about the Corinthian columns. They need to know about the main lobby and the amenities available, like the parlors, billiard rooms, shaving saloons . . . and what about the Men's Quarter? The ladies need to know about the bath facilities."

"You are correct, Harriet, as usual."

"I want people in Boston, New Orleans, Knoxville, Memphis, Charleston, Richmond, Philadelphia, and all around to know what a wonderful hotel you have built. I want people from all areas of the country to enjoy what you have created. John, you are way too modest. I want to read the article before it appears in print. When I read about the Maxwell House Hotel in the *Weekly*, I don't want anything left out."

"That's what I was hoping for. I'd like for you to look over the guest list soon."

"You know I will." And she did. She added Claiborne, Cynthia, and Grace Evans. John headed each of several pages with categories of folk to invite. Harriet suspected the categories, but had to smile when she noticed at the top of one of the pages the name," Friends of the Cause." Her eyes filled with tears as she read, "General Robert E. Lee, President Jefferson Davis, General John Bell Hood, General Nathan Bedford Forrest" and the remainder of the list of names filled the page. She was tempted to mark through the names of the Radical Republicans in Tennessee politics, but knew they, at least, needed to be invited. She wondered about the names she knew to be Unionist but remembered John saying, "It's time to move on." Most of the names she recognized but placed a question mark by some she didn't. She had planned to talk with John about the list but never saw it again after returning it to him.

The Sunday before the grand opening, John took Harriet, their children, and Mary Maxwell to the hotel for a visit. He had invited the Claibornes to attend, but illness prevented them from going. The walk from church to the hotel was only a block, but John chose to put everyone into the carriage and arrive at the hotel as though they were guests. While he unlocked the front door, Harriet pointed out and explained the Corinthian columns to the children. May nearly fell backwards trying to see the tops of the columns.

"Mother, how many columns are there?"

"You tell me. Count them."

"I counted eight." Martha was standing next to her mother and smiled at the challenge.

"Correct. Each child can have a column. Elizabeth, how many will be left?"

"Two. One for you and one for Father."

"Very good, Elizabeth. That's a good way to remember. Children, before we go inside, let's remember not to touch anything and listen to your father as he explains things." Martha moved ahead of the family and took her father's hand.

"I'm so happy this day has finally come. I'm so proud of you." John could only smile at his eldest daughter. He too, was happy and proud. His emotions were very near the surface; he had to fight back tears. The tour was rewarding for John. He heard the excitement in his children's voices as they climbed the grand staircase and went into a guest room. Harriet and Mary inspected a bathroom while the children followed their father. After the tour, John was helping the children back into the carriage, when six-year-old Jesse summed up the family's feelings, "Father, I think we should move into the hotel."

"I agree with Jesse," Harriet added, "when can we move in?"

The grand opening was all John had hoped for. Folk at all levels of Nashville society were duly impressed at what they saw and experienced. John and Harriet welcomed each guest. Harriet kept her promise to be polite to everyone regardless of her dislike of some who came. John seemed to know each guest by name. Harriet smiled and used a standard greeting, "Welcome to the Maxwell House. Enjoy yourself and do come again."

After the formal dinner, John made several comments about the construction history of the hotel and then introduced the three Maxwell sisters, telling about their pioneer ancestors in Nashville. The sisters—Annie, Mary, and Harriet—stood hand-in-hand and accepted the standing ovation from the guests. They were proud, but Harriet was the most proud, for she was both a Maxwell and an Overton.

For the next several years, the hotel became a hub of activities for the Overtons. Harriet used the hotel as a place to socially nurture her children. At dinners and other special occasions, she found a place for her maturing children. They were taught table manners, social graces, and properly introduced to society. Prominent Nashville families were invited to join the Overton table for Sunday dinner. Harriet was aware that lifelong connections could and would be made around good food and conversation. She did not hesitate to laud the virtues of her children, when she knew it would be for their benefit. She practiced with Martha and honed her own skills as each child moved up in rank. Harriet envisioned grand parties in the ballroom. *This is the place*, she thought, *for debutante parties, cotillions, the New Year's Day reception, the Jackson Day Ball, and other seasonal events.* Nashville would be ready to meet the Gilded Age.

John used the hotel setting for business conversations. The Men's Quarter proved to be a perfect place for sharing ideas and building business relationships. Many careers were launched in the Quarter, and politics were hotly debated on a routine basis.

By the early 1870s, the majority of the Tennessee General Assembly and Senate shifted back to the Democratic Party. Sounds of political celebration echoed throughout the hotel.

John introduced a tradition to Nashville that the Maxwell House was the place to be for Christmas dinner. The event was widely advertised and well

supported by the citizens of Nashville and the surrounding communities. Harriet was always excited with John's planning for the event.

"What's the featured food going to be this year?" John would smile. He was grateful for Harriet's interest.

"This year we are having Tennessee Opossum, Calf's Head, and Leg of Cumberland Black Bear. I invited Jack Daniel to be the host. I'm hoping he will bring some of his best Lynchburg whiskey."

"You will need plenty of whiskey if you expect the ladies to eat opossum!"

"I'm also introducing a special blend of coffee."

"I hope it's better than that concoction you had last year."

"I promise you, Harriet, this coffee blend is going to become famous."

Harriet had read, with interest, an article about the success of the Fisk Jubilee Singers on their European tour. They had performed in several countries, highlighted by singing for Queen Victoria of England. Impressed with their efforts, the Queen provided funds to create a floor-to-ceiling portrait of the original nine singers in the school's new building. *I'll bet*, she thought as she reflected, *a fund-raising event at the hotel would help Fisk. Maybe the Singers could give a concert at the hotel during the Christmas season. I'll need to mention it to John.* Harriet found time to be totally involved in John's projects and many of her own.

The same year the hotel opened, Harriet joined a group of ladies in the Nashville area to dedicate the Confederate Circle at the Mount Olivet Cemetery. She was proud to walk with the Ladies Memorial Society as they climbed the hill to the circle, carrying arms full of flowers from her greenhouse. As she passed the final resting place of John's parents, she paused and had a flashback of her mother-in-law Mary Overton. *How supportive,* she thought, *Mary was of me. She trusted me with Travellers Rest. What a wonderful lady! I love you, Mary Overton.* She walked fast to keep pace with the ladies of the Society. As she stood on the pathway intersecting the circle of graves, tears came to her eyes. She had always been thankful to God for watching over John, John Jr., and Thomas during the war, but now she felt a sense of guilt looking at the markers. *These men also had loved ones praying for their safety. They are here in this cold ground miles from their homes and loved ones. Someday there needs to be a statue in this circle to show to the world what these brave soldiers of the Confederacy did for the Cause.* Harriet felt a sense of oneness with this hallowed ground.

On the way home, in the carriage, she wiped away a tear just thinking about the morning's experience.

After dinner that evening, Harriet said, "John, I want you to promise me something."

"What's that, Harriet?"

"If I die before you, I want you to do some things for me. I want you to take the flag in the large room and wrap me in it. I want to be buried in it. And before you put me in the ground, I want you to drive my remains by the Confederate Circle one last time. If it's possible, bury me in a position so I can see the Circle."

"Why facing the Circle?"

"Because on resurrection morning, I want to be with friends."

"Harriet, are you serious?"

"Excuse the pun, but I'm dead serious!" John laughed as he shook his head.

"Consider it done. I will fulfill your wishes."

The next morning she wrote down on paper what she had told John and dated the page. When she was placing the page in her treasure box, she decided to review the list of JOHN OVERTON FAMILY EVENTS she had begun years ago and updated as events occurred. She sat down in her chair as she read the noted events:

> Judge John Overton died 1833
> John Overton II and Rachel Harding married 1841
> John Overton III born 1842
> Rachel Harding Overton died 1842
> Martha Maxwell died 1845
> John Overton II and Harriet Virginia Maxwell married 1850
> Martha Maxwell Overton born 1853
> Jesse Maxwell died 1856
> Jackson May Overton born 1856
> Mary McConnell Overton born 1858
> Elizabeth Lea Overton born 1860
> Mary McConnell White May Overton died 1862
> Jesse Maxwell Overton born 1863
> Robert Lee Overton born 1866
> John Overton III and Matilda Watkins married 1866
> Samuel Watkins Overton, first grandchild, born 1867
> John Overton, IV born 1869
> John Overton, Jr. elected to the HOUSE 38$^{TH}$ General Assembly of Tennessee ('73-75) from Shelby County 1873
> Lea Overton born 1875
> John Overton, Jr. elected to the SENATE 39$^{TH}$ General Assembly of Tennessee ('75-'77) from Shelby County 1875

As she read each line, flashbacks of faces and events flooded her mind. She enjoyed the moments from the past. Rather than putting the pages back in her treasure box, she found the Overton family Bible and placed them there. At dinner that evening, she told John and Martha about the pages in the Bible.

"Harriet, you may need to add another page." John was looking at Martha. She was looking down at her dinner plate.

"Why is that?"

"Well, one Jacob McGavock Dickinson came to the hotel yesterday and asked that he might visit us and talk about a very important matter—involving Martha."

"Martha!" There was excitement in Harriet's voice. "Is there anything your father and I should know before Jacob comes?"

"No," Martha answered. "I guess you and Father will just need to wait for Jacob to come."

"Well, John, what other news do you have?" Martha breathed a sigh of relief and continued eating her dinner.

John was a prophet of sorts about the additional pages to the JOHN OVERTON FAMILY EVENTS. In rather quick succession, Harriet recorded lines of events and added more pages.

> Jacob McGavock Dickinson and Martha McConnell Overton married 1876
> John Overton Dickinson born 1876
> Jackson May Overton and Nannie Hensley married 1877
> John Overton, Sr. elected to the HOUSE 40th General Assembly of Tennessee ('77-'79) from Davidson County 1877
> John Thompson and Mary Maxwell Overton married 1878
> Rachel Overton born 1878
> Hugh L. Craighead and Elizabeth Lea Overton married 1878
> Mary Hamilton Thompson born 1879
> John Overton born 1880
> Henry Dickinson born 1881
> Harriet Maxwell Thompson born 1881
> Harriet Overton born 1882
> Conn Overton Thompson born 1883
> Jennie Overton born 1883
> Nannie Hensley Overton born 1884
> John Thompson, Jr. born 1885
> Two-story addition to the north side completed 1885
> William Thompson Overton born 1886
> Overton Thompson born 1888

Harriet put the pen aside after making the last entry. She allowed the ink to dry before placing the page in the Bible. Her eyes scanned the several pages. She laughed as she thought, *Years from now, when someone reads this, they will surely think the Overtons were very prolific. Overton Thompson is the sixteenth grandchild in the family. Maybe I should record some of the other events in the family. No, I'll leave that task for someone else.*

John entered the room and found Harriet daydreaming and gazing out the window. He saw and recognized the pages on the table.

"Harriet, hello, Harriet." His voice brought her back to reality.

"Yes. I was just . . . ."

"Just keeping up with our growing family?"

"Do you realize, we have sixteen grandchildren, old fellow?"

"Sounds like the Overton rabbits to me!" She laughed aloud at his comment.

"John, really!"

"Have you ever thought of helping to start a church?"

"No, are you planning to start one?"

"I had lunch today with John Thompson and Dr. James McNeilly."

"Is Mary with child again?"

"No! I mean, I don't know. Dr McNeilly is the pastor of Moore Memorial Presbyterian in town."

"I know that, John. Dr. McNeilly was a chaplain in the Confederate Army at the Battle of Nashville."

"Anyway, they are talking about starting a church down on Douglas Avenue just a block or so off Franklin Pike. That's the end of the steam car line that begins downtown and goes out Eighth Avenue. A number of new homes are being built in the area."

"Is that close to where our boys have the stud farm?"

"Yes, exactly."

"And the Session wants to establish a new church in that area? Are they serious about that?"

"John and Mary have offered to buy the land for the future church. They are suggesting that it be named Glen Leven Presbyterian."

"How appropriate."

"Anyway, I would like to be involved, but I didn't make any commitments."

"Who would the Session place there as pastor?"

"I don't have an answer for that."

"John Overton, I know you. If you plan to be involved, you will be totally involved. So tell me what you're thinking about the church."

"I would want to support the church financially and provide leadership."

"I agree, under one condition."

"And what's that?"

"You will continue to take me to the hotel for Sunday dinner."

"It will be my pleasure. By the way, you'll be proud of me. I turned down a project."

"What was it?"

"Someone from the mayor's office asked me to have a part in the Tennessee Centennial Exposition."

"Is that the place out near the university where all the construction is going on? What did they want you to do?"

"They wanted me to host some of the out-of-town dignitaries."

"Like who?"

"They didn't say and I didn't ask. With my luck, it would be someone like Andrew Johnson! Anyway, I'm already busy with the hotel and working with the program committee at Mount Olivet for the presentation of the Confederate Monument."

"In my humble opinion, the Monument is the most important project. Is there a projected unveiling date yet?"

"Yes, May 16 of next year."

"John, do you realize it has taken twenty-four years after the war to erect the Monument?"

"That is a shame. So many of our faithful soldiers would have taken pleasure in seeing a monument in their honor."

John greeted the sun as it rose on May 16, 1889. He was in his nightclothes when Harriet found him on the gallery.

"John, you are going to do wonderfully at the dedication."

"I wish I didn't need to use these dang eyeglasses."

"If you expect to read your words at the dedication, you will need to use them. After all, you are fifty-eight years old."

After breakfast, the Overtons traveled to the Mount Olivet Cemetery. Harriet had cut a basketful of roses. A cemetery official directed the Overton's driver where to park the carriage. The gathered crowd was already huge. John and Harriet walked the short distance to the platform and VIP seating. Every few feet they were stopped and greeted by strangers who remembered kindnesses the Overtons had shown them during the war years and since that time. Finally, they found their seats. Harriet looked around at the sea of people who had come. She had hoped hundreds would come; thousands did. When John pointed to the statue, Harriet could not contain her emotions. Her tears flowed freely. She saw for the first time the forty-five-foot high, Vermont granite statue. The top was covered.

"Harriet, under that cover is the biggest Confederate soldier you'll ever see. He's nine feet tall." Harriet was impressed as she stood with the others and applauded, as the covering was removed. She placed both hands over her mouth in amazement. John stood on the platform and raised his hands to quiet the crowd. He placed his hat in the chair behind him, pulled several sheets of paper from his coat pocket, and addressed the thousands who gathered.

> Ladies and Gentlemen:
> For many years I have longed to witness the scenes we
> are now enacting, and I am profoundly thankful that I have
> not gone down to my grave before this tardy justice has
> been rendered to those valiant sons of Tennessee who
> joyfully sacrificed their lives "in the noblest cause that
> tongue or sword of mortal ever lost or gained."

Harriet was so proud. She was tempted to turn around and survey the crowd but kept her eyes glued on John. He stopped one time to wipe the

perspiration off his reading glasses. She smiled, remembering the scene on the gallery earlier in the day. He continued.

> Our sister Kentucky, whose soldiers charged in companionship
> with ours over many a bloody field, has sent one of her
> distinguished sons to proclaim her approbation of this event.
> We welcome him for his own renown, but give him thrice
> welcome for the sympathies which have prompted him to
> come and mingle with our humble offerings the tribute of
> his matchless eloquence to our beloved dead.
> I have the honor to present to you the orator of the day,
> The Honorable W. C. P. Breckinridge.

The unveiling was the talk of Nashville for months and even made the *Weekly*.

At one of those promised Sunday dinners a few months later, Harriet introduced John to Mrs. Caroline Meriweather Goodlett and Mrs. Kate Litton Hickman.

"John, these ladies are putting the finishing touches on legal papers for a new auxiliary."

"I'm delighted to meet you and have you at the Maxwell House. I trust everything is to your liking, Tell me about your auxiliary."

"We are calling it The Auxiliary Association of the Confederate Soldiers Home. We plan to raise money to maintain and support the Confederate Soldiers Home in Davidson County." John looked at Harriet.

"Are you a member of the auxiliary?"

"Yes."

"Ladies, I commend you for your benevolent efforts. When you need financial assistance for your work, I will be the first in line with a contribution. If you will excuse me, I need to attend to some hotel business. Harriet, I will meet you in the lobby shortly."

Harriet threw her full support behind the auxiliary. Her time, finances, and lovely flowers were offered to extol the achievements and welfare of the soldiers. Regardless of rank, each soldier was a Confederate hero to Harriet.

The Glen Leven Presbyterian church was organized on May 4, 1890. John Overton was named the first Elder. Harriet was so proud of him. Later in the evening, she added another grandchild and tragic death to her list:

> ➤ Joseph Hamilton Thompson born 1890
> ➤ Nannie Hensley Overton died 1890
> ➤ Elizabeth Belle Overton Lea died 1890

Dr. McNeilly was called to be the first pastor. He planned and directed the dedication of the new church building on April 5, 1891. John, Harriet, and a number of their extended family sat together as charter members of the new congregation. Dr. McNeilly was eloquent in his comments. "We are grateful to the Moore Memorial congregation who had the vision and provided

sponsorship. They also gave their pastor. First Presbyterian Church encouraged its members in this community to unite with this congregation. We owe a debt of gratitude to the families who purchased and gave the land and provided major financial aid for the construction of this place of worship." He did not mention names, but all eyes in the packed sanctuary turned toward the Thompsons and Overtons seated together. Harriet patted John's arm as they stood to sing.

At home she thought about adding the church dedication to her list of EVENTS, but didn't. Rather, she added two more personal events to her list:

> ➢ Jesse Maxwell Overton and Sarah Gladys Cheney Williams married 1891
> ➢ Jacob McGavock Dickinson born 1891

Harriet spent days of solitude working in her greenhouse. Occasionally one of her children would visit, bringing a grandchild or two for her to dote on. She treasured those times of sitting on the gallery, resting in her rocking chair, and reminiscing with old friends. Some days she was involved with the auxiliary. Sundays were spent at church and dinner at the hotel. When she didn't see her boys at church, she made a side trip off Franklin Pike to their horse farm. She didn't stay long. Seeing them for a few moments was always important. She kept a constant vigil on adding to the list of EVENTS:

> ➢ Robert Lee Overton and Nancy Baxter married 1892
> ➢ Elizabeth Thompson born 1892
> ➢ Edmond Baxter Overton born 1892
> ➢ Elizabeth Williams Overton born 1893
> ➢ John Hamilton Overton born 1894
> ➢ John Williams Overton born 1894

For years, Harriet watched her son May grieve for his wife. When Nannie passed in 1890, nothing seemed to console him. She had died too young, leaving May with three small children to rear—Rachel, John, and Harriet— who spent many hours with their grandmother. Harriet would watch the children at play and remember, *I know how they must be feeling. My sisters and I were in the same situation. These children need a place they can call home and put down some roots. John and I need to help May work through his feelings. He's much too young to carry such a heavy load.*

Harriet never turned away from hard situations. She was willing to confront matters to solve problems. Right now in her life, May's feelings were a problem. She considered carefully the approach she would take with him. She had counted on him for many things while John was away during the war. They had always been able to reason with each other. She would speak to him adult-to-adult. He did not need motherly advice; he needed sound reasoning.

Harriet looked at her watch and knew it was about time for May to come by and pick up his children. He parked his buckboard next to the steps, grabbed a leather pouch, and walked up the steps to the gallery. The children

were on the upper gallery playing when he arrived and scampered down the steps to greet him. Each time was the same—a happy reunion and a hug for each child.

"Did you bring us something?" Rachel spotted the pouch.

"No, this is for Grandmother. Would you like to give it to her?" Harriet appeared at the side door.

"May, when did you get here?"

"I just arrived."

"How has your day been at the farm?"

"I didn't go to the farm today. I was at the Maxwell and had lunch with Father. I stopped by the bank and then drove out here for the children. Mother, do you have some time to talk?" Rachel dropped the pouch and ran back up the steps to join John and Harriet.

"Thank you, Rachel." She was already out of sight.

"Father sent the pouch. He wanted you to know he will be late coming home this evening. He's handling some business at the hotel."

"As usual. You wanted to talk?"

"Father mentioned at lunch today that he's concerned about my mental health. He thinks I'm in a low mood."

"What do you think?"

"I miss Nannie so much." May began to cry. Harriet moved close to him and patted his hand. She did not say a word but waited. "Nannie was my whole world. I loved her the first day I met her. We were so happy together. Why did she have to die?"

"Son, that is a God-sized question." Mother and son were quiet for several minutes.

"Anyway, Father thinks it might be a good idea for the children and me to move here."

"You know we have plenty of room. You and the children could have all of the upstairs or the new addition. Your father and I seldom go up there. I would love for you to be here." Harriet was wondering, *Did John talk to me about this, or is he reading my thoughts again?* Harriet noticed a slight smile on May's face. She was encouraged. *Maybe,* she pondered, *moving here would be a good tonic for his heartbreak.*

May called to his children. "It's time to go home."

Harriet was smiling when May turned back to her. She kissed him on the cheek. "You can come home anytime you like, son. Travellers Rest will always be your home. Good-bye, children. It's always a delight to see you. Come again soon." Harriet stood on the steps and watched the buckboard fade out of sight.

She dumped the contents of the pouch on the table. She stacked several newspapers together and positioned the *Weekly* on top. Her interest in the *Weekly* had waned in the last few years. The publication had become too political for her liking. She spotted the tip of an envelope wedged in the

*Weekly.* Retrieving it, she discovered the exquisite handwriting of her friend, Caroline Goodlett. She admired the envelope for a moment and then broke the wax seal on the back.

> *Dear Harriet,*
> *I trust this brief note finds you in good health. My purpose*
> *in writing is to enlist your help. I have invited Anna Rains of*
> *Savannah, Georgia to be my guest at the Maxwell House for the*
> *purpose of finding a way of unifying all women's confederate*
> *organizations. I've had this dream for a couple of years. Please*
> *join us on September 9 upcoming. I have reserved space at the*
> *Frank Cheatham Bivouac building for a general meeting on*
> *September 10. I am, your admiring friend,*
>
> *Mrs. Michael (Caroline) Goodlett*

Harriet accepted the invitation and made a social call at the Goodlett home. She selected some of her very best roses as a gift.

"Harriet, do come in. I hope you like herb tea. I have a tray waiting in the parlor."

"These are for you." She handed Caroline the basket of roses and was pleased at her reaction.

"These are lovely. You are so kind. Are these from your famous greenhouse?"

"Yes. They were cut only a few hours ago." Caroline handed the basket to the maid with instructions to put the roses in a vase and bring them to the parlor.

"Thank you so much for accepting my invitation."

"I'm ready and willing to support any effort to honor our soldiers."

"Yes. Your reputation for supporting the Cause is widely known. That's why I wanted you to have a leading role in the unification."

Harriet discovered during the visit that Caroline and Anna Rains had been in correspondence for some time. The two had agreed to invite all interested ladies from all the Confederate states. Caroline handed Harriet a copy of the open invitation that would appear in every major city newspaper in the south and a similar invitation in the *Confederate Veteran*. Harriet was about to comment when Caroline spoke.

"Harriet, Anna and I would like for you to be the Temporary Chairman for the September 10th meeting." Harriet looked up from the papers she was holding. Her mouth was open, but no sound was coming out. Caroline was smiling when she poured tea and handed the cup and saucer to her guest.

"I know you will want to consider the offer. Just know, Anna and I are in agreement and believe you are the ideal person for the task. If you will take this responsibility, Anna and I can be objective during the meeting."

"Yes, it will be an honor to be the Temporary Chairman."

"Wonderful! Mrs. John Hickman has already agreed to be the Temporary Secretary. I believe we are on our way to an exciting adventure."

Harriet went directly to the Maxwell House Hotel to tell John the news. She called him out of a meeting with no apology for her action. He met her in the lobby. His facial expression was serious.

"Harriet, is there a problem? Is one of the grandchildren hurt?"

"No! I wanted you to be the first person to kiss the Temporary Chairman of a meeting being planned for all southern, Confederate ladies."

"What are you talking about?"

"Kiss me first." He responded with some gentle urging. "Caroline Goodlett and Anna Raines have asked me to be the Temporary Chairman of the September 10th meeting here in Nashville. We will be meeting at the Bivouac and I will be the Temporary Chairman."

"Harriet, I am very proud of you and glad you are involved. Can you stay for lunch? I'll be out of my meeting in time for lunch."

"Oh, your meeting. No. I want to stop by Glen Leven and tell Mary my good news."

"Give the Thompsons my greeting." Harriet was out the front door as John was speaking.

The organizational meeting for the National Daughters of the Confederacy was a great success. About thirty delegates attended the September 10th meeting at the Bivouac. In addition to her responsibilities, Harriet signed the original charter of the NDC and graciously provided a red rose for each delegate. The local newspaper reported that the delegation selected a name, adopted a charter, and established a working constitution. Most importantly to the Nashville ladies, the Nashville chapter of the NDC would always be known as Number 1. Ten days later they filed a charter for incorporation with Davidson County.

A year later, meeting in Atlanta, the organization name was changed to United Daughters of the Confederacy. The name change made little difference to the ladies of Number 1, who referred to themselves as the "mother chapter."

John was thumbing through some back issues of the *Weekly* when Harriet came to breakfast.

"Good morning. Did you find anything interesting in those old issues of the *Weekly?*" He responded, "The editors are still trying to find someone to blame for the market crash of '93."

"That's old news. I have some newer issues of the paper, if you want to read them."

"I was reading about a fellow up in Pennsylvania who is producing a sweet chocolate slab."

"What do you mean by a slab?" She questioned. John handed her the paper.

"It's a rectangular shape. Something like a brick."

"That's a big piece of chocolate." Harriet laughed.

" I don't think the slab is as thick as a brick. I'll just wire this candy maker, Hershey, and have him send me a sample for the hotel."

"When it comes, I want to see it. John, you remember we are having a special guest for dinner tomorrow evening. I've also invited the Dickinsons, the Thompsons, the Leas, and hopefully, May will join us. I need you home early tomorrow. I don't want my sister Mary and me here alone with that Yankee."

"Now Harriet, I thought we agreed a long time ago to put the past behind us."

"Well, John Overton, apparently, we still disagree. What can you tell me about this Taft fellow?"

"The gentleman's name is Judge William Howard Taft. He is the former Solicitor General of the United States and currently is a judge on the United States Court of Appeals for the Sixth Circuit."

"If you are late, I may yet shoot a Yankee." She tried to look serious but broke into laughter.

"I will be here on time, hopefully, to prevent another war."

The next evening, Judge Taft arrived early. He was aware of the history of Travellers Rest and was hoping to learn more about Judge John Overton. Harriet was informed that Judge Taft had arrived. *Where is John? He told me he would be here on time. Now I'm left here with this Yankee.* When she stepped on the gallery, she saw the Judge looking around the property and staring at each stack of cannonballs.

"Good evening, madam. My name is Howard Taft. Who might you be?" He tipped his top hat and offered a small bow. Harriet was fuming inside. As she walked down the gallery, her only thought was, *Where is that John Overton? I'm going to skin him alive!*

"May I inquire as to these cannonballs?" Harriet moved down the steps and picked off the top ball on the pyramid, placing it in the Judge's hand. Mary watched the scene from the window of the large room.

"These, sir, were shot at me hot, but I'm giving you one cold! My name is Mrs. John Overton. Please come in." The Judge carried the ball with him. Harriet was just finishing the introductions of the Thompsons and May when John arrived. He did not need to ask how Harriet was doing. He could see in her eyes.

"Judge Taft, this is my husband John Overton. We call his father Judge Overton and him Colonel Overton of the Confederate Army. The Colonel rode with General John Bell Hood."

"That's John Overton, sir. We are delighted to have you at Travellers Rest." John was surprised to see the cannonball and, therefore, did not extend his hand. He looked at Harriet. She had a sheepish grin on her face.

"Harriet, perhaps the Judge would like to see the house and hear some of its history."

"Good. I'll wait for our other guests to arrive while you escort him through the house. Be sure you tell him about the west side of the house."

"Judge, if you will, follow me. Let me put that cannonball on the table with your hat." Returning to the large room after a brief tour, the Judge spotted the Confederate flag displayed between the windows.

"Mr. Overton, what does that flag represent?" The question hung heavy in the room. The silence was deafening. All eyes turned to Harriet. John closed his eyes and waited.

"Sir, that is the flag of my country!" Harriet had turned and faced the Judge. "It will hang there proudly as long as there is breath in my body. Then I will be buried with that flag wrapped around me." Harriet's impassioned monologue bounced off the walls until the room was silent again. All eyes, this time, were fixed on Judge Taft. Silence.

"Please," Harriet commanded, "come to the table. Judge, you are seated next to the Colonel." The Judge was in full view of the flag throughout the evening. Periodically, John glanced at Harriet, seated in her usual place, at the far end of the table. Each time their eyes met, she was smiling. At the last light of day, Judge Taft stood and offered a final toast of the evening.

"I offer my gratitude to one and all for this splendid event and meaningful conversation. Moreover, a special thanks to Harriet, whose courage for living is an inspiration to us all." The sound of clinking glasses filled the room. Judge Taft walked to his carriage, holding his top hat in one hand and a cannonball in the other. Harriet smiled at her guests as they parted, but her thought was on the Judge. *That man is a true politician, if I ever met one. With a little bit of help, he could be President of the United States.*

That night, as she was waiting for sleep to come, she practiced what Dr. McNeilly had said in his sermon the previous Sunday: "we need to take time to count our blessings." Her thoughts began with John. *We have been married 45 years, and he is still the love of my life. I have given birth to six children and all of them are still alive. One is even living in my home. I survived a terrible war. I have lived long enough to see our soldiers properly honored. I am blessed with . . . .* Her sleep was rewarding and she greeted the next day with vigor.

John turned the daily management of the Maxwell House over to a trusted young man. Other than dining every Sunday, he only made one trip a week to the hotel. He was pleased with its progress and was satisfied it was in good management hands. At least once a week he rode down to the horse farm managed by May. Often he found Jesse and Robert there. His three sons were always eager to show him their latest purchase or discuss business matters. He followed a rule of business with his sons that his father had taught him. As a ten-year-old lad heading off to New Orleans to experience the world, the Judge told him, "Never give advice unless it is requested." When he felt good, he stopped by Glen Leven to visit with Mary. He enjoyed her company and

seeing the grandchildren was an extra bonus. Mary and John had seven children, ranging in age from sixteen to three years old.

The Glen Leven church was growing in membership. More houses were being built in the community, as Nashville expanded in all directions. John's leadership at church was in the background, and Dr. McNeilly counted on his support and encouragement. Harriet's contribution was more visible. She arranged for flowers to be in the church each Sunday. When the flowers did not come from Travellers Rest and her greenhouse, she personally contacted other ladies in the membership to provide them. One Sunday after church, Harriet felt a tug on her dress. Her granddaughter, Harriet Maxwell Thompson, was standing behind her.

"Grandmother, Mother needs to talk with you. She's gone to the carriage to tend to Elizabeth."

"Tell her I'll be right out." Harriet whispered to John and then went to find Mary.

"Hello, Mary." Harriet touched the side of Elizabeth's face and then patted her on the arm. "Harriet said you wanted to see me."

"Could you ride with us to the hotel?" Mary's question puzzled Harriet.

"Yes, let me tell your father." When she returned, Mary Hamilton, the oldest Thompson child, had joined her mother and two sisters. All were situated in the carriage and they left for the hotel.

"Well, tell me, Mary Hamilton and Harriet, how are you doing at the Academy?"

"Very well, thank you."

"Did you know I went to the Academy when I was your age?"

"Mother told us you finished early. You were only fifteen years old."

"My two sisters, Annie and Mary, also went to the Academy."

"Mother," Mary shifted Elizabeth in her lap. "A week or so ago Father stopped by Glen Leven for a visit. While he was there, he had some kind of spell and fell on the floor. It took the three of us to get him into a chair."

"What are you saying?"

"I'm saying, Father is not well. He needs to see a doctor. I've already talked to Jesse, Robert, and May." Harriet was silent.

"Grandmother, I saw Grandfather at church this morning, and he seemed to be having a problem with his breathing. As I was talking to him, he had a hard time focusing on me and was holding his chest."

"Mary, your father has not said a word of any of this to me."

"He doesn't want to worry you. He swore us to secrecy about the fall."

"Your father is seventy-four, soon to be seventy-five years old. These things happen to older people."

"Mother! That reasoning is not acceptable. His body is bowed. His steps are tottering. He is falling. His condition is feeble."

"He will never agree to see a doctor."

"We . . . you . . . must do something."

"Suppose I suggest we go to Bon Air."

"Good, that will be a start. The rest and fresh air will do you both good. You know if he stays at the plantation, he will continue to work."

"You're right, Mary. Old age has reached your father so gradually; I did not notice his condition."

The time spent at Bon Air did wonders for John and Harriet. The fresh air and change in environment allowed them to laugh and reminisce. Harriet heard, for the first time, some of his wartime experiences. She dug into her memory and talked about her feelings of being alone after the birth of Jesse. They both recalled and shared stories of their childhood experiences that neither had ever heard. Harriet broached the subject of their health but got no response from John. There were small pockets of his life he did not share, and health was one of them.

"Harriet, tomorrow is the last Sunday in the month. Next Sunday will be Holy Communion at church. I really need to be there to help. It's my duty."

"I know. That's important to you. We will leave here midweek." Harriet did not fault John nor try to change his mind. He had been overly patient in staying as long as he did. She was happy for the slow pace of daily activities.

"John, how would you like to have a big family gathering this fall? We could invite our six children and their families. Maybe John and his family could come in from Memphis."

"Are you serious? I could arrange for a special room at the hotel and talk to the chef."

"No. I mean have everyone at our home. We could use the large room and the gallery. I could assign each family a part of the meal."

"How many people are we talking about?"

"Let's see . . . probably about forty."

"That is quite a family." That evening, Harriet revisited the EVENTS list and realized she needed to add the names of Robert's son and Jesse's daughter:

➤ Robert Lee Overton, Jr. born 1896
➤ Harriet Virginia Maxwell Overton born 1897

As she closed the Bible, Harriet thought about John's words, *That is quite a family.*

# 31. Well Done John and Harriet

The Overton family gathered for the celebration. Little did they realize at the time that this would be the last happy occasion for the entire family. Harriet arranged for John to sit in his favorite rocking chair on the gallery. He was at the center of all the activities. He greeted each family member, but he needed help remembering some of the grandchildren's names. At some point during the day, each of his seven children sat by his side for a private conversation. The children recalled events from their past and were thrilled to hear their father's hearty laugh. Harriet was never far from John throughout the whole day. Martha sat on the bench next to her mother. May pulled up a chair and joined them.

"Mama," Martha asked, "how do you think Father is doing?" Harriet glanced away, composing herself. May answered.

"Martha, two days ago Claiborne found Father on the floor in the barn. He was trying to get on his horse and apparently lost his balance. The horse was spooked and bolted out of the barn. It was early in the day, and I had not yet gone to the horse farm. Claiborne and I had to carry Father from the barn to the house."

"Your father," Harriet added, "is losing ground. It started when we returned from Bon Air. He does not sleep soundly. He shuffles his feet when he walks. His breathing is very labored. He gasps for breath when he walks from the bedchamber to the dining room."

"Oh, Mama, what can I do? What does his doctor say?"

"Your father's heart is not strong. His memory comes and goes. His body is just wearing out. His doctor gave him some powder to help him sleep. He has spurts of energy. Last week May and I took him in the carriage over to Mayfield. His mother left a box she wanted buried over there. That box has been in his dresser since her death in 1862. For some reason he remembered it and had an urgent need to carry out his mother's wishes."

"Mama, tell Martha about Dr. McNeilly's visit." May moved his chair closer to his mother and leaned toward her.

"Dr. McNeilly spent about an hour with your father on Tuesday after Communion Sunday. We were having a nice conversation when out of the blue he said, 'Pastor, I was born in this house and soon I will die here.'" Martha gasped and put her hand to her mouth.

"Did he really say that?"

"Yes. I was shocked. Dr. McNeilly was silent. In his next breath, your father said, 'Pastor, did you know General Hood stayed in this house?' He showed him the invitation he received from Mrs. Jefferson Davis to be a pallbearer at the funeral of Jefferson. Your father also told Dr. McNeilly he would no longer be serving Communion at church."

"Father has always considered it his duty to serve Communion to the congregation."

"Yes, I was very surprised at his decision."

"Do you have a plan for his care?"

"Yes. I've turned the small parlor back into a bedchamber. I've hired Archer's grandson Jake to be his companion. He will be with him at all times. In fact, your father calls him Eli." Martha glanced over at her father and saw the young black man sitting in a chair behind him.

"Eli? Wasn't that the name of Father's . . . .?"

"Yes. His body servant was Eli."

The Overton children returned many times during the next several months to visit their father. He enjoyed seeing them and especially the grandchildren. He was confined to his bed most of the time. Each time a daughter left their father's room, she was in tears. The sons shook their heads in sadness. On December 12, Elizabeth was leaving her father's bedside to go find her mother. She turned when she heard him gasp. His arms were slightly raised and his lips moved.

"Mama! Mama, come quickly! Father is . . . ." Harriet and Elizabeth held each other tightly and sobbed. Jake sat on the floor next to the fireplace and felt tears roll down his cheeks, splattering as they hit the wood floor.

"Eli ...uh ... Jake," Harriet extended her hand to help him stand to his feet. "Go tell Claiborne Mr. Overton has passed. Then, ride to Dr. McNeilly's home and tell him about Mr. Overton." He walked to the door, stopped, and moved back toward Harriet. She did not realize he was by her side.

"Mama, I believe Jake wants to say something to you."

"Yes?" Harriet turned to face him.

"Miz Harriet. Mister Overton be a mighty fine man." She could not respond with words but put her arms around him and realized he had verbalized her thoughts. *Mister Overton be a mighty fine man.*

On the day of John Overton's funeral, Dr. McNeilly arrived an hour before the service. He was surprised to find the Knights Templar already there. *I suppose they will escort their friend to the graveyard.* He spent time with each Overton child, beginning with John Junior. He had something affirming to say to each child about their father. He finally found Harriet sitting in a chair next to John's casket. He sat next to her without saying a word. He held her hand, allowing her of compose herself. She handed him an envelope.

"Pastor, this came in the morning mail. Please open it and read the contents." He found a Mourning Card signed by Mrs. Jefferson Davis.

"Can you believe I sent her a Mourning Card just ten days ago?" He smiled and maintained his silence.

Dr. McNeilly gathered the Overton family, opened his Bible, unfolded several sheets of paper, and began.

> It is nearly seventy-eight years since, in this room, began the
> life of a man dear to us all because of his noble character and manifold

deeds of kindness. And now, after long and faithful service to God and man, that life, having passed through many vicissitudes closes amid the old scenes, familiar since childhood. The pilgrimage ends amid the generations of his loved ones, who rise up to perpetuate his name, to cherish his memory, and to extend his influence. And we, who knew him, come today to express our thankfulness to God for the gift of such a man, our witness to his virtues, and our sorrow at his departure.

As he continued, Pastor McNeilly read from the Gospels, summarizing the life of Joseph of Arimathea.

Joseph of Arimathea, a rich man of old, in a critical moment showed himself one of our Lord's truest friends, and used his means to render the last offices of respect and affection for the crucified Redeemer. He came in the extremity of the disciples' poverty and brought just what they needed for the service of the Master. It will be profitable for us to note some of the points of similarity.

1. Joseph was very modest.
2. Joseph was a man of calm, well-poised judgment.
3. Joseph's courage was conspicuous, when the occasion demanded.
4. It is said that Joseph was a good man.
5. Joseph was a just man.

Harriet hung on every word and smiled in agreement. Her tears had been shed for John in private. Her children and friends knew that and were not surprised that she was so strong.

The ride to Mount Olivet was cold but allowed Harriet time to reflect. Each turn of the carriage wheel seemed to flood her mind with thoughts of her life with John. As she looked out the carriage window, she was pleased to see the Knights Templar. *John did the same for many of his friends on many occasions,* she thought. May, Martha, and Mary rode in the carriage with her to the cemetery. They talked, remembered, and told funny stories about John. The winter wind whipped through the crowd as they stood around the gravesite. Harriet looked up the hill toward the Confederate monument, saw a vision of John standing before thousands of people, and heard his voice. The winter cold gave her a chill. On the return trip to Travellers Rest, Harriet requested that Elizabeth, Jesse, and Robert ride with her in the carriage. She tried to create the same memory activity with them, but realized they did not have the time with their father the older three children had experienced. She felt a pang of sadness when she realized they had few stories to remember. She sneezed and pulled her coat close to her throat.

"Mama, are you all right?" Elizabeth, who had no children, was always mothering others. "I hope you're not getting sick. I'll fix you some hot herb tea when we get home and then you can go to bed. You need rest."

"Lizzie, I'll be fine."

"I'm planning to stay with you for a few days until you get stronger. I've already talked to the others and they agree."

"You really don't need to stay."

"Mama," Jesse interrupted the conversation. Harriet was happy for him to change the subject. "Judge Lea handed me a copy of Father's Last Will and Testament. He said there were no surprises in his wishes. The Judge will wait to hear from you before proceeding."

"Thank you, Jesse, I'll send him a note soon. Is there anything of your father's you boys would like to have?"

"Mama, we can do that later. Right now, we are concerned about you. We'll come back soon and talk."

"That will be fine."

Harriet was pleased to find John Junior standing by the fireplace in the room where his father had died just days before. He was looking at the program from the Reunion of the United Confederate Veterans. It was addressed to Harriet Overton and signed by J. B. Morgan. John returned the program to the table.

"John, thank you for coming to the house. We've not had much time to talk about . . . ."

"Mother." Harriet was surprised. "Grandmother Overton would never allow me to call you Mother, but it now feels so natural."

"It does for me as well. In recent years my children have called me Mama." John did not react, but continued.

"I need to tell you something. The last time I was here, Father took me to the train station. The last thing he said to me was, 'Son, I doubt whether I shall ever see you again in this world. I am quite old and am growing very feeble. But whatever may come, I want to say to you, that as to my future, I not only think, but I know it is all well with me.'"

"That sounds like your father. He was a mighty fine man. John, would you mind throwing another log on that fire? All of a sudden, I'm very cold."

"Would you consider coming back to Memphis with me? The winter is somewhat milder there."

"I appreciate the offer, but I have a plantation to run. It's time to butcher, and spring planting is just around the corner."

"You know, Mother, you are always welcome to come. My home is your home." Harriet stood. She still had John's will in her pocket.

"I'm going to the kitchen and get some herb tea. Would you like some?"

"No, thank you."

"John, this is your father's Last Will and Testament. I want you to read it, and then I want to talk to you about it." She went toward the kitchen and saw Elizabeth coming toward her with a tray.

"Mama, get out of this cold! You are going to catch pneumonia."

"Lizzie, one does not catch pneumonia; one takes pneumonia."

"Whatever. I brought a cup for John, if he wants some tea. After your visit, you need to get to bed."

"Yes ma'am, Miss Nightingale." Harriet returned to the room with the tray.

"Elizabeth has prepared tea for us. Unless your father changed his mind in the last year, my understanding of his final wishes are correct."

"Father was very generous."

"I plan for Judge Lea to be here when you read the Last Will and Testament to the other children in about two weeks. You will need to come back for the reading, since you are the Executor. I know you're on a schedule, but I have one additional offer. If there is anything of your father's you would like to have, let me know, and I will see that it is kept safe."

"There is only one thing. I would like to have the gloves he wore during the war."

"I will need to find them, but be assured they will be saved for you."

"I really do need to go, so I won't miss my train."

"Very well. I will have Eli ... I mean, Jake, take you to the station."

"You mean . . . Eli is . . . ." Harriet laughed.

"No. We have a new Eli. His name is really Jake, but your father called him Eli."

May spent most of the next morning gathering his father's things from around the house—clothes, shoes, shaving equipment, and his private stash of tobacco products. Harriet interrupted the gathering.

"May, I want to keep your father's tall leather boots and his black suit. You can put those on my bed. The rest you can offer to your brothers or take them down to the cabins for the workers. I appreciate you doing this task for me. I was dreading having to go through his things. Would you check upstairs in the storage room for any old trunks?"

"What do you want me to do with his riding horse? I could take him down to the stud farm."

"No, leave him here. Is he the type of horse that could pull Claiborne's milk wagon?"

"You mean the wagon Claiborne takes to the Maxwell?"

"Yes."

"Yes, the horse could pull the wagon."

"Is it tame enough for the grandsons to ride?"

"Well, yes, they could manage with some training."

"May, do you and the children like living here? Does it feel like home?"

"Mama, Travellers Rest will always be my home. No matter who lives here in the future, it will always be my home."

"I needed to hear that from you. I'm glad. By the way, I've invited your brothers and sisters to come here two weeks from today to hear your father's Last Will and Testament read. John Junior is coming back from Memphis."

Harriet could not detect any tension in the room when her children gathered. They were seated around the table in the large room. Judge Lea was directed to the chair usually occupied by John Overton.

"Children, please be seated. I have invited you here today to hear the Last Will and Testament of your father. You need to know, I allowed John Junior the opportunity to read the document while he was here for the funeral. He is the Executor of your father's wishes. I invited the Judge to answer any questions you may have. John, if you are ready."

"Thank you, Mother." Martha looked at May and then at her mother. Harriet was smiling.

"The document is rather curt and pointed. It reflects our father at his best." Harriet began coughing.

"Excuse me, John. Lizzie, will you please pour me a glass of water?"

"Mama, it sounds like your condition has worsened rather than getting better. I will be taking you to your doctor tomorrow."

"We can talk about it later. Please continue, John."

"As I was saying, our father was very pointed in his wishes." He unfolded a surveyor's map detailing the Overton property. "Everything will be in Mother's name. At her demise, the map shows the division of the Overton property into sections. There is a provision for May and Robert to pay Jesse cash to equalize his smaller section." Harriet coughed deeply several times. The map was passed around the table and finally came back to John. "I'll be asking the Judge to advise me about paying for Father's funeral expenses and other bills that may be presented. There are three other matters I would like to mention. First, Father put me in charge of the Memphis property some years ago. I will continue to provide a yearly accounting to our Mother." Martha squirmed in her chair and then stood.

"John, why do you consistently refer to Mama as your Mother?" She sat down in a huff. John looked at Harriet, and she nodded.

"Martha, that was the third thing I was planning to say, but I can tell all of you now. Your mother came into my life when I was about eight years old. I never knew my birth mother. She died when I was an infant. Your mother was my tutor. Our grandmother Overton ordered me to refer to my tutor as Miss Maxwell. Your mother loved me more than a student. I watched each of you being loved by her as children, and I still observe that love today. After Father died, I asked her if I could call her Mother. She suggested Mama, but I want to keep it at Mother. I . . . ."

"I for one," May looked straight at Martha, "have no problem with how you address Mama. The bond you have with Mama is between the two of you."

"Martha," John was standing, "I would never want to offend you in any way, and if I have, I apologize."

"No apology is needed from you, John." May did not take his eyes off of Martha. Harriet had seen this exchange so many times between these two as children. She knew what was coming.

"John," Martha was composed, "I simply wanted an explanation and you gave me one. I'm satisfied. Thank you. I believe you have a third point to discuss."

"Yes, I do. Thank you, Martha. I'm leaving a statement with Judge Lea to the effect, that I relinquish all legal rights to our Mother's Last Will and Testament. At the appropriate time, many years from now, the section of land given to me by our father will be divided among the six of you.

"Children, all seven of you, if you will excuse us, I have business with the Judge."

"Yes, Mama." Martha spoke for her siblings and led them out of the room.

"Judge," Harriet was still holding her glass of water, "I need to talk to you about my Last Will and Testament. I also have one other concern." He took pen in hand and removed several sheets of paper from his folder. "I have written out my wishes." She handed the paper to the Judge. "I am in agreement with John's wishes. In addition, I want any money from Bon Air to go for the education of May's children. Funds from the Maxwell House are to be used for Mary Maxwell and Ann Claiborne. Certain items in the house I have assigned to various individuals." The Judge was scanning the page as Harriet spoke.

"You have been very specific. This is excellent."

"When I pass, I want my funeral in this house. I want to be presented wrapped in that flag." Harriet pointed between the large windows. "I want the Bivouac to escort me to Mount Olivet and place me next to John."

"Harriet, is that the Frank Cheatham Bivouac?"

"Yes."

"You really don't need to put your final arrangements in the document."

"Judge, those are my wishes. I would like to have a personal copy of the document in addition to the original."

"I will see to it within the next couple of days. I'll also add John Junior's wishes."

Harriet walked the Judge to the door and closed it behind him. She walked through the small parlor on her way to her bedchamber. Lizzie and Martha were sitting on the sofa. Harriet focused a motherly glare on Martha.

"Now that that is over, let's talk about your health, Mama."

"What about my health, Martha?"

"Elizabeth will be taking you to your doctor tomorrow. You must do something about your cough."

"You are very demanding."

"Yes, I am. I wonder where I learned that. Do you want me to stomp my foot?" The question caused all three ladies to laugh and broke the tension in the room.

"What time should I be ready?" Martha and Elizabeth smiled at each other and breathed a sigh of relief.

The next day when the carriage arrived, Harriet was looking through the window of her bedchamber. *I thought Lizzie was taking me to the doctor. I guess Martha wanted to make certain I'd get there.*

"Good morning, Martha. Good morning, Elizabeth."

"Good morning, Mama, I trust you slept well." Martha helped her mother into the carriage. "Mama, about yesterday and John."

"I want to say one thing about yesterday, and then the subject will be closed. I was proud of you. You had a concern and you expressed it. You also witnessed a true southern gentleman in action." Elizabeth could not believe what she was hearing. "Now, let's talk about this morning's appointment."

"What needs to be said?"

"Well, Lizzie, I know you and Martha will want to hear what the doctor tells me. So at the appropriate time I will invite both of you into his office. However, first I will talk with him privately."

"Yes, ma'am, I understand." Harriet covered her mouth to block a cough she knew was coming.

Harriet's report was not good, as the daughters had suspected. In fact, it was much worse than expected. The coughing, the chills, the sore throat, the fever—all pointed to influenza. The doctor mentioned that the next stage could be pneumonia. Elizabeth nodded and looked at her mother.

"I suggest your mother get plenty of fresh air and rest."

"Doctor," Martha quizzed, "Won't the cold air of February aggravate her condition and bring on pneumonia?"

"Yes, but she has a suggestion." Martha and Elizabeth turned to their mother with questioning looks.

"I will take a couple of the servants and go to Pass Christian for several months. When the weather warms up in Nashville, I'll come home."

"Mama, in addition to your plans, Lizzie, Hugh, Jacob, and I will be going with you. We can stop by Jacob's office now and he can make our reservations."

"I'd suggest," the doctor added, "you not delay the trip. The sooner you get to a warmer climate, the faster you will recover."

Two days later, May helped load the bags and trunks onto the wagon and sent it on to the depot. He helped his mother and two servants into the carriage and was about to close the door when Harriet said, "May, you have always been a good son. I want you to take care of Travellers Rest."

"Yes, Mama." He noticed a tone of finality in her voice."

"Get out of this freezing weather. I don't want you taking a chill." He waved as he backed away from the carriage.

"Get well, Mama. I love you." He saw her wave and smile as the carriage pulled away. Back inside the house he noticed the Overton Family Bible was open and the sheet of paper with the heading OVERTON FAMILY EVENTS:

> Mary White May died 1898
> John Overton, Senior died at Travellers Rest on December 12, 1898

May recognized his Mama's handwriting. He smiled as he straightened the pages and closed the Bible.

The train ride to New Orleans was tiring for all in the party, especially Harriet. She could not eat, fearing that the motion of the train would make her sick to her stomach. Rest was impossible. Elizabeth encouraged her to close her eyes, but she would not. Jacob had arranged to have carriages waiting in New Orleans to transport the party to Pass Christian. They were there when the party arrived, but Martha insisted they rest a couple of days before going on. It was apparent to Martha and Elizabeth that their mama was not improving. The medicine she was taking was not easing her coughing nor preventing her chills. Harriet felt miserable, and the look on her face was proof. Martha asked the hotel manager about finding a doctor for her.

"Ma'am, it's impossible to find a doctor on Saturday and Sunday in this town. However, I will continue to inquire. And your mother's name?"

"Her name is Mrs. John Overton."

"The Mrs. John Overton of Nashville and The Maxwell House?"

"Yes. In fact, the hotel was named for her. Does that make a difference in finding a doctor?"

"I will do my very best to locate one for Mrs. Overton."

"Thank you, sir. I will appreciate any help you can give us." The manager asked several of his employees if they knew of an available doctor. He had no success. He was nowhere to be found on Monday morning when the Overton party checked out and left for Pass Christian. However, there was no charge for their stay in the hotel.

The slight breeze off the Gulf of Mexico was a pleasant change from the cold winter winds of Nashville. Martha helped her mama into sleeping clothes.

"Mama, I want you to rest every second you can. Elizabeth and I will check on you. When you are hungry, we will get you some food. The servant will stay with you. I'll open the windows to let lots of fresh air into your room. You rest now." Martha kissed her on the forehead.

"Thank you for everything, Martha." Harriet's breathing was labored and shallow. Elizabeth was standing outside the door.

"How is she, Martha?"

"Mama is very sick."

"Can you or Hugh get a wire back to May? Tell him we have arrived and mama is very sick. Ask him to get the message to Mary, Jesse, Robert, and John."

"We will do that. I'll go right now."

"I'm going to take Jacob and try to find a doctor for her. When you get back, check on Mama and make certain she takes her medicine and gets plenty to drink."

"Martha, do you think . . . think Mama . . . is . . . ."

"I don't really know. You know Mama; she is always in charge. If she wants to . . . to . . . she will."

In two hours, Martha was back with a local doctor. Elizabeth was sitting in a chair outside Harriet's room.

"Elizabeth, this is Dr. Marks. Dr. Marks, this is my sister, Mrs. Craighead. How is Mama doing?"

"She has been sleeping, but her breathing is very heavy."

"Dr. Marks," Martha used her in-charge voice, "the doctor in Nashville mentioned something about *la grippe*. Are you familiar with that condition?"

"I've read about it and know the symptoms but have not really seen a case." Harriet was awake when the doctor approached her.

"Mama, this is Dr. Marks. He has come to help you. He's going to examine you." Harriet smiled at her youngest daughter and then closed her eyes.

"Mrs. Overton, do you hurt anywhere?" She lifted her hand and pointed to her head.

"Can you breathe deeply for me?" Harriet shook her head. Dr. Marks moved away from the bedside and looked at Harriet. He went to the door and motioned for Martha and Elizabeth to follow.

"You mother is very sick. She has all the classic symptoms of influenza or *la grippe*. Her pulse is high, but her shallow breathing causes that. There is a rattle sound in her chest. That suggests pneumonia. The medicine she is taking is correct, but it is working slowly. Keep fresh air in her room. She needs to eat. You need to force liquids into her."

"What else can we do?" Martha's voice was very soft, almost a whisper.

"Is your mother a fighter?"

"What do you mean?"

"Does she have the will to live? The medicine will help, but she must want to live."

"Dr. Marks, I wish I knew the answer to your question."

"I'm going to New Orleans for a few days of training. I'll ask about *la grippe*. I should be back here by Sunday evening. I'll drop by and check on Mrs. Overton. Encourage your mother to fight for her life."

The next evening, Martha had dinner brought to Harriet. Elizabeth propped her mother up in bed.

"Mama, you need to eat to get your strength back."

"Lizzie, nothing tastes good. Maybe I can eat some bread soaked in the broth."

"I will fix all you want to eat."

"What day of the week is it?"

"Today is Saturday, the eighteenth day of February. We were so busy in January, we forgot to celebrate your birthday. Maybe we'll just have your birthday tomorrow with a cake and punch."

"I think sixty-seven years is long enough to live, don't you?" Elizabeth dropped the spoon in the bowl and watched the broth spill over the side. Martha looked up from her book.

"Mama, don't talk like that. You haven't even reached your three score and ten yet. You always taught us it takes courage for living."

"Lizzie, it does take courage for living, but it also takes courage for dying. Remember all our brave young soldiers who had the courage for dying? Anyway, your father is waiting for me over there, and I must go to him." Harriet lifted her hand and pointed to the window.

"Over where?" Martha stood and moved her chair closer to the bed. Harriet prattled on about unrelated subjects. Part of the time, she was back at the Hall with her sisters. The next minute she was on a paddleboat going down the Mississippi River. Beads of perspiration formed on her forehead. Elizabeth placed a cool cloth on her Mama's forehead. Harriet closed her eyes and was silent. Martha lifted the light cover to see whether Harriet was still breathing. Thirty-five minutes passed.

"Girls! Harriet was wideawake. "I want you to wrap me in the flag and lay me next to your father." Martha and Elizabeth moved to the foot of the bed and stood watching their mother.

"What flag?" Martha was trying to be brave and hold back her tears.

"My flag in the large room."

"Oh, your flag at home."

"Yes, my flag in the next room."

"Mama, where are you right now?" Elizabeth felt her mama was losing her grasp on reality.

"I'm in my bedchamber. What are you doing here?"

"It's time for your medicine." Martha's hand trembled as she directed the spoon toward her mama's mouth.

"Thank you, John. I must take my rest now." Martha's eyes were full of tears as she turned away from the bed. Elizabeth went to her and they held each other for several minutes.

Martha tried to sleep in the early hours of Sunday. She was restless. Jacob held her close, hoping she would doze, but she didn't. Her tears soaked his sleeping shirt. Elizabeth was having a similar experience in the next room.

In the morning when they entered Harriet's room, the servant was raising the window.

"How was her night?" Martha questioned in a soft voice.

"Miz Overton have a fretful sleep. She be talking to John somebody. She be sleeping sound fer about two hours."

"Mrs. Craighead and I will take over now. You may go have breakfast and rest. We'll come get you if we need you."

"Ya, ma'am."

"Tell the cook to send in some breakfast. We'll need some oats, warm bread, and herb tea."

"Ya, ma'am."

Elizabeth pushed open the second window to bring in the fresh air. Martha dropped a fresh towel into the basin of water on the washstand. They both heard her gasp for air and turned toward her. Elizabeth put her hand on her Mama's arm and shook her gently. Harriet did not respond. She repeated the action with a little more force. Harriet was peaceful—at last.

"Oh, Mama! Please wake up! Please wake up!" Elizabeth was sobbing.

"Mama has passed, Elizabeth. She is happy now—no more pain and suffering. But best of all, she's with Father." Martha guided Elizabeth to a chair near the bed. She tried to cry, but no tears came.

"Elizabeth, you stay here. I'm going to get Jacob."

By the time Dr. Marks arrived in the afternoon for his promised visit, all arrangements had been made to take Harriet home. The sheriff and undertaker had arrived and took Harriet's body to be prepared for the trip back to Nashville. Jacob had sent a wire to May earlier telling him of Harriet's death. He was busy the rest of the morning making travel arrangements for the family.

May waited in the church parking lot for the morning service to end. His heavy winter coat felt good as he looked over the crowd to find Mary, Jesse, and Robert. As he approached his sister, he removed his hat, revealing the tears in his eyes.

"Mary, Mama . . . " May could not complete the sentence. Mary's Bible and purse fell to the ground as she grabbed May.

"May, what's wrong! What about Mama?" May buried his face into her coat. The next word she heard was not what she was expecting.

"Mama's dead." Mary held May's face in her hands and shook him.

"What did you say?!" Jesse and Robert reached May and Mary at the same time. May handed the wire to Jesse. He read it and removed his hat, burying his face in it. Mary turned from May to Robert.

"Robert, Mama is dead." He stood there in shock not knowing what to do or say. Mary, like her Mama, was a lady of action. She had not shed a tear. She was giving orders.

"May, find all the family and get them back into the church. I need to find John and Pastor McNeilly." Slowly, one by one, the family gathered and sat in the front pews. The Overton men had composed themselves, but not Mary. The crisis of the moment had passed and her grief began. John held her close as Pastor McNeilly spoke.

"Her children rise up and call her blessed." Pastor McNeilly's head was shaking as he prayed. "We have not completed our grieving for John Overton. Now our grieving is doubled. Harriet Overton—mother, grandmother, and

friend—has passed from this life into the next. Lord, we are sad at the news. Help us in our time of need." After the amen, Mary stood and faced her relatives. She dabbed her eyes with a handkerchief.

"May, you will need to tell your children and the servants of Mama's death. Jesse, you will need to find the Dickinson children and inform them."

"What about John in Memphis and Judge Lea?" Robert was speaking through his sniffles.

"Robert, you make those contacts. You need to send a wire also to the Brinkleys in Memphis."

"I can do that."

"Dr. McNeilly, I will contact you as soon as Martha and Elizabeth arrive. We will want to have Mama's service at Travellers Rest."

News of Harriet's sudden death reached far and wide. Newspapers throughout Tennessee reprinted her obituary from the Nashville newspapers. Resolutions of respect to her memory came from the Legislature of Tennessee, the Colonial Dames of America, the Ladies' Hermitage Association, the United Daughters of the Confederacy, the Frank Cheatham Bivouac, and scores of others.

On February 21, Dr. McNeilly stood in the same spot at Travellers Rest where, sixty-seven days earlier, he had stood to face the same audience, minus one.

> The making of a real home is one of the noblest and most blessed works ever wrought by human effort on this earth.

Smiles came to the faces of the Overton children.

> There can be no nobler nor holier sphere for the exercise of all womanly gifts and graces than the home.

Dr. McNeilly paused and turned to look at the flag-wrapped body.

> Today we come to pay our tribute and love and tears to the blessed memory of one who filled up the measure of her duty in this glorious sphere of womanhood. Mrs. Harriet Maxwell Overton had no ambition beyond being a true wife and mother. It was her constant effort to make the home and the family life sweet and pure—

He flipped through his Bible, stopping at Proverbs 31, and read, "Who can find a virtuous woman?" After reading through verses 10-31, he began to answer the question relating it to the life of Harriet.

1. The first thing that gave her influence was her practical common sense.
2. Another striking trait of her character was her enthusiasm.
3. Mrs. Overton was sincere.
4. She was thoroughly conscientious.
5. Again we saw in her a remarkable spirit of kindness.
6. One other thing noticeable in her disposition was her religious spirit.

Dr. McNeilly's words echoed throughout the house, seeking every space where Harriet had lived for so many years. He invited the family to view Harriet's body before the lid was closed for the final time. Martha rearranged the Confederate flag, making certain the bar and stars crossed her Mama's heart.

Outside, members of the Bivouac lined up to receive the casket. There was no shortage of gray uniforms and Confederate flags in the processional to Mount Olivet. As the wagon, holding the casket, traveled on Franklin Pike, it passed a group of gray-haired men standing at attention with their hands over their hearts. At another place near the Glen Leven church, a horn was heard playing *Dixie*. A large crowd had gathered at the cemetery to pay their final respects. Harriet's casket was lowered into the ground as the Overton children fulfilled their Mama's final wish. No sooner had Dr. McNeilly spoken his final amen than the February crisp air was filled with the distinctive cry of the Rebel Yell. Martha glanced up toward the statue of the Confederate soldier and thought, *What a fitting tribute to a noble lady, whose courage for living will long be remembered and duplicated in the generations to come.*

Months after Harriet's death and funeral, Robert stopped by Travellers Rest to visit his brother. May was on the gallery, holding the Overton Bible in his lap.

"Robert, have you ever seen Mama's record of OVERTON EVENTS?"

"I'm not sure what you're talking about." May handed him the pages. Robert smiled as he read his name and the names of his children. "It's not complete."

"What needs to be added?" Robert went into the house and returned with a quill and ink.

"I need to add the name of our new son."

> ➢ Perkins Baxter Overton born 1899

"Robert, why don't you add Mama's name, and the list will be complete?" He wrote:

> ➢ Harriet Virginia Maxwell Overton died at Pass Christian,
>    Mississippi, on February 19, 1899

May took the pages, straightened them, placed them in the Bible, closed the cover, and said, "Done!"

# Epilogue

One of the final tributes to Harriet came from the Colonial Dames of America.

*Whereas*, God in his wise providence has taken from our midst Mrs. Harriet M. Overton, an esteemed member of this society; whose sudden and unexpected death was an event deeply deplored by us. Now, therefore, in order to give expression to our respect for her memory, and our grief for her loss,

*Resolved*, that this society, with the community at large, feel most keenly her death; that her charities and good offices were wisely distributed; and that her life, filled with good deeds, was a noble example of true womanhood to those who survive her, and a beautiful heritage left to her sorrowing children.

*Resolved*, that a copy of these resolutions be sent by the secretary to her family.

Mrs. W. D. Gale, President.

Mrs. J. C. Bradford.

Secretary of the National Society of Colonial Dames in the state of Tennessee

Fifty-five years after Harriet's death, the Colonial Dames of America in Tennessee graciously honored her again by turning her home, Travellers Rest, into a museum. Today you can visit the very place where Harriet committed her life to John Overton, birthed and nurtured their children, withstood the impact of the Civil War in her backyard, and, on occasions, stomped her foot.

… till death do us part.

CPSIA information can be obtained at www.ICGtesting.com
Printed in the USA
LVOW081959240911

247655LV00001B/5/P